Digital Watermarking

The Morgan Kaufmann Series in Multimedia Information and Systems
Series Editor, Edward Fox

Digital Watermarking

Ingemar J. Cox

Matthew L. Miller

Jeffrey A. Bloom

MORGAN KAUFMANN PUBLISHERS

AN IMPRINT OF ACADEMIC PRESS
A Harcourt Science and Technology Company
SAN FRANCISCO SAN DIEGO NEW YORK BOSTON
LONDON SYDNEY TOKYO

Senior Editor: Rick Adams
Publishing Services Manager: Scott Norton
Assistant Publishing Services Manager: Edward Wade
Associate Production Editor: Marnie Boyd
Assistant Acquisitions Editor: Karyn Johnson
Cover Design: Frances Baca Design
Text Design: Side By Side Studios/Mark Ong
Composition: Interactive Composition Corporation
Technical Illustration: Dartmouth Publishing, Inc.
Copyeditor: Daril Bentley
Proofreader: Ken DellaPenta
Indexer: Bill Meyers
Printer: Courier Corporation

Cover credits: The background image, used here as a watermark, is artwork from the *Hypnerotomachia Poliphili,* a Renaissance work published in 1499 that is renowned for its use of mysterious images and hidden messages. By permission of the Harry Ransom Humanities Research Center, The University of Texas at Austin.

Designations used by companies to distinguish their products are often claimed as trademarks or registered trademarks. In all instances in which Morgan Kaufmann Publishers is aware of a claim, the product names appear in initial capital or all capital letters. Readers, however, should contact the appropriate companies for more complete information regarding trademarks and registration.

DISCLAIMER: The purpose of this book is to provide readers general information about digital watermark technology as of the book's publication date. The authors have included sample code (and other illustrations) of digital watermark technology based on their original work and ideas from existing technology. Neither the authors nor the publisher are aware of any third party patents or proprietary rights that may cover any sample code (or illustrations) in this book; however, the sample code is included AS IS and without any warranty of any kind. The authors and the Publisher DISCLAIM ALL EXPRESS AND IMPLIED WARRANTIES, including warranties of merchantability and fitness for any particular purpose. Your use or reliance upon any sample code or other information in this book will be at your own risk. No one should use any sample code (or illustrations) from this book in any software application without first obtaining competent legal advice.

Morgan Kaufmann Publishers
340 Pine Street, Sixth Floor, San Francisco, CA 94104-3205, USA
http://www.mkp.com

ACADEMIC PRESS
A Harcourt Science and Technology Company
525 B Street, Suite 1900, San Diego, CA 92101-4495, USA
http://www.academicpress.com

Academic Press
Harcourt Place, 32 Jamestown Road, London, NW1 7BY, United Kingdom
http://www.academicpress.com

Library of Congress Control Number: 2001094368
ISBN: 1-55860-714-5

This book is printed on acid-free paper.

This book is dedicated to the memory of

Ingy Cox

Age 12
May 23, 1986 to January 27, 1999

The light that burns twice as bright
burns half as long—
and you have burned so very very brightly.

Eldon Tyrell to Roy Batty in *Blade Runner*.
Screenplay by Hampton Fancher and David Peoples.

Contents

Appendix D: Notation and Common Variables 483

Preface

Watermarking, as we define it, is the practice of hiding a message about an image, audio clip, video clip, or other work of media within that work itself. Although such practices have existed for quite a long time—at least several centuries, if not millennia—the field of *digital* watermarking only gained widespread popularity as a research topic in the latter half of the 1990s. A few earlier books have devoted substantial space to the subject of digital watermarking [135, 104, 128]. However, to our knowledge, this is the first book dealing exclusively with this field.

Purpose

Our goal with this book is to provide a framework in which to conduct research and development of watermarking technology. This book is not intended as a comprehensive survey of the field of watermarking. Rather, it represents our own point of view on the subject. Although we analyze specific examples from the literature, we do so only to the extent that they highlight particular concepts being discussed. (Thus, omissions from the bibliography should not be considered as reflections on the quality of the omitted works.)

Most of the literature on digital watermarking deals with its application to images, audio, and video, and these application areas have developed somewhat independently. This is in part because each medium has unique characteristics, and researchers seldom have expertise in all three. We are no exception, our own backgrounds being predominantly in images and video. Nevertheless, the fundamental principles behind still image, audio, and video watermarking are the same, so we have made an effort to keep our discussion of these principles generic.

The principles of watermarking we discuss are illustrated with several example algorithms and experiments (the C source code is provided in Appendix C). All of these examples are implemented for image watermarking only. We decided to use only image-based examples because, unlike audio or video, images can be easily presented in a book.

The example algorithms are very simple. In general, they are not themselves useful for real watermarking applications. Rather, each algorithm is intended to provide a clear illustration of a specific idea, and the experiments are intended to examine the idea's effect on performance.

The book contains a certain amount of repetition. This was a conscious decision, because we assume that many, if not most, readers will not read the book from cover to cover. Rather, we anticipate that readers will look up topics of interest and read only individual sections or chapters. Thus, if a point is relevant in a number of places, we may briefly repeat it several times. It is hoped that this will not make the book too tedious to read straight through, yet will make it more useful to those who read technical books the way we do.

Content and Organization

Chapters 1 and 2 of this book provide introductory material. Chapter 1 provides a history of watermarking, as well as a discussion of the characteristics that distinguish watermarking from the related fields of data hiding and steganography. Chapter 2 describes a wide variety of applications of digital watermarking and serves as motivation. The applications highlight a variety of sometimes conflicting requirements for watermarking, which are discussed in more detail in the second half of the chapter.

The technical content of this book begins with Chapter 3, which presents several frameworks for modeling watermarking systems. Along the way, we describe, test, and analyze some simple image-watermarking algorithms that illustrate the concepts being discussed. In Chapter 4, these algorithms are extended to carry larger data payloads by means of conventional message-coding techniques. Although these techniques are commonly used in watermarking systems, some recent research suggests that substantially better performance can be achieved by exploiting side information in the encoding process. This is discussed in Chapter 5.

Chapter 6 analyzes message errors, false positives, and false negatives that may occur in watermarking systems. It also introduces whitening.

The next three chapters explore a number of general problems related to fidelity, robustness, and security that arise in designing watermarking systems, and present techniques that can be used to overcome them. Chapter 7 examines the problems of modeling human perception, and of using those models in watermarking systems. Although simple perceptual models for audio and still images are described, perceptual modeling is not the focus of this chapter. Rather,

we focus on how any perceptual model can be used to improve the fidelity of the watermarked content.

Chapter 8 covers techniques for making watermarks survive several types of common degradations, such as filtering, geometric or temporal transformations, and lossy compression.

Chapter 9 describes a framework for analyzing security issues in watermarking systems. It then presents a few types of malicious attacks to which watermarks might be subjected, along with possible countermeasures.

Finally, Chapter 10 covers techniques for using watermarks to verify the integrity of the content in which they are embedded. This includes the area of fragile watermarks, which disappear or become invalid if the watermarked Work is degraded in any way.

Acknowledgments

First, we must thank several people who have directly helped us in making this book. Thanks to Karyn Johnson, Jennifer Mann, and Marnie Boyd of Morgan Kaufmann for their enthusiasm and help with this book. As reviewers, Ton Kalker, Rade Petrovic, Steve Decker, Adnan Alattar, Aaron Birenboim, and Gary Hartwick provided valuable feedback. Harold Stone and Steve Weinstein of NEC also gave us many hours of valuable discussion. And much of our thinking about authentication (Chapter 10) was shaped by a conversation with Dr. Richard Green of the Metropolitan Police Service, Scotland Yard. We also thank M. Gwenael Doerr for his review.

Special thanks, too, to Valerie Tucci, our librarian at NEC, who was invaluable in obtaining many, sometimes obscure, publications. And Karen Hahn for secretarial support. Finally, thanks to Dave Waltz, Mitsuhito Sakaguchi, and NEC Research Institute for providing the resources needed to write this book. It could not have been written otherwise.

We are also grateful to many researchers and engineers who have helped develop our understanding of this field over the last several years. Our work on watermarking began in 1995 thanks to a talk Larry O'Gorman presented at NECI. Joe Kilian, Tom Leighton, and Talal Shamoon were early collaborators. Joe has continued to provide valuable insights and support. Warren Smith has taught us much about high-dimensional geometry. Jont Allen, Jim Flanagan, and Jim Johnston helped us understand auditory perceptual modeling. Thanks also to those at NEC Central Research Labs who worked with us on several watermarking projects: Ryoma Oami, Takahiro Kimoto, Atsushi Murashima, and Naoki Shibata.

Each summer we had the good fortune to have excellent summer students who helped solve some difficult problems. Thanks to Andy McKellips and Min Wu of Princeton University and Ching-Yung Lin of Columbia University. We also had

the good fortune to collaborate with professors Mike Orchard and Stu Schwartz of Princeton University.

We probably learned more about watermarking during our involvment in the request for proposals for watermarking technologies for DVD disks than at any other time. We are therefore grateful to our competitors for pushing us to our limits, especially Jean-Paul Linnartz, Ton Kalker (again), and Maurice Maes of Philips; Geoffrey Rhoads of Digimarc; John Ryan and Patrice Capitant of Macrovision; and Akio Koide, N. Morimoto, Shu Shimizu, Kohichi Kamijoh, and Tadashi Mizutani of IBM (with whom we later collaborated). We are also grateful to the engineers of NEC's PC&C division who worked on hardware implementations for this competition, especially Kazuyoshi Tanaka, Junya Watanabe, Yutaka Wakasu, and Shigeyuki Kurahashi.

Much of our work was conducted while we were employed at Signafy, and we are grateful to several Signafy personnel who helped with the technical challenges: Peter Blicher, Yui Man Lui, Doug Rayner, Jan Edler, and Alan Stein (whose real-time video library is amazing).

We wish also to thank the many others who have helped us out in a variety of ways. A special thanks to Phil Feig—our favorite patent attorney—for filing many of our patent applications with the minimum of overhead. Thanks to Takao Nishitani for supporting our cooperation with NEC's Central Research Labs. Thanks to Kasinath Anupindi, Kelly Feng, and Sanjay Palnitkar for system administration support. Thanks to Jim Philbin, Doug Bercow, Marc Triaureau, Gail Berreitter, and John Anello for making Signafy a fun and functioning place to work. Thanks to Alan Bell, for making CPTWG possible. Thanks to Mitsuhito Sakaguchi (again), who first suggested that we become involved in the CPTWG meetings. Thanks to Shichiro Tsuruta, for managing PC&C's effort during the CPTWG competition, and H. Morito of NEC's semiconductor division. Thanks to Dan Sullivan for the part he played in our collaboration with IBM. Thanks to the DHSG co-chairs who organized the competition: Bob Finger, Jerry Pierce, and Paul Wehrenberg. Thanks also to the many people at the Hollywood studios who provided us with the content owners' perspective: Chris Cookson and Paul Klamer of Warner Brothers, Bob Lambert of Disney, Paul Heimbach and Gary Hartwick of Viacom, Jane Sunderland and David Grant of Fox, David Stebbings of the RIAA, and Paul Egge of the MPAA. Thanks to Christine Podilchuk for her support. It was much appreciated. Thanks to Bill Connolly for interesting discussions. Thanks to John Kulp, Rafael Alonso, the Sarnoff Corporation, and John Manville of Lehman Brothers for their support. And thanks to Vince Gentile, Tom Belton, Susan Kleiner, Ginger Mosier, Tom Nagle, and Cynthia Thorpe.

Finally, we thank our families for their patience and support during this project: Susan and Zoe Cox, Geidre Miller, and Pamela Bloom.

Example Watermarking Systems

In this book, we present a number of example watermarking systems to illustrate and test some of the main points. Discussions of test results provide additional insights and lead to subsequent sections.

Each investigation begins with a preamble. If a new watermarking system is being used, a description of the system is provided. Experimental procedures and results are then described.

The watermark embedders and watermark detectors that make up these systems are given names and are referred to many times throughout the book. The naming convention we use is as follows: All embedder and detector names are written in sans serif font to help set them apart from the other text. Embedder names all start with E_ and are followed by a word or acronym describing one of the main techniques illustrated by an algorithm. Similarly, detector names begin with D_ followed by a word or acronym. For example, the embedder in the first system is named E_BLIND (it is an implementation of blind embedding), and the detector is named D_LC (it is an implementation of linear correlation detection).

Each system used in an investigation consists of an embedder and a detector. In many cases, one or the other of these is shared with several other systems. For example, in Chapter 3, the D_LC detector is paired with the E_BLIND embedder in System 1 and with the E_FIXED_LC embedder in System 2. In subsequent chapters, this same detector appears again in a number of other systems. Each individual embedder and detector is described in detail in the first system in which it is used.

In the following, we list each of the 19 systems described in the text, along with the number of the page on which its description begins, as well as a brief review of the points it is meant to illustrate and how it works. The source code for these systems is provided in Appendix C.

Blind Embedding and Linear Correlation Detection: The blind embedder E_BLIND simply adds a pattern to an image. A reference pattern is scaled by a strength parameter, α, prior to being added to the image. Its sign is dictated by the message being encoded.

The D_LC linear correlation detector calculates the correlation between the received image and the reference pattern. If the magnitude of the correlation is higher than a threshold, the watermark is declared to be present. The message is encoded in the sign of the correlation.

Fixed Linear Correlation Embedder and Linear Correlation Detection: This system uses the same D_LC linear correlation detector as System 1, but introduces a new embedding algorithm that implements a type of informed embedding. Interpreting the cover Work as channel noise that is known, the E_FIXED_LC embedder adjusts the strength of the watermark to compensate for this noise, to ensure that the watermarked Work has a specified linear correlation with the reference pattern.

Block-Based, Blind Embedding, and Correlation Coefficient Detection: This system illustrates the division of watermarking into *media space* and *marking space* by use of an extraction function. It also introduces the use of the correlation coefficient as a detection measure.

The E_BLK_BLIND embedder performs three basic steps. First, a 64-dimensional vector, v_o, is extracted from the unwatermarked image by averaging 8×8 blocks. Second, a reference mark, w_r, is scaled and either added to or subtracted from v_o. This yields a marked vector, v_w. Finally, the difference between v_o and v_w is added to each block in the image, thus ensuring that the extraction process (block averaging), when applied to the resulting image, will yield v_w.

The D_BLK_CC detector extracts a vector from an image by averaging 8×8 pixel blocks. It then compares the resulting 64-dimensional vector, v, against a reference mark using the correlation coefficient.

8-Bit Blind Embedder, 8-Bit Detector: The E_SIMPLE_8 embedder is a version of the E_BLIND embedder modified to embed 8-bit messages. It first constructs a message pattern by adding or subtracting each of eight reference patterns. Each reference pattern denotes one bit, and the sign of the bit determines whether it is added or subtracted. It then multiplies the message pattern by a scaling factor and adds it to the image.

The D_SIMPLE_8 detector correlates the received image against each of the eight reference patterns and uses the sign of each correlation to determine the most likely value for the corresponding bit. This yields the decoded message. The detector does not distinguish between marked and unwatermarked images.

Trellis-Coding Embedder, Viterbi Detector: This system embeds 8-bit messages using trellis-coded modulation. In the E_TRELLIS_8 embedder, the 8-bit message is redundantly encoded as a sequence of symbols drawn from an alphabet of 16 symbols. A message pattern is then constructed by adding together reference patterns representing the symbols in the sequence. The pattern is then embedded with blind embedding.

The D_TRELLIS_8 detector uses a Viterbi decoder to determine the most likely 8-bit message. It does not distinguish between watermarked and unwatermarked images.

Block-Based Trellis-Coding Embedder and Block-Based Viterbi Detector That Detects by Re-encoding: This system illustrates a method of testing for the presence of multi-bit watermarks using the correlation coefficient. The E_BLK_8 embedder is similar to the E_TRELLIS_8 embedder, in that it encodes an 8-bit message with trellis-coded modulation. However, it constructs an 8×8 message mark, which is embedded into the 8×8 average of blocks in the image, in the same way as the E_BLK_BLIND embedder.

The D_BLK_8 detector averages 8×8 blocks and uses a Viterbi decoder to identify the most likely 8-bit message. It then re-encodes that 8-bit message to find the most likely message mark, and tests for that message mark using the correlation coefficient.

Block-Based Watermarks with Fixed Normalized Correlation Embedding: This is a first attempt at informed embedding for normalized correlation detection. Like the E_FIXED_LC embedder, the E_BLK_FIXED_CC embedder aims to ensure a specified detection value. However, experiments with this system show that its robustness is not as high as might be hoped.

The E_BLK_FIXED_CC embedder is based on the E_BLK_BLIND embedder, performing the same basic three steps of extracting a vector from the unwatermarked image, modifying that vector to embed the mark, and then modifying the image so that it will yield the new extracted vector. However, rather than modify the extracted vector by blindly adding or subtracting a reference mark, the E_BLK_FIXED_CC embedder finds the closest point in 64 space that will yield a

specified correlation coefficient with the reference mark. The D_BLK_CC detector used here is the same as in the E_BLK_BLIND/D_BLK_CC system.

Block-Based Watermarks with Fixed Robustness Embedding: This system fixes the difficulty with the E_BLK_FIXED_CC/D_BLK_CC system by trying to obtain a fixed estimate of robustness, rather than a fixed detection value. After extracting a vector from the unwatermarked image, the E_BLK_FIXED_R embedder finds the closest point in 64 space that is likely to lie within the detection region even after a specified amount of noise has been added. The D_BLK_CC detector used here is the same as in the E_BLK_BLIND/D_BLK_CC system.

Dirty-Paper-Coded Watermarks with Fixed Robustness Embedding: With this system, we illustrate informed coding with the use of a *dirty-paper code.* Dirty-paper codes are codes in which many dissimilar vectors represent the same message.

The E_DIRTY_PAPER embedder is essentially the same as the E_BLK_FIXED_R embedder, except that, before modifying the extracted vector, it searches through a set of different reference marks that all represent the same message. The reference mark that already has the highest correlation with the extracted vector is the one that is embedded.

The D_DIRTY_PAPER detector computes the correlation coefficients between an extracted vector and all the reference marks. If the highest correlation coefficient it finds is above a threshold, it declares that the watermark is present. The message is determined according to which reference mark yielded that highest threshold.

Lattice-Coded Watermarks: This illustrates a method of watermarking with dirty-paper codes that can yield much higher data payloads than are practical with the E_DIRTY_PAPER/D_DIRTY_PAPER system. Here, the set of code vectors is not random. Rather, each code vector is a point on a lattice. Each message is represented by all points on a sublattice.

The embedder takes a 345-bit message and applies an error correction code to obtain a sequence of 1,380 bits. It then identifies the sublattice that corresponds to this sequence of bits and quantizes the cover image to find the closest point in that sublattice. Finally, it modifies the image to obtain a watermarked image close to this lattice point.

The detector quantizes its input image to obtain the closest point on the entire lattice. It then identifies the sublattice that contains this point, which corresponds to a sequence of 1,380 bits. Finally, it decodes this bit sequence to obtain a 345-bit message. It makes no attempt to determine whether or not a watermark is present,

but simply returns a random message when presented with an unwatermarked image.

Blind Embedding and Whitened Linear Correlation Detection: This system explores the effects of applying a whitening filter in linear correlation detection. It uses the E_BLIND embedding algorithm introduced in System 1.

The D_WHITE detector applies a whitening filter to the image and the watermark reference pattern before computing the linear correlation between them. The whitening filter is an 11×11 kernel derived from a simple model of the distribution of unwatermarked images as an elliptical Gaussian.

Block-Based Blind Embedding and Whitened Correlation Coefficient Detection: This system explores the effects of whitening on correlation-coefficient detection. It uses the E_BLK_BLIND embedding algorithm introduced in System 3.

The D_WHITE_BLK_CC detector first extracts a 64 vector from the image by averaging 8×8 blocks. It then filters the result with the same whitening filter used in D_WHITE. This is roughly equivalent to filtering the image before extracting the vector. Finally, it computes the correlation coefficient between the filtered, extracted vector and a filtered version of a reference mark.

Perceptually Limited Embedding and Linear Correlation Detection: This system begins an exploration of the use of perceptual models in watermark embedding. It uses the D_LC detector introduced in System 1.

The E_PERC_GSCALE embedder is similar to the E_BLIND embedder in that, ultimately, it scales the reference mark and adds it to the image. However, in E_PERC_GSCALE the scaling is automatically chosen to obtain a specified perceptual distance, as measured by Watson's perceptual model.

Perceptually Shaped Embedding and Linear Correlation Detection: This system is similar to System 13, but before computing the scaling factor for the entire reference pattern the E_PERC_SHAPE embedder first *perceptually shapes* the pattern.

The perceptual shaping is performed in three steps. First, the embedder converts the reference pattern into the block DCT domain (the domain in which Watson's model is defined). Next, it scales each term of the transformed reference pattern by a corresponding *slack* value obtained by applying Watson's model to the cover image. This amplifies the pattern in areas where the image can easily hide noise, and attenuates in areas where noise would be visible. Finally, the resultant shaped pattern is converted back into the spatial domain. The

shaped pattern is then scaled and added to the image in the same manner as in E_PERC_GSCALE.

Optimally Scaled Embedding and Linear Correlation Detection: This system is essentially the same as System 14. The only difference is that perceptual shaping is performed using an "optimal" algorithm, instead of simply scaling each term of the reference pattern's block DCT. This shaping is optimal in the sense that the resulting pattern yields the highest possible correlation with the reference pattern for a given perceptual distance (as measured by Watson's model).

Watermark Embedding Using Modulo Addition: This is a simple example of a system that produces erasable watermarks. It uses the D_LC detector introduced in System 1.

The E_MOD embedder is essentially the same as the E_BLIND embedder, in that it scales a reference pattern and adds it to the image. The difference is that the E_MOD embedder uses modulo 256 addition. This means that rather than being clipped to a range of 0 to 255 the pixel values wrap around. Therefore, for example, 253 + 4 becomes 1. Because of this wraparound, it is possible for someone who knows the watermark pattern and embedding strength to perfectly invert the embedding process, erasing the watermark and obtaining a bit-for-bit copy of the original.

Semi-fragile Watermarking: This system illustrates a carefully targeted semi-fragile watermark intended for authenticating images. The watermarks are designed to be robust against JPEG compression down to a specified quality factor, but fragile against most other processes (including more severe JPEG compression).

The E_DCTQ embedder first converts the image into the block DCT domain used by JPEG. It then quantizes several high-frequency coefficients in each block to either an even or odd multiple of a quantization step size. Each quantized coefficient encodes either a 0, if it is quantized to an even multiple, or a 1, if quantized to an odd multiple. The pattern of 1s and 0s embedded depends on a key that is shared with the detector. The quantization step sizes are chosen according to the expected effect of JPEG compression at the worst quality factor the watermark should survive.

The D_DCTQ detector converts the image into the block DCT domain and identifies the closest quantization multiples for each of the high-frequency coefficients used during embedding. From these, it obtains a pattern of bits, which

it compares against the pattern embedded. If enough bits match, the detector declares that the watermark is present.

The D_DCTQ detector can be modified to yield localized information about where an image has been corrupted. This is done by checking the number of correct bits in each block independently. Any block with enough correctly embedded bits is deemed authentic.

Semi-fragile Signature: This extends the E_DCTQ/D_DCTQ system to provide detection of distortions that only effect the low-frequency terms of the block DCT. Here, the embedded bit pattern is a semi-fragile signature derived from the low-frequency terms of the block DCT.

The E_SFSIG embedder computes a bit pattern by comparing the magnitudes of corresponding low-frequency coefficients in randomly selected pairs of blocks. Because quantization usually does not affect the relative magnitudes of different values, most bits of this signature should be unaffected by JPEG (which quantizes images in the block DCT domain). The signature is embedded in the high-frequency coefficients of the blocks using the same method used in E_DCTQ.

The D_SFSIG detector computes a signature in the same way as E_SFSIG and compares it against the watermark found in the high-frequency coefficients. If enough bits match, the watermark is deemed present.

Pixel-by-Pixel Localized Authentication: This system illustrates a method of authenticating images with pixel-by-pixel localization. That is, the detector determines whether each individual pixel is authentic.

The E_PXL embedder embeds a predefined binary pattern, usually a tiled logo that can be easily recognized by human observers. Each bit is embedded in one pixel according to a secret mapping of pixel values into bit values (known to both embedder and detector). The pixel is moved to the closest value that maps to the desired bit value. Error diffusion is used to minimize the perceptual impact.

The D_PXL detector simply maps each pixel value to a bit value according to the secret mapping. Regions of the image modified since the watermark was embedded result in essentially random bit patterns, whereas unmodified regions result in the embedded pattern. By examining the detected bit pattern, it is easy to see where the image has been modified.

Introduction

Hold an American $20 bill up to the light. If you are looking at the side with the portrait of president Andrew Jackson, you will see that the portrait is echoed in a watermark on the right. This watermark is embedded directly into the paper during the papermaking process, and is therefore very difficult to forge. It also thwarts a common method of counterfeiting in which the counterfeiter washes the ink out of $20 bills and prints $100 bills on the same paper.

The watermark on the $20 bill (Figure 1.1), just like most paper watermarks today, has two properties that relate to the subject of the present book. First, the watermark is hidden from view during normal use, only becoming visible as a result of a special viewing process (in this case, holding the bill up to the light). Second, the watermark carries information about the object in which it is hidden (in this case, the watermark indicates the authenticity of the bill).

In addition to paper, watermarking can be applied to other physical objects and to electronic signals. Fabrics, garment labels, and product packaging are examples of physical objects that can be watermarked using special invisible dyes and inks [224, 228]. Electronic representations of music, photographs, and video are common types of signals that can be watermarked.

The techniques presented in this book focus on the watermarking of electronic signals. We adopt the following terminology to describe these signals. We refer to a specific song, video, or picture—or to a specific copy of such—as a *Work*,[1] and to the set of all possible Works as *content*. Thus, audio music is an example

1. This definition of the term *Work* is consistent with the language used in the United States Copyright Laws [273]. Other terms that have been used can be found in the disscussion of this term in the glossary.

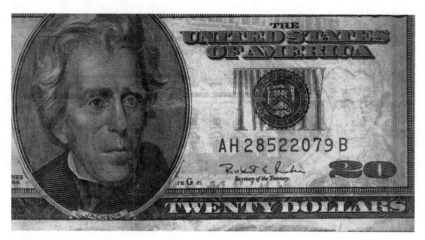

Fig. 1.1 American $20 bill.

of content, and the song "Satisfaction" by the Rolling Stones is an example of a Work. The original unwatermarked Work is sometimes referred to as the *cover Work,* in that it hides or "covers" the watermark. We use the term *media* to refer to the means of representing, transmitting, and recording content. Thus, the audio CD on which "Satisfaction" is recorded is an example of a medium.

We define *watermarking* as the practice of imperceptibly altering a Work to embed a message about that Work.[2]

In general, a watermarking system of the type we will discuss consists of an *embedder* and a *detector,* as illustrated in Figure 1.2. The embedder takes two inputs. One is the message we want to encode as a watermark, and the other is the cover Work in which we want to embed the mark. The output of the watermark embedder is typically transmitted or recorded. Later, that Work (or some other that has not been through the watermark embedder) is presented as an input to the watermark detector. Most detectors try to determine whether a watermark is present, and if so, output the message encoded by it.

In the late 1990s there was an explosion of interest in digital systems for the watermarking of various content. The main focus has been on photographs, audio, and video, but other content—such as binary images [296], text [27, 28, 171], line drawings [250], three-dimensional models [16, 197], animation parameters [106], executable code [251], and integrated circuits [153, 131]— have also been marked. The proposed applications of these methods are many and

2. Some researchers do not consider imperceptibility as a defining characteristic of digital watermarking. This leads to the field of perceptible watermarking [29, 98, 185, 180, 186], which is outside of the scope of this book.

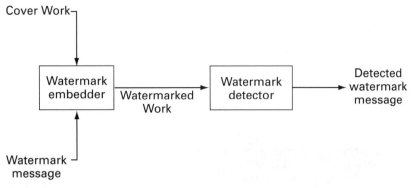

Fig. 1.2 A generic watermarking system.

varied, and include identification of the copyright owner, indication to recording equipment that the marked content should not be recorded, verification that content has not been modified since the mark was embedded, and the monitoring of broadcast channels looking for marked content.

1.1 Information Hiding, Steganography, and Watermarking

Watermarking is closely related to the fields of information hiding and steganography. These three fields have a great deal of overlap and share many technical approaches. However, there are fundamental philosophical differences that affect the requirements, and thus the design, of a technical solution. In this section, we discuss these differences.

Information hiding (or *data hiding*) is a general term encompassing a wide range of problems beyond that of embedding messages in content. The term *hiding* here can refer to either making the information imperceptible (as in watermarking) or keeping the existence of the information secret. Some examples of research in this field can be found in the International Workshops on Information Hiding, which have included papers on such topics as maintaining anonymity while using a network [138] and keeping part of a database secret from unauthorized users [189]. These topics definitely fall outside our definition of watermarking.

Steganography is a term derived from the Greek words *steganos,* which means "covered," and *graphia,* which means "writing." It is the art of concealed communication. The very existence of a message is secret. An oft-cited example of steganography is a story from Herodotus [117], who tells of a slave sent by his master, Histiæus, to the Ionian city of Miletus with a secret message tattooed

Table 1.1 Four categories of information hiding. Each category is described with an example in the text. (CW refers to *cover Work*.)

	CW Dependent Message	CW Independent Message
Existence Hidden	Steganographic Watermarking (Example 1)	Covert Communication (Example 2)
Existence Known	Non-steganographic Watermarking (Example 3)	Overt Embedded Communications (Example 4)

on his scalp. After tattooing, the slave grew his hair back in order to conceal the message. He then journeyed to Miletus and, upon arriving, shaved his head to reveal the message to the city's regent, Aristagoras. The message encouraged Aristagoras to start a revolt against the Persian king. In this scenario, the message is of primary value to Histiæus and the slave is simply the carrier of the message.

We can use this example to highlight the difference between steganography and watermarking. Imagine that the message on the slave's head read, "This slave belongs to Histiæus." In that this message refers to the slave (cover Work), this would meet our definition of a watermark. Maybe the only reason to conceal the message would be cosmetic. However, if someone else claimed possession of the slave, Histiæus could shave the slave's head and prove ownership. In this scenario, the slave (cover Work) is of primary value to Histiæus, and the message provides useful information about the cover Work.

Systems for inserting messages in Works can thus be divided into watermarking systems, in which the message is related to the cover Work, and non-watermarking systems, in which the message is unrelated to the cover Work. They can also be independently divided into steganographic systems, in which the very existence of the message is kept secret, and non-steganographic systems, in which the existence of the message need not be secret. This results in four categories of information hiding systems, which are summarized in Table 1.1. An example of each of the four categories helps to clarify their definitions.

■ In 1981, photographic reprints of confidential British cabinet documents were being printed in newspapers. Rumor has it that to determine the source of the leak, Margaret Thatcher arranged to distribute uniquely identifiable copies of documents to each of her ministers. Each copy had a different word spacing that was used to encode the identity of the recipient. In this way, the source of the leaks could be identified [5]. This is an example

of steganographic watermarking. The hidden patterns were watermarks in that they encoded information related to the recipient of each copy of the documents, and were steganographic in that the ministers were kept unaware of their existence so that the source of the leak could be identified.

■ The possibility of steganographically embedded data unrelated to the cover Work (i.e., messages hidden in otherwise innocuous transmissions) has always been a concern to the military. Simmons provides a fascinating description of covert channels [246], in which he discusses the technical issues surrounding verification of the SALT-II treaty between the United States and the Soviet Union. The SALT-II treaty allowed both countries to have many missile silos but only a limited number of missiles. To verify compliance with the treaty, each country would install sensors, provided by the other country, in their silos. Each sensor would tell the other country whether or not its silo was occupied, but nothing else. The concern was that the respective countries might design the sensor to communicate additional information, such as the location of its silo, hidden inside the legitimate message.

■ An example of a non-steganographic watermark (i.e., the presence of the watermark is known) can be seen at the web site of the Hermitage Museum in St. Petersburg, Russia.[3] The museum presents a large number of high-quality digital copies of its famous collection on its web site. Each image has been watermarked to identify the Hermitage as its owner, and a message at the bottom of each web page indicates this fact, along with the warning that the images may not be reproduced. Knowledge that an invisible watermark is embedded in each image helps deter piracy.

■ Overt, embedded communication refers to the known transmission of auxiliary, hidden information that is unrelated to the signal in which it is embedded. It was common practice in radio in the late 1940s to embed a time code in the broadcast at a specified frequency (800 Hz, for example) [222]. This time code was embedded at periodic intervals, say every 15 minutes. The code was inaudibly hidden in the broadcast, but it was not a watermark because the message (the current time) was unrelated to the content of the broadcast. Further, it was not an example of steganography because the presence of an embedded time code can only be useful if its existence is known.

By distinguishing between embedded data that relates to the cover Work and hidden data that does not, we can anticipate the different applications and requirements of the data-hiding method. However, the actual techniques used for watermarking may be very similar, or in some cases identical, to those used in

3. See *http://www.hermitagemuseum.org.*

non-watermarking systems. Thus, although this book focuses on watermarking techniques, most of these techniques are applicable to other areas of information hiding.

1.2 History of Watermarking

Although the art of papermaking was invented in China over a thousand years earlier, paper watermarks did not appear until about 1282, in Italy.[4] The marks were made by adding thin wire patterns to the paper molds. The paper would be slightly thinner where the wire was and hence more transparent.

The meaning and purpose of the earliest watermarks are uncertain. They may have been used for practical functions such as identifying the molds on which sheets of papers were made, or as trademarks to identify the paper maker. On the other hand, they may have represented mystical signs, or might simply have served as decoration.

By the eighteenth century, watermarks on paper made in Europe and America had become more clearly utilitarian. They were used as trademarks, to record the date the paper was manufactured and to indicate the sizes of original sheets. It was also about this time that watermarks began to be used as anticounterfeiting measures on money and other documents.

The term *watermark* seems to have been coined near the end of the eighteenth century and may have been derived from the German term *wassermarke* [248] (though it could also be that the German word is derived from the English [125]). The term is actually a misnomer, in that water is not especially important in the creation of the mark. It was probably given because the marks resemble the effects of water on paper.

About the time the term *watermark* was coined, counterfeiters began developing methods of forging watermarks used to protect paper money. In 1779, the *Gentleman's Magazine* [95] reported that a man named John Mathison

> ... had discovered a method of counterfeiting the water-mark of the bank paper, which was before thought the principal security against frauds. This discovery he made an offer to reveal, and of teaching the world the method of detecting the fraud, on condition of pardon, which, however, was no weight with the bank.

John Mathison was hanged.

Counterfeiting prompted advances in watermarking technology. William Congreve, an Englishman, invented a technique for making color watermarks by inserting dyed material into the middle of the paper during papermaking. The

4. Much of our description of paper watermarking is obtained from [125].

resulting marks must have been extremely difficult to forge, because the Bank of England itself declined to use them on the grounds that they were too difficult to make. A more practical technology was invented by another Englishman, William Henry Smith. This replaced the fine wire patterns used to make earlier marks with a sort of shallow relief sculpture, pressed into the paper mold. The resulting variation on the surface of the mold produced beautiful watermarks with varying shades of gray. This is the basic technique used today for the face of President Jackson on the $20 bill.

Examples of our more general notion of watermarks—imperceptible messages about the objects in which they are embedded—probably date back to the earliest civilizations. David Kahn, in his classic book *The Codebreakers,* provides interesting historical notes [130]. An especially relevant story describes a message hidden in the book *Hypnerotomachia Poliphili,* anonymously published in 1499. The first letters of each chapter spell out "Poliam Frater Franciscus Columna Peramavit," assumed to mean "Father Francesco Columna loves Polia."[5]

Four hundred years later, we find the first example of a technology similar to the digital methods discussed in this book. In 1954, Emil Hembrooke of the Muzak Corporation filed a patent for "watermarking" musical Works. An identification code was inserted in music by intermittently applying a narrow notch filter centered at 1 kHz. The absence of energy at this frequency indicated that the notch filter had been applied and the duration of the absence used to code either a dot or a dash. The identification signal used Morse code. The 1961 U.S. Patent describing this invention states [112]:

> The present invention makes possible the positive identification of the origin of a musical presentation and thereby constitutes an effective means of preventing such piracy, i.e. it may be likened to a watermark in paper.

This system was used by Muzak until around 1984 [283]. It is interesting to speculate that this invention was misunderstood and became the source of persistent rumors that Muzak was delivering subliminal advertising messages to its listeners.

It is difficult to determine when *digital* watermarking was first discussed. In 1979, Szepanski [262] described a machine-detectable pattern that could be placed on documents for anti-counterfeiting purposes. Nine years later, Holt *et al.* [119] described a method for embedding an identification code in an audio signal. However, it was Komatsu and Tominaga [142], in 1988, who appear to

5. This translation is not universally accepted. Burke [34] notes that the two words of the title of the book are made up by the author. Burke goes on to claim that the word *Poliphili,* assumed to mean "lover of Polia," might also mean "the Antiquarian"; in which case, the secret message might be better translated as "Father Francesco Columna was deeply devoted to archeological studies."

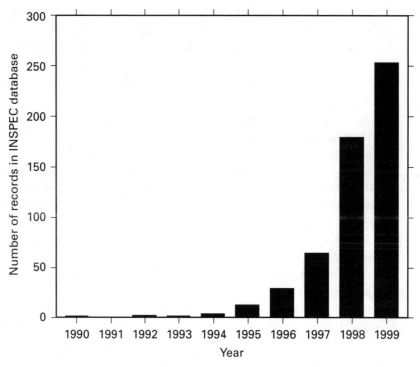

Fig. 1.3 Annual number of papers published on watermarking during the 1990s [38].

have first used the term *digital watermark*. Still, it was probably not until the early 1990s that the term *digital watermarking* really came into vogue.

About 1995, interest in digital watermarking began to mushroom. Figure 1.3 is a histogram of the number of papers published on the topic [38]. The first Information Hiding Workshop (IHW) [5], which included digital watermarking as one of its primary topics, was held in 1996. The SPIE began devoting a conference specifically to *Security and Watermarking of Multimedia Contents* [293, 294], beginning in 1999.

In addition, about this time, several organizations began considering watermarking technology for inclusion in various standards. The Copy Protection Technical Working Group (CPTWG) [14] tested watermarking systems for protection of video on DVD disks. The Secure Digital Music Initiative (SDMI) [242] made watermarking a central component of their system for protecting music. Two projects sponsored by the European Union, VIVA [70] and Talisman [109], tested watermarking for broadcast monitoring. The International Organization for Standardization (ISO) took an interest in the technology in the context of designing advanced MPEG standards.

In the late 1990s several companies were established to market watermarking products. Technology from the Verance Corporation was adopted into the first phase of SDMI and was used by Internet music distributors such as Liquid Audio. In the area of image watermarking, Digimarc bundled its watermark embedders and detectors with Adobe's Photoshop.

1.3 Importance of Digital Watermarking

The sudden increase in watermarking interest is most likely due to the increase in concern over copyright protection of content. The Internet had become user friendly with the introduction of Marc Andreessen's Mosaic web browser in November of 1993 [1], and it quickly became clear that people wanted to download pictures, music, and videos. The Internet is an excellent distribution system for digital media because it is inexpensive, eliminates warehousing and stock, and delivery is almost instantaneous. However, content owners (especially large Hollywood studios and music labels) also see a high risk of piracy.

This risk of piracy is exacerbated by the proliferation of high-capacity digital recording devices. When the only way the average customer could record a song or a movie was on analog tape, pirated copies were usually of a lower quality than the originals, and the quality of second-generation pirated copies (i.e., copies of a copy) was generally very poor. However, with digital recording devices, songs and movies can be recorded with little, if any, degradation in quality. Using these recording devices and using the Internet for distribution, would-be pirates can easily record and distribute copyright-protected material without appropriate compensation being paid to the actual copyright owners. Thus, content owners are eagerly seeking technologies that promise to protect their rights.

The first technology content owners turn to is cryptography. Cryptography is probably the most common method of protecting digital content. It is certainly one of the best developed as a science. The content is encrypted prior to delivery, and a decryption key is provided only to those who have purchased legitimate copies of the content. The encrypted file can then be made available via the Internet, but would be useless to a pirate without an appropriate key. Unfortunately, encryption cannot help the seller monitor how a legitimate customer handles the content after decryption. A pirate can actually purchase the product, use the decryption key to obtain an unprotected copy of the content, and then proceed to distribute illegal copies. In other words, cryptography can protect content in transit, but once decrypted, the content has no further protection.

Thus, there is a strong need for an alternative or complement to cryptography: a technology that can protect content even after it is decrypted. Watermarking has the potential to fulfill this need because it places information within the content

where it is never removed during normal usage. Decryption, re-encryption, compression, digital-to-analog conversion, and file format changes—a watermark can be designed to survive all of these processes.

Watermarking has been considered for many copy prevention and copyright protection applications. In copy prevention, the watemark may be used to inform software or hardware devices that copying should be restricted. In copyright protection applications, the watermark may be used to identify the copyright holder and ensure proper payment of royalties.

Although copy prevention and copyright protection have been major driving forces behind research in the watermarking field, there are a number of other applications for which watermarking has been used or suggested. These include broadcast monitoring, transaction tracking, authentication (with direct analogy to our $20 bill example), copy control, and device control. These applications are discussed in the next chapter.

Applications and Properties

Watermarking can be used in a wide variety of applications. In general, if it is useful to associate some additional information with a Work, this metadata can be embedded as a watermark. Of course, there are other ways to associate information with a Work, such as placing it in the header of a digital file, encoding it in a visible bar code on an image, or speaking it aloud as an introduction to an audio clip. The question arises: when is watermarking a better alternative? What can watermarking do that cannot be done with simpler techniques?

Watermarking is distinguished from other techniques in three important ways. First, watermarks are imperceptible. Unlike bar codes, they do not detract from the aesthetics of an image. Second, watermarks are inseparable from the Works in which they are embedded. Unlike header fields, they do not get removed when the Works are displayed or converted to other file formats. Finally, watermarks undergo the same transformations as the Works. This means that it is sometimes possible to learn something about those transformations by looking at the resulting watermarks. It is these three attributes that make watermarking invaluable for certain applications.

The performance of a given watermarking system can be evaluated on the basis of a small set of properties. For example, *robustness* describes how well watermarks survive common signal processing operations, *fidelity* describes how imperceptible the watermarks are, and so forth. The relative importance of these properties depends on the application for which the system is designed. For example, in applications where we have to detect the watermark in a copy of a Work that has been broadcast over an analog channel, the watermark must be robust against the degradation caused by that channel. However, if we can reasonably expect that a Work will not be modified at all between embedding and detection, the watermark's robustness is irrelevant.

In this chapter, we first describe several applications that can be implemented with watermarking and examine the advantages watermarking might have over alternative technologies. This discussion includes several examples of planned or actual watermarking systems in use today. We then describe several properties of watermarking systems, discussing how their relative importance and interpretation varies with application. The chapter concludes with a brief discussion of how performance can be assessed.

2.1 Applications

We examine seven proposed or actual watermarking applications: broadcast monitoring, owner identification, proof of ownership, transaction tracking, authentication, copy control, and device control. For each of these applications, we try to identify what characteristics of the problem make watermarking a suitable solution. To do this we must carefully consider the application requirements and examine the limitations of alternative solutions.

2.1.1 Broadcast Monitoring

In 1997, a scandal broke out in Japan regarding television advertising. At least two stations had been routinely overbooking air time. Advertisers were paying for thousands of commercials that were never aired [139]. The practice had remained largely undetected for more than 20 years, in part because there were no systems in place to monitor the actual broadcast of advertisements.

There are several types of organizations and individuals interested in broadcast monitoring. Advertisers, of course, want to ensure that they receive all of the air time they purchase from broadcasters, such as the Japanese television stations caught in the 1997 scandal. Performers, in turn, want to ensure that they get the royalties due them from advertising firms. A 1999 spot check by the Screen Actor's Guild found an average of $1,000 in underpaid royalties per hour of U.S. television programming [236]. In addition, owners of copyrighted Works want to ensure that their property is not illegally rebroadcast by pirate stations.

A low-tech method of broadcast monitoring is to have human observers watch the broadcasts and record what they see or hear. This method is costly and error prone. It is therefore highly desirable to replace it with some form of automated monitoring. Techniques for doing this can broadly be broken down into two categories. *Passive* monitoring systems try to directly recognize the content being broadcast, in effect simulating human observers (though more reliably and at lower cost). *Active* monitoring systems rely on associated information that is broadcast along with the content.

A passive system consists of a computer that monitors broadcasts and compares the received signals with a database of known Works. When the comparison

locates a match, the song, film, TV program, or commercial being aired can be identified. This is the most direct and least intrusive method of automated broadcast monitoring. It does not require the introduction of any associated information into the broadcast, and therefore does not require changes to advertisers' workflow. In fact, it does not require any cooperation with the advertisers or broadcasters.

However, there are a number of potential problems with implementing passive monitoring systems. First, comparing the received signals against a database is not trivial. In principle, we would like to divide the signals into recognizable units, such as individual frames of video, and search for them in the database. However, each frame of video consists of several million bits of information, and it would be impractical to use such a large bit sequence as an index for a database search. Thus, the system must first process the received signals into smaller signatures that are rich enough to differentiate between all possible Works yet small enough to be used as indices in a database search. Defining these signatures is difficult. Furthermore, broadcasting generally degrades the signals, and this degradation might vary over time, with the result that multiple receptions of the same Work at different times might lead to different signatures. This means that the monitoring system cannot search for an exact match in its database. Instead, it must perform a nearest-neighbor search, which is known to be substantially more complex [25, 41]. Because of the difficulty of deriving meaningful signatures and searching for nearest neighbors in a large database, it is difficult to design a passive monitoring system that is 100% reliable.

Even if the problem of searching the database is solved, storing and managing the database can be expensive because the database is large. Furthermore, the system should monitor several geographic locations simultaneously. In the United States, for example, we might want to monitor each of the roughly 120 television markets. Consequently, each site must either access a centralized database of known Works, store the database locally (with a capability for regular updating), or transmit the signatures back to a central processing facility.

Is such a system cost effective for broadcast monitoring? Of course, this depends on the value customers place on the information collected. In particular, because passive monitoring does not require the cooperation of those being monitored, it allows the monitoring service to tabulate competitive market research data. For example, such a system can be used to help Pepsi estimate how much Coca Cola spends on advertising in the Atlanta market. Because of this, both Nielsen Media Research (NMR) and Competitive Media Reporting (CMR) have deployed passive systems for monitoring television broadcast.[1] However, neither company uses passive monitoring for verification purposes (i.e., to verify that a

1. In fact, passive monitoring dates back at least to 1975 [187].

commercial was broadcast). The reason for this might be that the recognition system is simply not accurate enough. An accuracy of, say, 95% is adequate for acquiring competitive market research data. However, an error rate of 5% is too high for verification services. Imagine the consequences of erroneously informing Coca Cola that one in twenty of their commercials did not air.

Obtaining the accuracy required for a verification service probably requires an active monitoring system, in which computer-recognizable identification information is transmitted along with content. Active monitoring is technically simpler to implement than passive monitoring. The identification information is straightforward to decode reliably, and no database is required to interpret its meaning.

One way to implement an active system is to place the identification information in a separate area of the broadcast signal. For example, analog television broadcasts permit digital information to be encoded in the vertical blanking interval (VBI) of a video signal. This part of the signal, sent between frames, has no effect on the picture. Close captioning information is distributed in this manner, as is Teletext in Europe. Nielsen Media Research uses the VBI for its SIGMA advertisement monitoring service.

Unfortunately, embedding signals in the VBI can be problematic. In the United States, it is not always clear who legally controls the content of the VBI. Both cable and satellite operators stake a claim to it. Although U.S. law requires that the distributors deliver closed caption data to their customers in line 21 of the VBI [268, Sec. 305, 713][267], distributors have no legal obligation to maintain any other information that may have been inserted into the VBI by content providers. Consequently, an identification code placed in the VBI by an advertiser or network is not guaranteed to be transmitted. Moreover, the appended information is unlikely to survive format changes, such as conversion from analog to digital, without modification of existing hardware. In the past, this was not a significant problem, but it is increasingly a concern as television broadcasts move from analog to digital transmission.

For digital Works, there are similar active techniques that store identification codes in file headers. These techniques suffer the same types of problems as the VBI approach, in that intermediate handlers and ultimate distributors would have to guarantee delivery of the header information intact. Again, the data is unlikely to survive format changes without modification to existing systems.

Watermarking is an obvious alternative method of coding identification information for active monitoring. It has the advantage of existing within the content itself, rather than exploiting a particular segment of the broadcast signal, and is therefore completely compatible with the installed base of broadcast equipment, including both digital and analog transmission. The primary disadvantage is that the embedding process is more complicated than placing data in the VBI or in file headers. There is also a concern, especially on the part of content creators, that

the watermark may degrade the visual or audio quality of the Work. Nevertheless, there are a number of companies that provide watermark-based broadcast monitoring services.

2.1.2 Owner Identification

Under U.S. law, the creator of a story, painting, song, or any other original Work automatically holds copyright to it the instant the Work is recorded in some physical form.[2] Through 1988, if copyright holders wanted to distribute their Works without losing any rights, they had to include a copyright notice in every distributed copy. After 1988, this was changed so that the copyright notice is now no longer required. However, if a Work that is protected by copyright is misused, and the courts choose to award the copyright holder damages, that award can be significantly limited if a copyright notice of acceptable form and placement was not found on the distributed material [273, Sec. 401].

The exact form of the copyright notice is important. For visual Works, it must say either "Copyright *date owner*," "© *date owner*," or "Copr. *date owner*." Note that using "(C)" instead of "©" does not serve the same legal purpose. For sound recordings, the copyright notice takes the similar form "℗ *date owner*" and must be placed on the surface of the physical media, the label, or on the packaging so as to "give reasonable notice of the claim of copyright" [273, Sec. 402].

Textual copyright notices have several limitations as a technology for identifying the owner of a Work. For one, they are easy to remove from a document when it is copied, even without any intention of wrongdoing. For example, a professor copying pages out of a book (within the strictures of fair use) might neglect to photocopy the copyright notice on the title page. An artist using a legally acquired photograph in a magazine advertisement might crop off the portion of it that includes the copyright notice. Thus, subsequently a law-abiding citizen who wishes to to use a Work may not be able to determine whether the Work is protected by copyright. Even if the Work is assumed to be protected, it may be difficult to find the identity of the creator or person whose permission must be obtained.

A famous case in which the loss of text on an image caused just such problems is a photograph of Lena Sjööblom. This is perhaps the most common test image in image processing research and has appeared in countless journal articles and conference proceedings—all without any reference to its rightful owner, Playboy Enterprises, Inc. The image started out as a *Playboy* centerfold [215]. When this image was scanned for use as a test image, most of the image was cropped, leaving only Lena's face and shoulder. Unfortunately, in the process, the text that identified Playboy as the owner was also cropped (see Figure 2.1). The image has

2. Disclaimer: We are not lawyers. Although we have made some effort to ensure our information is correct, anything we say about American law or any other country's laws is interpretive.

Fig. 2.1 The often-used Lena image in image processing research is a cropped version of a 1972 *Playboy* centerfold. This portion of the original, lost to cropping, identifies the copyright owner.

since been distributed electronically around the world, and most researchers who include it in their papers are probably unaware that they are infringing Playboy's copyright. Playboy has decided to overlook the widespread use of this image [32].

Another problem with textual copyright notices for images is that they can be aesthetically ugly and may cover a portion of the image. Although it is usually possible to make them unobtrusive [29] (e.g., by placing them in an unimportant corner of the picture), such practice makes them more susceptible to being cropped. The situation is even worse in audio, where the copyright notice is placed on the physical medium (disk, tape, record, and so on) and on the packaging. Neither of these notices would normally be copied along with the audio content. In fact, for some audio content that may exist only in electronic form—on a web site, for example—no physical medium or packaging would even exist.

Because watermarks can be made both imperceptible and inseparable from the Work that contains them, they are likely to be superior to text for owner identification. If users of Works are supplied with watermark detectors, they should be able to identify the owner of a watermarked Work, even after the Work has been modified in ways that would remove a textual copyright notice. Digimarc's watermark for images was designed with precisely this application in mind. They achieved widespread distribution of their watermark detector by

bundling it with Adobe's popular image processing program, Photoshop. When Digimarc's detector recognizes a watermark, it contacts a central database over the Internet, and uses the watermark message as a key to find contact information for the image's owner.

The legal impact of such a system has not yet been tested in court. At present, given that the exact form of a copyright notice holds such legal significance, a copyright notice in a watermark probably would not suffice as an alternative to including the standard "©" notice. However, the system does make it easier for honest people to find out who they should contact about using an image.

2.1.3 Proof of Ownership

It is enticing to try to use watermarks not just to *identify* copyright ownership but to actually *prove* ownership. This is something a textual notice cannot do, because it can be so easily forged. For example, suppose an artist (call her Alice) creates an image and posts it on her web site, with the copyright notice "© 2001 Alice." An adversary (call him Bob) then steals the image, uses an image processing program to replace the copyright notice with "© 2001 Bob," and then claims to own the copyright himself. How is the dispute resolved?

One way of resolving such a dispute is by use of a central repository. Before putting her image on the Web, Alice could register the image with the Office of Copyrights and Patents by sending a copy to them. They archive the image, together with information about the rightful owner. Then, when a dispute between Alice and Bob arises, Alice contacts the Office of Copyrights and Patents to prove that she is the rightful owner.

However, Alice might decline to register her image because it is too costly. Registering with the Office of Copyrights and Patents costs approximately $30 per document.[3] With many images to be registered, this can add up to a substantial expense for a struggling artist. If Alice cannot afford this expense, she might find herself prosecuting Bob without the benefit of the Office of Copyrights and Patents on her side.

In such a case, Alice would have to show evidence that she created the image. For example, she might have the film negative if the image was originally a photograph. Or she might have early drafts if it is a Work of art. The trouble is, if Bob is truly determined to win the case, he can fabricate such evidence himself. He can make a new negative from the image, or falsely manufacture early drafts of his own. Even worse, if the image was created digitally, there might not have been any negative or early drafts in the first place.

3. The current registration fee can be obtained from the copyright office web site at *http://www.loc.gov/copyright*. The $30 cited represents the advertised fee at the time of this writing.

Can Alice protect her rights, and avoid incurring the cost of registration, by applying a watermark to her image? In the case of Digimarc's watermark, the answer is probably no. The problem with their system is that the detector is readily available to adversaries. As described in Section 2.2.7, and elaborated upon in Chapter 9, anybody who can detect a watermark can probably remove it. Thus, because Bob can easily obtain a Digimarc detector, he can remove Alice's watermark and replace it with his own.

To achieve the level of security required for proof of ownership, it is probably necessary to restrict the availability of the detector. When an adversary does not have a detector, removal of a watermark can be made extremely difficult. Therefore, when Alice and Bob go before the judge, Alice would produce her original copy of the image. Her original, and the disputed copy, would be entered into the watermark detector, and the detector would detect Alice's watermark.

However, even if Alice's watermark cannot be removed, Bob might be able to undermine her. As pointed out by Craver *et al.* [63], Bob, using his own watermarking system, might be able to make it appear as though *his* watermark were present in *Alice's* original copy of the image. Thus, a third party would be unable to judge whether Alice or Bob had the true original. This is described in more detail in Chapter 9.

This problem can be solved if we make a slight change in the problem statement. Instead of trying to directly prove ownership by embedding an "Alice owns this image" watermark message in it, we will instead try to prove that one image is derived from another. How this can be done is discussed in Chapter 9. Such a system provides indirect evidence that it is more likely the disputed image is owned by Alice than by Bob, in that Alice is the one who has the version from which the other two were created. The evidence is similar to that provided if Alice were to produce the negative from which the image was created, except that it is stronger, in that Bob can fabricate a negative but cannot fabricate a fake original that passes our test.

2.1.4 Transaction Tracking

In this application of watermarking, the watermark records one or more transactions that have taken place in the history of the copy of a Work in which it is embedded. For example, the watermark might record the recipient in each legal sale or distribution of the Work. The owner or producer of the Work would place a different watermark in each copy. If the Work were subsequently misused (leaked to the press or redistributed illegally), the owner could find out who was responsible.

In the literature on transaction tracking, the person responsible for misuse of a Work is sometimes referred to as a *traitor*, whereas a person who receives the Work from a traitor is a *pirate*. As this distinction is not meaningful when discussing other applications where piracy is an issue, we do not use this terminology.

Fig. 2.2 Example of a unique identification code printed in the background of a text document.

Instead, we use the term *adversary* to describe anyone who attempts to remove, disable, or forge a watermark for the purpose of circumventing its original purpose.

There are few technologies for transaction tracking that do not fall under our definition of watermarking. One common alternative to watermarking is to use visible marks. For example, highly sensitive business documents, such as business plans, are sometimes printed on backgrounds containing large gray digits (see Figure 2.2), with a different number for each copy. Records are then kept about who has which copy. These marks are often referred to as "watermarks" because they have a physical resemblance to paper watermarks. However, they are not watermarks in our sense of the term, in that we consider imperceptibility to be a defining characteristic. Of course, imperceptible watermarks are preferable to these visible marks for the same reasons watermarks are preferable to textual copyright notices (see Section 2.1.2).

An example of watermarking for transaction tracking was implemented by the now-defunct DiVX Corporation.[4] DiVX sold an enhanced DVD player that implemented a pay-per-view business model. They implemented a variety of

4. The demise of DiVX had nothing to do with their watermarking technology.

security technologies to prevent piracy of their disks, one of which was a watermark designed for transaction tracking. Each DiVX-enabled player would place a unique watermark into every video it played. If someone then recorded that video and started selling copies on the black market, the DiVX corporation could obtain one of the copies and identify the adversary (or, at least, the adversary's DiVX player) by decoding the watermark. To our knowledge, the DiVX watermark was never actually used to trace an adversary before DiVX ceased business.

Another example of transaction tracking is in the distribution of movie dailies. During the course of making a movie, the result of each day's photography is often distributed to a number of people involved in its production. These dailies are highly confidential, yet occasionally a daily is leaked to the press. When this happens, studios quickly try to identify the source of the leak. Studios can use visible text at the edges of the screen to identify each copy of the dailies. However, watermarks are preferable because the text is too easy to remove.

2.1.5 Content Authentication

It is becoming easier and easier to tamper with digital Works in ways that are difficult to detect. For example, Figure 2.3 shows a modification made to an image using Adobe Photoshop. On the left is the original image. On the right is the modified version. If this image were a critical piece of evidence in a legal case or police investigation, this form of tampering might pose a serious problem. The same problem exists with audio and video.

The problem of authenticating messages has been well studied in cryptography [252]. One common cryptographic approach to this problem is the creation of a *digital signature,* which is essentially an encrypted summary of the message. An asymmetric key encryption algorithm is used, so that the key required to encrypt the signature is different from that required to decrypt it. Only the authorized source of messages knows the key required for creating signatures. Therefore, an adversary who tries to change the message cannot create a new signature.

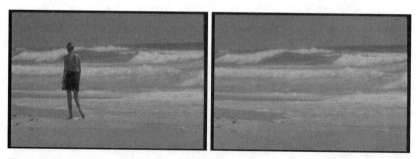

Fig. 2.3 Ease of modifying images: the woman in the image on the left was removed from the scene, resulting in the image on the right. This required about 10 minutes using Adobe Photoshop.

If someone subsequently compares the modified message against the original signature, he will find that the signatures do not match and will know that the message has been modified.

Digital signature technology has been applied to digital cameras by Friedman [88, 89], who suggests creating a "trustworthy camera" by computing a signature inside the camera. Only the camera would have the key required for creating the signature. Therefore, if we find that a copy of an image matches its signature, we can be sure it is bit for bit identical with the original.

These signatures are metadata that must be transmitted along with the Works they verify. It is thus easy to lose the signatures in normal usage. For example, consider an image authentication system that stores the metadata in a JPEG header field. If the image is converted to another file format that has no space for a signature in its header, the signature will be lost. When a signature is lost, the Work can no longer be authenticated.

A preferable solution might be to embed the signature directly into the Work using watermarking [175]. Epson offers such a system as an option on many of its digital cameras [81, 301, 278]. We refer to such an embedded signature as an *authentication mark*. Authentication marks designed to become invalid after even the slightest modification of a Work are called *fragile* watermarks.

The use of authentication marks eliminates the problem of making sure the signature stays with the Work. Of course, care must be taken to ensure that the act of embedding the watermark does not change the Work enough to make it appear invalid when compared with the signature. This can be accomplished by separating the Work into two parts: one for which the signature is computed, and one into which the signature is embedded. For example, several authors suggest computing a signature from the high-order bits of an image and embedding the signature in the low-order bits [10, 50].

If a Work containing an authentication mark is modified, the mark is modified along with it. This opens up the possibility of learning more about *how* the Work has been tampered with. For example, if an image is divided into blocks, and each block has its own authentication mark embedded in it, we would be able to gain a rough idea of which parts of the image are authentic and which parts have been modified. This and similar ideas have been suggested by many researchers [10, 290].

An example of where this type of localized authentication might be useful would be in a police investigation of a crime. Imagine that the police receive a surveillance video that has been tampered with. If the video is authenticated with a traditional signature, all the police would know is that the video is inauthentic and cannot be trusted. However, if they use a watermark designed to yield localized authentication, they might discover that each frame of the video is reliable except for a license plate on a car. This would be strong evidence that the identity of someone involved in the crime was removed from the video.

A different type of information that might be learned from examining a modified authentication mark is whether or not lossy compression has been applied to a Work. The quantization applied by most lossy compression algorithms can leave telltale statistical changes in a watermark that might be recognizable. The call for proposals for Phase II of SDMI required this functionality in an audio watermark.

Conversely, we might not care about whether a Work was compressed, and might only be concerned with whether more substantial changes were made, such as that indicated in Figure 2.3. This leads to the field of *semi-fragile* watermarks and signatures, which survive minor transformations, such as lossy compression, but are invalidated by major changes. Techniques for content authentication are discussed in more detail in Chapter 10.

2.1.6 Copy Control

Most of the applications of watermarking discussed so far have an effect only after someone has done something wrong. For example, broadcast monitoring helps catch dishonest broadcasters after they fail to air ads that were paid for, and transaction tracking identifies adversaries after they distribute illegal copies. These technologies serve as a deterrent against such wrongdoing. Clearly it is better, however, to actually prevent the illegal action. In the copy control application, we aim to *prevent* people from making illegal copies of copyrighted content.

The first and strongest line of defense against illegal copying is encryption. By encrypting a Work according to a unique key, we can make it unusable to anyone who does not have that key. The key would then be provided to legitimate users in a manner that is difficult for them to copy or redistribute. For example, many satellite television broadcasts are encrypted. The decryption keys are provided to each paying customer on a "smart card," which must be inserted into the customer's television set-top box. Anyone trying to watch or record the broadcast without a smart card would see only scrambled video.

There are three basic ways an adversary might try to overcome an encryption system. The first, and most difficult, is to decrypt the data without obtaining a key. This usually involves some form of search, in which the adversary exhaustively tries decrypting the signal with millions of keys. If the cryptographic system is well designed, the adversary will have to try every possible key. This is impractical if the keys are longer than 50 bits or so.

An easier approach for the adversary is to try to obtain a valid key. This might be done by reverse-engineering hardware or software that contains the key. An example of this approach is embodied in the DeCSS program written by Jon Johansen and two German collaborators [205]. CSS (Content Scrambling System) is the encryption system used to protect DVD video from illegal copying. Johansen *et al.* were able to reverse-engineer a DVD player and find its decryption

keys. This allowed them to produce DeCSS, which decrypts any CSS-encrypted video.

By far the easiest method of thwarting encryption is to legally obtain a key and pirate the content after it is decrypted. An adversary who wishes to tape and redistribute satellite broadcasts need only sign up as a customer, acquire a smart card, and connect the output of his set-top box to the input of his VCR. This points out a central weakness of cryptographic protection: ultimately, the content must be decrypted before it can be used, and once decrypted, all protection is lost.

What we would like is to somehow allow media to be perceived, yet still prevent it from being recorded. One technology for doing this, in the case of NTSC video, is Macrovision's Videocassette Anticopy Process [235]. This modifies the video signal in such a way as to confuse the automatic gain control on VCRs. The resulting signal is perfectly viewable on a television set, but produces something unwatchable if it is recorded with a VCR. However, this technology applies only to analog television signals. It is not applicable to audio, or to digital signals of any type. Thus, although Macrovision's system is suitable for preventing illegal video recording on existing VCRs, it is not suitable for use in recordable DVDs, digital VCRs, or any other digital video recording technology.

Because watermarks are embedded in the content itself, they are present in every representation of the content and therefore might provide a better method of implementing copy control.[5] If every recording device were fitted with a watermark detector, the devices could be made to prohibit recording whenever a never-copy watermark is detected at its input. This functionality is sometimes referred to specifically as *record control*. Such a system has been envisioned for use on video DVDs by the Copy Protection Technical Working Group (CPTWG), and for use in audio by the SDMI.

There is one substantial nontechnical problem in deploying a copy control system based on watermarking: How do we ensure that every recorder contains a watermark detector? There is no natural incentive for recorder manufacturers to incur the expense of incorporating the detectors in their products. In fact, there is a strong *disincentive,* in that the watermark detector actually *reduces* the value of the recorder from the customer's point of view. The customer would rather have a device that is capable of making illegal copies.

The direct solution to this problem would be to require watermark detectors in recorders by law. However, no such law currently exists, and enacting one would be difficult at best. Furthermore, this legal battle would have to be fought in every country in the world before watermarks could provide worldwide protection. For this reason, neither the CPTWG nor SDMI rely on such laws.

5. Most of our discussion of copy control with watermarking is taken from [20].

Instead, the CPTWG and SDMI place the requirement for watermark detectors in the patent licenses for technologies that manufacturers *want* to include in their devices. For example, the requirement for a video watermark detector is incorporated into the patent license for CSS. Thus, if manufacturers wish to produce DVD players and recorders that can play CSS-encrypted disks, they will be required by the CSS patent license to include watermark detectors.[6] This approach has the advantage that it relies on existing laws that are well established in most countries.

The patent-license approach has the disadvantage that it allows manufacturers to produce recorders that do not include watermark detectors, as long as they also do not include the desirable technology covered in the patent license. Thus, there may be perfectly legal DVD player/recorders that implement neither watermark detection nor CSS decryption. Such devices are referred to as *noncompliant,* whereas those that do implement watermarking and decryption are referred to as *compliant.* The existence of noncompliant recorders means that the watermark will not stop all possible illegal recordings.

To counter this, we can use an idea known as *playback control.* When an adversary uses a noncompliant recorder to make an illegal copy of a watermarked Work, that copy will contain the watermark. Compliant players can be required, by patent license, to check for watermarks in the content being played. When a player sees a `never-copy` watermark, it checks to determine whether it is playing a copy or an original. This can be done in a variety of ways, such as by checking whether the Work is properly encrypted or by looking for a special signature on the media. If it is playing a copy, the player shuts down.

Figure 2.4 illustrates the interaction of encryption, record control, and playback control in a world of legal compliant and noncompliant devices. A legal, encrypted copy of a Work, such as a DVD purchased from a video store, can be played on a compliant player, but not on a noncompliant player, because the noncompliant player cannot decrypt it. The output of the compliant player cannot be recorded on a compliant recorder, because the recorder would detect the watermark and shut down. However, such output *can* be recorded on a noncompliant recorder, resulting in an unencrypted, illegal copy of the Work. This copy can be played on a noncompliant player, because it is not encrypted, but it cannot be played on a compliant player, because the player would detect the watermark and prohibit playback. Thus, the customer has a choice between buying a compliant

6. Note that the fact that CSS has been hacked does not diminish its effectiveness as a means of persuading manufacturers to include watermark detectors in their hardware products. Regardless of whether CSS can be illegally decrypted with DeCSS, the manufacturers still require a license to incorporate decryption into their devices. If a manufacturer were to forego the license, and just use DeCSS in their product, they would not be able to sell many devices before they were prosecuted for patent infringement.

Fig. 2.4 Relationship between encryption and watermark-based copy control. Arrows indicate potential paths of content. Paths prevented by encryption, record control, or playback control are indicated with Xs.

device that can play legal, purchased content but cannot play pirated content or a noncompliant device that can play pirated content but not purchased content. The hope is that most customers will choose a compliant option.

2.1.7 Device Control

Copy control falls into a broader category of applications, which we refer to as *device control*. There are several other applications in which devices react to watermarks they detect in content. From the user's point of view, many of these are different from copy control in that they add value to the content, rather than restrict its use.

In 1953, Tomberlin *et al.* [271] described a system to reduce the cost of distributing piped music to offices, stores, and other premises. Traditionally, this music was distributed via land lines (i.e., dedicated telephone lines), which were expensive. MusicScan, the patent assignee, intended to reduce this cost by replacing the dedicated distribution system with a wireless broadcast system. However, it was too costly for this radio transmission to be dedicated to MusicScan's business. Instead, MusicScan premises would receive music from a commercial radio station that broadcasts commercials and talk, as well as music. Tomberlin *et al.*'s invention was to incorporate a watermark signal in the radio transmission that

indicated when the radio transmission should be ignored (e.g., when a commercial was being broadcast). This was accomplished with two control signals (embedded as either supersonic or subsonic audio frequencies) that indicated the beginning and end of broadcast segments that were to be blocked.

Another early application of watermarking for control is discussed in a 1981 patent by Ray Dolby [73]. At the time, a number of FM radio stations were broadcasting music using a noise-reduction technique called Dolby FM. To fully exploit Dolby FM, a radio required a corresponding decoder. Listeners had to rely on a listing of stations to determine which were broadcasting Dolby FM signals, so that they could manually turn their radio's decoder on or off. Dolby suggested that the radios could be made to automatically turn on their decoders in response to an inaudible tone broadcast within the audio frequency spectrum. Such a tone constitutes a simple watermark.

In 1989, Broughton and Laumeister were awarded a patent [31] for a technique that allows action toys to interact with television programs. In this technique, a simple video watermark modulates the intensities of horizontal scan lines within each field or frame of video. This modulation signal is detected by a light-sensitive device placed near the television. This detector, in turn, transmits a high-frequency infrared signal to interactive devices. In this manner, the actions of a toy can be synchronized with the video being watched on the television. Broughton and Laumeister also mention that modulation of the intensities of the scan lines gives rise to a detectable radio frequency (RF) signal and that this can also form the basis of an alternative detector. An RF detector has the advantage of not being sensitive to ambient lighting conditions and does not need an unrestricted view of the television display.[7]

In a more recent application of watermarking for device control, Digimarc's MediaBridge system embeds a unique identifier into printed and distributed images such as magazine advertisements, packaging, tickets, and so on. After the image is recaptured by a digital camera, the watermark is read by the MediaBridge software on a PC and the identifier is used to direct a web browser to an associated web site.

2.2 Properties

Watermarking systems can be characterized by a number of defining properties [109, 61, 212, 291], and in this section we highlight 10 of them. The relative importance of each property is dependent on the requirements of the application and the role the watermark will play. In fact, even the interpretation of a watermark property can vary with the application.

7. This video watermarking system later became known as VEIL and is used in a variety of applications including broadcast monitoring and interactive TV.

We begin by discussing a number of properties typically associated with a watermark embedding process: *effectiveness, fidelity,* and *payload*. We then turn to properties typically associated with detection: *blind* and *informed detection, false positive behavior,* and *robustness*. The next two properties, *security* and the use of secret *keys*, are closely related in that the use of keys is usually an integral part of any security feature inherent in a watermarking scheme. We then discuss the ability to change the message encoded by a watermark either by modifying the watermark itself or by representing the message with multiple watermarks. The section concludes with a discussion of the various *costs* associated with both watermark embedding and watermark detection.

2.2.1 Embedding Effectiveness

We define a watermarked Work as a Work that when input to a detector results in a positive detection. With this definition of watermarked Works, the *effectiveness* of a watermarking system is the probability that the output of the embedder will be watermarked. In other words, the effectiveness is the probability of detection immediately after embedding. This definition implies that a watermarking system might have an effectiveness of less than 100%.

Although 100% effectiveness is always desirable, this goal often comes at a very high cost with respect to other properties. Depending on the application, we might be willing to sacrifice some effectiveness for better performance with respect to other characteristics. As an example, consider a stock photo house that needs to embed *proof of ownership* watermarks in thousands of images each day. Such a system might have a very high fidelity requirement, and it may be the case that certain images cannot be successfully watermarked within those fidelity constraints. The photo house may then have to decide whether to allow the images to remain unmarked, and thus unprotected, or allow the introduction of more distortion to maintain a 100% effectiveness rate. In some cases, the former choice is preferable.

In some cases, the effectiveness of a watermarking system may be determined analytically. An example of this is presented in Section 6.6.2. It can also be estimated empirically by simply embedding a watermark in a large test set of images. The percentage of output images that result in positive detections will approximate the probability of effectiveness, provided the number of images in the set is sufficiently large and is drawn from the same distribution as the expected application images.

2.2.2 Fidelity

In general, the *fidelity* of a watermarking system refers to the perceptual similarity between the original and watermarked versions of the cover Work. However, when the watermarked Work will be degraded in the transmission process prior

to its being perceived by a person, a different definition of fidelity may be more appropriate. We may define the fidelity of a watermarking system as the perceptual similarity between the unwatermarked and watermarked Works at the point at which they are presented to a consumer.

Consider the case of watermarked video that will be transmitted using the NTSC broadcast standard, or audio that will be transmitted over AM radio. The quality of these broadcast technologies is relatively low, so that differences between the original and watermarked Works may become imperceptible after the channel degradations. Conversely, in HDTV and DVD video and audio, the signals are very high in quality, and require much higher fidelity watermarks.

In some applications, we can accept mildly perceptible watermarks in exchange for higher robustness or lower cost. For example, Hollywood dailies are not finished products. They are usually the result of poor transfers from film to video. Their only purpose is to show those involved in a film production the raw material shot so far. A small visible distortion caused by a watermark will not diminish their value.

2.2.3 Data Payload

Data payload refers to the number of bits a watermark encodes within a unit of time or within a Work. For a photograph, the data payload would refer to the number of bits encoded within the image. For audio, data payload refers to the number of embedded bits per second that are transmitted. For video, the data payload may refer to either the number of bits per field (or frame) or the number of bits per second. A watermark that encodes N bits is referred to as an *N-bit watermark*. Such a system can be used to embed any one of 2^N different messages.

Different applications may require very different data payloads. Copy control applications may require just 4 to 8 bits of information to be received over a period of, say, every 10 seconds for music and a period of perhaps 5 minutes for video. In such scenarios, the data rate is approximately 0.5 bits per second for music and 0.02 bits per second for video. In contrast, television broadcast monitoring might require at least 24 bits of information to identify all commercials, and this identification may need to occur within the first second of the start of the broadcast segment. Thus, the data rate in this application is 24 bits per second, over three orders of magnitude larger than for a video copy control application.

Many applications require a detector to perform two functions. It must determine if a watermark is present and, if so, identify which of the 2^N messages is encoded. Such a detector would therefore have $2^N + 1$ possible output values: 2^N messages plus "no watermark present."

In the watermarking research literature, many systems have been proposed in which there is only one possible watermark and the detector determines whether or not that watermark is present. These have sometimes been referred to as "one-bit" watermarks because there are 2^1 possible outputs: watermark present and

watermark absent. However, this is inconsistent with the previously described naming convention. We prefer to call these zero-bit watermarks because they have $2^0 + 1 = 2$ possible output values.

2.2.4 Blind or Informed Detection

In some applications, the original, unwatermarked Work is available during detection. For example, in a transaction-tracking application, it is usually the owner of the original Work who runs the detector, in order to discover who illegally distributed a given copy. The owner, of course, should still have an unwatermarked version of the Work and can thus provide it to the detector along with the illegal copy. This often substantially improves detector performance, in that the original can be subtracted from the watermarked copy to obtain the watermark pattern alone. The original can also be used for registration, to counteract any temporal or geometric distortions that might have been applied to the watermarked copy (see Chapter 8).

In other applications, detection must be performed without access to the original Work. Consider a copy control application. Here, the detector must be distributed in every consumer recording device. Having to distribute the unwatermarked content to every detector would not only be impractical, it would defeat the very purpose of the watermarking system.

We refer to a detector that requires access to the original, unwatermarked Work as an *informed detector*. This term can also refer to detectors that require only some information derived from the original Work, rather than the entire Work. Conversely, detectors that do not require any information related to the original are referred to as *blind detectors*. Whether a watermarking system employs blind or informed detection can be critical in determining whether it can be used for a given application. Informed detection can only be used in those applications where the original Work is available.

In the watermarking literature, systems that use informed detection are often called *private watermarking systems*, whereas those that use blind detection are called *public watermarking systems*. This terminology refers to the general usefulness of the systems in applications in which only a select group of people may detect the watermark (private watermarking applications) or applications in which everyone must be allowed to detect the watermark (public watermarking applications). In general, the original Works are only available in private applications, and therefore informed detectors cannot be used in public applications. However, for reasons discussed in Chapter 9, we usually avoid the use of "public" and "private."

2.2.5 False Positive Rate

A *false positive* is the detection of a watermark in a Work that does not actually contain one. When we talk of the false positive rate, we refer to the number of false positives we expect to occur in a given number of runs of the detector.

Equivalently, we can discuss the probability that a false positive will occur in any given detector run. There are two subtly different ways to define this probability, which are often confused in the literature. They differ in whether the watermark or the Work is considered the random variable.

In the first definition, the false positive probability is the probability that given a fixed Work and randomly selected watermarks the detector will report that a watermark is in that Work. The watermarks are drawn from a distribution defined by the design of a watermark generation system. Typically, watermarks are generated by either a bit-encoding algorithm or by a Gaussian, independent random number generator. In many cases, the false positive probability, according to this first definition, is actually independent of the Work, and depends *only* on the method of watermark generation.

In the second definition, the false positive probability is the probability that given a fixed *watermark* and randomly selected *Works* the detector will detect that watermark in a Work. The distribution from which the Work is chosen is highly application dependent. Natural images, medical images, graphics, music videos, and surveillance video all have very different statistics. The same is true of rock music, classical music, and talk radio. Moreover, while these distributions are different from one another, they are also likely to be very different from the statistics of the watermark generation system. Thus, false positive probabilities based on this second definition can be quite different from those based on the first definition. Experimental results, presented in Chapter 6, bear this out.

In most applications, we are more interested in the second definition of false positive probability than in the first. However, in a few cases, the first definition is also important, such as in the case of transaction tracking, in which the detection of a random watermark in a given Work might lead to a false accusation of theft.

The required false positive probability depends on the application. In the case of proof of ownership, the detector is used so rarely that a probability of 10^{-6} should suffice to make false positives unheard of. On the other hand, in a copy control application, millions of watermark detectors are constantly being run on millions of Works all over the world. If one unwatermarked Work consistently generates false positives, it could cause serious trouble. For this reason, the false positive rate should be infinitesimal. For example, the general consensus is that watermark detectors for DVD video should have a false positive probability of 1 in 10^{12} frames [20], or about 1 in 1,000 years of continuous operation.

2.2.6 Robustness

Robustness refers to the ability to detect the watermark after common signal processing operations. Examples of common operations on images include spatial filtering, lossy compression, printing and scanning, and geometric distortions (rotation, translation, scaling, and so on). Video watermarks may need to be

robust to many of the same transformations, as well as to recording on video tape and changes in frame rate, among other influences. Audio watermarks may need to be robust to such processes as temporal filtering, recording on audio tape, and variations in playback speed that result in wow and flutter.

Not all watermarking applications require robustness to all possible signal processing operations. Rather, a watermark need only survive the common signal processing operations likely to occur between the time of embedding and the time of detection. Clearly this is application dependent. For example, in television and radio broadcast monitoring, the watermark need only survive the transmission process. In the case of broadcast video, this often includes lossy compression, digital-to-analog conversion, analog transmission resulting in low-pass filtering, additive noise, and some small amount of horizontal and vertical translation. In general, watermarks for this application need not survive rotation, scaling, high-pass filtering, or any of a wide variety of degradations that occur only prior to the embedding of the watermark or after its detection. Thus, for example, a watermark for broadcast monitoring need not be robust to VHS recording.

In some cases, robustness may be completely irrelevant, or even undesirable. In fact, an important branch of watermarking research focuses on fragile watermarks. A fragile watermark is one designed so that it is *not* robust. For example, a watermark designed for authentication purposes should be fragile. Any signal processing application applied to the image should cause the watermark to be lost. Fragile watermarking is discussed in Chapter 10.

At the other extreme, there are applications in which the watermark must be robust to every conceivable distortion that does not destroy the value of the cover Work. This is the case when the signal processing between embedding and detection is unpredictable, or when the watermark must be secure against hostile attack (see next section). Robust watermarking is discussed in Chapter 8.

2.2.7 Security

The *security* of a watermark refers to its ability to resist hostile attacks. A hostile attack is any process specifically intended to thwart the watermark's purpose. The types of attacks we might be concerned about fall into three broad categories:

- Unauthorized removal
- Unauthorized embedding
- Unauthorized detection

Unauthorized removal and embedding are referred to as *active* attacks because these attacks modify the cover Work. Unauthorized detection does not modify the cover Work and is therefore referred to as a *passive* attack.

The relative importance of these attacks depends on the application. In fact, there are situations in which the watermark has no hostile enemies and need not

be secure against *any* type of attack. This is usually the case when a watermark is used to provide enhanced functionality to consumers. However, for applications that do require some level of security, it is important to understand the distinctions between these types of attack.

Unauthorized removal refers to attacks that prevent a Work's watermark from being detected. It is common to distinguish between two forms of unauthorized removal: *elimination* attacks and *masking* attacks. The distinction is subtle and is discussed in detail in Chapter 9. Intuitively, *elimination* of a watermark means that an attacked Work cannot be considered to contain a watermark *at all*. That is, if a watermark is eliminated, it is not possible to detect it even with a more sophisticated detector. Note that eliminating a watermark does *not* necessarily mean reconstructing the original, unwatermarked Work. Rather, the goal of the adversary is to make a new Work that is perceptually similar to the original, but will never be detected as containing a watermark. The original, itself, would satisfy this goal, but it is only one of many Works that would.

Masking of a watermark means that the attacked Work can still be considered to contain the watermark, but the mark is undetectable by existing detectors. More sophisticated detectors might be able to detect it. For example, many image watermark detectors cannot detect watermarks that have been rotated slightly. Thus, an adversary may apply a rotation that is slight enough to be unnoticeable, with the distorted image therefore having acceptable fidelity. Because the watermark detector is sensitive to rotations, the watermark will not be detected. Nevertheless, the watermark could still be detected by a more sophisticated detector capable of correcting for the rotation. Therefore, we can think of the watermark as still being present.

One interesting form of unauthorized removal is known as a *collusion* attack. Here, the attacker obtains several copies of a given Work, each with a different watermark, and combines them to produce a copy with no watermark. This is primarily a concern in transaction tracking, which entails putting a different watermark in each copy. With existing watermarking systems, it is generally believed that a fairly small number of copies suffices to make a collusion attack successful [254, 140, 82]. How serious this problem is depends on the context in which transaction tracking is being used. In the DiVX application described in Section 2.1.4, we can easily imagine that an adversary might obtain a dozen players and thus be able to remove the watermark. However, in the studio dailies application, it is very unlikely that any one employee will be able to obtain many different copies of a given film clip; therefore, collusion attacks are of less concern.

Unauthorized *embedding*, also referred to as *forgery*, refers to acts that embed illegitimate watermarks into Works that should not contain them. For example, consider an authentication application, discussed in Section 2.1.5. Here, we are not concerned with whether an adversary can render a watermark undetectable, in that doing so would cause the detector to, correctly, identify a Work

as inauthentic. However, if an adversary has the ability to perform unauthorized embedding, she can cause the detector to falsely authenticate an invalid Work.

Unauthorized *detection*, or *passive* attacks, can be broken down into three levels of severity. The most severe level of unauthorized detection occurs when an adversary detects and deciphers an embedded message. This is the most straightforward and comprehensive form of unauthorized reading. A less severe form of attack occurs when an adversary can detect watermarks, and distinguish one mark from another, but cannot decipher what the marks mean. Because watermarks refer to the Works in which they are embedded, the adversary might be able to divine the meanings of the marks by comparing them to their cover Works. The least severe form of attack occurs when an adversary is able to determine that a watermark is present, but is neither able to decipher a message nor distinguish between embedded messages.

In general, passive attacks are of more concern in steganography than in watermarking, but there are watermarking applications in which they might be important. For example, suppose we have a broadcast monitoring company that embeds watermarks for free, and then charges for the monitoring reports. An adversary who can read our watermarks could set up a competing service, without having to incur the cost of embedding.

Chapter 9 provides a framework for analyzing the security requirements of watermarking applications and discusses the difficulty of creating secure watermarks under various conditions. It also describes a few known, general attacks, and ways to counter (some of) them.

2.2.8 Cipher and Watermark Keys

In cryptography, security is usually provided by the use of secret *keys*. These can be thought of as more or less arbitrary sequences of bits that determine how messages are encrypted. In the simplest systems, a message encrypted with a given key can only be decrypted with the same key. Many watermarking systems are designed to use keys in an analogous manner. In such systems, the method by which messages are embedded in watermarks depends on a key, and a matching key must be used to detect those marks.

Before the introduction of keys, the security of most cryptographic algorithms relied on keeping those algorithms secret. This led to two problems. First, if the security of an algorithm was compromised, a completely new algorithm had to be developed. Second, because of the need for secrecy, it was not possible to disclose an algorithm to outside researchers for study. This meant that many security weaknesses were never discovered before the algorithms were actually in use. These problems are now largely solved by using keys.

In modern cryptographic algorithms, security is derived from securing only the key, not the entire algorithm. Thus, encryption and decryption algorithms

can be publicly disclosed and evaluated using one key. A different key can then be employed during actual use. Finally, if this key is compromised, it is not necessary to change the entire algorithm; only a new secret key must be selected.[8] Thus, a well-designed cipher should meet the following standards:

- Knowledge of the encryption and decryption algorithms should not compromise the security of the system.
- Security should be based on the use of keys.
- Keys should be chosen from a large *keyspace* so that searching over the space of all possible keys is impractical.

It is desirable to apply the same standards to watermarking algorithms. However, the security requirements for watermarks are often different from those for ciphers. Therefore, we cannot simply adapt cryptographic methods to watermarking. Cryptography is only concerned with the prevention of unauthorized reading and writing of messages. It can therefore be used in watermarking to prevent certain forms of passive attack and forgery, but it does not address the issue of watermark removal. This problem is analogous to the problem of signal jamming in military communications, and so it is to that field we must turn to find a possible solution.

To provide resistance to jamming and interference, the military developed *spread spectrum* communications, in which a narrow-band signal is spread over a much larger bandwidth. The exact form of the spreading is a secret known only by the transmitter and receivers. Without knowledge of the spreading function, it is almost impossible for an adversary to detect or interfere with a transmission. This spreading function is also based on a secret analogous to a key in cryptography (although it is seldom, if ever, referred to as such).

Watermark algorithms can be designed to use secret keys in a manner similar to that in spread spectrum. For example, one simple form of watermarking algorithm, described in the next chapter, adds a pseudo-random noise pattern (or *PN pattern*) to an image. For the system to work, the embedder and detector must use the same PN pattern. Thus, the PN pattern, or a seed used to generate the PN pattern, can be considered a secret key.

Ideally, it should not be possible to detect the presence of a watermark in a Work without knowledge of the key, even if the watermarking algorithm is known. Further, by restricting knowledge of the key to only a trusted group (i.e., by preventing an adversary from learning the key), it should become extremely

8. An important issue in any key-based system is that of *key management,* the procedures used to maintain secrecy of keys and replace those that have been compromised. This topic, however, is outside the scope of this book. The reader is directed to [7, 252, 240] for further information.

difficult, if not impossible, for an adversary to remove a watermark without causing significant degradation in the fidelity of the cover Work.

Because the keys used during embedding and detection provide different types of security from those used in cryptography, it is often desirable to use *both* forms of key in a watermarking system. That is, messages are first encrypted using one key, and then embedded using a different key. To keep the two types of keys distinct, we use the terms *cipher key* and *watermark key,* respectively. The relationship between cryptography, spread spectrum communications, and watermarking is discussed in more detail in Chapter 9.

2.2.9 Modification and Multiple Watermarks

When a message is embedded in a cover Work, the sender may be concerned about message modification. Whereas the ability to modify watermarks is highly undesirable in some applications, there are others in which it is necessary. For example, American copyright law grants television viewers the right to make a single copy of broadcasted programs for time-shifting purposes (i.e., you are permitted to make a copy of a broadcast for the noncommercial purpose of watching that broadcast at a later time). However, you are not permitted to make a copy of this copy. Thus, in copy control applications, the broadcasted content may be labeled copy-once and, after recording, should be labeled copy-no-more. This modification of the recorded video can be accomplished in a variety of ways. The most obvious manner is to simply alter the embedded watermark denoting copy-once so that it now denotes copy-no-more. However, if a watermark is designed to permit easy modification, there is the risk that illegal modification will become commonplace. Imagine a device or program that modifies the video from copy-once to copy-freely.

An alternative to altering the existing watermark is to embed a second watermark. The presence of both watermarks can then be used to denote the copy-no-more state. Conversely, the initial copy-once state can be denoted by two watermarks, the primary and secondary. The secondary watermark could be a relatively fragile watermark compared to the primary one, and its removal would denote copy-no-more. These two methods appear at first sight to be equivalent but in fact have very different false positive behaviors. Their implementation also raises technical challenges, such as the need to embed watermarks in compressed media without changing the bit rate [107, 221].

Another example of the need for multiple watermarks to coexist in a Work arises in the area of transactional watermarks. Content distribution often includes a number of intermediaries before reaching the end user. Thus, a record label might first want to include a watermark identifying itself as the copyright owner. The Work might then be sent to a number of music web sites. Each copy of the Work might have a unique watermark embedded in it to identify each distributor.

Finally, each web site might embed a unique watermark in each Work it sells for the purpose of uniquely identifying each purchaser.

2.2.10 Cost

The economics of deploying watermark embedders and detectors can be extremely complicated and depends on the business models involved [67]. From a technological point of view, the two principal issues of concern are the speed with which embedding and detection must be performed and the number of embedders and detectors that must be deployed. Other issues include whether the detectors and embedders are to be implemented as special-purpose hardware devices or as software applications or plug-ins.

In broadcast monitoring, both embedders and detectors must work in (at least) real time. This is because the embedders must not slow down the production schedule, and the detectors must keep up with real-time broadcasts. On the other hand, a detector for proof of ownership will be valuable even if it takes days to find a watermark. Such a detector will only be used during ownership disputes, which are rare, and its conclusion about whether the watermark is present is important enough that the user will be willing to wait.

Furthermore, different applications require different numbers of embedders and detectors. Broadcast monitoring typically requires a few embedders and perhaps several hundred detectors at different geographic locations. Copy control applications may need only a handful of embedders but millions of detectors embedded in consumer video and audio devices. Conversely, in the transaction-tracking application implemented by DiVX, in which each player embeds a distinct watermark, there would be millions of embedders and only a handful of detectors. In general, the more numerous a device needs to be for a given application the less it must cost.

2.3 Evaluating Watermarking Systems

Most people who deal with watermarking systems need some way of evaluating and comparing them. Those interested in applying watermarking to an application need to identify the systems that are most appropriate. Those interested in developing new watermarking systems need measures by which to verify algorithmic improvements. Such measures may also lead to ways of optimizing various properties.

2.3.1 The Notion of "Best"

Before we can evaluate a watermarking system, we need to have some idea of what makes one system better than another, or what level of performance would

be best. If we are interested in using a watermark for some specific application, our evaluation criteria must depend on that application. For example, if we are evaluating a video watermark for use in copy control, we might want to test its robustness to small rotations, in that these could be used as an attack (see Section 2.2.7). However, such robustness might be irrelevant for broadcast monitoring, because rotations are unlikely to occur during normal broadcasting, and we might not be concerned with security against active attacks.

If we are interested in testing the merit of a new watermarking system in comparison to existing systems, we have more flexibility in choosing our test criteria. In general, by showing that a new system provides an improvement in any one property, all else being equal, we can show that the system is worthwhile, at least for applications in which that property is important.

Moreover, an improvement in one property can often be traded for improvements in others. For example, suppose we have a watermarking system that carries a data payload of 20 bits, and we devise a way of extending this to 30 bits, without changing the false positive probability, robustness, or fidelity. Clearly, the new system would be better than the old for applications that can use greater data payload. However, for other applications, we can easily trade this higher payload for a lower false positive probability. This could be done by modifying the embedder to take only 20-bit messages, but to embed a 10-bit checksum along with each message. The detector, then, would extract all 30 bits and check whether the checksum is correct, declaring that no watermark is embedded if the check fails. This would result in a 20-bit system with a false positive probability 1,024 times lower than the original.

Furthermore, many watermark detectors employ a *detection threshold* parameter, which we can lower to translate our improved false positive probability into improved robustness. Further still, many embedders employ an *embedding strength* parameter, which trades robustness for fidelity. Thus, if we can verify that a new system carries larger payloads than an older one, we can often claim that it will be better for a wide variety of applications.

2.3.2 Benchmarking

Once the appropriate test criteria have been determined, we can turn our attention to developing a test. If we are evaluating watermarks for a specific application, each criterion can be laid out as a minimum requirement for a relevant property, and a suite of tests can be developed to measure whether systems meet those requirements. All tests of a given system must be performed using the same parameter settings at the embedder and detector (e.g., a constant embedding strength and detection threshold). An early example of such a testing program was the CPTWG's effort to test watermarks for copy control in DVD recorders [14] (see Section 2.1.6).

For purposes of watermarking research, there has been some interest in the development of a universal benchmark. This benchmark could be used by a researcher to assign a single, scalar "score" to a proposed watermarking system. The score could then be used to compare it against other systems similarly tested.

A proposed benchmark for image watermarking systems can be found in [151]. This proposal specifies a number of bits of data payload that must be embedded (80), along with a level of fidelity that must be maintained, as measured by a specific perceptual model (see Chapter 7 for more on perceptual modeling). Holding these two properties constant, then, the robustness of the system to several types of distortion is tested using a program called *Stirmark* [211]. This program applies distortions that have little effect on the perceptual quality of images, but are known to render most watermarks undetectable. The system's performance in these tests is combined into a single score.

Unfortunately, this benchmark can only be performed on certain watermarking systems and is only relevant to certain watermarking applications. Many watermarking systems are designed to carry very small data payloads (on the order of 8 bits or fewer), with very high robustness, very low false positive probability, and/or very low cost. Such systems typically employ codes that cannot be expanded to 80 bits (see Chapter 4). Furthermore, the tests performed by Stirmark are not critical to many applications that do not have stringent security requirements. They also do not represent a comprehensive test of the security required in applications in which an adversary is likely to have a watermark detector (see Chaper 9).

We believe that no benchmark can ever be relevant to all watermarking systems and applications. Thus, in this book, we test our example algorithms with experiments designed specifically for the points the algorithms illustrate. Almost every algorithm is a modification of one previously presented and is based on a theoretical discussion that suggests the modification should yield improved performance in some particular property. Typically, we try to hold as many other properties constant as possible while we test the effects of the modification.

2.3.3 Scope of Testing

In general, watermarking systems should be tested on a large number of Works drawn from a distribution similar to that expected in the application. For example, we would not necessarily expect an algorithm that was tuned to "Lena"[9] to be ideally suited for X-ray images, satellite photos, or animation frames. If a system is being tested without a specific application in mind, the Works it is tested on should be representative of a typical range of applications.

9. "Lena" is the common name for the image of Lena Sjööblom, discussed in Section 2.1.2. It is perhaps the most-often-used test image in image processing.

These two issues—size and typicality of the test set—are especially important in testing false positive rates. Imagine a watermark detector that will be examining a large number of Works, looking for one particular watermark pattern. If this system is required to have a false positive rate of 10^{-6}, we would expect to see, on average, no more than one false positive in every million Works examined. To truly verify this performance, we would need to present the detector with many millions of Works. Of course, in many cases, such a test might be infeasible, and we have to make do with tests that verify some statistical model used to predict the false positive rate (see Sections 6.2 and 6.6.1). Even these tests, though they do not require millions of Works, can be misleading if performed on too few.

For all of the experiments in this book, we started with a database of 20,000 stock images [51], at a resolution of 240×368 pixels. The majority of these images are photographs, but some of them are paintings and textures. Most of the experiments were run on 2,000 images chosen randomly from this set. Some false positive tests were performed on the full database.

2.4 Summary

This chapter has discussed several possible applications of watermarking, and how to judge various systems' suitability to them. The following are the main points covered.

- Most applications of watermarks can be performed with other technologies. However, watermarks offer three potential advantages over other techniques:
 - They are imperceptible.
 - They do not get removed when Works are displayed or converted to other file formats.
 - They undergo the same transformations as the Works in which they are embedded.
- We described the following seven possible applications in detail:
 - *Broadcast monitoring:* Identifying when and where Works are broadcast by recognizing watermarks embedded in them.
 - *Owner identification:* Embedding the identity of a Work's copyright holder as a watermark.
 - *Proof of ownership:* Using watermarks to provide evidence in ownership disputes.
 - *Transaction tracking:* Using watermarks to identify people who obtain content legally but illegally redistribute it.
 - *Content authentication:* Embedding signature information in content that can be later checked to verify it has not been tampered with.

- ⊞ *Copy control:* Using watermarks to tell recording equipment what content may not be recorded.
- ⊞ *Device control:* Using watermarks to make devices, such as toys, react to displayed content.
- ▪ The suitability of a given watermarking system for a given application may be judged in terms of the following properties of that system.
 - ⊞ *Embedding effectiveness:* The probability that the embedder will successfully embed a watermark in a randomly selected Work.
 - ⊞ *Fidelity:* The perceptual quality of watermarked content.
 - ⊞ *Data payload:* The amount of information that can be carried in a watermark.
 - ⊞ *Blind or informed detection:* Whether (a) the watermark detector can detect a watermark in a Work without extra information (*blind detection*) or (b) the detector requires some information related to the original version of a watermarked Work (*informed detection*).
 - ⊞ *False positive rate:* The frequency with which we should expect watermarks to be falsely detected in unwatermarked content.
 - ⊞ *Robustness:* The ability of the watermark to survive normal processing of content.
 - ⊞ *Security:* The ability of the watermark to resist hostile attacks.
 - ⊞ *Cipher and watermark keys:* Whether the system employs (a) cipher keys to control message encryption and (b) watermark keys to control embedding and detection.
 - ⊞ *Modification and multiple watermarks:* The possibility of changing embedded watermarks or embedding several watermarks in one Work.
 - ⊞ *Cost:* The computational cost of the embedder and detector.
- ▪ The required properties of a watermark strongly depend on the application. Thus, the appropriate evaluation criteria are application dependent.
- ▪ Benchmarking is a reasonable means of comparing watermarking systems. However, no benchmark is likely to be relevant to all applications.
- ▪ Watermarking systems should be tested on large data sets.
- ▪ If a watermarking system is improved so that it has better performance in one property, this can often be traded for better performance in other properties.

Models of Watermarking

The **first two chapters** of this book have discussed the field of watermarking at a fairly nontechnical level. With the present chapter, we begin our exploration of the detailed, technical principles. In this chapter, and throughout the rest of the book, we illustrate these principles with algorithms and experiments described in special sections called *Investigations*.

The goal of this chapter is to familiarize the reader with several conceptual models of watermarking. These models serve as ways of thinking about actual watermarking systems. They fall into two broad groups: models based on a view of watermarking as a method of communications, and models based on geometric views of watermarking algorithms.

The chapter begins with some background material. Section 3.1 describes the basic notational conventions used in equations throughout the book. Section 3.2 gives a brief description of traditional communications systems, outside the context of watermarking. The next two sections form the bulk of the chapter. In Section 3.3, we describe three different ways of modeling watermarking in terms of traditional communications. This is followed, in Section 3.4, by a discussion of geometric models of watermarking.

Finally, we conclude the chapter with a brief discussion of *correlation-based watermarking*. This is a subclass of possible watermarking algorithms that we believe encompasses the majority of proposed systems. Much of the analysis presented in the rest of this book is focused on these types of systems.

A note on terminology. In the foregoing chapters, we have been using the term *watermark* rather loosely. There are, however, several subtly different objects to which this term might refer: a pattern added to a Work, a message encoded by that pattern, or a pattern used for comparison during watermark detection. In informal discussions, the distinctions between these objects are not very important.

However, for more technical discussions, we must keep them clear. We therefore give each of them a unique name: *added pattern, message,* and *reference pattern,* respectively (see Section 3.3.1). We continue to use the term *watermark* informally, to mean any of these things.

3.1 Notation

In this section, we define some preliminary notational conventions. The section does not describe all notation used in this book; rather, it defines the notation necessary to begin our technical discourse. As we proceed through this chapter, and through the rest of the book, we introduce additional notation as needed. A complete list of notational conventions and commonly used variables is found in Appendix D. The following is organized according to the various types of variables we use.

- *Scalars:* Scalar values and individual members of sets are set in italic, upper or lower case: N, i, x, and so on. The magnitude of scalar value n is denoted $|n|$.
- *Sets:* Sets are set in a calligraphic font. For example, the set of real numbers is \mathcal{R}, and a set of messages is \mathcal{M}. The number of elements in set \mathcal{M} is denoted $|\mathcal{M}|$.
- *Vectors and Arrays:* One-dimensional vectors and higher-dimensional arrays (both of which are usually referred to as vectors in this text) are represented as boldface, lowercase letters; as, for example, \mathbf{c}, \mathbf{v}, and \mathbf{w}. Indices into these arrays are specified in square brackets. For example, the pixel of image \mathbf{c} at location x, y is specified by $\mathbf{c}[x, y]$.

 We are sometimes interested in a frequency transform domain representation of a vector. Typical frequency transforms discussed are the Fourier transform and the discrete cosine transform. In either case, we refer to the transform of the vector \mathbf{c} with upper case (\mathbf{C}) and rely on the context of the discussion to indicate the implied transform.

 We often use subscripts to indicate different versions of vectors. For example, if we know that a Work, \mathbf{c}, is an original Work, we indicate that fact by writing it as $\mathbf{c_o}$. A watermarked version of the Work is $\mathbf{c_w}$. In general, a Work that has been subjected to a noise process is $\mathbf{c_n}$, and a noisy, watermarked Work is denoted $\mathbf{c_{wn}}$. Occasionally, subscripts are also used to index into arrays of vectors.

 The Euclidian length of vector \mathbf{c} is denoted $|\mathbf{c}|$.

 The *sample mean* of a vector, denoted $\bar{\mathbf{c}}$ for vector \mathbf{c}, is the average of its elements. The *sample variance,* $s_{\mathbf{c}}^2$, is the average of $(\mathbf{c}[i] - \bar{\mathbf{c}})^2$.
- *Random Scalar Variables:* Random scalar variables are indicated with a sans serif font: r, m, and so on. Each such variable is associated with a probability

distribution or density function. The probability that the value r will be drawn from the distribution of r is written $P_r(r)$.

The *statistical mean* of r (i.e., the expected value of r) is written as μ_r. The *statistical variance* of r (i.e., the expected value of $(r - \mu_r)^2$) is written as σ_r^2.

■ *Random Vectors:* Random vectors are in the same font as random scalars, but are bold: **c**, **w**, and so on. As with random scalar variables, the probability that vector **c** will be drawn from the distribution of **c** is written $P_c(c)$.

The notation μ_c indicates the statistical mean of the distributions from which the elements of **c** are drawn. Similarly, σ_c^2 is the statistical variance of those elements.

The sample mean of a random vector is itself a random value, \bar{c}. The probability that \bar{c} takes on a given value is just the probability of drawing a vector from **c** that has a sample mean of that value. Similarly, the sample variance for a random vector is itself a random value, s_c. Note that we are not always strict in denoting what is and is not a random variable, but instead make the distinction when the distinction is important.

3.2 Communications

To understand the similarities and differences between watermarking and conventional communications, it is useful to briefly review the traditional model of a communications system. We first highlight some of the components of a communication system that will be relevant in our extension to watermarking. We then discuss a number of classes of transmission channels that have been found to be useful for thinking about watermarking. This section ends with a discussion of secure transmission systems.

3.2.1 Components of Communications Systems

Figure 3.1 illustrates the basic elements of the traditional communications model. We begin with a message, m, that we want to transmit across a communications

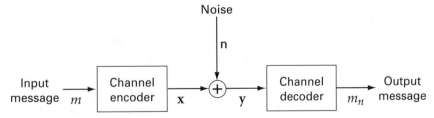

Fig. 3.1 Standard model of a communications system.

channel. This message is encoded by the *channel encoder* in preparation for transmission over the channel. The channel encoder is a function that maps each possible message into a code word drawn from a set of signals that can be transmitted over the channel. This code word is conventionally denoted as \mathbf{x}.

In practice for digital signals, the encoder is usually broken down into a *source coder* and a *modulator*. The source coder maps a message into a sequence of *symbols* drawn from some *alphabet*. The modulator converts a sequence of symbols into a physical signal that can travel over the channel. For example, it might use its input to modulate the amplitude, frequency, or phase of a physical carrier signal for radio transmission.

The actual form of the channel encoder's output depends on the type of transmission channel being used, but for our purposes we will think of \mathbf{x} as a sequence of real values, $\mathbf{x} = \{\mathbf{x}[1], \mathbf{x}[2], \ldots, \mathbf{x}[N]\}$, quantized to some arbitrarily high precision. We also assume that the range of possible signals is limited in some way, usually by a power constraint that says that

$$\sum_i (\mathbf{x}[i])^2 \leq p, \tag{3.1}$$

where p is a constant limit on power.

The signal, \mathbf{x}, is then sent over the transmission channel, which we assume is noisy. This means that the received signal, conventionally denoted \mathbf{y}, will generally be different from \mathbf{x}. The change from \mathbf{x} to \mathbf{y} is illustrated here as resulting from *additive noise*. In other words, the transmission channel is thought of as adding a random noise signal, n, to \mathbf{x}.

At the receiving end of the channel, the received signal, \mathbf{y}, enters into the *channel decoder,* which inverts the encoding process and attempts to correct for transmission errors. This is a function that maps transmitted signals into messages, m_n. The decoder is typically a many-to-one function, so that even noisy code words are correctly decoded. If the channel code is well matched to the given channel, the probability that the decoded message contains an error is negligibly small.

3.2.2 Classes of Transmission Channels

In designing a communications system of the type pictured in Figure 3.1, we usually regard the transmission channel as fixed. That is, we cannot design or modify the noise function that occurs during transmission. The channel can be characterized by means of a conditional probability distribution, $P_{\mathbf{y}|\mathbf{x}}(\mathbf{y})$, which gives the probability of obtaining \mathbf{y} as the received signal if \mathbf{x} is the transmitted signal.

Different transmission channels can be classified according to the type of noise function they apply to the signal and how that noise is applied. As previously mentioned, the channel illustrated in Figure 3.1 is an *additive noise* channel,

in which signals are modified by the addition of noise signals, $\mathbf{y} = \mathbf{x} + \mathbf{n}$. The noise signals might be drawn from some distribution independent of the signal being modified. The simplest channel to analyze (and perhaps the most important) is a Gaussian channel, in which each element of the noise signal, $\mathbf{n}[i]$, is drawn independently from a Normal distribution with zero mean and some variance, σ_n^2.

However, there are several non-additive types of channels that will be of concern. One of the most important is a *fading channel*, which causes the signal strength to vary over time. This can be expressed as a scaling of the signal, $\mathbf{y} = v[t]\mathbf{x}$, where $0 \le v[t] \le 1$ is an unknown value that may vary slowly with time or with each use of the channel. Such a channel might also include an additive noise component, rendering $\mathbf{y} = v[t]\mathbf{x} + \mathbf{n}$.

3.2.3 Secure Transmission

In addition to modeling the characteristics of the channel, we must often be concerned with the access an adversary may have to that channel. In particular, we are interested in applications that demand security against both *passive* and *active* adversaries. In the former case, an adversary passively monitors the transmission channel and attempts to illicitly read the message. In the latter case, the adversary actively tries to either disable our communications or transmit unauthorized messages. Both forms of adversary are common in military communications. A passive adversary simply monitors all military communications, whereas an active adversary might attempt to jam communications on the battlefield. These security threats were briefly discussed in Sections 2.2.7 and 2.2.8, and two approaches were outlined to defend against attacks: cryptography and spread spectrum communications.

Prior to transmission, cryptography is used to encrypt a message, or *cleartext*, using a key. It is this encrypted message (or *ciphertext*) that is transmitted. At the receiver, the ciphertext is received and then decrypted using the same or a related key to reveal the cleartext. This arrangement is depicted in Figure 3.2.

Fig. 3.2 Standard model of a communications channel with encryption.

Fig. 3.3 Standard model of a communications channel with key-based channel coding.

There are two uses of cryptography. The first is to prevent passive attacks in the form of unauthorized reading of the message. The second is to prevent active attacks in the form of unauthorized writing. However, cryptography does not necessarily prevent an adversary from knowing that a message is being transmitted. In addition, cryptography provides no protection against an adversary intent on jamming or removing a message before it can be delivered to the receiver.

Signal jamming (i.e., the deliberate effort by an adversary to inhibit communication between two or more people) is of great concern in military communications and has led to the development of *spread spectrum communication.* Here, modulation is performed according to a secret code, which spreads the signal across a wider bandwidth than would normally be required [214]. The code can be thought of as a form of key used in the channel coder and decoder, as illustrated in Figure 3.3.

The idea of spread spectrum communication is best illustrated with an example. One of the earliest and simplest spread spectrum technologies is known as *frequency hopping*[1] [179]. As the name suggests, in a frequency-hopping system the transmitter broadcasts a message by first transmitting a fraction of the message on one frequency, the next portion on another frequency, and so on. The pattern of hops from one to another frequency is controlled by a key that must be known to the receiver as well as the transmitter. Without this key, an

1. Frequency hopping was invented by Hedy Kiesler Markey and George Antheil. They are an unlikely pair to have invented such a major idea in communications. Hedy Kiesler Markey was a famous movie and pinup star in the Thirties and Forties, better known by her stage name, Hedy Lamarr. George Antheil was a pianist with whom Hedy Lamarr was rehearsing when she had the idea of frequency hopping. His main contribution was to suggest that player-piano rolls be used to encode the sequence of frequencies [30].

adversary cannot monitor the transmission. Jamming the transmission is also very difficult, in that it could only be done by introducing noise at *all* possible frequencies, which would require too much power to be practical.

Spread spectrum communications and cryptography are complementary. Spread spectrum guarantees delivery of signals. Cryptography guarantees secrecy of messages. It is thus common for both technologies to be used together. For those familiar with layered models of communications, spread spectrum can be thought of as responsible for the *transport layer,* and cryptography as responsible for the *messaging layer.*

3.3 Communication-based Models of Watermarking

Watermarking is, in essence, a form of communication. We wish to communicate a message from the watermark embedder to the watermark receiver. It is natural, then, to try to fit watermarking into the traditional model of a communications system.

In this section, we look at three ways to do this. The differences between these models lie in how they incorporate the cover Work into the traditional communications model. In the basic model, presented first, the cover Work is considered purely as noise. In the second model, the cover Work is still considered noise, but this noise is provided to the channel encoder as *side information.* Finally, the third model does not consider the cover Work as noise, but rather as a second message that must be transmitted along with the watermark message in a form of multiplexing.

3.3.1 Basic Model

In Figures 3.4 and 3.5, we show one way in which watermarking can be mapped into the framework of Figure 3.3. Figure 3.4 shows a system that uses an informed detector, and Figure 3.5 shows a system that uses a blind detector (these terms are defined in Chapter 2). In this mapping, watermarking is viewed as a transmission channel through which the watermark message is communicated. The cover Work is part of that channel.

Regardless of whether we are using an informed detector or a blind detector, the embedding process consists of two basic steps. First, the message is mapped into an *added pattern,* $\mathbf{w_a}$, of the same type and dimension as the cover Work, $\mathbf{c_o}$. For example, if we are watermarking images, the watermark encoder would produce a two-dimensional pixel pattern the same size as the cover image. When watermarking audio, the watermark encoder produces an audio signal. This mapping might be done with a watermark key.

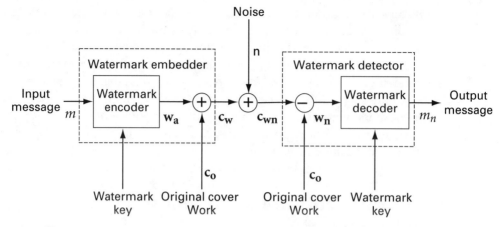

Fig. 3.4 Watermarking system with a simple informed detector mapped into communications model.

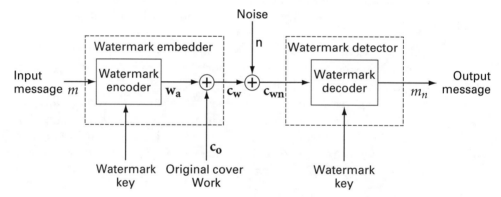

Fig. 3.5 Watermarking system with blind detector mapped into communications model. (Note that in this figure there is no meaningful distinction between the watermark detector and the watermark decoder.)

In many of the examples of embedding algorithms presented in this book, the added pattern is computed in several steps. We generally begin with one or more *reference patterns*, $\mathbf{w}_{r0}, \mathbf{w}_{r1}, \ldots$, which are predefined patterns, possibly dependent on a key. These are combined to produce a pattern that encodes the message, which we refer to as a *message pattern*, \mathbf{w}_m. The message pattern is then scaled or otherwise modified to yield the added pattern, \mathbf{w}_a.

Next, \mathbf{w}_a is added to the cover Work, \mathbf{c}_o, to produce the watermarked Work, \mathbf{c}_w. We refer to this type of embedder as a *blind embedder* because the encoder ignores the cover Work (in contrast to an *informed embedder*, defined in Section 3.3.2).

After the added pattern is embedded, we assume that the watermarked Work, c_w, is processed in some way, and we model the effect of this processing as the addition of noise. The types of processing the Work might go through include compression and decompression, broadcast over analog channels, image or audio enhancements, and so on. Such processing might also include malicious practices by adversaries intent on removing the watermark. The former distortions are discussed in Chapter 8, and security against tampering is discussed in Chapter 9. Note that all these types of processing are dependent on the watermarked Work; therefore, it is a simplification here to model their effects with additive noise.

If we are using an informed watermark detector (Figure 3.4), the detection process can consist of two steps. First, the unwatermarked cover Work may be subtracted from the received Work, c_{wn}, to obtain a received noisy watermark pattern, w_n. This is then decoded by a *watermark decoder,* with a watermark key. Because the addition of the cover Work in the embedder is exactly cancelled out by its subtraction in the detector, the only difference between w_a and w_n is caused by the noise process. Therefore, we can ignore the addition of the cover Work, which means that the watermark encoder, the noise process, and the watermark decoder together form a system that is exactly analogous to the communication system shown in Figure 3.3.

In more advanced informed detection systems, the entire unwatermarked cover Work is not necessary. Instead, some function of c_o, typically a data-reducing function, is used by the detector to cancel out "noise" effects represented by the addition of the cover Work in the embedder. For example, in [60], only a small fraction of DCT coefficients from the original image are required at the detector.

In a blind watermark detector (Figure 3.5), the unwatermarked cover Work is unknown, and therefore cannot be removed prior to decoding. Under these circumstances, we can make the analogy with Figure 3.3, where the added pattern is corrupted by the addition of a single noise pattern formed by the combination of the cover Work and the noise signal. The received, watermarked Work, c_{wn}, is now viewed as a corrupted version of the added pattern, w_a, and the entire watermark detector is viewed as the channel decoder.

In applications that require robustness, such as transaction tracking or copy control, we would like to maximize the likelihood that the detected message is identical to the embedded one. This is the same as the objective in a traditional communications system. However, it should be noted that in authentication applications the goal is not to communicate a message but to learn whether and how a Work has been modified since a watermark was embedded. For this reason, the models in Figures 3.4 and 3.5 are not typically used to study authentication systems.

Using the model of Figure 3.5, we can now construct a simple example of an image watermarking system with a blind detector.

Investigation

Blind Embedding and Linear Correlation Detection

The embedding algorithm in the system we describe here implements a blind embedder. We denote this algorithm by E_BLIND, which refers to this *specific* example of blind embedding rather than the generic concept of blind embedding. In fact, there are many other algorithms for blind embedding.

The detection algorithm uses linear correlation as its detection metric. This is a very common detection metric, which is discussed further in Section 3.5.

To keep things simple, we code only one bit of information. Thus, m is either 1 or 0. We assume that we are working with only grayscale images. Most of the algorithms presented in this book share these simplifications. Methods of encoding more than one bit are discussed in Chapters 4 and 5.

System 1: E_BLIND/D_LC

This system employs a single reference pattern, $\mathbf{w_r}$, which is an array of pixel intensities the same size as the cover image. This pattern might be predefined, or it might be generated randomly based on a watermark key. The message pattern, \mathbf{w}_m (which encodes our one-bit message, m), is equal to either $\mathbf{w_r}$ or $-\mathbf{w_r}$, depending on whether $m = 1$ or $m = 0$, respectively.

In the embedder, the message pattern, \mathbf{w}_m, is scaled by an input parameter, α, to yield the added pattern. The value α controls the trade-off between visibility and robustness of the watermark. Thus, the blind embedding algorithm computes the following:

$$\mathbf{w}_m = \begin{cases} \mathbf{w_r} & \text{if } m = 1 \\ -\mathbf{w_r} & \text{if } m = 0 \end{cases} \tag{3.2}$$

$$\mathbf{w_a} = \alpha\mathbf{w}_m \tag{3.3}$$

$$\mathbf{c_w} = \mathbf{c_o} + \mathbf{w_a}. \tag{3.4}$$

To detect the watermark, we must detect the signal $\pm\mathbf{w_r}$ in the presence of the noise caused by $\mathbf{c_o}$ and n. As is discussed in Section 3.5, the optimal way of detecting this signal in the presence of additive Gaussian noise is to compute the linear correlation between the received image, \mathbf{c}, and the reference pattern, $\mathbf{w_r}$, as

$$z_{\text{lc}}(\mathbf{c}, \mathbf{w_r}) = \frac{1}{N}\mathbf{c} \cdot \mathbf{w_r} = \frac{1}{N}\sum_{x,y} \mathbf{c}[x, y]\mathbf{w_r}[x, y], \tag{3.5}$$

where $\mathbf{c}[x, y]$ and $\mathbf{w_r}[x, y]$ denote the pixel values at location x, y in \mathbf{c} and $\mathbf{w_r}$, respectively, and N is the number of pixels in the image.

If $\mathbf{c} = \mathbf{c_o} + \mathbf{w_a} + \mathbf{n}$, then

$$z_{lc}(\mathbf{c}, \mathbf{w_r}) = \frac{1}{N}(\mathbf{c_o} \cdot \mathbf{w_r} + \mathbf{w_a} \cdot \mathbf{w_r} + \mathbf{n} \cdot \mathbf{w_r}). \tag{3.6}$$

Assuming that $\mathbf{c_o}$ and \mathbf{n} are drawn from Gaussian distributions, $\mathbf{c_o} \cdot \mathbf{w_r}$ and $\mathbf{n} \cdot \mathbf{w_r}$ are almost certain to have small magnitudes. On the other hand, $\mathbf{w_a} \cdot \mathbf{w_r} = \pm \alpha \mathbf{w_r} \cdot \mathbf{w_r}$ should have a much larger magnitude. Therefore, $z_{lc}(\mathbf{c}, \mathbf{w_r}) \approx \alpha \mathbf{w_r} \cdot \mathbf{w_r}/N$ for Works watermarked with $m = 1$, and $z_{lc}(\mathbf{c}, \mathbf{w_r}) \approx -\alpha \mathbf{w_r} \cdot \mathbf{w_r}/N$ for Works watermarked with $m = 0$.

In most applications, we would like the detector[2] to output a distinct message if the received content probably contains no mark. If the detector receives $\mathbf{c} = \mathbf{c_o} + \mathbf{n}$, we should expect the magnitude of $z_{lc}(\mathbf{c}, \mathbf{w_r})$ to be very small. We can therefore determine whether a watermark is present by placing a threshold, τ_{lc}, on the magnitude of $z_{lc}(\mathbf{c}, \mathbf{w_r})$. If $|z_{lc}(\mathbf{c}, \mathbf{w_r})| < \tau_{lc}$, then the detector reports that no watermark is present.

Thus, the D_LC detector outputs

$$m_n = \begin{cases} 1 & \text{if } z_{lc}(\mathbf{c}, \mathbf{w_r}) > \tau_{lc} \\ no\ watermark & \text{if } -\tau_{lc} \leq z_{lc}(\mathbf{c}, \mathbf{w_r}) \leq \tau_{lc}. \\ 0 & \text{if } z_{lc}(\mathbf{c}, \mathbf{w_r}) < -\tau_{lc} \end{cases} \tag{3.7}$$

The detection threshold has a direct effect on the false positive rate. A lower threshold means that there is a higher chance that an unwatermarked Work will be classified as watermarked. Methods for estimating the false positive probability from the detection threshold are discussed in Chapter 6.

Experiments

To test this system, we must choose a reference pattern to embed. In our first experiment, we used a white noise pattern with each pixel value drawn at random from a uniform distribution. The pattern was normalized to have unit variance and the embedding strength, α, was set to 1.0.

The E_BLIND embedder was applied to each of 2,000 images under the two conditions $m = 1$ and $m = 0$, yielding a total of 4,000 watermarked images. The D_LC detector was then applied. Figure 3.6 shows the distributions of $z_{lc}(\mathbf{c_w}, \mathbf{w_r})$ obtained. The distribution of detection values resulting from 2,000 unwatermarked images is illustrated by a dotted line in Figure 3.6.

We can choose a detection threshold based on the resulting false positive probability. Selecting a detection threshold of $\tau_{lc} = 0.7$ yields an estimated

2. We do not differentiate between a *watermark detector* and a *watermark decoder* here, or in most of the book.

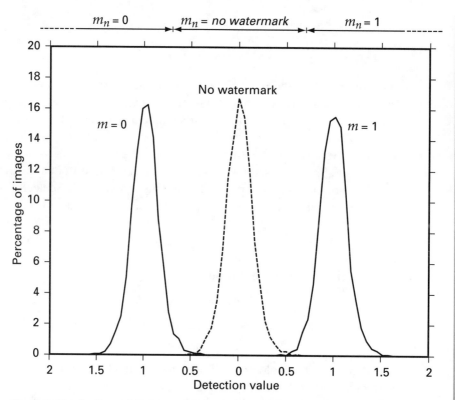

Fig. 3.6 Distributions of linear correlation values resulting from `System 1` (`E_BLIND`/`D_LC`) with a white noise reference pattern. The left-hand curve is the distribution when the embedded message was 0. The right-hand curve is the distribution when it was 1. The dashed curve is the distribution when no watermark was embedded. The legend at the top of the graph shows how the linear correlation decoder (`D_LC`) maps correlation values into messages.

false positive probability[3] of $P_{fp} \approx 10^{-4}$, according to a method introduced in Chapter 6. At this threshold, 57 images in which the message $m = 0$ was embedded were classified as having no watermark, as were 41 images in which the message $m = 1$ had been embedded. Recall from Chapter 2 that the *effectiveness* of a watermarking system is the probability that the output of the embedder will result in a positive, correct detection reported by the detector. Thus, with the current detection threshold, the measured effectiveness of the `E_BLIND`/`D_LC` system is approximately 98%.

The performance of this algorithm is highly dependent on the exact reference pattern used. For example, Figures 3.7 and 3.8 show the effects of using two

3. This false positive probability is too high for most applications. Nevertheless, it gives us a reference point to use in experiments.

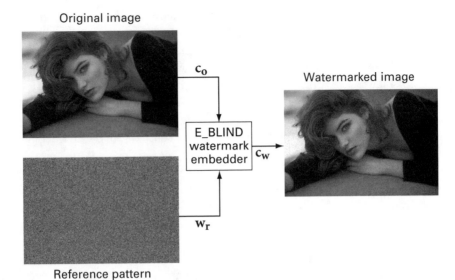

Fig. 3.7 Results of the blind embedding algorithm, E_BLIND, with a reference pattern constructed from uniformly distributed noise.

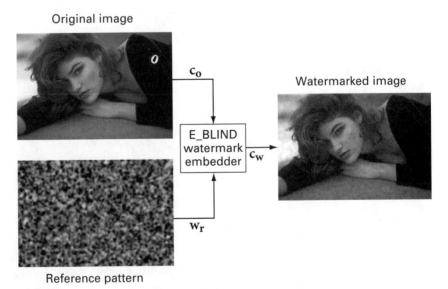

Fig. 3.8 Results of the blind embedding algorithm, E_BLIND, with a reference pattern constructed from low-pass filtering the uniformly distributed noise of Figure 3.7.

perceptually different reference patterns with the same embedding strength. The reference pattern in Figure 3.7 was made using a pseudo-random number generator to select an independent value for each pixel. The reference pattern in Figure 3.8 was made by applying a low-pass filter to the reference pattern of Figure 3.7. Although the two reference patterns have been normalized to have the same variance, and the value of alpha is equal in both cases, the watermarked image in Figure 3.8 has significantly worse fidelity than that in Figure 3.7 because the human eye is more sensitive to low-frequency patterns than to high-frequency patterns.

A second problem with low-frequency reference patterns is that they have a higher chance of generating false positives. This can be seen in a test we ran using the filtered pattern of Figure 3.7. The results of this second experiment are shown in Figure 3.9. The dashed curve shows the distribution of linear correlation values obtained when the detector is run on 2,000 unwatermarked images. These data correspond to a measured false positive rate of 42% and can be compared to the dotted line in Figure 3.6, which was computed

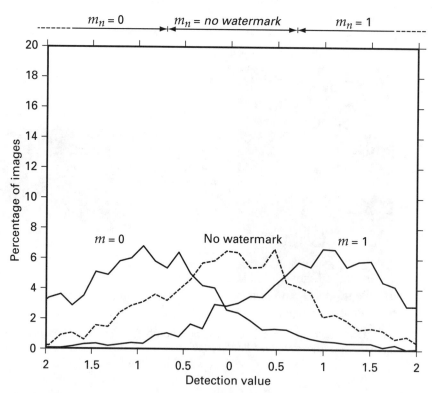

Fig. 3.9 Distribution of linear correlations between images and a low-pass filtered random noise pattern.

using the reference pattern from Figure 3.7. Clearly, the reference pattern in Figure 3.8 tends to have much higher magnitude correlations with unwatermarked images. This happens because images tend to have more energy in the low frequencies than in the high.

The high inherent correlations between the images and the reference pattern can also make it more difficult to embed a watermark. This can be seen by the distributions of detection values obtained from images watermarked with $m = 0$ and with $m = 1$, shown in Figure 3.9. The measured effectiveness of the system using this low-frequency reference pattern is only about 68%.

We can mitigate these problems by restricting the set of patterns from which $\mathbf{w_r}$ is drawn to those similar to the one in Figure 3.7 (i.e., by using a pseudo-random number generator to independently decide on the value of each pixel). Each such pattern can be uniquely identified by the seed used for the pseudo-random number algorithm.

This watermarking system works and is actually suitable for some applications. However, linear correlation is optimal only when the image and the noise are drawn from Gaussian distributions. As discussed in Chapters 6 and 8, these assumptions are not often justified. Furthermore, as described in Chapter 9, this system is vulnerable to a number of attacks. Nevertheless, several proposed watermarking systems are very similar to this one (for example, [15]), and it is useful as a starting point for our discussion.

3.3.2 Watermarking as Communication with Side Information at the Transmitter

Although some insights into robust watermarking with blind detectors can be gained by referring to the model in Figure 3.5, this model cannot accommodate all possible embedding algorithms, as it restricts the encoded watermark to be independent of the cover Work. Because the unwatermarked cover Work, $\mathbf{c_o}$, is obviously known to the embedder, there is no reason to enforce this restriction. Much more effective embedding algorithms can be made if we allow the watermark encoder to examine $\mathbf{c_o}$ before encoding the added pattern $\mathbf{w_a}$.

Figure 3.10 shows a model of watermarking that allows $\mathbf{w_a}$ to be dependent on $\mathbf{c_o}$. The model is almost identical to that in Figure 3.5, with the only difference being that $\mathbf{c_o}$ is provided as an additional input to the watermark encoder. Note that this change allows the embedder to set $\mathbf{c_w}$ to any desired value by simply letting $\mathbf{w_a} = \mathbf{c_w} - \mathbf{c_o}$. If we continue to consider the cover Work as part of the noise process $(\mathbf{c_o} + \mathbf{n})$ in the transmission channel, this new model is an example of a communications system with side information at the transmitter, as originally studied by Shannon [243]. In other words, the embedder is able to exploit some information about the channel noise, specifically $\mathbf{c_o}$ itself.

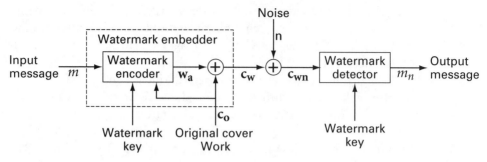

Fig. 3.10 Watermarking as communications with side information at the transmitter.

Since Shannon introduced the topic, several authors have studied communications with side information [53, 110, 299]. It has been discovered that in some types of channels it often does not matter whether the side information is available to the transmitter, the receiver, or both; its interference can be eliminated. Recently, a few researchers [45, 48, 59] have begun to apply the lessons learned about communications with side information to watermarking. We explore this topic in more detail in Chapter 5. For now, we illustrate some of the power of this approach by modifying the blind embedder/linear correlation detector (E_BLIND/D_LC) system to yield 100% effectiveness.

Investigation

Improving Effectiveness by Exploiting Side Information

In the preceding investigation, it was shown that the E_BLIND/D_LC watermarking system has less than 100% effectiveness when the detection threshold is $\tau_{lc} = 0.7$. This is evident in Figure 3.6, in that the tails of the distributions for $m = 1$ and $m = 0$ both cross the thresholds, τ_{lc} and $-\tau_{lc}$. The portions of these distributions that lie between the thresholds represent images in which the system will fail to embed a watermark (i.e., the linear correlation detector will report $m = no\ watermark$, even if no noise has been added to the image after embedding). The images that have this problem are those that have an unusually high-magnitude correlation with the reference pattern. If $c_o \cdot w_r / N$ is too large, subtracting αw_r from the image will fail to push the correlation below $-\tau_{lc}$, and we cannot embed $m = 0$. Similarly, if $c_o \cdot w_r / N$ is too far below zero, we cannot embed $m = 1$.

In applications that have strict requirements with respect to false positive rate, data payload, and fidelity, we may have to be satisfied with a system that has an effectiveness of less than 100%. However, there are other applications in

which we can compromise some of these other properties in exchange for 100% effectiveness. For example, the tracking of movie dailies is an application that has less stringent fidelity requirements. By monitoring the detection value *at the embedder,* we are be able to increase the embedding strength when necessary to ensure 100% effectiveness.

System 2: E_FIXED_LC/D_LC

The watermarking system used in this investigation employs a new embedding algorithm, designed to ensure 100% embedding effectiveness. This is done by adjusting the embedding strength, α, so that all watermarked images will have a fixed-magnitude linear correlation with the reference pattern. The embedding algorithm is thus called E_FIXED_LC. The system uses the same linear correlation detector described for System 1, D_LC.

To determine the necessary embedding strength, we first compute the inherent correlation between the cover Work and the message pattern, $\mathbf{c_o} \cdot \mathbf{w}_m / N$. In the E_BLIND embedder, we assumed that this value was small. In the E_FIXED_LC system, we do not make this assumption. Instead, we set α to explicitly account for the effects of this inherent correlation.

Our aim is to ensure that the magnitude of the detection strength is always some constant, greater than the detection threshold. We express this constant as $\tau_{lc} + \beta$, where τ_{lc} is the detection threshold, and $\beta > 0$ is an embedding strength parameter. The magnitude of the detection value obtained from an image immediately after embedding is given by

$$z_{lc}(\mathbf{c_w}, \mathbf{w}_m) = \frac{1}{N}(\mathbf{c_o} \cdot \mathbf{w}_m + \mathbf{w_a} \cdot \mathbf{w}_m), \qquad (3.8)$$

where \mathbf{w}_m is the message pattern and $\mathbf{w_a} = \alpha \mathbf{w}_m$. By substituting $\tau_{lc} + \beta$ for $z_{lc}(\mathbf{c_w}, \mathbf{w}_m)$, and solving for α, we obtain

$$\alpha = \frac{N(\tau_{lc} + \beta) - \mathbf{c_o} \cdot \mathbf{w}_m}{\mathbf{w}_m \cdot \mathbf{w}_m}. \qquad (3.9)$$

After computing α with this formula, the rest of the E_FIXED_LC algorithm proceeds the same way as the E_BLIND algorithm.

Experiments

This system was applied twice to 2,000 images; once with $m = 0$ and once with $m = 1$. The embedding parameters were $\tau_{lc} = 0.7$ and $\beta = 0.3$. The resulting distributions of detection values, $z_{lc}(\mathbf{c_w}, \mathbf{w_r})$, are shown in Figure 3.11. For reference, the D_LC detector was also applied to the 2,000 unwatermarked images. The resulting distribution of detection values, labeled *no watermark,* is shown with a dashed line. Note that the unwatermarked distribution is identical to that shown in Figure 3.6, in that the two watermarking systems

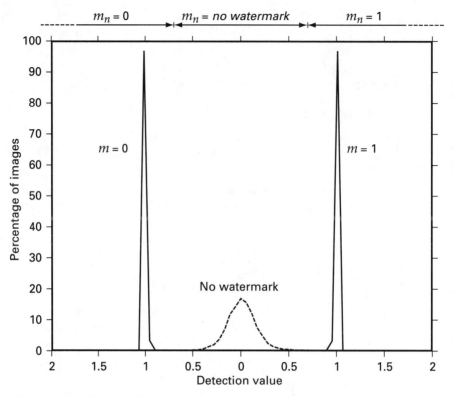

Fig. 3.11 Distributions of linear correlation values resulting from the
`E_FIXED_LC/D_LC` (`System 2`) watermarking system.

differ only in the embedding algorithm used, and the embedding algorithm
has no effect on unwatermarked images.

In theory, the detection values for all images embedded with $m = 1$ should
be equal to 1.0, and, similarly, all $m = 0$ images should be equal to -1.0. How-
ever, because of round-off and truncation errors, there is some variation in
the actual values obtained. Nevertheless, the distributions of detection values
when a watermark is embedded are clearly much narrower than those resulting
from the blind embedding algorithm (Figure 3.6).

With the detection threshold of $\tau_{lc} = 0.7$, all embedded watermarks were
detected correctly. Thus, the system had a measured effectiveness of 100%.

3.3.3 Watermarking as Multiplexed Communications

Figure 3.12 shows an alternative model of watermarking as communications.
Here, we no longer regard the cover Work as part of the transmission channel,
but rather as a second message to be transmitted along with the watermark

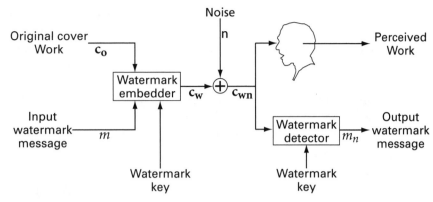

Fig. 3.12 Watermarking as simultaneous communications of two messages. (Pictured with a blind watermark detector. An informed detector would receive the original cover Work as additional input.)

message in the same signal, c_w. The two messages, c_o and m, will be detected and decoded by two very different receivers: a human being and a watermark detector, respectively.[4]

The watermark embedder combines m and c_o into a single signal, c_w. This combination is similar to the transmission of multiple messages over a single line in traditional communications by either time-division, frequency-division, or code-division multiplexing. One difference, however, is that in traditional communications the basic technology used for the different messages is the same, and the messages are separated by a single parameter (time, frequency, or code sequence). By contrast, in watermarking the two messages are separated by different technologies: watermark detection versus human perception. This is analogous to using, say, frequency division for one message and spread spectrum coding for the other.

After the signal passes through the transmission channel, it enters either a human perceptual system or a watermark detector. When viewing c_{wn}, the human should perceive something close to the original cover Work, with no interference from the watermark. When detecting a watermark in c_{wn}, the detector should obtain the original watermark message, with no interference from the cover Work. If the watermark detector is informed, it receives the original cover Work, or a function of the cover Work, as a second input.

This picture of watermarking emphasizes the symmetry between the watermark and the cover Work. One of the ways this symmetry manifests itself in the watermarking literature is in two different usages of the term *signal-to-noise ratio*.

4. In some cases, watermark detection involves a human observer. For example, in [143], a hidden image is made perceptible by rearranging the pixels of a cover image. A human observer is required to determine whether a valid hidden image is present.

In discussions of fidelity, "signal" refers to the cover Work, and "noise" refers to the watermark. In discussions of effectiveness and robustness, it is the other way around: "signal" refers to the watermark and "noise" refers to the cover Work. It is usually clear from the context which of these meanings is intended.

The symmetry in Figure 3.12 implies that solutions to problems in transmitting m should often have corresponding solutions to problems in transmitting c_o. For example, in the informed embedding algorithm, E_FIXED_LC, we saw that we can solve the problem of effectiveness in blind embedding by examining the cover Work before designing the added pattern. The embedder computes the interference between the cover Work and the reference pattern, by computing $c_o \cdot w_r$, and adjusts the amplitude of the added pattern to compensate, by changing the value of α. Similarly, when faced with fidelity problems, we can improve the system by first using a perceptual model to examine how the watermark interferes with the Work, and then adjusting w_a to reduce this interference as much as possible. This idea is discussed in detail in Chapter 7.

3.4 Geometric Models of Watermarking

The types of models described in the previous section allow us to draw from the field of communications when designing watermarking systems. Although we make use of such models in this book (primarily in Chapters 4 and 5), we also often conceptualize watermarking algorithms in *geometric* terms. This geometric view of watermarking is the topic of this section.

To view a watermarking system geometrically, we imagine a high-dimensional space in which each point corresponds to one Work. We refer to this space as *media space*. Alternatively, when analyzing more complicated algorithms, we may wish to consider projections or distortions of media space. We refer to such spaces as *marking spaces*. The system can then be viewed in terms of various regions and probability distributions in media or marking space. These include the following:

- The *distribution of unwatermarked Works* indicates how likely each Work is.
- The *region of acceptable fidelity* is a region in which all Works appear essentially identical to a given cover Work.
- The *detection region* describes the behavior of the detection algorithm.
- The *embedding distribution* or *embedding region* describes the effects of an embedding algorithm.
- The *distortion distribution* indicates how Works are likely to be distorted during normal usage.

We begin this section by discussing each of the previously listed distributions and regions in terms of media space. We then introduce the idea of marking space and discuss how it can be employed in designing watermarking systems. This

is illustrated with a watermarking system (`System 3 E_BLK_BLIND/D_BLK_CC`), which is slightly more complicated than the two described so far.

3.4.1 Distributions and Regions in Media Space

Works can be thought of as points in an N-dimensional *media space*. The dimensionality of media space, N, is the number of samples used to represent each Work. In the case of monochrome images, this is simply the number of pixels. For images with three color planes (e.g., red, green, and blue), N is three times the number of pixels. For continuous, temporal content (such as audio or video), we assume that the watermark is embedded in a fixed-length segment of the signal, and that the content is time sampled. Thus, for audio, N would be the number of samples in the segment. For video, N would be the number of frames in a segment multiplied by the number of pixels per frame (multiplied by 3 if the video is in color).

Because we are concerned here with digital content, each sample is quantized and bounded. For example, each pixel value of an 8-bit grayscale image is quantized to an integer between 0 and 255. This means that there is a finite (though huge) set of possible Works, and they are arranged in a rectilinear lattice in media space. Points between the lattice points, or outside the bounds, do not correspond to Works that can be represented in digital form. However, the quantization step size is generally small enough, and the bounds large enough, that we often gloss over this fact and assume that media space is continuous (i.e., that all points in the space, even those off the lattice, correspond to realizable Works). In the following we discuss each of the various probability distributions over media space, and regions within media space, that are of concern in analyzing watermarking systems.

Distribution of Unwatermarked Works

Different Works have different likelihoods of entering into a watermark embedder or detector. In audio, we are more likely to embed watermarks in music than in pure static. In video, we are more likely to embed watermarks in images of natural scenes than in video "snow." Content such as music and natural images possess distinct statistical distributions [84, 234, 247, 282], and we must take these distributions into account.

When estimating the properties of a watermarking system, such as false positive rate and effectiveness, it is important to model the *a priori* distribution of content we expect the system to process. This can be expressed either as a probability distribution over the lattice of points that represent digital Works or as a probability density function (PDF) over all points in media space.

There is a wide range of statistical models for the distribution of unwatermarked content. The simplest models assume that the distribution fits an elliptical Gaussian. Such a model is employed in the derivation of the `E_BLIND/D_WHITE` watermarking system (`System 11`) described in Chapter 6. More accurate models

of most media can be obtained using Laplacian or generalized Gaussian distributions. These are used in the analysis of lossy compression in Chapter 8. The most sophisticated models try to describe content as the result of random, parametric processes. Such models are not used in this book, but the interested reader is referred to [126, 272, 193] for discussions of their application to images.

It is important to keep in mind that the distribution of unwatermarked content is application dependent. For example, satellite images are drawn from a very different distribution than news photographs. Music is drawn from a different distribution than speech. This variety of different distributions for different classes of Works can cause problems. If we estimate a watermark detector's false positive rate using one distribution, and then use the detector in an application in which the unwatermarked Works are drawn from a different distribution, our estimate will not be accurate. The problem can be very serious in applications that require extremely low false positive rates, such as copy control.

Region of Acceptable Fidelity

Imagine taking an original image, c_o, and altering just a single pixel by one unit of brightness. This new image defines a new vector in media space, yet it is perceptually indistinguishable from the original image. Clearly, there are many such images, and we can imagine a region around c_o in which every vector corresponds to an image that is indistinguishable from c_o. If c_o is an audio signal, similarly small changes will result in indistinguishable sounds, and they also form a region in media space. We refer to the region of media space vectors that are essentially indistinguishable from the cover Work, c_o, as the *region of acceptable fidelity*.

It is extremely difficult to identify the true region of acceptable fidelity around a given Work, because too little is known about human perception. We usually approximate the region by placing a threshold on some measure of perceptual distance.[5] For example, it is common to use mean squared error (MSE) as a simple perceptual distance metric. This is defined as

$$D_{\mathrm{mse}}(c_1, c_2) = \frac{1}{N} \sum_{i}^{N} (c_1[i] - c_2[i])^2, \tag{3.10}$$

where c_1 and c_2 are N-dimensional vectors (N-vectors) in media space. If we set a limit, τ_{mse}, on this function, the region of acceptable fidelity becomes an N-dimensional ball (N-ball) of radius $\sqrt{N\tau_{\mathrm{mse}}}$.

In practice, the MSE function is not very good at predicting the perceived differences between Works [127]. For example, if c_1 is an image, and c_2 is a version

5. Note that by "measure of perceptual distance" we do not necessarily mean a perceptual distance *metric*. A true metric is symmetric and satisfies the triangle inequality [233]. Many of the functions in which we are interested are not symmetric. Therefore, we include the term *metric* only when discussing functions that are indeed metrics in the mathematical sense.

of c_1 that has been shifted slightly to the left, the two Works will appear essentially identical, but the MSE might be enormous. In other words, MSE does not account for visual tracking. Another example can be seen in Figures 3.7 and 3.8. The MSE distances between the watermarked and unwatermarked images in these two figures are 16.4 and 16.3, respectively, yet the watermarked image in the latter figure is clearly far worse than that in the former.

Some perceptual distance functions are asymmetric. In these functions, the two arguments have slightly different interpretations. By convention, we interpret the first argument as an original Work, and the second as a distorted version of it. For example, one commonly used asymmetric distance is based on the reciprocal of the signal-to-noise ratio (SNR):

$$D_{\mathrm{snr}}(\mathbf{c}_1, \mathbf{c}_2) = \frac{\sum_i^N (\mathbf{c}_2[i] - \mathbf{c}_1[i])^2}{\sum_i^N \mathbf{c}_1[i]^2}. \tag{3.11}$$

Here, the first argument, \mathbf{c}_1, is regarded as the signal, and the second, \mathbf{c}_2, as a noisy version of it. The distance measures how noisy \mathbf{c}_2 is in relation to \mathbf{c}_1.

More sophisticated distance functions that give better predictions of human judgment have been devised for both images and audio. These functions often measure perceptual distance in units of *just noticeable difference* or JND. Some general properties and uses of perceptual distance functions are discussed along with two specific functions in Chapter 7.

Detection Region

The *detection region* for a given message, m, and watermark key, k, is the set of Works in media space that will be decoded by the detector as containing that message. Like the region of acceptable fidelity, the detection region is often (but not always) defined by a threshold on a measure of the similarity between the detector's input and a pattern that encodes m. We refer to this measure of similarity as a *detection measure*.

In the D_LC detection algorithm, the detection measure is linear correlation, $z_{\mathrm{lc}}(\mathbf{c}, \mathbf{w_r})$. To find the shape of the detection regions for this detector, we begin by noting that the linear correlation between the received Work and the reference pattern, $\mathbf{c} \cdot \mathbf{w_r}/N$, is equal to the product of their Euclidean lengths and the cosine of the angle between them, divided by N. Because the Euclidean length of $\mathbf{w_r}$ is constant, this measure is equivalent to finding the orthogonal projection of the N-vector \mathbf{c} onto the N-vector $\mathbf{w_r}$. The set of all points for which this value is greater than τ_{lc} is just the set of all points on one side of a plane perpendicular to $\mathbf{w_r}$. The resulting half space is the detection region for $m = 1$. Similarly, the detection region for $m = 0$ is the set of all points on one side of a plane defined by $-\tau_{\mathrm{lc}}$.

A successful embedding of a watermark message results in a watermarked Work that lies within the intersection of the region of acceptable fidelity and the detection region. Figure 3.13 illustrates this point, using a region of acceptable

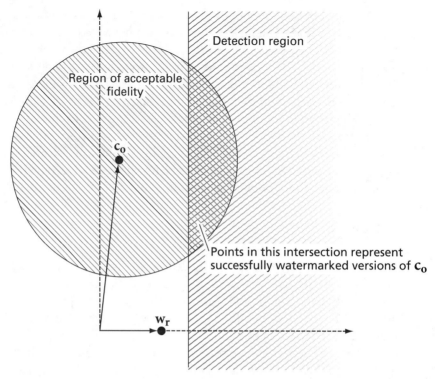

Fig. 3.13 The region of acceptable fidelity (defined by MSE) and the detection region (defined by linear correlation) for a watermarking system such as the `E_BLIND/D_LC` system of `System 1`.

fidelity based on MSE and a detection region based on thresholding the linear correlation between the received Work and a reference pattern, w_r (as in the `D_LC` algorithm). The figure shows the two-dimensional slice of media space that contains the two vectors c_o and w_r. The diagram is positioned so that w_r lies along the horizontal axis. Because randomly chosen vectors in high-dimensional space tend to be close to orthogonal, c_o lies near the vertical axis. The region of acceptable fidelity is an N-ball whose intersection with the diagram is a filled circle (or 2-ball). The plane that separates the detection region from the rest of media space intersects the diagram along a line perpendicular to w_r. All points within the circular region of acceptable fidelity and to the right of the planar edge of the detection region correspond to versions of c_o that are within an acceptable range of fidelity and that will cause the detector to report the presence of the watermark. In other words, these points represent successful embeddings of the watermark message in the cover Work.

Embedding Distribution or Region
A watermark embedder is a function that maps a Work, a message, and possibly a key into a new Work. This is generally a deterministic function such that for any

given original Work, $\mathbf{c_o}$; message, m; and key, k, the embedder always outputs the same watermarked Work, $\mathbf{c_w}$. However, the original Works are drawn randomly from the distribution of unwatermarked Works, and this leads us to view the embedder's output as random. The probability that a given Work, $\mathbf{c_w}$, will be output by the embedder is just the probability that a Work that leads to it, $\mathbf{c_o}$, is drawn from the distribution of unwatermarked Works. If several unwatermarked Works map into $\mathbf{c_w}$, the probability of $\mathbf{c_w}$ is just the sum of the probabilities of those Works. We refer to the resulting probability distribution as the *embedding distribution*.

Some embedding algorithms define an embedding distribution in which every point has a non-zero probability (assuming that every point in media space has a non-zero probability of entering the embedder). If we ignore the effects of clipping and rounding, this is the case with the embedding distribution defined by the E_BLIND image watermarking algorithm of System 1. Every possible image, even those outside the detection region, can be arrived at by applying the E_BLIND embedder to some other image. Figure 3.14 illustrates this point. Such algorithms necessarily have less than 100% effectiveness, in that there is some non-zero

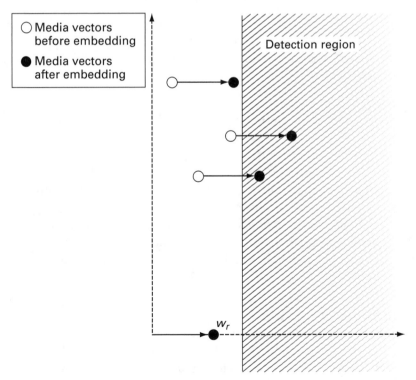

Fig. 3.14 Effect of the E_BLIND embedding algorithm of System 1. The same vector, $\mathbf{w_a} = \alpha \mathbf{w_r}$, is added in every case, regardless of the original Work.

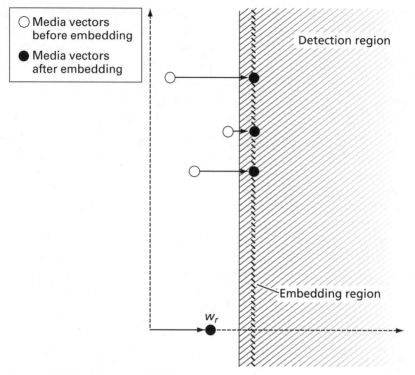

Fig. 3.15 Effect of the E_FIXED_LC embedding algorithm of System 2. The vector added to each unwatermarked Work is chosen to guarantee that the resulting Work lies on a planar *embedding region*.

probability that the embedder will output a Work that is outside the detection region.

Other algorithms, such as the E_FIXED_LC algorithm of System 2, have a limited set of possible outputs. For a given reference pattern, message, and embedding strength, β, the E_FIXED_LC algorithm will only output images that lie on a fixed plane, as illustrated in Figure 3.15. With such a system, it makes sense to discuss an *embedding region* for a given message, which is the set of all possible outputs of the embedder. The system has 100% effectiveness if, and only if, the embedding region is completely contained within the detection region.

Distortion Distribution

To judge the effects of attacks on watermarked content, we need to know the probability of obtaining a given distorted Work, c_{wn}, given that the undistorted, watermarked Work was c_w. This conditional probability distribution is exactly the same type of distribution used to characterize transmission channels in

traditional communication theory. We refer to this as the *distortion distribution* around c_w.

Theoretical discussions of watermarking often begin with the assumption that the distortion distribution can be modeled as additive Gaussian noise. This greatly simplifies analysis, but it does not model reality very well. Very few of the processes applied to digital content behave like Gaussian noise. In fact, very few of them are even random. During normal usage, the content will most likely be subject to distortions such as lossy compression, filtering, noise reduction, and temporal or geometric distortions. These are, in general, deterministic functions applied to the content. Therefore, the "noise" added as a result of the distortion is highly dependent on the content itself.

For example, consider the simple procedure of cropping a Work. In images, this is equivalent to setting columns and rows of pixels around the edge to black. In audio, it amounts to setting samples at the beginning or end of a clip to zero. These types of distortions can be expected to occur in many applications. Therefore, the result, c_{wn}, must be assigned a non-zero probability in the distortion distribution around any Work. Note that c_{wn} can be quite far away from c_w in media space. Moreover, points between c_{wn} and c_w might be very unlikely to occur (we would not expect several columns of pixels near the right edge of an image to be reduced to half their brightness, while the other pixels remain untouched). This means that the distortion distribution is multi-modal, which is very unlike anything that might be produced by a Gaussian noise process. As we shall see in Chapter 6, the true nature of the distortion distribution has a dramatic effect on the optimality of certain detection measures.

3.4.2 Marking Spaces

For simple watermarking systems, such as the E_BLIND/D_LC and E_FIXED_LC/D_LC systems, identifying the embedding and detection regions in media space is not very difficult. However, most applications require more sophisticated algorithms, which are more difficult to analyze in media space. When considering such systems, it is often useful to view part of the system as performing a projection or distortion of media space into a *marking space*. The rest of the system can then be viewed as a simpler watermarking system, operating in this marking space rather than media space.

Watermark detectors are often designed with an explicit notion of marking space. Such a detector consists of a two-step process, as illustrated in Figure 3.16. The first step, *watermark extraction*, applies one or more pre-processes to the content, such as frequency transforms, filtering, block averaging, geometric or temporal registration, and feature extraction. The result is a vector—a point in marking space—of possibly smaller dimensionality than the original. We refer to this vector as an *extracted mark*.

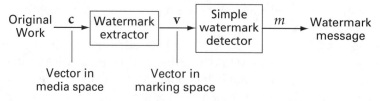

Fig. 3.16 General, two-step outline of a watermark detector.

The second step is to determine whether the extracted mark contains a watermark and, if so, decode the embedded message. This usually entails comparing the extracted mark against one or more predefined *reference marks* (although other methods are possible, as in Chapter 5). This second step can be thought of as a simple watermark detector operating on vectors in marking space.

Watermark embedders are not usually designed with any explicit use of marking space, but they can be. Such an embedder would be a three-step process, as illustrated in Figure 3.17. The first step is identical to the extraction step in a watermark detector, mapping the unwatermarked Work into a point in marking space.

The second step is to choose a new vector in marking space that is close to the extracted mark and (hopefully) will be detected as containing the desired watermark. We refer to the difference between this new vector and the original, extracted mark as the *added mark*. This second step can be thought of as a simple watermark embedder operating in marking space.

The third step is to invert the extraction process, projecting the new vector back into media space to obtain the watermarked Work. Our aim here is to find a Work that will yield the new vector as its extracted mark. If marking space has the same dimensionality as media space, this projection can be performed in a straightforward manner. However, if marking space has smaller dimensionality than media space, each point in marking space must correspond to many points in media space. Thus, there will be many Works that all yield the new vector as their extracted marks. Ideally, we would like to choose the one perceptually closest to the original Work. In practice, we generally use an approximate algorithm,

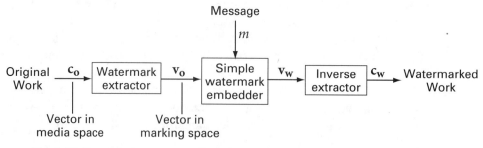

Fig. 3.17 General, three-step outline of a watermark embedder.

which, while not giving us the absolute closest such Work, nevertheless leads to one that is reasonably close.

In systems designed according to Figures 3.16 and 3.17, one purpose of the extraction function is to reduce the cost of the embedding and detection. A second purpose is to simplify the distribution of unwatermarked Works, the region of acceptable fidelity, and/or the distortion distribution so that simple watermarking algorithms will perform well. For example, by averaging groups of independent samples, we can obtain a marking space in which the distribution of unwatermarked Works is more closely Gaussian (because of the central limit theorem). By performing a frequency transform and scaling the terms by perceptually determined constants (see Chapter 7), we can obtain a marking space in which the region of acceptable fidelity is more closely spherical. By compensating for geometric and temporal distortions, we can obtain a marking space in which the distortion distribution is not multi-modal.

To illustrate the idea of a marking space, we now develop our last watermarking system of the chapter. This system is built according to Figures 3.16 and 3.17.

Investigation

Block-based, Blind Embedding and Correlation Coefficient Detection

In the system investigated here, we extract watermarks by averaging 8×8 blocks of an image. This results in a 64-dimensional marking space. Watermarks are embedded in marking space by simple, blind embedding, and the resulting changes are projected back to the full size.

Watermarks are detected in marking space using the *correlation coefficient* as a detection measure. This is a normalized version of the linear correlation measure used in the D_LC detector, discussed in detail in Chapter 6. As in the previous algorithms, the embedded message is a single bit, m, and the detector reports either the value of the embedded bit or that no watermark is present.

System 3: E_BLK_BLIND/D_BLK_CC

We begin by describing the D_BLK_CC detection algorithm, and then proceed to describe the E_BLK_BLIND embedder. The detection algorithm operates in two steps, as illustrated in Figure 3.16, namely:

1. Extract a mark, **v**, from the received Work, **c**.
2. Use a simple detection algorithm to detect a watermark in the extracted mark.

To extract a watermark from an image, the image is divided into 8×8 blocks, and all blocks are averaged into one array of 64 values. Thus, the extracted mark, \mathbf{v}, is

$$\mathbf{v}[i, j] = \mathcal{X}(\mathbf{c}) = \frac{1}{B} \sum_{x=0}^{w/8} \sum_{y=0}^{h/8} \mathbf{c}[8x + i, 8y + j], \tag{3.12}$$

where $0 \leq i < 8$ and $0 \leq j < 8$ are indices into the extracted mark, w and h are the width and height of the image, and B is the number of blocks in the image. This process is illustrated in Figure 3.18.

To detect a watermark in an extracted mark, the extracted mark is compared against a predefined reference mark. The reference mark in this system is an 8×8 array of values (i.e., a vector in marking space).

Original image (vector in media space, dimensionality = 128 x 192 = 24576)

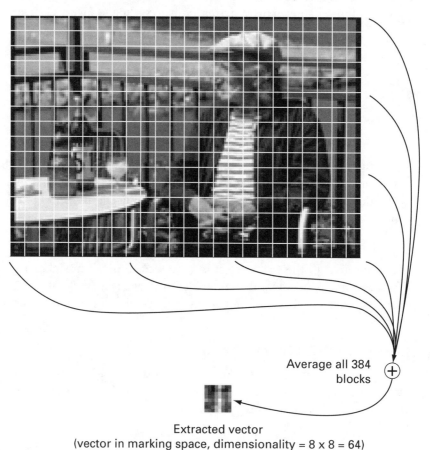

Average all 384 blocks ⊕

Extracted vector
(vector in marking space, dimensionality = 8 x 8 = 64)

Fig. 3.18 Watermark extraction process for the System 3, E_BLK_BLIND/D_BLK_CC (shown using a low-resolution image so that the blocks are large enough to illustrate).

In principle, to compare the extracted mark with the reference mark, the detector could use linear correlation in the same manner as the D_LC detector. However, as we shall see, this would lead to a detection algorithm mathematically identical to D_LC. To make the system more interesting, we use a modification of linear correlation, called the *correlation coefficient*, which is more robust to certain distortions.

Correlation coefficients differ from linear correlations in two ways. First, we subtract the means of the two vectors before correlating them. Thus, the detection value is unaffected if a constant is added to all elements of either of the vectors. Second, we normalize the linear correlation by the magnitudes of the two vectors. Thus, the detection value is uneffected if all elements of either vector are multiplied by a constant. As a result, a system using the correlation coefficient is robust to changes in image brightness and contrast. The correlation coefficient is defined as

$$z_{cc}(\mathbf{v}, \mathbf{w_r}) = \frac{\tilde{\mathbf{v}} \cdot \tilde{\mathbf{w}}_\mathbf{r}}{\sqrt{(\tilde{\mathbf{v}} \cdot \tilde{\mathbf{v}})(\tilde{\mathbf{w}}_\mathbf{r} \cdot \tilde{\mathbf{w}}_\mathbf{r})}}, \tag{3.13}$$

where $\tilde{\mathbf{v}} = (\mathbf{v} - \bar{\mathbf{v}})$ and $\tilde{\mathbf{w}}_\mathbf{r} = (\mathbf{w_r} - \bar{\mathbf{w}}_\mathbf{r})$, $\bar{\mathbf{v}}$ and $\bar{\mathbf{w}}_\mathbf{r}$ are the mean values of \mathbf{v} and $\mathbf{w_r}$ (respectively), and

$$\tilde{\mathbf{v}} \cdot \tilde{\mathbf{w}}_\mathbf{r} = \sum_{x=0}^{7} \sum_{y=0}^{7} \tilde{\mathbf{v}}[x, y]\tilde{\mathbf{w}}_\mathbf{r}[x, y]. \tag{3.14}$$

The correlation coefficient can be interpreted as the inner product of $\tilde{\mathbf{v}}$ and $\tilde{\mathbf{w}}_\mathbf{r}$ after each has been normalized to have unit magnitude. This is simply the cosine of the angle between the vectors and is bounded thus:

$$-1 \leq z_{cc}(\mathbf{v}, \mathbf{w_r}) \leq 1. \tag{3.15}$$

Like the D_LC detector, the D_BLK_CC detector outputs

$$m_n = \begin{cases} 1 & \text{if } z_{cc}(\mathbf{v}, \mathbf{w_r}) > \tau_{cc} \\ no\ watermark & \text{if } -\tau_{cc} \leq z_{cc}(\mathbf{v}, \mathbf{w_r}) \leq \tau_{cc}, \\ 0 & \text{if } z_{cc}(\mathbf{v}, \mathbf{w_r}) < -\tau_{cc} \end{cases} \tag{3.16}$$

where τ_{cc} is a constant threshold.

The embedding algorithm, E_BLK_BLIND, proceeds according to the three-step process previously described, namely:

1. Extract a mark, $\mathbf{v_o}$, from the unwatermarked Work, $\mathbf{c_o}$.
2. Choose a new vector, $\mathbf{v_w}$, in marking space that is close to the extracted mark but is (hopefully) inside the detection region.
3. Project the new vector back into media space to obtain the watermarked Work, $\mathbf{c_w}$.

The extraction process in the embedder is identical to that in the detector; namely, averaging 8×8 blocks to obtain a vector in 64-dimensional marking space.

For simplicity, watermarks are embedded in marking space using a blind embedding algorithm similar to E_BLIND. It might be preferable to use an embedder such as E_FIXED_LC, which yields a fixed detection value. However, constructing such an embedder for a correlation coefficient detector is rather complicated. We develop such embedders in Chapter 5. In the present system, the added mark, $\mathbf{w_a}$, is $\alpha\mathbf{w}_m$, where $\mathbf{w}_m = \mathbf{w_r}$ if $m = 1$, and $-\mathbf{w_r}$ if $m = 0$. The resulting vector is $\mathbf{v_w} = \mathbf{v_o} + \mathbf{w_a}$.

When projecting $\mathbf{v_w}$ into media space, we wish to find an image, $\mathbf{c_w}$, that is perceptually close to the original, $\mathbf{c_o}$. Because the extraction process is many-to-one, there are many possible ways to proceed. In this example we simply distribute each element of the desired change in the extracted mark uniformly to all contributing pixels. A simple way to do this is

$$\mathbf{c_w}[x, y] = \mathbf{c_o}[x, y] + (\mathbf{v_w}[x \bmod 8, y \bmod 8] - \mathbf{v_o}[x \bmod 8, y \bmod 8]),$$
(3.17)

where *mod* is the modulo operator. This step ensures that when the detector applies the extraction function to $\mathbf{c_w}$ the result will be $\mathbf{v_w}$, and the watermark will be detected.

Note that this embedding algorithm could be simplified by eliminating the previously listed steps 1 and 2, because $\mathbf{v_w} - \mathbf{v_o}$ is just the added mark, $\mathbf{w_a}$, which can be determined without these steps. However, in later systems (presented in Chapter 5), we modify this system to use more sophisticated embedding methods for step 2, and all three steps will be necessary. We therefore include all three steps here for purposes of illustration.

In principle, the performance of this watermarking system should be similar to that of the E_BLIND/D_LC system (System 1). In fact, if we were to use linear correlation in the detector, rather than the correlation coefficient, the performance would be *identical* to that of E_BLIND/D_LC using a reference pattern that consists of a single 8×8 pattern tiled over the full size of the image; that is, $\mathbf{w'_r}[x, y] = \mathbf{w_r}[x \bmod 8, y \bmod 8]$ (see Figure 3.19). This follows from the fact that the entire algorithm is linear. If our detection statistic were $z_{lc}(\mathbf{v}, \mathbf{w_r}) = \mathbf{v} \cdot \mathbf{w_r}/64$, then

$$z_{lc}(\mathbf{v}, \mathbf{w_r}) = \frac{1}{64} \sum_{i,j} \mathbf{v}[i, j]\mathbf{w_r}[i, j] \tag{3.18}$$

$$= \frac{1}{64} \sum_{i,j} \left(\frac{1}{B} \sum_{x=0}^{w/8} \sum_{y=0}^{h/8} \mathbf{c}[8x + i, 8y + j] \right) \mathbf{w_r}[i, j] \tag{3.19}$$

$$= \frac{1}{64B} \sum_{x,y} \mathbf{w_r}[x \bmod 8, y \bmod 8]\mathbf{c}[x, y] \tag{3.20}$$

$$= \frac{1}{N} \sum_{x,y} \mathbf{w'_r}[x, y]\mathbf{c}[x, y], \tag{3.21}$$

8 × 8 reference mark (**w**_r)

Tiled reference mark (**w'**_r)

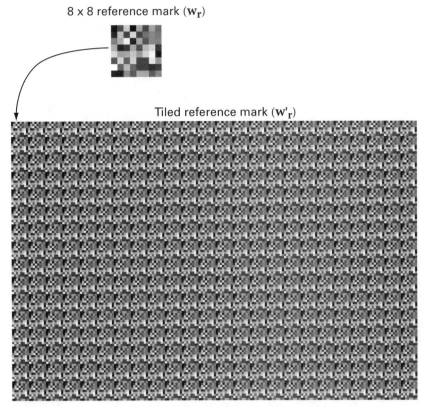

Fig. 3.19 8 × 8 reference mark for the E_BLK_BLIND/D_BLK_CC watermarking system of System 3, and the same reference mark tiled to create a reference pattern for use in the E_BLIND/D_LC system.

where N is the number of pixels in the image. Equation 3.21 is the same as the detection statistic used in D_LC. A similar argument shows that the E_BLK_BLIND embedder is essentially the same as the E_BLIND embedder. Thus, if we were using linear correlation as our detection measure, the block-averaging extraction process would have no effect. However, when we use the correlation coefficient for the detection measure, the extraction process has a substantial effect, in that it changes the factor by which the linear correlation is normalized.

This system has several strengths and weaknesses when compared to E_BLIND/D_LC. As mentioned, it is robust to certain changes in image brightness and contrast. The D_BLK_CC detector is also computationally cheaper than the D_LC detector. D_LC requires a multiply and add for each pixel when computing $\mathbf{c} \cdot \mathbf{w_r}$. In contrast, D_BLK_CC requires only one add per pixel when computing the extraction function, plus a handful of multiplies, adds, and divides when computing the correlation coefficient on the 8 × 8 extracted vector.

On the other hand, the number of possible reference marks, and hence the watermark key space, for E_BLK_BLIND/D_BLK_CC is much smaller than that for E_BLIND/D_LC. Moreover, many of those reference marks lead to poor statistical performance. This means that randomly generated reference marks tend not to work well, and the reference marks must be carefully selected.

Experiments

The E_BLK_BLIND/D_BLK_CC watermarking system was tested on 2,000 images using the reference mark illustrated in Figure 3.19. This mark was carefully selected to yield acceptable performance and was normalized to have unit variance. In Step 2 of the embedding algorithm, we set the embedding strength, $\alpha = 1$. The detection threshold was set to $\tau_{cc} = 0.55$, which gives an estimated false positive probability of about 10^{-6}, according to Equation 6.18 of Chapter 6.

The embedding performance is shown in Figure 3.20. As in Figures 3.6 and 3.11, this shows distributions of detection values for the images under

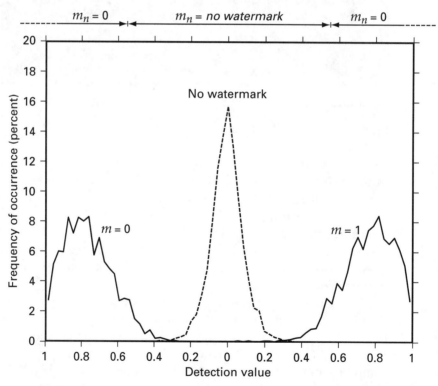

Fig. 3.20 Performance of the block-based blind embedder with a correlation coefficient detector (E_BLK_BLIND/D_BLK_CC) of System 3 on 2,000 images.

each of $m = 1$, $m = 0$, and *no watermark* conditions. Note that the *x*-axis ranges from just −1 to 1, since the correlation coefficient is bounded. The system had a measured effectiveness of about 92%.

3.5 Modeling Watermark Detection by Correlation

The preceding sections have discussed general models that may be used for virtually any watermarking system. The example systems we have used in our investigations, however, all fall into the class of *correlation-based* watermarking systems. Although this class does not include *all* possible watermarking systems, it does include the majority of the example systems presented in this book, and, we believe, the majority of systems proposed in the literature. We therefore conclude this chapter with a brief discussion of correlation-based detection measures.

There are several types of correlation used in watermark detection. The most basic is *linear correlation,* which we have seen in the D_LC detection algorithm. Other forms of correlation are distinguished by some normalization applied to vectors before the computation of their inner product. If we normalize two vectors to unit magnitude, we obtain the *normalized correlation* between them. Subtracting their means before computing normalized correlation gives us the *correlation coefficient* between them. We have seen the use of the correlation coefficient in the D_BLK_CC detection algorithm.

In some systems, such as those we have introduced so far, watermarking algorithms are explicitly built around the use of one of these types of correlation. In other systems, the use of correlation might be less obvious. Sometimes, a watermarking system is proposed that uses a detection method mathematically equivalent to the use of one form of correlation or another. These algorithms are often described without any reference to correlation.

Sometimes, correlation is a small part of the detection algorithm and is consequently not emphasized when the algorithm is described. For example, some detection algorithms proposed in the literature involve sophisticated feature detectors. The positions of detected features are either compared against a predefined set of positions [177] or are used to distort a watermark reference pattern that is then compared against the Work [12, 72, 295] (see Chapter 8). Although these comparisons are often performed using correlation, these algorithms are not typically considered correlation based, because their novelty and power lies in their use of feature detectors. Nevertheless, any analysis of their performance must involve an analysis of the effects of correlation.

The remainder of this section discusses the three main types of correlation measure previously described: linear correlation, normalized correlation, and the correlation coefficient. In each case, we provide some brief motivation for

the measure's use, a geometric interpretation of the resulting detection region, and a discussion of equivalent detection methods.

3.5.1 Linear Correlation

The linear correlation between two vectors, \mathbf{c} and $\mathbf{w_r}$, is the average product of their elements:

$$z_{lc}(\mathbf{v}, \mathbf{w_r}) = \frac{1}{N} \sum_i \mathbf{v}[i]\mathbf{w_r}[i]. \tag{3.22}$$

It is common practice in communications to test for the presence of a transmitted signal, $\mathbf{w_r}$, in a received signal, \mathbf{v}, by computing $z_{lc}(\mathbf{v}, \mathbf{w_r})$ and comparing it to a threshold. This practice is referred to as *matched filtering* and is known to be an optimal method of detecting signals in the presence of additive, white Gaussian noise.[6]

Geometric Interpretation

As pointed out in Section 3.4.1, the detection region that results from matched filtering comprises all points on one side of a hyperplane (see Figure 3.14). The hyperplane is perpendicular to the reference mark, and its distance from the origin is determined by the detection threshold.

One way of understanding the robustness of this detection region is to recognize that in high dimensions vectors drawn from a white Gaussian distribution tend to be nearly orthogonal to a given reference mark. Thus, when a vector is corrupted by additive white Gaussian noise, the noise tends to be parallel to the planar edge of the detection region, and rarely crosses that plane.

Equivalent Detection Methods

In general, any detection algorithm that computes a linear function of the samples in a Work and compares that function against a threshold can be considered to use linear correlation.

As a first example, an image watermark detection algorithm is proposed in [15], in which the pixels of an image are divided into two groups. The sum of the pixels in one group is subtracted from the sum of the pixels in the other group to obtain a detection statistic, which is then compared against a threshold to determine whether the watermark is present. This is equivalent to correlating the image against a pattern consisting of 1s and −1s. The pattern contains a 1 for

6. Matched filtering is known to be optimal in the following sense: for any given probability of obtaining a false positive (deciding that $\mathbf{v} = \mathbf{w_r} + \mathbf{n}$ when, in fact, $\mathbf{v} = \mathbf{n}$), matched filtering minimizes the probability of obtaining a false negative (deciding that $\mathbf{v} = \mathbf{n}$ when, in fact, $\mathbf{v} = \mathbf{w_r} + \mathbf{n}$). This fact can be shown by showing that matched filtering is equivalent to *Neyman-Pearson hypothesis testing* [111].

each pixel in the group that is added into the detection statistic, and a −1 for each pixel that is subtracted from it.

A less obvious example, again from image watermarking, can be found in [141]. Here, a discrete cosine transform (DCT) is applied to each 8 × 8 block of the image, and selected coefficients are grouped as ordered pairs. The basic idea is to encode one bit of watermark information in each pair, according to whether or not the first coefficient in the pair is larger than the second. For example, if the first coefficient is larger, this might encode a 1 bit. If it is smaller, this might encode a 0 bit. To implement such an algorithm with linear correlation, we define a pattern for each bit (see Chapter 4 for more on this idea). All coefficients of the block DCT for each pattern are 0, except for the pair of coefficients used to encode the bit. The first coefficient in the pair contains a 1; the second contains a −1. Thus, if we correlate the block DCT of one of these patterns against the block DCT of the image, the sign of the result will tell us whether the first coefficient is larger than the second. Because the DCT is a linear transform, we can get the same result by correlating the pattern with the image directly in the spatial domain.[7]

Beyond the linear types of methods previously described, most nonlinear detection algorithms can be split into a nonlinear extraction method (see Section 3.4.2), followed by a correlation-based detector. This is a worthwhile excercise if the distributions in marking space that result from the extraction process are straightforward. For example, if the distribution of unwatermarked Works and the distortion distribution are approximately Gaussian, the performance of correlation-based detection in marking space is easy to analyze.

3.5.2 Normalized Correlation

One of the problems with linear correlation is that the detection values are highly dependent on the magnitudes of vectors extracted from Works. For many extraction methods, this means that the watermark will not be robust against such simple processes as changing the brightness of images or reducing the volume of music. It also means that even when reference marks are drawn from a white Gaussian distribution a linear correlation detector's false positive probability is difficult to predict (see Chapter 6).

These problems can be solved by normalizing the extracted mark and reference mark to unit magnitude before computing the inner product between them.

7. The algorithms described here are not actually identical to that proposed in [141], because that system compares the *magnitudes* of the coefficients, rather than their signed values. This is equivalent to computing their correlation against a pattern dependent on the underlying Work. If both coefficients in a pair are positive, the pattern is constructed with +1 and −1 in the DCT domain, as we have described. If the first is positive and the second is negative, the pattern is +1 +1, and so on.

That is,

$$\tilde{\mathbf{v}} = \frac{\mathbf{v}}{|\mathbf{v}|}$$

$$\tilde{\mathbf{w}}_{\mathbf{r}} = \frac{\mathbf{w}_{\mathbf{r}}}{|\mathbf{w}_{\mathbf{r}}|}$$

$$z_{\mathrm{nc}}(\mathbf{v}, \mathbf{w}_{\mathbf{r}}) = \sum_i \tilde{\mathbf{v}}[i]\tilde{\mathbf{w}}_{\mathbf{r}}[i]. \qquad (3.23)$$

We refer to this measure as, simply, *normalized correlation*.

Geometric Interpretation

The detection region obtained by applying a threshold to normalized correlation is very different from that obtained by applying a threshold to linear correlation. Whereas linear correlation leads to a detection region containing all points on one side of a hyperplane, normalized correlation leads to a *conical* detection region. This follows from the fact that the inner product of two vectors is equal to the product of their Euclidian lengths and the cosine of the angle between them, rendering

$$\mathbf{v} \cdot \mathbf{w}_{\mathbf{r}} = |\mathbf{v}||\mathbf{w}_{\mathbf{r}}|\cos(\theta), \qquad (3.24)$$

where θ is the angle between \mathbf{v} and $\mathbf{w}_{\mathbf{r}}$. Thus, the normalized correlation between two vectors is just the cosine of the angle between them. Applying a threshold to this value is equivalent to applying a threshold to the angle between the vectors, rendering

$$\frac{\mathbf{v} \cdot \mathbf{w}_{\mathbf{r}}}{|\mathbf{v}||\mathbf{w}_{\mathbf{r}}|} > \tau_{\mathrm{nc}} \quad \Leftrightarrow \quad \theta < \tau_{\theta}, \qquad (3.25)$$

where

$$\tau_{\theta} = \cos^{-1}(\tau_{\mathrm{nc}}). \qquad (3.26)$$

Thus, the detection region for a given reference vector, $\mathbf{w}_{\mathbf{r}}$, is an N-dimensional cone (N-cone) centered on $\mathbf{w}_{\mathbf{r}}$ and subtending an angle of $2\tau_{\theta}$.

Figure 3.21 illustrates the detection region for one reference vector, $\mathbf{w}_{\mathbf{r}}$, and threshold, τ_{nc}. The figure shows a slice of marking space. The x-axis of the figure is aligned with the reference mark. The y-axis is an arbitrary direction orthogonal to the reference vector. The shaded region shows the set of points on the plane that will be detected as containing the reference mark, $\mathbf{w}_{\mathbf{r}}$. This region, being a two-dimensional slice of an N-dimensional cone, is the same for all planes that contain $\mathbf{w}_{\mathbf{r}}$. In other words, the figure would not change if we chose a different direction for the y-axis (provided it was still orthogonal to the x-axis). Note that the threshold illustrated here is very high. Lower thresholds lead to wider cones.

It may seem surprising that the detection region for normalized correlation is such a completely different shape from that for linear correlation. After all, if the

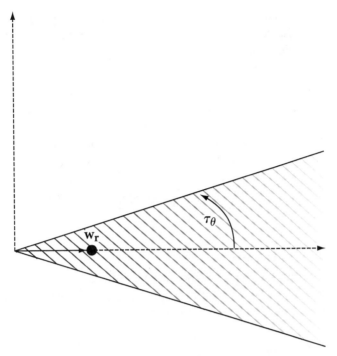

Fig. 3.21 Detection region obtained by thresholding normalized correlation, where τ_θ is given by Equation 3.26.

vectors have zero means, we might think that the sample standard deviation, $s_\mathbf{v}$, of the extracted mark, \mathbf{v}, should be a reasonable approximation of the *statistical* standard deviation, $\sigma_\mathbf{v}$, of the random process that generates elements of extracted vectors. Recall that the statistical standard deviation is the square root of the expected value of $(\mathbf{v} - \mu_\mathbf{v})^2$, where $\mu_\mathbf{v}$ is the expected value of \mathbf{v}. The sample standard deviation, $s_\mathbf{v} = |\tilde{\mathbf{v}}|/\sqrt{N}$, approaches the statistical standard deviation as N approaches infinity.

If we knew the statistical standard deviation, and we normalized linear correlation by it instead of by the $|\tilde{\mathbf{v}}|$ estimate, we would obtain a planar detection region, because we would just be scaling linear correlation by a constant factor. The difference between the planar detection region for scaled linear correlation and the conical detection region for normalized correlation illustrates the type of odd phenomenon that can arise when data is normalized by statistical parameters estimated from the data itself.

Equivalent Detection Methods

It is sometimes suggested that linear correlation can be used as a detection measure, but that the detector's threshold should be scaled by the magnitude of the

extracted mark. This is equivalent to the use of a normalized correlation detection measure. To see this, we begin by noting that the same behavior can be obtained by dividing the correlation by the extracted vector's magnitude, which leads to a detection measure of [60]

$$z_1(\mathbf{v}, \mathbf{w_r}) = \frac{\mathbf{v} \cdot \mathbf{w_r}}{|\mathbf{v}|}. \tag{3.27}$$

The only difference between this and normalized correlation, as defined previously, is that here we have not normalized the magnitude of the reference mark. However, reference marks are usually constrained to have some constant magnitude, in which case this z_1 measure differs from z_{nc} by at most a constant factor.

3.5.3 Correlation Coefficient

The final form of correlation we make use of in this book is the *correlation coefficient*, obtained by subtracting out the means of two vectors before computing the normalized correlation between them, as follows:

$$\tilde{\mathbf{v}} = \mathbf{v} - \bar{\mathbf{v}}$$
$$\tilde{\mathbf{w}}_\mathbf{r} = \mathbf{w_r} - \bar{\mathbf{w}}_\mathbf{r}$$
$$z_{cc}(\mathbf{v}, \mathbf{w_r}) = z_{nc}(\tilde{\mathbf{v}}, \tilde{\mathbf{w}}_\mathbf{r}). \tag{3.28}$$

This provides robustness against changes in the DC term of a Work, such as the addition of a constant intensity to all pixels of an image.

Geometric Interpretation

Normalized correlation and the correlation coefficient bear a simple, geometric relationship to each other: the correlation coefficient between two vectors in N-space is just the normalized correlation between those two vectors after projection into an $(N-1)$-space. That is, the subtraction of the two vectors' means amounts to a projection into a lower-dimensional space. This can be seen by viewing it as vector subtraction. For example, if \mathbf{v} is a three-dimensional vector, $[x, y, z]$, then $\mathbf{v} - \bar{\mathbf{v}} = [x, y, z] - [\bar{v}, \bar{v}, \bar{v}]$. The vector $[\bar{v}, \bar{v}, \bar{v}]$ describes the point on the diagonal of the coordinate system that lies closest to \mathbf{v}. Thus, the result of this subtraction is a vector that is orthogonal to the diagonal. This means that the resulting vector lies in an $(N-1)$-space that is orthogonal to the diagonal of the N-dimensional coordinate system. A simple, two-dimensional example is shown in Figure 3.22.

Because the correlation coefficient is just normalized correlation after a projection, we often use the two measures interchangeably, deriving principles

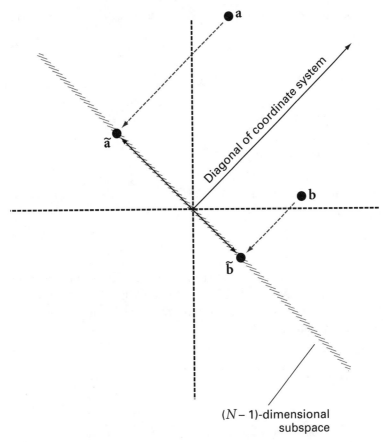

Fig. 3.22 Subtraction of mean x, y values from two two-dimensional vectors. This has the effect of projecting along the diagonal of the coordinate system into a one-dimensional subspace.

based on normalized correlation and illustrating them with systems that employ the correlation coefficient.

Equivalent Detection Methods

If we scale linear correlation by the sample standard deviation of an extracted vector, we obtain the following detection measure:

$$z_2(\mathbf{v}, \mathbf{w_r}) = \frac{\mathbf{v} \cdot \mathbf{w_r}}{s_{\mathbf{v}}} \tag{3.29}$$

Although this is only slightly different from the practice of scaling by the extracted mark's magnitude (detection measure z_1), it leads to detection by correlation coefficient rather than normalized correlation.

The sample standard deviation, $s_\mathbf{v}$, of the extracted vector, \mathbf{v}, can be expressed as

$$
\begin{aligned}
s_\mathbf{v} &= \sqrt{\frac{1}{N}\sum_i^N (v[i] - \bar{v}[i])^2} \\
&= \frac{1}{\sqrt{N}}|\mathbf{v} - \bar{\mathbf{v}}| \\
&= \frac{1}{\sqrt{N}}|\tilde{\mathbf{v}}|,
\end{aligned}
\tag{3.30}
$$

where $\tilde{\mathbf{v}}$ is as defined in Equation 3.28. Thus, the detection metric in such a system is given by

$$
z_2(\mathbf{v}, \mathbf{w_r}) = \sqrt{N}\frac{\mathbf{v}\cdot\mathbf{w_r}}{|\tilde{\mathbf{v}}|}.
\tag{3.31}
$$

If the reference marks are constrained to have constant magnitude and zero mean (which is common), this is equivalent to the correlation coefficient, in that $\mathbf{w_r} = \tilde{\mathbf{w}}_\mathbf{r}$ and $\mathbf{v}\cdot\tilde{\mathbf{w}}_\mathbf{r} = \tilde{\mathbf{v}}\cdot\tilde{\mathbf{w}}_\mathbf{r}$ (because the mean of \mathbf{v} has no effect on its dot product with a zero-mean vector).

3.6 Summary

This chapter has laid the groundwork for the technical discussion of the succeeding chapters by describing various ways of modeling watermarking systems. The main topics covered include the following:

- We described three models of watermarking systems based on the traditional model of a communications channel. These differ in how the cover Work is incorporated into the system.
 - In the basic model, the cover Work is considered noise added during transmission of the watermark signal.
 - In models of watermarking as communications with side information at the transmitter, the cover Work is still considered noise, but the watermark encoding process is provided with its value as side information.
 - In models of watermarking as multiplexing, the cover Work and the watermark are considered two messages multiplexed together for reception by two different "receivers": a human and a watermark detector, respectively.
- Works can be viewed as points in a high-dimensional *media space*. Within this space there are the following probability distributions and regions of interest.

- The *distribution of unwatermarked Works* indicates how likely each Work is.
- The *region of acceptable fidelity* is a region in which all Works appear essentially identical to a given cover Work.
- The *detection region* describes the behavior of the detection algorithm.
- The *embedding distribution* or *embedding region* describes the effects of an embedding algorithm.
- The *distortion distribution* indicates how Works are likely to be distorted during normal usage.
- Part of a watermarking system can be viewed as an *extraction process* that projects or distorts media space into a *marking space*. The rest can then be viewed as a simpler watermarking system that operates in marking space rather than in media space.
- Many watermarking systems fall into the class of *correlation-based systems*, in which the detector uses some form of correlation as a detection metric. This is true even of many systems not explicitly described as using correlation-based detection.
- The following are the main forms of correlation discussed in this book.
 - Linear correlation, computed as the inner product between two vectors divided by their dimensionality. Applying a threshold to this measure leads to a detection region bounded by a hyperplane.
 - Normalized correlation, computed by normalizing two vectors to unit magnitude before taking their inner product. Applying a threshold to this measure leads to a conical detection region.
 - Correlation coefficient, computed by subtracting the means from two vectors before computing their normalized correlation. This is equivalent to computing normalized correlation in a space with one fewer dimension. We often use the terms *normalized correlation* and *correlation coefficient* interchangeably.

Basic Message Coding

The example systems described in the previous chapter embed only one bit of information. In practice, most applications require more information than this. Thus, we now consider a variety of methods for representing messages with watermarks. In this chapter, we concentrate on methods that result in simple extensions of the watermarking systems described so far and that are mostly straightforward applications of methods used in traditional communications. The next chapter focuses on optimal use of side information (see Section 3.3.2), which entails a less conventional coding method.

Although we do not intend this chapter to serve as a comprehensive introduction to communications theory, we have written it assuming the reader has no prior knowledge of this field. Those who are familiar with the field may wish to skim.

We begin, in Section 4.1, by examining the problem of mapping messages into *message marks* (i.e., vectors in marking space). The simplest way to do this, which we refer to as *direct message coding,* is to predefine a separate reference mark for each message. However, this approach is not feasible for more than a small data payload. Thus, we discuss the idea of first representing messages with sequences of symbols, and subsequently mapping the symbol sequences into vectors in marking space. The section ends with an example of a simple watermarking system that uses blind embedding to embed 8-bit messages.

The performance of the system that ends Section 4.1 is not as good as we might want, and this leads us, in Section 4.2, to explore the field of error correction coding. We present an example trellis code and show that it significantly improves the performance of our watermarking systems.

Finally, in Section 4.3, we turn to the problem of determining whether or not a message is present in a Work. When messages are represented with sequences

of symbols, there are a number of ways to do this. We discuss three approaches and give an example system that uses one of them.

4.1 Mapping Messages into Message Vectors

The problem of multi-message watermarking can be cast as a problem of mapping messages into watermark vectors, and vice versa. In traditional communications systems, the analogous mapping—between messages and transmitted signals—is often performed on two levels: *source coding* maps messages into sequences of symbols and *modulation* maps sequences of symbols into physical signals. Watermarking systems can be constructed in the same way, with modulation taking the form of a mapping between sequences of symbols and watermark vectors.

We begin this discussion with the simplest approach, which assigns a predefined, unique watermark vector to each message. This approach can be viewed either as involving no intermediate representation of messages with symbols or as assigning a single symbol to each message. In our discussion, we take the former view and, accordingly, refer to the approach as *direct message coding*. In discussing direct message coding, we introduce the concept of *code separation* and examine desirable properties of codes for correlation-based watermarking systems.

We then move on to the subject of symbol sequences. Our discussion of this topic focuses on methods of mapping symbol sequences into watermark vectors (i.e., modulation). Four common methods are presented: *time division multiplexing* represents symbols with temporally disjoint watermark patterns, *space division multiplexing* represents them with spatially disjoint patterns, *frequency division multiplexing* represents symbols with patterns that are disjoint in the frequency domain, and *code division multiplexing* represents them with patterns that overlap in time/space and frequency but have zero correlation with one another. We argue that all of these can be considered special cases of code division multiplexing.

4.1.1 Direct Message Coding

The most straightforward approach to message coding is the assignment of a unique, predefined message mark to represent each message. Let the set of messages be denoted \mathcal{M} and the number of messages in the set, $|\mathcal{M}|$. We design a set of $|\mathcal{M}|$ message marks, \mathcal{W}, each of which is associated with a message. We use $\mathcal{W}[m]$ to denote the message mark associated with message m, $m \in \mathcal{M}$. To watermark a Work with message m, the embedder simply embeds message mark $\mathcal{W}[m]$. We refer to this as the *direct* coding method.

At the detector, detection values are computed for each of the $|\mathcal{M}|$ message marks. The most likely message is the one that corresponds to the message mark with the highest detection value. If this value is less than a threshold, the detector reports that no watermark is present. If the value is greater than the threshold, the detector outputs the index as the detected message. This is known as *maximum likelihood detection.*

How should we design the message marks for our messages? Obviously, each message mark should be chosen to have good behavior with respect to pre-dictable false positive rate, fidelity, robustness, and so on. However, in addition to these issues, we must also consider the likelihood that one message mark will be confused with another. Before being detected, the message mark is likely to be corrupted, either by the embedding algorithm (due to clipping, round-off, perceptual shaping, and so on) or by subsequent processing. If this corrup-tion changes the message mark too much, the watermark might be erroneously decoded as a different message. Thus, we wish to choose a set of message marks that have good *code separation* (i.e., marks that are far apart from one another in marking space).

If we are using either linear correlation or normalized correlation for our de-tection metric, achieving good code separation means ensuring that the message marks have low correlations with one another. The best case, in fact, is to arrange for each message mark to have *negative* correlation with each of the others, be-cause this would mean that embedding one message mark would *decrease* the correlations between the watermarked Work and the other message marks, thus decreasing the chances that a different message mark will be detected.

For a system with only two messages, such as the example systems described so far, the ideal is achieved by defining one message mark to be the negative of the other. Thus, the two marks have a correlation of −1 and achieve maximal separation. For maximal separation in a system with three messages, the angle between the marks should be 120 degrees, as shown in Figure 4.1. This figure shows three message mark vectors in a two-dimensional plane of marking space, along with their respective linear correlation detection regions for an arbitrary threshold. In the general case, the problem of designing an optimal set of $|\mathcal{M}|$ N-dimensional message marks is equivalent to the problem of placing $|\mathcal{M}|$ points on the surface of an N-dimensional sphere (N-sphere) such that the distance between the two closest points is maximized.

If the number of messages is large compared to the dimensionality of marking space, it is well established that randomly generated codes usually result in good code separation [54]. This is illustrated in Figure 4.2, which shows the result of a simple experiment in which 10,000 three-message codes were randomly generated in a three-dimensional space. In each code, the message marks were chosen from an i.i.d. Gaussian distribution. The figure is a histogram of the

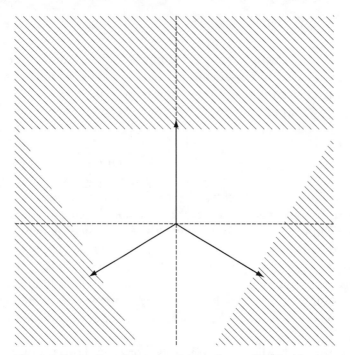

Fig. 4.1 Optimal arrangement of detection regions for three messages using linear correlation detection.

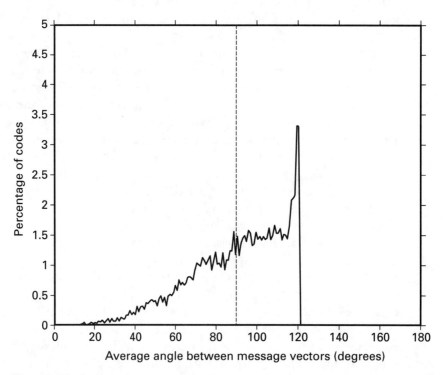

Fig. 4.2 Distribution of average angles between three message vectors in randomly generated, three-dimensional codes.

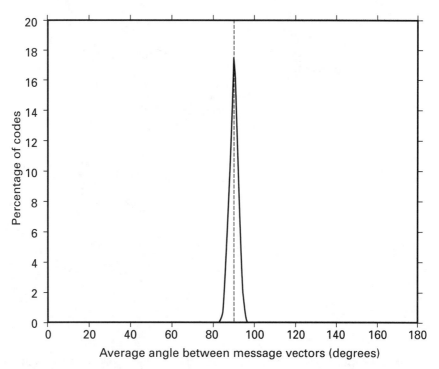

Fig. 4.3 Distribution of average angles between three message vectors in randomly generated 256-dimensional codes.

average angle between all pairs of message vectors in each code. Note that the most common average angles were close to the optimal angle of 120 degrees. This effect becomes more pronounced in higher dimensions.

On the other hand, if the number of messages is small compared to the dimensionality of marking space, randomly generated message vectors are likely to be orthogonal to one another. This is illustrated in Figure 4.3, which shows the results of an experiment similar to that in Figure 4.2, except that the three-message codes were generated in a 256-dimensional space. In this case, the most common average angle was 90 degrees.

An interesting and useful property of orthogonal message marks is that in a linear correlation–based watermarking system more than one message can be embedded in a single Work. Because each message mark has no effect on correlation with other message marks, embedding an additional mark has no effect on the detectability of any mark previously embedded. This situation is illustrated in Figure 4.4, which shows two orthogonal (i.e., zero-correlation) message vectors in a two-dimensional plane of marking space, together with their respective detection regions. The plane is actually divided into *three* detection

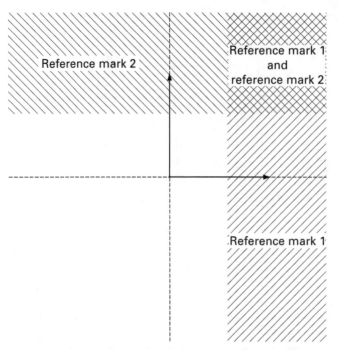

Fig. 4.4 Detection regions for two orthogonal watermarks, showing overlap where both watermarks are detected.

regions: one for message 1, one for message 2, and one for both messages. In the following section, we take advantage of this property to encode messages with combinations of marks.

4.1.2 Multi-symbol Message Coding

Direct message coding is effective, but does not scale well. Because the detector must compute the detection value for each of $|\mathcal{M}|$ reference marks, the approach is not feasible when $|\mathcal{M}|$ is large. For example, if we wish to embed just 16 bits of information, the detector would have to store and compare against 65,536 different reference marks, taking up to 65,536 times the computation required for a 0-bit watermark. Encoding on the order of 100 bits in this manner is completely impractical.

This problem can be dramatically reduced by first representing each message with a sequence of symbols, drawn from an *alphabet*, \mathcal{A}. Each symbol in a sequence can then be embedded and detected independently with its own reference mark.

If each message is represented with a sequence of L separate symbols, drawn from an alphabet of size $|\mathcal{A}|$, we can represent up to $|\mathcal{A}|^L$ different messages. Detecting these messages requires only a fraction of the processing required with direct message coding. For example, suppose we use an alphabet of $|\mathcal{A}| = 4$ symbols and a message length of $L = 8$. This can represent up to $|\mathcal{A}|^L = 65,536$ different messages, or 16 bits of information. At the detector, detection of each of the eight symbols requires comparison with each of the four reference marks, for a total of 32 comparisons, which is considerably fewer than the 65,536 required in a system that represents each message with its own reference mark.

The simplest method of embedding a sequence of symbols is to independently embed a reference mark for each symbol. In the type of systems discussed so far, this would amount to adding L reference marks to the cover Work. Alternatively, and more generally, we can think of the embedder as first modulating the sequence of symbols into a single message mark, and then embedding this message mark. In the following, we discuss a few such forms of modulation.

Time and Space Division Multiplexing

One straightforward method of modulating symbol sequences is to divide the Work into disjoint regions, either in space or time, and embed a reference mark for one symbol into each part. That is, the message mark is constructed by concatenating several reference marks.

For example, to embed a sequence of eight symbols into an audio clip of length l samples, we would use reference marks of length $l/8$. To embed four symbols into an image of dimensions w pixels \times h pixels, we would use reference marks of dimensions $w/2 \times h/2$.

These methods are referred to as *time division* and *space division multiplexing,* respectively. Note that time division multiplexing is essentially the same as the standard method of communicating over temporal channels.

Frequency Division Multiplexing

Alternatively, we can divide the Work into disjoint bands in the frequency domain, and embed a reference mark for one symbol in each. That is, the message mark is constructed by adding together several reference marks of different frequencies. This is referred to as *frequency division multiplexing.*

One way to implement frequency division multiplexing is to define a watermark extraction function that involves a frequency transform, and then design an embedder and detector according to the structures described in Section 3.4.2. The simple watermark embedder employed in this structure should divide its input into segments and embed one symbol in each. Thus, the simple embedder can be essentially identical to one designed for a simple time or space division multiplexing system.

Code Division Multiplexing

As an alternative modulation method, we can take advantage of the fact that several uncorrelated reference marks embedded in the same work have no effect on one another in a linear correlation system. This leads to a system analogous to *code division multiplexing* in spread spectrum communications.

If we are representing messages with sequences of L symbols drawn from an alphabet of size $|\mathcal{A}|$, we define a set of $L \times |\mathcal{A}|$ reference marks, \mathcal{W}_{AL}. Each mark corresponds to a given symbol at a given index in the sequence. Let $\mathcal{W}_{AL}[i, s]$ correspond to symbol s at location i. The message mark is constructed by adding together the appropriate reference marks.

For example, Figure 4.5 illustrates a possible set of 8×8 reference marks for use in an image watermarking system such as E_BLK_BLIND/D_BLK_CC, which

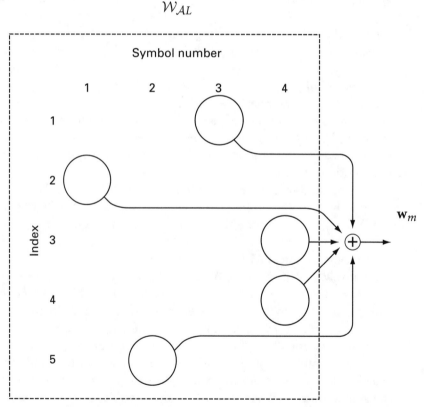

Fig. 4.5 Example of code division multiplexing using 8×8 reference marks. Each row of \mathcal{W}_{AL} corresponds to one position in the symbol sequence. Each column corresponds to one symbol. Thus, there are five representations of each symbol; one for each possible position in the symbol sequence. Selected reference marks are added to encode a message.

uses a marking space arrived at by averaging 8×8 image blocks. The table of 8×8 marks, $\mathcal{W}_{AL}[1 \ldots 5, 1 \ldots 4]$, can be used to modulate sequences of $L = 5$ symbols drawn from an alphabet of size $|\mathcal{A}| = 4$. The figure shows the encoding of the symbol sequence 3, 1, 4, 4, 2; namely,

$$\mathbf{w}_m = \mathcal{W}_{AL}[1, 3] + \mathcal{W}_{AL}[2, 1] + \mathcal{W}_{AL}[3, 4] + \mathcal{W}_{AL}[4, 4] + \mathcal{W}_{AL}[5, 2], \quad (4.1)$$

where \mathbf{w}_m is the resulting message mark.

We need to ensure that all reference marks added into \mathbf{w}_m are close to orthogonal. Each mark represents a symbol in a distinct symbol position, so that two marks will be added together only if they correspond to symbols in different positions. For example, we might add $\mathcal{W}_{AL}[1, 3]$ and $\mathcal{W}_{AL}[2, 1]$ in a single message mark, but we would never embed both $\mathcal{W}_{AL}[1, 3]$ and $\mathcal{W}_{AL}[1, 1]$. Thus, we can ensure that the embedded marks are orthogonal or nearly orthogonal by ensuring only that for any two symbols, a and b (including the case where $a = b$), $\mathcal{W}_{AL}[i, a] \cdot \mathcal{W}_{AL}[j, b] \approx 0$, if $i \neq j$.

We also need to ensure that we do not confuse one symbol for another in a given location. This means that if $a \neq b$, the two reference marks used to encode them at index i, $\mathcal{W}_{AL}[i, a]$ and $\mathcal{W}_{AL}[i, b]$, must be maximally distinguishable. As discussed earlier, this objective is best served by making these reference marks have negative correlation.

In some cases, we may be concerned with the problem of registering a Work to counter temporal delay or geometric translation (see Chapter 8). Under these circumstances, we might need the reference marks for different symbol positions to be not only uncorrelated with one another but uncorrelated with *shifted* versions of one another. That is, we wish the marks for different symbol positions to have low *cross correlations*. Otherwise, a temporal or geometric shift might cause the reference mark for a symbol in one position to be confused with that for a different symbol and/or position. For the one-dimensional case of temporal shifting, this is a well-studied problem. Several sets of code vectors that exhibit low cross correlations have been developed, including *gold-sequences* and *m-sequences*. Many of these are described in [237]. For geometric shifting, the problem is less well studied, but some efforts have been made to extend one-dimensional sequences to two-dimensional patterns [176, 275, 276, 277, 69].

Equivalence of Code Division Multiplexing to Other Approaches

Time, space, and frequency division multiplexing can be viewed as special cases of code division multiplexing. Consider a length $L = 8$ message modulated for embedding in an audio clip using time division multiplexing. This is done by concatenating eight short reference marks. We can, alternatively, view each of the added reference marks as being added to the *entire* message mark if we just pad

Fig. 4.6 Interpretation of time division multiplexing as code division multiplexing.

the marks with zeros. This point is illustrated in Figure 4.6. At the top of the figure is a sequence of eight short reference marks that might be embedded in an audio signal to represent a sequence of eight symbols. Below this are eight full-length reference marks that add up to the signal at the top. Note that these full-length marks are orthogonal to one another, in that only one of them is non-zero in any given element.

Figure 4.7 is the corresponding illustration for space division multiplexing. Thus, in a sequencing system, each reference mark has non-zero values in only $1/L^{\text{th}}$ of its elements, and $\mathcal{W}_{AL}[i, s]$ is just a shifted version of $\mathcal{W}_{AL}[j, s]$ if $i \neq j$.

Similarly, frequency division multiplexing can be implemented by defining patterns that are band limited in the frequency domain, and then converting them to the temporal or spatial domains. If the frequency transform used is linear (such as the Fourier or discrete cosine transforms), then patterns that do not overlap in the frequency domain will have zero correlation in the temporal or spatial domains, even though they overlap in time or space.

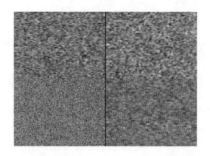

Fig. 4.7 Interpretation of space division multiplexing as code division multiplexing.

Investigation

Simple Eight-bit Watermarks

We now present a simple example of a watermarking system using code division to embed integer messages, represented as sequences of 8 bits. That is, the message length, L, is 8, and the alphabet size, $|\mathcal{A}|$, is 2. This system is based on the E_BLIND/D_LC system. We refer to this new system as E_SIMPLE_8/D_SIMPLE_8.

System 4: E_SIMPLE_8/D_SIMPLE_8

In the E_SIMPLE_8/D_SIMPLE_8 system, the mapping of a message into a sequence of symbols is simply a mapping of the message into a bit string. To modulate a message, the i^{th} bit of the string is then mapped into $\mathcal{W}_{AL}[i, 1]$ if it is 1, or $\mathcal{W}_{AL}[i, 0]$ if it is 0.

The two reference patterns for a given location must be maximally distinguishable from each other. As pointed out previously, two vectors are maximally distinguishable when one is the negative of the other. Therefore, we can construct an optimal binary system by designing a single reference pattern, \mathbf{w}_{ri}, for each bit location, i, and using that pattern to encode a 1, or the negation of that pattern to encode a 0. In other words, for any bit location, i, $\mathcal{W}_{AL}[i, 1] = \mathbf{w}_{ri}$ and $\mathcal{W}_{AL}[i, 0] = -\mathbf{w}_{ri}$.

Each of the base reference patterns, $\mathbf{w}_{r1}, \mathbf{w}_{r2}, \ldots, \mathbf{w}_{r8}$, is generated pseudo-randomly according to a given seed, which can be considered a watermark key. They are drawn from i.i.d. Gaussian distributions. We normalize each pattern to have zero mean. To ensure that our test results are comparable with those of other systems in this book, we normalize the modulated message pattern, \mathbf{w}_m, to have unit variance (it already has zero mean because its component reference patterns have zero means).

Thus, the message pattern, \mathbf{w}_m, that encodes a given message, m, expressed as a sequence of bits, $m[1], m[2] \ldots m[s]$, is given by

$$\mathbf{w}_{mi} = \begin{cases} \mathbf{w}_{ri} & \text{if } m[i] = 1 \\ -\mathbf{w}_{ri} & \text{if } m[i] = 0 \end{cases} \tag{4.2}$$

$$\mathbf{w}_{\text{tmp}} = \sum_i \mathbf{w}_{mi} \tag{4.3}$$

$$\mathbf{w}_m = \frac{\mathbf{w}_{\text{tmp}}}{s_{\mathbf{w}_{\text{tmp}}}}, \tag{4.4}$$

where \mathbf{w}_{tmp} is just the version of the message mark before normalization, and $s_{\mathbf{w}_{\text{tmp}}}$ is its sample standard deviation.

The E_SIMPLE_8 embedder computes the message mark according to Equation 4.4 and embeds it using blind embedding. Thus, the watermarked image, $\mathbf{c_w}$, is given by

$$\mathbf{c_w} = \mathbf{c_o} + \alpha \mathbf{w}_m, \tag{4.5}$$

where $\mathbf{c_o}$ is the original image, and α is a strength parameter input by the user.

The D_SIMPLE_8 detector correlates the received image, \mathbf{c}, against each of the eight base reference patterns, $\mathbf{w}_{r1}, \ldots, \mathbf{w}_{r8}$, and uses the sign of each correlation to determine the most likely value for the corresponding bit. This yields the decoded message. The detector does not distinguish between marked and unwatermarked images. If an image is not watermarked, the output message

is essentially random. (Section 4.3 discusses methods of detecting the presence of multi-symbol watermarks.)

Experiments

To test the E_SIMPLE_8/D_SIMPLE_8 system, we embedded six different messages in each of 2,000 images. The messages embedded were $m = 0, 255, 101, 154, 128,$ and 127. This resulted in 12,000 watermarked images.

The embedding strength, α, had to be higher than 1, which we used in most of our preceding experiments, as we are effectively embedding eight different watermarks. Because the message pattern is scaled to have unit standard deviation, each of the eight patterns embedded has an effective strength of roughly $\alpha/\sqrt{8}$. If $\alpha = 1$, these individual patterns are not reliably embedded and detected. Thus, we used an embedding strength of $\alpha = 2$.

Out of the 12,000 messages embedded, a total of 26 messages were not correctly detected. Although this may sound like a small number, it would probably not be acceptable for many applications. The problem lies in the amount of code separation achieved using the simple coding scheme of this system. That is, the maximum correlation between two different message vectors is high enough that when the image is added as "noise" one message vector gets confused with another. To reduce this problem, we can turn to the field of error correction coding.

4.2 Error Correction Coding

If every possible symbol sequence of a given length is used to represent a message, it is easily demonstrated that, using code division modulation, some of the resulting vectors will have poor code separation. This problem motivates the introduction of error correction codes. We describe trellis codes and Viterbi decoding as an example.

4.2.1 The Problem with Simple Multi-symbol Messages

In direct message coding, we can choose any set of message marks we wish. Thus, we can ensure that the angle between any pair of message marks is maximal. In any multi-symbol system, however, code separation depends on the methods used for source coding and modulation. In the case of the type of system used by E_SIMPLE_8/D_SIMPLE_8, where every possible sequence of symbols represents a distinct message and sequences are modulated with some form of code division, there is a lower limit on the inner product, and, hence, an upper limit on the angle between the resulting message marks.

To see why this is the case, consider a system with an alphabet size, $|\mathcal{A}|$, of four and a message length, L, of three. Let

$$\mathbf{w}_{312} = \mathcal{W}_{AL}[1, 3] + \mathcal{W}_{AL}[2, 1] + \mathcal{W}_{AL}[3, 2] \tag{4.6}$$

be the message mark embedded in a Work to represent the symbol sequence 3, 1, 2. Now examine the inner product between this message mark and the message mark that encodes the sequence 3, 1, 4 (which differs only in the last symbol); namely,

$$\mathbf{w}_{314} = \mathcal{W}_{AL}[1, 3] + \mathcal{W}_{AL}[2, 1] + \mathcal{W}_{AL}[3, 4] \tag{4.7}$$

The inner product between these two is given by

$$\begin{aligned}
\mathbf{w}_{312} \cdot \mathbf{w}_{314} &= (\mathcal{W}_{AL}[1, 3] + \mathcal{W}_{AL}[2, 1] + \mathcal{W}_{AL}[3, 2]) \\
&\quad \cdot (\mathcal{W}_{AL}[1, 3] + \mathcal{W}_{AL}[2, 1] + \mathcal{W}_{AL}[3, 4]) \\
&= \mathcal{W}_{AL}[1, 3] \cdot (\mathcal{W}_{AL}[1, 3] + \mathcal{W}_{AL}[2, 1] + \mathcal{W}_{AL}[3, 4]) \\
&\quad + \mathcal{W}_{AL}[2, 1] \cdot (\mathcal{W}_{AL}[1, 3] + \mathcal{W}_{AL}[2, 1] + \mathcal{W}_{AL}[3, 4]) \\
&\quad + \mathcal{W}_{AL}[3, 2] \cdot (\mathcal{W}_{AL}[1, 3] + \mathcal{W}_{AL}[2, 1] + \mathcal{W}_{AL}[3, 4]) \tag{4.8}
\end{aligned}$$

Because all marks for one location are orthogonal to all marks for any other location, this reduces to

$$\begin{aligned}
\mathbf{w}_{312} \cdot \mathbf{w}_{314} &= \mathcal{W}_{AL}[1, 3] \cdot \mathcal{W}_{AL}[1, 3] + \mathcal{W}_{AL}[2, 1] \cdot \mathcal{W}_{AL}[2, 1] \\
&\quad + \mathcal{W}_{AL}[3, 2] \cdot \mathcal{W}_{AL}[3, 4] \tag{4.9}
\end{aligned}$$

Suppose all the marks are normalized to have unit variance. This means $\mathcal{W}_{AL}[1, 3] \cdot \mathcal{W}_{AL}[1, 3]$ and $\mathcal{W}_{AL}[2, 1] \cdot \mathcal{W}_{AL}[2, 1]$ both equal N (the dimensionality of marking space), while $\mathcal{W}_{AL}[3, 2] \cdot \mathcal{W}_{AL}[3, 4]$ is bounded from below by $-N$. Thus, $\mathbf{w}_{312} \cdot \mathbf{w}_{314} \geq N$, and the inner product between the two closest encoded messages cannot possibly be lower than this.

In general, the smallest possible inner product between two message marks that differ in h symbols is $N(L - 2h)$. Thus, as L increases, the message marks of the closest pair become progressively more similar.

4.2.2 The Idea of Error Correction Codes

We can solve this problem by defining a source coding system in which *not* every possible sequence of symbols corresponds to a message. Sequences that correspond to messages are referred to as *code words*. The sequences that do not correspond to messages are interpreted as corrupted code words. By defining the mapping between messages and code words in an appropriate way, it is possible to build decoders that can identify the code word closest to a given corrupted

sequence (i.e., decoders that correct errors). Such a system is an *error correction code*, or *ECC*.

Error correction codes are typically implemented by increasing the lengths of symbol sequences. Thus, to use an ECC encoder, we begin by representing our message in the straightforward way described previously. For example, if we have 16 possible messages, we could represent the message with a sequence of four bits. The ECC encoder, then, takes this sequence as input, and outputs a longer sequence, say, seven bits. Of all the $2^7 = 128$ possible 7-bit words, only 16 would be code words. The set of code words can be defined in such a way that if we start with one code word, we have to flip at least three bits to obtain a code word that encodes a different message. When presented with a corrupted sequence, the decoder would look for the code word that differs from it in the fewest number of bits. If only one bit has been flipped between encoding and decoding, the system will still yield the correct message.

Note that if we have a 7-bit code ($L = 7$) encoding 4-bit messages and ensuring that the code words of every pair differ in at least three bits ($h = 3$), the maximum inner product between any two code words will be $N(L - 2h) = N(7 - 2 \times 3) = N$. This is better than the performance we would get without error correction, where messages are coded with only four bits ($L = 4$) and two messages can differ in as few as one bit ($h = 1$). In that case, the maximum inner product would be $N(L - 2h) = N(4 - 2) = 2N$.

A less typical implementation of an error correction code increases the size of the alphabet, rather than the length of the sequences. For example, our 4-bit messages might be encoded with sequences of symbols drawn from an alphabet of size 4, rather than a binary alphabet of size 2. In principle, this would be equivalent to a system that lengthens 4-bit binary sequences to eight bits. The only difference is the way in which we would implement subsequent modulation.

There are many error correction codes available. One of the simplest, and earliest, is the *Hamming code* [232], which ensures that any two coded messages always differ in at least three bits, and allows correction of single-bit errors. This type of code can be used to realize the 7-bit coding of 4-bit messages described previously. More sophisticated codes, such as *BCH* [232] and *trellis codes* [280], allow a greater number of errors to be corrected. Some of the best-performing codes fall into the class of *turbo codes* [17], which a few researchers have begun using to encode watermark messages [210, 77].

These codes are often described in terms of methods of correcting symbol errors. Different codes are suitable for different types of errors. For example, *random* errors are well handled by Hamming codes, whereas *burst* errors (errors in groups of consecutive symbols) are better handled by BCH codes. However, because all code words are ultimately modulated, we can view all codes as convenient methods of generating well-separated message marks.

4.2.3 Example: Trellis Codes and Viterbi Decoding

To illustrate the idea of error correction codes, we now present an example of a *trellis code* (or *convolutional code*). Trellis codes are generally known to have good performance and serve as a foundation for some interesting research in watermarking [48, 115] (we briefly discuss this research in Chapter 5). In the following we describe the encoding and decoding processes for our example code. For more on the theory behind this type of coding, see [280].

Encoding

The encoder can be implemented as a state machine, as illustrated in Figure 4.8. The machine begins in state A and processes the bits of the input sequence one at a time. As it processes each input bit, it outputs four bits and changes state.

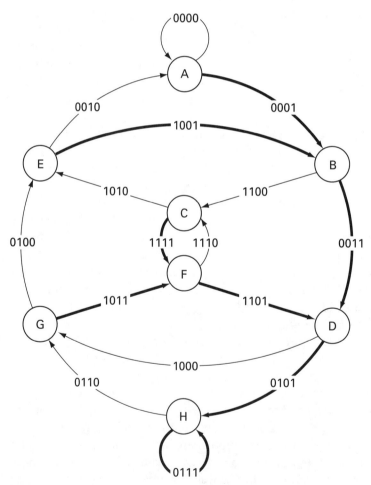

Fig. 4.8 An eight-state convolutional code.

If the input bit is a 0, it traverses the light arc coming from the current state and outputs the four bits with which that arc is labeled. If the input bit is a 1, it traverses the dark arc and outputs that arc's 4-bit label. Thus, a 4-bit message will be transformed into a 16-bit code word after encoding.

For example, consider encoding the 4-bit sequence 1010. Beginning at state A, we process the first (leftmost) bit in the sequence. The bold arc from state A is labled 0001, and those will be the first four bits of the coded word. The machine is now in state B when it processes the next bit, a 0. The light arc from state B is labeled 1100, and those will be the next four bits. Continuing on like this, we end up encoding our original 4-bit sequence with the 16-bit sequence 0001 1100 1111 1110. Note that each bit of the message effects not only the four bits used to encode it but also the encoding of several subsequent bits. Thus, the subsequent bits contain redundant information about earlier bits.

Figure 4.9 shows an alternative representation of the code, in a diagram called a *trellis*. Here, we have $8(L+1)$ states, where L is the length of the input sequence. Each row of states corresponds to one state in Figure 4.8 at different times. Thus,

Fig. 4.9 Trellis representation of the code in Figure 4.8. Each row corresponds to one of the eight states. Each column corresponds to an iteration of the encoding (column 0 is before encoding starts, column 1 is after encoding the first bit, and so on) The labels along the arcs have been removed for clarity. The highlighted path corresponds to the encoding of 1010.

state A0 in Figure 4.9 corresponds to state A in Figure 4.8 at the beginning of the encoding process, state A1 corresponds to state A after the first input bit has been processed, and so on. Each possible code word corresponds to a path through this trellis starting at state A0. Figure 4.9 highlights the code word for input 1010.

The straightforward way of modulating code words generated by this code is to treat them as sequences of $4L$ bits, which are modulated in the same manner as in the E_SIMPLE_8/D_SIMPLE_8 system. Alternatively, we can replace the 4-bit arc labels with symbols drawn from a 16-symbol alphabet. This would lead us to assign a unique reference mark to each arc in the trellis of Figure 4.9 (one each for each of the 16 symbols in each of the L sequence locations). The message mark resulting from a given code word, then, is simply the sum of the reference marks for the arcs along the path that corresponds to that code word. This is known as *trellis-coded modulation* and is the approach we will take.

Decoding

Decoding a trellis-coded message is a matter of finding the most likely path through the trellis. In our case, the most likely path is the one that leads to the highest linear correlation or inner product between the received vector and the message vector for that path. This can be found efficiently using an algorithm known as a *Viterbi decoder*.

The Viterbi algorithm relies on the fact that the most likely path *through* each node in the trellis always includes the most likely path *up to* that node. Thus, once we find the most likely path from A0 to some node further into the trellis, we can forget about all the other possible paths from A0 to that node.

The algorithm proceeds by traversing the trellis from left to right. For each of the eight states in the columns of the trellis, it keeps track of the most likely path so far from A0 to that state, and the total inner product between the received vector and the reference marks along that path. In each iteration, it updates these paths and products. When it reaches the end of the trellis (i.e., the end of the coded message), it has found the most likely path from A0 to each of the eight final states. It is then a simple matter to decide which of the resulting eight paths is most likely.

We now describe the algorithm in more detail. To begin with, let us assume that the most likely path through the trellis is not restricted to the start point A0. We will introduce a simple method of enforcing this restriction later.

In this description, we use the following notation:

- \mathbf{v} is the received vector being decoded.
- $\mathbf{w}_{i,j}$ is the reference mark associated with the arc in the trellis from state i to state j. For example, $\mathbf{w}_{A0,B1}$ is the reference mark associated with the arc from state A0 to state B1.

- $\mathbf{p}[A \ldots H]$ is an array of eight paths. At any given time, $\mathbf{p}[i]$ is the most likely path that leads up to state i in the current column. For example, when processing column 3, $\mathbf{p}[C]$ is the most likely path that leads up to state C3.
- $\mathbf{z}[A \ldots H]$ is an array of eight inner products. At any given time, $\mathbf{z}[i]$ is the total product between the received vector, \mathbf{v}, and the reference marks for path $\mathbf{p}[i]$.

At the beginning of the algorithm, $\mathbf{p}[A \ldots H]$ are initialized to the null path, and $\mathbf{z}[A \ldots H]$ are initialized to 0. In the first iteration, we compute the inner product between the received vector and the 16 reference marks associated with the arcs that go from states in column 0 to states in column 1. To find the total product between the received vector and a path from a state in column 0 to a state in column 1, we add the product with the corresponding arc to the value in \mathbf{z} that corresponds to the column 0 state. For example, the inner product for the path from A0 to B1 is just $\mathbf{z}[A] + \mathbf{v} \cdot \mathbf{w}_{A0,B1}$. Similarly, the product for the path from E0 to B1 is $\mathbf{z}[E] + \mathbf{v} \cdot \mathbf{w}_{E0,B1}$.

By comparing the inner products for the two paths that lead up to a state in column 1, we can decide which path to that state is most likely, and update \mathbf{p} and \mathbf{z} accordingly. Thus, for example, if

$$\mathbf{z}[A] + \mathbf{v} \cdot \mathbf{w}_{A0,B1} > \mathbf{z}[E] + \mathbf{v} \cdot \mathbf{w}_{E0,B1}, \tag{4.10}$$

then we would update

$$\mathbf{z}[B] \leftarrow \mathbf{z}[A] + \mathbf{v} \cdot \mathbf{w}_{A0,B1} \tag{4.11}$$

$$\mathbf{p}[B] \leftarrow \mathbf{p}[A] \text{ concatenated with the arc from A0 to B1.} \tag{4.12}$$

This process is repeated L times, until we reach the end of the trellis. At that point, we identify the most likely path by finding the highest value in \mathbf{z}. The path can then be converted into a decoded message.

To ensure that the most likely path always starts at A0, we can modify this algorithm by initializing only $\mathbf{z}[A]$ to 0 at the beginning. The other elements of \mathbf{z} are initialized to an extreme negative value, indicating that the corresponding nodes have not yet been reached.

Investigation

Eight-bit Trellis-coded Watermarks

We now present a watermarking system, E_TRELLIS_8/D_TRELLIS_8, which employs the code of Figure 4.8 to embed 8-bit messages.

System 5: E_TRELLIS_8/D_TRELLIS_8

The E_TRELLIS_8 embedder takes an 8-bit message as input and maps it into a message pattern using trellis-coded modulation. One slight modification to the algorithm previously presented is that before modulating the message it appends two 0 bits onto the end, resulting in a 10-bit message to be modulated. This is done so that the code will provide some redundancy for the last bit in the message.

As in the E_SIMPLE_8 embedder, the message pattern, \mathbf{w}_m, is normalized to have zero mean and unit variance before embedding. This means that both systems have similar fidelity impacts when used with the same embedding strength parameter. The message pattern is embedded using blind embedding.

The D_TRELLIS_8 detector applies the Viterbi decoding algorithm described previously to map images into messages. Like the embedder, this detector is slightly modified for the extra two bits. Because we know, *a priori*, that these two bits must be 0, we restrict the decoder to ignore bold arcs during the last two iterations of decoding. In all other ways, the decoding algorithm is exactly as described previously.

The detector does not distinguish between marked and unmarked images. For every image, it outputs a sequence of eight bits. If an image is not watermarked, the resulting bits are essentially random.

Experiments

To test this system, we ran the same experiment as was run on the E_SIMPLE_8/D_SIMPLE_8 system. Namely, 2,000 images were embedded with six different messages, resulting in 12,000 watermarked images. The embedding strength, again, was $\alpha = 2$.

Note that because we pad the message with two 0 bits there are 10 reference marks embedded rather than only eight. Thus, each mark is effectively embedded with an embedding strength of $\alpha/\sqrt{10}$.

In spite of the weaker embedding of individual reference marks, however, the performance of the E_TRELLIS_8/D_TRELLIS_8 system was significantly better than that of E_SIMPLE_8/D_SIMPLE_8. In all 12,000 watermarked images, only one message was incorrectly decoded, compared with 26 for the latter.

4.3 Detecting Multi-symbol Watermarks

The two watermarking systems introduced previously are able to carry higher data payloads than those introduced in preceding chapters, but they lack the ability to distinguish between Works that contain watermarks and Works that

do not. That is, these two detection algorithms map any Work into a sequence of eight bits, regardless of whether that Work contains a watermark or not. We now turn our attention to the problem of deciding whether or not a multi-symbol watermark is present in a Work.

In the case of direct message encoding, when the watermark consists of only one symbol, it is straightforward to determine whether a mark is present. The detector computes a detection value for each of the $|\mathcal{M}|$ messages. Only the highest of these is assumed to have any relevance to the embedded watermark. Thus, if the highest detection value is greater than a threshold, the detector can conclude that the corresponding watermark is present. The shape of the resulting detection region depends only on the way the detection value is computed.

By contrast, in the case of a simple multi-symbol system (such as the E_SIMPLE_8/D_SIMPLE_8 system described previously), the detector obtains several detection values that are assumed to reflect the presence of the individual symbols. By comparing different combinations of these values against a threshold, we can obtain different detection regions. Alternatively, we can apply a detection test that does not use the individual symbol detection values at all. A similar range of options is also open to us in more complex systems, such as E_TRELLIS_8/D_TRELLIS_8.

We discuss three basic approaches to the problem of determining presence of a multi-symbol watermark. The first approach involves dividing the set of all possible messages into two sets: *valid* messages, which might be embedded by a watermark embedder, and *invalid* messages, which are never embedded. If a watermark detector detects an invalid message, it concludes that no watermark was embedded. The second approach uses linear correlation to decide whether all the symbols that encode the message were actually embedded. The third approach uses normalized correlation to determine whether the most likely message mark was actually embedded. Since the purpose of these techniques is to distinguish between watermarked and unwatermarked Works, we include a brief analysis of the false positive probability for each.

4.3.1 Detection by Looking for Valid Messages

A straightforward method of detecting whether or not a watermark is present in a Work is to declare that only a small subset of all possible symbol sequences represents legal messages.

Application

As a simple example, suppose we want to build a system that can embed 2^{16} different messages. We can represent each message with a sequence of 16 bits, and then append a 9-bit checksum obtained by adding the first eight bits of the message to the second eight bits of the message. This means that only 1 in every

$2^9 = 512$ possible bit sequences corresponds to a legal message. In the detector, we decode all 25 bits, and then add the first eight bits to the second eight bits and compare the result with the last nine bits. If the result matches, we say that the watermark is present.

This approach is commonly proposed for watermarking systems that have a high data payload [210, 266]. In fact, systems with very high payloads, such as 1,000 bits or more in a single Work (see Chapter 5), are often presented without discussion of how to determine whether a watermark is present [48, 45], since it can be assumed that the vast majority of possible messages will be defined as invalid by the application. For example, consider a watermark that is supposed to encode a passage of text as a string of 100 ASCII characters. Because most possible strings of characters are not meaningful, it can reasonably be assumed that any Work that yields an intelligible string actually contains a watermark.

False Positive Probability

When watermarks are detected by distinguishing between valid and invalid messages, the false positive probability is easy to estimate. We begin by assuming that each message is as likely as any other to be found in an unwatermarked Work. This assumption is satisfied for a binary system if each bit has a 50% chance of being a 1, and if the bits are uncorrelated. In such a case, the probability of a false positive is simply the fraction of possible messages that is declared invalid.

Thus, in the previous example of 16-bit messages with 9-bit checksums, the false positive probability is $1/512$. Clearly, if such an approach is to be reasonable for applications requiring very low false positive probabilities, the symbol sequences must be much longer, so that a much smaller fraction of them can be defined as valid.

4.3.2 Detection by Detecting Individual Symbols

An alternative method of detecting presence of a length, L, multi-symbol watermark is to test for each symbol independently, and report that the watermark is present only if every symbol's detection value exceeds a threshold.

Application

This approach is applicable when the detection values are linear correlations. However, as we shall see in the next section, it runs into trouble with normalized correlations.

When this strategy is applied in a system that uses linear correlation, the resulting detection regions are defined by the intersection of several hyperplanes. The four detection regions for a 2-bit binary system are illustrated in Figure 4.10. In this figure, the y-axis is the reference vector for bit 0, \mathbf{w}_{r0}, and the x-axis is the reference vector for bit 1, \mathbf{w}_{r1}. There are four possible messages, 00, 01, 10, and

Fig. 4.10 Detection regions for four possible messages encoded with two orthogonal watermark patterns. A watermark is detected only if the linear correlations between the Work and *both* patterns are above a threshold.

11, each of which has a distinct detection region. Any Work that lies outside all four detection regions is considered to contain no message.

False Positive Probability

To find the false positive probability, we begin with the probability that a given reference mark yields a correlation over the threshold. This can be estimated using the methods described in Chapter 6. We denote this probability as P_{fp0}. From P_{fp0}, we shall estimate the probability, P_{fp1}, that the most likely symbol at a given sequence location has a detection value higher than the threshold. Finally, we shall use P_{fp1} to estimate the probability that the most likely symbols in *all* of the sequence locations are over the threshold. This is the probability of a false positive, P_{fp}.

To estimate P_{fp1}, recall that for each of the L locations in the sequence of symbols being decoded the detector performs $|\mathcal{A}|$ correlations and selects the symbol that yields the highest value. It is this highest correlation value that will be compared against the threshold. Thus, P_{fp1} is the probability that at least one of $|\mathcal{A}|$ correlations exceeds the threshold when there is no watermark present. If

we assume that the $|\mathcal{A}|$ marks for a given location are highly distinguishable, the probability, P_{fp1}, that at least one of them yields a correlation over the threshold is roughly equal to the sum of their separate probabilities; thus:

$$P_{\mathrm{fp1}} \approx |\mathcal{A}| \, P_{\mathrm{fp0}} \tag{4.13}$$

From P_{fp1} we can now estimate the probability of a false positive. The detector only reports a detection if all L maximum correlations it finds are over the threshold. Assuming that the maximum correlation for each location is independent of that for all other locations, the probability, P_{fp}, that all of them will exceed the threshold, when running the detector on an unwatermarked Work, is given by

$$P_{\mathrm{fp}} = P_{\mathrm{fp1}}^{L} \approx (|\mathcal{A}| \, P_{\mathrm{fp0}})^{L} \tag{4.14}$$

If the size of the alphabet is small enough, relative to the message sequence length, L, then P_{fp} is usually lower than P_{fp0}. This means that as the sequence length increases we can reduce the detection threshold and maintain the same overall false positive probability.

4.3.3 Detection by Comparing against Quantized Vectors

The strategy described in the preceding section relies on the fact that the presence of several orthogonal reference marks has no effect on each mark's linear correlation detection value. Unfortunately, if the detector uses normalized correlation instead of linear correlation, the strategy will not work because the addition of each new pattern always decreases the detection value for all others.

For example, consider two orthogonal reference marks, \mathbf{w}_{r1} and \mathbf{w}_{r2}. The projected vector extracted from a Work with only \mathbf{w}_{r1} embedded might be $\mathbf{v}_1 = \mathbf{v_o} + \mathbf{w}_{\mathrm{r1}}$. Its normalized correlation with \mathbf{w}_{r1} is

$$\begin{aligned} z_{\mathrm{nc}}(\mathbf{v}_1, \mathbf{w}_{\mathrm{r1}}) &= \frac{(\mathbf{v_o} + \mathbf{w}_{\mathrm{r1}}) \cdot \mathbf{w}_{\mathrm{r1}}}{|\mathbf{v_o} + \mathbf{w}_{\mathrm{r1}}| \, |\mathbf{w}_{\mathrm{r1}}|} \\ &= \frac{\mathbf{v_o} \cdot \mathbf{w}_{\mathrm{r1}} + \mathbf{w}_{\mathrm{r1}} \cdot \mathbf{w}_{\mathrm{r1}}}{|\mathbf{v_o} + \mathbf{w}_{\mathrm{r1}}| \, |\mathbf{w}_{\mathrm{r1}}|} \end{aligned} \tag{4.15}$$

Now, if we add in \mathbf{w}_{r2} to obtain $\mathbf{v}_2 = \mathbf{v_o} + \mathbf{w}_{\mathrm{r1}} + \mathbf{w}_{\mathrm{r2}}$, and test for \mathbf{w}_{r1} again, we have

$$\begin{aligned} z_{\mathrm{nc}}(\mathbf{v}_2, \mathbf{w}_{\mathrm{r1}}) &= \frac{(\mathbf{v_o} + \mathbf{w}_{\mathrm{r1}} + \mathbf{w}_{\mathrm{r2}}) \cdot \mathbf{w}_{\mathrm{r1}}}{|\mathbf{v_o} + \mathbf{w}_{\mathrm{r1}} + \mathbf{w}_{\mathrm{r2}}| \, |\mathbf{w}_{\mathrm{r1}}|} \\ &= \frac{\mathbf{v_o} \cdot \mathbf{w}_{\mathrm{r1}} + \mathbf{w}_{\mathrm{r1}} \cdot \mathbf{w}_{\mathrm{r1}}}{|\mathbf{v_o} + \mathbf{w}_{\mathrm{r1}} + \mathbf{w}_{\mathrm{r2}}| \, |\mathbf{w}_{\mathrm{r1}}|} \end{aligned} \tag{4.16}$$

The numerator is unaffected. However, because \mathbf{w}_{r1} and \mathbf{w}_{r2} are orthogonal, $|\mathbf{v_o} + \mathbf{w}_{\mathrm{r1}} + \mathbf{w}_{\mathrm{r2}}| > |\mathbf{v_o} + \mathbf{w}_{\mathrm{r1}}|$, so $z_{\mathrm{nc}}(\mathbf{v}_2, \mathbf{w}_{\mathrm{r1}}) < z_{\mathrm{nc}}(\mathbf{v}_1, \mathbf{w}_{\mathrm{r1}})$. The amount by which \mathbf{w}_{r1}'s detection value is decreased depends on the magnitude with which \mathbf{w}_{r2} is embedded. The stronger we make \mathbf{w}_{r2}, the weaker \mathbf{w}_{r1} becomes.

Now suppose we compare both the detection values for $\mathbf{w_{r1}}$ and $\mathbf{w_{r2}}$ against a threshold to decide whether a watermark is present. Let $z_{nc}(\mathbf{v}, \mathbf{w_{r1}})$ and $z_{nc}(\mathbf{v}, \mathbf{w_{r2}})$ be the two detection values, respectively. We say a watermark is present if $z_{nc}(\mathbf{v}, \mathbf{w_{r1}}) > \tau_{nc}$ and $z_{nc}(\mathbf{v}, \mathbf{w_{r2}}) > \tau_{nc}$. This is equivalent to comparing only the lesser of the two against the threshold as follows:

$$\min(z_{nc}(\mathbf{v}, \mathbf{w_{r1}}), z_{nc}(\mathbf{v}, \mathbf{w_{r2}})) > \tau_{nc}. \tag{4.17}$$

Because increasing the detection value for one pattern decreases the value for the other, $\min(z_{nc}(\mathbf{v}, \mathbf{w_{r1}}), z_{nc}(\mathbf{v}, \mathbf{w_{r2}}))$ attains its highest value when $z_{nc}(\mathbf{v}, \mathbf{w_{r1}}) = z_{nc}(\mathbf{v}, \mathbf{w_{r2}})$. Thus, the highest possible value for $z_{min} = \min(z_{nc}(\mathbf{v}, \mathbf{w_{r1}}), z_{nc}(\mathbf{v}, \mathbf{w_{r2}}))$, obtained by setting $|\mathbf{w_{r1}}| = |\mathbf{w_{r2}}| = K$ and $\mathbf{v} = \mathbf{w_{r1}} + \mathbf{w_{r2}}$, is

$$\begin{aligned} z_{min} &= \frac{\mathbf{w_{r1}} \cdot \mathbf{w_{r1}}}{|\mathbf{w_{r1}} + \mathbf{w_{r2}}||\mathbf{w_{r1}}|} \\ &= \frac{K^2}{(\sqrt{2}K)K} \\ &= \frac{1}{\sqrt{2}}. \end{aligned} \tag{4.18}$$

Thus, if we set our threshold higher than $1/\sqrt{2}$, we cannot possibly obtain any detections. In general, if we are embedding L orthogonal patterns, the best we can expect for the minimum of all L normalized correlations is $1/\sqrt{L}$.

A geometric interpretation of this limitation is shown in Figure 4.11. This shows the four individual detection regions for the four reference marks employed in a binary (i.e., 2-ary) system, such as that shown in Figure 4.10. The threshold has been set high enough that no two detection regions overlap, which means that no Works can be detected as containing more than one of the marks. Embedding two marks at equal strength in this case would make them both undetectable.

To solve this problem, we can use a different test for presence of the watermark. Rather than try to determine whether the mark is present on a symbol-by-symbol basis, we first identify the most likely message mark, and then test for that message mark as a whole. Identifying the most likely message mark amounts to a form of vector quantization.

Application

A general method for finding the most likely message mark and testing for its presence begins by decoding the extracted vector, \mathbf{v}, in the usual way. This gives a sequence of symbols, $m[1] \ldots m[L]$. At this point, we re-encode the decoded message to obtain a single message mark. In the simplest case, the message mark obtained is just the summation of the most likely reference marks. In more sophisticated systems, the decoding and re-encoding steps might include application of error correction codes.

Fig. 4.11 A geometric interpretation of the upper bound on normalized correlations for four reference marks in a 2-ary system.

The re-encoding gives us the message mark, \mathbf{w}_m, which would be embedded in a Work to embed the message m. We now apply a test for presence of \mathbf{w}_m, as if it were the only possible watermark in the system. If we wish to use normalized correlation detection, we can compute the normalized correlation between the extracted vector, \mathbf{v}, and \mathbf{w}_m, and compare the resulting value against a threshold. This results in the detection regions shown in Figure 4.12.

False Positive Probability

In general, the false positive probability is bounded from above by the number of possible messages, $|\mathcal{M}|$, times the probability that any one message will yield a false positive, P_{fp0}. This bound is tight when the detection regions for the different messages do not overlap.

For example, in a system that uses normalized correlation as a detection measure, the detection region for each message is an N-cone (see Chapter 3). If the angle subtended by these cones is less than the minimum angle between two message vectors, none of the cones overlap, and the probability of obtaining a false positive with the entire system is exactly the sum of the false positive probabilities for the $|\mathcal{M}|$ separate messages. Assuming that these probabilities are all the same, P_{fp0}, the probability of false positives is simply $P_{fp} = |\mathcal{M}| P_{fp0}$.

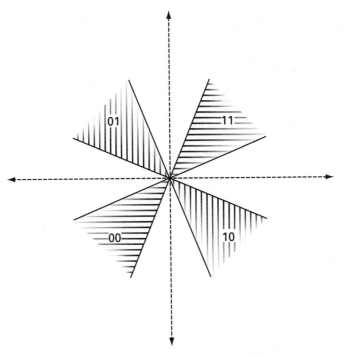

Fig. 4.12 Illustration of the re-encoding method for four reference marks.

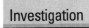

Investigation

Block-based 8-bit Watermarking with Normalized Correlation Detection

We illustrate the method of Figure 4.12 by presenting a modified version of the E_BLK_BLIND/D_BLK_CC system. The system presented here embeds and detects 8-bit watermarks, and uses the correlation coefficient to determine whether or not a watermark is present.

System 6: E_BLK_8/D_BLK_8

The E_BLK_8 embedder is almost identical to E_BLK_BLIND, except that rather than taking a 1-bit message and an 8×8 reference mark as input it takes an 8-bit message, m, and a seed for a pseudo-random number generator. The message is encoded with the trellis code of Figure 4.9. As in the E_TRELLIS_8 algorithm described previously, two 0s are appended to the message before encoding, to add some redundancy for the last few bits. This results in a sequence of 10 symbols drawn from a 16-symbol alphabet.

The symbol sequence is then modulated using code division in the same way as in E_TRELLIS_8 except that 8×8 reference marks are used instead of full-size reference patterns. Finally, the resulting message mark, \mathbf{w}_m, is embedded in the same way as in E_BLK_BLIND.

The D_BLK_8 detector begins by extracting a vector, \mathbf{v}, in the same manner as D_BLK_CC. The extracted vector is then decoded using a Viterbi decoder, to obtain the received message, m. This is the message that is most likely to be in the image.

To determine whether or not the message actually *is* in the image, the detector then *re-encodes m*, using the same encoding used by the embedder. This yields the message mark, \mathbf{w}_m, that is most likely to have been embedded. If the normalized correlation between \mathbf{w}_m and the extracted vector, \mathbf{v}, is greater than a threshold, τ_{cc}, the detector concludes that the watermark is present and it outputs m. Otherwise, it outputs *no watermark*.

Experiments

This system was tested on our usual set of 2,000 images. Each image was embedded with the messages $m = 0, 255, 101, 154, 128$, and 127, resulting in a total of 12,000 watermarked images. The embedding strength was $\alpha = 2$. The detection threshold was $\tau_{cc} = 0.65$, which leads to an estimated false positive probability of about 10^{-6}.

The seed for the random number generator was carefully chosen. As with the other systems in this chapter, because the reference marks are generated pseudo-randomly, different seeds result in different amounts of code separation. In the E_SIMPLE_8/D_SIMPLE_8 and E_TRELLIS_8/D_TRELLIS_8 systems, this is not a serious problem because, in the high dimensionality of media space, the variation in code separation is small. However, in the E_BLK_8/D_BLK_8 system, marking space has only 63 dimensions (64 dimensions minus one for zeroing the means). Because of this low dimensionality, the variation in the amount of code separation is more severe.

Because we are encoding only eight bits, it is possible to enumerate all 256 message vectors that result from a given seed, and correlate each of them against all others. The maximum correlation found gives an idea of how good the seed is. Good seeds lead to low maximum correlations. In this way, we can try several different seeds and choose the one that leads to the best code. The seeds we tested led to maximum correlations between about 0.73 and 0.77. For our experiments, we used a seed that led to 0.73.

Figure 4.13 shows the distribution of detection values obtained. The dashed line indicates detection values obtained when the D_BLK_8 detector was run on 2,000 unwatermarked images. The solid line indicates the detection values obtained on the 12,000 watermarked images. There were no false positives detected. The E_BLK_8 embedder failed to embed in only 109 of the trials, giving it a measured effectiveness of over 99%.

Fig. 4.13 Test results for the E_BLK_8/D_BLK_8 watermarking system.

As shown in Figure 4.13, the detection values obtained from unwatermarked images are considerably higher than those obtained with our earlier, 1-bit watermarking systems. This is because each reported detection value is effectively the maximum of 256 possible values. That is, the D_BLK_8 detection algorithm obtains the same value that would be obtained from a detector that exhaustively correlated against each of the 256 possible message vectors and returned the highest value.

Note that because the detection threshold ($\tau_{cc} = 0.65$) is less than the maximum correlation between message marks (0.73) there is some risk of obtaining bit errors. That is, the detection cones for at least two different messages overlap. If the embedder moves a Work into the cone for one of these messages, the result might actually be closer to the other message, thus resulting in a different message being detected. However, this did not occur in our experiment. Out of the 12,000 messages embedded, 16 were not correctly decoded, but in each of those cases the correlation coefficient was below 0.65. Therefore, the detector output *no watermark* rather than an incorrect message.

4.4 Summary

This chapter has discussed basic methods for mapping messages into watermarks. Our focus here has been on simple methods of modifying the types of watermarking systems presented as examples in earlier chapters. The following points were made.

- Message coding is often implemented in two steps:
 1. *Source coding* maps messages into sequences of symbols.
 2. *Modulation* maps sequences of symbols into message marks that can be embedded in content.

- The key issue in the design of a code is *code separation* (i.e., the distances between different message marks in marking space). If these distances are too small, there will be a high chance that one message embedded in a Work will be detected as a different message. In the case of correlation-based watermarks, the distance of interest is the correlation between message marks.

- Randomly generated codes, in which each message maps directly into a message mark, are likely to exhibit good behavior.
 - If the number of messages is large compared to the dimensionality of marking space, the average code separation of a random code is likely to be close to optimal.
 - If the number of messages is small compared to the dimensionality of marking space, random message marks are likely to have correlation close to zero.
 - Zero correlation between marks can be useful if we wish to embed more than one distinct message in a linear correlation watermarking system.

- Multi-symbol codes, in which messages are first mapped into sequences of symbols (source coding) and then systematically mapped into message marks (modulation), reduce computational complexity.

- Modulation can be performed in a variety of ways, including the following:
 - *Time division multiplexing:* Dividing a Work in the temporal domain and embedding one symbol in each segment.
 - *Space division multiplexing:* Dividing a Work in the spatial domain and embedding one symbol in each segment.
 - *Frequency division multiplexing:* Dividing the Work in the frequency domain and embedding one symbol in each segment.
 - *Code division multiplexing:* Using a different reference mark for each possible combination of symbol and sequence location.

- Error correction coding (ECC) increases the code separation of multi-symbol codes, bringing their performance closer to that of random codes. An example of a trellis code with a Viterbi decoder was presented.

■ There are several ways a detector can determine whether or not a multi-symbol message is present in a Work. These include the following:

⊞ Define a large fraction of possible messages to be "invalid" by, for example, appending a checksum to the end of each embedded message. Any message with an incorrect checksum is invalid. If a valid message is detected, the detector declares that the watermark is present.

⊞ Apply a separate detection test to each symbol in the message. If all the symbols are detected, the detector declares that the watermark is present.

⊞ Identify the most likely message mark in the Work. A simple, general way to do this is to demodulate and decode the most likely message, and then re-encode and re-modulate that message to obtain the most likely message mark. Once the most likely mark is identified, apply a separate test for its presence in the Work, such as computing the correlation coefficient between the mark and an extracted vector.

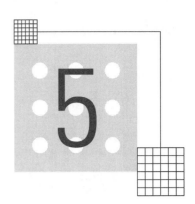

Watermarking with Side Information

The watermarking systems presented in the preceding chapter all fit into the basic model shown in Figure 5.1. In each embedder, a message, m, is first encoded as a message mark, \mathbf{w}_m. This is then modified by simple scaling to obtain an added mark, \mathbf{w}_a, which is added to the cover Work. The detectors are blind, in that they are not given any information about the original, unwatermarked Work. The embedders in these systems can be thought of as blind in the same sense. They ignore the available information about the cover Work during both the coding of the message (*blind coding*) and the modification of the message mark in preparation for embedding (*blind embedding*).

In contrast, in Chapter 3, we discussed two types of systems that cannot be fit into Figure 5.1. The first type was systems that use *informed detection* (see Section 3.3.1 of Chapter 3), in which the detector is provided with information about the original, unwatermarked cover Work. It can then subtract this information from the received Work, eliminating any interference between the cover Work and the watermark. With an informed detector, then, the detectability of the watermark is affected only by the distortions to which the watermarked Work is subjected after embedding; it is not affected by the cover Work itself.

The second type of non-blind system discussed in Chapter 3 was a system that uses *informed embedding* (see Section 3.3.2 of Chapter 3). Here, the embedder examines the cover Work during the modification of the message mark in preparation for embedding. This was illustrated with the E_FIXED_LC/D_LC watermarking system (System 2), in which the message mark is scaled so that we obtain a fixed linear correlation detection value. Using this technique, we found it is possible to obtain virtually 100% effectiveness.

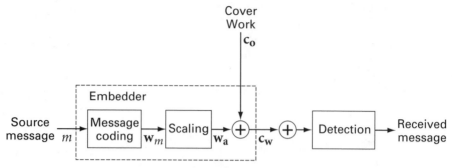

Fig. 5.1 Watermarking with blind embedders.

In the present chapter, we first examine the idea of informed embedding in more detail. Specifically, we look at systems that fit into the model of Figure 5.2. In this context, embedding can be cast as an optimization problem. We are either trying to maximize the robustness of the watermark while maintaining a fixed fidelity or trying to maximize the fidelity while maintaining a fixed robustness. Implementing either of these strategies requires a means of measuring fidelity and robustness.

Historically, the earliest examples of informed embedding used only perceptual models. These systems locally amplified or attenuated the added watermark pattern to improve fidelity. Such systems are discussed in Chapter 7. However, these early systems do not employ any explicit consideration of the detection region, and the perceptual shaping is treated as a form of noise.

In Section 5.1 we concentrate on the issue of estimating robustness and use a simple mean square error for fidelity. We develop techniques for performing informed embedding when the detector uses normalized correlation rather than linear correlation, and argue that in this case the detection statistic itself is not a good measure of robustness.

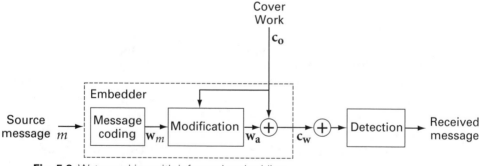

Fig. 5.2 Watermarking with informed embedding.

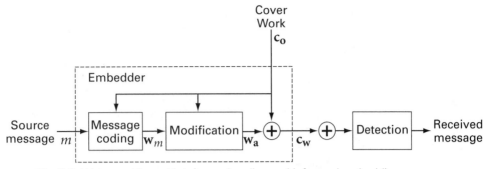

Fig. 5.3 Watermarking with informed coding and informed embedding.

Section 5.2 then introduces the idea of *informed coding*, in which the cover Work is examined during the message coding process so that a given message might be mapped into different message marks for different cover Works. Specifically, we look at systems that fit into the model of Figure 5.3, which employs both informed coding and informed embedding.

The general approach to informed coding is to use what we term *dirty-paper codes,* in which each message can be represented by several dissimilar code vectors. The embedder searches through the set of code vectors for a given message and embeds the one that is closest to the cover Work. The detector tests for all the code vectors and identifies the message associated with the one it finds. Theoretical analysis has shown that under certain simplifying assumptions this type of system should be able to obtain the same performance as systems that use informed detection. In other words, the cover Works should have *no effect* on detectability of the watermark.

The theoretical analysis of dirty-paper codes does not tell us how to build them in practice. In general, the analysis refers only to random codes, which are only practical to implement for very small data payloads. We therefore conclude this chapter, in Section 5.3, with a discussion of some preliminary attempts to realize the theoretical promise of dirty-paper codes with more practical systems. (Readers who are unfamiliar with information theory, and particularly the concept of channel capacity, may wish to read Section A.1 of Appendix A before reading this chapter.)

5.1 Informed Embedding

The basic idea of informed embedding was introduced in Chapter 3 and illustrated with the E_FIXED_LC/D_LC watermarking system. In an informed

embedder, the pattern, $\mathbf{w_a}$, added to a Work depends on the message mark, \mathbf{w}_m, and the Work itself.

In this section, we more closely examine the problem of designing informed embedders. We begin by looking at how the design of an informed embedder can be cast as an optimization problem. We then examine two different methods for assessing the strength of embedded watermarks: first, by looking at the detection measure itself, and second by defining a different measure that attempts to predict the robustness of the embedded mark. We conclude that although the former approach is fine for simple, linear correlation systems, the latter approach is required for normalized correlation.

5.1.1 Embedding as an Optimization Problem

In the absence of a fidelity constraint (i.e., no need to preserve the cover Work), the optimal method of informed embedding is trivial. Consider a simple watermarking system that operates directly in media space. The optimal strategy for choosing the added pattern, without concern for fidelity, would be to subtract the cover Work from the message pattern. Thus, $\mathbf{w_a} = \mathbf{w}_m - \mathbf{c_o}$. This subtraction has been referred to as *precancellation* [203, 43]. When $\mathbf{w_a}$ is added to the cover Work to obtain the watermarked Work, the result is just $\mathbf{c_w} = \mathbf{w}_m$. The detectability of the watermark would then depend only on the distortions subsequently applied to $\mathbf{c_w}$.

For most watermarking systems, the "optimal" system, described previously, would be unacceptable, in that it simply replaces the cover Work with the message pattern and thus results in an output signal that does not resemble the original Work at all. However, in systems that project Works into a marking space much smaller than media space, the approach is occasionally feasible. Recall that in such systems we embed by first extracting a mark, $\mathbf{v_o}$, from the Work, and then choosing an added mark, $\mathbf{v_a}$, and adding it to $\mathbf{v_o}$ to obtain the watermarked vector, $\mathbf{v_w}$. The Work is then modified so that it yields $\mathbf{v_w}$ when the extraction process is applied. It is sometimes possible to modify Works so that they yield any arbitrary vector, while still maintaining fidelity. This allows us to let $\mathbf{v_w}$ equal the message mark, \mathbf{v}_m. Nevertheless, in most cases, $\mathbf{v_w}$ must lie somewhere between the message mark and the original extracted mark, $\mathbf{v_o}$.

When fidelity requirements prevent us from using the simple approach of setting $\mathbf{v_a} = \mathbf{v}_m - \mathbf{v_o}$, the problem of finding the best added mark, $\mathbf{v_a}$, can be cast as an optimization problem. The specific optimization problem we wish to solve depends on the application. There are two main possibilities:

- Find the added mark that maximizes robustness while keeping within a prescribed limit on perceptual distortion.
- Find the added mark that minimizes perceptual distortion while maintaining a prescribed level of robustness (the approach used in the E_FIXED_LC embedder).

More complicated expressions of the problem, where we try to balance the trade-off between fidelity and robustness, are also possible. For example, we may specify a maximum level of distortion *and* a minimum level of robustness. If the watermark cannot be embedded within both constraints, one or the other should be automatically relaxed. Thus, the embedder might try to maximize robustness while staying within the maximum distortion. However, if the highest robustness attainable is lower than a specified minimum, the perceptual constraint is relaxed.

To implement any of these strategies, we need methods for measuring perceptual distortion and robustness. Methods for measuring perceptual distortion are discussed in Chapter 7. Methods for measuring robustness are discussed in the following.

5.1.2 Optimizing with Respect to a Detection Statistic

The simplest way to measure robustness is to assume that a watermark with a high detection value is more robust than one with a low detection value, so that the detection statistic itself becomes our measure of robustness. Thus, when embedding a watermark with fixed robustness, the user specifies a desired detection value, and the embedder tries to achieve that detection value with the minimum possible distortion. For example, in the E_FIXED_LC embedder, we specify a desired linear correlation as the sum of the detection threshold, τ_{lc}, and a "strength" parameter, β.

The assumption that high detection values indicate high robustness is generally true for linear correlation. A high detection value means the watermarked vector is far from the detection threshold, and more distortion of any type can be applied before the watermark is undetectable. However, this assumption is *not* true for many other detection statistics, including normalized correlation. To see that the assumption can fail, we now develop an algorithm for embedding watermarks with a fixed normalized correlation, and show experimentally that higher normalized correlations do not always result in more robust watermarks.

The experiment we wish to perform requires a new embedding algorithm, because the E_FIXED_LC algorithm is inappropriate for normalized correlation. The reason for this is illustrated in Figure 5.4. This figure shows the effect of the embedding algorithm on several unwatermarked Works. Each open circle represents the location in marking space of an unwatermarked Work and is connected by an arrow to a filled circle that represents the corresponding water-marked Work. The E_FIXED_LC algorithm ensures that the linear correlation between each watermarked Work and the watermark vector is constant, which means that they all lie in a narrow embedding region. The shaded area shows the detection region for a normalized correlation detector. Because the embedding

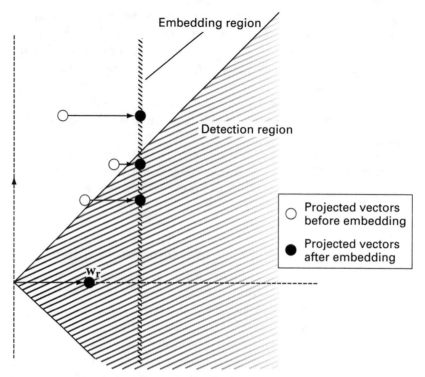

Fig. 5.4 Illustration of the problem associated with a fixed linear correlation embedding strategy. The figure shows the embedding region for a fixed linear correlation embedder and the detection region for a normalized correlation detector. Because the embedding region is not entirely contained in the detection region, some Works will fail to be watermarked.

region is not completely contained within the detection region, it is clear that the E_FIXED_LC embedder will fail to embed the watermark in some Works. We therefore need an embedding algorithm that creates a different embedding region, one that does lie completely within the detection region.

The solution we test here is to fix the normalized correlation at some desired value, a_{nc}, rather than fixing the linear correlation. For each Work, the embedder finds the closest point in marking space that has the desired normalized correlation with the watermark. If we use Euclidian distance to determine proximity, this approach would lead to the embedding behavior illustrated in Figure 5.5.

Implementing the fixed normalized correlation embedder is a simple matter of geometry. The embedding region is the surface of a cone, centered on the reference vector, $\mathbf{w_r}$. Therefore, we are trying to find the closest point on a cone to a given point, $\mathbf{v_o}$. Clearly, this point will lie in the plane that contains both $\mathbf{w_r}$ and $\mathbf{v_o}$. Thus, we begin by reducing the problem to two dimensions by using Gram-Schmidt orthonormalization to find two orthogonal coordinate axes for

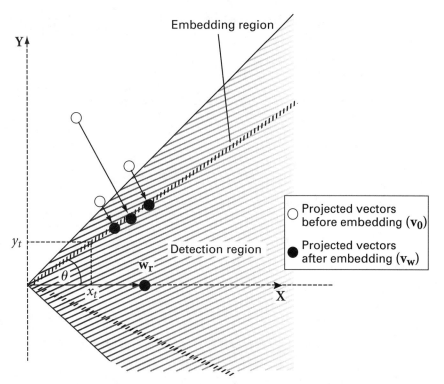

Fig. 5.5 Illustration of the behavior of a fixed normalized correlation embedding strategy. Here the embedding region is entirely within the detection region. Thus, the embedder should have 100% effectiveness.

this plane:

$$X = \frac{\mathbf{w_r}}{|\mathbf{w_r}|} \tag{5.1}$$

$$Y = \frac{\mathbf{v_o} - X(\mathbf{v_o} \cdot X)}{|\mathbf{v_o} - X(\mathbf{v_o} \cdot X)|} \tag{5.2}$$

Each point on the plane can be expressed with an x and y coordinate as $x\mathbf{X} + y\mathbf{Y}$. The **X**-axis is aligned with the reference vector. The coordinates of $\mathbf{v_o}$ are

$$x_{\mathbf{v_o}} = \mathbf{v_o} \cdot X \tag{5.3}$$

$$y_{\mathbf{v_o}} = \mathbf{v_o} \cdot Y \tag{5.4}$$

Note that $y_{\mathbf{v_o}}$ is guaranteed to be positive.

The embedding region intersects with the **XY** plane along two lines, as shown in Figure 5.5. Because $y_{\mathbf{v_o}}$ is positive, the closest point will be on the upper line. This line is described by the vector x_t, y_t, with $x_t = \cos(\theta)$ and $y_t = \sin(\theta)$, where θ is half the angle subtended by the cone of the embedding region. Because

$\theta = \cos^{-1}(t_{nc})$, where t_{nc} is the desired normalized correlation, we have

$$x_t = t_{nc} \tag{5.5}$$

$$y_t = \sqrt{1 - t_{nc}^2} \tag{5.6}$$

The closest point to $\mathbf{v_o}$ along the line described by x_t, y_t is

$$x_{\mathbf{v_w}} = x_t(x_t x_{\mathbf{v_o}} + y_t y_{\mathbf{v_o}}) \tag{5.7}$$

$$y_{\mathbf{v_w}} = y_t(x_t x_{\mathbf{v_o}} + y_t y_{\mathbf{v_o}}) \tag{5.8}$$

Finally, the watermarked version of $\mathbf{v_o}$ is given by

$$\mathbf{v_w} = x_{\mathbf{v_w}} X + y_{\mathbf{v_w}} Y \tag{5.9}$$

Using Equations 5.2 through 5.9, we can now construct an informed embedder for a system that uses normalized correlation as its detection statistic.

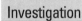

Investigation

Fragility of a Fixed Normalized Correlation Strategy for Informed Embedding

We now modify the E_BLK_BLIND/D_BLK_CC (System 3) watermarking system to embed with fixed normalized correlation. As in that system, the system developed here embeds one bit of information, either $m = 0$ or $m = 1$. The target normalized correlation is specified as the sum of the detection threshold, τ_{lc}, that will be used in the detector and a "strength" parameter, β.

This investigation will reveal that the robustness of watermarks to additive white noise can actually *decrease* with increased β. The reason for this is explained at the end of the investigation.

System 7: E_BLK_FIXED_CC/D_BLK_CC

The basic steps of the E_BLK_BLIND algorithm are

1. Use the extraction function, $X(\cdot)$, to extract a vector, $\mathbf{v_o}$, from the unwatermarked image, $\mathbf{c_o}$.
2. Compute a new vector in marking space, $\mathbf{v_w}$, that is acceptably close to $\mathbf{v_o}$ but lies within the detection region for the desired watermark, $\mathbf{w_r}$.
3. Perform the inverse of the extraction operation on $\mathbf{v_w}$ to obtain the watermarked image, $\mathbf{c_w}$.

The details of the extraction and inverse extraction processes are described in Chapter 3 and will not be changed here. Instead, we concentrate only on step 2, computing $\mathbf{v_w}$ according to the method previously described.

As in the E_BLK_BLIND embedding algorithm, we encode a 1-bit message, m, by determining the sign of a given 8×8 reference mark, $\mathbf{w_r}$:

$$\mathbf{w}_m = \begin{cases} \mathbf{w_r} & \text{if } m = 1 \\ -\mathbf{w_r} & \text{if } m = 0 \end{cases} \tag{5.10}$$

With a target normalized correlation of $t_{cc} = \tau_{cc} + \beta$, an extracted mark of $\mathbf{v_o} = X(\mathbf{c_o})$, and the given message mark, \mathbf{w}_m, we can directly apply Equations 5.2 through 5.9 to obtain the new vector, $\mathbf{v_w}$, for step 2. Step 3 then proceeds exactly as in E_BLK_BLIND, to obtain the watermarked image.

Experiments

As with other watermarking systems, we first test the performance of the E_BLK_FIXED_CC/D_BLK_CC system with no distortions applied between embedding and detection. Two thousand images were embedded with messages of $m = 0$ and $m = 1$, using two different values of β, resulting in 4,000 watermarked images. The detection threshold was $\tau_{cc} = .55$. The two values of β were $\beta = .25$ and $\beta = .40$. Figures 5.6a and b show the results. As expected, the normalized correlations obtained from E_BLK_FIXED_CC fall into a very narrow range, and a higher value of β increases the average.

We would hope that increasing β should increase robustness. To test this, we applied a simple attack to all the watermarked images by adding white, Gaussian noise, with a standard deviation of 10. We then ran the D_BLK_CC detector on the distorted images, using the same threshold value as was used during embedding, $\tau_{cc} = 0.55$. In the case of $\beta = 0.25$, about 85% of the watermarks were correctly detected after the white noise attack. Increasing β to 0.40, however, actually *decreased* the percentage of surviving watermarks to 66%. Thus, the higher value of β yielded *worse* robustness than did the lower value.

These results indicate that, unlike with linear correlation, higher normalized correlations do not necessarily lead to higher robustness. This can be explained by realizing that, whereas linear correlation measures the magnitude of the signal, normalized correlation essentially measures the signal-to-noise ratio. The signal-to-noise ratio can be high even if the signal is very weak, as long as the noise is proportionally weak. However, if we add a fixed amount of noise to a weak signal, the resulting signal-to-noise ratio plummets.

This is exactly what happened in our experiment. Figure 5.7 gives a geometric illustration of the problem. With a high value of β, the E_BLK_FIXED_CC embedder yields a vector close to the origin of the cone. Perturbing this vector in almost any direction is likely to send it outside the detection region. A low value of β yields a vector deeper within the cone, and thus more resilient to noise.

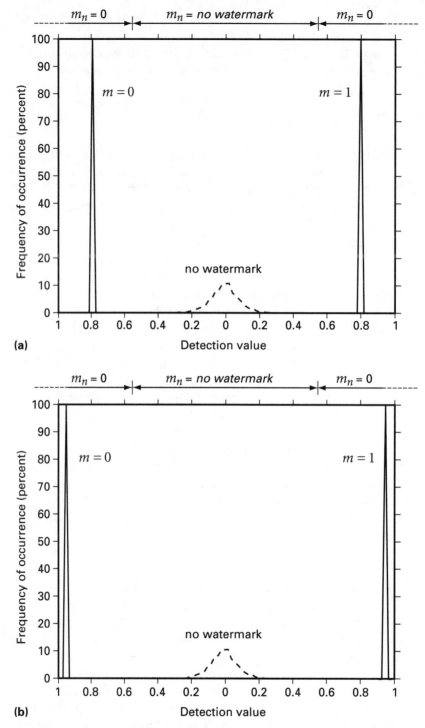

Fig. 5.6 Distribution of detection values for two different values of β in the E_BLK_FIXED_CC/D_BLK_CC system. The strength parameter for these experiments was (a) $\beta = 0.25$ and (b) $\beta = 0.40$.

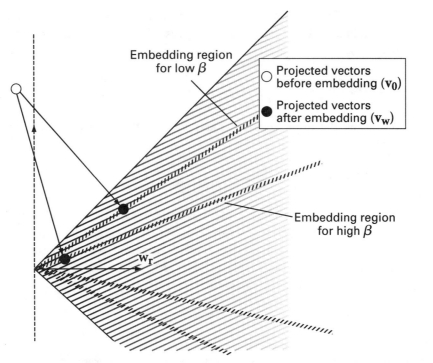

Fig. 5.7 Illustration of the problems associated with a fixed normalized correlation embedding strategy.

5.1.3 Optimizing with Respect to an Estimate of Robustness

The problem with the E_BLK_FIXED_CC algorithm is that its "strength" parameter, β, is based on the wrong measure. Normalized correlation does not measure robustness. Thus, we need to express our optimization problem with respect to a different measure, one that is more directly related to robustness.

The formula used for such a measure is dependent on the method of detection. Here, we describe a measure of robustness for normalized correlation, derived in [59] and tested in [184]. This measure estimates the amount of white, Gaussian noise that can be added to the embedded vector, $\mathbf{v_w}$, before it is expected to fall outside the detection region. The reason for basing this measure on Gaussian noise, rather than on some more realistic form of degradation, is that correlation coefficients are not inherently robust against it. If we ensure that our watermarks are robust against this type of noise, we help to ensure they are robust against other types of degradations, for which the correlation coefficient may be better suited.

The estimated amount of noise the mark can survive is derived as follows. If we add a noise vector, n, to $\mathbf{v_w}$, the resulting normalized correlation is given by

$$z_{nc}(\mathbf{v_w} + \mathbf{n}) = \frac{(\mathbf{v_w} + \mathbf{n}) \cdot \mathbf{w_r}}{|\mathbf{v_w} + \mathbf{n}||\mathbf{w_r}|}. \tag{5.11}$$

Assuming the noise vector is likely to be orthogonal to both $\mathbf{v_w}$ and $\mathbf{w_r}$, we have

$$z_{nc}(\mathbf{v_w} + \mathbf{n}) \approx \frac{\mathbf{v_w} \cdot \mathbf{w_r}}{\sqrt{\mathbf{v_w} \cdot \mathbf{v_w} + \mathbf{n} \cdot \mathbf{n}}|\mathbf{w_r}|}. \tag{5.12}$$

We are interested in finding the magnitude of noise, $R = \sqrt{\mathbf{n} \cdot \mathbf{n}}$, that causes $z_{nc}(\mathbf{v_w} + \mathbf{n})$ to fall below the threshold, τ_{nc}. The embedder will work with any value that is a monotonic function of R. Therefore, we will be satisfied, instead, with the maximum allowable value of R^2. Replacing $z_{nc}(\mathbf{v_w} + \mathbf{n})$ with τ_{nc} in Expression 5.12, and solving for R^2, leads to

$$R^2 = \left(\frac{\mathbf{v_w} \cdot \mathbf{w_r}}{\tau_{nc}|\mathbf{w_r}|} \right)^2 - \mathbf{v_w} \cdot \mathbf{v_w}. \tag{5.13}$$

This gives us a rough measure of how robustly $\mathbf{v_w}$ represents $\mathbf{w_r}$.

We now wish to make an embedder that holds R^2 constant, rather than holding z_{nc} constant. Contours of constant R^2, for a given threshold, are shown in Figure 5.8. As can be confirmed algebraically, these contours are hyperbolae. Note that each hyperbola has a positive and a negative part. We wish to ensure that the correlation between the watermark and the selected vector, $\mathbf{v_w}$, is positive. Therefore, we restrict our embedder to only the positive portion of the hyperbola. In other words, the embedder will not only hold R^2 constant, but also ensure that z_{nc} is positive. Thus, our embedding region in N-dimensional marking space is not a cone but one half of an N-dimensional, two-sheet hyperboloid.[1]

The embedder must find the point, $\mathbf{v_w}$, on the hyperboloid that is closest to a given point, $\mathbf{v_o}$. Although this problem can be solved analytically, the solution involves solving a quartic equation, which is complicated to implement. For the sake of simplicity, therefore, we implement our next example system using an exhaustive search.

1. A hyperboloid is obtained by rotating a hyperbola about one of its axes. With hyperbolae oriented like those in Figure 5.8, a rotation about the y-axis will result in a single surface, called a *one-sheet* hyperboloid. A rotation about the x-axis will result in two surfaces (one for the positive part and one for the negative part), or a *two-sheet* hyperboloid. We restrict the embedding region to the positive sheet of the two-sheet hyperboloid.

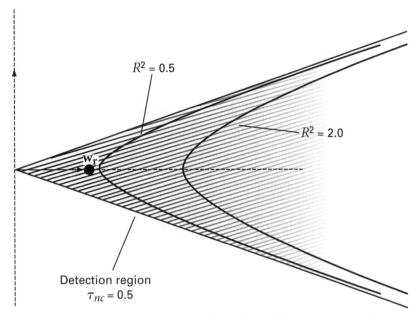

$R^2 = 0.5$

$R^2 = 2.0$

$\mathbf{w_r}$

Detection region
$\tau_{nc} = 0.5$

Fig. 5.8 Normalized correlation detection region with two constant robustness embedding contours.

Investigation

Fixed Robustness Embedding
for a Normalized Correlation Detector

We now present a watermarking system that embeds according to the robustness estimate given in Equation 5.13.

System 8: E_BLK_FIXED_R/D_BLK_CC

The E_BLK_FIXED_R embedder is essentially the same as the E_BLK_FIXED_CC embedder, except that it maintains a constant R^2 instead of a constant normalized correlation. The target value of R^2 is provided by the user as a "strength" parameter. This is instead of the β value used in E_BLK_FIXED_CC.

As mentioned previously, rather than finding $\mathbf{v_w}$ analytically we perform a simple, exhaustive search, illustrated in Figure 5.9. This figure lies in the same **XY** plane as used for fixed normalized correlation embedding. We test several possible values of y_{v_w} within the range of 0 to y_{v_o}, computing for each the value of x_{v_w} that results in a point on the hyperbola. This can be found analytically by substituting the vectors x_{v_w}, y_{v_w} and 1, 0 into Equation 5.13 for \mathbf{v} and $\mathbf{w_r}$,

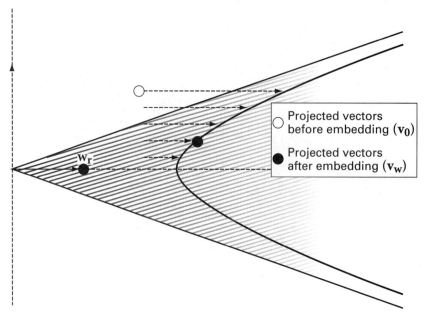

Fig. 5.9 Illustration of exhaustive search for the closest point on a hyperbola. Each dashed line points to one search location. The search location resulting in the shortest distance to $\mathbf{v_o}$ is chosen.

respectively, and then solving for x_{v_w}, which yields

$$x_{v_w} = \sqrt{\frac{\tau_{nc}^2 \left(R^2 + y_{v_w}^2 \right)}{1 - \tau_{nc}^2}} \qquad (5.14)$$

For each resulting point, x_{v_w}, y_{v_w}, we compute the distance to x_{v_o}, y_{v_o}. The point with the smallest distance yields the final values of x_{v_w}, y_{v_w} used in Equation 5.9 to obtain $\mathbf{v_w}$.

Experiments

Figures 5.10a and b show the performance of the E_BLK_FIXED_R embedding algorithm for a given detection threshold, τ_{nc}, and two different values of R^2; namely, $R^2 = 10$ and $R^2 = 30$. Note that the range of detection values obtained after embedding watermarks is wider than that obtained from E_BLK_FIXED_CC. This is because the E_BLK_FIXED_R embedder only ensures that the detection value is above the threshold, τ_{nc}. Beyond that, it is willing to trade the magnitude of the detection value for higher robustness.

Figure 5.11 shows three histograms of the R^2 robustness values. The left, solid line is the result of using the E_BLK_FIXED_R embedder with a target R^2 value of 10, and the right solid line is the result of a target R^2 value of 30. The dotted line is the result of using the E_BLK_FIXED_CC embedder with $\beta = 0.40$. Note that the E_BLK_FIXED_CC embedder yielded many images with very low R^2.

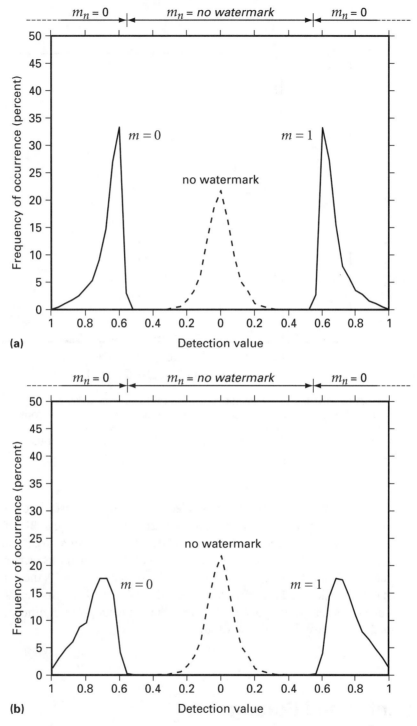

Fig. 5.10 Distribution of detection values for two different values of R^2 in the E_BLK_FIXED_R/D_BLK_CC system. The strength parameter for these experiments was (a) $R^2 = 10$ and (b) $R^2 = 30$.

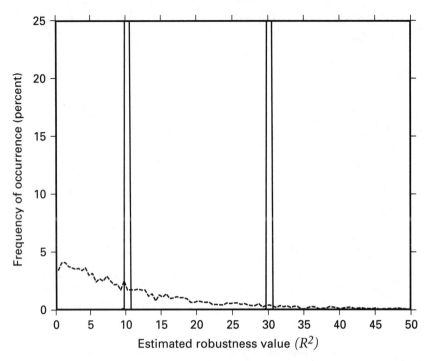

Fig. 5.11 Comparison of robustness values for fixed correlation coefficient embedding (dashed line) and fixed robustness embedding (solid lines). The tops of the two histograms for the fixed robustness of $R^2 = 10$ and $R^2 = 30$ have been clipped so that more of the detail of the fixed-correlation-coefficient embedding robustness can be seen.

To verify that increasing R^2 does indeed increase the robustness of the watermark, we performed the same robustness experiment on the E_BLK_FIXED_R images as performed on the E_BLK_FIXED_CC images. For a target robustness value of $R^2 = 10$, we found that about 80% of the watermarks were correctly detected. When the target robustness was increased to $R^2 = 30$, the percentage of correctly detected watermarks increased to almost 99%. This shows that the watermarks embedded using a higher R^2 target value were significantly more likely to survive the addition of noise.

5.2 Informed Coding

Informed embedding algorithms yield better performance than their blind counterparts. However, the previously described algorithms do not take full advantage

of the information available, in that they do not use side information during the message coding process. In these algorithms each message is represented by a unique code vector that is independent of the cover Work.

We can use side information during the coding process to select between several alternative code vectors for the desired message, embedding the one that requires the least distortion of the Work. By combining such a strategy with informed embedding, it is theoretically possible to achieve significantly better performance than with informed embedding alone. We therefore now turn to the topic of *informed coding*.

We begin by briefly discussing a theoretical result obtained by Costa [53]. This result implies that the channel capacity of a watermarking system might not depend on the distribution of unwatermarked content. Rather, it should depend only on the distortions the watermark must survive (i.e., the desired level of robustness). Although Costa's result can be applied to watermarking only by making some unrealistic assumptions, it is nevertheless encouraging. Furthermore, similar results have been shown for channels that are closer approximations to true watermarking systems.

Because Costa's result is not directly applicable to watermarking, we do not present a detailed discussion of his proof here (this can be found in Appendix B). Instead, we focus on the basic concepts behind it. We describe these concepts in two steps. First, we show a similar result for a simpler channel than that studied by Costa. This introduces the idea of a *dirty-paper code,* in which each message can be represented by several alternative code words. Second, we discuss the use of dirty-paper codes for more complex channels. This introduces the combination of informed coding and informed embedding. We conclude this discussion with an investigation that combines a random dirty-paper code with the fixed-robustness embedding strategy described in Section 5.1.3.

5.2.1 Writing on Dirty Paper

In 1983, well before the rise of research in digital watermarking, Costa [53] posed the following problem: imagine we have a piece of paper covered with independent dirt spots of Normally distributed intensity, and we write a message on it with a limited amount of ink. The dirty paper, with the message on it, is then sent to someone else, and acquires more Normally distributed dirt along the way. If the recipient cannot distinguish between the ink and the dirt, how much information can we reliably send?[2]

2. We have added some details beyond Costa's description of this problem to improve the analogy with the channel he studied. Specifically, he described the analogy without the limit on ink and the second layer of dirt.

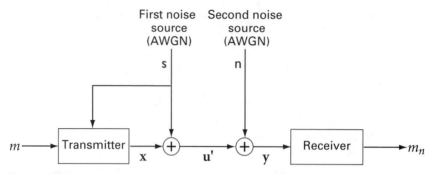

Fig. 5.12 Dirty-paper channel studied by Costa. There are two noise sources, both generating additive white Gaussian noise. The transmitter is told the effect of the first noise source before it chooses a vector, **x**, to transmit.

Costa posed this problem as a colorful analogy for the communications channel shown in Figure 5.12.[3] The channel has two independent, white Gaussian noise sources. Before the transmitter chooses a signal to send, **x**, it is told the exact noise, **s** = s, that will be added to that signal by the first source. This noise is analogous to the first coat of dirt on the sheet of paper, which we examine before writing our message. The signal the transmitter sends is limited by a power constraint

$$\frac{1}{N} \sum_{i}^{N} \mathbf{x}[i]^2 \le p \tag{5.15}$$

This is analogous to the limitation on the amount of ink we can use in writing our message. The noise added by the second noise source, n, is unknown to the transmitter. This second noise source is analogous to the coat of dirt the paper picks up in transit. Costa showed the rather surprising result that the first noise source *has no effect on the channel capacity.*

Costa's dirty paper analogy is almost identical to watermarking with blind detection. The dirty paper, **s**, plays the role of the cover Work. The transmitted signal, **x**, plays the role of the added pattern. The power constraint, p, expresses a fidelity requirement. The second noise source, n, plays the role of distortions that occur during normal processing or malicious tampering. Because the dirty-paper channel is so closely analogous to watermarking, Costa's result is exciting for watermark designers. If a watermarking system behaves enough like this dirty-paper channel, its maximum data payload should not depend on the cover media.

3. In discussing this channel, and others like it, we emphasise that they are *not* watermarking systems by using the standard communications variables **x**, **s**, and **y** instead of the corresponding variables in a watermarking system: $\mathbf{w_a}$, $\mathbf{c_o}$, and $\mathbf{c_n}$.

Unfortunately, there are substantial differences between the dirty-paper channel and a true watermarking system. In watermarking, the two noise sources—the cover Work and subsequent distortion—are rarely Gaussian. The distribution of unwatermarked content is generally more complex than this (see Chapter 3), and the noise applied by subsequent distortions is not only non-Gaussian but is dependent on the watermarked Work (see Chapter 8). Furthermore, expressing the fidelity constraint as a power constraint implies measuring distortions with the mean-squared error distance metric, known to be a poor predictor of perceptual distance (see Chapter 7). Thus, we cannot immediately conclude from Costa that the capacity of watermarking is independent of the distribution of unwatermarked content.

Nevertheless, Costa's result still implies that watermarking can greatly benefit from using side information during the watermark coding process, even if the improvement does not completely negate the effect of the cover Work. This implication has received some support from subsequent theoretical work.

Moulin and O'Sullivan [190] studied channels that are better models of watermarking than the dirty-paper channel (see Appendix B). In their system, they replace the second noise source with a hostile adversary who is intentionally trying to remove the watermark. They found that for this channel if the cover Work is drawn from a Gaussian distribution and the fidelity constraint is expressed as a power constraint, Costa's result still holds. That is, the capacity of the channel is independent of the variance of unwatermarked content. They also found that if the distribution of unwatermarked content is non-Gaussian, the result is approximately true, provided the limit on power, p, is small compared to the variance of the content. Because we can usually assume the fidelity constraint is tight compared to the variability in the content, this provides some additional support for believing that Costa's result might be true of real watermarking systems.

The relevance and potential benefit of Costa's work make it worthwhile to examine the basic techniques used to prove his result. The details, being tied to the assumptions of Gaussian noise and a simple power constraint, are not necessarily of interest to us. These details are discussed in Appendix B. The basic ideas are discussed in the following.

5.2.2 A Dirty-paper Code for a Simple Channel

The core idea in using side information during message coding is a class of codes we term *dirty-paper codes,* in reference to Costa's analogy.[4] Unlike a conventional code—which assigns a single, unique code word to each message—a

4. Costa did not invent dirty-paper codes. Such codes are implicit in the work of Gel'fand and Pinsker, on which Costa's work was based (see Appendix B). However, Costa's idea of a dirty-paper channel provides us with a colorful name for these codes.

Fig. 5.13 Simplified dirty-paper channel of Figure 5.12. Here, the first noise source does not generate arbitrary vectors but randomly chooses one of two specific noise vectors: $\mathbf{s} = \mathbf{s}_1$ or $\mathbf{s} = \mathbf{s}_2$.

dirty-paper code assigns several alternative code words to each message. To see how this type of code can remove the impact of the first noise source on channel capacity, we begin by examining a channel that is even simpler than Costa's channel.

In the channel we shall study here (Figure 5.13), we restrict the first noise source to producing only one of two specific noise vectors: $\mathbf{s} = \mathbf{s}_1$ or $\mathbf{s} = \mathbf{s}_2$. The second noise source, however, still generates additive white Gaussian noise. Thus, this system is analogous to a dirty-paper system in which there are only two possible initial patterns of dirt on the paper.

Suppose that the first noise source generates \mathbf{s}_1. The transmitter must now choose a vector, \mathbf{x}, limited by the power constraint, p, with which to encode a message. Because it knows in advance that \mathbf{s}_1 will be added to \mathbf{x}, it can, instead, choose a desired value of this sum, $\mathbf{u} = \mathbf{x} + \mathbf{s}_1$. After choosing \mathbf{u}, the transmitter sets $\mathbf{x} = \mathbf{u} - \mathbf{s}_1$. To ensure that the power constraint is satisfied, it must limit the choice of \mathbf{u} to lie within a ball of radius \sqrt{Lp} centered at \mathbf{s}_1, where L is the length of the code words.

If we ignore, for the moment, the possibility that the first noise source will generate \mathbf{s}_2 instead of \mathbf{s}_1, we can see that the problem of choosing \mathbf{u} is essentially the same as that of choosing a signal to transmit over a simple AWGN channel. The only difference is that in the simple AWGN case the ball of possible signals is centered around 0, whereas in the channel of Figure 5.13 (with $\mathbf{s} = \mathbf{s}_1$) the ball of possible signals is centered around \mathbf{s}_1. Thus, the number of distinct code vectors we can place within this ball, without risking confusion between them after the addition of white Gaussian noise, is the same as that for the AWGN channel.

Of course, a similar situation arises if the first noise source generates \mathbf{s}_2 instead of \mathbf{s}_1. The transmitter must then choose a \mathbf{u} from within a radius \sqrt{Lp}

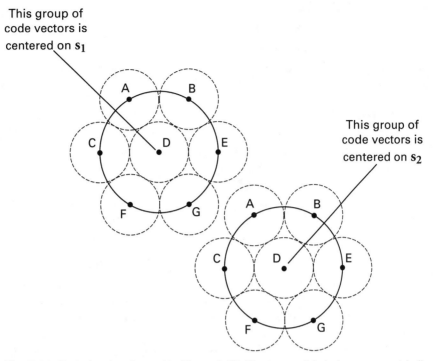

Fig. 5.14 Code for the channel in Figure 5.13. The two solid circles represent balls of radius \sqrt{Lp}, centered on s_1 and s_2, respectively. Within each ball, seven code vectors are arranged, representing messages A through G. The dashed circle around each code vector indicates the likely effect of the second noise source in the channel.

ball centered at s_2. If s_1 and s_2 are sufficiently different from each other, the transmitter can simply use two different sets of code vectors, as illustrated in Figure 5.14. Here, each ball has 2^{LR} code vectors in it, where R is the rate of the code.[5] The code vectors are far enough from one another that they are unlikely to be confused after addition of noise with a power of σ_n^2. For each possible message, there are two code vectors: one in the ball around s_1 and one in the ball around s_2.

When using the code of Figure 5.14, the transmitter decides on a value of \mathbf{u} based on the message to be transmitted, m, and the vector that will be added by the first noise source. If $\mathbf{s} = \mathbf{s}_1$, the transmitter sets \mathbf{u} equal to the code vector for m that lies in the ball around \mathbf{s}_1. If $\mathbf{s} = \mathbf{s}_2$, it uses the code vector that lies in the ball around \mathbf{s}_2. It then transmits $\mathbf{x} = \mathbf{u} - \mathbf{s}$.

5. See Section A.1 of Appendix A for a definition of *code rate*.

Note that subtracting the first noise source from the selected code vector is analogous to the simple form of informed embedding discussed at the beginning of Section 5.1.1. There we dismissed this approach as unworkable in most cases because it would violate the fidelity constraint. However, in a dirty-paper code, the problem is dealt with by choosing a code word that is close to the given noise vector (cover Work).

The receiver receives $y = x + s + n = u + n$. It then searches for the code vector closest to y, and outputs the message associated with the code vector it finds. The resulting communication is reliable, even though the receiver does not know beforehand whether $s = s_1$ or s_2.

Using the code of Figure 5.14 in this manner, we can transmit the same amount of information as we would be able to transmit if there were no first noise source. Thus, the capacity is clearly unaffected by that noise.

5.2.3 Dirty-paper Codes for More Complex Channels

The code described in the preceding section achieves the capacity of the channel in Figure 5.14. However, what if the balls around s_1 and s_2 were to overlap? And what about more realistic systems, in which the first noise source might generate *any* value for s?

In these cases, we cannot provide a distinct set of code vectors for each possible value of s. Instead, some code words must be "shared" by different values of s. We shall also see that to achieve full capacity some more sophisticated form of informed embedding is required. These two issues—sharing code words and informed embedding with a dirty-paper code—are discussed in the following.

Sharing Code Words

To handle a case in which the first noise source generates arbitrary vectors, we would like to generate a set of code vectors such that, whatever the value of s, we will always find at least one code for each message within a distance of \sqrt{Lp} around it. This idea is illustrated in Figure 5.15. A code such as this can be generated by first choosing a set, \mathcal{U}, of vectors (represented in the figure by solid dots) and then dividing that set into subsets, or *cosets,* corresponding to the possible messages, $\mathcal{U}_A, \mathcal{U}_B, \mathcal{U}_C$, and so on. All codes in any given coset represent the same message, and they are widely distributed so that one of them will probably be close to s, whatever value s may take.

The simplest method for using a code such as that in Figure 5.15 is very similar to that for using the code of Figure 5.14. Given a message, m, and a known noise vector, $s = s$, the transmitter finds the member, u, of \mathcal{U}_m that is closest to s, where \mathcal{U}_m is the set of code words that represent message m. It then transmits $x = u - s$. The receiver finds the member of \mathcal{U} that is closest to the received vector, y,

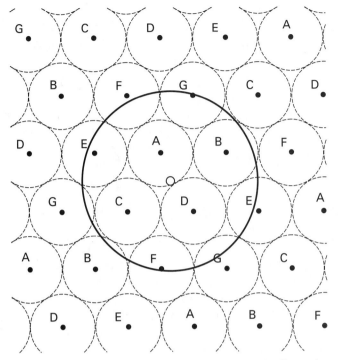

Fig. 5.15 A possible code for the case in which the first noise source can generate arbitrary vectors, **s**. The code vectors, shown as black dots, are divided into seven cosets to represent seven different messages. The coset for each code is indicated by a letter. The dashed line around each code shows the expected amount of noise. A possible value for **s** is shown as a small open circle in the center of the figure. The larger, dark circle around it is the ball of points the transmitter may choose without violating the power constraint. Note that this ball contains one code from each of the seven cosets.

and identifies the received message by determining which coset contains this code vector. For some channels (such as that in Figure 5.13), this method of communication can achieve full capacity.

Informed Embedding with Dirty-paper Codes

Unfortunately, for many channels (including Costa's dirty-paper channel), it is not quite possible to achieve full capacity with the simple method of communication described previously. This can be seen intuitively by reflecting a little on Figure 5.15. To achieve full capacity, we wish to ensure that there is *exactly one* code word for each message within the ball around any given value of **s**. In Figure 5.15, we have chosen a value of **s** for which this is the case. However, the code word for message G is right on the edge of the ball. If we chose a value of **s** slightly below the one pictured, we would lose that code word for message G,

without picking up another one. The only way to ensure that there is *always* a code word for message G is to ensure that when one G code word is on the edge of the ball another is already inside it. Thus, in the balls around some values of **s** there must be two code words that both represent G, meaning that the total number of distinct messages must be smaller than the number of code words that fit into the ball.

To solve this problem, we can introduce an additional trick. Rather than transmit **x** = **u** − **s**, we will transmit some other function of **u** and **s**. For example, we might let[6]

$$\mathbf{x} = \alpha(\mathbf{u} - \mathbf{s}), \tag{5.16}$$

where α is a scalar value between 0 and 1. After adding **s**, this results in **u**′ = α**u** + (1 − α)**s**, or a weighted average of **u** and **s**. This is analagous to a slightly more sophisticated form of informed embedding that chooses a watermarked vector between the original cover Work and the message mark.

At first glance, the idea of using Equation 5.16 might seem counterproductive. If we use this, then instead of receiving **u** + **n**, the receiver obtains α**u** + (1 − α)**s** + **n**. Haven't we just given the receiver a noisier version of **u**? The answer is *yes*, but we have also given the transmitter a little more freedom in choosing a value for **u**. In general, α(**u** − **s**) is a shorter vector than **u** − **s**. This means that the transmitter may choose a code vector that lies a little outside the radius \sqrt{Lp} ball around **s**, without violating the power constraint. It is as if the power constraint is relaxed by a factor of $1/\alpha$ during selection of **u** (the subsequent weighted averaging of **u** and **s** will ensure that the transmitted vector is within the original power constraint). This is illustrated in Figure 5.16. Thus, there is a trade-off: the closer α is to 1, the less noise is added to **u**, but the more strict the power constraint during the search; the closer α is to 0, the greater the noise, but the more relaxed the power constraint during the search. Depending on the channel, the optimal value of α might lie anywhere between these two extremes.

Equation 5.16 is just one example of how **x** might be chosen. With the correct value of α, it is known to achieve capacity for dirty-paper channels. However, because of the differences between watermarking and the dirty-paper channel, this function may not be the most appropriate for our purposes. For real watermarking systems, we would most likely wish to use a more sophisticated method of informed embedding, such as those discussed in Section 5.1. This idea motivates the next investigation.

6. Costa used **x** = **u** − α**s** rather than the function in Equation 5.16, because it is easier to analyze. However, our function is equivalent to Costa's if we just scale all code words by α. We use Equation 5.16 here because we find its geometric interpretation more intuitive.

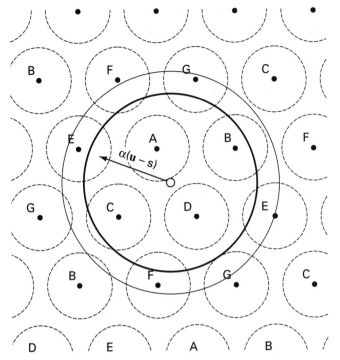

Fig. 5.16 A different way of using a dirty-paper code. Here, the transmitter will transmit $\alpha(\mathbf{u} - \mathbf{s})$. This means that the received vectors will be a bit noisier than if we transmitted $\mathbf{u} - \mathbf{s}$. Therefore, the code words must be spaced farther apart to maintain the same reliability. On the other hand, the power constraint is relaxed slightly, and the transmitter can choose a value for \mathbf{u} in the radius \sqrt{Lp}/α ball, which is represented by the larger, lighter circle. The arrow shows a possible transmitted vector for the message E. Note that because $\alpha < 1$ this vector does not extend all the way from \mathbf{s} (the open circle) to the code for E. However, E is still the closest code word.

Investigation

Informed Coding and Informed Embedding in a System Using Normalized Correlation Detection

We now present an example of a watermarking system similar to that in [182]. This system combines informed embedding with a simple dirty-paper code. Here, we modify the E_BLK_FIXED_R/D_BLK_CC system (System 8) to represent each possible message with more than one reference mark. These reference marks play the role of the code words, $\mathbf{u} \in \mathcal{U}$, in the foregoing discussion.

We show experimentally that using larger numbers of reference marks leads to better performance. Specifically, watermarks with the same estimated robustness and false positive probabilities can be embedded with better fidelity.

System 9: E_DIRTY_PAPER/D_DIRTY_PAPER

This watermarking system is a simple extension of the E_BLK_FIXED_R/ D_BLK_CC system. As in that system, watermark vectors are extracted by summing 8×8 blocks, and the presence of a watermark is tested with the correlation coefficient.

The system uses two sets of reference marks, W_0 and W_1, to encode one bit of information. Each mark in each of the two sets is generated by a Gaussian random number generator. The initial seed to the random number generator serves as the key.

When embedding a 0, the E_DIRTY_PAPER embedder first extracts a vector from the Work to be watermarked. It then finds the reference mark in W_0 that has the highest correlation with this extracted vector. Finally, this mark is embedded using the same constant robustness algorithm employed in the E_BLK_FIXED_R embedder. The same process is used to embed a 1, except that the reference mark is drawn from W_1.

The D_DIRTY_PAPER detector extracts a vector from its input image. It then computes the correlation coefficient between this vector and all reference marks in both W_0 and W_1. If the highest such correlation coefficient is below a given detection threshold, τ_{cc}, the detector reports that no watermark is present. Otherwise, if the best match is a mark in W_0, the detector reports that a 0 was embedded, and if it is a mark in W_1, the detector reports that a 1 was embedded.

The behavior of this system is illustrated in Figure 5.17. The shaded area in this figure represents the detection region for one message. Because the message can be represented with any of several reference marks, its detection region is the union of several cones. The curve within each cone indicates a contour of constant robustness. The open circles represent unwatermarked Works. The arrows and filled circles indicate the behavior of the embedding algorithm, which finds the closest cone in the detection region and then moves the Work to the closest point of sufficient robustness within that cone.

Because the embedder and detector both use exhaustive search to find the best matches in W_0 and W_1, this system is only practical when the size of these sets is small. In the next section, we discuss systems that can handle much larger sets of reference marks. However, our present purpose is simply to illustrate the use of multiple marks for each message.

Fig. 5.17 Behavior of the E_DIRTY_PAPER/D_DIRTY_PAPER watermarking system.

Experiments

We tested the E_DIRTY_PAPER/D_DIRTY_PAPER system with various numbers of reference marks in \mathcal{W}_0 and \mathcal{W}_1. In each test, we made two versions of each of 2,000 images: one with a 0 embedded and one with a 1 embedded.

The detection threshold was chosen to yield an overall false positive probability of roughly 10^{-6}. This probability was computed by first estimating the probability that a random Work will lie within one detection cone (using a method described in Chapter 6), and then multiplying that estimate by the total number of cones in the system; namely, $|\mathcal{W}_0| + |\mathcal{W}_1|$. This means that tests conducted with larger numbers of reference marks had to use higher detection thresholds (narrower cones) to maintain the same false positive probability.

In addition to constant false positive probability, we also had constant payload (always 1 bit) and constant estimated robustness (because we used the constant robustness embedding algorithm of E_BLK_FIXED_R). This means

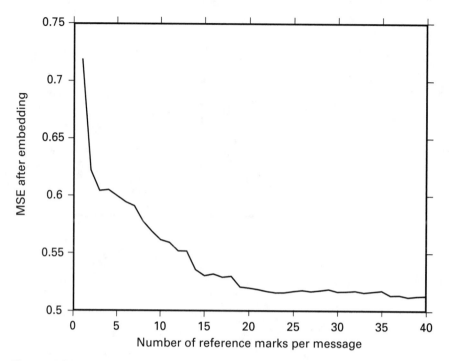

Fig. 5.18 Mean squared error caused by embedding watermarks with the E_DIRTY_PAPER embedder, as a function of the number of reference marks per message.

that the only performance parameter that should change as we vary the number of reference marks is fidelity.

Figure 5.18 shows the average mean squared error (MSE) between original and watermarked versions of images, as a function of the number of reference marks. This indicates that as we increased from 1 to 40 reference marks per message the amount of distortion required to embed a watermark decreased by about 30%.

5.3 Structured Dirty-paper Codes

Random codes such as those employed in the E_DIRTY_PAPER/D_DIRTY_PAPER system have a high likelihood of producing good performance. Unfortunately, they are not practical in general. Both the encoder and the decoder are required to find the closest code word to a given vector, and for large, purely random codes this requires prohibitive computational time or storage. To attain large payloads in practice, we must use codes structured in a manner that allows efficient search

for the closest code word to a given vector. This leads us to consider the subject of *structured codes* [76].

Of course, a similar problem arises when messages are coded without using side information, as discussed in Chapter 4. There, the search problem only exists at the decoder, in that the encoder need only select the unique code word for the desired message. In the systems of Chapter 4, the problem is solved by using error correcting codes, which define certain sequences of symbols to be valid code words. Efficient algorithms exist for finding the valid code word closest to a received code word or vector.

In the case of implementing dirty-paper codes, we might try to use the same error correcting codes as discussed in Chapter 4. However, we are faced with the additional problem, at the embedder, of finding the closest code word in a *subset* of the valid code words; namely, the subset that represents the desired messages. Existing error correcting codes are not designed for this.

In this section, we review some of the work that has been done on designing structured dirty-paper codes. Most of this work centers on the idea of lattice codes, in which the code words are points in a regular lattice [45, 223, 80]. These are discussed in Section 5.3.1. Section 5.3.2 then introduces the alternative method of *syndrome coding* [48, 218, 217], which can employ any existing error correction code for coding with side information. Finally, we point out that one important but extremely simple type of dirty-paper code is implicit in the practice of embedding watermarks in the least-significant bits of a Work. This is explained briefly in Section 5.3.3.

5.3.1 Lattice Codes

In a *lattice code*, each code word is a point on a regular lattice. The points in a simple N-dimensional lattice can be constructed by adding integer multiples of N distinct vectors. Thus, because each message mark, \mathbf{w}_m, is a point in a lattice, we can describe it as the sum of one or more reference marks, $\mathbf{w}_{r0}, \mathbf{w}_{r1}, \ldots, \mathbf{w}_{rN}$, multiplied by integers, $\mathbf{z}[0], \mathbf{z}[1], \ldots, \mathbf{z}[N]$:

$$\mathbf{w}_m = \sum_i \mathbf{z}[i]\mathbf{w}_{ri}. \tag{5.17}$$

An example of a two-dimensional lattice code is illustrated in Figure 5.19.

In the simplest case, the reference marks are orthogonal to one another. With such a code, finding the integers \mathbf{z} that describe the closest code word to any given vector, \mathbf{v}, is a simple matter of quantizing. For each integer, $\mathbf{z}[i]$, we first find the length of \mathbf{v} projected onto \mathbf{w}_{ri} as

$$l[i] = \frac{\mathbf{v} \cdot \mathbf{w}_{ri}}{|\mathbf{w}_{ri}|}. \tag{5.18}$$

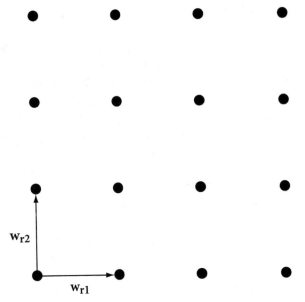

Fig. 5.19 A two-dimensional orthogonal lattice defined by two reference vectors, \mathbf{w}_{r1} and \mathbf{w}_{r2}.

We then divide this by the length of \mathbf{w}_{ri} and round to the nearest integer:

$$\mathbf{z}[i] = \left\lfloor \frac{l[i]}{|\mathbf{w}_{ri}|} + 0.5 \right\rfloor = \left\lfloor \frac{\mathbf{v} \cdot \mathbf{w}_{ri}}{\mathbf{w}_{ri} \cdot \mathbf{w}_{ri}} + 0.5 \right\rfloor. \tag{5.19}$$

More sophisticated codes may use non-orthogonal reference vectors, or multiplication by nonlinear functions of \mathbf{z}, but the task of finding the closest code word to a given vector is still quite simple.

To use side information with a lattice code, we need to divide the set of lattice points into $|\mathcal{M}|$ subsets, where \mathcal{M} is the set of possible messages. This can be done by first representing the messages with sequences of N symbols, $m[1], m[2], \ldots, m[N]$ (where N is the number of reference marks) and then using each dimension of the lattice to code one symbol. If the symbols are drawn from an alphabet of size $a = |\mathcal{A}|$, the value of the ith symbol in the sequence is represented by $\mathbf{z}[i] \bmod a$. The closest point to a given vector, \mathbf{v}, in the sublattice for message $m = m[1], m[2], \ldots, m[N]$ is given by

$$\mathbf{z}_m[i] = a \left\lfloor \frac{l[i]/|\mathbf{w}_{ri}| - m[i]}{a} + 0.5 \right\rfloor + m[i]. \tag{5.20}$$

This technique was first proposed in this form by Chen and Wornell [44, 45], who refer to it as *dithered index modulation* (DIM). Variations of this idea appeared earlier, such as watermarking by quantizing transform coefficients [188] and least-significant bit watermarking (see Section 5.3.3).

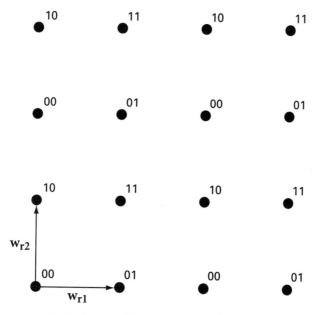

Fig. 5.20 The lattice of Figure 5.19 divided into four cosets for use as a 2-bit dirty-paper code.

For an example of dithered index modulation, suppose that our messages are represented with sequences of binary bits and that we represent the value of the ith bit with $z[i]$ mod 2 (i.e., if $z[i]$ is even, bit i is 0; if $z[i]$ is odd, bit i is 1). In the case of the two-dimensional lattice in Figure 5.19, this binary coding would divide the set of lattice points into four subsets, each labeled with a 2-bit binary sequence, as illustrated in Figure 5.20.

Given an extracted mark, \mathbf{v}, it is a straightforward matter to encode a message with a code such as that in Figure 5.20. The process follows.

1. Find the integers, \mathbf{z}_m, that describe the closest code word in the sublattice for the desired message, m, using Equation 5.20.
2. Find the message mark by computing

$$\mathbf{w}_m = \sum_i \mathbf{z}_m[i]\mathbf{w}_{\mathbf{r}i}. \tag{5.21}$$

3. Apply an informed embedding function, $f()$, to \mathbf{w}_m and \mathbf{v} to obtain the added mark $\mathbf{w}_\mathbf{a}$. For example, this might be $\mathbf{w}_\mathbf{a} = \alpha(\mathbf{w}_m - \mathbf{v})$, as in Equation 5.16.

The message can then be embedded as a watermark by letting $\mathbf{v}_w = \mathbf{v} + \mathbf{w}_\mathbf{a}$. Several variations on this basic design are reviewed in [223, 76].

Lattice codes are appealing for their computational simplicity, but have some inherent limitations. First, simple orthogonal lattices (such as that illustrated in

Fig. 5.21 A two-dimensional hexagonal lattice defined by two reference vectors, \mathbf{w}_{r1} and \mathbf{w}_{r2}.

Figure 5.19) do not pack code words together very efficiently. For example, in two dimensions, it is better to use a hexagonal lattice, as shown in Figure 5.21. This lattice ensures the same minimum distance between code words as the orthogonal lattice, but packs more code words into the same area. Several good lattices for higher-dimensional spaces are also known [49]. However, the payloads that can be carried with simple orthogonal lattices are already vastly higher than those that can be carried with systems that do not use side information for coding. Therefore, even using a suboptimal lattice can be worthwhile.

A second problem with lattice codes is that they are inherently weak against valumetric scaling, such as amplitude changes in audio or contrast changes in images. Even a small amount of scaling can move a Work from the detection region for one message into the detection region for another. Although there may be some watermarking applications for which this type of distortion is of no concern, in most applications it can present a serious problem. Solving this problem requires the use of an extraction process that yields marks that are invariant to scaling.

For example, [213] describes an audio watermarking scheme that uses an extraction process in which an audio signal is correlated against a delayed version of itself, with the result normalized by the signal's recent energy level. This is equivalent to taking the normalized correlation between two nearby segments of the signal. The resulting values are then sampled to obtain an extracted vector in

marking space. Messages can be encoded with a lattice code in this space. Because the normalization causes extracted vectors to remain unchanged with changes in audio volume, the lattice code's weakness against scaling is immaterial. In principle, extraction functions such as this can be applied to media other than audio, such as still images.

Investigation

Watermarking with a Lattice Code

To illustrate the use of lattice codes, we now present a simple example, using an orthogonal lattice code directly in media space. The system we present here is based on that proposed by Chen and Wornell [46] and is related to an earlier system proposed in [260].

System 10: E_LATTICE/D_LATTICE

The E_LATTICE/D_LATTICE watermarking system embeds one bit per 256 pixels in an image. As our test images are $240 \times 368 = 88,320$ pixels, this system embeds $88,320/256 = 345$ bits in each image.

In the E_LATTICE embedder, the 345 message bits are first encoded with the trellis code of Chapter 4, reproduced in this chapter as Figures 5.22 and 5.23. This produces a sequence of 1,380 coded bits. Embedding these bits with the lattice coding system described previously requires correlating the image against 1,380 orthogonal reference marks. If the reference marks are non-zero everywhere in the image, these correlations are costly. To make the system more efficient, we use a simple form of spatial sequencing, dividing the image into 8×8 blocks and embedding one bit into each. Each bit is embedded by correlating a block against a single 8×8 reference pattern, $\mathbf{w_r}$, and quantizing the result to an odd or even integer.

Thus, the exact steps of the E_LATTICE embedding algorithm are as follows:

1. Encode the message into a sequence of coded bits, $m_c[1]$, $m_c[2]$, ..., $m_c[1380]$.
2. Divide the cover image, $\mathbf{c_o}$, into 1,380 8×8 blocks.
3. Modify each block to embed a corresponding bit. Let \mathbf{c}_i be the ith block in the image. To find the pattern to add to this block, we first compute

$$l[i] = \frac{\mathbf{c}_i \cdot \mathbf{w_r}}{|\mathbf{w_r}|} \tag{5.22}$$

$$\mathbf{z}_m[i] = 2 \left\lfloor \frac{l[i]/(\beta|\mathbf{w_r}|) - m_c[i]}{2} + 0.5 \right\rfloor + m_c[i], \tag{5.23}$$

where β is an input parameter that specifies the spacing of the lattice.

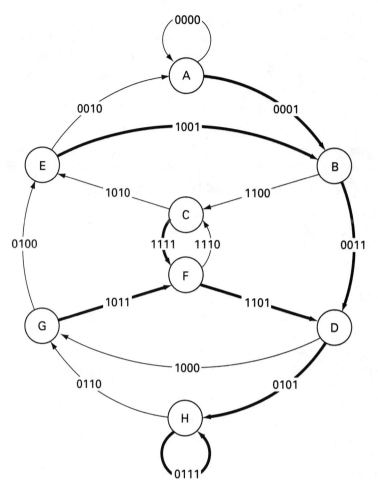

Fig. 5.22 An eight-state convolutional code (reproduced from Chapter 4).

We then find the added pattern, \mathbf{w}_{ai}, as

$$\mathbf{w}_{ai} = \alpha(\beta \mathbf{z}_m[i]\mathbf{w_r} - \mathbf{c}_i). \tag{5.24}$$

After adding all \mathbf{w}_{ai}s to their respective \mathbf{c}_is, we have the watermarked image.

The D_LATTICE detector is simpler than the embedder. At each block, we compute $\mathbf{z}[i]$ as

$$\mathbf{z}[i] = \left\lfloor \frac{\mathbf{c}_i \cdot \mathbf{w_r}}{\beta \mathbf{w_r} \cdot \mathbf{w_r}} + 0.5 \right\rfloor. \tag{5.25}$$

From this, we then detect each bit of the coded message. Bit i of the coded message is 1 if $\mathbf{z}[i]$ is odd, and 0 if it is even. This coded message is then decoded with a Viterbi decoder to yield 345 message bits. The detector does not attempt to determine whether or not a watermark was actually embedded.

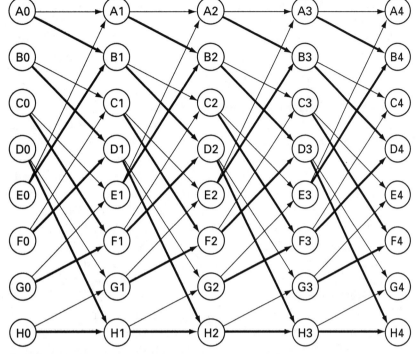

Fig. 5.23 Trellis representation of the code in Figure 5.22 (reproduced from Chapter 4).

Experiments

To test the performance of this system, we embedded random messages in 2,000 images with $\alpha = 0.9$ and $\beta = 3$, using the same reference mark used for our earlier experiments on block-based watermarking systems. A different message was embedded in each image. We then ran the D_LATTICE detector and compared the detected messages bit-for-bit with the embedded messages.

It is possible, due to round-off and clipping errors, for some bits to be incorrectly embedded. This occurred with about 0.03% of the bits. One way to fix this problem would be to apply an iterative embedding process, which tests to ensure that each bit is properly embedded and makes further modifications if it is not.

5.3.2 Syndrome Codes

Chou *et al.* [48] have suggested that *syndrome codes* might be effective for use in watermarking. These codes are based on a subtle modification of traditional error correcting codes, and were first introduced by Pradhan and Ramchandran [218].

To understand them we must first understand the concepts of *base* or *message bits*, *parity bits*, and *syndromes*. These concepts are described in the next section, followed by a description of syndrome codes themselves. All of the following discussion is presented in terms of the trellis code shown in Figures 5.22 and 5.23 (see Chapter 4 for a description of this code).

Base Bits, Parity Bits, and Syndromes

Examine the state diagram of our trellis code (Figure 5.22) and notice that the last bit of the label for each arc is the same as the input bit that traverses that arc. That is, each dark arc, traversed when an input bit equals 1, is labeled with a 4-bit sequence that ends in 1. Each light arc, traversed when an input bit equals 0, is labeled with a sequence that ends in 0. This means that every fourth bit in a code word matches a bit in the corresponding message. For example, the message 1010 is coded into the 16-bit sequence 0001 1100 1111 1110. Taking every fourth bit of this word yields the message again, 1010.

It is easy to see that when designing a code such as that in Figure 5.22 we can always ensure that a predefined subset of the bits in a code word matches the bits in the source message. This is simply a matter of labeling the arcs properly. It turns out that this property can also be ensured for *any* error correcting code [232]. Thus, in discussing error correcting codes it is common to assume that the code has been designed in this manner, so that code words always consist of bits that correspond to the source message and bits that are added by the code.

The bits that correspond to the message are typically referred to as *message bits*. However, applied to syndrome codes, this terminology is not appropriate. To avoid confusion, we refer to these bits here as *base bits*. The bits in a code word that are added by the code are known as *parity bits*.

The *syndrome* of a received word is a bit pattern that gives some indication of the errors in that word. Imagine that we receive a word that might contain some bit errors. One way to check for errors would be to pull the base bits out of the word and run them through the encoder to find out what the parity bits should be. For example, suppose we receive 0001 1110 1111 1111. The base bits in this word are 1011, and the parity bits are 000 111 111 111. Running the base bits through the encoder yields a code word of 0001 1100 1111 1101, which has parity bits 000 110 111 110. These differ from the received parity bits in two places: the sixth bit and the last bit. Thus, if we exclusive OR our recomputed parity bits with the received parity bits, we obtain a bit pattern of 000 001 000 001. This bit pattern is known as the received word's syndrome.

Note that the syndrome itself does not necessarily tell us how to correct the errors, in that each 1 bit in the syndrome might be the result of an error in a parity bit or an error in a base bit. In the previous example, the first 1 bit in the syndrome indicates a parity bit that was flipped, whereas the second 1 bit indicates a base bit that was flipped. Nevertheless, the syndrome gives a rough

idea of how badly corrupted the word is, and it is often possible to determine the corrected word from the syndrome by taking advantage of the structure of the code. However, we will make a different use of syndromes.

Carrying Messages in Syndromes

The idea of syndrome coding is that the message is carried in a word's syndrome, rather than in its base bits. Thus, to decode a syndrome-coded message, we compute its syndrome using some error correction code. For example, in a syndrome code based on the code in Figure 5.22, the word 0001 1100 1111 1110 represents the message 000 000 000 000, because all of its parity bits match those obtained by running the base bits through the encoder. The word 0001 1110 1111 1111 represents the message 000 001 000 001.

A syndrome code is a dirty-paper code because there are many different ways to represent the same message. Basically, for a given message there is a code word that has each possible combination of base bits. For example, we can obtain a code word for 000 000 000 000 by running any sequence of four bits through the encoder. We can obtain a word for 000 001 000 001 by running any sequence of four bits through the encoder and subsequently flipping the sixth and last parity bits.

When we use a syndrome code to encode a message for embedding in some Work, we need to find the code word that has that message as a syndrome and that is closest to a vector extracted from the Work. This can be done with a modified version of the Viterbi algorithm.

We begin by building a trellis, such as that of Figure 5.23, but with some of the label bits flipped according to the message we want to encode in the syndrome. For example, if our message is 000 001 000 000, we would flip the last parity bit in the label of each arc between nodes H1 through H1 and A2 through H2. This ensures that whatever path we take through the trellis the sixth bit of the resulting code word will differ from the sixth bit of a word coded with an unmodified version of the trellis. Thus, the syndrome of the code word will match our message.

We then use the Viterbi algorithm to find the path through this modified trellis that best matches the input Work. The trellis has already been modified so that every path through it represents our message. Therefore, what comes out of this "decoding" process is the code word closest to the Work. This is the code word we embed.

5.3.3 Least-significant-bit Watermarking

Long before the relationship between Costa's analysis and watermarking was noticed, a simple lattice code was already commonly used for watermarking and data hiding. This is the method of embedding information in the least significant bits of a Work's binary representation.

To see that least-significant-bit watermarking employs a dirty-paper code, consider every possible Work as a code word. The coset for a given message is the subset of these code words that contains that message in its least-significant bits. When the embedder replaces the least significant bits of a Work with a given message, it is finding the code word in that message's coset that is closest to the original Work. When the detector extracts the least significant bits from a Work, it is identifying the coset the Work is in.

Least-significant-bit watermarking is not robust at all (even trivial changes in a Work can cause significant errors), but it is nevertheless important for a number of applications. It is commonly used as a method of steganography [128]. It is also sometimes used as a *fragile watermark* for content authentication (see Chapter 10).

5.4 Summary

This chapter has explored the potential impact of side information on the performance of watermarking systems. The main points made here include:

- During watermark embedding, the cover Work is known to the embedder and can be treated as side information about the communications channel rather than as unknown noise.
- *Informed embedding* refers to the use of side information after a message mark has been generated. This can be viewed as an optimization problem in one of two ways:
 - Maximize robustness while maintaining a constant fidelity.
 - Maximize fidelity while maintaining a constant robustness.
- Although, in linear correlation systems the detection statistic can serve as an estimate of robustness, this is not as effective for normalized correlation systems. In such systems, we must optimize with respect to a more explicit estimate of robustness, such as an estimate of the amount of white noise that may be added before the Work is expected to reach the edge of the detection region.
- *Informed coding* refers to the use of side information during the selection of a message mark. This can be done by defining a *dirty-paper code* in which each message is represented by several alternate vectors. We then select the mark that represents the desired message and is closest to the cover Work.
- By combining informed coding and informed embedding, it is possible to obtain much better performance than with simple blind coding and embedding. In fact, there is reason to believe that the amount of information we can reliably embed might be independent of the distribution of unwatermarked content.

■ In practice, informed coding for more than a very small data payload requires a *structured dirty-paper code,* in which the code vectors are arranged to allow for fast nearest-neighbor searches. We reviewed two types of such structured codes:

 ⊞ In a *lattice* code, the code vectors are points on a regular lattice. Different messages are represented with sublattices, and finding the nearest code vector is a simple matter of rounding. Lattice codes are simple to implement, but they are susceptible to scaling distortions such as changing the contrast in an image or changing the volume of an audio signal.

 ⊞ In a *syndrome* code, messages are represented in the syndromes of words that deviate from a given error correction code.

■ The simple practice of embedding watermarks in the least-significant bits of a Work is a special case of a lattice dirty-paper code.

Analyzing Errors

Errors are inevitable in even the best-designed watermarking systems. In this chapter, we discuss three types of error: false positive errors, false negative errors, and message errors. A *false positive error* occurs when the detector incorrectly indicates that a watermark is present. Conversely, a *false negative error* occurs when a detector incorrectly indicates the absence of a watermark. A *message error* occurs when a watermark detector incorrectly decodes a message.

The designer of a watermarking system must determine what error rates are acceptable during the specification phase of the design. It is therefore necessary to develop models for the errors of interest. The purpose of these models is twofold. First, a model allows us to select a detection threshold to meet the specifications. Second, experimental verification of the model allows us to be confident that the specified error rates will not be exceeded.

The severity of these errors depends on the application. For example, in a broadcast monitoring application to confirm that advertisements are aired, a false negative is very serious, in that it leads to the erroneous conclusion that an advertisement was not broadcast. This, in turn, may have serious adverse repercussions on the relationship between the broadcaster and the advertiser. In contrast, false positives lead to the conclusion that the advertisement is being aired more frequently than expected. This situation is also erroneous, but it does not result in mistrust or litigation between the broadcaster and the advertiser.

Message errors are considered in Section 6.1. (The reader is also directed to Chapter 4.) The false positive probability is examined in detail in Section 6.2. A simple Gaussian error model is described and the concepts of random-watermark and random-Work false positives are introduced. The section concludes with an Investigation that highlights the differences between these two forms of false

positives and the importance of accurate modeling. The false negative probability is highly affected by the distortions the Work undergoes between the times of embedding and detection. Section 6.3 discusses this issue and the relationship between false negative errors and security, robustness, and effectiveness. It should be noted that whereas false positives depend only on the detection algorithm, false negatives also depend on the embedding algorithm. We have seen in Chapter 5 that different embedding algorithms can have very different robustness characteristics.

False positive and false negative errors are coupled. For example, it is easy to guarantee no missed detections (i.e., no false negatives) if we set our threshold to the smallest value possible. However, the number of false positive errors then becomes overwhelming. Section 6.4 introduces the concept of a receiver operating charactertisic (ROC) curve as a method of presenting the trade-off between the false positive and false negative rates.

It is common to assume that the additive noise that distorts a watermark is white (i.e., the elements of the noise vector are uncorrelated with one another). However, there are many cases for which this is not true. The Investigation of Section 6.2 includes such a case. When this assumption is false, the error model can perform very poorly. To solve this problem, Section 6.5 describes the use of a whitening filter commonly used to decorrelate noise prior to detection. It is well known that when a signal is corrupted by additive white Gaussian noise, linear correlation is the optimum detection statistic. Thus, whitening improves detection performance by transforming a signal corrupted by nonwhite noise into one in which the noise is white and optimum detection can be achieved.

In Section 6.6, we utilize the concepts outlined in Sections 6.2 through 6.5 to measure and model the errors present in some example algorithms based on using the normalized correlation statistic for detection.

6.1 Message Errors

A message error occurs when a watermark decoder incorrectly decodes a message. When direct message coding is used, the detector mistakenly decodes one message when, in fact, another message was embedded. Similarly, for multi-symbol messages, the detector will erroneously decode one or more symbols. When a binary alphabet is used, these errors are *bit errors*, and the *bit error rate*, or BER, is a measure of the frequency of bit errors.

Bit, symbol, or message errors occur when noise distorts the embedded signal such that the signal is moved from one detection region to another. This is why

maximizing robustness to distortion requires maximizing the separation between codes. Chapter 4 discussed a number of ways in which this can be achieved.

One common method of protecting multi-bit or multi-symbol messages is to use some form of error detection and correction code. There are many such codes [97], and the choice of a particular code will depend on the types of errors expected in the watermark application and the computational constraints of the design. For example, in an image watermarking application, cropping may be a common distortion. If the symbols of the message are encoded using spatial multiplexing in which each successive bit is embedded in the next spatial region, cropping will result in *burst errors*. That is, a sequence of successive bits will either be deleted or corrupted. In this case, it is appropriate to choose an error correction code that is robust to burst errors. Cyclic codes (such as the Reed-Solomon code) have good burst error properties. Another solution to the problem of burst errors due to cropping is to randomize the spatial location of each encoded bit. In this way, cropping no longer manifests itself as a burst error but as a random error. In this case, block codes may be most suitable, such as parity-check codes.

An error detection and correction code will specify the maximum number of bit errors it can detect. If the actual number of bit errors exceeds this maximum, uncorrected bit errors will occur. The seriousness of these errors will depend strongly on the application. In some applications, certain message errors are more serious than others. For example, in a copy control application we might have a copy-once message, indicating that a recorder may make a first-generation copy of a Work but may not make a copy of the copy (see Section 2.2.9 of Chapter 2). Confusing this message occasionally with copy-freely might not be a serious problem, in that it might allow second-generation copies of only portions of Works (e.g., individual movie scenes or brief segments of songs). On the other hand, confusing it with never-copy, even very rarely, could be a severe problem, in that it would prevent users from making first-generation copies they are entitled to make and would be perceived as equipment malfunctions.

When messages are encoded with sequences of symbols, critical pairs of messages, such as copy-once and never-copy in the previous example, should differ in as many symbols as possible to reduce the chance that they will be confused. It is also possible to intentionally design watermarking systems in which symbols are embedded with varying levels of reliability. For example, [297] describes a system in which the bits of a message are divided into two groups. A small group of bits is embedded with a high degree of robustness, and a larger group of bits is embedded with less robustness. In this system, critical information can be encoded in the robust bits, whereas the other bits are used to encode less important information.

Bit error rates can be modeled [97]. This requires a characterization of the transmission channel. For example, for binary symbols we might ask whether the channel is symmetric. That is, is the probability of detecting a 0 when a 1 was embedded the same as the probability of detecting a 1 when a 0 was embedded? Such a channel is referred to as a *binary symmetric channel*. Alternatively, the channel might be a *binary erasure channel*, in which the channel output has not just two values but a third that indicates indecision. Is the noise additive, white Gaussian? What is the probability of a single bit error? Are the errors independent or are burst errors common? Such issues have received considerable attention from the communications community, and the reader should consult these sources for further information. In addition, [113, 116, 148, 114, 47] contain a number of investigations of bit error rates for watermarking applications. The following Investigation describes a simple Gaussian model for bit error rate that is sometimes appropriate.

Investigation

A Gaussian Model for Bit Error Rate

In Chapter 4 we described a watermarking algorithm for embedding eight bits of data in an image. This system, E_SIMPLE_8/D_SIMPLE_8 (System 4), represents each of the eight bits by an orthogonal, white noise pattern that is either added or subtracted depending on whether the corresponding bit is a 1 or a 0. The message mark, \mathbf{w}_m, is a combination of these eight patterns that is then scaled by $1/\sqrt{8}$ to have unit variance. The watermarked work, \mathbf{c}_w, is then given by

$$\mathbf{c_w} = \mathbf{c_o} + \alpha \mathbf{w}_m, \tag{6.1}$$

where α is an arbitrary constant. Each bit is therefore embedded with a strength of $\alpha/\sqrt{8}$.

To detect bit i, we linearly correlate the watermarked Work with the corresponding reference pattern, \mathbf{w}_{ri}. If the correlator output is greater than zero, a 1 bit is present; otherwise, a 0 bit is present.

We assume that the detector output for each bit is Gaussian distributed. This assumption is valid for watermark patterns that are white. However, we will see in the next section that this assumption is invalid when the watermark patterns are not white.

For each bit, the mean value of the linear correlation, μ_{lc}, is

$$\mu_{lc} = \frac{\alpha}{\sqrt{2}}, \tag{6.2}$$

and the variance, σ_{lc}^2, is

$$\sigma_{lc}^2 = \sigma_{w_{ri}}^2 \left(\sigma_{c_o}^2 + \sigma_n^2 \right), \tag{6.3}$$

where the variance of each reference pattern, $\sigma_{w_{ri}}^2 = 1$, and $\sigma_{c_o}^2$ and σ_n^2 are the variances of the cover Work and the channel noise, respectively. The probability of a bit error is then

$$p = \int_{-\infty}^{0} \frac{1}{\sqrt{2\pi}\sigma_{lc}} e^{-\frac{(x-\mu_{lc})^2}{2\sigma_{lc}^2}} \, dx \tag{6.4}$$

$$= \int_{-\infty}^{-\mu_{lc}} \frac{1}{\sqrt{2\pi}\sigma_{lc}} e^{-\frac{x^2}{2\sigma_{lc}^2}} \, dx \tag{6.5}$$

$$= \int_{\mu_{lc}}^{\infty} \frac{1}{\sqrt{2\pi}\sigma_{lc}} e^{-\frac{x^2}{2\sigma_{lc}^2}} \, dx \tag{6.6}$$

$$= \mathrm{erfc}\left(\frac{\mu_{lc}}{\sigma_{lc}} \right), \tag{6.7}$$

where

$$\mathrm{erfc}(x) = \frac{1}{\sqrt{2\pi}} \int_{x}^{\infty} e^{-\frac{t^2}{2}} \, dt. \tag{6.8}$$

Experiments

To test this model, we watermarked 2,000 images with 10 random 8-bit messages and $\alpha = 2$, resulting in 20,000 watermarked images. The mean value of the linear correlation is given by

$$\mu_{lc} = \frac{2}{\sqrt{8}} = \frac{1}{\sqrt{2}}, \tag{6.9}$$

and the measured standard deviation of pixel values in the images, σ_{c_o}, was found to be 59. We then added white, Gaussian noise with eight different standard deviations, $\sigma_n = 0, 20, 40 \ldots 140$. For each noise value, we detected the 20,000 8-bit messages and determined the number of bit errors. The measured and predicted error rates are plotted in Figure 6.1.

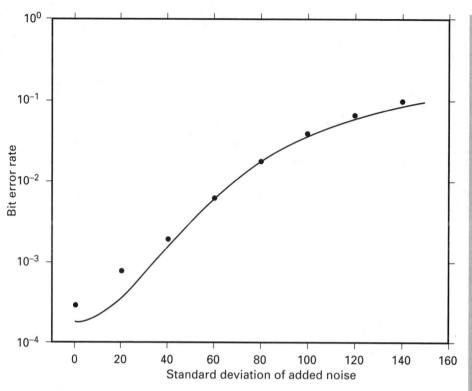

Fig. 6.1 Measured and predicted bit error rates for the E_SIMPLE_8/D_SIMPLE_8 (System 4).

There is good agreement between the measured and predicted rates. The deviation at low bit error rates is due to the fact that at low noise values the image noise dominates, and this noise is not Gaussian.

6.2 False Positive Errors

A false positive occurs when a watermark detector indicates the presence of a watermark in an unwatermarked Work. The *false positive probability* is the likelihood of such an occurrence, and the *false positive rate* measures the frequency of false positives. A false positive probability of 10^{-4} indicates that we expect, on average, one false positive for every 10,000 detection attempts.

Figure 6.2 illustrates how and why false positive errors can occur. The left-hand curve represents the frequency of occurrence of each possible value that can be output from the watermark detector when no watermark is actually present.

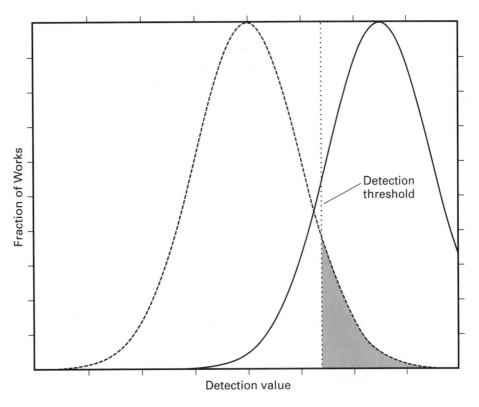

Fig. 6.2 Example detector output distributions and a detection threshold. The shaded area represents the probability of a false positive.

Similarly, the curve to the right represents the frequency of detector output values when a watermark is present. The vertical line represents the decision boundary, τ: if the detector output value is less than τ, the watermark is declared absent; otherwise, the watermark is declared present. False positive errors are possible because there is a finite chance the detector will output a value greater than or equal to τ when no watermark is present.

The shaded area underneath the curve represents the probability of a false positive. The magnitude of this probability depends on the threshold value and the shape of the curve. Thus, modeling the false positive probability can be reduced to modeling the shape of this curve. Several models are presented in this chapter.

The false positive model depends on the watermark detection algorithm and the manner in which the detector is used. In particular, the detector may be looking for one of many watermarks in a single Work, a single watermark in many Works, or many watermarks in many Works. In the first case, we can

consider the watermark to be a random variable. In the second case, the Work is the random variable, and in the third case, both the watermark and the Work are considered random. This leads to the concepts of *random-watermark false positive* and *random-Work false positive.*

For example, copy control applications require the detector to search for a small set of *a priori* known watermarks in millions of different Works. In this scenario, the probability of obtaining a false positive depends on the specific reference marks used and on the distribution of unwatermarked content (i.e., it is the Works that are random). On the other hand, in the DiVX application (see Section 2.1.4 of Chapter 2), it was envisioned that there would be millions of DiVX players, and each would embed a unique watermark into the video stream. When a pirated copy of a video was discovered, DiVX intended to determine the source of the illegal copy by searching for the presence of any one of these millions of watermarks in the pirated video Work. In this scenario, the watermarks can be considered random and, because the Works to be examined are also *a priori* unknown, these too are best modeled as a random variable. To the best of our knowledge, the case of a constant Work and random watermarks does not accurately model any real application. However, the random-watermark false positive is reported extensively in the literature and is of theoretical interest. It is important for an application to identify whether the watermark and/or the Work is random, in that watermarks and Works usually have very different distributions. The random-watermark false positive probability and random-Work false positive probability are now discussed in more detail.

6.2.1 Random-Watermark False Positive

The random-watermark false positive probability models the watermark as a random variable and treats the Work as a constant. This is the situation in which the Work or Works are all known *a priori* and in which the number of watermarks is very large and is drawn from a random distribution. Such a scenario most closely models the situation for transaction watermarks. In transaction applications, the number of different watermarks is potentially very large, in that one is needed to identify each customer. When an illicit Work is discovered, the watermark detector must look for the presence of one of these watermarks in the Work in question. However, unless the set of Works to be watermarked was known during the design of the watermarking algorithm, each Work searched should be considered to be drawn from a distribution of Works.

Although there are few if any real applications for which the false positive error is accurately represented by the random-watermark false positive probability, it is nevertheless common to find this case experimentally examined in the literature. This is because the theoretical analysis is easy and the experimental verification is very straightforward. The detector output distribution is primarily determined by the distribution from which the randomly chosen watermark reference patterns

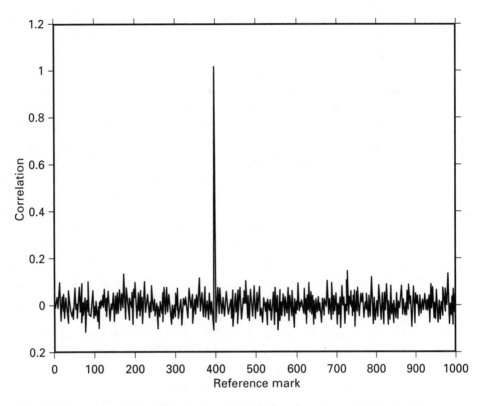

Fig. 6.3 A commonly used illustration of the ability of a watermark detector to discriminate between reference marks. This Work was watermarked with the reference mark associated with location 400 on the x-axis, where the linear correlation value is very high.

are drawn. Because this distribution is directly under our control, the detector output distribution can be accurately modeled. The experimental verification can be performed without the need for a large number of images. In fact, only one is required. Instead, a large number of watermarks are needed, but these can be dynamically generated using a pseudo-random number (PN) generator.

Experimental results of random-watermark false positive tests are often displayed as shown in Figure 6.3, where the x-axis represents many randomly selected reference vectors and the y-axis shows the resulting detection value. Here, the large difference between the value obtained from the one reference vector originally embedded (shown at location 400 on the x-axis) and the other reference vectors is presented as a demonstration of the ability of the watermarking system to distinguish between reference marks. However, although this plot provides qualitative information on the ability of the watermark detector to differentiate between watermarks, we prefer a more informative and quantitative plot of the false positive probability as a function of detection threshold, as shown in Figure 6.4.

6.2.2 Random-Work False Positive

Now consider the situation in which many different Works are being examined for the presence of one or a small number of watermarks. In this case, we characterize the *Works* as a random variable and refer to the chance of finding a specific watermark in an unwatermarked Work as the random-Work false positive probability.

This is the probability we are most concerned with in many common applications of watermarking. For example, in a copy control application all possible music or video must be examined for the presence of a small number of watermarks that indicate the recording and playback permissions assigned to a Work. In this case, it is natural to consider the watermarks as constant and the enormous variety of possible Works as a random variable.

Modelling the random-Work false positive probablity requires an accurate model of the distribution of unwatermarked content. This can be very difficult to model. For example, in the E_BLIND/D_LC system (System 1), in which we simply add a globally attenuated reference pattern to the Work in media space, the detector output distribution will depend almost directly on the distribution of Works. In contrast, in the E_BLK_BLIND/D_BLK_CC (System 3), where the image is reduced to a single composite 8×8 block and detection is performed using the correlation coefficient, the detector output distribution is determined by the distribution of composite 8×8 blocks. This distribution may be very different from the distribution of underlying Works.

The difference between random-watermark and random-Work false positives is highlighted in the following Investigation. In particular, we see that a Gaussian model of the detector output distribution can be suitable for a random-watermark application, but does not satisfactorily model the detector output distribution for a random-Work application.

Investigation

Examining the Difference between Random-Work and Random-Watermark False Positive Behaviors

In this Investigation, we examine the false positive behavior for linear correlation detection under both random-watermark and random-Work conditions. We first develop a simple model that assumes that the random distribution is a Gaussian. Two experiments are then performed. The first applies the detector to three Works and searches for the presence of 20,000 random watermarks. The second experiment looks for just three watermarks in 20,000 images (i.e., the Works are random).

Our experiments were performed using the D_LC linear correlation detection algorithm of System 1. Thus, the detector output, z_{lc}, is given by

$$z_{lc} = \frac{1}{N} \sum_i \mathbf{w}_r[i]\mathbf{c}[i], \qquad (6.10)$$

where \mathbf{w}_r is a watermark reference pattern and \mathbf{c} is a Work. Equation 6.10 has denoted the watermark as the random vector, and the Work as a constant. For convenience, we will make this random-watermark assumption in the derivation of the false positive probability. Of course, for the random-Work case, the situation is reversed.

Each $\mathbf{w}_r[i]\mathbf{c}[i]$ is a random value drawn from a similar distribution to $\mathbf{w}_r[i]$, but scaled by a value, $\mathbf{c}[i]$. Assuming that the central limit theorem [111] holds, z_{lc} will have a Gaussian distribution with mean, μ_{lc},

$$\mu_{lc} = \mu_w \mu_c \qquad (6.11)$$

and standard deviation, σ_{lc}, given by

$$\sigma_{lc} = \sigma_w |\mathbf{c}|. \qquad (6.12)$$

If the watermark vectors are chosen to have a mean of zero, the detector output, z, will also have a mean value of zero. The probability that the detector will output a value of x is then given by

$$P_z(x) = \frac{1}{\sqrt{2\pi}\sigma_{lc}} \exp\left(\frac{-x^2}{2\sigma_{lc}^2}\right) \qquad (6.13)$$

and the probability of a false positive is

$$P_{fp} = \int_\tau^\infty P(x)\, dx = \int_\tau^\infty \frac{1}{\sqrt{2\pi}\sigma_{lc}} \exp\left(\frac{-x^2}{2\sigma_{lc}^2}\right) dx \qquad (6.14)$$

$$= \operatorname{erfc}\left(\frac{\tau}{\sigma_{lc}}\right), \qquad (6.15)$$

where erfc denotes the complementary error function defined in Equation 6.8.

The linear correlation algorithm uses the D_LC detector, which is actually testing for the presence of two watermarks: either \mathbf{w}_r, which means the watermark message is 1, or $-\mathbf{w}_r$, which means the message is 0. Thus, with each run of the detector we have two opportunities to obtain a false positive.

The random-watermark false positive probability, $P_{\mathrm{fp(D_LC)}}$, is therefore given by

$$P_{\mathrm{fp(D_LC)}} = \mathrm{erfc}\left(\frac{\tau_{\mathrm{lc}}}{\sqrt{2}\sigma_{\mathrm{lc}}}\right). \qquad (6.16)$$

Experiment 1

The D_LC linear correlator was applied to three images, using 20,000 different reference marks. Each reference mark was generated by drawing its elements independently from a Gaussian distribution, and normalizing the result to have zero mean and unit length. Figure 6.4 shows the resulting false positive rates for each image, as a function of the detection threshold τ_{lc}. The measured rates are indicated by the stars in the graphs. The rates predicted with Equation 6.16 are shown with solid lines.

As we can see from these curves, whereas the false positive behavior varies slightly from one image to the next, the false positive prediction is quite accurate in this range of detection threshold. The variability from one image to the next is due to differences in the standard deviation of the images. This dependence is modeled in Equation 6.12. Given that the *measured* false positive rates fall to zero at high thresholds, we cannot directly assess the accuracy of the model at very low false positive probabilities.

Experiment 2

If we now consider the random-Work false positive probability, we might expect very similar results. After all, we are still applying Equation 6.10; only now, **c** is the random variable. However, the elements of **c** are the individual pixels of the image, and these are known to be highly correlated spatially. We illustrate the impact of this dependence by considering the random-Work false positive behavior for three different reference marks, each having the same length but different directions. The results presented in the following are generated using the same D_LC linear correlation detector.

The three different reference marks we constructed are shown in the left-hand column of Figure 6.5. These reference marks differ only in their direction in media space. If the simple Gaussian model is accurate, we would expect identical false positive curves.

To test this, we applied the D_LC linear correlation detector to 20,000 images using each of the three reference marks. For each reference mark, we plot the false positive frequency found using a variety of thresholds. The solid line represents the predictions. The reference marks can be seen to have wildly different false positive behaviors. The range of detection values depends on how similar the patterns are to naturally occurring images. (See [168] for a

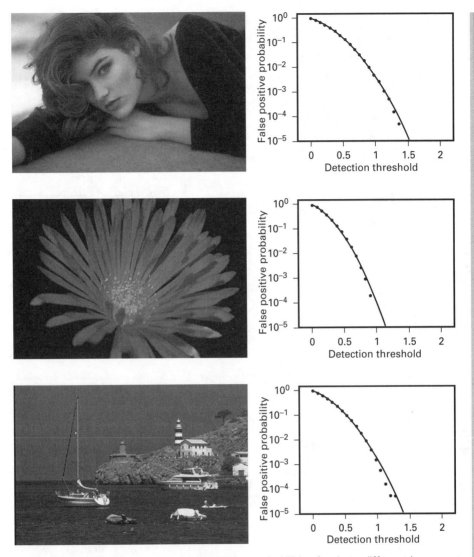

Fig. 6.4 Random-watermark false positive probabilities for three different images at varying detection thresholds applied to linear correlation. Each image was tested against 20,000 reference marks. The solid lines are the theoretical predictions. The points are the measured results.

detailed study of how the design of watermark reference patterns affects error probabilities in a simple image watermarking system.)

The Gaussian model does not accurately predict the random-Work false positive probability even though it is a very good model of the random-watermark false positive probability. Clearly random-Work and random-watermark false positive probabilities are not the same.

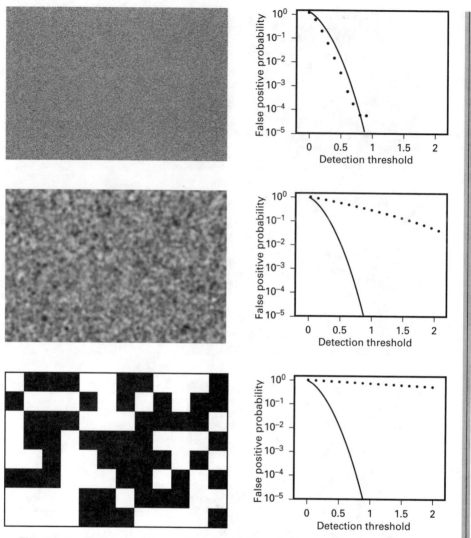

Fig. 6.5 Random-Work false positive probabilities for three different reference patterns at varying detection thresholds applied to linear correlation. The graphs were calculated using 20,000 images from the Corel database.

6.3 False Negative Errors

A false negative occurs when a watermark detector fails to detect a watermark that is present. The *false negative probability* is the statistical chance that this will occur, and the *false negative rate* measures the frequency of occurrences.

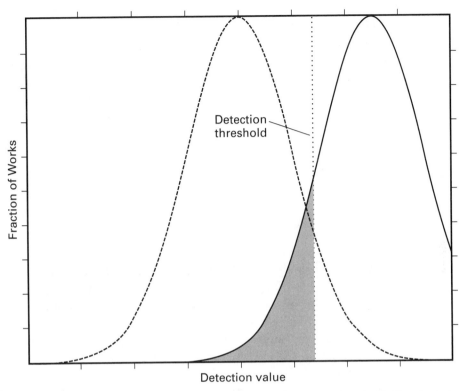

Fig. 6.6 Example detector output distributions and a detection threshold. The shaded area represents the probability of a false negative.

Figure 6.6 indicates that a false negative occurs because the detector output distribution, represented by the right-hand curve, intersects the threshold τ. Thus, there is a finite possibility that the detector output will be less than the threshold, τ, even when a watermark is present in the Work.

An analysis of the false negative probability can follow the same lines as that for the false positive probability. Again, we can identify the exact types of false negative probabilities that are most relevant to a given application. Once more we can make a distinction between random-watermark and random-Work probabilities. If we are going to embed a million different watermarks into different copies of a small number of Works, we are most interested in random-watermark false negative probabilities. If we are going to embed a small number of different watermarks into a million Works, we should examine random-Work probabilities.

However, unlike the case of false positive probabilities, there are many more variables to consider before analyzing the probability of a false negative. This is because false negative probabilities are highly dependent on both the watermark

detector *and* the embedder, and what happens to a Work between the time a watermark is embedded and the time it is detected. A watermark might be severely distorted by filtering, analog transmission, lossy compression, or any of a wide variety of processes, thus increasing the probability of a false negative. It might also be attacked by some adversary, using an algorithm specifically designed to result in nearly 100% false negatives. Before beginning to estimate the false negative probability, we must specify what processes are expected between embedding and detection.

The possible choices of expected processes can be divided into three main categories, each of which corresponds to a property of watermarking systems discussed in Chapter 2:

- The *security* of a system is its ability to survive attack by hostile adversaries. In many cases, the greatest security concern is that an adversary might make the watermark undetectable. Modifications of a Work for the purpose of defeating a watermark detector are known as unauthorized removal attacks.

 A watermarking system's level of security against these attacks can be thought of as the probability of detection after an attack by a random adversary. This is just the complement of the probability of a missed detection (false negative) after attack by a random adversary. That is, the level of security is $1 - P_{fn}$. (Of course, it is extremely difficult to quantify this probability.)

- The *robustness* of a system is its ability to survive normal processing, such as filtering, analog transmission, and lossy compression. Robustness can vary wildly from one type of processing to another. For example, a watermark that is highly robust to analog transmission might be completely eliminated by lossy compression. Thus, it is usually best to talk about a system's robustness *to a specific process*.

 A watermarking system's level of robustness to some process can be thought of as the probability the watermark will be detected after that process is applied. This is just the opposite of the probability of a false negative after application of the process (i.e., $1 - P_{fn}$).

- The *effectiveness* of a system is its ability to embed and detect watermarks when there is *no* intervening attack or processing. This is just the complement of the probability of a false negative immediately after the watermark is embedded (i.e., $1 - P_{fn}$).

Robustness and security are discussed in Chapters 8 and 9, respectively. The effectiveness of watermarking systems is addressed analytically in Section 6.6.2 for a system similar to the E_BLK_BLIND/D_BLK_CC watermarking system of System 3. Empirical results for many of the example watermarking systems are presented throughout the book.

6.4 ROC Curves

In every watermarking system there is a trade-off between the probability of false positives and the probability of false negatives. As the threshold increases, the false positive probability decreases and the false negative probability rises. The performance of the system can only be interpreted by considering both probabilities at once. In this section, we describe the *receiver operating characteristic curve*, or *ROC curve*, which is a standard graphical tool for interpreting the performance of communications systems [111].

To this point, we have shown our experimental results by plotting histograms of detection values. These provide an intuitive picture of the results. If the histogram of the detection values obtained from unwatermarked content (which we usually plot with dashed lines) is well separated from the detection values obtained from watermarked content (usually solid lines), then it is clear that many thresholds between them will yield both low false positive probabilities and low false negative probabilities. Figures 3.6, 3.11, and 3.20 in Chapter 3 all indicate such thresholds at the tops of the graphs.

ROC curves are an alternative to these histogram plots. A ROC curve is a parametric curve that plots the false positive probability (usually the x-axis) against the false negative probability (usually the y-axis) as a function of threshold.

The generation of a ROC curve for a real watermarking system usually requires the use of a theoretical model of either the false positive or false negative behavior of the system. To illustrate this point, we first present a ROC curve of a hypothetical watermarking system that has very poor performance. The purpose of this illustration is to examine the relationship between the ROC curve and the type of histograms used in Chapter 3. We then examine a histogram from one of the real watermarking systems presented in Chapter 3. We find that there is not enough data to generate a useful ROC curve. This is the typical case for a real watermarking system. To remedy this, we propose building a model of the false positive behavior, the false negative behavior, or both, and using these models to interpolate the required data. In the example presented, we model the false positive behavior and use the measured false negatives to generate a ROC curve.

6.4.1 Hypothetical ROC

Figure 6.7a shows an example, based on a hypothetical watermarking system. For comparison, a normalized histogram of the same information is shown in Figure 6.7b. This plots the relative frequencies of detection values for unwatermarked and watermarked content. To help compare the two plots, we have labeled three possible threshold values on each of them. The three marks on the curves in Figure 6.7b correspond to the three marks on the curve in Figure 6.7a. With the threshold set to correspond to the point marked 2 in the normalized histogram,

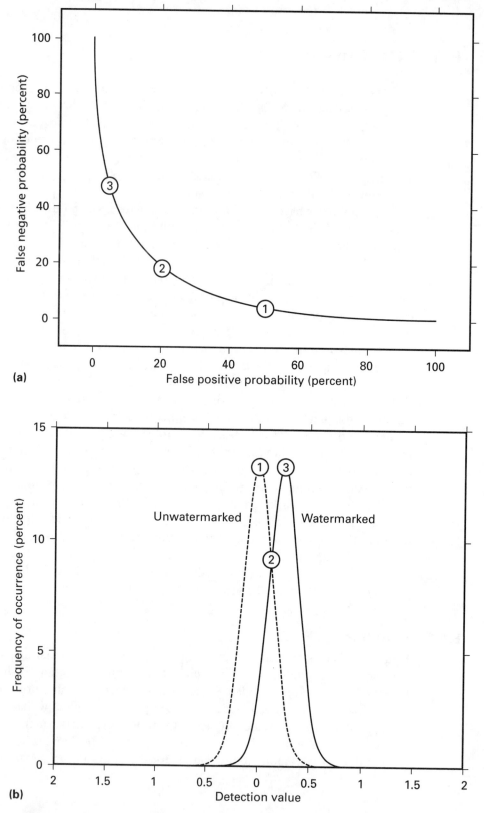

Fig. 6.7 ROC curve (a) and normalized histogram (b) for a hypothetical watermarking system. The numbered circles indicate corresponding threshold values.

the false positive probability is equal to the false negative probability. This fact is reflected in the location of point 2 in the ROC curve. With the threshold set to the detection value corresponding to the point marked 1, the false positive probability is 0.5 and the false negative probability is low. Similarly, at 3, the false negative probability is 0.5 and the false positive probability is low.

The hypothetical watermarking system shown in Figure 6.7 has very poor performance. A quick glance at either of the two graphs shows that to obtain a reasonable false positive probability we must choose a threshold that leads to a high probability of false negatives. In real watermarking systems it should be possible to find thresholds that lead to very small probabilities of either type of error.

6.4.2 Histogram of a Real System

Consider the histogram plotted in Figure 6.8. This is based on real experimental data; namely, the results obtained in Chapter 3 for the E_BLIND/D_LC watermarking system (System 1) on unwatermarked images (dashed line) and on images marked with a message of $m = 1$ (solid line).

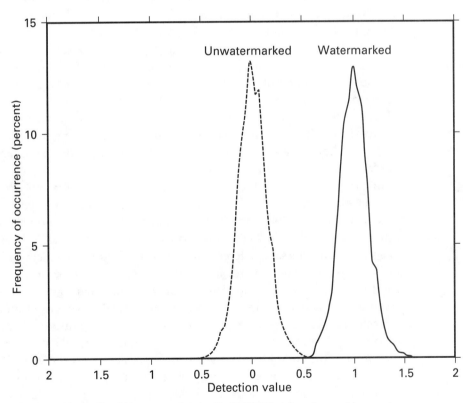

Fig. 6.8 Normalized histogram for the E_BLIND/D_LC watermarking system.

The problem with the empirical data plotted here is that during the test there was only a very small overlap between detection values obtained from water-marked and unwatermarked images, which was not enough to make a meaningful ROC curve. The lowest detection value obtained from a watermarked image was 0.46. The highest value from an unwatermarked image was 0.60. Thus, if we were to plot a ROC curve with this data, the false negative rate would be exactly 0 for any threshold below 0.46, and the false positive rate would be 0 for any threshold above 0.60. The curve would be vertical on the left, horizontal on the right, and only informative in a very small region near the lower left corner. ROC curves are informative in providing a graphical representation of the trade-off between false positive and false negative behavior, but in this case there is almost no trade-off and we cannot generate a useful ROC curve.

6.4.3 Interpolation along One or Both of the Axes

Of course, even though we did not obtain a detection value over 0.60 from unwatermarked data, we cannot conclude that we will never obtain one. In theory, if we were to test enough unwatermarked images, we would probably find some with quite high detection values, allowing us to measure the frequencies with which those high values arise and plot a more meaningful ROC curve. However, such an experiment would require an impractical amount of computation.

Instead, a meaningful ROC curve can be plotted by estimating one or both of the probabilities along the axes. For example, we might model the probability of a false positive at high thresholds. This model would then give us non-zero false positive probabilities at thresholds that yield non-zero false negative rates in our test. The validity of a ROC curve plotted in this way depends on the accuracy of our false positive probability model.

In cases where it is difficult to estimate error probabilities analytically, we can make our estimates by extrapolating empirical data. The experiment that generated the data plotted in Figure 6.8 tested random-Work probabilities (the detector was applied to 2,000 unwatermarked images and 2,000 watermarked images, all using the same reference mark). As previously discussed, it is difficult to estimate the random-Work false positive probabilities, because the images are drawn from a distribution that is not white and Gaussian. However, if we assume that the distribution of detection values is approximately Gaussian, we can estimate the false positive probabilities by computing the sample mean and variance of the detection values obtained from unwatermarked data. These are then used in the complimentary error function. Figure 6.9 shows a ROC curve computed in this manner from the data used in Figure 6.8. Because the false positive probabilities at higher thresholds are extremely low, we have made this plot with a logarithmic x-axis.

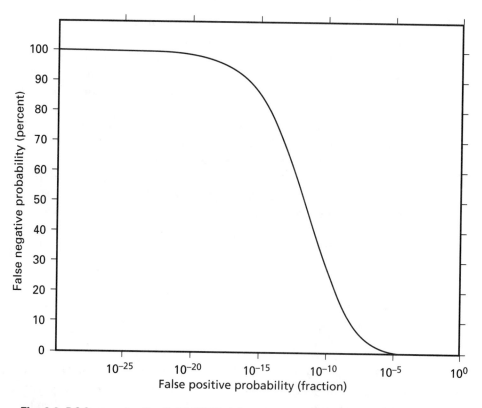

Fig. 6.9 ROC curve for the E_BLIND/D_LC watermarking system. The false positive probability for the ROC curve has been estimated by fitting a Gaussian distribution to the test results for unwatermarked images (dashed line in Figure 6.8), and the x-axis is plotted on a logarithmic scale.

6.5 The Effect of Whitening on Error Rates

The model used in the Investigation of Section 6.2 assumes that the random vectors are additive white Gaussian. When a signal is corrupted by AWGN noise, linear correlation is an optimum method of detection. However, if linear correlation is used when the noise is *not* additive white Gaussian, detection will be suboptimal and the detector output will not behave as predicted. This situation occurred when we applied the D_LC detector to random Works. We observed that for the random-Work false positive estimation our simple model breaks down. This is often the case for random-Work false positives, in that most forms of content (be it music, photographs or movies) cannot be modeled by an independent white Gaussian distribution. The true distribution of unwatermarked content is more complex.

Multimedia content typically exhibits strong spatial and/or temporal correlations. For example, image pixels in close proximity to one another typically have similar brightness. Temporal correlations exist in audio and video signals. A common approach to processing correlated data is to first decorrelate the data and then apply signal processing algorithms that are optimum for white noise. Decorrelation can be accomplished through the application of a *whitening* or *decorrelating* filter, which is designed to eliminate or at least reduce the correlation present. Thus, a whitening filter can significantly improve the performance of detectors that assume the noise is uncorrelated.

To use a whitening filter, \mathbf{f}_{wh}, in a linear correlation watermark detector we first convolve both the received Work, \mathbf{c}, and the reference pattern, $\mathbf{w_r}$, with \mathbf{f}_{wh}, and then compute the correlation between the resulting patterns. That is

$$z_{wh}(\mathbf{c}, \mathbf{w_r}) = z_{lc}(\mathbf{c}', \mathbf{w_r}') \tag{6.17}$$

where

$$\mathbf{c}' = \mathbf{c} * \mathbf{f}_{wh} \tag{6.18}$$

$$\mathbf{w_r}' = \mathbf{w_r} * \mathbf{f}_{wh}, \tag{6.19}$$

and $*$ indicates convolution.

Whitening filters are a standard tool in designing signal detectors. The use of such a filter for image watermarking was first suggested by Depovere *et al.* [71]. They pointed out that a simple, horizontal difference filter applied to the rows of an image would remove most of the correlation between horizontally adjacent pixels. This difference filter yields acceptable results when applied directly to images. However, it is not necessarily applicable to other media. It is also not necessarily applicable to vectors that have been extracted from Works using various other processes.

A more general approach to designing whitening filters can be applied if we assume that the elements of unwatermarked Works are drawn from a correlated Gaussian distribution. That is, we assume the probability of obtaining $\mathbf{c_o}$ is given by

$$P(\mathbf{c_o}) = \frac{1}{(\sqrt{2\pi})^N \sqrt{\det(\mathbf{R})}} \exp\left(-\frac{(\mathbf{c_o} - \mu_{c_o})^T \mathbf{R}^{-1}(\mathbf{c_o} - \mu_{c_o})}{2}\right) \tag{6.20}$$

where \mathbf{R} is a covariance matrix. In this case, the whitening filter can be obtained by extracting the center row from the matrix square root of inverse of \mathbf{R}, (i.e., $\sqrt{\mathbf{R}^{-1}}$).

The derived filter whitens vectors drawn from the distribution described by \mathbf{R}. However, if this filter is applied to vectors drawn from another distribution, it will not have a whitening effect. In fact, if it is applied to vectors drawn from a distribution that is already white, it will have the effect of *introducing* correlations.

A consequence of this is that whitening often has opposite effects on random-Work and random-watermark false positive probabilities. Suppose the watermarks are drawn from a white Gaussian distribution, whereas the Works are drawn from some correlated distribution. Without whitening, the random-watermark false positive probability is easily predicted, but the random-Work false positive probability is more complex. Applying a whitening filter designed to decorrelate the Works makes the random-Work false positive probability behave better, but causes the *random-watermark* false positive probability to become badly behaved. When we are more concerned with random-Work false positive probabilities than with random-watermark false positive probabilities, as is the case in most applications, the use of whitening filters is usually justified.

It must also be noted that the tails of the distribution of detection values are greatly affected by any mismatch between the Gaussian model and the true distribution of unwatermarked media. For example, suppose we are using a whitening filter in a video watermark detection system. We have derived the filter based on a simple correlated Gaussian model of the distribution of unwatermarked frames. This model might be reasonably accurate for normal shots of actors, scenery, and so forth. However, every now and then a film contains a short closeup of a television screen showing only video noise. Video noise is largely uncorrelated, and therefore the whitening filter will introduce correlations into these scenes. The result may be a higher chance of a false positive.

Nevertheless, whitening can be a useful tool when we are either unconcerned with the tails of the distribution of detection values, have a limited set of unwatermarked Works entering the system (e.g., no shots of video noise), or employ an extraction process that results in a nearly Gaussian distribution.

Investigation

Whitened Linear Correlation Detection

Our purpose here is to illustrate both the derivation and use of a whitening filter. We therefore choose not to use the approximate whitening filter suggested in [71] (namely, $\mathbf{f}_{wh} = [-1, 1]$). Instead, we derive a more sophisticated whitening filter based on the assumption, found in [168], that the correlation between two pixels is proportional to the Manhattan distance between them. When this assumption is accurate, our whitening filter will be optimum.

System 11: E_BLIND/D_WHITE

To derive the whitening filter, we assume an elliptical Gaussian model of the distribution of unwatermarked images, using the covariance matrix suggested

by Linnartz *et al.* [168]. This covariance matrix is given as

$$\mathbf{R}[i_1, i_2] = q^{|x_1-x_2|+|y_1-y_2|} \tag{6.21}$$

for every pair of pixels, i_1, i_2, where (x_k, y_k) is the position of pixel i_k, and q is a constant. Linnartz *et al.* suggest that q should lie between 0.90 and 0.99. We use $q = 0.95$. Substituting the resulting covariance matrix into Equation 6.20 yields an elliptical Gaussian distribution.

Because $\mathbf{R}[i_1, i_2]$ drops off fairly rapidly with the distance between i_1 and i_2, we can find all significant values of \mathbf{R} within a limited pixel window. We therefore concern ourselves only with the correlations between pixels in an 11×11 window. Thus, the matrix \mathbf{R} has dimensions 121×121.

To find the whitening filter, we first compute the matrix square root of the inverse of \mathbf{R}. This results in the matrix \mathbf{g}_{wh}. The rows of this matrix are approximately the same as one another, apart from a shift. The central row, row 61, gives us a reasonable whitening filter, \mathbf{f}_{wh}. Reshaping this row to an 11×11 matrix yields the filter shown in Table 6.1 (rounded to the nearest tenth).

The system investigated here uses the E_BLIND blind embedder first introduced in System 1. The D_WHITE detection algorithm is essentially the same as the D_LC algorithm, except that it convolves the image, \mathbf{c}, and the reference mark, $\mathbf{w_r}$, by \mathbf{f}_{wh} before computing the linear correlation. The reference mark is normalized to have unit variance after filtering. Thus, the detector computes

$$z_{wh}(\mathbf{c}, \mathbf{w_r}) = \frac{1}{N}(\mathbf{f}_{wh} * \mathbf{c}) \cdot \left(\frac{\mathbf{f}_{wh} * \mathbf{w_r}}{s_{wh}}\right), \tag{6.22}$$

where \mathbf{c} is the input image, $\mathbf{w_r}$ is a predefined reference pattern of the same dimensions as \mathbf{c}, and s_{wh} is the sample standard deviation of $\mathbf{w_r} * \mathbf{f}_{wh}$. D_WHITE

Table 6.1 Whitening filter used in D_WHITE detection algorithm.

0.0	0.0	0.0	0.0	0.1	−0.2	0.1	0.0	0.0	0.0	0.0
0.0	0.0	0.0	0.0	0.1	−0.3	0.1	0.0	0.0	0.0	0.0
0.0	0.0	0.0	0.0	0.2	−0.5	0.2	0.0	0.0	0.0	0.0
0.0	0.0	0.0	0.1	0.4	−1.1	0.4	0.1	0.0	0.0	0.0
0.1	0.1	0.2	0.4	1.8	−5.3	1.8	0.4	0.2	0.1	0.1
−0.2	−0.3	−0.5	−1.1	−5.3	15.8	−5.3	−1.1	−0.5	−0.3	−0.2
0.1	0.1	0.2	0.4	1.8	−5.3	1.8	0.4	0.2	0.1	0.1
0.0	0.0	0.0	0.1	0.4	−1.1	0.4	0.1	0.0	0.0	0.0
0.0	0.0	0.0	0.0	0.2	−0.5	0.2	0.0	0.0	0.0	0.0
0.0	0.0	0.0	0.0	0.1	−0.3	0.1	0.0	0.0	0.0	0.0
0.0	0.0	0.0	0.0	0.1	−0.2	0.1	0.0	0.0	0.0	0.0

then uses this value to determine its output thus:

$$m_N = \begin{cases} 1 & \text{if } z_{wh}(\mathbf{c}, \mathbf{w_r}) > \tau_{wh} \\ no\ watermark & \text{if } -\tau_{wh} \leq z_{wh}(\mathbf{c}, \mathbf{w_r}) \leq \tau_{wh}. \\ 0 & \text{if } z_{wh}(\mathbf{c}, \mathbf{w_r}) < -\tau_{wh} \end{cases} \tag{6.23}$$

Experiment 1

To evaluate the whitening filter, we compared the performance of the E_BLIND/D_WHITE system with the E_BLIND/D_LC system of Chapter 3. Once again we ran the detector on 2,000 unwatermarked images and the same images after embedding a message, $m = 0$ or a $m = 1$.

Figure 6.10 shows the performance obtained using the D_WHITE algorithm to detect watermarks embedded with E_BLIND. This should be compared against the results obtained using a linear correlation detector without whitening (e.g., the D_LC detector) on the same watermarked images (Figure 3.6 in Chapter 3). Clearly, the degree of separation between the three cases (no watermark, watermark message = 1, and watermark message = 0) is significantly greater than with the D_LC detector.

Experiment 2

To examine the effect of whitening on false positives, we repeated Experiment 2 of the Investigation in Section 6.2.2 using the D_WHITE detector to look for three different watermarks in 20,000 images.

Figure 6.11 shows the measured random-Work false positive probabilities for three different reference marks. These results should be compared against those shown in Figure 6.5, which were obtained without whitening. Note that with whitening the false positive behaviors of the different patterns are far more similar to one another than without. Thus, whitening allows us greater freedom in the selection of our reference marks.

Figure 6.11 also reveals that the measured false positive probabilities still deviate significantly from the predicted curve. The derivation of the whitening filter assumes that the noise is drawn from a correlated *Gaussian* distribution. The experiments suggest that this assumption is not accurate. In fact, several studies have suggested that a Laplacian or generalized Gaussian distribution is a more accurate model for images [225, 192].

Experiment 3

Figure 6.12 shows the random-Work false positive probabilities when the Works are not drawn from the natural distribution. Here, the Works are

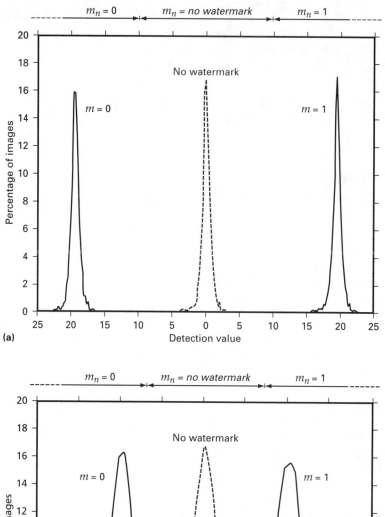

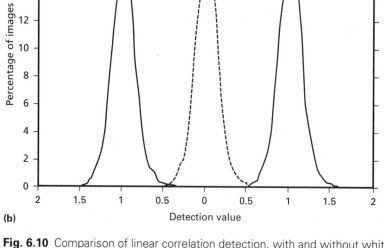

Fig. 6.10 Comparison of linear correlation detection, with and without whitening, on watermarks embedded with the E_BLIND embedder. (a) Performance of D_WHITE detection algorithm and (b) performance of D_LC detection algorithm as reported in Figure 3.6.

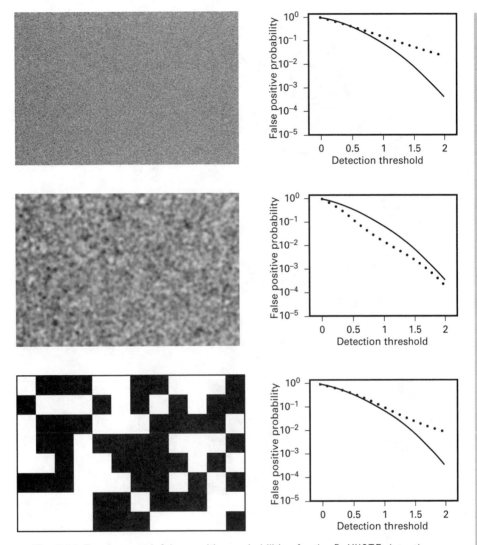

Fig. 6.11 Random-work false positive probabilities for the D_WHITE detection algorithm, using three different reference marks and various thresholds. The graphs were calculated using 2,000 randomly chosen images from the Corel database.

pure random images, with each pixel drawn independently from a uniform distribution between black and white. This is a rough simulation of the video noise mentioned earlier. The whitening filter introduces correlation into the distribution of vectors that are compared against the filtered reference mark, and the resulting false positive rates are much higher than those illustrated in Figure 6.11. Note that the graphs in these two figures show the same range of thresholds along their x-axes. This illustrates one of the risks of using a whitening filter.

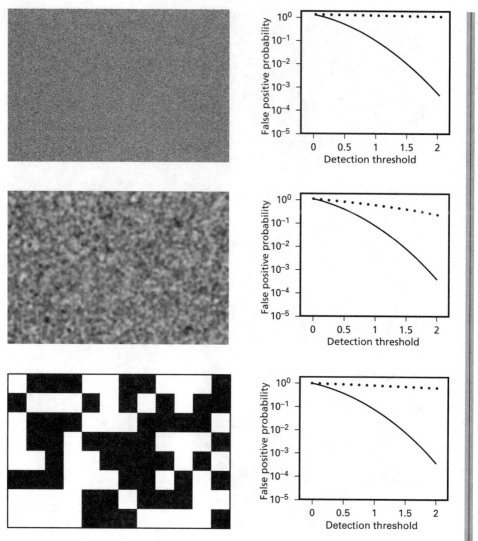

Fig. 6.12 Random-Work false positive probabilities for the D_WHITE detection algorithm, with 2,000 randomly generated (synthetic) images rather than natural images.

6.6 Analysis of Normalized Correlation

Our discussion of error models has so far focused on the use of linear correlation as a detection statistic. However, there are several other forms of related measures, as described in Section 3.5 of Chapter 3. In particular, normalized correlation, or correlation coefficient, is often preferred because of its robustness to

amplitude changes in the Work. Despite the superficial similarity between linear and normalized correlation, the shape of their detection regions is very different and results in different error rates. Because normalized correlation is one of the most common detection measures, we devote the rest of this chapter to an analysis of the false positive and false negative error to which it leads.

6.6.1 False Positive Analysis

In the Investigation of Section 6.2, we modeled the output from a linear correlator by a Gaussian distribution. Here we examine two models that can be used for normalized correlation.

The approximate Gaussian method, presented first, assumes that the output from the normalized correlation detector has a Gaussian distribution. Because normalized correlation is bounded between ±1, we expect that this model will perform poorly at the tails of the distribution. This is indeed the case. Nevertheless, if our false positive requirement is moderate (i.e., the detection threshold is far enough from these bounds), then the Gaussian approximation may be acceptable.

The second model gives an exact value for the probability of a false positive, under the assumption that the random vectors (watermarks or Works) are drawn from a radially symmetric distribution. The analysis is based on examining the intersection of conical detection regions with the surface of a sphere, both of which are in a very high dimensional space. The Investigation of the spherical method shows that random-watermark false positives are accurately predicted. For random-Work false positives, a reasonable match between theory and experiment is obtained if whitening is applied during detection.

Approximate Gaussian Method

The simplest method of estimating false positive probabilities is to assume that the distribution of detection values obtained from unwatermarked Works is Gaussian. We refer to this as the *approximate Gaussian method*.

To find the variance of the assumed Gaussian distribution, begin by considering the random-watermark false positive probability for a given Work using a linear correlation detector, with the elements of the reference mark drawn from identical, independent distributions. From Equation 6.12, the standard deviation, σ_{lc}, is

$$\sigma_{lc} = |\mathbf{v}|\sigma_{w_r}; \tag{6.24}$$

where \mathbf{v} is the extracted vector. Remember that the normalized correlation, z_{nc}, is given by

$$z_{nc} = \frac{\mathbf{v} \cdot \mathbf{w}_r}{|\mathbf{v}||\mathbf{w}_r|}, \tag{6.25}$$

with its standard deviation, σ_{nc}, being

$$\sigma_{nc} = \frac{|\mathbf{v}|\sigma_{\mathbf{w}_r}}{|\mathbf{v}||\mathbf{w}_r|}. \tag{6.26}$$

The magnitude of the reference mark is approximately

$$|\mathbf{w}_r| = \sqrt{N}\sigma_{\mathbf{w}_r}, \tag{6.27}$$

where N is the number of dimensions in mark space. Thus, the variance of the assumed Gaussian is

$$\sigma_{nc}^2 = \frac{1}{N}. \tag{6.28}$$

This leads to the following estimate of false positive probability, when the normalized correlation is tested against a threshold of τ_{nc}:

$$P_{fp} \approx \mathrm{erfc}\left(\sqrt{N}\tau_{nc}\right). \tag{6.29}$$

Investigation

An Evaluation of the Accuracy of the Approximate Gaussian Method

Here we investigate the accuracy of the random-watermark false positive probability estimated using the approximate Gaussian method. The evaluation is performed using the D_BLK_CC watermark detector, previously described in Chapter 3.

Experiments

To test the accuracy of the approximate Gaussian method for estimating random-watermark false positive probabilities, we ran the D_BLK_CC detector on three different images with one million random watermarks per image. By testing this large number of watermarks, we obtain reasonable observed false positive rates for higher thresholds, where we shall see that the approximate Gaussian approach breaks down.

Figure 6.13 shows the results. The points on the graphs show the observed false positive rates for various thresholds. The solid lines show the estimate obtained from Equation 6.29.[1] The approximate Gaussian method is

1. Note that these estimates were computed using $N = 63$, even though the D_BLK_CC detector computes its detection value from a 64-dimensional vector (an 8×8 summed block). This is because the detector uses the correlation coefficient, which is the same as normalized correlation in a space with one fewer dimension. Note also that the estimate is independent of the Work, so the solid line is the same in each of the graphs.

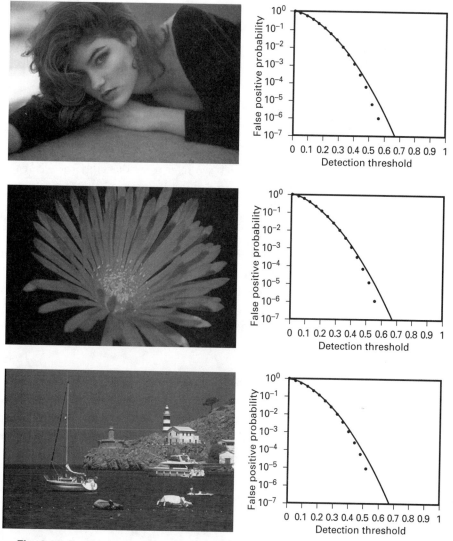

Fig. 6.13 Random-watermark false positive rates for the correlation-coefficient-based D_BLK_CC detection algorithm. Empirical results (points) are for 1,000,000 random reference marks compared against the three illustrated images, using the D_BLK_CC detector. Theoretical estimates (solid lines) are computed using the approximate Gaussian method.

reasonably accurate when the detection threshold is low. However, as the threshold exceeds 0.4, the approximate Gaussian method begins to overestimate the false positive probability. Clearly, the overestimation will become dramatic when the threshold is greater than 1, because in such a case the approximate Gaussian method yields a non-zero estimate, when in truth it is impossible for a normalized correlation value to exceed 1, whether or not a watermark

is present. Thus, if our application's requirements are strict enough that the false positive behavior must be accurately modeled at values smaller than 10^{-5}, we need a different method of estimating the false positive probability.

Spherical Method

A more precise method of estimating probability of a false positive when using normalized correlation is described in [183] and is presented in Section B.3 of Appendix B. This method, which we refer to as the *spherical method,* gives an exact value for the probability, under the assumption that the random vectors are drawn from a radially symmetric distribution. In the appendix, we derive the spherical method for the case of a random watermark, \mathbf{w}_r, and a constant Work, \mathbf{c}. That is, we assume that the probability of obtaining a given random vector, \mathbf{w}_r, depends only on the length of \mathbf{w}_r and is independent of the direction of \mathbf{w}_r. A white Gaussian distribution satisfies this assumption.

If a random N-dimensional vector is drawn from a radially symmetric distribution, the probability that its normalized correlation with some constant vector will be over a given threshold, τ_{nc}, is given exactly by [183]

$$P_{\text{fp}} = \frac{\int_0^{\cos^{-1}(\tau_{nc})} \sin^{N-2}(u)\, du}{2 \int_0^{\pi/2} \sin^{N-2}(u)\, du}. \tag{6.30}$$

Evaluating Equation 6.30 requires calculation of the integral $I_d(\theta) = \int_0^\theta \sin^d(u)\, du$, with $d = N - 2$. This integral has a closed-form solution for all

Table 6.2 Closed-form solutions for $I_d(\theta)$

d	$I_d(\theta)$
0	θ
1	$1 - \cos(\theta)$
2	$\dfrac{\theta - \sin(\theta)\cos(\theta)}{2}$
3	$\dfrac{\cos^3(\theta) - 3\cos(\theta) + 2}{3}$
4	$\dfrac{3\theta - (3\sin(\theta) + 2\sin^3(\theta))\cos(\theta)}{8}$
5	$\dfrac{4\cos^3(\theta) - (3\sin^4(\theta) + 12)\cos(\theta) + 8}{15}$
>5	$\dfrac{d-1}{d}I_{d-2}(\theta) - \dfrac{\cos(\theta)\sin^{d-1}(\theta)}{d}$

integer values of d. Table 6.2 provides the solutions for $d = 1$ through 5. When $d > 5$, the solution can be found by the recursive formula shown on the last row of the table.

As with linear correlation, there is usually a difference between random-Work and random-watermark false positive probabilities, insofar as there is usually a difference between the distributions from which Works and reference marks are drawn. The accuracy of the estimates obtained from Equation 6.30 depends on how close the distribution is to the radially symmetric ideal.

Investigation

An Evaluation of the Spherical Method

For the random-watermark false positive probability we can ensure that the distribution is radially symmetric by drawing the elements of watermark vectors independently from identical Gaussian distributions. However, for a random Work, the distribution is generally not radially symmetric. In this case, the false positive rate can become more predicable through the use of whitening.

This Investigation describes three experiments. In Experiment 1, we report on the accuracy of the spherical method for estimating the random-watermark false positive probability. Experiment 2 then measures the accuracy of the method for estimating the random-Work false positive probability. To improve the performance of this estimate, we introduce E_BLK_BLIND/D_WHITE_BLK_CC (System 12), which applies a whitening filter prior to applying the correlation coefficient detector. Experiment 3 measures the accuracy of the spherical method for estimating the random-Work false positive rate of this system.

Experiment 1

Figure 6.14 shows the measured and predicted random-watermark false positive probability using the D_BLK_CC watermark detector. Figure 6.14 plots the estimates obtained using Equation 6.30 against the results of the experiment shown in Figure 6.13. This figure illustrates a near-perfect match between prediction and observation, even at high thresholds.

Experiment 2

Next, we look at the case of estimating the random-Work false positive probability using the spherical method. Of course, in the case of random-Work false positive probabilities, the distribution is unlikely to be radially symmetric. Figure 6.15 shows the random-Work false positive rates for three different

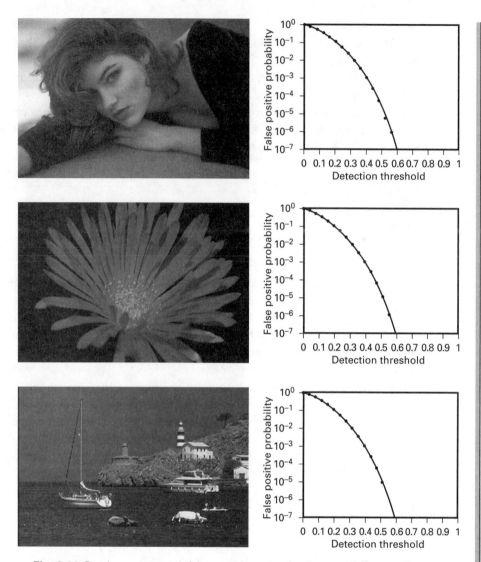

Fig. 6.14 Random-watermark false positive rates for the correlation-coefficient-based D_BLK_CC detection algorithm. Empirical results (points) are for 1,000,000 random reference marks compared against the three illustrated images, using the D_BLK_CC detector. Estimated probabilities (solid lines) are computed using the spherical method.

reference marks using the D_BLK_CC detector. These were computed by testing 20,000 images.

Again, the points show the observed false positive rates, and the solid lines show the prediction. Here we find that the observed rates are often quite different from the estimates, indicating that the distribution from which the summed 8×8 blocks are drawn is not radially symmetric.

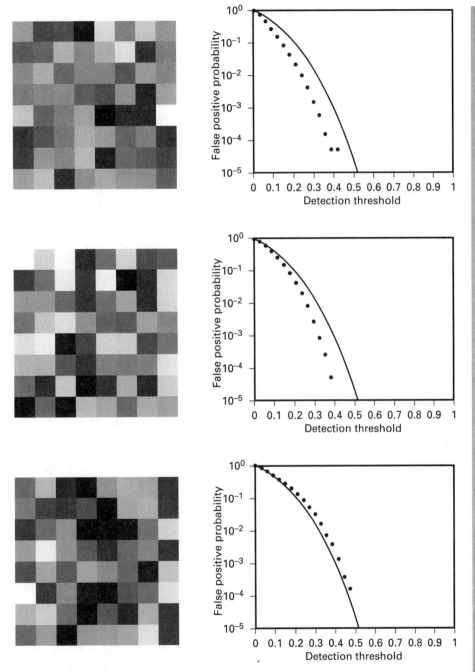

Fig. 6.15 Random-Work false positive rates for D_BLK_CC detector. Results (points) are for 20,000 images from the Corel database compared against the three illustrated reference marks using the D_BLK_CC detector. Estimated probabilities (solid lines) are computed using the spherical method.

System 12: E_BLK_BLIND/D_WHITE_BLK_CC

We can rectify the problem to some extent by using a whitening filter, as described for linear correlation. This leads to the D_WHITE_BLK_CC detection method. This is a modification of the E_BLK_BLIND/D_BLK_CC watermarking system (System 3). The only difference is that the D_WHITE_BLK_CC detector applies the whitening filter derived for the D_WHITE detection algorithm (System 11).

Recall that the extraction process used in the E_BLK_BLIND/D_BLK_CC system divides the image into 8×8 blocks, and then averages them to obtain a single 8×8 block that serves as a 64-dimensional projected vector. If the pixels in the image are uncorrelated, the elements of the extracted vector will also be uncorrelated.

Of course, the pixels in most images are not uncorrelated, but we can roughly decorrelate them by applying the whitening filter employed in the D_WHITE detector (Table 6.1). Because the summation is a linear process that preserves adjacency, we will obtain essentially the same results if we apply the filter after accumulation (with wraparound) as we would obtain by applying the filter before accumulation. Thus, the D_WHITE_BLK_CC detection algorithm begins by performing the averaging of the D_BLK_CC algorithm, to obtain an extracted 8×8 block, \mathbf{v}. It then applies the whitening filter to both the extracted block and the reference mark, $\mathbf{w_r}$, and computes the normalized correlation between them:

$$
\begin{aligned}
\mathbf{v}' &= \mathbf{f}_{wh} * \mathbf{v} - \overline{(\mathbf{f}_{wh} * \mathbf{v})} \\
\mathbf{w_r}' &= \mathbf{f}_{wh} * \mathbf{w_r} - \overline{(\mathbf{f}_{wh} * \mathbf{w_r})}.
\end{aligned}
\tag{6.31}
$$

If the detection value, $z_{cc}(\mathbf{v}', \mathbf{w_r}')$, is above a threshold, τ_{wcc}, the detector reports that a 1 was embedded. If it is below the negative of the threshold, it reports that a 0 was embedded. Otherwise, it reports that there was no watermark detected.

Because of the whitening filter, we expect the elements of \mathbf{v}' to have low correlation with one another. Because of the accumulation, we expect each element of \mathbf{v}' to be drawn from an approximately Gaussian distribution, since it is the sum of a large number of roughly uncorrelated values. Because we can assume that pixels in different locations are drawn from the same distribution, we expect the Gaussian distributions from which the elements of \mathbf{v}' are drawn to be identical. This means that \mathbf{v}' should be drawn from a distribution that is close to radially symmetric.

Experiment 3

The D_WHITE_BLK_CC system leads to random-Work false positive behavior that is much more predictable than that for D_BLK_CC. Figure 6.16 shows the

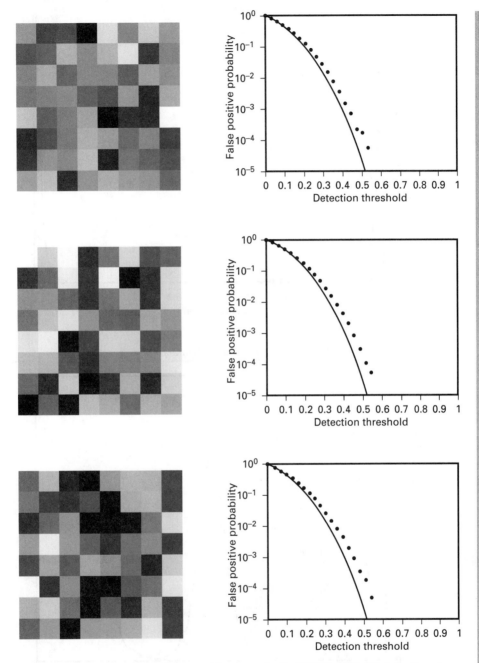

Fig. 6.16 Random-Work false positive rates for D_WHITE_BLK_CC detection algorithm. Results are for 20,000 images from the Corel database compared against the three illustrated reference marks using the D_WHITE_BLK_CC detector.

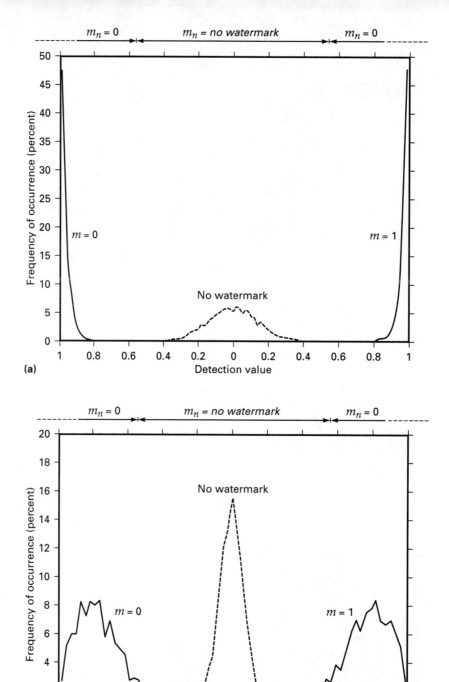

Fig. 6.17 Comparison of correlation coefficient detection, with and without whitening, on watermarks embedded with the E_BLK_BLIND embedder. (a) Performance of D_WHITE_BLK_CC detection algorithm and (b) performance of D_BLK_CC detection algorithm as reported in Figure 3.20.

false positive results when we perform the same experiment as that shown in Figure 6.15. These results are closer to the false positive rates predicted by Equation 6.30.

Figure 6.17a shows the performance of the D_WHITE_BLK_CC detector when applied to images that were marked with the E_BLK_BLIND embedder. This should be compared against Figure 3.20, which is reproduced here as Figure 6.17b. The comparison shows that applying the whitening filter significantly improves the separation between detection values from unwatermarked and watermarked images. This improvement is similar to the improvement obtained by using a whitening filter in a linear correlation system (Figure 6.10).

6.6.2 False Negative Analysis

It is difficult to make general claims about the false negative performance of a watermarking system when only its detection statistic is specified. We therefore constrain ourselves to estimating the false negative probability for a specific combination of embedder and detector, under the assumption that Works are not altered between embedding and detection. Specifically, we estimate the effectiveness of a system that employs a blind embedder and a normalized correlation detector, similar to the E_BLK_BLIND/D_BLK_CC watermarking system of System 3. The false negative analysis is based on the spherical method of analyzing false positives.

We begin by estimating the random-watermark false negative probability (i.e., the probability that a randomly selected watermark will fail to be embedded in a given Work). We assume that we have a fixed, extracted mark, $\mathbf{v_o}$, which was extracted from the Work in question, and we select a random reference mark, $\mathbf{w_r}$, from a radially symmetric distribution. We further assume that the reference mark is normalized to have unit magnitude. We then embed the reference mark with blind embedding, such that

$$\mathbf{v_w} = \mathbf{v_o} + \alpha \mathbf{w_r}, \tag{6.32}$$

where α is a constant scaling factor entered by the user. The probability of a false negative, P_{fn}, is the probability that

$$z_{\mathrm{nc}}(\mathbf{v_w}, \mathbf{w_r}) < \tau_{\mathrm{nc}}. \tag{6.33}$$

In Section B.3 of Appendix B, it is shown that the converse of P_{fn}—that is, the effectiveness (the probability of a *true positive*)—can be found by applying Equation 6.30 with a threshold higher than the detection threshold. This threshold depends on the magnitude of the vector extracted from the original Work

and the embedding strength. The resulting formula for the probability of true positives, P_{tp}, is

$$P_{tp} = \frac{\int_0^{\phi} \sin^{N-2}(u)\, du}{2 \int_0^{\pi/2} \sin^{N-2}(u)\, du}, \tag{6.34}$$

where

$$\phi = \cos^{-1}(\tau_{nc}) + \sin^{-1}\left(\frac{\alpha}{|\mathbf{v_o}|}\sqrt{1 - \tau_{nc}^2}\right). \tag{6.35}$$

Here, $|\mathbf{v_o}|$ is the magnitude of the vector extracted from the original Work, α is the embedding strength, and τ_{nc} is the detection threshold. The probability of a false negative is just $P_{fn} = 1 - P_{tp}$.

The case of random-Work false negatives is more complex. We have a specific reference mark and wish to estimate the probability that a blind embedder, using a fixed value of α, will be unable to embed this mark in a randomly selected Work. Estimating this probability is more complicated than estimating the random-watermark probability because we cannot assume that the Work is normalized to fixed magnitude. This means that whether the watermark is successfully embedded depends on both the direction and length of the vector extracted from the random Work.

If we assume that random Works are drawn from a radially symmetric distribution, and we know the probability density function for their magnitudes, we can estimate the probability of successful embedding by finding the expected value of Equation 6.34. However, as we already know that random Works are not drawn from a radially symmetric distribution (at least, without whitening), we limit the following investigation to random-watermark false negative probabilities.

Investigation

Evaluation of the Spherical Method of Estimating False Negative Rates

We used the E_BLK_BLIND/D_BLK_CC (System 3) to evaluate the accuracy of the spherical method for predicting the false negative rate.

Experiments

We embedded one million randomly generated watermarks in each of three images using the E_BLK_BLIND embedder. The embedding strength was set to a low value of $\alpha = 0.1$, so that the false negative rate would be high enough to measure. We then used the D_BLK_CC detector to measure the resulting detection value, and compared it against several detection thresholds.

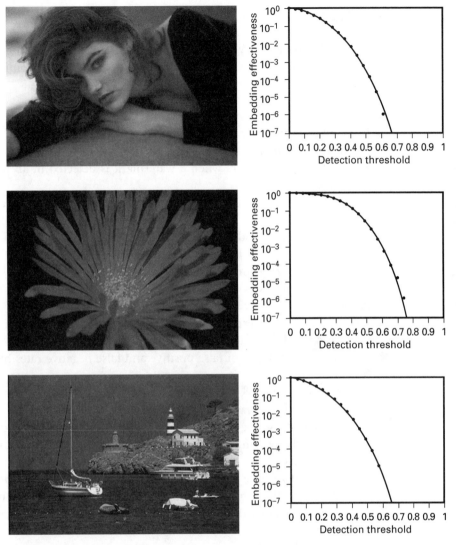

Fig. 6.18 Results of effectiveness tests on the E_BLK_BLIND/D_BLK_CC system. The points show the fraction of watermarks successfully embedded in each image. The solid lines show the predicted effectiveness obtained from Equation 6.34.

The results are shown in Figure 6.18. Here, we plot the embedding effectiveness (i.e., 1 minus the false negative rate) as a function of detection threshold. The points show the experimental data, and the curves show the prediction made using Equation 6.34. This clearly indicates that the predictions are quite accurate.

6.7 Summary

This chapter discussed the types of errors that occur in watermarking systems and how these errors can be modeled and measured. The main points of this chapter were:

- There are three main types of errors.
 - A *message error* occurs when the decoded message is not the same as the message that was embedded.
 - A *false positive* occurs when a watermark is detected in an unwatermarked Work.
 - A *false negative* occurs when a watermark is *not* detected in a watermarked Work.
- When messages are coded as binary strings, message error rates are often expressed as *bit error rates* (*BER*), which measure the frequency with which individual bits are incorrectly decoded.
- Error correction codes can be used to increase code separation, and thus decrease message error rates.
- The suitability of an error correction code depends on the watermarking application and the distortions that are anticipated.
- Various different types of false positive and false negative rates might be relevant.
 - *Random-watermark* false positives and negatives occur when a Work is fixed and the watermark is chosen at random. These are easy to analyze because the distribution of watermarks is determined by the design of the system. However, they are not necessarily relevant in most applications.
 - *Random-Work* false positives and negatives occur when the *watermark* is fixed and the *Work* is chosen at random. These are more difficult to analyze because they depend on the distribution of unwatermarked content.
- The tradeoff between false positive and false negative rates can be plotted with a *receiver operating characteristic* (or *ROC*) curve.
- It is rarely possible to plot a ROC curve using only empirical data. One or both axes must be estimated with a model.
- Many watermarking system are based on the assumption that the samples or pixels in unwatermarked content are uncorrelated. This assumption is generally incorrect.
- Application of a *whitening filter* can help decorrelate samples of a cover Work, and improve the performance of systems designed on this assumption. This was demonstrated for both linear correlation and normalized correlation systems.

- If a whitening filter is applied to signals for which it was not designed, it can *introduce* correlations and increase error rates. Thus, whitening filters must be used with caution.
- Two methods for analyzing the performance of normalized correlation detectors were presented.
 - The *approximate Gaussian* method models the distribution of detection values as a Gaussian distribution. This yields reasonable predictions at low detection thresholds, but overestimates false positive probabilities as the threshold increases toward 1.
 - The *spherical* method yields exact predictions of false positive probabilities under the assumption that random vectors are drawn from a radially symmetric distribution. It can also be used to predict random-watermark false negative probabilities for blind embedders.

Using Perceptual Models

Watermarks are supposed to be imperceptible. This raises two important questions. How do we measure a watermark's perceptibility? And how can we embed a watermark in a Work such that it cannot be perceived? In this chapter, we describe the use of perceptual models to answer these questions.

In many applications, design trade-offs prevent a watermark from being imperceptible in all conceivable Works, viewed or heard under all conditions by all observers. However, imperceptibility should not be viewed as a binary condition. A watermark may have a higher or lower level of perceptibility, meaning that there is a greater or lesser likelihood that a given observer will perceive it. Section 7.1 discusses some basic experimental methodologies for measuring this likelihood and introduces the idea of estimating perceptibility with automated perceptual models.

Any automated perceptual model must account for a variety of perceptual phenomena, the most important of which are briefly described in Section 7.2. Many models of the human auditory system (HAS) [13, 202] and the human visual system (HVS) [287, 66, 173, 274, 281] have been constructed. In Section 7.3, we describe simple models of human audition and vision.

Finally, Section 7.4 describes several ways a perceptual model can be incorporated into a watermarking system to control the perceptibility of watermarks. These range from using the model for simple adjustment of a global embedding strength to distorting the embedded mark so as to maximize detectability for a given perceptual impact. Example image watermarking techniques, using the HVS model of Section 7.3.1, are described and tested in this section.

7.1 Evaluating Perceptual Impact of Watermarks

Few, if any, watermarking systems produce watermarks that are perfectly imperceptible. However, the perceptibility of a given system's watermarks may be high or low compared against other watermarks or other types of processing, such as compression. In this section, we address the question of how to measure that perceptibility, so that such comparisons can be made. We begin with a discussion of two types of perceptibility that can be of concern.

7.1.1 Fidelity and Quality

In the evaluation of signal processing systems, there are two subtly different types of perceptibility that may be judged: *fidelity* and *quality*. Fidelity is a measure of the similarity between signals before and after processing. A high-fidelity reproduction is a reproduction that is very similar to the original. A low-fidelity reproduction is dissimilar, or distinguishable, from the original. Quality, on the other hand, is an absolute measure of appeal. A high-quality image or high-quality audio clip simply looks or sounds good. That is, it has no obvious processing artifacts. Both types of perceptibility are significant in evaluating watermarking systems.

To explore the difference between fidelity and quality, consider the example of video from a surveillance camera. The video is typically grayscale, low resolution, compressed, and generally considered to be of low *quality*. Now consider a watermarked version of this video that looks identical to the original. Clearly, this watermarked Work must also have low quality. However, because it is indistinguishable from the original, it has high *fidelity*.

It is also possible to have high quality and low fidelity. Consider a watermarking scheme that modifies the timbre of the baritone in a recording of a quartet. The watermarked Work may sound very good (i.e., have very high quality). In fact, depending on how the algorithm works, the change in the baritone's voice might actually be considered an *improvement* in quality. It would, however, be distinguishable from the original and therefore have a lower fidelity. In this case, a listener will be able to distinguish between the original and watermarked Works, but of the two, may not be able to identify the original.

For some watermarking applications, fidelity is the primary perceptual measure of concern. In these cases, the watermarked Work must be indistinguishable from the original. An artist may require this of a transaction watermark or a patient may require this of a watermark applied to his medical images. However, there are applications of watermarking for which quality, rather than fidelity, is the primary perceptual concern. After all, it is rare that the viewer/listener of a watermarked Work has access to the unwatermarked original for comparison. In these cases, the quality of a watermarked Work is required to be as high as that of the original. Thus, the important quantity is the *change* in quality due to the watermarking process.

Consideration must be given to the appropriate versions of the original and watermarked Work used in any evaluation of quality and fidelity. For example, consider a movie watermarked immediately after the telecine process (the process that digitizes the frames of the film). At this point, the image quality is extremely high. Fidelity and quality can be evaluated in the production studio, directly after the watermark is applied to the video source, but this is not the content seen by consumers. Instead, we are often shown an NTSC version of the movie, which may have also undergone lossy MPEG-2 compression along part of the broadcast channel. Thus, it may be more appropriate for quality and fidelity evaluations to take place under normal viewing conditions (i.e., after the broadcast process and on a consumer television). The International Telecommunications Union (ITU), in its guidelines for the testing of television picture quality, specifies separate testing conditions for home and laboratory assessments [181].

The importance of including the transmission channel in the evaluation is that the transmission channel can have significant effects on the perceptibility of a watermark. In some cases, the noise introduced by the channel can act to hide the watermark noise, thus making the watermark less perceptible.[1] In other cases, however, the channel can increase the perceptibility of the watermark. For example, adaptive compression schemes may devote more bits to representation of the watermark component, thus reducing the number of bits devoted to the original content of the Work and thereby reducing the quality of the compressed watermarked Work.

7.1.2 Human Evaluation Measurement Techniques

Although the claim of imperceptibility is often made in the watermarking literature, rigorous perceptual quality and fidelity studies involving human observers are rare. Some claims of imperceptibility are based on automated evaluations, discussed in Section 7.1.3. However, many claims are based on a single observer's judgments on a small number of trials. These empirical data points are not sufficient for proper perceptual evaluation or comparison of watermarking algorithms. However, the two experimental techniques described next can provide statistically meaningful evaluations.

In studies that involve the judgment of human beings, it is important to recognize that visual and auditory sensitivities can vary significantly from individual to individual. These sensitivities also change over time in any one individual. Therefore, it is common that studies involving human evaluation use a large number of subjects and perform a large number of trials. The results of a study

1. The concept of one signal (in this case the transmission noise) reducing the perceptibility of another (in this case hiding the watermark noise) is called *masking* and is discussed later in this chapter.

may be specific to the population from which the subjects are drawn (young adults, ages 18 to 25, for example).

Perhaps the most important point to note here is that the experiments are statistical in nature. Different observers will behave differently. One observer might claim to see a difference in a pair of images, whereas another observer may not. Sometimes these discrepancies are random. Other times, the discrepancies reflect the very different perceptual abilities of observers. In fact, it is well known that a small percentage of people have extremely acute vision or hearing. In the music industry these people are often referred to as *golden ears* and in the movie industry as *golden eyes,* and they are commonly employed at quality control points in the production process.

In psychophysics studies, a level of distortion that can be perceived in 50% of experimental trials is often referred to as a *just noticeable difference,* or *JND.* Even though some golden eyes or golden ears observers might be able to perceive a fidelity difference of less than one JND, this difference is typically considered the minimum that is generally perceptible. JNDs are sometimes employed as a unit for measuring the distance between two stimuli. However, while the notion of *one* JND has a fairly consistent definition (perceptible 50% of the time), multiple JNDs can be defined in various ways. Watson, in the work described in Section 7.2, defines JNDs as linear multiples of a noise pattern that produces one JND of distortion [286].

A classical experimental paradigm for measuring perceptual phenomena is the *two alternative, forced choice* (2AFC) [101]. In this procedure, observers are asked to give one of two alternative responses to each of several trial stimuli. For example, to test the quality impact of a watermarking algorithm, each trial of the experiment might present the observer with two versions of one Work. One version of the Work would be the original; the other would be watermarked. The observer, unaware of the differences between the Works, must decide which one has higher quality. In the case where no difference in quality can be perceived, we expect the responses to be random. Random choices suggest that observers are unable to identify one selection as being consistently better quality than the other. Thus, 50% correct answers correspond to zero JND, while 75% correct corresponds to one JND.

The 2AFC technique can also be used to measure fidelity. Consider an experiment in which the observer is presented with three Works. One is labeled as the original. Of the other two, one is an exact copy of the original and the other is the watermarked version. The subject must choose which of the two latter Works is identical to the original (see Figure 7.1). Again, the results are tabulated and examined statistically. Any bias in the data represents the fact that the observers could distinguish between the original and watermarked Works, and serves as a measure of the fidelity of the watermarking process.

An interesting variation on these tests is to vary the strength of the watermark during the experiment. Typically, an S-type curve is expected when the probability

Original

A

B

Fig. 7.1 A two alternative, forced choice experiment studying image fidelity. The observer is asked to choose whether image A or image B is the same as the image labeled "Original."

Table 7.1 Quality and impairment scale as defined in ITU-R Rec. 500.

Five-Grade Scale			
Quality		Impairment	
5	Excellent	5	Imperceptible
4	Good	4	Perceptible, but not annoying
3	Fair	3	Slightly annoying
2	Poor	2	Annoying
1	Bad	1	Very annoying

of correct answers is plotted against the watermark strength. Clearly, when the strength is very low, the probability that the watermark will be correctly identified is 50% (i.e., random chance). When the watermark strength is very high, the probability of a correct answer will be 100%. In the intermediate region between these two extremes, the non-zero probability of discernment indicates that some observers are able to perceive the watermark in some Works. The perceptual goal of a watermarking scheme is to keep these probabilities under some application-specific threshold.

A second, more general experimental paradigm for measuring quality allows the observers more latitude in their choice of responses. Rather than selecting one of two Works as the "better," observers are asked to rate the quality of a Work, sometimes with reference to a second Work. For example, the ITU-R Rec. 500 quality rating scale specifies a quality scale and an impairment scale that can be used for judging the quality of television pictures [181]. These scales, summarized in Table 7.1, have been suggested for use in the evaluation of image watermarking quality [150].

7.1.3 Automated Evaluation

The experimental techniques previously outlined can provide very accurate information about the fidelity of watermarked content. However, they can be very expensive and are not easily repeated. An alternative approach is the use of an algorithmic quality measure based on a perceptual model. The goal of a perceptual model is to predict an observer's response. The immediate advantages of such a system are that it is faster and cheaper to implement and, assuming the use of a deterministic model, the evaluation is repeatable, so that different methods can be directly compared. A number of perceptual models are available for judging the fidelity of watermarked Works. One in particular [274] has been proposed for use in normalizing various image watermarking techniques prior to a benchmark evaluation of robustness [151].

In practice it is very difficult to accurately predict the human judgment of perceptual fidelity, and even more difficult to predict human judgment of perceptual quality. Most of the models currently available measure fidelity, evaluating the perceptible difference between two signals. Recall, however, that high fidelity implies little change in quality. Two Works that are truly indistinguishable necessarily have the same quality.

Ideally, a perceptual model intended for automated fidelity tests should predict the results of tests performed with human observers. However, for purposes of comparing the fidelity of different watermarking algorithms, it is sufficient for the model to provide a value that is monotonically related to the results of human tests. That is, it is not necessary for the model to predict the exact results of tests performed with human observers, but simply to predict the relative performance of different algorithms in those tests. Thus, it is sufficient for the model to produce a measure of the perceptual distances between watermarked and unwatermarked Works, without calibrating those distances in terms of expected test results.

When we refer to a "perceptual model," we mean more precisely a function, $D(c_o, c_w)$, that gives a measure of the distance between an original Work, c_o, and a watermarked Work, c_w. One of the simplest distance functions is the mean squared error (MSE) function discussed in Chapter 3. This is defined as

$$D_{mse}(c_o, c_w) = \frac{1}{N} \sum_{i}^{N} (c_w[i] - c_o[i])^2. \tag{7.1}$$

Although MSE is often used as a rough test of a watermarking system's fidelity impact, it is known to provide a poor estimate of the true fidelity [127, 96].

A perceptual model such as MSE can err by either underestimating or overestimating the perceptibility of the difference between two Works. For example, suppose we interpret MSE as indicating the visual impact of adding white noise. Then, as shown in Figure 7.2, MSE generally underestimates the perceptual difference when that difference is a low-frequency signal. The figure shows an image and two modified versions of it. The top modified image was produced by adding white noise to the original. The bottom image was produced by adding low-pass-filtered noise. MSE, as a perceptual model, suggests that these two images should be perceptually equivalent, in that the two images have the same MSE compared to the original. However, clearly the low-pass signal is more visible.

On the other hand, Figure 7.3 shows a case in which MSE overestimates perceptual distance. Here, the second modified image was produced by simply shifting the original down and to the right. Although the original and the shifted images are almost indistinguishable, the MSE between them is very large. For comparison, the top modified image was produced by adding enough white noise to get the same MSE. Clearly, MSE is wrong in predicting that these two versions of the original should be perceptually equivalent.

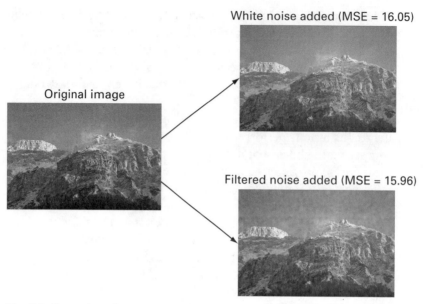

Fig. 7.2 Illustration of a case in which mean squared error (MSE) underestimates perceptual distance.

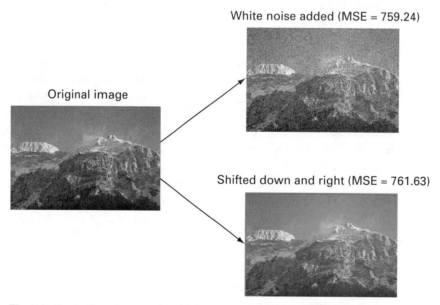

Fig. 7.3 Illustration of a case in which mean squared error (MSE) overestimates perceptual distance.

Care must be taken in choosing the perceptual model used for fidelity evaluations and in interpreting the results of such a model. The issues involved in model selection include the trade-off between accuracy and computational cost, and the fact that the accuracy of any particular model may be limited to a class of distortions. For example, like MSE, many visual models overestimate the perceptual impact of slight geometric transformations (rotation, scaling, translation, skew, and so on). A watermarking algorithm that introduces geometric transformations, such as [177], is bound to perform poorly when measured with such a model, even if the changes are completely imperceptible.

7.2 General Form of a Perceptual Model

The problem with the MSE measure is that it treats changes in all terms of the Work equally. However, human perception mechanisms are not uniform. For example, the human auditory system (HAS) responds differently depending on the frequency and loudness of the input. Similarly, the response of the human visual system (HVS) varies with the spatial frequency, brightness, and color of its input. This suggests that all components of a watermark may not be equally perceptible.

Perceptual variations can be measured, and models constructed to account for them. A perceptual model generally attempts to account for three basic types of phenomena: *sensitivity, masking,* and *pooling.* In this section, we briefly explain what is meant by these three terms.

7.2.1 Sensitivity

Sensitivity refers to the ear's or eye's response to direct stimuli. In experiments designed to measure sensitivity, observers are presented with isolated stimuli and their perception of these stimuli is tested. For example, it is common to measure the minimum sound intensity required to hear a particular frequency and to repeat this over a range of frequencies. Although there are many different aspects of a signal to which the eye or ear is sensitive, the primary stimuli or characteristics measured are frequency and loudness (or brightness). Color and orientation are also significant in image and video data.

Frequency Sensitivity

The responses of both the HAS and the HVS to an input signal are frequency dependent. In hearing, variations in frequency are perceived as different tones. Figure 7.4 shows one model of the ear's sensitivity as a function of frequency [269]. The graph gives the minimum audible sound level, which is the reciprocal of sensitivity, for each frequency. This curve indicates that the ear is most sensitive to frequencies around 3 kHz and sensitivity declines at very low (20 Hz) and very high (20 kHz) frequencies.

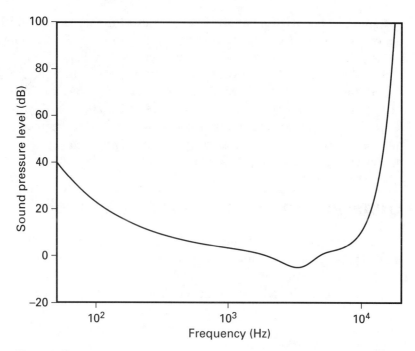

Fig. 7.4 Frequency response of the human ear based on the Terhardt model [269]. This curve represents the absolute threshold, or quiet threshold, for an average young listener with acute hearing.

In vision, there are three forms of frequency response. One is to *spatial* frequencies, a second is to *spectral* frequencies, and the third is to *temporal* frequencies.

Spatial frequencies are perceived as patterns or textures. The spatial frequency response is usually described by the sensitivity to luminance contrast (i.e., changes in luminance) as a function of spatial frequency. This is called the contrast sensitivity function (CSF), one model of which is illustrated in Figure 7.5 [178]. The figure clearly implies that we are most sensitive to luminance differences at mid-range frequencies and that our sensitivity decreases at lower and higher frequencies. This is analogous to the human auditory system.

Two-dimensional spatial frequency patterns can be represented by their magnitude and orientation. It has been shown that the sensitivity of the eye is not only dependent on frequencies of different patterns but on their orientations [36, 37, 265]. In particular, the eye is most sensitive to vertical and horizontal lines and edges in an image and is least sensitive to lines and edges with a 45-degree orientation.

Spectral frequencies are perceived as colors. The lowest level of color vision consists of three separate color systems [52]. The normal responses of each of these systems are shown in Figure 7.6. The low-frequency response, often called

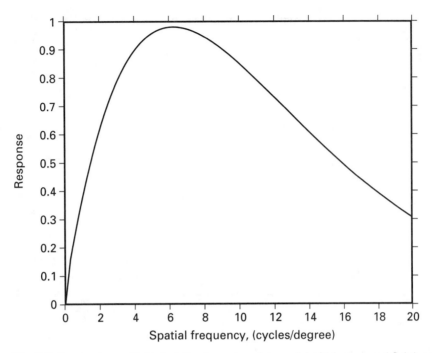

Fig. 7.5 Contrast sensitivity function based on the model of Mannos and Sakrison [178]. This curve represents the reciprocal of the minimum spatial sinusoidal amplitude, at each frequency, at which the variation is perceived.

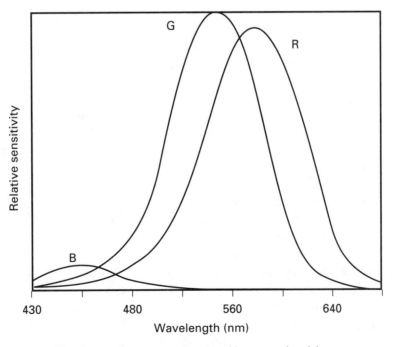

Fig. 7.6 The three color systems in normal human color vision.

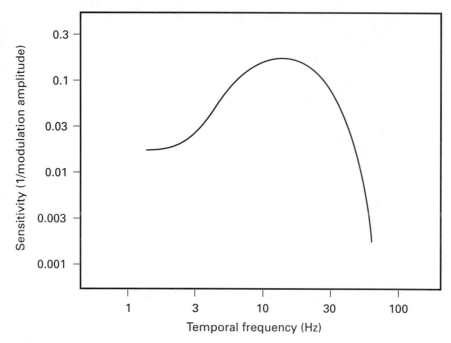

Fig. 7.7 This curve shows the measured sensitivity of the HVS to temporal sinusoidal variation. The data represents one of a family of curves given in [136]. The sensitivity is the reciprocal of the minimum temporal sinusoidal amplitude, at each frequency, at which the variation is perceived. For a more detailed discussion of this experiment, see [136] or [52].

the blue channel, is shown to be significantly lower than the other two channels. For this reason, several color watermarking systems place a large proportion of the watermark signal in the blue channel of an RGB image [109, 238].

Temporal frequencies are perceived as motion or flicker. Figure 7.7 shows the result of an experiment measuring the eye's response to various temporal frequencies [136]. The result shows that sensitivity falls off very rapidly for frequencies above 30 Hz. This is why television and cinema frame rates do not exceed 60 frames per second.

Loudness/Brightness Sensitivity

A number of studies of human hearing have measured the minimum intensity change detectable as a function of intensity level [35]. Although the experimental approaches can differ, the general result is that we are able to discern smaller changes when the average intensity is louder (i.e., the human ear is more sensitive to changes in louder signals than in quieter signals).

The opposite is true of the eye, which is less sensitive to brighter signals. Brightness sensitivity is nonlinear [52] and has been modeled with a log relationship [102, 253], cube root relationship [178], and with more complicated models [66].

It is a common practice in image processing to compensate for this nonlinearity prior to the application of linear processes.

7.2.2 Masking

Context affects perception. Thus, although we might be able to hear an isolated tone at some particular sound intensity, this tone may become completely inaudible if a second tone at a nearby frequency is louder. Similarly, a texture that is easy to see in isolation might be difficult to see when added to a highly textured image. That is, the presence of one signal can hide or mask the presence of another signal. Masking is a measure of an observer's response to one stimulus when a second "masking" stimulus is also present.

Figure 7.8 shows an original image and the result of adding a uniform noise pattern to it. Although the noise is uniform, its visibility within the image is very non-uniform and is clearly dependent on the local image structure. In the relatively flat, homogeneous regions of the sky, the noise is clearly visible. In comparison, in the highly textured mountains, the noise is almost completely invisible.

There are many masking phenomena. In vision, two principal cases are frequency masking, in which the presence of one frequency masks the perception of another, and brightness masking, in which the local brightness masks contrast changes. In audio, there exists similar frequency and loudness masking conditions. In addition, temporal masking also occurs in which the perception of a sound may be masked by a previous sound or even by a future sound.

7.2.3 Pooling

Sensitivity and masking models can be used to provide an estimate of the perceptibility of a change in a particular characteristic (e.g., a single frequency). However, if multiple frequencies are changed rather than just one, we need to know how to combine the sensitivity and masking information for each frequency. In a model of perceptual distance, combining the perceptibilities of separate distortions gives a single estimate for the overall change in the Work. This is known as *pooling*. It is common to apply a formula of the form

$$D(\mathbf{c_o}, \mathbf{c_w}) = \left(\sum_i |\mathbf{d}[i]|^p \right)^{\frac{1}{p}}, \tag{7.2}$$

where $\mathbf{d}[i]$ is an estimate of the likelihood that an observer will notice the difference between $\mathbf{c_o}$ and $\mathbf{c_w}$ in an individual parameter, such as a temporal sample, spatial pixel, or Fourier frequency coefficient. Equation 7.2 is often referred to as a *Minkowski summation* or an L_p-*norm*. In the case of audio, a linear summation, with $p = 1$, may be appropriate, whereas for images a value of $p = 4$ is more typical.

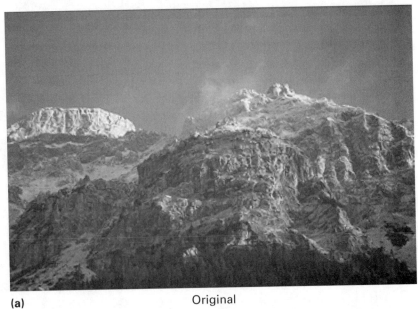

(a) Original

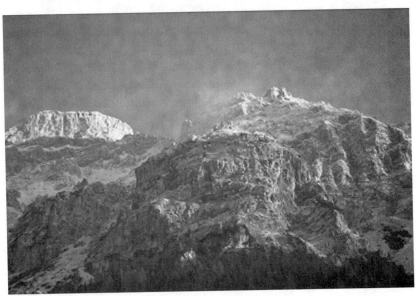

(b) Watermarked

Fig. 7.8 A low-frequency watermark pattern has been embedded into an image (a) by the E_BLIND embedding algorithm, resulting in a watermarked image (b). The watermark is plainly visible in the relatively flat regions of the image (sky) but is well masked in the textured areas (mountains).

7.3 Two Examples of Perceptual Models

Using the ideas of sensitivity, masking, and pooling, we now describe two perceptual models. The first is due to Watson [286] and is a model for measuring visual fidelity. The second is an audio model that is a simplification of the MPEG-1 Layer 1 lossy audio compression standard [129].

Watson describes a perceptual model that tries to estimate the number of JNDs between images. This model is far better than MSE at estimating the perceptual effects of noise added to images. For the two noisy images of Figure 7.2, it gives distances of 38.8 and 158.8, respectively, thus reflecting the difference in perceptual fidelity. However, this model still relies on proper synchronization and overestimates the effect of shifts. It also underestimates the effect of certain blocking artifacts.

The MPEG-1 Layer 1 model does not try to estimate the number of JNDs between audio signals. Instead, it tries to identify those frequency components that are perceptually insignificant (i.e., the coefficients that are below the threshold of hearing). This model can be used in watermarking to identify the components that may be replaced with watermark data.

Although the two models measure different perceptual properties, both models have been used as the basis for watermarking algorithms [216, 24, 261, 93]. Later in this chapter, we use Watson's model as part of a number of investigations.

7.3.1 Watson's DCT-based Visual Model

This model estimates the perceptibility of changes in individual terms of an image's block DCT (explained in the following), and then pools those estimates into a single estimate of perceptual distance, $D_{wat}(\mathbf{c_o}, \mathbf{c_w})$, where $\mathbf{c_o}$ is an original image and $\mathbf{c_w}$ is a distorted version of $\mathbf{c_o}$. Although this model, being block based, is not ideal for watermarking, we describe it here because it serves as a simple illustration of the ideas previously discussed.

Perceptual models can be based on a variety of signal representations. Watson's model uses the *block DCT transform,* which proceeds by first dividing the image into disjoint 8×8 blocks of pixels. If our image is denoted by \mathbf{c}, we denote the i, j^{th} pixel in block number k by $c[i, j, k]$, $0 \le i, j \le 7$. Each of these blocks is then transformed into the DCT domain, resulting in the block DCT of the image, \mathbf{C}. By $\mathbf{C}[i, j, k]$, $0 \le i, j \le 7$, we denote one term of the DCT of the k^{th} block. $\mathbf{C}[0, 0, k]$ is the DC term (i.e., the mean pixel intensity in the block). This transform generally concentrates the image energy into the low-frequency coefficients of each block.

Watson chose to base his model on the block DCT domain because he intended it for use in JPEG image compression. JPEG compresses images by converting them to the block DCT domain and quantizing the resulting terms according

to frequency-dependent step sizes. Using Watson's model to estimate percepti-bility of the resulting quantization noise, it is possible to adapt the quantization step sizes to the specific characteristics of each image. However, we intend to use the model for evaluating and controlling watermark embedding algorithms. Therefore, we describe it here without further reference to JPEG.

Watson's model consists of a sensitivity function, two masking components based on luminance and contrast masking, and a pooling component.

Sensitivity

The model defines a frequency sensitivity table, \mathbf{t}. Each table entry, $\mathbf{t}[i, j]$, is approximately the smallest magnitude of the corresponding DCT coefficient in a block that is discernible in the absence of any masking noise (i.e., the amount of change in that coefficient that produces one JND). Thus, a smaller value indicates that the eye is more sensitive to this frequency. This sensitivity table is a function of a number of parameters, including the image resolution and the distance of an observer to the image. It is derived in [3]. In the implementation of this perceptual model for the examples in this chapter, a set of parameter values has been chosen. The resulting frequency sensitivity table is shown as Table 7.2.

Luminance Masking

Luminance adaptation refers to the fact that a DCT coefficient can be changed by a larger amount before being noticed if the average intensity of the 8×8 block is brighter. To account for this, Watson's model adjusts the sensitivity table, $\mathbf{t}[i, j]$, for each block, k, according to the block's DC term. The luminance-masked threshold, $\mathbf{t_L}[i, j, k]$, is given by

$$\mathbf{t_L}[i, j, k] = \mathbf{t}[i, j](\mathbf{C_o}[0, 0, k]/C_{0,0})^{a_T}, \tag{7.3}$$

where a_T is a constant with a suggested value of 0.649, $\mathbf{C_o}[0, 0, k]$ is the DC coefficient of the k^{th} block in the original image, and $C_{0,0}$ is the average of the DC coefficients in the image. Alternatively, $C_{0,0}$ may be set to a constant value representing the expected intensity of images.

Table 7.2 DCT frequency sensitivity table.

1.40	1.01	1.16	1.66	2.40	3.43	4.79	6.56
1.01	1.45	1.32	1.52	2.00	2.71	3.67	4.93
1.16	1.32	2.24	2.59	2.98	3.64	4.60	5.88
1.66	1.52	2.59	3.77	4.55	5.30	6.28	7.60
2.40	2.00	2.98	4.55	6.15	7.46	8.71	10.17
3.43	2.71	3.64	5.30	7.46	9.62	11.58	13.51
4.79	3.67	4.60	6.28	8.71	11.58	14.50	17.29
6.56	4.93	5.88	7.60	10.17	13.51	17.29	21.15

Fig. 7.9 Relative luminance-masking thresholds for Figure 7.8a. Bright areas indicate blocks with high luminance-masking values.

Equation 7.3 indicates that brighter regions of an image will be able to absorb larger changes without becoming noticeable. This is illustrated in Figure 7.9, which shows the luminance-masking values for the image of Figure 7.8a.

Contrast Masking

The luminance-masked threshold, $t_L[i, j, k]$, is subsequently affected by contrast masking. Contrast masking (i.e., the reduction in visibility of a change in one frequency due to the energy present in that frequency) results in a masking threshold, $s[i, j, k]$, given by

$$s[i, j, k] = \max \left\{ t_L[i, j, k], |C_o[i, j, k]|^{w[i,j]} t_L[i, j, k]^{1-w[i,j]} \right\}, \tag{7.4}$$

where $w[i, j]$ is a constant between 0 and 1 and may be different for each frequency coefficient. Watson uses a value of $w[i, j] = 0.7$ for all i, j. The final thresholds, $s[i, j, k]$, estimate the amounts by which individual terms of the block DCT may be changed before resulting in one JND. We refer to these thresholds as *slacks*. Figure 7.10 shows the slacks computed for Figure 7.8a.

Pooling

To compare an original image, c_o, and a distorted image, c_w, we first compute the differences between corresponding DCT coefficients, $e[i, j, k] = C_w[i, j, k] - C_o[i, j, k]$. We then scale these differences by their respective slacks, $s[i, j, k]$, to obtain the perceptible distance, $d[i, j, k]$, in each term:

$$d[i, j, k] = \frac{e[i, j, k]}{s[i, j, k]}. \tag{7.5}$$

Fig. 7.10 Relative masking thresholds, or *slacks,* for Figure 7.8a. The brightness of each pixel here is proportional to the slack of the corresponding block-DCT coefficient.

Thus, $\mathbf{d}[i, j, k]$ measures the error in the i, j^{th} frequency of block k as a fraction or multiple of one JND.

The individual errors computed in Equation 7.5 must be combined or pooled into a single perceptual distance, $D_{\text{wat}}(\mathbf{c_o}, \mathbf{c_w})$. Watson employs two forms of pooling. The first combines the errors across blocks, and the second combines the errors over the different frequencies within blocks. However, his suggested exponent for the L_p-norm is the same for both classes of errors. Therefore, the two forms of pooling can be combined into the single equation

$$D_{\text{wat}}(\mathbf{c_o}, \mathbf{c_w}) = \left(\sum_{i, j, k} |\mathbf{d}[i, j, k]|^p \right)^{\frac{1}{p}}, \tag{7.6}$$

where Watson recommends a value of $p = 4$.

7.3.2 A Perceptual Model for Audio

The audio model presented here, which is used for watermarking in [261, 93], provides a measure of the threshold of hearing in the presence of a given audio signal. For each frequency, the model estimates the minimum sound energy needed to be perceived. These estimates can be used to predict whether or not a given change in a given frequency will be audible.

To obtain the thresholds of hearing, we first partition the signal into overlapping *frames* or *windows.* This is usually accomplished using a Hamming or Hanning window [105] as a filtering step. Each audio frame, $\mathbf{c}[t]$, is then analyzed independently in the Fourier domain, applying sensitivity and frequency

masking functions to obtain an estimate, $\mathbf{t}[f]$, of the minimum sound energy needed for an observer to discern a tone at each frequency, f. Although in [261, 93] no attempt is made to pool the results into a single measure of overall perceptibility, we include a brief discussion of how pooling might be performed.

Sensitivity

Sound pressure level (SPL) measures the intensity of sound, in decibels (dB), relative to a reference intensity of 20 μ Pascals,[2] as

$$SPL = 20 \log_{10} \frac{p}{20}, \tag{7.7}$$

where p is the sound pressure of the stimulus in Pascals. The *absolute threshold of hearing* is defined in db SPL as the minimum intensity needed in a pure tone for it to be detected by a human in a noiseless environment. The absolute threshold of hearing was previously illustrated in Figure 7.4 and can be modeled by the function

$$T_q(f) = 3.64 \left(\frac{f}{1000} \right)^{-0.8} - 6.5 \exp^{-0.6(f/1000-3.3)^2} + 10^{-3} \left(\frac{f}{1000} \right)^4. \tag{7.8}$$

The threshold, $T_q(f)$, is approximately the magnitude of the smallest change discernible in a quiet environment.

Masking

The ear can be modeled as a series of overlapping bandpass filters. These filters are characterized by their *critical bandwidth*. The critical bandwidth is characterized as follows. Consider a narrow-band noise source that we perceive with a certain loudness. If the bandwidth of the noise source is increased, the perceived loudness will remain constant until the bandwidth exceeds the critical bandwidth, at which point we perceive an increase in loudness. The critical bandwidth varies with frequency measured in hertz. It is common to model the ear by a series of discrete critical bands, which we denote by z, where $1 \leq z \leq Z_t$ and Z_t is the total number of critical bands. These discrete critical bands are tabulated in Table 7.3.

The threshold in each critical band is a function of the apparent energy in that band and whether the frame sounds like noise or a tone. The apparent energy in each band depends on the real energy in a neighborhood of bands. Thus, to determine the masking threshold in each frequency, we must

1. determine the energy in each critical band
2. determine the *apparent* energy in each critical band due to the spread of energy from one critical band to another
3. determine whether the current audio frame is noise-like or tone-like
4. determine the masking threshold

2. One Pascal is equivalent to one Newton per square meter (N/m^2).

Table 7.3 Critical band frequencies, taken from [202].

z	Center freq. in Hertz	Bandwidth L[z]–H[z]	z	Center freq. in Hertz	Bandwidth L[z]–H[z]	z	Center freq. in Hertz	Bandwidth L[z]–H[z]
1	50	–100	10	1,175	1,080–1,270	19	4,800	4,400–5,300
2	150	100–200	11	1,370	1,270–1,480	20	5,800	5,300–6,400
3	250	200–300	12	1,600	1,480–1,720	21	7,000	6,400–7,700
4	350	300–400	13	1,850	1,720–2,000	22	8,500	7,700–9,500
5	450	400–510	14	2,150	2,000–2,320	23	10,500	9,500–12,000
6	570	510–630	15	2,500	2,320–2,700	24	13,500	12,000–15,500
7	700	630–770	16	2,900	2,700–3,150	25	19,500	15,500–
8	840	770–920	17	3,400	3,150–3,700			
9	1,000	920–1,080	18	4,000	3,700–4,400			

The energy present in each critical band, $\mathbf{B}[z]$, is given by

$$\mathbf{B}[z] = \sum_{f=\mathbf{L}[z]}^{\mathbf{H}[z]} |\mathbf{C}[f]|, \tag{7.9}$$

where $\mathbf{L}[z]$ and $\mathbf{H}[z]$ are the lower and upper frequencies in critical band z, given in Table 7.3, and $|\mathbf{C}[f]|$ is the magnitude of frequency f in the spectrum, \mathbf{C}.

The spreading of energy across critical bands is modeled by the *basilar membrane spreading function*, $SF(z)$,

$$SF(z) = 15.81 + 7.5(z + 0.474) - 17.5\sqrt{1 + (z + 0.474)^2}. \tag{7.10}$$

The apparent energy per critical band after spreading, $\mathbf{B_a}[z]$, is given by

$$\mathbf{B_a}[z] = \sum_{z'=z-z_0}^{z+z_1} \mathbf{B}[z - z'] SF(z'), \tag{7.11}$$

where z_0 and z_1 represent the extent of the neighborhood over which spreading is significant.

Masking depends not just on the magnitude of the apparent energy in a critical band but on whether the energy is predominantly noise-like or tone-like. To determine how noise-like or tone-like the audio frame is, we next calculate the *spectral flatness measure*, SFM_{db}, as

$$SFM_{db} = 10 \log_{10} \left(\frac{\left[\prod_{z=1}^{Z_t} \mathbf{B_a}[z] \right]^{\frac{1}{Z_t}}}{\frac{1}{Z_t} \sum_{z=1}^{Z_t} \mathbf{B_a}[z]} \right) = \frac{\mu_g}{\mu_a}, \tag{7.12}$$

where μ_g and μ_a are, respectively, the geometric and arithmetic means of the power spectral density in each critical band. From the spectral flatness measure,

a "coefficient of tonality," α, is derived:

$$\alpha = \min\left(\frac{SFM_{db}}{-60}, 1\right). \tag{7.13}$$

When α is close to 1, the audio window is tone-like; whereas if α is close to 0, the window is noise-like. The coefficient of tonality is then used to calculate an offset, $\mathbf{O}[z]$, given by

$$\mathbf{O}[z] = \alpha(14.5 + z) + (1 - \alpha)5.5. \tag{7.14}$$

The apparent energy in each critical band, $\mathbf{B_a}[z]$, is converted to decibels and the offset, $\mathbf{O}[z]$, is subtracted to obtain the masking in that band. Thus, the threshold in dB is

$$\mathbf{t_{db}}[z] = 10\log_{10}\mathbf{B_a}[z] - \mathbf{O}[z], \tag{7.15}$$

or in Pascals,

$$\mathbf{t_{SPL}}[z] = 10^{\mathbf{t_{db}}[z]/10}. \tag{7.16}$$

To determine how much each frequency, f, within a critical band can be altered, $\mathbf{t_{SPL}}[z]$ is normalized by the number of discrete frequencies in the corresponding band. Thus, the normalized detection threshold, $\mathbf{t_n}[f]$, is given by

$$\mathbf{t_n}[f] = \frac{\mathbf{t_{SPL}}[z_f]}{N_{z_f}}, \tag{7.17}$$

where z_f is the critical band that contains frequency f, and N_{z_f} is the number of points in the critical band.

The final masking threshold, $\mathbf{t}[f]$, is obtained by comparing the normalized threshold, $\mathbf{t_n}[f]$, with the threshold of absolute hearing, $\mathbf{t_q}[f]$, as

$$\mathbf{t}[f] = \max(\mathbf{t_n}[f], \mathbf{t_q}[f]). \tag{7.18}$$

Pooling

At this point, we have the masking threshold available in each frequency. This is the minimum sound pressure level discernible. If the actual energy, $|\mathbf{C}[f]|$, present at a frequency, f, is below this threshold, $\mathbf{t}[f]$, then it is inaudible. In this case, the signal, $|\mathbf{C}[f]|$, can be altered provided that the modified value does not exceed the masking threshold. If the actual energy present exceeds the corresponding masking threshold, this model cannot indicate by how much the value can be indiscernibly changed.[3] Because the changes to one frequency

3. In [261, 93], this model is used by a watermark embedder to identify all perceptibly insignificant frequencies (i.e., those frequencies for which $|\mathbf{C}[f]| \leq \mathbf{t}[f]$). The embedder then replaces these values with a watermark signal. Clearly such a procedure will not be robust to lossy compression, but may be quite practical for certain applications, particularly authentication.

are independent from changes to other frequencies, this is equivalent to pooling with an L_∞-norm.

The audio model we have described here is relatively simple. Other models are possible, including models that estimate the maximum allowable change in a frequency, even when the energy in that frequency exceeds the masking threshold. In these circumstances, other forms of pooling are appropriate. For example, [13] suggests a L_1-norm or simple summation.

7.4 Perceptually Adaptive Watermarking

So far, this chapter has focused on perceptual models designed to measure the perceptibility of embedded watermarks. Of course, we would like to use these models to not only measure the perceptibility of marks once they are embedded but to *control* that perceptibility during the embedding process. Watermarking systems that attempt to shape the added pattern according to some perceptual model are generally referred to as *perceptually adaptive* systems. We now turn to the problem of how such systems can be created.

The simplest use of a perceptual model during embedding is for automatic adjustment of the embedding strength to obtain a particular perceptual distance. We begin this section with an example image watermark embedding method, E_PERC_GSCALE, which uses Watson's model to decide on a global embedding strength, α. The performance of this algorithm is used as a benchmark for comparison against the methods presented in the remainder of the section.

A more sophisticated use of perceptual modeling is to locally scale (or *perceptually shape*) the watermark, attenuating some areas and amplifying others, so that the watermark is better hidden by the cover Work. In Section 7.4.1, we discuss a straightforward embedding method, which multiplies each term of the watermark reference pattern by a value computed with a perceptual model. We follow this, in Section 7.4.2, with a discussion of optimal and near-optimal ways of using perceptual modeling in correlation-based watermarking systems.

Investigation

Perceptually Limited Embedding

Perceptually limited embedding describes a technique for setting the embedding strength parameter to limit the perceptual distortion introduced. We can refer to this process as a global scaling of the message pattern. This terminology will be useful when we introduce local scaling in Section 7.4.1.

System 13: E_PERC_GSCALE

The E_PERC_GSCALE algorithm is a simple modification of the E_BLIND embedding algorithm of Chapter 3 (System 1), in which the embedding strength, α, is adjusted to obtain a fixed perceptual distance, D_{target}, as measured by Watson's perceptual model. Thus, the watermarked Work will be given by

$$\mathbf{c_w} = \mathbf{c_o} + \mathbf{w_a}, \tag{7.19}$$

where $\mathbf{c_o}$ is the original unwatermarked Work and $\mathbf{w_a}$ is the added pattern. The added pattern is given by $\mathbf{w_a} = \alpha\mathbf{w}_m$, where \mathbf{w}_m is a message pattern given by

$$\mathbf{w}_m = \begin{cases} \mathbf{w_r} & \text{if } m = 1 \\ -\mathbf{w_r} & \text{if } m = 0 \end{cases}, \tag{7.20}$$

where $\mathbf{w_r}$ is a reference pattern.

The perceptual distance between $\mathbf{c_w}$ and $\mathbf{c_o}$, as measured by Watson's model, $D_{wat}(\mathbf{c_o}, \mathbf{c_w})$, is a linear function of α. To see this, let $\mathbf{C_w}$, $\mathbf{C_o}$, and \mathbf{W}_m be the block DCT transforms of $\mathbf{c_w}$, $\mathbf{c_o}$, and \mathbf{w}_m, respectively. Because the block DCT is a linear transform, we have

$$\mathbf{C_w} = \mathbf{C_o} + \alpha\mathbf{W}_m. \tag{7.21}$$

According to the pooling function used in Watson's model (Equation 7.6), the perceptual distance between $\mathbf{c_w}$ and $\mathbf{c_o}$ is estimated as

$$D_{wat}(\mathbf{c_o}, \mathbf{c_w}) = \sqrt[4]{\sum_{i,j,k}\left(\frac{\mathbf{C_w}[i,j,k] - \mathbf{C_o}[i,j,k]}{\mathbf{s}[i,j,k]}\right)^4}, \tag{7.22}$$

where \mathbf{s} is an array of slacks based on estimated sensitivity functions of the eye and the masking properties of $\mathbf{c_o}$. Substituting $\alpha\mathbf{W_m}[i,j,k]$ for $\mathbf{C_w}[i,j,k] - \mathbf{C_o}[i,j,k]$ gives

$$D_{wat}(\mathbf{c_o}, \mathbf{c_w}) = \sqrt[4]{\sum_{i,j,k}\left(\frac{\alpha\mathbf{W}_m[i,j,k]}{\mathbf{s}[i,j,k]}\right)^4} \tag{7.23}$$

$$= \alpha\sqrt[4]{\sum_{i,j,k}\left(\frac{\mathbf{W_m}[i,j,k]}{\mathbf{s}[i,j,k]}\right)^4} \tag{7.24}$$

$$= \alpha\, D_{wat}(\mathbf{c_o}, \mathbf{c_o} + \mathbf{w}_m). \tag{7.25}$$

Thus, to set $D_{wat}(\mathbf{c_o}, \mathbf{c_w})$ equal to a desired perceptual distance, D_{target}, we obtain α as

$$\alpha = \frac{D_{target}}{D_{wat}(\mathbf{c_o}, \mathbf{c_o} + \mathbf{w_r})}. \tag{7.26}$$

In practice, round-off and clipping can cause watermarks embedded with this α to have different numbers of JNDs. To mitigate this problem, we perform an exhaustive search of values between 0.2α and 1.1α, looking for the one that, with round-off and clipping, yields the closest value to the desired number of JNDs.

Experiments

Using this embedding algorithm, we embedded messages of 0 and 1 in 2,000 images with a white-noise reference pattern and $D_{\text{target}} = 4$. The distribution of perceptual distances between the watermarked and unwatermarked versions of these images, as measured by Watson's model, is shown in Figure 7.11. This shows that the algorithm achieved a tight distribution around a distance of 4. The deviations from this distance result from round-off and clipping errors.

The distribution of linear correlations between the watermarked images and the reference pattern is shown in Figure 7.12. Note that at this fidelity constraint the algorithm achieves very poor separation between the detection values for watermarked and unwatermarked images. These values are

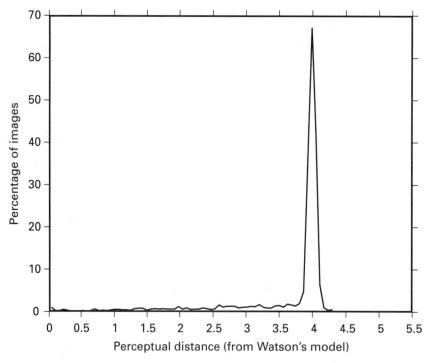

Fig. 7.11 Histogram of perceptual distances obtained using the E_PERC_GSCALE embedding algorithm, with a target perceptual distance of 4. Results of test on 2,000 images.

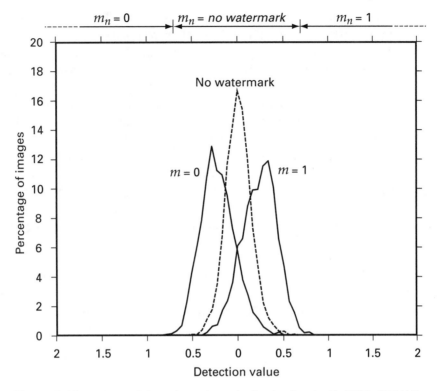

Fig. 7.12 Histograms of detection values obtained using the E_PERC_GSCALE embedder with a target perceptual distance of 4. Results of test on 2,000 images.

considerably worse than values achieved (with the same limit on perceptual distance) by embedding algorithms developed in the following sections. The E_PERC_GSCALE algorithm and results are provided here for baseline comparison.

7.4.1 Perceptual Shaping

Intuitively, we should be able to embed a stronger watermark if we amplify the mark in the areas where it is well hidden (e.g., the mountains in Figure 7.8) and attenuate it in areas where it is plainly perceptible (e.g., the sky in Figure 7.8). We refer to such a strategy as *perceptual shaping*. Some examples of the application of this idea to image watermarking are given in [259, 216, 68, 9].

To apply perceptual shaping in a watermark embedder, we need a model that assigns a perceptual slack, $s[i]$, to each term of the cover Work, expressed in some domain. In the case of Watson's model, a slack is assigned to each term of an image in the block DCT domain. Other perceptual models for images assign slacks to

pixels in the spatial domain [281], frequencies in the Fourier domain, or terms in various wavelet domains [285]. Similarly, perceptual models for audio exist in the time, Fourier, Bark, and wavelet domains [202]. After obtaining the slacks with the model, we transform the message pattern into the domain of the perceptual model, and scale each term by its slack. Transforming back into the temporal or spatial domain yields a *shaped pattern* that can be well hidden in the cover Work. A simple version of this embedding process, designed for a watermarking system that uses media space as its marking space, is illustrated in Figure 7.13.

In several implementations of the perceptual shaping idea, the shaping applied in the embedder is inverted at the detector [220]. This is shown in Figure 7.14 for an informed detector. Given the original Work, the detector's perceptual model computes the exact slacks by which the message pattern was scaled during embedding. A watermark pattern, extracted from the watermarked Work by subtracting the original Work, is then transformed into the domain of the perceptual model, divided by the slacks, and transformed back into media space. If the watermarked Work was not distorted or modified in any way between embedding and detection, the resulting pattern is exactly the reference pattern used by the embedder. Detection can then proceed as before, with a comparison between the unscaled, extracted watermark and the reference watermark. Alternatively, the slacks can

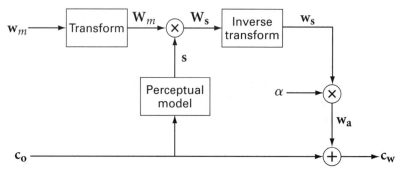

Fig. 7.13 Basic design of an embedder that uses perceptual shaping. (In this embedder design, marking space is the same as media space.)

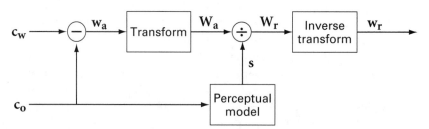

Fig. 7.14 Basic design of an informed detector that inverts perceptual shaping.

be used to scale the message pattern in the detector, and thus provide a more appropriate signal for comparison with the extracted pattern.

Although inversion of perceptual shaping works best with informed detection, it can be approximated in a blind detector as well [220, 55]. One approach is to apply the perceptual model to the received (possibly watermarked and noisy) Work. Assuming that the application of the watermark to the cover Work is perceptually transparent, the watermarked Work and the original Work should have similar masking characteristics, and the slacks derived from the two should be similar. Thus, the informed detection system of Figure 7.14 can be applied in a blind detector by substituting the received Work for the cover Work.

Inversion of perceptual shaping in the detector is not always necessary. Instead, the detector may disregard the embedder's use of perceptual shaping. A system designed in this way essentially views perceptual shaping as a distortion of the watermark. If watermark detection is robust to the noise introduced by this shaping, a detector that does not invert the shaping will still detect the watermark.

Ordinarily, a distortion of the embedded watermark, such as that caused by perceptual shaping, would reduce its detectability. This suggests that perceptual shaping in the embedder, without the corresponding inversion in the detector, should lead to lower detection values. However, perceptual shaping allows the watermark to be embedded with greater strength, and the net result is a mark that gives a higher detection value. For example, consider a linear correlation system with a message pattern, \mathbf{w}_m, which, after shaping, results in some *shaped pattern*,[4] $\mathbf{w_s}$. This shaped pattern can be viewed as a distorted, scaled version of the message pattern:

$$\mathbf{w_s} = \gamma \mathbf{w}_m + \mathbf{g}, \tag{7.27}$$

where γ is a scalar and \mathbf{g} is a vector orthogonal to \mathbf{w}_m. The vector \mathbf{g} can be thought of as a "masking" pattern, which distorts the reference mark to make it less perceptible. Suppose $\gamma = 1/2$. Adding $\mathbf{w_s}$ to a cover Work would lead to half the linear correlation we would get by adding \mathbf{w}_m to the Work. However, because of the perceptual shaping we might be able to more than double the energy of $\mathbf{w_s}$ before the fidelity becomes comparable with that of adding \mathbf{w}_m. That is, if

$$\mathbf{c_{ws}} = \mathbf{c_o} + \alpha_s \mathbf{w_s} \tag{7.28}$$

and

$$\mathbf{c_{wm}} = \mathbf{c_o} + \alpha_m \mathbf{w}_m, \tag{7.29}$$

then the perceptual quality of $\mathbf{c_{ws}}$ might be as good as or better than that of $\mathbf{c_{wm}}$, even for values of α_s greater than $2\alpha_m$ (because $\mathbf{w_s}$ is better hidden by $\mathbf{c_o}$ than is

4. The shaped pattern is not necessarily the added pattern, in that it might be scaled before being added.

\mathbf{w}_m). The linear correlation between $\mathbf{c}_{\mathbf{ws}}$ and \mathbf{w}_m is

$$z_{\mathrm{lc}}(\mathbf{c}_{\mathbf{ws}}, \mathbf{w}_m) = \frac{1}{N}(\mathbf{c_o} + \alpha_s \mathbf{w_s}) \cdot \mathbf{w}_m$$

$$= \frac{1}{N}(\mathbf{c_o} + \alpha_s \gamma \mathbf{w}_m + \alpha_s \mathbf{g}) \cdot \mathbf{w}_m$$

$$= \frac{1}{N}\mathbf{c_o} \cdot \mathbf{w_r} + \alpha_s \gamma \mathbf{w}_m \cdot \mathbf{w}_m. \tag{7.30}$$

If $\gamma(\alpha_s/\alpha_m) > 1$, this is higher than the correlation between $\mathbf{c}_{\mathbf{wm}}$ and \mathbf{w}_m; namely,

$$z_{\mathrm{lc}}(\mathbf{c}_{\mathbf{wm}}, \mathbf{w}_m) = \frac{1}{N}\mathbf{c_o} \cdot \mathbf{w}_m + \mathbf{w}_m \cdot \mathbf{w}_m. \tag{7.31}$$

Figure 7.15 shows a geometric interpretation of this point. The figure illustrates a 2D slice through media space that contains both the message pattern, \mathbf{w}_m, and the unwatermarked Work, $\mathbf{c_o}$. The x-axis is aligned with the reference pattern. The ellipse represents a region of acceptable fidelity, as measured by some perceptual model. We see that only $1 \times \mathbf{w}_m$ can be added to $\mathbf{c_o}$ before reaching the limit of

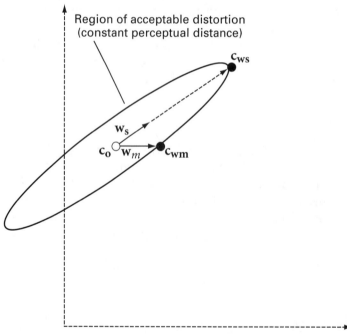

Fig. 7.15 Geometric explanation that perceptual shaping can result in stronger detection. This is a 2D slice of media space, with the x-axis aligned with the message pattern, \mathbf{w}_m. Even though the perceptually scaled pattern, $\mathbf{w_s}$, is not perfectly aligned with \mathbf{w}_m, it may be scaled by a much larger value before reaching the same level of perceptual distortion. This results in a point further along the x-axis and, hence, with a higher linear correlation.

acceptable distortion, leading to one possible watermarked Work, c_{wm}. Applying a perceptual shaping algorithm to \mathbf{w}_m, with reference to c_o, might result in the vector \mathbf{w}_s. Although the correlation between \mathbf{w}_s and \mathbf{w}_m is less than one, we can scale \mathbf{w}_s by a large amount before reaching the perceptual limit. The resulting watermarked Work, c_{ws}, has much higher correlation with \mathbf{w}_m than does c_{wm}.

Investigation

Perceptually Shaped Embedding

We now present a 1-bit image watermark embedding algorithm, E_PERC_SHAPE, which employs Watson's perceptual model for perceptual shaping. This algorithm is similar to that proposed by Podilchuk and Zeng [216]. The algorithm is designed to embed with a constant perceptual distance, as measured by that model. This is accomplished by choosing the embedding strength, α, in the same manner as in the E_PERC_GSCALE algorithm (Equation 7.26), with the exception of replacing the message mark, \mathbf{w}_m with a perceptually shaped mark, \mathbf{w}_s.

System 14: E_PERC_SHAPE

The E_PERC_SHAPE algorithm begins, like most other examples we have presented, by using the message, m, to determine the sign of the pattern, it will embed, \mathbf{w}_m. It differs from the other embedding algorithms in that it now uses the Watson model to perceptually shape \mathbf{w}_m. First, it computes the block DCT, \mathbf{C}_o, of the cover work and applies Equations 7.3 and 7.5 to obtain an array of slacks, \mathbf{s}. Each slack, $\mathbf{s}[i, j, k]$, estimates the amount by which the i, j^{th} term of block k may be changed before leading to one JND. Next, the embedder takes the block DCT, \mathbf{W}_m, of the message pattern and multiplies each term by the corresponding slack:

$$\mathbf{W}_s[i, j, k] = \mathbf{W}_m[i, j, k]\mathbf{s}[i, j, k]. \tag{7.32}$$

Applying the inverse block DCT to \mathbf{W}_s yields the perceptually shaped version of the reference pattern, \mathbf{w}_s. Finally, to obtain the watermarked Work, the shaped pattern is added to the original Work after being multiplied by a scaling factor α, as

$$c_w = c_o + \alpha \mathbf{w}_s. \tag{7.33}$$

The scaling factor is given by a local search around

$$\alpha = \frac{D_{\text{target}}}{D_{\text{wat}}(c_o, c_o + \mathbf{w}_a)}, \tag{7.34}$$

where D_{target} is a target perceptual distance entered as a parameter.

Experiments

Figure 7.16 shows the result of using the E_PERC_SHAPE algorithm to embed a watermark in an image. The target perceptual distance here was chosen to obtain roughly the same linear correlation with the reference mark as obtained from Figure 7.8b. (Figure 7.16 gives a detection value of 3.83, and Figure 7.8b gives a detection value of 3.91.) Figure 7.17 shows the difference between the original image and the image watermarked by E_PERC_SHAPE. In these figures we see that the E_PERC_SHAPE algorithm suppresses the noise that is visible in the sky in Figure 7.8b. To compensate for the loss of detection strength in the sky, the E_PERC_SHAPE algorithm has amplified the watermark in the mountainous area, where it is not as visible. Of course, at this level of embedding strength, the watermark is still visible, primarily in the form of blocking artifacts around the edges of the mountains. These artifacts result from the block-based design of the perceptual model, which means that it underestimates the perceptibility of edges along block boundaries.

In actual use, we would not embed with such large perceptual distances. Figure 7.18 shows the distributions of detection values obtained by embedding watermarks in 2,000 images with the E_PERC_SHAPE algorithm, using a target perceptual distance of $D_{target} = 4$. These results should be compared against

Fig. 7.16 Image with watermark embedded by E_PERC_SHAPE algorithm. This yields roughly the same detection value as the image in Figure 7.8b, which was created by the E_BLIND algorithm.

Fig. 7.17 Perceptually shaped watermark that is added by E_PERC_SHAPE algorithm to create Figure 7.16. Note that there is less energy in the area of the sky than in the area of the mountains.

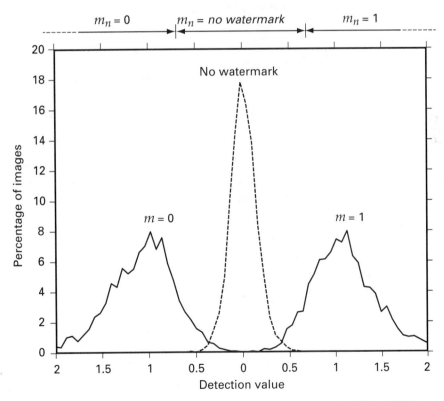

Fig. 7.18 Detection results obtained after embedding with the E_PERC_SHAPE algorithm and a perceptual limit of 4 JNDs, as measured by Watson's model. Results from test on 2,000 images.

those in Figure 7.12. This shows that for a fixed perceptual distance, perceptual shaping greatly increases the detection value.

7.4.2 Optimal Use of Perceptual Models

The perceptual shaping strategy used by the E_PERC_SHAPE algorithm is founded on the intuitive notion that the watermark should be amplified in some areas and attenuated in others. Of course, there are other ways we might use a perceptual model to shape the watermark, rather than the linear scaling described so far. For example, we might choose an amplitude for the reference pattern and then clip each term by the corresponding slack assigned by the model. This would ensure that no term is changed by more than one (estimated) JND. Alternatively, we might apply some nonlinear scaling, multiplying by slacks raised to a constant power. But what is the optimal use of a given perceptual model in embedding watermarks?

Depending on the application, we can specify two alternative optimal behaviors for the embedder. On the one hand, we might want the embedder to maximize the robustness of an embedded mark, while maintaining a constant perceptual distance. On the other hand, we might want to minimize perceptual distance while maintaining a constant robustness. In the case of linear correlation systems, we can replace the word *robustness* in these two specifications with *detection value*, in that increasing linear correlation generally increases robustness. In the case of normalized correlation, we should use a separate robustness measure, such as the R^2 value described in Chapter 5.

For either of these two notions of optimality, in some cases it is possible to analytically compute the optimal pattern to be added. We begin by considering such a case; namely, a linear correlation system with a perceptual model that uses a scaled L_p-norm for pooling.

Optimal Perceptual Shaping in a Linear Correlation System

Consider a watermarking system using a blind, linear correlation–based detector. Assume that this detector operates directly in media space. Therefore, the detection value it computes is just

$$z_{lc}(\mathbf{c}, \mathbf{w}_m) = \frac{1}{N}\mathbf{c} \cdot \mathbf{w}_m, \tag{7.35}$$

representing the likelihood that work \mathbf{c} contains mark \mathbf{w}_m. The D_LC detection algorithm of Chapter 3 is an example of such a detector. If we are given a perceptual model that estimates perceptual distance between two Works, $D(\mathbf{c}_o, \mathbf{c}_w)$, we can try to build an optimal embedder for this system, where optimality is

specified in either of the ways discussed previously. That is, the embedder might either try to maximize the correlation between the watermarked Work and the reference pattern, while keeping the perceptual distance constant, or try to minimize perceptual distance while keeping the correlation constant. We examine the former case first.

Fixed Fidelity We want to maximize $z_{lc}(\mathbf{c_w}, \mathbf{w}_m)$ while keeping $D(\mathbf{c_o}, \mathbf{c_w})$ constant. Equivalently, we can maximize $z_{lc}(\mathbf{w_a}, \mathbf{w}_m)$ while keeping $D(\mathbf{c_o}, \mathbf{c_o} + \mathbf{w_a})$ constant, where $\mathbf{w_a}$ is the added pattern.

Many perceptual distance measures can be reduced to the form

$$D(\mathbf{c_o}, \mathbf{c_w}) = \sqrt[P]{\sum_i \left(\frac{\mathbf{C_w}[i] - \mathbf{C_o}[i]}{\mathbf{s}[i]} \right)^P}, \tag{7.36}$$

where $\mathbf{C_w}$ and $\mathbf{C_o}$ are $\mathbf{c_w}$ and $\mathbf{c_o}$ after application of some energy-preserving linear transform, such as the DCT or Fourier transform, and where \mathbf{s} is an array of slack values based on the human sensitivity functions and the masking properties of $\mathbf{c_o}$. Assuming such a perceptual model, we can rephrase the constraint on our optimization problem as

$$D(\mathbf{c_o}, \mathbf{c_o} + \mathbf{w_a})^P = \sum_i \left(\frac{\mathbf{W_a}[i]}{\mathbf{s}[i]} \right)^P = D^P_{\text{target}}, \tag{7.37}$$

where $\mathbf{W_a}$ is the transform of the added pattern and D^P_{target} is a constant. Because the correlation between two vectors is the same as the correlation between transformed versions of them (assuming an energy-preserving linear transform), we can rephrase the objective of our optimization problem as maximizing $z = z_{lc}(\mathbf{W_a}, \mathbf{W}_m)$.

The solution to this optimization problem can be found with the technique of Lagrange multipliers by solving the equation

$$F' - \lambda G' = 0, \tag{7.38}$$

where

$$F' = \frac{\partial z_{lc}}{\partial \mathbf{W_a}[i]} = \mathbf{W}_m[i] \tag{7.39}$$

$$G' = \frac{\partial D^P_{\text{target}}}{\partial \mathbf{W_a}[i]} = P \frac{\mathbf{W_a}[i]^{P-1}}{\mathbf{s}[i]^P}. \tag{7.40}$$

Solving Equation 7.38 for $\mathbf{W_a}[i]$ yields

$$\mathbf{W_a}[i] = \left(\frac{\mathbf{W}_m[i]\mathbf{s}[i]^P}{\lambda P}\right)^{\frac{1}{P-1}} \tag{7.41}$$

$$= \alpha(\mathbf{W}_m[i]\mathbf{s}[i]^P)^{\frac{1}{P-1}}, \tag{7.42}$$

where

$$\alpha = \left(\frac{1}{\lambda P}\right)^{\frac{1}{P-1}} \tag{7.43}$$

and a specific choice of λ will depend on the particular choice of D_{target} in Equation 7.37. We can compute the optimal $\mathbf{w_a}$ by first computing a shaped pattern, $\mathbf{W_s}$, as

$$\mathbf{W_s}[i] = (\mathbf{W_m}[i]\mathbf{s}[i]^P)^{\frac{1}{P-1}} \tag{7.44}$$

and applying the inverse transform to obtain $\mathbf{w_s}$. Next, compute the correct value of α as

$$\alpha = \frac{D_{\text{target}}}{D(\mathbf{c_o}, \mathbf{c_o} + \mathbf{w_s})} \tag{7.45}$$

and let

$$\mathbf{w_a} = \alpha\mathbf{w_s}. \tag{7.46}$$

Fixed Linear Correlation Now suppose that instead of maximizing linear correlation for a given perceptual distance we want to minimize perceptual distance for a given linear correlation. Therefore, we want to minimize Equation 7.37 while satisfying the constraint

$$z_{\text{lc}}(\mathbf{c_w}, \mathbf{w}_m) = z_{\text{target}}, \tag{7.47}$$

where z_{target} is a constant. This constraint can be rewritten as

$$z_{\text{lc}}(\mathbf{c_o} + \mathbf{w_a}, \mathbf{w}_m) = z_{\text{lc}}(\mathbf{c_o}, \mathbf{w}_m) + z_{\text{lc}}(\mathbf{w_a}, \mathbf{w}_m)$$
$$= z_{\text{lc}}(\mathbf{c_o}, \mathbf{w}_m) + z_{\text{lc}}(\mathbf{W_a}, \mathbf{W}_m) = z_{\text{target}}. \tag{7.48}$$

Because $z_{\text{lc}}(\mathbf{c_o}, \mathbf{w}_m)$ is constant, the constraint on $z_{\text{lc}}(\mathbf{W_a}, \mathbf{W}_m)$ is

$$z_{\text{lc}}(\mathbf{W_a}, \mathbf{W}_m) = z'_{\text{target}}, \tag{7.49}$$

where $z'_{\text{target}} = z_{\text{target}} - z_{\text{lc}}(\mathbf{c_o}, \mathbf{w}_m)$. This optimization problem can be solved with Lagrange multipliers, in the same manner as the previous problem, and the solution has essentially the same form. Specifically, $\mathbf{w_a}$ is given by Equations 7.44

and 7.46, but with a different value of α. In this case, after computing $\mathbf{w_s}$, instead of computing α with Equation 7.45 we compute it as

$$
\alpha = \frac{z'_{\text{target}}}{z_{\text{lc}}(\mathbf{w_s}, \mathbf{w}_m)}
$$
$$
= \frac{z_{\text{target}} - z_{\text{lc}}(\mathbf{c_o}, \mathbf{w}_m)}{z_{\text{lc}}(\mathbf{w_s}, \mathbf{w}_m)}. \tag{7.50}
$$

Investigation

Optimally Scaled Embedding

We now describe a watermark embedding algorithm that maximizes the linear correlation for a fixed fidelity, where fidelity is measured by the Watson model.

System 15: E_PERC_OPT

The E_PERC_OPT embedding algorithm is essentially the same as the E_PERC_SHAPE algorithm, except that instead of linearly scaling the block DCT terms of the reference pattern by their respective slacks we use the optimal formula described previously. In the Watson perceptual model, pooling is performed by an L_4-norm; thus,

$$
D_{\text{wat}}(\mathbf{c_o}, \mathbf{c_o} + \mathbf{w_a}) = \sqrt[4]{\sum_{i, j, k} \left(\frac{\mathbf{W_a}[i, j, k]}{\mathbf{s}[i, j, k]} \right)^4}, \tag{7.51}
$$

where $\mathbf{W_a}[i, j, k]$ is the i, jth term of the kth block in the block DCT of $\mathbf{w_a}$, and $\mathbf{s}[i, j, k]$ is the corresponding slack. This means we can use Equation 7.44 with $p = 4$ to find the optimal perceptual shaping of the added mark. This gives

$$
\mathbf{W_s}[i, j, k] = (\mathbf{W}_m[i, j, k]\mathbf{s}[i, j, k]^4)^{\frac{1}{3}}. \tag{7.52}
$$

Embedding is then completed by computing the inverse block DCT of $\mathbf{W_s}$ to obtain $\mathbf{w_s}$, determining α according to Equation 7.45, and letting $\mathbf{c_w} = \mathbf{c_o} + \alpha\mathbf{w_s}$.

Experiments

Figure 7.19 plots the distribution of detection values obtained using the E_PERC_OPT algorithm, with $D_{\text{target}} = 4$. Comparing these results with those in Figure 7.18 (included here with dotted lines) shows that the E_PERC_OPT algorithm generally leads to stronger detection values than does E_PERC_SHAPE for the same perceptual distance. Although the improvement in performance

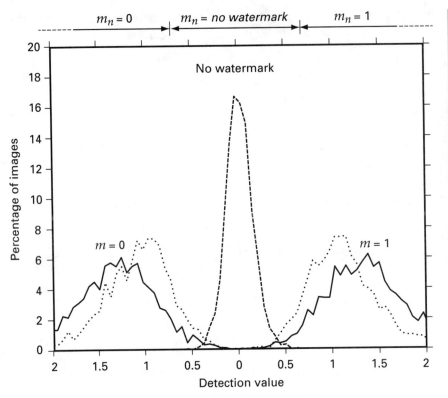

Fig. 7.19 Detection results obtained after embedding with the E_PERC_OPT algorithm and a perceptual limit of 4 JNDs (as measured by Watson's model). The results for the E_PERC_SHAPE algorithm are included for comparison (dotted lines). Results are from tests on 2,000 images.

shown by Figure 7.19 may not appear large, it can have a noticeable effect on the overall effectiveness of the embedding algorithm. For example, with a threshold of 0.7, the E_PERC_SHAPE algorithm succeeds in embedding watermarks in about 89% of the images. This goes up to 95% with the E_PERC_OPT algorithm.

Optimal Perceptual Shaping in a Normalized Correlation System

If our watermarking system uses normalized correlation as its detection statistic, the optimal use of a perceptual model is more complex than for linear correlation systems. As pointed out in Chapter 5, and illustrated by E_BLK_FIXED_CC/D_BLK_CC (System 7), we cannot assume that high detection values correspond to high robustness. Instead, we must use a different measure of robustness, such as the R^2 value used in E_BLK_FIXED_R (System 8). However, even in the simple case of the E_BLK_FIXED_R algorithm, which tries to minimize the Euclidian distance between the watermarked and unwatermarked versions of

the Work, the R^2 measure leads to a problem that is complex to solve analytically. In that algorithm we resort to a brute-force search to find a near-optimal solution. When we replace Euclidian distance with a more sophisticated perceptual distance function, the optimization problem is almost certain to become more difficult.

In a normalized correlation system with a sophisticated perceptual model, one possible way of finding an optimal (or nearly optimal) shaped pattern is to use a general search technique, such as simulated annealing, gradient descent, or the simplex method [219]. If the system works in media space, or in any marking space with very high dimensionality, the number of independent variables may make direct search prohibitive. For example, to watermark a 720×480 pixel image we would need to solve a problem with 345,600 variables. This is more than most general search techniques can handle.

An alternative sub-optimal solution is to embed the watermark as though we are using linear correlation. This relies on the fact that, generally, increasing linear correlation increases R^2. To see why, note that in media space R^2 is defined as

$$R^2 = \left(\frac{\mathbf{c_w} \cdot \mathbf{w}_m}{\tau_{\mathrm{nc}} \|\mathbf{w}_m\|} \right)^2 - \mathbf{c_w} \cdot \mathbf{c_w}, \tag{7.53}$$

where $\mathbf{c_w}$ is the proposed watermarked Work, \mathbf{w}_m is the watermark message pattern, and τ_{nc} is the threshold we expect the detector to use. If perceptual shaping increases the linear correlation between $\mathbf{c_w}$ and \mathbf{w}_m without making too large a difference in $\mathbf{c_w} \cdot \mathbf{c_w}$, it increases R^2. Thus, an algorithm (such as E_PERC_OPT) that maximizes $\mathbf{c_w} \cdot \mathbf{w}_m$ should generally lead to large values of R^2.

Investigation

The Effect of Perceptually Shaped Embedding on Detection Using Normalized Correlation

We now present a brief investigation to test the claim that the E_PERC_OPT embedder generally increases robustness for a correlation coefficient detector, D_BLK_CC, even though the embedder is optimized for linear correlation.

Experiments

To test this claim, we used E_PERC_GSCALE and E_PERC_OPT to embed a watermark in 2,000 images with a tiled reference pattern, and a constant perceptual distance of 4. Each 8×8 block of this reference pattern is identical to all others, as shown in Figure 7.20. As pointed out in Chapter 3, such a reference pattern should be detectable by the D_BLK_CC detection algorithm, which extracts watermarks by summing 8×8 blocks, and then uses the correlation coefficient to compare them against a reference mark.

Fig. 7.20 Tiled watermark pattern used to test effectiveness of E_PERC_OPT as an embedder when watermarks are detected by the D_BLK_CC detection algorithm.

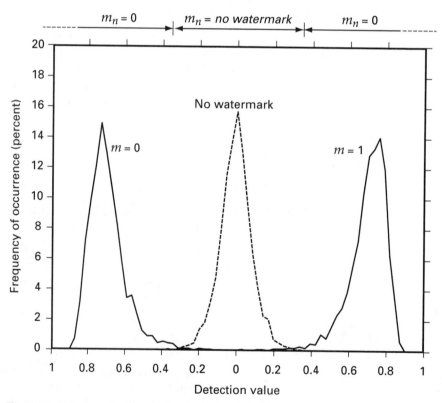

Fig. 7.21 Detection results obtained after embedding a tiled pattern with the E_PERC_OPT algorithm and detecting with the D_BLK_CC detector. Results from test on 2,000 images.

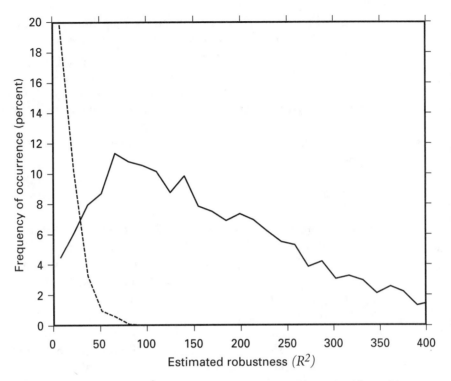

Fig. 7.22 Comparison of R^2 robustness values obtained by embedding with E_PERC_GSCALE (dotted line) and E_PERC_OPT(solid line). Images in which watermarks were not successfully embedded are not included in this graph. Results from test on 2,000 images.

Figure 7.21 shows the distributions of detection values computed in D_BLK_CC, indicating that the embedded watermark is, in fact, detected by that algorithm. Figure 7.22 shows that the watermarks embedded by E_PERC_OPT tend to have higher robustness, as measured with R^2, than do those embedded by E_PERC_GSCALE. This means that the perceptual shaping performed by E_PERC_OPT generally increases R^2, even though E_PERC_OPT is optimized for linear correlation.

7.5 Summary

Perceptual modeling is an important aspect of a watermarking system. The main points of this chapter were:

- Perceptibility can be based on either fidelity or quality.
 - Fidelity measures the relative similarity between two signals.
 - Quality is an absolute measure of appeal.

■ The just noticeable difference or JND is a psychophysical measure of the level of distortion that can be perceived in 50% of experimental trials.

■ Experimental trials are often performed using a two alternative forced choice (2AFC).

■ Human trials are expensive and automated evaluations are often preferred based on perceptual models of the human visual and auditory systems.

■ Mean square error (MSE) is a poor perceptual model.

■ More sophisticated perceptual models generally account for three basic phenomena: sensitivity, masking and pooling.

⊞ Sensitivity measures an observer's response to isolated stimuli.

⊞ Masking measures an observer's response to one stimulus when a second "masking" stimulus is also present.

⊞ Pooling combines the perceptibilities of separate distortions to give a single estimate of the overall change in the Work.

■ Two examples of perceptual modeling were described: Watson's DCT-based visual model and the MPEG-1, Layer 1 audio model.

■ Perceptual modeling can be used in a variety of ways for perceptually adaptive watermarking.

⊞ The perceptual distance can be used to determine a global scaling factor.

⊞ Perceptual shaping allows for local amplification and attenuation depending on the local properties of the cover Work.

⊞ In the case of a linear correlation detector, a perceptual model can be used to find the optimal mark to embed.

⊞ For normalized correlation, the optimization is more difficult. However, unlike System 7, the E_PERC_OPT embedder also benefits normalized correlation.

Robust Watermarking

Many applications require watermarks to be detected in Works that may have been altered after embedding. Watermarks designed to survive legitimate and everyday usage of content are referred to as *robust* watermarks. In this chapter, we present several general methods for making watermarks robust and discuss specific methods for handling some of the most common types of processing.

We draw a distinction between robust watermarks and *secure* watermarks.[1] Whereas robust watermarks are designed to survive normal processing, secure watermarks are designed to resist any attempt by an adversary to thwart their intended purpose. Because in most applications a watermark cannot perform its function if it is rendered undetectable, robustness is a necessary property if a watermark is to be secure. In other words, if a watermark can be removed by application of normal processes, it cannot be considered secure. However, robustness is not sufficient for security, because secure watermarks must also be capable of surviving novel processes that are specifically designed to remove them. Thus, the designer of a secure watermark must consider the range of *all possible* attacks. The designer of a robust watermark can limit his attention to the range of *probable* processing. Secure watermarks are discussed in Chapter 9.

In designing a robust watermark it is important to identify the specific processes that are likely to occur between embedding and detection. Examples of processes a watermark might need to survive include lossy compression, digital-to-analog-to-digital conversion, analog recording (such as VHS or audio tape),

1. Not all authors make this distinction. Instead, they use the term *robustness* to refer to the ability to survive *all* forms of distortion, hostile or otherwise. We believe, however, that resistance to hostile attacks is technically very different from resistance to normal processing, and we therefore use *robustness* to refer exclusively to the latter.

printing and scanning, audio playback and re-recording, noise reduction, format conversion, and so on. However, robustness to a given process often comes at some expense in computational cost, data payload, fidelity, or even robustness to some other process. It is therefore wise to ignore those processes that are unlikely in a given application. For example, a video watermark designed for monitoring television advertisements will need to survive the various processes involved in broadcasting—digital-to-analog conversion, lossy compression, and so on—but need not survive other processes, such as rotation or halftoning.

Section 8.1 of this chapter describes several general approaches to making watermarks robust. Some of these aim to make the watermark robust to a wide range of possible distortions. Others are general frameworks for obtaining robustness to specific distortions.

In Section 8.2, we analyze the effects of some *valumetric* distortions (i.e., distortions that change the values of individual pixels or audio samples). Common valumetric distortions that occur to photographs, music, and video can often be modeled as combinations of additive noise, amplitude changes, linear filtering, and/or quantization. *Temporal* and *geometric* distortions (such as delay, translation, rotation, and scaling) are discussed in Section 8.3.

8.1 Approaches

There are several broad strategies for making watermarks detectable after their cover Works are distorted. Some of these aim to make watermarks robust to all possible distortions that preserve the value of the cover Work. Others are strategies for handling specific types of distortions. In practice, a watermarking system will employ multiple strategies for handling various types of distortion. For example, image watermarking systems commonly use *redundant embedding* (Section 8.1.1) to handle cropping, filtering, and addition of band-limited noise, but use *inversion at the detector* (Section 8.1.5) to handle geometric distortions.

Sections 8.1.1 through 8.1.4 describe strategies for ensuring that watermarks are unmodified, or only slightly modified, by normal processing. These rely on finding transform domains in which some terms are likely to be unaffected by processing.

In contrast, Sections 8.1.5 and 8.1.6 describe methods based on inverting the effect of distortions. In these, we allow the watermark to be modified by the distortion, but we counteract that modification in either the detector (Section 8.1.5) or embedder (Section 8.1.6). These types of strategies are often used to handle temporal and geometric distortions (see Section 8.3).

A note on terminology: in Sections 8.1.1 through 8.1.4 we talk about embedding watermarks "in" certain coefficients. For example, a watermark might be embedded in the low-frequency Fourier coefficients. This means that the reference watermark has non-zero values in the low frequencies of its Fourier

representation, but zeros (or small magnitudes) in the high frequencies. It does not necessarily mean that the computation of watermark embedding is performed in the Fourier domain. A low-frequency reference pattern can just as easily be represented and embedded in some other domain, such as the spatial or temporal domain. In other words, the description and analysis of a watermark may be performed in one domain, while embedding and detection are implemented in another.

8.1.1 Redundant Embedding

Often, when a Work is distorted not all coefficients in its representation are affected equally. As a trivial example, consider an image cropped along its right side. In a pixel representation of this image, only the rightmost pixels are affected; the remaining pixels are untouched. A more interesting example occurs when a Work is convolved with a band-pass filter. If the Work is represented in the spatial or temporal domain, this filtering is likely to change all samples. However, in the Fourier domain the filter affects only the frequencies outside the passband.

One general strategy for surviving a wide variety of distortions is to embed a watermark redundantly across several coefficients. If some of these coefficients are damaged, the watermark in other coefficients should remain detectable. A simple example of this approach is the spatial tiling used in the E_BLK_BLIND/D_BLK_CC system (System 3). This tiling provides robustness against spatially varying distortions, such as cropping.

Watermarks that are embedded redundantly by tiling can be detected in a number of ways. One method is to combine data from all the tiles in a Work and then decode the result. This is the method employed in the D_BLK_CC detector, which adds all the tiles together and tests for the watermark in their average.

Another method is to test for the watermark in each tile independently, announcing that the mark is present if it is detected in more than some fraction of the locations. This approach is employed in several proposed systems, such as [12].

Yet another method is to test for the watermark in each tile, and then combine the resulting detection values. For example, we could compute the correlation coefficient between the reference vector and each 8×8 block in an image, and then compare the sum of all the results against a threshold [56]. Note that if we used linear correlation instead of the correlation coefficient, this would be the same as computing the correlation between the entire image and a tiled reference pattern, such as that shown in Figure 7.20.

Although the most obvious examples of redundant embedding involve tiling, other approaches are possible. In general, we can say that a watermark is embedded redundantly, in some domain, if the watermark can be detected in several subsets of the coefficients. For example, consider a white noise watermark embedded in an image with the E_BLIND blind embedder. Although this is not a tiled pattern, the watermark is redundantly embedded in the spatial domain because

it is detectable from several subimages (assuming perfect registration between the subimage and the reference pattern).

The idea of redundant embedding can be taken a step further by embedding a message into a Work multiple times, using different watermark encodings, where each encoding is designed to survive a distinct set of distortions. Because the Work is unlikely to undergo all distortions to which the marks are susceptible, at least one of the marks is likely to survive. This idea is explored in [172].

8.1.2 Spread Spectrum Coding

When applied in the frequency domain, the idea of redundant embedding leads to the well-known communications paradigm of spread spectrum coding. In a spread spectrum communications system, messages are encoded with sequences of symbols (see Chapter 4). The symbols are transmitted in a temporal sequence, each one being represented by a signal referred to as a *chip*. Typically, chips are pseudo-random sequences of 1s and 0s. In the frequency domain, they are spread across a wide range of frequencies. Thus, if the signal is distorted by some process that damages only a fraction of the frequencies, such as a band-pass filter or addition of band-limited noise, the chips will still be identifiable.

Figure 8.1 illustrates a simple spread spectrum audio watermarking system, similar to that proposed in [220]. At the embedder, we begin with a message, m, which is error encoded and denoted m_c. Let m_c be represented by a sequence of symbols drawn from a reasonably large alphabet, such as the 128 ASCII characters. Each message symbol is then spread spectrum modulated into a 512-bit pseudo-random sequence (or chip). The resulting sequence of chips is perceptually shaped, and then added to the audio cover Work. At the receiver, the reverse process takes place. First, the perceptual shaping is (approximately) inverted. Next, each chip is identified by correlating against the 128 chips in the alphabet, and choosing the one with the best correlation. This produces a sequence of error-coded symbols that are then decoded to produce the message, m.

Spread spectrum communications have two characteristics that are important to watermarking. First, the signal energy inserted into any one frequency is very small. This very low signal-to-noise ratio reduces the risk of perceptible artifacts. Note, however, that despite the low signal-to-noise ratio present in any single frequency the detector output signal may still have a high signal-to-noise ratio as

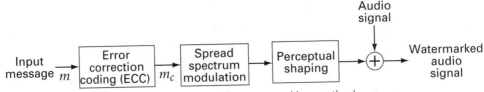

Fig. 8.1 Simple spread spectrum audio watermarking method.

it de-spreads or concentrates the energy present in a large number of frequencies. Second, the fact that the watermark is dispersed over a large number of frequencies also provides robustness to many common signal distortions.

8.1.3 Embedding in Perceptually Significant Coefficients

In practice, it is not always appropriate to embed a watermark in *all* coefficients of a Work's representation. Some coefficients are so susceptible to distortions that they are unlikely to be useful. For example, most forms of image processing damage the high frequencies in an image's Fourier representation. That is, lossy compression quantizes many high frequencies to zero, halftoning adds high-frequency noise, scanning applies a low-pass filter before sampling, and so on. It is almost certain, therefore, that any watermark information placed in high frequencies will be damaged in a processed image. If the information in such unreliable coefficients is used during detection, it will likely reduce the reliability of the system.

Furthermore, fidelity constraints may mean that any watermark energy embedded in unreliable coefficients must be offset by a reduction of energy in more reliable coefficients. Thus, even if watermark data in unreliable coefficients were useful during detection, its cost may outweigh its benefit. It is better to put as much of the watermark as possible into reliable coefficients.

How do we decide which coefficients are reliable and which are not? One very general answer, proposed in [60], is that coefficients that are *perceptually significant* are likely to be reliable, whereas those that are *perceptually insignificant* are likely to be unreliable. An ideal perceptually significant coefficient is one that never changes unless the Work is perceptibly distorted. In general, all of the normal compression, transmission, and display technologies applied to a Work are specifically designed to preserve perceptually significant features.

Conversely, a watermark need not necessarily survive a process that damages perceptually significant coefficients. By definition, damaging these coefficients degrades the perceptible quality of a Work. If the resulting Work is so badly distorted that its value is lost, the information embedded in it may no longer be useful. For example, an audio clip that has been processed to the point of being unrecognizable is not protected by copyright law [273]. Therefore, a copyright notice embedded as a watermark would not be meaningful.[2]

A major problem with embedding in perceptually significant coefficients is that it is directly opposed to the objective of creating imperceptible watermarks.

2. This is a peculiar characteristic of watermarking, as opposed to other forms of data hiding. As we have defined it, a watermark carries information that pertains to the cover Work. Therefore, the watermark usually becomes irrelevant if the cover Work is unrecognizable or worthless. This contrasts with, for example, an application of steganography for covert communications, where the hidden message is unrelated to the cover Work and is likely to retain its value even if the cover Work is completely lost.

To make a watermark imperceptible, we might want to put most of its energy into perceptually *insignificant* coefficients. This, in fact, is one of the effects of the example perceptual shaping algorithms described in the previous chapter, which generally move image watermark energy into high frequencies. Thus, the objective of fidelity is often fundamentally opposed to the objective of robustness.

The solution to this problem employed in [60] is to spread the watermark over a large number of perceptually significant coefficients in the frequency domain. Because spread spectrum coding allows a very small energy to be used in each frequency, the change in each coefficient can be small enough to be imperceptible.

An alternative solution is to embed in coefficients that have medium levels of perceptual significance. That is, their perceptual significance is neither so high that we cannot embed a watermark in them imperceptibly nor so low that they are unlikely to survive normal processing. For example, many image watermarking techniques embed in images' middle frequencies, avoiding the lowest frequencies because they are too perceptible, and avoiding the highest frequencies because they are too unreliable [209, 208, 123].

8.1.4 Embedding in Coefficients of Known Robustness

When we embed in perceptually significant coefficients, we are attempting to make a watermark that will survive all conceivable processes that preserve a Work's value. However, in many applications we are not concerned with all conceivable processes, but with a specific set of processes that might occur between embedding and detection. In such cases, we can deal with these processes more directly.

First, the watermark should be described in a domain that is likely to be robust to the processes of interest. For example, if we are more concerned with having an image watermark survive spatial shifting than we are with having it survive linear filtering, we might choose to embed in the image's Fourier magnitudes. In some cases, it might be best to use other domains, such as the log-polar Fourier transform [200, 162] (discussed in Section 8.3) or the cepstrum transform [15, 22, 198].

Once we have chosen a representation in which to describe our watermark, we can identify the coefficients that best survive the expected distortions. For some distortions, this can be done analytically. For others, it can be done by empirical test. The tests are straightforward and involve comparing the content directly after embedding and directly before detection. By comparing corresponding coefficients, it is possible to determine how the channel between the embedder and the detector affects each coefficient. Such experiments need to be performed over a wide variety of content, and numerous trials are often needed to build a satisfactory model with sufficient statistical reliability.

For example, consider a video watermarking system that must survive recording on VHS tape. If the watermark is to be described in the block DCT domain,

we need to identify the coefficients of an 8×8 DCT that are least affected by this recording. This can be accomplished by recording a large number of frames onto the tape, and then redigitizing them and comparing their block DCT coefficients.

In the above example, we perform a statistical test over many Works, and then determine a fixed set of coefficients to use in the watermark. However, a given coefficient might behave differently in different Works. Consider the problem of making watermarks survive adaptive compression. Adaptive compression algorithms, such as those in [127, 202], examine the Works being compressed and adjust the amount of quantization applied to each coefficient. Consequently, a given coefficient might be heavily quantized in one Work and quantized very little in another. This suggests that a watermark should be embedded into a different set of coefficients for each Work.

One technique for tailoring the choice of coefficients to individual Works is to measure the relative robustness of each coefficient just prior to embedding a watermark. This can be done by applying several simulated distortions to the Work and measuring their effects on the representation of that Work in the chosen domain. The watermark is then embedded into the coefficients found to be most robust, which might be a different set of coefficients for each Work. The list of coefficients used is provided to the detector along with the (possibly distorted) marked Work. Such a system has been investigated in [158]. Of course, this technique requires an informed detector.

8.1.5 Inverting Distortions in the Detector

The previously discussed approaches attempt to create a watermark that remains relatively unchanged after normal processing. A fundamentally different approach is to attempt, during the detection process, to invert any processing that has been applied since the watermark was embedded.

Many processes can be either exactly or approximately inverted. For example, if an audio clip is delayed by an integral number of samples, the detector can exactly invert the process by simply advancing the clip by the same number of samples (if we ignore the effect of cropping). A clockwise rotation of an image can be inverted by a counterclockwise rotation of the same angle. For rotations that are not multiples of 90 degrees, this inversion is likely to be approximate because of problems with interpolation and round-off error. If a detector can determine that one of these processes has been applied to a Work between the time of embedding and the time of detection, it can apply the inverse process to the Work to obtain a close approximation of its unprocessed version.

Alternatively, depending on the watermarking algorithm, it may be possible for a detector to apply a distortion to the reference watermark, rather than applying the inverse distortion to the Work. For example, consider an image watermark detector that computes the linear correlation between the received Work and a reference pattern, as in the D_LC algorithm of System 1. If such a detector determines

that the Work has probably been filtered by a low-pass filter, it can detect the mark by applying the same filter to the reference pattern before computing the correlation. This might be preferred over applying the inverse process to the received Work for reasons of computational cost, or because the inverse process is imprecise or unstable.

The difficult step in inverting distortions in the detector is determining what distortion to invert. In the worst case, the detector might have to apply an exhaustive search, testing for a watermark after inverting each of a large number of possible processes. For example, an image watermark detector might try to detect after rotating the image 0 degrees through 359 degrees in increments of 1 degree.

For some types of processing, it is possible to reduce the cost of search and false positive probability. If an algorithm can identify one or a small number of candidate distortions that are likely to have taken place, the detector need test for watermarks after inverting only those distortions. Such an algorithm must be specifically defined for each class of distortions.

The problem of identifying the distortion is generally easier in an informed detector than in a blind detector, because an informed detector has the possibility of comparing the received Work against the original. When the correct inverse process is applied to the received Work, it should match the original (with the exception of its watermark, if it has one). For many types of processes, fast algorithms exist to find the parameters that lead to the best match between two Works. The approach of inverting distortions at the detector is most commonly applied for temporal and geometric distortions, as discussed in Section 8.3.

8.1.6 Pre-inverting Distortions in the Embedder

In some circumstances, there may be a small set of very well-defined distortions a watermark must survive. For example, there are a small number of well-defined formats for video signals, and a given video signal might be converted from one to another. For illustrative purposes, we focus on the way DVD video players handle the *aspect ratio*, or relative width and height, of the picture.[3] Standard NTSC and PAL televisions have an aspect ratio of 4:3 (i.e., the television is 4 units wide and 3 units high). On the other hand, high-definition television (HDTV) has an aspect ratio of 16:9. To support both formats, DVD disks store the full 16:9 image, and offer two methods of squeezing the picture onto 4:3 standard television screens. In *letterbox* format, the picture is reduced in size so that it fits onto the 4:3 screen in its entirety, with some black lines added above and below. In *panscan* format, the picture fills the 4:3 screen, but is cropped at the left and right. These formats are illustrated in Figure 8.2.

3. The reader is directed to [264] for more detail on how DVD handles aspect ratio.

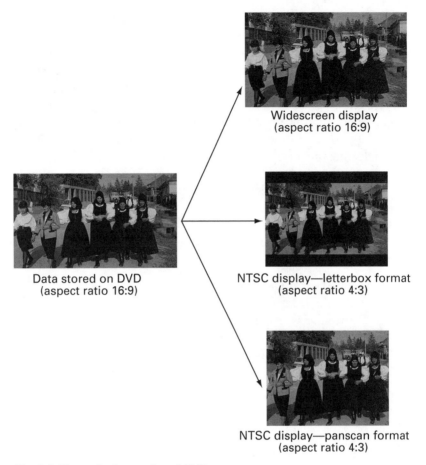

Fig. 8.2 Three display modes of DVD.

Watermarks for DVD video should be embedded in the widescreen (16:9) source. Consequently, the watermark would be detected when displayed on a widescreen. However, both letterbox and panscan modes introduce distortions that may cause the watermark to go undetected. Thus, we have a small number (two) of well-defined geometric distortions the watermarked Work is likely to undergo.

To combat each of these distortions, we can embed a special watermark in the original format. This watermark is pre-distorted such that after conversion to the corresponding display mode (panscan or letterbox) the watermark will be detected. The basic idea is to embed more than one watermark in the content. The first watermark is not pre-distorted and will be detected by the watermark detector when no format conversions occur. A second watermark is pre-distorted

for letterbox. A third is pre-distorted for panscan. Depending on the display mode, only one of the three watermarks will be detected.

Multiple watermarks can be inserted in content either by embedding one on top of another or by time multiplexing. In the latter case, one frame of a video sequence might contain the first watermark, the second frame the next watermark, and so on. Or the multiplexing may be coarser, with the first watermark being embedded in the first 10 seconds of video, the next watermark in the next 10 seconds, and so on. The disadvantage of such an approach is that for a given format the corresponding watermark is only detectable $1/N$th of the time, where N is the number of pre-distorted watermarks. The alternative of overlaying these multiple watermarks avoids this problem. However, each watermark must be embedded with, on average, $1/N$th the power if fidelity constraints are to be conserved.

The simplest procedure for embedding a pre-distorted watermark consists of three steps:

1. Apply the expected distortion to the Work being watermarked (e.g., conversion to letterbox or panscan mode).
2. Embed the watermark in the distorted Work. At this point, the watermark embedder is unaware of the distortion. It simply embeds a watermark in the same manner as for undistorted content.
3. Apply the inverse distortion to the watermarked, distorted Work.

Note that this procedure can be applied with any watermark embedding algorithm.

Unfortunately, the previously outlined procedure can introduce unacceptable fidelity loss when applied with a distortion that is not perfectly invertible. In both letterbox and panscan conversion, some information is lost, and therefore the inverse distortion of the last step must introduce some distortion in image quality. For this reason, it may be preferable to apply a slightly more complicated procedure, which works for certain types of distortions [58].

1. Make a copy of the Work being watermarked and apply the expected distortion to it, obtaining a distorted copy of the Work, c_d.
2. Create a watermarked version of the distorted copy, c_{dw}.
3. Find the pattern that was added to the distorted copy, c_d, in Step 2: $w_{da} = c_{dw} - c_d$.
4. Perform the inverse distortion on the added pattern, w_{da}, to yield the corresponding pattern, w_a, for the original image. For example, if the transformation to be compensated for was "letterbox" mode, w_a would be obtained by vertically expanding w_{da}.
5. Finally, add w_a to the original cover Work, c_o, to obtain the watermarked Work, c_w.

These steps are illustrated in Figure 8.3.

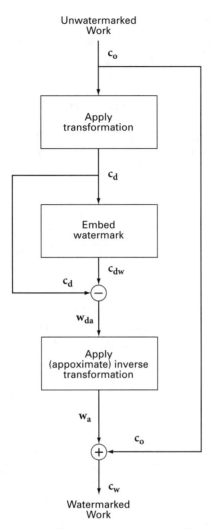

Fig. 8.3 The embedding process for inserting a pre-distorted watermark.

When the distortion is later applied to the watermarked Work, c_w, the result will be approximately the same as the watermarked, distorted Work, c_{dw}, created in Step 2. Thus, the watermark will be detected by the same procedure designed to detect a normal watermark.

In the rare circumstance in which we can identify a small number of specific distortions the watermark must survive, pre-distorting watermarks at the embedder can have several advantages. First, it is very general, being applicable to any watermarking system for almost any distortion, as long as the distortion is approximately invertible. Second, it adds no cost to the detector, which is important in applications for which detector cost must be minimized. Finally, it

can be implemented after detectors are deployed. This can be important if a new distortion is introduced into normal content handling (e.g., if a new format conversion is introduced into the DVD standard).

8.2 Robustness to Valumetric Distortions

We now examine the effects of four major types of valumetric distortion on watermark detection: additive noise, amplitude changes, linear filtering, and lossy compression. Most of these can be countered with simple applications of the previously discussed techniques.

8.2.1 Additive Noise

Some processes that might be applied to a Work have the effect of adding a random signal. That is,

$$c_n = c + n, \tag{8.1}$$

where c is a Work and n is a random vector chosen from some distribution, independently of c. For example, audio broadcast over a radio channel might be corrupted by white noise, resulting in a hiss or static. Similarly, video broadcast over a television channel might pick up video snow. In these cases, the noise is independent of the Work. Such noise processes are cases of *additive noise.*

Because additive noise is independent of the Work, it is easy to address analytically. For this reason, most analysis of watermarking algorithms assumes that Works are transmitted over additive noise channels. For example, almost all the discussion of robustness in Chapters 3 through 5 addresses only additive noise. As a result, most robust watermarking algorithms are specifically designed to survive this type of distortion. In the following investigation we examine the effects of additive white noise on two of our example watermarking systems.

Investigation

Effects of Additive Noise

In the case of watermarking systems that employ linear correlation, the detection statistic is known to be optimal in the presence of additive white Gaussian noise. Thus, we can reasonably expect that the addition of such noise will have little effect on detection.

In the case of watermarking systems that employ normalized correlation, the detection statistic is not optimal for additive noise. However, in Chapter 5, normalized correlation's weakness against this type of distortion is explicitly handled by the design of a *robustness measure, R^2,* that estimates the amount of

noise a given watermark can survive. The E_BLK_FIXED_R (System 8) embedding algorithm is then designed to ensure that all watermarks are embedded with a specific robustness to additive noise. Thus, we expect the addition of noise to this system to have little effect on detection as long as the noise is small compared to that specified by the R^2 value.

Experiment 1

Two thousand images were watermarked by the E_FIXED_LC fixed linear correlation embedder (see System 2). We used this embedder, rather than the simpler E_BLIND embedder, because it minimizes the variance in detection values for undistorted images, and this makes it easier to see the effect subsequent distortion has on detection variance. The images were embedded with a threshold value of $\tau_{lc} = 0.7$, strength parameter of $\beta = 0.3$, and message $m = 1$, giving a target linear correlation of 1. Each image was then distorted 10 times with additive white noise of 16 different powers, and the detection values were measured by the D_LC detector. Figure 8.4 shows the result of

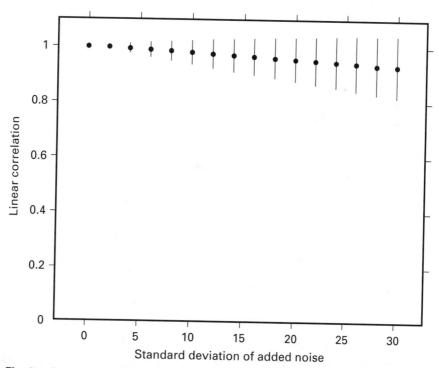

Fig. 8.4 Results of additive white Gaussian noise test using E_FIXED_LC/D_LC watermarking system. The points show the mean detection values obtained. The error bars indicate the standard deviations of detection values (mean value plus or minus 1 standard deviation).

this robustness experiment. The points on the graph show the mean detection values obtained as a function of noise amplitude. The error bars show the standard deviations of those detection values (mean plus or minus one standard deviation).

The mean detection value shown in Figure 8.4 should be unaffected by noise, in that the addition of any noise pattern has as much chance of increasing linear correlation with the watermark as it has of decreasing it. In fact, the mean detection value remains high, but it does decrease slightly as the amplitude of the noise increases. This decrease is not directly due to the added noise but to the fact that the pixel values are rounded and clipped to 8-bit values after the noise is added.

Unlike the means of the detection values, the standard deviations increase as noise amplitude increases. As a result, an increasing fraction of images should fall below the threshold. However, this does not become a serious problem within the range of noise added during the experiment, and, with a detection threshold of $\tau_{lc} = 0.7$, the watermark is successfully detected in more than 97% of the images even at the highest noise amplitude tested. At the maximum noise amplitude the image is so severely distorted that it might no longer be of interest.

Experiment 2

Two thousand images were watermarked by the E_BLK_FIXED_R embedder (see System 8), with a detection threshold of $\tau_{nc} = 0.55$ and a target robustness value of $R^2 = 30$. Each image was distorted 10 times with each of 16 different powers of noise, and the detection values were measured by the D_BLK_CC detector. Figure 8.5 shows the results of this experiment.

This graph shows that the addition of noise affects the mean normalized correlation more seriously than it affects linear correlation. However, for more than 85% of the images the detection values still remain above the threshold of $\tau_{nc} = 0.55$ after adding noise with a standard deviation of 18. Figure 8.6 shows an example of an image with this much noise added.

Note that in Figure 8.5 the variance of detection values in undistorted images is larger than that for the E_FIXED_LC/D_LC system. This is because the E_BLK_FIXED_R embedder is holding the robustness constant, but allows the detection value to vary (see Chapter 5 for more on this issue). Up to a point, as the amount of noise increases, the detection value variance actually *decreases* slightly. This reflects the nonlinear nature of normalized correlation. At values close to 1 or −1, normalized correlation is much more sensitive to small changes in the extracted vector than it is at values close to 0.

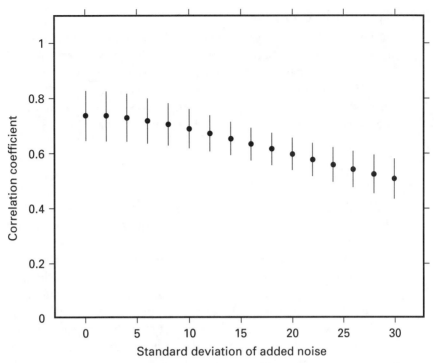

Fig. 8.5 Results of additive white Gaussian noise test using E_BLK_FIXED_R/D_BLK_CC watermarking system. The points show the mean detection values obtained. The error bars indicate the standard deviations of detection values (mean value plus or minus 1 standard deviation).

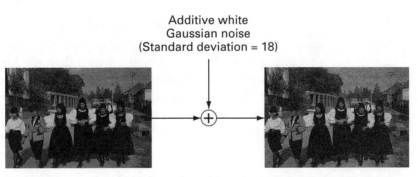

Fig. 8.6 Visual effect of adding noise with a standard deviation of 18.

8.2.2 Amplitude Changes

In theoretical discussions of watermarking systems, it is tempting to deal with only additive noise, because this form of distortion is easy to analyze. However, in reality, many, if not most, processes applied to watermarked Works are not well modeled by additive noise. The change in a Work is usually correlated with the Work itself. In fact, many processes are *deterministic* functions of the Work. A simple, but important, example is that of changes in amplitude. That is,

$$c_n = \nu c, \tag{8.2}$$

where c is a Work and ν is a scaling factor. For music, this simply represents a change of volume. In images and video, it represents a change in brightness and contrast.

If a watermark is to be fully robust to amplitude changes, the detection region in media space must be a set of rays emanating from the origin. That is, if c_w is a watermarked Work, the detection region must include all points along the ray from the origin of media space (i.e., pure black or pure silence) through c_w. Of course, linear correlation does not have this property, in that it changes linearly with amplitude. Normalized correlation, on the other hand, is specifically designed to be independent of amplitude.

Investigation

Effects of Amplitude Change

In this investigation we examine the effects of amplitude in two of our example watermarking systems. We look first at a system that uses linear correlation detection, in which we expect detection values to vary with changes in amplitude. Then we examine a normalized correlation system in which we expect to find that the scaling has little, if any, effect on the detection value.

Experiment 1

The E_FIXED_LC/D_LC linear correlation system from System 2 was used to embed watermarks in 2,000 images. The contrast of each of these watermarked images was then modified by scaling the amplitude of the image by several scaling factors between $\nu = 1$ and $\nu = 0$. The resulting detection values are plotted in Figure 8.7, with the scale factor decreasing from left to right, so

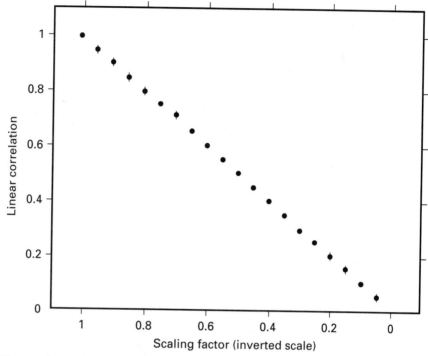

Fig. 8.7 Results of contrast scaling test using E_FIXED_LC/D_LC watermarking system. The points show the mean detection values obtained. The error bars indicate the standard deviations of detection values.

that the severity of the attack increases from left to right. This figure shows, not surprisingly, that linear correlation falls off linearly with decreasing scale.

Experiment 2

The experiment was then repeated with the E_BLK_FIXED_R/D_BLK_CC watermarking system of System 8, in which the detection statistic is a correlation coefficient. Again, 2,000 images were watermarked and the amplitudes scaled. Figure 8.8 shows the detection results, again plotted with the scale factor decreasing from left to right, so that the severity of the attack increases from left to right. These results show that normalized correlation remains fairly constant with scale, except that at very low scaling factors detection becomes much more noisy, and the mean begins to decline. This is caused by the quantization of the scaled pixel intensities to 8-bit values.

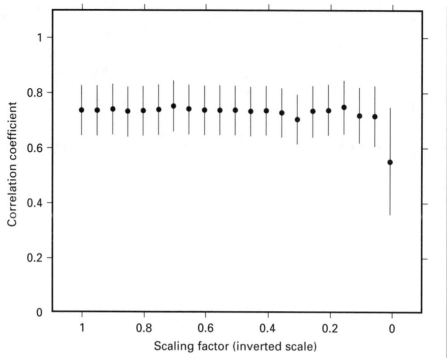

Fig. 8.8 Results of contrast scaling test using E_BLK_FIXED_R/D_BLK_CC watermarking system. The points show the mean detection values obtained. The error bars indicate the standard deviations of detection values.

8.2.3 Linear Filtering

Another common type of signal processing that changes Works in a deterministic fashion is linear filtering. That is,

$$c_n = c * f, \tag{8.3}$$

where c is a Work, f is a filter, and $*$ denotes convolution. Many normal operations on images and audio are explicitly implemented with linear filters. The blurring and sharpening effects in image editing programs apply simple filtering operations, as do base and treble adjustments in a stereo system. In addition, many lossy processes, although not explicitly implemented with filters, can be modeled by them. For example, distortions due to VHS recording can be modeled by applying a low-pass filter to each scan line of video. Playback of audio over loudspeakers can also be approximated as a filtering operation.

If a filter is symmetric about its center in the temporal or spatial domain, all coefficients in its Fourier representation are real. Because convolution in the

temporal or spatial domains corresponds to multiplication in the Fourier domain, filtering with a symmetric filter is equivalent to scaling each element of a Work's Fourier representation by a real-valued scalar. Thus, we can think of each frequency as being either attenuated or amplified by a symmetric filter.

Application of an asymmetric filter affects not only the amplitudes but the phases of the frequencies in a Work's Fourier representation. Like the change in amplitude, the change in phase is frequency dependent. The phases of some frequencies might be changed substantially, whereas others are left unaffected.

The effects of a filter on watermark detection depend on how much energy the added watermark pattern has in each frequency. In general, changes in frequencies where the reference pattern has high energy have a greater effect on detection than do changes in frequencies where the reference pattern has little or no energy. Thus, to make a watermark robust to a known group of filters that might be applied to a Work, we should design the reference pattern to have most of its energy in the frequencies the filters change the least. This idea is examined in the following investigation.

An alternative way to make watermarks survive filtering is to design a watermark extraction method, or detection statistic, that is invariant to convolution with symmetric filters. Note that such convolution affects only the magnitude of each Fourier coefficient and has no effect on its phase. Thus, if only the phase is used during detection, the watermark will be unaffected by this filtering. This idea has been employed in at least two watermarking systems [199, 132].

Investigation

Effects of Low-Pass Filtering

In this investigation, we test the hypothesis that the effects of low-pass filtering depend on the frequency content of the reference pattern. Robustness to low-pass distortion is measured for two reference patterns that have different spectral characteristics.

Experiment 1

The E_FIXED_LC embedder of System 2 was used to embed a Gaussian, white noise pattern in 2,000 images. Because we expect this pattern to be fragile against low-pass filtering, we used a higher embedding strength, $\beta = 1.3$, than in most of our experiments. With a detection threshold of $\tau_{lc} = 0.7$, this gave a target correlation of 2.

The watermarked images were then distorted with Gaussian, low-pass filters of varying standard deviation (width). The filters were computed as

$$f[x, y] = \frac{f_o}{\sum_{x,y} f_o[x, y]},$$ (8.4)

where

$$f_o[x, y] = e^{-\frac{x^2+y^2}{2\sigma^2}}$$ (8.5)

and the range of x, y included all large values of $f_o[x, y]$. As the width, σ, of the filter increased, more distortion was introduced.

The D_LC detector was then applied, and the resulting detection values are shown in Figure 8.9. This graph indicates that the white noise pattern is extremely sensitive to low-pass filtering. The detection values begin falling off sharply when the filter width exceeds 0.4, and the watermark goes largely undetected when the filter width reaches only 0.8. Figure 8.10 shows that the

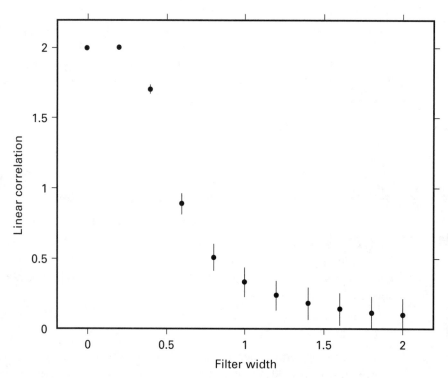

Fig. 8.9 Results of low-pass filtering test using E_FIXED_LC/D_LC watermarking system and a white-noise watermark reference pattern. The points show the mean detection values obtained. The error bars indicate the standard deviations of detection values.

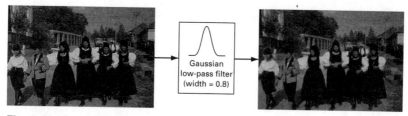

Fig. 8.10 Visual effect of convolving an image with a Gaussian low-pass filter with a width of 0.8.

visual impact of filtering with a Gaussian filter with a width of 0.8 is not terribly significant.

Experiment 2

Next, we modified the reference pattern and repeated the experiment. A band-limited reference pattern was created by filtering high and low frequencies out of the white-noise pattern. The low frequencies were filtered out because they are difficult to embed with high fidelity. The high frequencies were filtered out because they are most affected by low-pass filters. Figure 8.11 shows the resulting reference pattern. Such mid-frequency reference patterns are used in many watermarking algorithms (see, for example, [209, 208, 123]).

Fig. 8.11 Mid-frequency watermark reference pattern created by filtering highest and lowest frequencies out of a white-noise pattern.

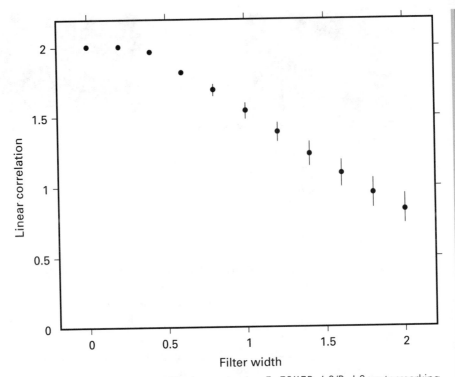

Fig. 8.12 Results of low-pass filtering test using E_FIXED_LC/D_LC watermarking system and a mid-frequency watermark reference pattern. The points show the mean detection values obtained. The error bars indicate the standard deviations of detection values.

This pattern was embedded into 2,000 images again using the E_FIXED_LC embedder, with $\tau = 0.7$, $\beta = 1.3$, and the resulting images were filtered as before. The detection values that resulted from application of the D_LC detector are shown in Figure 8.12. Because correlation with this mid-frequency reference pattern is independent of the highest frequencies, its detection essentially ignores the aspects of the image that are most damaged by low-pass filtering, and the detection values fall off much more slowly. The watermark is still detected in about 85% of the images after filtering with a filter of width 2. Figure 8.13 shows that the visual impact of such a filter is quite noticeable. In some applications, we would not require the watermark to survive more serious distortions.

Of course, as discussed in Chapters 3 and 6, different reference patterns can have wildly different false positive and fidelity behaviors in the E_FIXED_LC/D_LC watermarking system. In a practical implementation of a mid-frequency watermark, care must be taken to ensure that the false positive rate and the fidelity impact are not too high.

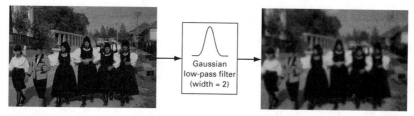

Fig. 8.13 Visual effect of convolving an image with a Gaussian low-pass filter with a width of 2.

8.2.4 Lossy Compression

In lossy compression, a Work is represented in such a way that when the Work is decompressed the result is *not an identical* copy of the original. The loss of information can be acceptable because the computer representation of the signal contains redundancy with respect to what is needed for human perception.

Many people have recognized that there is a fundamental conflict between watermarking and lossy compression. An ideal lossy compressor should quantize all perceptually equivalent Works into a single compressed representation. No two compressed representations should result in perceptually identical Works. If this is not the case, then the lossy compression algorithm is not removing all of the redundancy present in the Work. Now, clearly, if a watermark is to survive lossy compression, the compressed representations of the original and watermarked Works must be different. However, if this is true, our ideal model of lossy compression requires that the original and watermarked Works must be perceptually distinct. In other words, it should not be possible to have a watermark survive lossy compression without affecting the fidelity of the Work.

An interesting illustration of the conflict is provided in [304]. If we are given a lossy compression algorithm and a watermark that survives the compression process, we can use the data payload available to the watermark to encode a portion of the compressed representation. In so doing, we improve the compression algorithm and remove the redundancy the watermarking algorithm was originally exploiting. Admittedly, this is likely to provide only a small gain in compression rate. Fortunately, in practice, lossy compression algorithms are far from ideal, and it is still reasonably straightforward for a watermarking algorithm to survive lossy compression while maintaining excellent fidelity.

8.2.5 Quantization

In this section, we examine the effects of quantization. Quantization can be modeled as

$$c_n[i] = q \left\lfloor \frac{c[i]}{q} + 0.5 \right\rfloor, \tag{8.6}$$

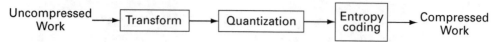

Fig. 8.14 General form of many lossy compression algorithms.

where q is a constant *quantization factor*, and $\lfloor x + 0.5 \rfloor$ rounds x to the nearest integer. A minor form of this distortion occurs as part of most watermark embedding processes, when the watermarked Work is quantized to integer values ($q = 1$) before being stored. We have seen the effect of this quantization in Figure 8.8, where it made watermarks undetectable in many images that were scaled to nearly 0 brightness. However, the most serious quantization usually takes place during lossy compression.

Most common lossy compression algorithms follow the basic structure shown in Figure 8.14. First, a linear, energy-preserving transform, such as the DCT or wavelet transform, is applied to the Work being compressed. Next, each of the resulting terms is independently quantized, in the manner shown in Equation 8.6. Finally, some combination of entropy coding techniques (such as Huffman coding, run-length coding, or predictive coding) is applied to represent the quantized Work with the smallest number of bits practical. Because the transform and entropy coding steps are lossless, the watermark need only survive the quantization step. It is for this reason we devote the rest of this section to discussing the effects of quantization.

Characteristics of Quantization Noise

It is often tempting to assume that quantization is equivalent to the addition of independent noise, which was discussed in Section 8.2.1. The amount of error quantization adds to any given term of the Work depends on where that term lies within the range between two integral multiples of the quantization factor, q. If it lies exactly on a multiple of q, quantization will have no effect on it, and the error will be 0. If it lies exactly between two multiples of q, it will be either increased or decreased by $q/2$. At first glance, it would seem that each term might lie anywhere within the range between the two closest multiples of q, with equal probability, so that the noise added to it is drawn from a uniform distribution between $-q/2$ and $q/2$. This would imply that quantization should have little effect on linear correlation.

In fact, the assumption of independent quantization noise is reasonably accurate when q is relatively small. Widrow [289] pointed out that the maximum value of q that leads to independent noise can be found by applying a version of Nyquist's sampling theorem. The sampling theorem states that a continuous signal can be reconstructed from a sampled version if the sampling frequency is at least twice the highest frequency present in that signal. Widrow showed that

if the "quantization frequency," $\phi = 2\pi/q$, is at least twice as high as the highest frequency present in the Fourier transform of a random variable's PDF, that PDF can be reconstructed from the quantized PDF. More importantly, he showed that under these conditions the resulting quantization noise is independent of the random variable.

Unfortunately, in watermarking we have little control over either the quantization factor or the PDF of the unwatermarked content, and Widrow's condition frequently is not satisfied. If it were satisfied, we should expect linear correlation to be robust to quantization errors, in that it is robust against additive noise. However, the following investigation shows that linear correlation can be quite sensitive to quantization.

Investigation

Effects of Simulated JPEG Compression

In this Investigation, we simulate the effects of JPEG compression by applying quantization in the block-DCT domain. We examine the effect of such quantization on watermarks embedded by the E_FIXED_LC embedder and detected with the D_LC detector.

Experiments

A white-noise watermark was embedded in each of 2,000 images using the E_FIXED_LC embedder with an expected threshold of $\tau_{lc} = 0.7$ and a "strength" of $\beta = 0.3$. To quantize in the block-DCT domain, each watermarked image was divided into 8×8 pixel blocks and the two-dimensional DCT of each block was computed. The DCT coefficient values were then quantized to integer multiples of a quantization factor, q, using a different value for q for each of the 64 terms of a block. Finally, the inverse DCT was applied.

The quantization factors were obtained by multiplying a global quantization level, Q, by the matrix of term-specific quantization factors shown in Table 8.1. This is the luminance quantization matrix used in the JPEG lossy compression algorithm [206]. Thus, for example, when Q was 2, the DC term of each 8×8 block was quantized with a quantization factor of $q = 32$, and the highest-frequency term was quantized with $q = 198$.

The results of applying the D_LC detector to the watermarked, quantized images are shown in Figure 8.15. The x-axis of the figure indicates different values of Q (with $Q = 0$ indicating no quantization). The y-axis indicates the resulting detection values. Clearly, quantization can have a significant effect on linear correlation.

Table 8.1 Luminance quantization matrix used in JPEG. The upper left value (16) is the base quantization factor for the DC term of each 8 × 8 block. The lower right value (99) is the base quantization factor for the highest-frequency terms. These base values are multiplied by a global quantization value (Q) to obtain the actual quantization factor used.

16	11	10	16	24	40	51	61
12	12	14	19	26	58	60	55
14	13	16	24	40	57	69	56
14	17	22	29	51	87	80	62
18	22	37	56	68	109	103	77
24	35	55	64	81	104	113	92
49	64	78	87	103	121	120	101
72	92	95	98	112	100	103	99

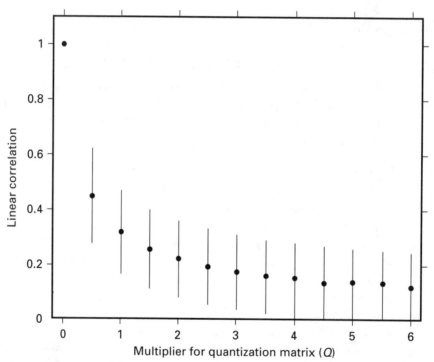

Fig. 8.15 Effect of quantization on linear correlation detection. Two thousand images were watermarked with white-noise reference marks, using the E_FIXED_LC embedding algorithm (τ_{lc} = 0.7, β = 0.3). They were then converted to the block DCT domain, and the DCT coefficients were quantized by quantization factors computed as $Q \times q[i]$, where Q is a global multiplier (x-axis in this graph), and $q[i]$ is a frequency-dependent quantization value (see Table 8.1). Points show mean detection values. Bars show plus and minus one standard deviation.

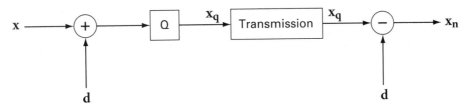

Fig. 8.16 Subtractive dithered quantization.

Analytic Model of Quantization Noise on Linear Correlation

To obtain a more accurate model of quantization's effect on linear correlation watermark detection, it is useful to view the watermarking and quantization process, together, as a case of *dithered quantization*. This is a modified quantization process sometimes used in communications to control the effect of quantization noise.

A dither signal, **d**, is added to the original signal, **x**, prior to quantization. This dither signal is usually a pseudo-random signal. After quantization, the signal is commonly transmitted to one or more receivers that then attempt to reconstruct the signal. In *subtractive dither*, the dither signal is subtracted from the quantized signal in order to reconstruct the signal, as shown in Figure 8.16. In *non-subtractive dither*, the receiver does not have access to the dither signal. Schuchman [241] showed that if a well-chosen dither signal is added to the input signal prior to quantization, the quantization error will be independent of the input signal, **x**.

If the dither signal, **d**, in Figure 8.16 is replaced by the unwatermarked cover Work, c_o, and the transmitted signal, **x**, is replaced by the watermark reference pattern, w_r, the result is exactly a classical blind embedder. Subtractive dither is equivalent to informed detection, in which the original Work is subtracted from the received Work, and non-subtractive dither is equivalent to blind detection. Several authors have observed these equivalences [48, 78, 79].

Eggers and Girod [79] have used the results from Schuchman to analyze how the watermark signal is affected by quantization.[4] They argue that the effect of quantization on watermark detection is determined by the expected correlation between the quantization noise and the watermark reference pattern, $E(nw_r)$. This is the same as the expected product of any element of n and any element of w_r; that is, $E(nw)$, where n is any element of n and w is any element of w_r.

The analysis of [79], along with the necessary background from [241], is presented in Section B.5 of Appendix B. To apply this analysis, we first need to

4. Eggers and Girod chose to consider the watermark as the dither signal. Because we are interested in detection of the watermark signal rather than the cover Work, we consider the watermark to be the signal and the content to be the dither.

specify the probability density functions for the watermark and the content. The probability distribution for the watermark is up to the designer of the watermarking system. For convenience, we will assume it is Gaussian; that is,

$$P_w(x) = \frac{1}{\sigma_w\sqrt{2\pi}} e^{-\frac{x^2}{2\sigma_w^2}}.$$

(8.7)

As discussed in Chapter 3, the probability distribution for the content is difficult to model accurately. In Chapter 6, when deriving the whitening filter for D_WHITE (System 11), we assumed an elliptical Gaussian distribution as a model of image pixel values. In that case, the Gaussian assumption led to a reasonable result (i.e., the resulting whitening filter works). However, Eggers and Girod investigated the use of an elliptical Gaussian model for the distribution of coefficients in an image's block DCT and found that the resulting predictions of $E(nw)$ did not match experimental results. Instead, they suggested using a Laplacian distribution, as recommended in [19, 225], or a generalized Gaussian, as recommended in [19, 192]. The generalized Gaussian yielded better results, but it was not possible to compute $E(nw)$ analytically. We therefore conclude this section by showing the equation for $E(nw)$ when the content, \mathbf{c}, is drawn from a Laplacian distribution with zero mean and standard deviation σ_c:

$$P_c(x) = \frac{1}{\sqrt{2}\sigma_c} e^{-\frac{\sqrt{2}}{\sigma_c}|x|}.$$

(8.8)

Under these assumptions, the expected value, $E(nw)$, is given by

$$E(nw) = \sigma_w^2 \sum_{b=-\infty}^{\infty} (-1)^b \frac{1}{1 + 2(\pi b\sigma_c/q)^2} e^{-2(\pi b\sigma_w/q)^2}.$$

(8.9)

Figure 8.17 shows the results of a simple, numerical experiment, verifying that Equation 8.9 accurately predicts $E(nw)$. One hundred thousand values for \mathbf{c} and w were drawn at random from the distributions described by Equations 8.7 and 8.8, with $\sigma_c = 2$ and $\sigma_w = 0.2$. For each of several quantization factors, 100,000 values of n were computed from the values of \mathbf{c} and w, and the average value of nw was found. The results are plotted as points in the figure. The solid line plots the expected values of nw, as computed by Equation 8.9. Note that when q is very large the expected value of nw tends toward $-\sigma_w^2 = -0.04$. Thus, for $q/\sigma_c > 0.5$ the quantization noise is independent of the watermark signal. However, for values less than this there is a negative correlation that diminishes the output from a linear correlator. Eggers and Girod have examined the usefulness of this result in predicting the effects of JPEG compression [79].

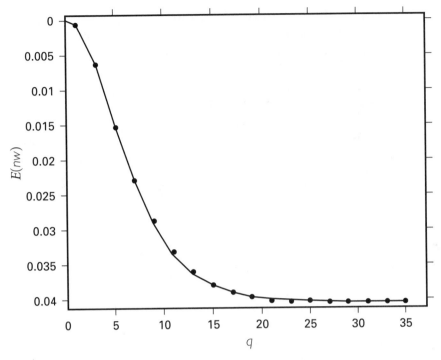

Fig. 8.17 Normalized expected value of the detection value as a function of the quantization step size q. The solid line represents the predicted value, whereas the points represent the results of a simulation.

8.3 Robustness to Temporal and Geometric Distortions

Whereas the previous section examined the traditional sources of noise in a communications system, this section addresses temporal and geometric distortions. Temporal distortion, affecting audio and video signals, includes delay and temporal scaling. Geometric distortion affecting image and video data includes rotation, spatial scaling, translation, skew or shear, perspective transformation, and changes in aspect ratio. In both the temporal and geometric cases the distortion can be global, affecting all samples similarly, or may vary locally.

Although many different approaches have been investigated [75], robustness to temporal and geometric distortion remains one of the most difficult outstanding areas of watermarking research. Most suggested approaches fall into one of the following categories: exhaustive search, synchronization or registration, autocorrelation, invariant watermarks, and implicit synchronization. We examine each of these techniques in turn, but first describe the temporal and geometric distortions themselves.

8.3.1 Temporal and Geometric Distortions

Temporal scaling in audio commonly occurs as a result of simple speed changes in tape players. In video, temporal scaling often occurs in conversions between the frame rates of different television standards. In both audio and video, shifts can occur whenever a watermark detector is presented with signals taken from an arbitrary point in the audio or video signal stream.

Audio scaling may also result from the application of sophisticated processes designed to change the duration of sounds without changing the wavelengths of their component sinusoids [74, 83, 154, 103]. However, these more sophisticated forms of scaling are not discussed in this chapter.

A Work that has been subjected to a time scaling of s and then a delay of δ can be written as

$$\mathbf{c_n}[t] = \mathbf{c}[st + \delta]. \tag{8.10}$$

Geometric distortions to video commonly occur when video undergoes format changes, as in the case illustrated in Figure 8.2, and when standard definition video is upsampled to high-definition formats. Geometric distortions to photographs commonly occur through a variety of user manipulations, some intentional and others unintentional. Often, printing, photocopying, and scanning will introduce a variety of unintended geometric distortions.

In two-dimensional visual data there are two, potentially different, scaling parameters and two different translation parameters. When the vertical and horizontal scaling factors differ, there will be a change in the *aspect ratio*. Additionally, a visual Work can undergo rotation and shear (or skew). All of these geometric distortions can be expressed as an affine transformation given by

$$\begin{bmatrix} x_n \\ y_n \end{bmatrix} = \begin{bmatrix} a & b \\ c & d \end{bmatrix} \begin{bmatrix} x_0 \\ y_0 \end{bmatrix} + \begin{bmatrix} x_t \\ y_t \end{bmatrix}, \tag{8.11}$$

where (x_0, y_0) represents the undistorted location of each pixel and (x_n, y_n) represents the distorted location. Whereas the translation is completely represented by the vector (x_t, y_t), the two-by-two matrix is used to define all other affine transformations. For example, scaling can be described by the matrix

$$\begin{bmatrix} s_x & 0 \\ 0 & s_y \end{bmatrix}, \tag{8.12}$$

with change in aspect ratio occurring when $s_x \neq s_y$. Rotation by an angle θ can be implemented with the matrix

$$\begin{bmatrix} \cos\theta & -\sin\theta \\ \sin\theta & \cos\theta \end{bmatrix}. \tag{8.13}$$

Shear in the x-dimension and the y-dimension can be respectively described by the matrices

$$\begin{bmatrix} 1 & a \\ 0 & 1 \end{bmatrix} \tag{8.14}$$

and

$$\begin{bmatrix} 1 & 0 \\ b & 1 \end{bmatrix}. \tag{8.15}$$

In addition to these affine distortions, other common geometric distortions include reflection, perspective distortion, and geometric warping.

Different watermark patterns have different levels of *natural robustness* to temporal and geometric distortions. In the one-dimensional case, the linear correlation between a delayed, time-scaled Work and the reference mark, $\mathbf{w_r}$, will only be high if $\mathbf{w_r}[t] \cdot \mathbf{w_r}[st + \delta]$ is high. Thus, the correlation between a reference mark and a delayed, time-scaled version of itself defines its natural robustness to delays and scales. For sufficiently small values of s and δ, many one-dimensional reference marks will show some natural robustness. Low-pass signals exhibit some natural robustness to small shifts. However, the autocorrelation of a truly white noise signal drops to zero at a shift of only one sample. Similarly, different two-dimensional reference patterns exhibit varying degrees of natural robustness to shift, rotation, scaling, skew, and so on [39, 40].

8.3.2 Exhaustive Search

The simplest approach for watermark detection after a temporal or geometric distortion is an exhaustive search. After defining a range of likely values for each distortion parameter and a search resolution for each, every combination of parameters is examined. The search range can often be constrained by the assumption that if any distortions were applied they have had minimal impact on the perceptual quality of the Work. The resolution of the search can be determined by the natural robustness of the reference pattern to the distortions of interest.

Each combination of distortion parameter values represents a hypothetical distortion that might have been applied to the Work after the watermark had been embedded. The search can involve inverting each hypothetical distortion and then applying the watermark detector once for each possible reference pattern. Alternatively, we can apply the hypothetical distortion to the reference pattern prior to detection.

When considering an exhaustive search, two primary issues arise, both related to the large number of applications of the watermark detector. The first, and perhaps most obvious, concern is computational cost. The amount of computation necessary increases with the size of the search space.

Consider an audio source sampled at 14.1 kHz in which a watermark is embedded once each second. If we allow for simple temporal scaling of ±3%, an exhaustive search might examine all temporal scalings from 97% to 103% in 0.1% increments, and temporal delays of ±0.5 seconds in increments of 1 sample. This search would require about $N = 860,000$ detection operations.

In two-dimensional Works, the size of the search space can increase dramatically. For example, consider an exhaustive search that examines all rotations from −179 to +180 degrees in 1-degree increments, horizontal and vertical scalings from 50% to 200% in 1% increments, and vertical and horizontal translations of ±100 pixels in increments of 1 pixel. This search would require about $N = 330$ *billion* detection operations.

The second important issue that arises with multiple applications of a watermark detector is the effect on the false positive probability. For each unwatermarked Work, we test N distorted versions in the detector. If the watermark is found in at least one of these versions, the detector will produce a false positive. Denoting the random-work false positive probability of any single version of a Work by P_{fp}, the probability that at least one of the N versions will cause a false positive is bounded by $N \times P_{fp}$. When N is large, this can be unacceptable.

Computation and false positive probability are two practical forces that limit the size of the search space. Thus, effective uses of exhaustive search rely on techniques that result in small searches [108]. For example, in an image marking space constructed by summing all 8×8 blocks (as in the E_BLK_BLIND and D_BLK_CC algorithms), all image translations can be roughly modeled as circular shifts of the 8×8 extracted vector. Thus, a full translational search, with one pixel resolution in both vertical and horizontal dimensions, would require only 64 applications of the detector.

8.3.3 Synchronization/Registration in Blind Detectors

Both the computational cost and the increase in false positive probability associated with an exhaustive search can be avoided if the Work suspected of containing a watermark can be aligned with the reference pattern prior to a single application of the watermark detector. This process is called *synchronization* in audio literature and *registration* in image processing literature. When the original Work is available at the detector, techniques from the pattern recognition literature can be used to align the original Work with the Work suspected of containing a watermark [33, 174, 155, 255, 300, 279].

A common synchronization approach for blind detectors is the embedding of a dedicated synchronization pattern in addition to the payload-carrying reference patterns [270, 207, 65]. Because the synchronization pattern is known, the detector can employ one of many well-known registration techniques. As with all watermark patterns, synchronization patterns are designed to have very

low power compared to that of the Work. To ease the registration task in such a "noisy" environment, the synchronization pattern can be specially designed for easy identification in the face of temporal and geometric distortions [227].

With this approach, watermark detection involves first finding the registration pattern in a suspect Work. The temporal/geometric distortion that had been applied to that Work can then be identified by comparison of the extracted registration pattern and the embedded registration pattern. That distortion is inverted and detection of the data-carrying watermark proceeds.

Systems that rely on synchronization patterns to correct for temporal and/or geometric distortions have two failure modes. As we have previously discussed, a false negative can occur because of problems with the payload-carrying watermark. It may not have been effectively embedded or it may have been distorted, intentionally or unintentionally, between the time of embedding and detection. The second potential cause of a false negative is problems with the synchronization pattern. A correct positive detection requires that both the payload-carrying marks and the synchronization pattern be successfully embedded and successfully detected.

The use of a synchronization pattern also has negative security implications. Typically, the same synchronization pattern is used for many different Works. This eases the task of the detector in finding a distorted synchronization pattern, but it may also allow the synchronization pattern to be discovered from a set of watermarked Works. Once the synchronization pattern is discovered by an adversary, it can be removed, thus limiting the ability of the watermarking scheme to counter the effects of temporal and geometric distortions. It is therefore important that the synchronization pattern itself be as secure as the data-carrying watermark (see Chapter 9 for a detailed discussion of security).

If the synchronization pattern is added along with the data-carrying watermark, the fidelity of the resulting Work is likely to decrease. Alternatively, the amplitude of these marks can be reduced to maintain the fidelity, but this will likely reduce the overall robustness of the system to additive noise, filtering, and so on. Thus, the use of synchronization patterns to provide robustness to temporal and geometric distortions comes at a cost to either fidelity or general robustness.

8.3.4 Autocorrelation

In some cases, the embedded pattern can serve both as the synchronization pattern and as the payload-carrying pattern. Typically, this requires that the data-carrying watermark have some properties that allow for synchronization [227]. In the *autocorrelation* approach, this property is periodicity.

The autocorrelation of a Work typically has a large peak at zero (corresponding to the signal energy) and then decays rapidly at non-zero shifts. This is even more

true when examining the autocorrelation of a "white" or uniformly distributed signal. When a periodic, white synchronization pattern is embedded in a Work, the resulting autocorrelation will contain a periodic train of peaks identifying periodicity of the added pattern in the Work. This, in turn, can be used to identify and invert any scaling applied to the Work since the embedding of the synchronization pattern [120, 121, 147].

Autocorrelation methods have significant potential. However, similar to the approach of adding a synchronization mark, they have two failure modes. For successful detection, both the identification of the temporal/geometric distortion and the detection of the watermark after inversion of that distortion must be successful. Depending on the application, both of these processes may need to be robust and/or secure.

8.3.5 Invariant Watermarks

Rather than detect and invert the temporal and geometric distortions, an alternative approach is the design of watermarks that are invariant to such distortions. The Work is projected to an invariant feature vector as part of the signal extraction process.

Consider the following derivation of a one-dimensional feature vector that is invariant to delay and scaling of the temporal axes. It starts with a commonly used feature vector that is invariant to shifts or delays, the Fourier magnitude [26]. Next, note that scaling of a Work's time axis appears as a scaling of the frequency axis in the Fourier domain, so that in one dimension we can write

$$|\mathcal{F}\{\mathbf{c}(st-\delta)\}| = \frac{1}{s}|\mathbf{C}(f/s)|. \tag{8.16}$$

This scaling of the frequency axis can be treated as a shift along a log axis by defining the signal, \mathbf{C}', as follows:

$$\mathbf{C}'(u) \equiv \mathbf{C}(e^u), \tag{8.17}$$

so that

$$\mathbf{C}'(\log f) = \mathbf{C}(f). \tag{8.18}$$

Equation 8.16 can then be written as

$$|\mathcal{F}\{\mathbf{c}(st-\delta)\}| = \frac{1}{s}|\mathbf{C}'(\log f - \log s)|. \tag{8.19}$$

Therefore, in this domain, temporal delay has no effect, and temporal scaling is seen as a coordinate shift and a change in amplitude. By applying a second Fourier magnitude we can ensure that the only effect of temporal scaling and

delay is a change in amplitude; that is,

$$|\mathcal{F}\{|\mathcal{F}\{\mathbf{c}(st-\delta)\}|\}| = \left|\mathcal{F}\left\{\frac{1}{s}|\mathbf{C}'(\log f - \log s)|\right\}\right| \tag{8.20}$$

$$= \frac{1}{s}|\mathcal{F}\{|\mathbf{C}'(\log f)|\}|. \tag{8.21}$$

We can then use a detection statistic that is invariant to amplitude changes, such as normalized correlation. This is an example of a time-scale and time-delay invariant representation of a one-dimensional signal.

These ideas have been extended to two dimensions to build feature vectors that are invariant to rotation, scaling, and translation. The trick is to represent the Fourier image in polar coordinates and then apply a logarithmic transformation to the radial axis. This can be implemented with a Fourier-Mellin transform [124, 298, 244, 245, 165]. Watermarking methods have been proposed that use these techniques as part of the watermark extraction process [200, 162]. A similar approach has been taken to generate watermarks that are invariant to changes in aspect ratio [163].

8.3.6 Implicit Synchronization

There is a class of blind detection watermarking techniques in which the suspect Work goes through a synchronization process prior to detection. However, rather than a synchronization pattern, the actual features of the Work are used. The watermark is embedded at a time or geometry relative to the features of the original Work. We refer to this type of synchronization as *implicit synchronization* because the synchronization pattern is implied by the Work itself.

A simple application of this approach is that of [295], in which a watermark signal is embedded in an audio stream just after the detection of "salient points." In this example, salient points are defined as locations at which the signal is climbing fast to a peak value. Such an approach will provide robustness to delay because the location of the watermark remains constant relative to the salient points.

Similarly, [11, 231, 12, 72] are examples in which feature points are extracted from an image. The reference patterns representing the watermark are then warped to fit the geometries implied by those points.

In another approach, the marking space is defined as a canonical, normalized space based on the geometric image moments [4]. Based on these moments, an image is transformed into a form that is independent of its scale or orientation. This form is also invariant to horizontal and vertical reflection. The marking is applied in this space, and then the inverse transformation restores the original reflection, orientation, and scale. During detection, the moments are again

calculated and used to estimate the normalization parameters. Once the image is normalized, the watermark can be detected.

Implicit synchronization requires that the salient features be reliably extracted during detection. Some distortions may affect the locations of salient features relative to the Work. When these distortions are applied after watermark embedding but before detection, the implicit synchronization can fail and the watermark can go undetected.

8.4 Summary

The robustness of a watermarking method is a measure of the ability of the watermark to survive legitimate and everyday usage of the content. General methods for achieving high robustness were presented along with specific methods for handling some of the most common types of processing. The main points of this chapter were:

- We discussed several general approaches to making watermarks robust.
 - *Redundant embedding* can increase robustness to cropping, filtering, and additive noise. The redundancy can be in the sample domain, the frequency domain, or any other domain in which only part of the signal is distorted by processing.
 - *Spread spectrum* watermark reference patterns are redundant in the spatial and frequency domains. These provide general robustness against filtering, additive noise, and cropping.
 - Embedding watermarks in perceptually significant components of content ensures their robustness against any processing that maintains acceptable fidelity.
 - It is sometimes possible to explicitly identify components of content that are robust to expected processes and embed the watermark in these. If the detector is informed, this may be done on a Work by Work basis.
 - If a detector can determine that a specific process has been applied to a Work since the time it was watermarked, the detector might either invert that process, or apply it to the reference mark.
 - Sometimes, we can anticipate that watermarks will be subject to one of a small collection of possible distortions. In these cases, it may be possible to apply the inverse distortion during the embedding process.
- Valumetric distortions (as opposed to geometric distortions) can often be modeled as combinations of additive noise, amplitude changes, linear filtering, and lossy compression.
- Linear correlation detection is specifically designed for robustness to additive noise. The use of a robustness metric in the embedder can also provide robustness to additive noise in a normalized correlation detector.

■ The use of normalized correlation provides robustness to amplitude changes.

■ The use of mid-frequency reference patterns provides robustness to low-pass filtering.

■ In theory, lossy compression is diametrically opposed to watermarking, since compression attempts to remove all redundancy from content, and watermarks attempt to code information in that redundancy. In practice, however, lossy compression algorithms are far from perfect, and it is possible to make watermarks that survive them.

■ Most lossy compression algorithms involve quantizing a Work in some transform domain.

■ The noise introduced by quantization is not always well-modeled as independent, additive noise. We presented a method for predicting the impact of quantization on linear correlation given a distribution of unwatermarked content, a watermark distribution, and a quantization step size.

■ Geometric distortions, such as temporal delay or spatial scaling, are generally more difficult to handle than valumetric distortions, and robustness against them is a current topic of research. We presented several broad approaches to this problem.

⊞ *Exhaustive search* entails inverting a large number of possible distortions, and testing for a watermark after each one. As the number of possible distortions increases, the computational cost and false positive probability using this approach can become unacceptable.

⊞ Synchronization/Registration patterns can be embedded in content to simplify the search. These prevent an increase in the false alarm rate and are usually more computationally efficient than exhaustive search. However, they introduce two failure modes: failure to correctly detect the registration pattern and failure to detect the watermark after registration.

⊞ In the autocorrelation approach, we embed a periodic watermark and register based on the peaks in a Work's autocorrelation pattern.

⊞ *Invariant watermarks* can be constructed using such techniques as log-polar Fourier transforms. These remain unchanged under certain geometric distortions, thereby eliminating the need to identify the specific distortions that have occurred.

⊞ In *implicit synchronization*, we register according to feature points found in the original, unwatermarked Work. This depends on development of a reliable feature-extraction method.

Watermark Security

The *security* of a watermark refers to its ability to resist intentional tampering, as opposed to the common signal distortions discussed in Chapter 8. Intentional tampering or hostile attack becomes an issue when someone is motivated to prevent a watermark from serving its intended purpose. Watermarks can be attacked in a variety of different ways, and each application requires its own type of security.

We begin, in Section 9.1, with a discussion of the types and levels of security that might be required of a watermarking application. We then discuss the relationship between watermarking and cryptography, in Section 9.2. We find that there are cryptographic tools that can be directly applied to watermarking systems to achieve some types of security. Those security areas in which cryptographic tools are helpful are distinguished from those that must be addressed in other ways. Finally, in Section 9.3, we describe a number of well-known attacks on watermarking systems. For some of these attacks, reliable countermeasures are known, but security against some others remains a topic of research.

9.1 Security Requirements

The security requirements for a watermarking system vary greatly from application to application. In some applications watermarks need not be secure at all, because there is no motivation to tamper with or circumvent the watermark's intended pupose. For example, most of the device-control applications described in Section 2.1.7 use watermarks only to add value to the content in which they are embedded. In such cases, no one benefits from tampering, and therefore the watermarks need not be secure against any form of malicious attack, although they still need to be robust against normal processing.

Those applications that do require security often must defend against very different forms of attacks. In some cases, the types of security required can even vary between different implementations of the same application. For example, a copy-control system (Chapter 2) might use watermarks to identify copyrighted Works that people are not allowed to copy. Such watermarks should be secure against unauthorized removal. Alternatively, a copy-control system could use watermarks to identify Works that people *are* allowed to copy. The absence of a watermark indicates that copying is not allowed. With such a design, an adversary is not motivated to remove watermarks but to *embed* watermarks. Thus, a watermarking algorithm for this second copy-control system must be designed to prevent unauthorized embedding.

Furthermore, the *level* of security required by different applications can vary, depending on the level of sophistication of expected adversaries. Any military application of watermarks would require the highest levels of security possible, because the adversaries must be assumed to have all of the resources of an enemy nation at their disposal. At the other extreme, an application meant to restrict small children's access to certain Works may need to be secure only against the simplest attacks, if any.

In this section, we first discuss some broad restrictions that various applications place on manipulations of their watermarks. Specifically, in a given application, certain people may be restricted from embedding, detecting, and/or removing watermarks. Within each of these categories of restriction there are subtle variations on the types of attack an adversary may attempt. For example, an adversary restricted from detecting marks may attempt to fully detect and decode the watermark message, or may attempt only to determine that the watermark is present, without reading the message it contains. These variations are the topic of Section 9.1.3. Finally, we discuss the assumptions to be made about the adversary when judging the security of a watermark.

9.1.1 Restricting Watermark Operations

In every application of watermarking, some people must have the ability to embed, detect, and/or remove watermarks, whereas others must be restricted from performing some, or all, of these actions. Secure watermarks are required to enforce these restrictions. Consider the following three scenarios.[1]

1. Those familiar with the literature on cryptography will recognize the names of Alice and Bob in these scenarios. These two, along with Carol and eavesdropping Eve, are standard characters in descriptions of cryptography problems. We use them here for the same reason they are used in cryptography: because they are more interesting than simply A, B, and C. However, by using these characters, we do not mean to imply that the problems we are describing are necessarily cryptographic problems or that they can be addressed with cryptographic solutions. The relationship between cryptography and watermarking is addressed in Section 9.2.

■ *Scenario 1:* Alice is an advertiser who embeds a watermark in each of her radio commercials before distributing them to 600 radio stations. She then monitors the radio stations with a watermark detector, logging the broadcast of her commercials and later matching her logs with the 600 invoices she receives, thus identifying any false charges. Bob operates one of these 600 radio stations and would like to air one of his own commercials in place of one of Alice's. However, he still wants to charge Alice for the air time. Therefore, Bob secretly embeds Alice's watermark into his own advertisement and airs it in place of Alice's commercial. Alice detects this watermark and is fooled into believing that her advertisement was correctly broadcast.

■ *Scenario 2:* Alice owns a watermarking service that, for a nominal fee, adds an owner identification watermark to images that will be accessed through the Internet. Alice also provides an expensive reporting service to inform her customers of all instances of their watermarked images found on the Web. Her customers use this information to identify any unauthorized distribution of their images. Bob builds his own web crawler that can detect watermarks embedded by Alice, and offers a cheaper, competing reporting service, luring away Alice's reporting service customers. Bob can offer a cheaper service because he does not incur the cost associated with embedding watermarks.

■ *Scenario 3:* Alice owns a movie studio, and she embeds a copy-control watermark in her movies before they are distributed. She trusts that all digital recorders capable of copying these movies contain watermark detectors and will refuse to copy her movie. Bob is a video pirate who has a device designed to remove the copy protection watermark from Alice's movies. Using this device, Bob is able to make illegal copies of Alice's movies.

In each of these scenarios, Bob manages to circumvent the intended purpose of Alice's watermarks by performing an operation he is not authorized to perform. In Scenario 1, he performs an *unauthorized embedding* operation, or *forgery attack,* by embedding a watermark that only Alice should be able to embed. In Scenario 2, he performs an *unauthorized detection* operation, or *passive attack,* by detecting watermarks that only Alice should be able to detect. In Scenario 3, he performs an *unauthorized removal* operation by removing watermarks that no one should be able to remove. Each of these three categories of attack poses its own technological challenges to the designers of secure watermarks.[2]

2. A fourth type of attack, *unauthorized changing,* has the adversary, Bob, change the message encoded in the watermark. An example of this type of attack might occur if Alice embeds a message that says, "This Work belongs to Alice" and Bob changes it to "This Work belongs to Bob." This type of attack has received little attention in the published literature, and it is difficult to imagine a way to do it other than a combination of unauthorized removal and unauthorized embedding. That is, Bob must first remove Alice's original mark, and then embed his own mark. We therefore do not address this attack as a separate case in this chapter.

Table 9.1 Operational table for the applications of the three scenarios presented. The label "Y" means this operation must be allowed, and the label "N" means that this operation must be prevented. The label "–" indicates that the system will work regardless of whether the operation is allowed.

	Embed	Detect	Remove
Broadcast Monitoring			
Advertiser	Y	Y	–
Broadcaster	N	N	–
Public	N	N	–
Web Reporting			
Marking Service	Y	Y	–
Reporting Service	–	Y	–
Public	N	N	N
Copy Control			
Content Provider	Y	Y	–
Public	–	Y	N

The importance of preventing each type of attack depends on the application. It is useful to analyze the security requirements of an application by specifying who is allowed to perform which operations. For a given application, we divide the world into a number of different groups and assign a set of permissions to each. The resulting operational table will determine the security properties required of the watermarking system.

Table 9.1 shows the permissions for a number of different groups in each of the three scenarios described. Note that for many entries we do not care whether a particular group can perform some operation, because it would have no direct impact on the purpose of the watermarking system. However, it may turn out to be difficult or impossible to deny a group permission for one operation while allowing them to perform another. For example, it is an open question whether a system can be designed that allows an individual to embed a watermark without giving him or her the ability to remove it. If it is impossible, we would have to deny the public the ability to embed watermarks in the copy-control application, changing the "–" in the lower left of Table 9.1 to an "N."

9.1.2 Public and Private Watermarking

Two special cases of permission combinations are shown in Table 9.2. In both cases, the world is divided into a group of *trusted* individuals, who are usually the people the watermark is designed to benefit, and the *public*, who are generally

Table 9.2 Operational table for two categories of watermarking application: *private watermarking* and *public watermarking*.

	Embed	Detect	Remove
Private Watermarking			
Trusted	Y	Y	–
Public	N	N	N
Public Watermarking			
Trusted	Y	Y	–
Public	N	Y	N

assumed to be potential adversaries. In the first case, often referred to as *private watermarking,* the public is not allowed to access the watermarks in any way. In the second case, often referred to as *public watermarking,* the public is allowed to detect the watermarks, but nothing else. In this usage, "public" and "private" watermarking refer to security requirements of the application.

Similar terminology is often used to describe watermarking *algorithms.* Thus, *private watermarks* or *private watermarking systems* refer to technologies appropriate for the first set of security requirements in Table 9.2. Similarly, *public watermarks* or *public watermarking systems* refer to technologies appropriate for the second set of security requirements. Unfortunately, this usage of "public" and "private" is ambiguous, because most technologies can be used for either type of application.

As a first example, systems that employ informed detectors are often referred to as "private," on the assumption that the public does not have access to the original Works, which are needed for detection. However, there can be public watermarking applications in which the public *does* have access to the original Works. Consider a hypothetical NASA web site containing space probe imagery. Each original image is accompanied by a number of versions, which have been enhanced by some image processing technique. Each of the enhanced images is watermarked with a text string describing the processing that has been applied. Given the original image and an enhanced image, an informed detector reveals the string describing the enhancement processes. In this scenario, we have an informed detector being used in a public watermarking application.

As a second example, systems that employ blind detection, without using keys, are often referred to as "public," on the assumption that the public knows the detection algorithm. However, if the algorithm is kept secret, it can still be used for a private watermarking application. Of course, the security of such a system would be difficult to verify before deployment (see Section 9.1.4).

As a final example, systems that employ blind detection, but *do* use keys, are equally suitable for both types of application. Here, the difference between a "public" system and a "private" system is merely a matter of how the keys are distributed.

In addition to this problem with using "public" and "private" to describe watermarking technologies, their usage invites confusion with public-key cryptography, which employs both a public and a private key. Therefore, in this book we avoid use of the terms *public watermarking* and *private watermarking*.

9.1.3 Categories of Attack

Tables 9.1 and 9.2 give a broad indication of who is permitted to perform which actions. Within the three categories of action represented by the columns there are many subtle variations. It is often possible for an adversary to perform one or more parts of an unauthorized action, even if he is unable to perform the action completely. For example, watermark detection generally comprises two separate steps: detecting the presence of the mark and decoding the embedded message. In some systems, it may be easy for an adversary to detect the presence of the mark but difficult to decode the message. Depending on the application, such partial attacks can be serious concerns. It is therefore necessary to differentiate each of the three broad categories of unauthorized actions into more specific *types* of attacks.

Unauthorized Embedding

The most complete type of unauthorized embedding entails the adversary composing and embedding an original message. For example, suppose Alice has a business such as that in Scenario 2, except that she charges only for embedding owner IDs and gives away the web-monitoring software for free. If Bob wants to use the web-monitoring software without paying Alice, he will try to embed his own identification mark. To do so he must compose a new message that identifies a Work as his, and build a tool for embedding it. As we shall see in Section 9.2.3, such an attack can easily be prevented with standard cryptographic techniques.

A less complete type of unauthorized embedding occurs when the adversary obtains a pre-composed legitimate message, rather than composing a novel message, and embeds this message illicitly in a Work. For example, in Scenario 1, Bob wants to embed Alice's ID into his radio advertisement before broadcasting it. If Alice's watermarking system is not well designed, Bob might be able to determine the reference pattern Alice uses to encode her ID within commercials. He could then copy that pattern into his own advertisement, often without having to understand anything about how the message is encoded. This type of attack, known as a *copy attack* [152], is discussed in more detail in Sections 9.2 and 9.3.3.

Unauthorized Detection

In some applications for which the ability to detect should be restricted, we are primarily concerned with preventing people from actually decoding what a watermark says. For example, a hospital might embed the names of patients into their X-rays. For reasons of privacy, unauthorized individuals should be prohibited from reading the marks and identifying the patients. In this case, it is sufficient to prevent the adversary from decoding the mark, and this can be done with standard cryptographic tools (see Section 9.2.3).

In other applications, however, the adversary might be satisfied with simply knowing whether or not a watermark is present, and need not know what message the watermark encodes. Strictly speaking, this is a problem of steganography, not watermarking. Nevertheless, it is conceivable that a watermarking application might arise in which the system can be compromised by an adversary who merely identifies whether or not a mark is present in a given Work. Furthermore, as we shall see in Sections 9.3.5 and 9.3.6, the ability to detect the presence of a watermark can be a great advantage to an adversary who is trying to remove marks. Thus, it is conceivable that if a watermark is to be secure against unauthorized removal it must also be secure against this type of unauthorized detection. Security against decoding, without security against detection, is not enough.

A third type of unauthorized detection, which lies between full decoding and mere detection, occurs when an adversary can distinguish between marks that encode different messages, even though he does not know what those messages are. That is, given two watermarked Works he can reliably say whether their respective marks encode the same or different messages. This type of attack is a problem if the adversary can determine the meaning of the messages in some way other than actually decoding them. For example, in Scenario 2, Bob wants to steal Alice's customers by finding their IDs in watermarks on the Web. Alice might attempt to guard against this by using a secret code for associating watermarks with her clients, thus preventing Bob from decoding the watermarks to identify the owners of the Works. However, if Bob can reliably determine whether or not two Works contain the same mark, he can still steal Alice's business. He simply asks any prospective client to provide him with one example of a Work Alice has watermarked. When he finds other Works on the Web that contain the same watermark, he knows they belong to this customer. In this case, Bob does not need to know how Alice encodes the ID of each customer in the watermarks.

Unauthorized Removal

In general, a watermark is considered removed from a Work if it is rendered undetectable. The most extreme case of such removal would restore the Work to its original unwatermarked form. In all watermarking applications that require security against unauthorized removal, it is necessary to prevent an adversary

from recovering the original. However, it is difficult to think of an example in which such prevention provides *sufficient* security.

In the vast majority of applications, the adversary will try to modify the watermarked Work such that it *resembles* the original and yet does not trigger the watermark detector. The original Work is just one of an extremely large number of Works that fit this description. Thus, showing that an adversary cannot recover the original is only a minor step toward showing that a watermark is secure against removal.

The adversary can employ a fidelity constraint requiring that the distortion introduced by the attack has minimal perceptual impact. This is similar to the use of a fidelity constraint for embedding, but the perceptual model used by an adversary need not be the same as that used for embedding. Further, the fidelity requirements of the adversary are usually less stringent than those of embedding [190, 42]. In this case, the fidelity is measured between the watermarked Work and the attacked Work.

Within the range of Works that will satisfy the adversary, a distinction is often made between those in which the watermark is truly gone and those in which the watermark is still present but can only be detected by a more sophisticated detector than the one being used. We refer to the former as *elimination* attacks, and to the latter as *masking* attacks.

As an example of a masking attack, consider an image watermarking system in which the detector is unable to detect watermarks in images that have been rotated slightly. Thus, an adversary might "remove" a mark from an image by applying a small rotation. However, presumably a smarter detector, employing some sort of registration and search, would be able to invert the rotation and still detect the watermark.

This contrasts with an elimination attack in which the adversary tries to estimate the embedded watermark pattern and subtract it. The result of such an attack might be a fairly close approximation of the original Work (though not necessarily an exact reconstruction of the original).

Intuitively, the distinction between elimination attacks and masking attacks seems clear. When viewed in media space, however, this distinction becomes less apparent. Both the rotation attack and the estimate-and-subtract attack move points from within the detection region (i.e., watermarked Works) to points outside the detection region (i.e., unwatermarked Works). Replacing the detector with one that performs a geometric search merely changes the detection region to include the Works attacked by rotation. This is illustrated schematically in Figure 9.1. If we can counter the rotation attack by creating a more sophisticated detector, why can't we counter every attack this way?

Clearly, an attack that recovers the exact original Work cannot be countered by modifying the detector. We can identify other attacks that also cannot be addressed in this way by examining where the attacked Works lie in media space in

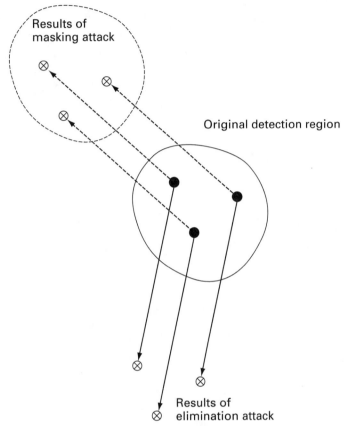

Portion of detection region
added by smarter detector

Results of
masking attack

Original detection region

Results of
⊗ elimination attack

Fig. 9.1 Illustration of elimination and masking attacks. The solid contour indicates an arbitrary detection region, defined by the original detector. The solid arrows illustrate a possible effect of an elimination attack, whereas the dashed arrows illustrate a masking attack. The masking attack can be countered by using a smarter detector, which adds the dashed contour to the detection region.

relation to the distribution of unwatermarked content. In the case of the rotation attack, the attacked Works still have unusual properties that the embedding process gave them. That is, they are very unlikely to occur in the distribution of unwatermarked Works. Thus, if we modify the detection region to include an area around the attacked Works, we will not substantially increase the false positive probability.

On the other hand, the attack that estimates and subtracts the reference pattern results in Works that are quite likely to arise without embedding. If we modify

the detection region to include an area around these attacked Works, we will increase the false positive rate unacceptably.

Thus, we can define elimination attacks as those that move watermarked Works into regions of media space where unwatermarked Works are likely, and masking attacks as those that move watermarked Works into regions in which unwatermarked Works are not likely. This difference between masking attacks and elimination attacks is illustrated in Figure 9.2.

The distinction between elimination attacks and masking attacks can be important in applications in which it is feasible to modify the detector after the

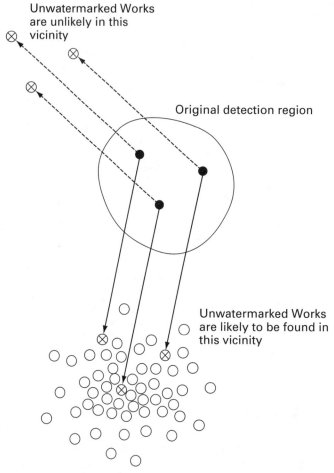

Fig. 9.2 Illustration of the significant difference between elimination and masking attacks. The crowd of open circles indicates a region of media space in which unwatermarked Works are very likely. The elimination attack (solid arrows) moves watermarked Works into this region. The masking attack (dashed arrows) moves watermarked Works into a region in which unwatermarked Works are not likely.

attack is discovered. For example, in a transaction-tracking application, only the owner of a Work might need to detect watermarks. If an adversary attempts to thwart the system by applying a masking attack, so that the owner's watermark detector will not detect the marks in pirated Works, the owner has a chance of upgrading his detector to a smarter one that can detect the distorted watermark. On the other hand, if the adversary can apply an elimination attack, the owner has little chance of detecting the marks, even with a better detector. Thus, in applications in which it is possible to update the detector, masking attacks are less serious than elimination attacks.

System Attacks

Before concluding this discussion of types of attacks on watermarking systems, we must point out that not all attacks are attacks on the watermarks themselves. An adversary can often thwart the system without having to perform any of the previously discussed unauthorized actions. Attacks that exploit weaknesses in how the watermarks are used, rather than weaknesses in the watermarks themselves, can be broadly referred to as *system attacks*.

As a simple example of a system attack, consider a copy-control application in which every recording device includes a computer chip for detecting the watermark. An adversary might open the recorder and just remove the chip, thereby causing the recorder to allow illegal copying. In such an attack, the security of the watermark itself is irrelevant.

Of course, in this book we are discussing only watermarking technology, and therefore system attacks such as removal of a detector chip are outside our scope. However, it is important to keep these types of attacks in mind when designing a system that employs watermarks. The adversary will always attack the weakest link in the security chain.

9.1.4 Assumptions about the Adversary

In evaluating the ability of watermarking technologies to meet the types of requirements laid out in Tables 9.1 and 9.2, it is necessary to make some assumptions about the capabilities of the adversary. What does he know about the watermarking algorithm? What tools does he have at his disposal? For example, if he is trying to remove a watermark, does he know how the mark was embedded? Does he have a detector he can experiment with?

If the Attacker Knows Nothing

The simplest assumption is that the adversary knows nothing about the algorithms and has no special tools (such as a watermark detector). Under these circumstances, the adversary must rely on general knowledge of the weaknesses from which most watermarking algorithms suffer. For example, suppose an

adversary thinks a Work might be watermarked and wants to remove that mark. He might try applying various distortions he knows mask most watermarks, such as noise-reduction filters, extreme compression, or small geometric or temporal distortions. This is the basic approach taken by the Stirmark program [151], which often succeeds in making watermarks undetectable.

If the Attacker Has More than One Watermarked Work

In some cases, it is possible for an adversary to obtain multiple watermarked Works. The adversary can often exploit this situation to remove watermarks, even when he does not know the algorithm. Attacks that rely on possession of several watermarked Works are known as *collusion attacks*.

There are two basic types of collusion attacks. In one, the adversary obtains several different Works that contain the same watermark and studies them to learn how the algorithm operates. The simplest example of such an attack has the adversary averaging several different marked Works. If all Works have the same reference pattern added to them, this averaging would yield something close to that pattern. The averaged pattern can then be subtracted from Works to remove the watermark.

A variation on this first type of collusion attack can be performed when watermarks are embedded redundantly in tiles (see Chapter 8). If the same watermark pattern is added to several pieces of a Work, the adversary can view those pieces as separate Works and perform a collusion attack to identify the pattern. This type of attack was successfully applied to one of the audio watermarking systems proposed for use in the Secure Digital Music Initiative (SDMI) [21].

The other type of collusion attack involves the adversary obtaining several copies of the same Work, with different watermarks in them. In this case, the adversary might be able to obtain a close approximation of the original Work by combining the separate copies. The simplest combination is to average the copies, thereby mixing the different marks together and reducing their amplitude. More sophisticated techniques, which can remove some watermarks using a small number of copies of a Work, are described in [254].

Boneh and Shaw [23] have posed the problem of designing *collusion-secure codes* (i.e., codes that are secure against this second type of collusion). Suppose a Work is distributed to n individuals, with a distinct code word embedded in each copy. The code is said to be *c-secure* if, when up to c individuals collude, there is a high probability that the resulting Work will contain enough information to identify at least one of the colluders.

This can occur if portions of the code words for all colluders are identical. When comparing their respective copies, the colluders learn nothing about how to corrupt these portions of the watermarks, and therefore we can assume that they will be unaffected by the attack. If these unaffected portions of the code words carry enough information, we can identify at least one of the colluders.

Following Boneh and Shaw's lead, several researchers have studied the design of binary c-secure codes [166, 170, 194].

If the Attacker Knows the Algorithms

For systems that require a very high level of security, the assumption that the adversary knows nothing about the watermarking algorithm is generally considered unsafe. It is often difficult to keep the algorithms completely secret. Furthermore, if an algorithm is to be kept secret, only a small number of researchers can be allowed to study it. This means that serious security flaws can go undiscovered until after the system is deployed.

For these reasons, the cryptographic community advocates assuming that the adversary knows everything about the algorithm except one or more secret keys. This is known as *Kerckhoff's assumption* [137]. Not only do cryptographers assume the adversary knows the algorithm, they often ensure that he does by publishing it themselves. This allows their peers to study the algorithm and try to find flaws in it.

An adversary who has complete knowledge of a watermarking algorithm may be able to find and exploit weaknesses in the detection strategy. For example, he may be able to identify specific distortions for which the detector cannot compensate and thus apply a successful masking attack. In addition, knowledge of the watermarking algorithm may help an adversary determine the secrets that describe a specific watermark. For example, consider an algorithm that creates a tiled watermark pattern (like our block-based algorithms). Knowing that the extraction process averages tiles, the adversary might be able to determine tile size and create an estimate of the reference mark. Once the adversary has gained the secret, he might be able to perform unauthorized embedding, unauthorized detection, or unauthorized removal of the watermark.

If the Attacker Has a Detector

In all of the previously discussed cases, we have assumed that despite what the adversary knows about the watermarking algorithm he does not have any special tools at his disposal. If, however, the application dictates that the adversary must have permission to perform some action, we must assume that he has the tools required for that action. The case that has received the most study is the one in which the adversary is allowed to detect watermarks, but not allowed to remove them. In this case, we must assume that the adversary has a watermark detector.

Even if the adversary knows nothing about the algorithm, access to a detector gives him a tremendous advantage in attacking the watermark. We can think of the detector as a "black box" or "oracle" to which the adversary can submit a modified Work and find out whether or not it is inside the detection region. By making iterative changes to the Work, and testing after each change, it is possible

to learn a great deal about how the detection algorithm operates. For example, this approach is exploited in the *sensitivity analysis* attack, which is described in detail in Section 9.3.5.

An even more difficult security problem arises if the adversary has a detector and knows how it works. In essence, he knows the detection algorithm and any key required to detect the specific marks in question. To date, no watermarking algorithm has been proposed that can prevent unauthorized removal under these conditions. However, as discussed in the next section, a few researchers are attempting to apply the principles of asymmetric-key cryptography to the problem.

9.2 Watermark Security and Cryptography

In this section we discuss the relationships between encryption and watermarking. We examine cryptographic techniques for restricting watermark embedding and detection. In many cases, the problems of unauthorized embedding and detection are directly analogous to problems studied in cryptography and can be solved by straightforward application of cryptographic tools. The problem of unauthorized removal, however, does not have a direct analog in the world of cryptography, and therefore it is less obvious how cryptographic techniques might be used to solve it. A discussion of this topic concludes the section. (Those unfamiliar with cryptographic concepts such as 1-way hashing and asymmetric keys may wish to read Section A.2 of Appendix A before proceeding.)

9.2.1 The Analogy between Watermarking and Cryptography

Watermark embedding and detection can sometimes be considered analogous to encryption and decryption. In symmetric key cryptography, we have an encryption function, $E_K(\cdot)$, that takes a key, K, and some *cleartext, m*, and produces a *ciphertext, m_c*. That is,

$$m_c = E_K(m). \tag{9.1}$$

The ciphertext can be decrypted to reveal the original plaintext message using a decryption function, $D_K(\cdot)$, and the corresponding key, K. That is,

$$m = D_K(m_c). \tag{9.2}$$

In watermarking, we have an embedding function, $\mathcal{E}(\cdot)$, that takes a message, m, and an original Work, c_o, and outputs a watermarked Work, c_w. Similarly, we have a detection function, $\mathcal{D}(\cdot)$, that takes a (possibly) watermarked Work and outputs a message. In many watermarking systems, the mapping between watermarked Works and messages is controlled by a watermark key, K. In the case of informed detection, the detection key can be considered to include a function

of the original Work. That is, we can think of a system with informed detection as simply associating a unique key with each Work. Thus, we can characterize almost any watermarking system by the equations

$$\mathbf{c_w} = \mathcal{E}_K(\mathbf{c_o}, m) \tag{9.3}$$

and

$$m = \mathcal{D}_K(\mathbf{c_w}), \tag{9.4}$$

which are similar to Equations 9.1 and 9.2.

With this analogy between cryptography and watermarking, it is reasonable to expect that the problems outlined in Section 9.1.3 might be resolved using appropriate cryptographic methods. In Sections 9.2.2 and 9.2.3 we examine the use of cryptgraphic tools for restricting watermark detection and embedding, respectively. On the other hand, as we discuss in Section 9.2.4, the problem of unauthorized watermark removal does not have a direct analog in cryptography. We discuss the limitations of cryptographic tools in preventing unauthorized watermark removal.

9.2.2 Preventing Unauthorized Detection

Let us first examine the problem of confidential communication between Alice and Bob. In the context of watermarking, this requires that they prevent the unauthorized detection and decoding of the watermark message. Ideally, they would like to use a watermarking system that is secure against these categories of attack.

Unfortunately, it is sometimes impractical to make a watermarking system that is truly secure against unauthorized detection and decoding of messages. In general, for a watermarking system to be secure against these attacks, it must have a very large key space. That is, there must be a very large set of distinct keys from which Alice and Bob's key is drawn. If the key space is too small, an adversary (Eve) can identify the right key by brute-force search (assuming she knows the watermarking algorithm, which is the safest assumption). The difficulty is that the design of a watermarking algorithm is often a compromise between many conflicting requirements, and may be constrained to have a small key space.

In such circumstances, the problem of unauthorized decoding can be solved by a straightforward application of cryptographic algorithms. We add a level of traditional encryption to the system. The message is encrypted before it is embedded, and decrypted after it is detected. Such a system requires two keys: the watermark key, K_w, controls the watermarking layer, and the encryption key, K_c, controls the encryption layer. Thus, at the embedder, the watermarked work is given by

$$\mathbf{c_w} = \mathcal{E}_{K_w}(\mathbf{c_o}, m_c) = \mathcal{E}_{K_w}(\mathbf{c_o}, E_{K_c}(m)). \tag{9.5}$$

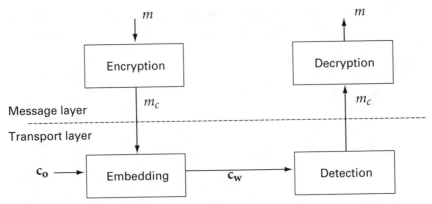

Fig. 9.3 A two-layered watermarking system. The top layer is responsible for ensuring that messages are secure. The bottom layer is responsible for ensuring that they are securely transported.

At the detector, the reverse process is employed:

$$m = D_{K_c}(D_{K_w}(\mathbf{c_w})). \tag{9.6}$$

Such a system is illustrated in Figure 9.3. When the watermark uses sequences of symbols to encode messages (see Chapter 4), the division of labor between the encryption and watermarking layers of this system can be nicely described: the encryption layer obscures messages, whereas the watermarking layer obscures symbols.

As indicated in Figure 9.3, the encryption and watermarking layers can be viewed as analogous to two layers of a networking system. Networking systems are generally divided into several layers, each of which is responsible for a specific task. The two layers shown here are the *message layer*, responsible for determining what messages to transmit over the network, and the *transport layer*, responsible for ensuring that transmitted messages arrive uncorrupted. In the system of Figure 9.3, encryption is part of the message layer, and the watermarking system, together with the cover Work, is part of the transport layer.

The addition of an encryption layer ensures message security (i.e., that someone who detects the watermark cannot decode its meaning). In addition, in certain systems it can prevent the adversary from determining the presence of a watermark. Specifically, if a watermark system is designed to determine the presence of a watermark by distinguishing between valid and invalid messages (see Section 4.3.1), it may be impossible to identify valid messages without decrypting. Hence, an adversary that has the watermark key but does not have the cipher key would be unable to determine the presence of a watermark [6, 62].

Unfortunately, in most watermarking systems encryption does not prevent the detection of the encrypted message. This is true for systems that determine

the presence of a message by comparing a detection statistic against a threshold (see Sections 4.3.2 and 4.3.3). This is also true for systems in which the presence of watermarks can be detected by other means. For example, a watermark embedded in the least significant bits of a Work can produce tell-tale statistical artifacts in the Work's histogram. These artifacts can be exploited to distinguish between watermarked and unwatermarked Works, even if the marks themselves are indistinguishable from noise [288, 87].

This limitation of encryption is intuitively clear from the message layer/transport layer analogy of Figure 9.3. Preventing unauthorized detection without decoding is a problem of transport security, in that the adversary is essentially detecting the fact that a message is being transmitted. In contrast, encryption is part of the message layer and is concerned with issues of message confidentiality, authentication, integrity, and non-repudiation [240]. Thus, unauthorized detection is unlikely to be prevented by any straightforward application of cryptographic tools.

9.2.3 Preventing Unauthorized Embedding

Now let's consider the problem of unauthorized embedding. This problem is closely analogous to the cryptographic problem of authenticating the sender, which can be solved with either asymmetric-key cryptography or cryptographic signatures, depending on the size of the messages. Thus, a straightforward approach to preventing unauthorized watermark embedding would be to use either of these cryptographic tools in the message layer of Figure 9.3. That is, before embedding a message, we could either encrypt it using asymmetric-key cryptography or append a cryptographic signature.

These straightforward approaches prevent one type of unauthorized embedding attack, discussed in Section 9.1.3; namely, an attack in which the adversary composes a novel message and embeds it. Even if the adversary knows the embedding algorithm and watermark key, K_w, he cannot correctly encrypt his message, or create a valid cryptographic signature, unless he also knows the encryption key. Thus, as long as Bob keeps his private encryption key secret, Alice can verify that he is the source of an embedded message by using the corresponding public decryption key.

However, these simple solutions do not address the second type of unauthorized embedding, discussed in Section 9.1.3; namely, an attack in which the adversary finds an existing valid message and embeds it in a Work. The copy attacks discussed in Section 9.3.3 are examples in which the adversary extracts the valid watermark from a legitimately watermarked Work and copies it to an unwatermarked target Work. If the watermark is encrypted with a private key, it is copied over in its encrypted form and is still decodable with the corresponding public key. If the watermark has a cryptographic signature, the signature is copied

along with it and still matches the hash of the message. Thus, the forgery will appear completely legitimate.

One interpretation is that the message embedded in the Work is indeed a valid message but the cover Work is wrong. Because watermarks by definition carry information about the Works in which they are embedded, the messages cannot be properly interpreted without reference to the Work. The message "You may copy this" embedded in an image of Winnie the Pooh means that you are authorized to copy that particular image and no other. Thus, strictly speaking, the cover Work must be considered an implicit part of the message. To guard against copy attacks, then, Alice must be able to validate the *entire* watermark message, including its link to the cover Work.

How can this link be validated? One possibility is to append a description of the cover Work into the embedded message, which is then protected with either asymmetric-key encryption or a cryptographic signature. When Alice receives the watermarked Work, she validates this description and compares it with the Work.

There are several variations on the basic idea of appending a description of the cover Work to an embedded message. One obvious approach would be to append the entire cover Work to the message before computing a cryptographic signature. Then the message and the signature would be embedded. Unfortunately, this approach would fail because the embedding process modifies the Work, which makes the signature invalid.

To work around this problem, we might sign only a portion of the Work, such as the lowest-frequency components, rather than the entire Work. If the embedding process is designed in such a way that it does not change this portion of the Work, the signature should still be valid after the watermark is embedded. Thus, to embed a watermark, Bob performs the following steps:

1. Construct a description of the cover Work based on information unlikely to change, such as the lowest-frequency components.
2. Compute a one-way hash of the watermark message concatenated with the description of the cover Work.
3. Encrypt the hash with a private key, thus obtaining a cryptographic signature.
4. Embed the watermark message along with the signature, using an embedding algorithm that does not change the description computed in Step 1.

To detect and validate a watermark, Alice performs the following steps:

1. Detect and decode the watermark, obtaining a message and a cryptographic signature.
2. Construct the same description of the cover Work that Bob constructed.

3. Compute the one-way hash of the watermark message concatenated with the description of the cover Work.
4. Decode the cryptographic signature using Bob's public key.
5. Compare the decoded signature against the hash of the message and cover Work description. If they are identical, Alice knows that Bob composed this message and embedded it in this Work.

These procedures are illustrated in Figure 9.4.

One difficulty with this system is that if the Work is expected to suffer some degradation between embedding and detection, the description used in the watermark signature must be extremely robust. If even one bit of this description changes, the one-way hash will change completely, and the signature will be

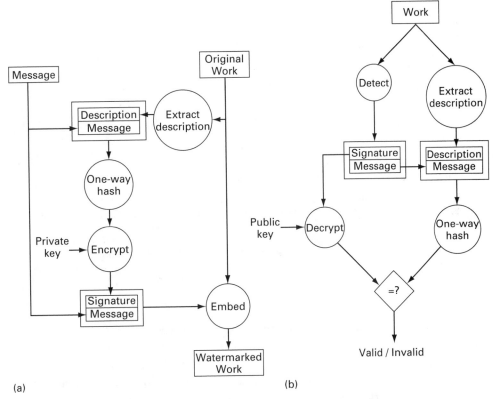

(a) (b)

Fig. 9.4 A method of linking watermarks to their cover Works. During embedding (a), a one-way hash is applied to both the watermark message and a robust description of the Work. This is then encrypted with a private key to form a cryptographic signature, which is embedded along with the message. For watermark validation (b), the message and signature are first extracted from the Work. The message is then sent through a one-way hash along with a robust description of the Work, calculated in the same way as during embedding. If the result matches the decrypted signature, the Work and watermark are valid.

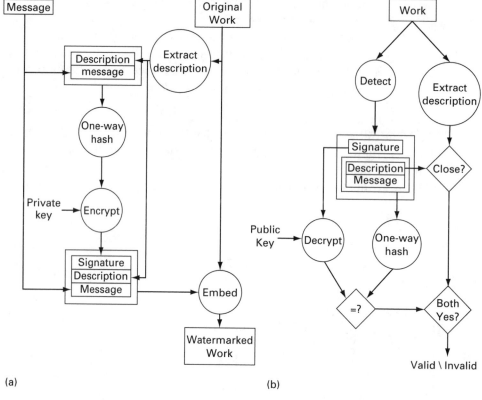

(a) (b)

Fig. 9.5 An alternative method for linking watermarks to cover Works. The embedding process (a) is very similar to that shown in Figure 9.4, except that the robust description of the Work is embedded along with the message and signature. In validation (b), the signature is used to validate the message and the embedded description. The embedded description is then compared against a newly computed description to verify that the Work matches the one in which the watermark was originally embedded. This match need not be exact for the watermark to be validated.

invalid. To alleviate this problem, we might use a different approach, illustrated in Figure 9.5. Here, Bob still computes a description of the Work and uses it in a cryptographic signature. However, when embedding the message and the signature, he also embeds the description. Alice, then, can obtain the exact description of the Work Bob used to compute the signature. She uses the signature to verify that all of the embedded information (i.e., the message and the description) is valid. She then performs an inexact comparison between the embedded description and a description of the received Work. For example, she might calculate the correlation between these two descriptions and compare it against a threshold. This system allows the description that Alice computes to differ slightly from the one Bob computed, without invalidating the signature.

In either of these systems, the method of describing the Work must be designed to describe the Work's most perceptually significant features. More precisely, it must be extremely difficult to find two perceptually different Works that yield the same description. Otherwise, when copying a watermark from a legitimate Work to some target Work, the adversary might be able to modify the target Work so that its description matches that of the legitimate Work, and thus make the signature valid.

The previously described systems for linking a watermark to its cover Work illustrate an important limitation of the network layer analogy illustrated in Figure 9.3. The power of this layered communication model is that each layer can be considered independent of the other layers, provided an interface between the levels is clearly defined. However, for watermarking, these systems imply that if we are to link the message with the Work, the message (cryptographic) layer must be tailored to the specific transport (watermarking) system being used. First, it must incorporate knowledge of the cover Work into the cryptographic protection of the message. Second, it must know the watermarking algorithm to determine what properties of the Work are unaffected by the embedding process.

9.2.4 Preventing Unauthorized Removal

Although the analogy between watermarking and cryptography is useful to counter unauthorized embedding and decoding, its utility is not clear in the case of unauthorized removal. This is because there is no direct analogy between unauthorized removal and any of the main cryptographic problems. In the terminology of Figure 9.3, unauthorized removal is strictly a problem with the transport layer: an adversary prevents a transmitted message from arriving.

When the adversary is neither authorized to embed nor to decode, we turn to spread spectrum techniques, rather than cryptographic techniques, to prevent unauthorized removal. The problem becomes similar to that of secure military communications, for which spread spectrum is used to ensure delivery of the message.

As discussed in Section 3.2.3, spread spectrum communication transmits a signal over a much larger spectrum than the minumum needed. The signal spreading is determined by a key that a receiver must also be in possession of in order to detect the signal. Spread spectrum communications are very difficult to jam or remove and the probability of unauthorized detection is extremely small.

When spread spectrum is used for secure military communications, the spreading function is designed to make the modulated message appear to an adversary like background noise. This makes it very difficult for an adversary to determine if a transmission is occurring. When spread spectrum is used for secure watermarking, the added patterns can also be designed to have the same spectral characteristics as the background, which in this case is the cover Work. Again, this

makes it difficult for an adversary to determine whether a watermark is present in a Work and helps maintain the fidelity of the cover Work [220]. Interestingly, in [257] it is concluded that the form of watermark most secure against Wiener filtering attacks, discussed in Section 9.3.2, is one whose power spectrum resembles that of the cover Work.

Because spread spectrum communication spreads the signal energy over a very large spectrum, and an adversary is unable to transmit sufficient power over such a broad spectrum, jamming is not practical. Similarly, for watermarking, an adversary is unable to add sufficient noise to the cover Work to be confident of eliminating the watermark without seriously degrading the fidelity.

Spread spectrum techniques are useful when the adversary is not authorized to embed or decode. Unfortunately, there are many applications, including copy control, for which the adversary must be assumed to have the ability to detect marks. In this case, spread spectrum techniques cannot ensure secure transmission. Many researchers suspect that such applications are inherently insecure. However, this conjecture has not been proven, and there are a number of dissenting points of view.

One line of research being investigated is based on the belief that watermarking can be made secure by creating something analogous to an asymmmetric-key cryptographic system. That is, we would like the watermark embedder to use one watermark key, and the watermark detector to use a different watermark key. The assumption is that knowledge of the detection key is not sufficient to allow an adversary to remove a watermark. A few such asymmetric-key watermarking systems have been proposed, which either use different keys at the embedding and detection stages or a key only for embedding, and no key for detection [92, 91, 276, 80]. Although these proposals possess an asymmetry analagous to asymmetric-key cryptography, they have not yet been shown to prevent watermark removal. In fact, most of these are probably susceptible to attacks such as sensitivity analysis (Section 9.3.5).

The aim of these asymmetric-key watermarking systems is similar to that of asymmetric-key encryption systems. Recall that in asymmetric-key cryptography we have two different descriptions of a single mapping between strings of cleartext and strings of ciphertext, based on two different keys. Similarly, in asymmetric-key watermarking, the aim is to construct two descriptions of a mapping between Works and embedded messages. As in asymmetric-key cryptography, these two descriptions should make different operations computationally feasible. One, based on the embedding key, should make it easy to map from messages to Works. The other, based on the detection key, should make it easy to map from Works to messages.

However, there are some fundamental differences between watermarking and cryptography that make the standard asymmetric-key encryption systems unsuitable for our application. First, in watermarking, the mapping between Works

and messages must be many-to-one, so that a given message may be embedded in any given Work. In asymmetric-key cryptography, the mapping between cleartext and ciphertext is always one-to-one. Second, the set of Works that all map into the same message—the detection region for that message—must be clustered in such a way as to produce robust watermarks. That is, if a watermarked Work that maps into a given message is modified slightly, the resulting Work should still map into the same message. Asymmetric-key encryption algorithms map cleartext into ciphertext in a pseudo-random fashion. A small change in the cleartext results in a large change in the ciphertext, and vice versa. These differences are illustrated schematically in Figure 9.6.

Asymmetric-key watermarking can also be viewed geometrically as a matter of constructing two different descriptions of a single shape—the detection region for a given message—rather than as two different descriptions of a mapping. Under this view, the description based on the embedding key makes it easy to find a point within the shape (a watermarked Work) that is close to a point outside the shape (an unwatermarked original). The detection key makes it easy

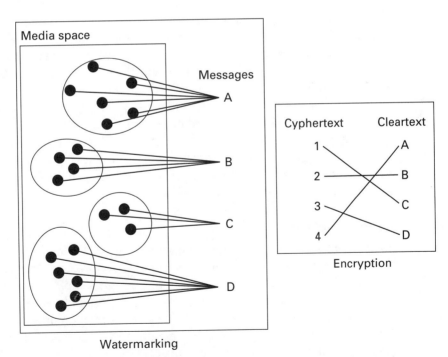

Fig. 9.6 Illustration of the differences between watermark mappings and cryptographic mappings. Watermark mappings are many-to-one and must map groups of similar Works into the same message (i.e., the detection regions for different messages must be robust). Cryptographic mappings are one-to-one and random.

to determine whether a point is within the shape, but makes it difficult to find a nearby point outside the shape. It is an open question whether such a pair of descriptions of a shape can be constructed.

It should be noted that asymmetric-key watermarking might not be the only way to prevent unauthorized removal by adversaries who know the detection algorithms and keys. For example, it might be possible to make a secure system by making the detection region different from the embedding region. The embedding region would be simple, so that it would be easy to find a point within it that is near a given point outside. The detection region would be complicated, so that no matter how it is described it would never be easy to find a point outside that is close to a given point inside. If the detection region completely contained the embedding region, embedding and detecting watermarks would be easy, but it would be difficult to remove them, *even with complete knowledge of both the embedding and detecting keys*. If such a system can be constructed, it would provide security against removal without the need to keep keys secure.

9.3 Some Significant Known Attacks

In this section we describe a number of known attacks on the security of watermarking systems. Some, such as copy attacks and ambiguity attacks, can be successfully addressed, either directly or indirectly, with the cryptographic tools previously described. For others, such as sensitivity analysis attacks and gradient descent attacks, reliable countermeasures are not known. We can, however, identify the basic security weaknesses that allow these attacks to be successful and thus suggest the direction toward more secure watermarking methods.

We start this section with an attack that cannot be addressed within the confines of watermarking. The scrambling attack, rather, is an attack on the *system* in which watermarking is being used. As such, it must be addressed at the system level and, as we will see, this may often be impossible.

9.3.1 Scrambling Attacks

A *scrambling attack* is a system-level attack in which the samples of a Work are scrambled prior to presentation to a watermark detector and then subsequently descrambled. The type of scrambling can be a simple sample permutation or a more sophisticated pseudo-random scrambling of the sample values. The degree of scrambling necessary depends on the detection strategy. For example, a permutation of 8×8 blocks of an image will not prevent the D_BLK_CC detector from finding the watermark, but will thwart the D_LC detector.

The only constraint is that the scrambling be invertible or near invertible. A near invertible or lossy scrambling attack should result in a Work that is perceptually similar to the watermarked Work.

A well-known scrambling attack is the *mosaic attack,* in which an image is broken into many small rectangular patches, each too small for reliable watermark detection [212]. These image segments are then displayed in a table such that the segment edges are adjacent. The resulting table of small images is perceptually identical to the image prior to subdivision. This technique can be used in a web application to evade a web-crawling detector. The scrambling is simply the subdivision of the image into subimages, and the descrambling is accomplished by the web browser itself.

The mosaic attack is convenient for an adversary because most web browsers will correctly "descramble" the image. More general scrambling attacks require the receiver of the pirated Works to obtain a descrambling device or program. For example, to circumvent proposed copy-control systems in video recorders, a consumer might purchase both an inexpensive scrambler and descrambler. By scrambling the input to the video recorder, the adversary can cause the watermark to be undetectable, so that the recorder would allow recording. On playback, the recorded, scrambled video is passed through the descrambling device prior to viewing. Although legislation in many countries forbids the sale of devices solely intended to circumvent copyright law, an argument could be made that the scrambling devices also have legitimate uses, such as allowing adults to prevent their children from viewing inappropriate content.

9.3.2 Pathological Distortions

For a watermark to be secure against unauthorized removal, it must be robust to any process that maintains the fidelity of the Work. This process may be a *normal* process, in which case we are requiring that a secure watermark be robust. However, it may also be a process unlikely to occur during the normal processing of the Work. Any process that maintains the fidelity of the Work could be used by an adversary to circumvent the detector by masking or eliminating the watermark. The two most common categories of such pathological distortions, geometric/temporal distortions (attacks on synchronization) and noise removal distortions, are described in the following.

Synchronization Attacks

Many watermarking techniques, including all systems presented in this book, are sensitive to synchronization. By disturbing this synchronization, an adversary attempts to mask the watermark signal. Examples of simple synchronization distortions include delay and time scaling for audio and video, and rotation, scaling, and translation for images and video. These simple distortions can be implemented such that they vary over time or space. More complex distortions include pitch-preserving scaling and sample removal in audio, and shearing, horizontal reflection, and column or line removal in images. Even more complex

distortions are possible, such as nonlinear warping of images. A number of these distortions are applied by the StirMark [151] program, a tool that applies many different distortions to a watermarked Work.

Linear Filtering and Noise Removal Attacks

Linear filtering can also be used by an adversary in an attempt to remove a watermark. For example, a watermark with significant energy in the high frequencies might be degraded by the application of a low-pass filter. In addition, any watermarking system for which the added pattern is "noise-like" is susceptible to noise removal techniques.

For certain types of watermarking systems, [257] shows that Wiener filtering is an optimal linear-filtering/noise-removal attack. It is argued that Wiener filtering is a worst-case linear, shift-invariant process when (1) the added pattern is independent of the cover Work, (2) both the Work and the watermark are drawn from zero-mean Normal distributions, and (3) linear correlation is used as the detection statistic.

The authors show that the security of a watermark against Wiener filtering can be maximized by selecting the power spectrum of the added pattern to be a scaled version of the power spectrum of the original Work, as

$$|\mathbf{W_a}|^2 = \frac{\sigma_{\mathbf{w_a}}^2}{\sigma_{\mathbf{c_o}}^2}|\mathbf{C_o}|^2, \tag{9.7}$$

where $|\mathbf{C_o}|^2$ is the power spectrum of the cover Work, $|\mathbf{W_a}|^2$ is the power spectrum of the added pattern, and $\sigma_{\mathbf{w_a}}^2$ and $\sigma_{\mathbf{c_o}}^2$ are the variances of the distributions from which the added pattern and cover Work are drawn. This is an intuitive result suggesting that when the watermark "looks like" the cover Work an adversary will have a difficult time separating the two.

9.3.3 Copy Attacks

A *copy attack* occurs when an adversary copies a watermark from one Work to another. As such, it is a form of unauthorized embedding.

The term *copy attack* was introduced in [152], which describes a particular method of implementing it. Given a legitimately watermarked Work, $\mathbf{c_{1w}}$, and an unwatermarked target Work, $\mathbf{c_2}$, this method begins by applying a watermark removal attack to $\mathbf{c_{1w}}$ to obtain an approximation of the original, $\hat{\mathbf{c}}_1$. For this step, the authors proposed using a nonlinear noise-reduction filter. However, in principle, any method of estimating the original Work should suffice. The next step is to estimate the added watermark pattern by subtracting the estimated original from the watermarked Work:

$$\hat{\mathbf{w}}_a = \mathbf{c_{1w}} - \hat{\mathbf{c}}_1. \tag{9.8}$$

Finally, the estimated watermark pattern is added to the unwatermarked Work to obtain a watermarked version thus:

$$c_{2w} = c_2 + \hat{w}_a. \tag{9.9}$$

This method has been shown to work with several commercial image watermarking systems, and it would clearly work with our E_BLIND/D_LC and E_BLK_BLIND/D_BLK_CC example systems.

The method of [152] depends on being able to obtain a reasonable approximation of the original Work, \hat{c}_1. It might therefore seem that the attack can be countered by ensuring that it is infeasible to obtain such an approximation. However, depending on the watermarking algorithm, there can be other ways of performing a copy attack that do not involve reconstructing the original. As a simple example, consider a watermark embedded in the least significant bits of a Work, c_{1w}. It is quite infeasible to reconstruct the original version of this Work, because the LSBs of the original were probably random. However, it is trivial to perform a copy attack: we need only copy all LSBs of c_{1w} into the LSBs of the target Work, c_2. Thus, the fact that reconstructing the original is virtually impossible with the LSB watermarking algorithm does not provide sufficient protection against a copy attack. A more sophisticated example, discussed in Section 10.3.1, can be found in [118].

A possible approach to countering copy attacks is to use cryptographic signatures that link the watermark to the cover Work, as suggested in Section 9.2.3. These ensure that if a watermark is successfully copied from a legitimately watermarked Work to an unwatermarked Work, the detector will be able to determine that the watermark does not belong with the latter Work.

9.3.4 Ambiguity Attacks

Ambiguity attacks[3] create the appearance that a watermark has been embedded in a Work when in fact no such embedding has taken place. An adversary can use this attack to claim ownership of a distributed Work. She may even be able to make an ownership claim on the original Work. As such, ambiguity attacks can be considered a form of unauthorized embedding. However, they are usually considered system attacks.

Ambiguity Attacks with Informed Detection

The ambiguity attack described in [64] works against systems that use an informed detector. The adversary, Bob, defines his fake watermark to be a randomly generated reference pattern. He then subtracts this pattern from the watermarked

3. Sometimes called the *Craver attack* or the *IBM attack* after their introduction in [64] by Craver *et al.* of IBM.

Work that Alice has distributed, to create his fake original. Although the fake watermark has a very low correlation with Alice's distributed Work, it has a high correlation with the difference between the distributed Work and the fake original. If we assume that the reference pattern selected by Bob is uncorrelated with the one used by Alice (this will be the case with very high likelihood), the difference between Alice's true original and Bob's fake original will also have high correlation with the fake watermark. Thus, a situation is created in which both Alice and Bob can make equal claims of ownership. Although Alice can claim that both the distributed Work and Bob's "original" are descendants of her original, in that her watermark is detected in both, Bob can make the same claim. Bob's watermark is detected in both the distributed Work and Alice's true original.

Ambiguity Attacks with Blind Detection

An ambiguity attack against a system that uses blind detection can be performed by constructing a fake watermark that appears to be a noise signal but has a high correlation with the distributed Work. Such a reference pattern can be built by extracting and distorting some features of the distributed Work. This reference pattern, which by definition is found in the distributed Work, is very likely found in the true original. The adversary subtracts the reference pattern from the distributed Work to create his fake original and then locks both his fake original and his fake watermark in a safe.

In the following investigation, we illustrate an ambiguity attack on the E_BLIND embedder. We assume blind detection.

Investigation

Ambiguity Attack on a System with Blind Detection

As an example of this attack, consider the two images of Figure 9.7. The image in Figure 9.7a will be called the *true original*. This image has been watermarked with the E_BLIND embedding algorithm of System 1, and the resulting *distributed image* is shown in Figure 9.7b. To create a fake watermark that has a high correlation with the distributed image but looks like noise, the adversary might replace the magnitude of the Fourier transform of the distributed image with random values. This signal, shown in Figure 9.8a after scaling to have unit length, has a correlation of nearly 17.0 with the distributed image. However, this signal does not look like a random noise pattern because the edges in the image are so dominant.

The edge structure in Figure 9.8a can easily be destroyed by introducing some random noise into the Fourier phase. We accomplished this by adding independent, random values to the image pixels before calculating the Fourier

(a)

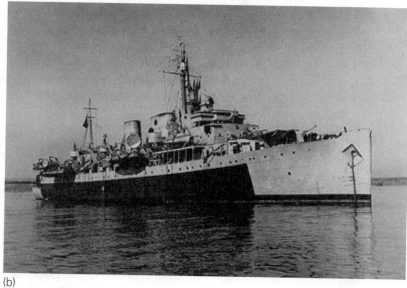

(b)

Fig. 9.7 The original image (a) has been watermarked with the E_BLIND embedder using the white noise reference pattern of System 1 to generate the distributed image (b).

(a)

(b)

Fig. 9.8 Fake watermarks generated by (a) replacing the Fourier magnitudes of the distributed image with random noise and (b) further adding some random noise to the Fourier phase components.

transform. Thus, the fake watermark shown in Figure 9.8b was generated via the following steps:

1. Add random noise to the distributed image (Figure 9.7b).
2. Calculate the Fourier transform of the resulting noisy image.
3. Scale the Fourier coefficients to have random magnitudes (unrelated to their original magnitudes).
4. Invert the Fourier transform and normalize to unit variance.

Even though this pattern looks like pure white noise, it has a correlation of 0.968 with the distributed image.

The adversary must now create his fake original. To do this he could simply subtract the fake watermark from the distributed image, but this would result in an original that is exactly orthogonal to the fake watermark. Although we would expect a random pattern to have a very low correlation with an original image, it is highly unlikely that the correlation would be exactly zero. Thus, the claims of the adversary would appear suspicious if his reference pattern were to have zero correlation with his original. To remedy this, the adversary constructs his fake original by subtracting only a portion of the fake watermark from the distributed image. The fake original, shown in Figure 9.9, was created by subtracting 99.5% of the fake watermark from the distributed image. The results, presented in Table 9.3, show that watermark detection alone cannot be used to disambiguate the contradicting descendency claims of the true owner and the adversary.

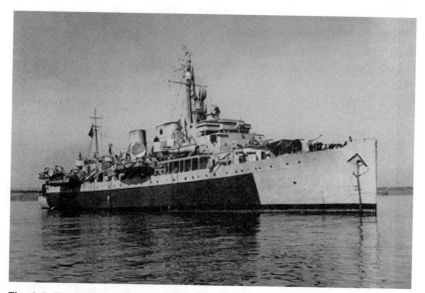

Fig. 9.9 The fake original constructed by subtracting 99.5% of the fake reference pattern from the distributed image.

Table 9.3 The correlation values, as reported by the D_LC detector run on the original image, c_o, the distributed image, c_d, and the adversary's fake original, c_f, for the owner's watermark, w_r, and the adversary's fake watermark, w_f. From these detection values, it is not possible to determine which of c_o and c_f is the true original.

	c_o	c_d	c_f
w_r	−0.016	0.973	0.971
w_f	0.968	0.970	0.005

Countering Ambiguity Attacks

Note that it is not possible to prevent an adversary from using this technique to create a fake original and a fake watermark. The primary defense against this class of attacks is for the true owner of the Work to use a watermarking technique that can ensure that his original could not have been forged as previously described. The true owner can then argue that the evidence in support of his ownership claim is stronger than that of the adversary.

The security hole being exploited by these ambiguity attacks has been called *invertibility* [64]. A watermarking scheme is invertible if the inverse of the embedding is computationally feasible. The embedding inverse is a function that acting on a distributed Work, c_d, produces a fake original Work, c_f, and a watermark, w_f, such that the regular embedding function, $\mathcal{E}(\cdot)$, will embed the fake watermark into the fake original, resulting in the distributed Work. Symbolically, given the embedding function $\mathcal{E}(w, c)$, it is possible to create a function

$$\mathcal{E}^{-1}(w_f, c_d) = c_f \qquad (9.10)$$

such that

$$\mathcal{E}(w_f, c_f) = c_d. \qquad (9.11)$$

In the E_BLIND and E_BLK_BLIND algorithms of Chapter 3, the embedding function is the addition of a noise pattern. The inverse embedding function is simply the subtraction of that noise pattern.

Ambiguity attacks cannot be performed with non-invertible embedding techniques (i.e., those embedding techniques for which the inverse is not computationally feasible to devise). One approach for creating such a non-invertible embedder is to make the reference pattern dependent on the content of the original Work such that the reference pattern cannot be generated without access to the original. The use of one-way hash functions in this dependency ensures that

the adversary cannot produce a fake original that will generate the correct fake watermark.

For example, consider generating a watermark reference pattern by seeding a pseudo-noise generator with a hash of the original image. An adversary may in reasonable time find a random watermark that has a high correlation with the distributed image. However, this random watermark would not be generated by a PN generator seeded with a hash of the fake original. It is virtually impossible to find a watermark that is pseudo-randomly generated from a hash of the fake and which has a high correlation with the distributed image.

9.3.5 Sensitivity Analysis Attacks

Sensitivity analysis is a technique used for unauthorized removal of a watermark when the adversary has a black-box detector. Described in [169, 57, 133], the sensitivity analysis attack uses the detector to estimate the direction that yields a short path from the watermarked Work to the edge of the detection region. It is based on an assumption that the direction of a short path can be well approximated by the normal to the surface of the detection region and that this normal is relatively constant over a large part of the detection region. The correlation detection methods described in this book all satisfy these requirements.

The attack can be stated in three steps, illustrated in Figure 9.10 for a linear correlation detection region. The first step is to find a Work that lies very close to the detection region boundary, denoted Work A in the figure. This Work need not be perceptually similar to the watermarked Work (if it were, no further processing would be necessary). The boundary of the detection region can be reached in a number of ways by altering the watermarked Work. Some methods include decreasing the amplitude (contrast or volume) of the watermarked Work, replacing samples with the mean value of the Work, or building a linear combination of the watermarked Work and a different Work known to be unwatermarked. In all three cases, the distortion can be slowly increased until the watermark fails to be detected.

The second step is the approximation of the direction of the normal to the surface of the detection region at Work A. This can be accomplished with an iterative technique (described in material to follow), which is at the heart of the sensitivity analysis attack. Once the normal has been estimated, the third step is to scale and subtract the normal from the watermarked Work.

Two methods of estimating the N-dimensional normal vector have been proposed. In [169] the vector is found by considering the effects of N independent modification vectors. Each of these is separately added to or subtracted from Work A with increasing amplitude until the detector ceases to detect the watermark. The normal to the surface is then approximated by the weighted sum of the N modification vectors, in which each is weighted by the negative of the corresponding scale factor found.

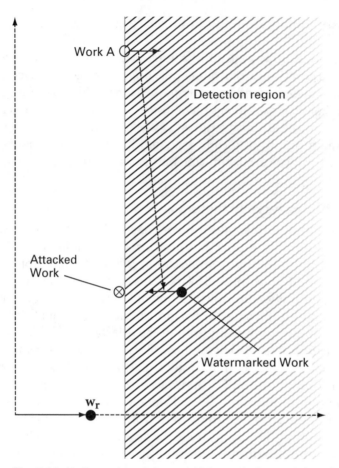

Fig. 9.10 An illustration of the sensitivity analysis attack for a linear correlation detection region. Work A is a Work that lies on the boundary of the detection region. The normal to the surface of the detection region at Work A is estimated (pointing into the detection region), and the resulting vector is scaled and subtracted from the watermarked Work.

In [133] the technique for estimating the normal to the detection region surface at Work A is iterative. For each iteration a random vector is added to Work A and the detection decision recorded. If the resulting Work causes a positive detection, the random vector is added to the estimate of the normal. If the resulting work does not contain the watermark, the random vector is subtracted from the estimate.

Note that the success of this attack relies on the assumption that the normal to the boundary of the detection region at some point, probably distant from the watermarked Work, can be used by the adversary to find a short path out of the detection region. This is the case for the two detection regions defined by placing thresholds on linear correlation or normalized correlation. A sensitivity analysis

attack would not be successful if the curvature of the detection region boundary were such that the normal at one point on the surface provided little information about the direction of a short path. Construction of a detection region with this property remains an open research problem.

The following is an investigation in which we apply a sensitivity analysis attack to the D_LC detector.

Investigation

Sensitivity Analysis Attack

We begin with the same distributed image used in the previous investigation, shown in Figure 9.7b. The detector we will use is a modified version of the D_LC linear correlation detector, which outputs a 0 if the magnitude of the detection value is lower than a threshold of $\tau_{lc} = .7$ and outputs a 1 if the magnitude of the detection value is greater than or equal to the threshold.

To find an image on the detection region boundary, we have set random pixels of the image to neutral gray (equal to the mean of all pixel values) and have presented the resulting image to the detector. The detection decision changed from 1 to 0 after changing roughly 20,000 pixels. The boundary image, Work A (as shown in Figure 9.11), is the last image we obtained in which the detection decision was 1.

Fig. 9.11 An example starting image, Work A, for the sensitivity analysis attack. This image is on the detection region boundary in that the watermark is detected in this image, but a slight change can cause the watermark to become undetected.

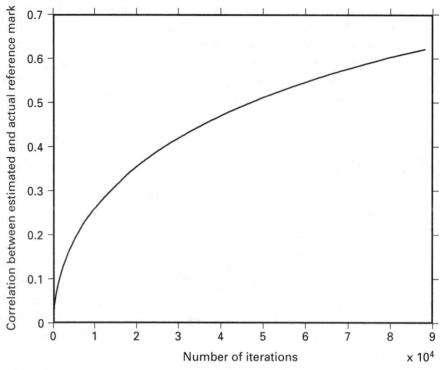

Fig. 9.12 The correlation between the estimated normal vector and the actual watermark reference pattern as a function of iteration number.

Next, we used the iterative method to estimate the normal to the surface of the detection region. In each iteration, a white noise pattern with zero mean was generated and added to Work A. The pattern was then subtracted from the estimated vector if it caused the Work to move out of the detection region; otherwise, it was added to the estimate. As the number of iterations increases, the estimate becomes more and more similar to the reference mark added to the image by the E_BLIND embedder. This can be seen in Figure 9.12, which plots the correlation between the estimated vector (after normalization to zero mean and unit variance) and the reference mark as a function of the number of iterations.

After nearly 90,000 iterations, the normalized correlation between the estimated normal vector and the reference vector is over 0.6. Although this is far from perfect, it is close enough that the watermark can now be removed with little impact on fidelity. The final step is to scale the estimated vector and subtract it from the watermarked Work. We used a simple binary search to find the minimum scaling factor required to make the watermark undetectable. The resulting image is shown in Figure 9.13.

Fig. 9.13 The attacked image with watermark removed. This image has a detection value of 0.699, which is below the detection threshold.

9.3.6 Gradient Descent Attacks

In contrast to sensitivity analysis attacks, a *gradient descent* attack requires that the adversary have a detector that reports the actual detection values, rather than the final binary decision. The adversary uses the change in detection value, as the Work is slowly modified, to estimate the gradient of the detection statistic at the watermarked Work. It is assumed that the direction of steepest descent is the direction of a short path out of the detection region.

Figure 9.14 illustrates the attack for the case of detection by normalized correlation. In this figure, the reference pattern is a vector lying on the *x*-axis. The two white lines indicate the boundaries of the detection region. The shading indicates the normalized correlation at each point in the plane, with high values shown as white and low values as black.

Given a watermarked Work, we can use any search strategy to determine the local gradient of steepest descent. The Work can be moved along this path by some amount, and the process can iterate until the resulting Work falls just outside the detection region boundary.

The success of this attack relies on the assumption that the local gradient will point in the direction of a short path to the boundary. This is certainly the case for many detection statistics, including linear correlation and normalized correlation. To defend against this attack, the detection statistic within the detection region should not be monotonically decreasing toward the boundary. Instead, it

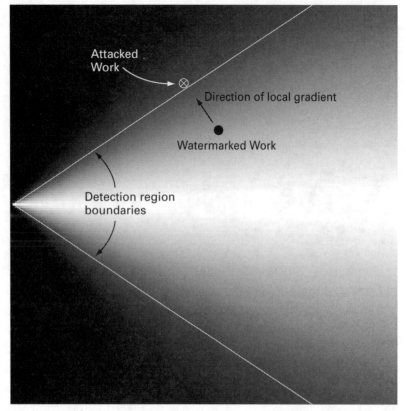

Fig. 9.14 How a local gradient is used to find a short path out of the detection region.

should contain many local minima such that the direction of the local gradient will not provide any information helpful in determining a short path out of the detection region.

9.4 Summary

This chapter discussed the security of a watermark. Security is the resistance of a watermark to attempts by an adversary to defeat the purpose of the watermark. This is in contrast to the robustness of a watermark, which is its resistance to normal processing. The following main points were made in this chapter:

- The types of security required of a watermarking system vary with each application. Applications can require prevention of one or more of the following:
 - Unauthorized embedding
 - Unauthorized detection

- ⊞ Unauthorized removal
- ⊞ System attacks
- ⊞ Within each of these types of restriction, varying degrees of security are required by an application.
- ⊞ Many of the security requirements can be met by the incorporation of cryptographic tools, such as the following, to ensure the integrity of various aspects of the watermark message.
 - ⊞ Encrypting embedded messages prevents unauthorized decoding.
 - ⊞ Asymmetric-key cryptography or cryptographic signatures can be used to verify who embedded a watermark, thus preventing one form of unauthorized embedding.
 - ⊞ Cryptographic signatures can be extended to verify that a watermark belongs in the cover Work in which it is found.
- ⊞ The terms *private watermarking* and *public watermarking* do not imply any relationship to private-key and public-key cryptography.
- ⊞ Private watermarking is not synonymous with informed detection.
- ⊞ Many security requirements cannot be directly addressed with cryptographic tools. In general, such issues as the following continue to be open research problems.
 - ⊞ Preventing unauthorized detection *without* decoding requires that the watermark must not change the statistical properties of the Work.
 - ⊞ Preventing masking removal requires more sophisticated detectors that can detect and invert the masking distortion.
 - ⊞ Preventing true removal requires preventing adversaries from identifying the boundary of the detection region. This is particularly difficult when the adversary has a detector.
- ⊞ A number of known attacks were described. These were
 - ⊞ scrambling attacks
 - ⊞ pathological distortions
 - ⊞ copy attacks
 - ⊞ ambiguity attacks
 - ⊞ sensitivity analysis attacks
 - ⊞ gradient descent attacks

Content Authentication

In this chapter, we focus on how a watermark can be used to assist in maintaining and verifying the integrity of its associated cover Work. This is in contrast to the previous chapter, which is concerned with maintaining the integrity of the watermark itself.

The ease of tampering with photographs was demonstrated in Chapter 2 (Figure 2.3). Video and audio signals can also be easily altered. In many circumstances, alterations to content serve legitimate purposes. However, in other cases, the changes may be intentionally malicious or may inadvertently affect the interpretation of the Work. For example, an inadvertent change to an X-ray image might result in a misdiagnosis, whereas malicious tampering of photographic evidence in a criminal trial can result in either a wrong conviction or acquittal. Thus, in applications for which we must be certain a Work has not been altered, there is a need for verification or authentication of the integrity of the content. Specifically, we are interested in methods for answering the following questions:

- ■ Has the Work been altered in any way whatsoever?
- ■ Has the Work been *significantly* altered?
- ■ What parts of the Work have been altered?
- ■ Can an altered Work be restored?

Many non-watermarking methods exist for answering these questions. For example, one method for answering the first question (i.e., has the Work been altered at all) is to append a cryptographic signature to it, as discussed in Appendix A. Even without cryptographic signatures, forensic specialists can often detect modifications to images and audio by identifying anomalies, such as missing shadows or discontinuities in background noise. Forensic analysis can also

319

provide answers to determine where and how a Work was altered. The problem of restoring corrupted content has received much attention from the image and signal processing communities, especially in the context of restoring content that has degraded with age. With all of these alternative approaches, why might we be interested in using watermarks?

There are two potential benefits to using watermarks in content authentication. First, watermarks remove any need to store separate, associated metadata, such as cryptographic signatures. This can be important in systems that must deal with legacy issues, such as old file formats that lack fields for the necessary metadata. A second potential advantage of watermarks is more subtle: a watermark undergoes the same transformations as the Work in which it is embedded. Unlike an appended signature, the watermark itself changes when the Work is corrupted. By comparing the watermark against a known reference, it might be possible to infer not just that an alteration occurred but what, when, and where changes happened.

These advantages must be weighed against the added complexity of using a watermark for authentication rather than appending a digital signature. Furthermore, there is a potentially serious adverse side effect of watermarking: embedding a watermark changes a Work, albeit in a known and controlled manner. If we want to verify that Works are not changed, some applications may find even imperceptible alterations unacceptable.

Whether the advantages of watermarking outweigh the disadvantages probably depends on the application. However, it is not yet clear how important watermarks will become for verifying and maintaining the integrity of content. In many real applications of authentication, legacy issues may not be a problem. Moreover, the potential advantages of watermarks for localizing changes, identifying the type of alteration, and restoring the Work have yet to be fully realized.

The remainder of this chapter discusses issues involved in using watermarks to answer the four questions posed previously and describes a few basic methods that have been proposed. Section 10.1 deals with the question of simply determining whether or not a Work has been altered. Because a Work is considered altered if even one bit has been changed, we refer to this as *exact authentication*. In contrast, Section 10.2 discusses the question of determining whether a Work has been changed in a *significant* way. Here, we tolerate certain acceptable changes, such as flipping a single bit in a single pixel of an image, but try to detect unacceptable changes, such as removing a person from a photograph of a crime scene. We refer to this as *selective authentication*. Section 10.3 discusses the question of *localization* (i.e., identifying the time or location of those portions of a Work that have been altered, while verifying that other parts remain unchanged). Many authentication watermarks are designed to address this question. Finally, Section 10.4 discusses some research into the use of watermarks to aid in the *reconstruction* of Works that have been corrupted.

10.1 Exact Authentication

The most basic authentication task is to verify that a Work has not been altered *at all* since it left a trusted party. If even a single bit has been changed, the Work is regarded as inauthentic. By insisting on a perfect copy, we avoid any need to design algorithms that can differentiate between acceptable and unacceptable alterations. Each Work is just a collection of equally important bits.

We discuss two approaches to using watermarks for *exact* authentication. The first involves generating watermarks specifically designed to become undetectable when the Work is modified. The second involves embedding cryptographic signatures, which become invalid when the Work is modified.

The final topic of this section deals with a problem that arises in applications in which exact authentication is necessary; namely, that changes introduced to the cover Work by a watermark are sometimes unacceptable themselves. In such cases, a watermark might be embedded in a manner that allows exact removal or erasure, so that the original Work can be restored, bit-for-bit, during the authentication process.

10.1.1 Fragile Watermarks

A *fragile watermark* is simply a mark likely to become undetectable after a Work is modified in any way. Until now, we have considered fragility undesirable, seeking instead to design robust watermarks that can survive many forms of distortion. However, fragility can be an advantage for authentication purposes. If a very fragile mark is detected in a Work, we can infer that the Work has probably not been altered since the watermark was embedded. At least, it is unlikely the Work has been accidentally altered. Verifying that there has been no *malicious* alteration is discussed later.

A simple example of a fragile watermark is the least-significant-bit (LSB) watermark described in Chapter 5. Most global processes, such as filtering or lossy compression, effectively randomize the least significant bits of a Work's representation. Thus, if a predefined bit sequence is embedded in the least-significant-bit plane of a Work, detection of this pattern implies that the Work has not undergone any such process.

In some applications, a different form of fragile watermark can be made by using an embedding method specific to the particular representation of the Work [297]. For example, several researchers have suggested methods of hiding information in halftoned representations of images [263, 8, 284, 90]. Another example of such a watermark, specific to the MPEG representation of video, is suggested in [167]. In MPEG, each frame of video is encoded in one of three formats, called I-, B-, and P-frames. Typically, MPEG encoders use regular sequences of frame types. However, there is no requirement that the coding sequence be regular, and

it is possible to encode information by varying the sequence of frame types. It is then possible to authenticate the received MPEG stream. However, the decoded baseband video cannot be re-encoded as an authentic MPEG stream because the information regarding the order of I-, B-, and P-frames is lost in the decoding process. That is, the watermark does not survive MPEG decoding. If we assume that any change of the Work entails decoding and re-encoding, the presence of such a watermark in the MPEG stream indicates that no change has occurred.[1]

Although fragile watermarks indicate that a Work has not been inadvertently modified, the use of predefined patterns cannot guarantee that no one has intentionally tampered with the Work. This is because an adversary can easily forge a fragile watermark if the embedded pattern is not dependent on the cover Work. In the case of an LSB watermark, forgery is a simple matter of copying the least significant bits from the authentic Work to the tampered cover Work. In the case of an MPEG frame-type mark, the adversary can encode the tampered video with an encoder modified to use the same sequence of frame types as the original MPEG stream. Thus, the fragility of a watermark provides only limited authentication capabilities.

10.1.2 Embedded Signatures

The application of cryptographic authentication to images and other content is well understood. For example, Friedman [88, 89] proposed that "trustworthy cameras" be equipped with processors to compute an authentication signature that would be appended to the image. Of course, the authentication signature must be transmitted along with the associated Work. If the signature is transmitted as metadata within a header, there is a risk that this metadata may be lost, especially if the content undergoes a variety of format changes.

Watermarking can reduce the risk that the authentication signature is lost by embedding the signature within the cover Work. This permits format conversions to occur without the risk of losing the authentication information. Thus, representing the authentication signature as a watermark may allow the system to work with legacy systems that would otherwise have to be redesigned in order to guarantee that the header information is preserved.

Note that the signature may be embedded with either a robust or a fragile watermark. If the watermark is robust, the signature will (usually) be correctly extracted even if the Work has been modified. With a correct signature and a modified Work, it is extremely unlikely that the signature computed from the

1. It is debatable whether techniques such as the MPEG method mentioned here are "watermarks" in the strictest sense, in that they embed information in the representations of Works, rather than in the Works themselves.

corrupted Work will match the correct signature. However, it is also extremely unlikely that a random signature will match a modified Work, and therefore the system will Work equally well with a fragile watermark. Because fragile watermarks are generally simpler than robust marks, they are typically preferred for embedding authentication signatures [292].

Of course, the very process of embedding a watermark alters the Work, causing the subsequent authentication test to fail. To prevent this, it is usually necessary to partition the Work into two parts, one of which is to be authenticated and the other to be altered to accommodate a watermark.

A simple example is to partition a Work such that the least-significant-bit (LSB) plane holds the authentication signature computed from the remaining bits of the Work. Note that in this arrangement we only need a small number of bits, say 160, to hold the signature. Thus, all but 160 bits of the Work can be authenticated. If desired, the specific 160 bits used can be determined from a key shared between sender and receiver.

10.1.3 Erasable Watermarks

In some applications, even the minimal distortion introduced by embedding a 160-bit signature might be unacceptable. For example, in medical applications, *any* modification of an image might become an issue in a malpractice suit. It might be easy to convince an engineer that such an embedded signature will not change a doctor's interpretation of an image, but will the same arguments be persuasive in a courtroom? In such circumstances, the only way to guarantee that no significant change has occurred is for there to be no change at all. This has led to an interest in using *erasable watermarks*[2] for authentication (i.e., watermarks that can be removed from their associated cover Works to obtain exact copies of the original unwatermarked Works).

If an erasable watermark can be constructed, there is no problem with cryptographic signatures becoming invalid after embedding. The following steps outline a general protocol:

1. The originator of a Work computes a signature using *all* information in the Work. The signature is then embedded in an erasable manner within the Work.
2. The recipient of the Work extracts and records the embedded signature.
3. The recipient erases the watermark from the cover Work. At this point, the Work should be identical to the original unwatermarked Work.

2. These watermarks have also been called *invertible* [86]. However, we prefer not to use this term because it has a conflicting meaning in the context of ambiguity attacks [64].

4. To verify this, the recipient computes a one-way hash of the Work and compares this to the hash decoded from the sender's signature.

5. If and only if the computed and retrieved hashes are identical is the received cover Work authentic.

The design of an erasable watermark poses a fundamental problem. In brief, it is theoretically impossible to make an erasable mark that can be embedded in 100% of digital content. We discuss this problem in the following, and illustrate its impact with a simple investigation. We then describe a general method of working around this problem. This method results in erasable watermarks that can be embedded in all content *likely* to arise in a given application, and can thus be used in practice.

Fundamental Problem with Erasability

Ideally, an erasable watermarking system for authentication would be able to (1) embed a signature with 100% effectiveness, (2) restore the watermarked Work to its original state, and (3) have a very low false positive probability. Unfortunately, when marking digital media, achieving the latter two of these ideal requirements makes it impossible to achieve the first.

Digital Works are typically represented with a fixed number of bits. Thus, there is a fixed, finite, albeit very large, set of possible Works. For example, each of the images used for the experiments in this book is represented by 240×368 pixels, and each pixel is represented by 8 bits. Thus, there are a total of 2^{706560} possible images in the space of original unwatermarked images.

Erasability requires that the original Work can be recovered from the watermarked Work. This means that no two unwatermarked Works entered into the embedder can result in the same watermarked Work. That is, each unwatermarked Work must map to its own, unique watermarked Work. Thus, if the embedder can successfully embed a watermark into every possible Work (i.e., every one of the 2^{706560} possible images), the number of *watermarked* Works must be equal to the number of *possible* Works (i.e., there must be 2^{706560} distinct watermarked images). If watermarked Works are represented with the same number of bits as unwatermarked Works, this means that *all* Works must be considered watermarked. Therefore, the only way to achieve 100% effectiveness is to allow for 100% false positives.

Note that this problem does not arise with non-erasable watermarking systems. In such systems, we can allow many unwatermarked Works to map into each watermarked Work, and thus the number of watermarked Works can be a small fraction of the total number of possible Works. For example, consider LSB watermarking, in which we replace the least significant bits of a Work with a given message. Using this system, any pair of unwatermarked Works that differ only in their least significant bits will result in the *same* watermarked Work. Thus,

if there are N samples or pixels in each Work, 2^N different Works map into each watermarked Work, and only 1 in 2^N possible Works needs to be considered watermarked. The following investigation illustrates the problem with a simple form of erasable watermark.

Investigation

Watermarking with Modulo Addition

To illustrate how an erasable watermark might be constructed, and how the fundamental problem with embedding effectiveness is manifested, we describe an algorithm for embedding an erasable watermark in 8-bit images. We then examine the conditions under which the watermark embedder will fail.

System 16: E_MOD/D_LC

We denote our erasable watermark by E_MOD/D_LC. It is a simple modification of the E_BLIND/D_LC system. At first glance, the E_BLIND embedding algorithm might seem already to serve our purpose. That algorithm computes the marked image, c_w, as

$$c_w = c_o + \alpha w_m \tag{10.1}$$
$$w_m = \pm w_r, \tag{10.2}$$

where c_o is the original image, w_m is a watermark message pattern, w_r is a watermark reference pattern, and α is a strength parameter. Suppose that a predefined value of α is always used during embedding, so that the recipient of the image knows this value *a priori*. After determining the message pattern, w_m, that was embedded, the recipient should be able to remove the mark by computing

$$c'_o = c_w - \alpha w_m. \tag{10.3}$$

In principle, this should yield an exact copy of c_o.

However, Equation 10.2 cannot be exactly implemented in practice, in that adding the reference pattern might result in pixel values that lie outside the 8-bit range of 0 to 255. That is, the output of this equation might not be a member of the set of 2^{706560} possible images. In our initial implementation of the E_BLIND algorithm, we solved the problem by clipping all pixel values to the range of 0 to 255. However, because the recipient of the image does not know which pixels are clipped, there is no way to recover the exact original.

One solution to the problem of clipping is to restrict the intensity range of input images to between, say, 10 and 245. Then, assuming that the amplitude

of the added watermark pattern does not exceed ±10, no underflow or over-flow will occur and clipping will be avoided. Unfortunately, in many applications we will not be able to enforce this constraint.

Honsinger *et al.* [122] propose solving this problem by the use of modulo arithmetic, rather than through clipping. Thus, the addition of, say, 5 to an 8-bit value of 253 does not result in clipping at 255 but in a value of 2. Similarly, subtracting 5 from the value 2 results in the original value of 253. As long as a large enough fraction of the pixels does not wrap around, the D_LC detector should be able to detect the watermark. The E_MOD embedding algorithm computes each pixel of the watermarked image as

$$\mathbf{c_w}[x, y] = (\mathbf{c_o}[x, y] + a\mathbf{w}_m[x, y]) \bmod 256 \tag{10.4}$$

Of course, this wraparound process can produce perceptible artifacts in the form of "salt-and-pepper" noise. This is illustrated in Figure 10.1, in which we have used the E_MOD algorithm to embed a white-noise watermark pattern. Where the pattern caused pixel values to wrap around, the pixels appear as isolated black or white dots.

Although salt-and-pepper artifacts might appear ugly, it must be remembered that they will be removed when the original Work is recovered. Thus,

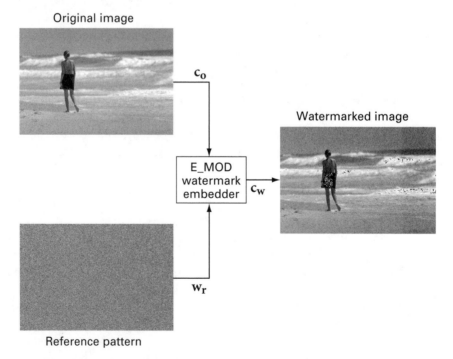

Fig. 10.1 Effect of embedding a watermark with the E_MOD embedding algorithm. Note the "salt-and-pepper" noise apparent in the darkest and lightest areas.

whether the salt-and-pepper noise is important depends on what will be done with the watermarked Works prior to erasing the watermark. For example, suppose the watermarked Works are used only for browsing. Once a user has identified a Work of interest, he authenticates it and reconstructs the original before proceeding to use it for other tasks. In such a scenario, the watermarked Works need only be recognizable, and salt-and-pepper artifacts might not be a serious problem.

Experiment 1

The salt-and-pepper noise also adversely affects watermark detection. However, for most of the images in our test set, its impact is not too severe. This is shown by the results of our first experiment, in which the E_MOD algorithm was used to embed two different watermarks in each of 2,000 images, one representing a message of $m = 0$ and the other representing $m = 1$. The resulting frequencies of different detection values, as measured by the D_LC detector, are shown in Figure 10.2. The embedder succeeded in embedding the mark most of the time.

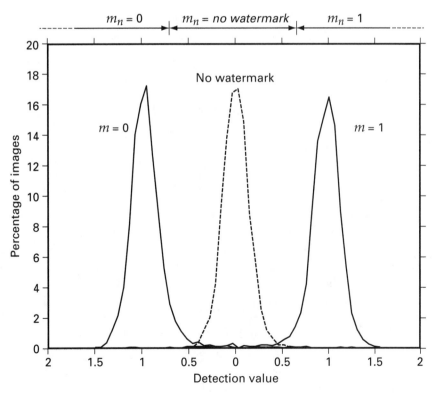

Fig. 10.2 Test results for E_MOD/D_LC watermarking system.

Experiment 2

We know that there must be large classes of images for which the E_MOD embedder will fail. Can we characterize these? Clearly, the embedder is likely to fail on images whose pixel values are predominantly close to the extremes of the allowable range. Thus, we would not wish to use this algorithm to authenticate black-and-white line drawings, in which each pixel is either 0 or 255. However, it is also likely to fail on images whose histograms are relatively flat.

The problem with a flat histogram is that the distribution of pixel values is unchanged when something is added to it modulo 256. Correlation-based detection depends on the fact that for any element of the reference pattern, $\mathbf{w_r}[x, y]$, the expected value of $\mathbf{w_r}[x, y](\mathbf{c_o}[x, y] + \mathbf{w_r}[x, y])$ is greater than the expected value of $\mathbf{w_r}[x, y]\mathbf{c_o}[x, y]$, with $\mathbf{c_o}[x, y]$ drawn randomly from the distribution of pixel values in the image. This is true regardless of the distribution of $\mathbf{c_o}[x, y]$.

Whether the same relation holds when addition is modulo 256—that is,

$$E(\mathbf{w_r}[x, y]((\mathbf{c_o}[x, y] + \mathbf{w_r}[x, y]) \bmod 256))$$
$$> E(\mathbf{w_r}[x, y]\mathbf{c_o}[x, y]), \tag{10.5}$$

is dependent on the distribution of $\mathbf{c_o}[x, y]$. In particular, when $\mathbf{c_o}[x, y]$ is uniformly distributed between 0 and 255, $(\mathbf{c_o}[x, y] + \mathbf{w_r}[x, y]) \bmod 256$ is also uniformly distributed between 0 and 255. Thus, the two expected values are the same and, on average, the embedding process should have no effect on the detection value.

This was verified with our second experiment, which was a repeat of the first except that prior to watermark embedding we applied histogram equalization, as described in [100]. Histogram equalization is a common image enhancement technique that adjusts pixel values so that the resulting image histogram is flat. The results are shown in Figure 10.3. Here there is essentially no difference between the distribution of detection values obtained from marked and unmarked images, and therefore all three curves lie on top of one another. The embedding system failed completely.

Algorithms such as E_MOD must be used with great care. In applications for which we can be sure that the vast majority of pixel values will be far from the two extremes of 0 and 255, watermarks can be embedded reliably. If, however, images are likely to be saturated, such as black-and-white line drawings, or processed by histogram equalization, the algorithm is likely to fail, and a different approach will be required.

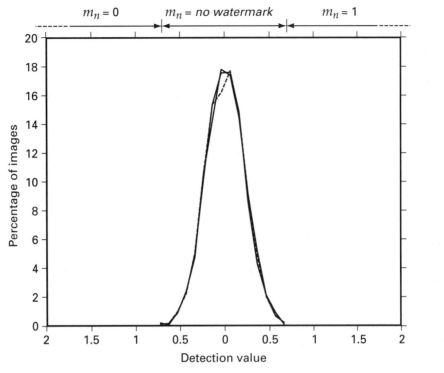

Fig. 10.3 Test results for E_MOD/D_LC watermarking system when used on images with equalized histograms.

A General Solution for Erasability

The previous section and accompanying Investigation illustrated how sensitive the property of erasability can be to the distribution of Works. Fridrich *et al.* [86, 99] recognized this and have proposed a variety of algorithms that try to work around this issue. Their algorithms can broadly be described as follows.

Let A represent the information that is altered in the cover Work, c_o, when we embed a message m of N bits. This information must be less than or equal to 2^N. For example, if the embedding algorithm replaced the LSB plane of an image or audio signal, then A is the information contained in the LSB plane. Fridrich *et al.* showed that erasability is possible provided A is compressible. If A can be losslessly compressed to M bits, $N - M$ additional bits can be erasably embedded in the cover Work.

Authentication then consists of the following steps:

1. Find the information, A, that will be altered during the embedding process.

2. Construct a message, m, that is the concatenation of a lossless compression of A together with a cryptographic signature, S, derived from the cover Work.
3. Embed the message in the cover Work.
4. To verify the Work, extract the message, m, and its component pieces (i.e., the compressed version of A and the digital signature, S).
5. Use the compressed version of A together with the watermarked Work to reconstruct the original Work.
6. Compute the signature of the reconstructed Work and compare it to the extracted signature, S.
7. If the two match, the cover Work is authentic.

This solution to the problem explicitly identifies the class of Works that cannot be authenticated (i.e., those Works for which A is incompressible). By choosing the embedding process carefully, we can ensure that A is compressible for Works likely to be drawn from the distribution of unwatermarked content.

An implementation, designed for images, was described in [86]. In natural images, neighboring pixels are strongly correlated. This leads to correlations between neighboring bits within a bit plane. Thus, we can expect that some bit planes in an image can be sufficiently compressed to implement an erasable watermark.

The proposed implementation begins by attempting to compress the LSB plane (using the JBIG [195] lossless image compression algorithm), because changes to this plane will have the least impact on fidelity. If after compression there is sufficient space to embed an additional 128-bit signature, the algorithm is successful. However, if the LSB plane is not sufficiently compressible, the second bit plane is tested. This continues until a bit plane is found that can be compressed enough to allow the additional 128-bit signature to be embedded. It was noted in [86] that for most high-quality images the signature can be embedded in one of the lowest three bit planes, though some distortion is noticeable. This work was extended in [99] using a different property of images that exhibits greater redundancy and is therefore more easily compressed.

10.2 Selective Authentication

Exact authentication is appropriate in many applications. For example, a change of just one or two characters in a text message—a handful of bits—can result in a substantially different meaning. However, in an image or an audio clip, a change of a couple bits rarely makes a difference of any importance. In fact, such distortions as lossy compression can change many bits in a Work, with the express intention of making no change in its perceptual quality. Thus, even though the two images of Figure 10.4 appear identical, (a) is a JPEG-compressed version

(a)

(b)

Fig. 10.4 Two nearly identical images. Image a is the original. Image b has been JPEG compressed with a quality factor of 95%.

of (b). In many applications, the perceptual similarity between images suggests that the compressed version is authentic. However, the image in Figure 10.4b will fail to pass an exact authentication test. This leads to a desire to develop tools that can perform *selective* authentication, in which only *significant* changes cause authentication to fail.

We begin this section with a discussion of possible requirements for a selective authentication system. The central issue here is deciding what types of trans-formations or distortions are significant enough to cause authentication to fail. We then discuss three basic approaches to building such systems. The first two approaches, *semi-fragile watermarks* and *semi-fragile signatures,* parallel the two approaches to exact authentication discussed in the preceding section. The third approach, *tell-tale watermarks,* is potentially more interesting, as it points toward systems that can identify the specific transformations a Work has undergone, rather than simply saying whether or not the Work has been significantly altered.

10.2.1 Legitimate versus Illegitimate Distortions

The requirements of a selective authentication system can be expressed in terms of distortions that might be applied to a Work, such as lossy compression, filter-ing, editing, and so on. We divide these distortions into two groups: *legitimate distortions* and *illegitimate distortions.* When a Work undergoes a legitimate dis-tortion, the authentication system should indicate that the Work is authentic. Conversely, when a Work undergoes an illegitimate distortion, the processed Work should be categorized as inauthentic.

For many distortions, the correct group might seem obvious. For example, high-quality lossy compression, as illustrated in Figure 10.4, should probably be legitimate, in that it has essentially no perceptible effect. On the other hand, substantial editing, of the type illustrated in Figure 10.5, should probably be illegitimate, in that it can completely change the interpretation of the Work. Other distortions, however, are not as obvious. For example, consider low-quality lossy compression, as shown in Figure 10.6. The impact of this compression is perceptible, but few would consider it significant. Should it be legitimate?

The answer depends on the application. A basic rule of thumb is to consider the conclusions that might be drawn from Works when they are used as intended. Any distortions that will not change those conclusions should be legitimate. For example, medical images are generally used to help diagnose illnesses and other disorders. If we disregard for the moment the legal issues regarding medical imag-ing, any distortion that will not affect a diagnosis can be considered legitimate.

Care must be taken when applying this rule of thumb. In some cases, a modified Work that appears to be an acceptable copy of the original might in fact lead to different conclusions. In a critical field such as medical imaging, therefore, the division of distortions into legitimate and illegitimate groups should be based on controlled studies, rather than on subjective judgment.

Fig. 10.5 Tampered version of the image in Figure 10.4a.

Fig. 10.6 Image after JPEG compression with a quality factor of 20.

In many applications, the choice of which distortions to authorize is not only a technical decision but a legal one. In fact, if we were implementing an authentication system for medical images, we would likely be *primarily* concerned with the legal problems. This is even more true of other applications of authentication systems, such as authenticating evidence in criminal court cases.

In these circumstances, the division of distortions into legitimate and illegitimate groups is a result of case law.

The set of legitimate distortions determined by case law is not always predictable. Sometimes, whether or not a distortion is legitimate depends as much on the relative skill of the lawyers arguing the first test case as it does on the technical merits of the argument. This can lead to some surprising inconsistencies. For instance, some distortions might be allowed if the processing took place in the spatial or temporal domain, but might not be allowed if the processing took place in the frequency domain, even if the processing is linear and the results are equivalent. There are also likely to be variations from country to country and state to state, and the set of legitimate distortions can change over time.

Given such inconsistent and changing requirements, an ideal selective authentication system would first identify the distortions that have been applied to a Work. Once these distortions have been identified, it is a straightforward matter to determine whether any of them are illegitimate. This is the aim of tell-tale watermarking, as discussed in Section 10.2.4. Of course, identifying those distortions a Work has undergone from an almost infinite set of possible distortions, many of which may not be known to the designer, is difficult, to say the least.

If the requirements are consistent and can be identified *a priori,* then an alternative system is possible in which we design a watermark that is only robust to the legitimate distortions. This arrangement does not attempt to identify the distortions a Work has undergone but simply outputs a single bit of information indicating whether the Work is considered authentic or inauthentic. This is the aim of semi-fragile watermarks and semi-fragile signatures, as discussed in Sections 10.2.2 and 10.2.3. Proving a watermark will survive legitimate distortions is straightforward. However, the converse problem of proving a watermark will not survive all illegitimate distortions is, once again, very difficult.

10.2.2 Semi-fragile Watermarks

A *semi-fragile watermark* describes a watermark that is unaffected by legitimate distortions, but destroyed by illegitimate distortions. As such, it provides a mechanism for implementing selective authentication.

If the distinction between legitimate and illegitimate distortions is roughly based on perceptibility, creating a semi-fragile watermark is similar to creating a robust watermark. After all, the goal of robustness is to ensure that the watermark survives manipulations until the cover Work is so damaged that its value is lost. Beyond that point, we do not care whether a robust watermark survives. With a semi-fragile watermark, we still want to ensure that the watermark survives manipulation up to the point at which the Work's value is lost, but we also want to ensure that the watermark *does not* survive beyond that point. This can often be achieved by carefully tuning a robust watermark so that it is likely to be destroyed

if the distortion exceeds a particular level. Several proposed semi-fragile systems are examples of this approach[3] [164, 303, 226].

The problem of designing a semi-fragile watermark becomes more difficult when the list of legitimate distortions is more specific, as is the case for the medical and legal applications discussed in Section 10.2.1. In these cases, we want our mark to survive certain distortions, and not survive others, even when the perceptual impact of the illegitimate distortions may be negligible. Thus, in these circumstances, the semi-fragile watermark must be designed with the specific legitimate distortions in mind.

There is a wide variety of distortions that might be considered legitimate, and each distortion might require its own specific type of semi-fragile watermark. However, for illustrative purposes, we will concentrate on one broad class of distortions: lossy compression by quantization in a transform domain.

As discussed in Chapter 8, many lossy compression systems involve converting a Work into some transform domain, such as the wavelet or block DCT domain, and then quantizing the coefficients to reduce their entropy. Coefficients are quantized either coarsely or finely, depending on how easy it is to perceive changes in them. How can we make a semi-fragile watermark that survives a certain amount of compression, applied by a specific compression algorithm, yet disappears after almost any other type of manipulation?

A possible answer lies in the following property of quantization. Let $x \diamond q$ be the result of quantizing x to an integral multiple of the quantization step size, q:

$$x \diamond q = q \left\lfloor \frac{x}{q} + .5 \right\rfloor. \tag{10.6}$$

If a is a real-valued scalar quantity, and q_1 and q_2 are quantization step sizes, with $q_2 \le q_1$, then

$$((a \diamond q_1) \diamond q_2) \diamond q_1 = a \diamond q_1. \tag{10.7}$$

In other words, if we quantize a to an even multiple of q_1, and subsequently quantize by q_2, we can undo the effect of the second quantization by again quantizing to a multiple of q_1, as long as $q_2 \le q_1$. This can be exploited by having the watermark embedder and detector quantize transform coefficients by preselected step sizes [160]. As long as the quantization performed during compression uses smaller step sizes, the watermark should survive. This basic idea is employed to create the E_DCTQ/D_DCTQ authentication system, described in the following.

3. Most of the systems cited here also employ the idea of block-based authentication for localization. This is discussed in more detail in Section 10.3.

Semi-fragile Watermarking by Quantizing DCT Coefficients

The E_DCTQ/D_DCTQ image authentication system we present here uses a semi-fragile watermark designed to survive specific levels of JPEG compression. It is based on the system that Lin and Chang proposed in [160] (and extended to MPEG video in [161]), but is simplified here to serve as a pure example of a semi-fragile watermark.[4]

In the JPEG image compression system, images are quantized in the block DCT domain. The quantization step size for each coefficient depends on its frequency. By default, the step sizes are obtained by multiplying a predefined quantization array (Table 10.1) by a given constant factor. The constant factor is usually a simple function of a "quality factor" between 0 and 100, which is entered by the user. Although it is possible for JPEG encoders to use more sophisticated algorithms (e.g., designing a unique quantization array for each image), the authentication system described here is targeted at the default JPEG behavior.

System 17: E_DCTQ/D_DCTQ

The E_DCTQ embedder embeds a pseudo-random bit pattern into an image. It takes two input parameters, other than the image to be watermarked: the seed for generating the pseudo-random bit pattern and controlling other pseudo-random operations, and a strength parameter, α, which specifies the level of JPEG compression the watermark should survive. This strength parameter is expressed as the largest multiplier that may be applied to the default matrix before an image should be considered invalid.

Four bits are embedded in the high-frequency DCT coefficients of each 8×8 block in the image. Let b be the value of one of the bits. The method for embedding this bit proceeds as follows:

1. Select seven coefficients, $C[0]$, $C[1]$, . . . , $C[6]$, from the set of 28 coefficients, shown shaded in Figure 10.7. The sets of coefficients selected for the four bits are disjoint, so that each coefficient is involved in only one bit. We ignore the low-frequency coefficients here because changing them is assumed to lead to unacceptably poor fidelity.

4. The example does not include the semi-fragile signature of Lin and Chang's system. This will be added in Section 10.2.3. It also does not include their system's localization feature (see Section 10.3) or restoration feature (see Section 10.4).

Table 10.1 Luminance quantization matrix used in JPEG. The upper left value (16) is the base quantization factor for the DC term of each 8×8 block. The lower right value (99) is the base quantization factor for the highest-frequency term. These base values are multiplied by a global quantization value to obtain the actual quantization factor used. (Note: this table is duplicated from Chapter 8.)

16	11	10	16	24	40	51	61
12	12	14	19	26	58	60	55
14	13	16	24	40	57	69	56
14	17	22	29	51	87	80	62
18	22	37	56	68	109	103	77
24	35	55	64	81	104	113	92
49	64	78	87	103	121	120	101
72	92	95	98	112	100	103	99

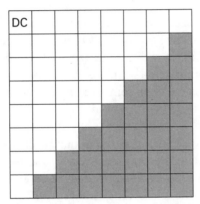

Fig. 10.7 DCT coefficients used to embed a semi-fragile watermark in the E_DCTQ/D_DCTQ authentication system. The upper-left element of this diagram corresponds to the DC term of each 8×8 block DCT. The shaded elements correspond to the terms used in the watermark.

2. Divide each of the coefficients by its corresponding quantization factor, and round to the nearest integer. That is,

$$\mathbf{C}_I[i] = \left\lfloor \frac{\mathbf{C}[i]}{\alpha \mathbf{q}[i]} + .5 \right\rfloor, \tag{10.8}$$

where $\mathbf{q}[i]$ is the value in Table 10.1 that corresponds to coefficient $\mathbf{C}[i]$.

3. Take the least significant bit of each of the resulting integers, $\mathbf{C}_I[0]$, $\mathbf{C}_I[1], \ldots, \mathbf{C}_I[6]$, and exclusive-or them together to obtain the current bit value, b_e, represented by these coefficients.

4. If $b_e \neq b$, flip the least significant bit of one of the integers. The one to flip is the one that will cause the least fidelity impact. Let $\mathbf{C_{wI}}[0]$, $\mathbf{C_{wI}}[1]$, ..., $\mathbf{C_{wI}}[6]$ denote the result. That is, $\mathbf{C_{wI}}[i] = \mathbf{C_I}[i]$ for all i unless $b_e \neq b$, in which case the least significant bit of one member of $\mathbf{C_{wI}}$ differs from that of the corresponding $\mathbf{C_I}$.

5. Multiply the members of $\mathbf{C_{wI}}$ by their corresponding quantization factors to obtain the watermarked versions of the DCT coefficients, $\mathbf{C_w}[0]$, $\mathbf{C_w}[1]$, ..., $\mathbf{C_w}[6]$:

$$\mathbf{C_w}[i] = \alpha \mathbf{q}[i] \mathbf{C_{wI}}[i]. \tag{10.9}$$

In theory, this algorithm should always succeed in embedding all bits. In practice, however, a few bits will be corrupted when the image is converted to the spatial domain, and each pixel is clipped and rounded to an 8-bit value. To compensate for this, we run the embedder on the image repeatedly, until all bits are correctly embedded.

The D_DCTQ detection algorithm takes as input an image to be authenticated and the same seed that was given to the embedder. It then simply performs the first three steps of the embedding algorithm to extract each bit, b_e. These are compared against the corresponding bits in the pseudo-random bit pattern, and the percentage of bits that match is compared against a threshold, τ_{match}. If this percentage is greater than the threshold, the image is declared authentic.

In theory, the threshold should be set at $\tau_{match} = 100\%$; that is, all bits should match. However, JPEG compression and decompression entails some clipping and round-off error, which sometimes corrupts embedded bits, even when the quantization multiplier is less than the embedding strength, α. Thus, we set $\tau_{match} = 85\%$.

Experiments

To test the performance of this system, watermarks were embedded in 2,000 images, with a strength of $\alpha = 0.3$. Each image was then subjected to some distortion and tested for authenticity with a threshold of $\tau_{match} = 85\%$. Two types of distortion were tested: DCT quantization and low-pass filtering.

The results for DCT quantization, which simulates JPEG compression, are shown in Figure 10.8. The horizontal axis indicates the multipliers for the quantization matrix. The vertical axis indicates the percentage of images that were detected as authentic. As expected, detection rates were largely unaffected when the multiplier was less than the strength parameter, and fell off rapidly at higher multipliers.

The results for low-pass filtering are shown in Figure 10.9. It is clear that even though the watermark survived fairly severe JPEG compression, even

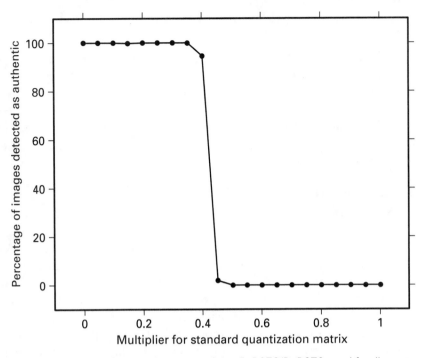

Fig. 10.8 Results of quantization test of the E_DCTQ/D_DCTQ semi-fragile watermark authentication system.

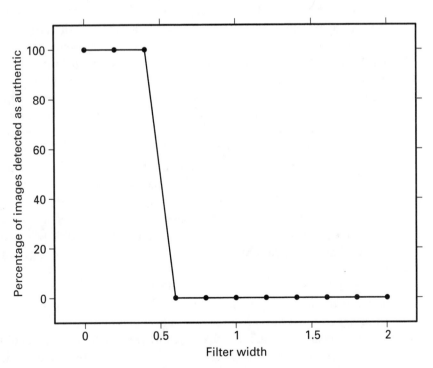

Fig. 10.9 Results of low-pass filtering test of the E_DCTQ/D_DCTQ semi-fragile signature authentication system.

mild low-pass filtering quickly destroyed it. This performance is comparable with the performance of a white noise watermark, tested in Chapter 8 (Figure 8.9), which we judged to be very fragile. Thus, if the mark is detected, we can be reasonably sure that the image has not been low-pass filtered, or JPEG compressed with a quantization multiplier much higher than 0.3.

10.2.3 Embedded, Semi-fragile Signatures

Semi-fragile watermarks, like their fragile counterparts, are often not secure against malicious tampering. This is because they can succumb to copy attacks (see Section 9.3.3 of Chapter 9). In addition, semi-fragile watermarks are only able to authenticate those properties of an image they are embedded within. For example, in the E_DCTQ/D_DCTQ system, the authentication watermark is only embedded in the high-frequency coefficients of the block DCT, because embedding in the low-frequency coefficients is too visible. However, this means that only changes in the high frequencies affect the watermark. If an illegitimate distortion changes the low frequencies, while leaving the high frequencies untouched, it will not affect the watermark, and the system will incorrectly report the image as authentic.

These problems can be addressed by identifying features of a Work that are invariant to legitimate distortions, but not to illegitimate distortions, and using them to construct a signature [239, 256]. Because the signature is unaffected by legitimate distortions, but changed by others, we refer to it as a *semi-fragile signature*.

Like the cryptographic signatures used for exact authentication (Section 10.1.2), a semi-fragile signature can be embedded as a watermark. However, in this case, the watermark cannot be fragile, because it must be able to survive any legitimate distortion. An appropriately designed semi-fragile watermark can be useful here, in that such a watermark might complement the signature. That is, although both the signature and the watermark are designed to survive legitimate distortions, they might be fragile against different sets of illegitimate distortions.

There are at least two advantages of using semi-fragile signatures. First, in such a system, each Work has a different watermark embedded. This means that an adversary cannot make a forgery appear authentic by performing a simple copy attack.

Second, the signature can be based on properties of the Work that we cannot change without causing unacceptable fidelity problems. For example, we can base a signature on the perceptually significant components of a Work [175, 18] in some transform domain, such as the low-frequency coefficients of the block DCT. We can then embed this signature in more easily alterable coefficients, such as the high-frequency coefficients of the block DCT. Of course, the embedded

signature must still survive legitimate distortions. This arrangement is illustrated with the E_SFSIG/D_SFSIG authentication system.

Investigation

Semi-fragile Signatures Embedded with Semi-fragile Watermarks

We consider a system that extracts a signature from the low-frequency terms of the block DCTs of an image and embeds it in the high-frequency terms using a semi-fragile watermark. Both the semi-fragile signatures and the semi-fragile watermarks are designed to survive JPEG compression up to a given quantization multiplier, but are altered by most any other process. The method of extracting these signatures is taken from Lin and Chang [160].

System 18: E_SFSIG/D_SFSIG

In this system, the embedder, E_SFSIG, extracts a semi-fragile signature from each image and then uses E_DCTQ to embed it. To extract signatures, we take advantage of a property of quantization. That is, if two values are quantized by the same step size, the resulting values maintain the same relation to one another. That is, if $a > b$, then $a \diamond q \geq b \diamond q$, where \diamond is the quantization operator defined in Equation 10.6.

A signature for the image is extracted as follows:

1. Convert the image into the block DCT domain.
2. Group the blocks of the image into pseudo-random pairs, according to a given seed.
3. In each pair of blocks, compare n corresponding low-frequency coefficients to obtain n bits of the binary signature. That is, we compute each of the n bits as

$$
\text{bit} = \begin{cases} 0 \text{ if } \mathbf{C}[i,\, j,\, k_0] < \mathbf{C}[i,\, j,\, k_1] \\ 1 \text{ if } \mathbf{C}[i,\, j,\, k_0] \geq \mathbf{C}[i,\, j,\, k_1] \end{cases}, \tag{10.10}
$$

where $i,\, j$ are the coordinates of a low-frequency coefficient, $\mathbf{C}[i,\, j,\, k]$ is the $i,\, j^{\text{th}}$ coefficient in the k^{th} block of the image, and k_0 and k_1 are the indices of two blocks that have been grouped.

The shaded elements of Figure 10.10 indicate the set of coefficients used to compute signatures in our experiments.

During standard JPEG compression, every block is quantized by the same quantization table. Therefore, ideally JPEG should not change our signatures.

Fig. 10.10 DCT coefficients used to compute semi-robust signatures in the E_SFSIG/D_SFSIG authentication system. The upper-left element of this diagram corresponds to the DC term of each 8 × 8 block DCT. The shaded elements correspond to the terms used in the signature.

The only changes that should occur happen when corresponding coefficients in two paired blocks are quantized to the same value (often 0). If $C[i, j, k_0]$ was originally less than $C[i, j, k_1]$, this quantization causes the signature bit to change from a 0 to a 1. Changes can also occur as a result of clipping and rounding after JPEG quantization, and this is particularly a problem when two paired coefficients are close to equal.

The E_SFSIG embedder computes a set of signature bits and embeds them into the high-frequency coefficients of the block DCT in a pseudo-random order, according to the same method used in E_DCTQ. The D_SFSIG detector extracts the embedded bits and compares them to the signature it computes from the image. During this comparison it ignores any signature bits computed from pairs of coefficients that are close to equal (wherever $|C[i, j, k_0] - C[i, j, k_1]| < \varepsilon$), because these might have been flipped during JPEG quantization. It then computes the percentage of the remaining signature bits (those extracted from unequal coefficient pairs) that match the embedded bits. If this percentage is over a given threshold, τ_{match}, it reports that the image is authentic.

Experiments

To test the performance of this system, watermarks were embedded in 2,000 images, with a strength of $\alpha = 0.3$. Each image was then subjected to some distortion and tested for authenticity with $\varepsilon = 4$ and a threshold of $\tau_{match} = 85\%$. Three types of processing were tested: DCT quantization, low-pass filtering, and additive low-frequency noise.

Figure 10.11 shows the results of quantization, and Figure 10.12 shows the results of low-pass filtering. Because the semi-fragile signature is relatively

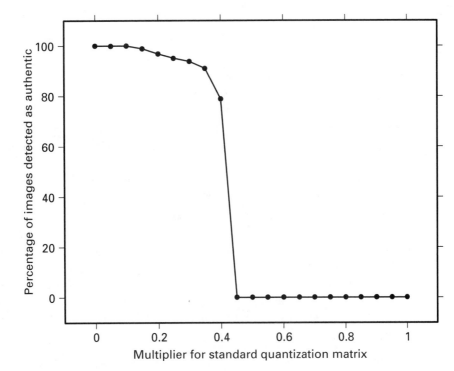

Fig. 10.11 Results of quantization test of the E_SFSIG/D_SFSIG authentication system.

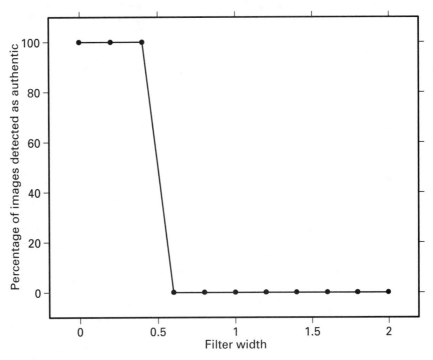

Fig. 10.12 Results of low-pass filtering test of the E_SFSIG/D_SFSIG authentication system.

unaffected by these two processes (except as a result of round-off and clipping), the authenticity results were very similar to those from the E_DCTQ/D_DCTQ authentication system (Figures 10.8 and 10.9).

The two systems, E_DCTQ/D_DCTQ and E_SFSIG/D_SFSIG, are expected to behave differently when the distortion affects the low-frequency components of the image. In this case, the semi-fragile signature should become invalid. Watermarks were embedded in 2,000 images using both the E_DCTQ and the E_SFSIG embedder, and each of the 4,000 watermarked images was corrupted by the addition of low-frequency noise. This noise has little effect on the high-frequency terms of the block DCTs. Therefore, the semi-fragile watermark should survive. However, in the E_SFSIG/D_SFSIG system the low-frequency noise will change the semi-fragile signature, so that it will longer match the embedded signature.

The results are plotted in Figure 10.13. Although the E_DCTQ/D_DCTQ system reports a large percentage of images as authentic, even at very high levels of noise, the E_SFSIG/D_SFSIG system identifies a decreasing number of images as authentic as the amount of noise increases.

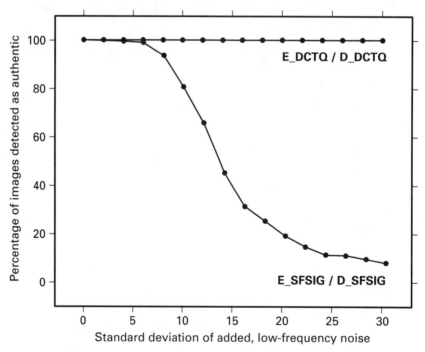

Fig. 10.13 Results of low-frequency noise test of the E_DCTQ/D_DCTQ and E_SFSIG/D_SFSIG authentication systems.

10.2.4 Tell-tale Watermarks

The two semi-fragile approaches previously described are appropriate for applications in which there is a clear distinction between legitimate and illegitimate distortions. However, in applications for which this distinction might change over time, or differ from place to place, we would like to obtain information about *how* a Work has been corrupted, rather than simply *whether* it has been corrupted. One possible way of investigating how a Work has been corrupted is to examine how a known, embedded watermark has been corrupted. This type of watermark has been referred to as a *tell-tale watermark.*

In [146, 303] it has been suggested that a watermark be embedded in the wavelet domain, using a form of quantization marking similar to that in the E_DCTQ/D_DCTQ system. The authenticator then examines various subsets of the wavelet decomposition, finding the number of embedded bits in each band that do not match the original watermark. This gives an idea of how badly each subband has been corrupted. Because different distortions corrupt different subbands of wavelet coefficients, it is possible to hypothesize how the Work has been distorted. For example, if all low-frequency coefficients are substantially corrupted but high-frequency coefficients are fairly intact, we can conclude that a high-pass filter has been applied to the Work. If all frequencies in a narrow spatial area have been equally corrupted, we might conclude that the area has been substantially edited.

The most general forms of tell-tale watermark would distinguish between a wide variety of different distortions. Research into such general schemes is still in its infancy. However, there has been substantial research into the narrower problem of using watermarks to determine *where* a Work has been altered. Although this can be thought of as a special case of tell-tale watermarking, it has received enough attention to warrant an independent discussion.

10.3 Localization

Many authentication methods based on watermarking have the ability to identify times or regions of the Work that have been corrupted, while verifying that the remainder of the Work has not been changed. This capability is referred to as *localization.*

Localization is useful because knowledge of when or where a Work has been altered can be used to infer (1) the motive for tampering, (2) possible candidate adversaries, and (3) whether the alteration is legitimate. For example, consider a photograph of a vehicle traveling along a highway. If our authenticator simply states that the image has been modified, the tampered image is useless. However, if the authenticator also indicated that the modification only occurred within

the region of the vehicle's license plate, then the photograph is still very useful in determining the make, model, and color of the car.

This section briefly discusses two closely related approaches to localization. The first, *block-wise authentication,* divides a Work into contiguous blocks and embeds an authentication watermark into each block independently. The second, *sample-wise authentication,* is an extreme case of block-wise authentication in which each block is reduced to the size of one sample. The section then goes on to discuss security issues that must be considered when using a localized authentication method.

10.3.1 Block-wise Content Authentication

Most localized authentication methods rely on some form of *block-wise authentication,* in which the Work is divided into a number of disjoint temporal or spatial regions, each of which is authenticated separately. If part of the Work is modified, only the affected regions fail to authenticate.

Investigation

Block-wise Authentication

The E_DCTQ/D_DCTQ authentication system can easily be modified to perform localization, as modification of any given 8 × 8 block in an image affects only the bits embedded in that block. This is done by modifying the D_DCTQ detector to measure the number of correctly embedded bits in each independent block, and output a map of which blocks are valid and which are not. The change to the D_DCTQ detector is in the reporting of results rather than in the detection algorithm, and therefore we will not introduce a new system name here.

This investigation is intended to simply illustrate the localization functionality gained by examining each block independently. We show this by applying the localized authentication system to an image and modifying the image prior to presentation to the detector.

First, we embedded an authentication mark into the image in Figure 10.4a, using E_DCTQ. Then, the watermark image was tampered with, and the woman was removed from the image by copying all the altered pixels from Figure 10.5 into the corresponding locations in the watermarked image. Finally, we used the D_DCTQ algorithm to label the inauthentic blocks. Figure 10.14 shows the results. Each block that was labeled inauthentic by the D_DCTQ detector is marked with an ×.

Fig. 10.14 Localized authentication using the E_DCTQ/D_DCTQ system.

10.3.2 Sample-wise Content Authentication

The spatial acuity with which a block-based authentication system localizes tampering depends on the block size. Because smaller block sizes lead to more precise localization, it might be desirable to reduce the blocks to single samples, resulting in *sample-wise authentication*. However, as we shall see, there are potential security risks associated with small block sizes, and these risks are greatest in sample-wise authentication. To illustrate the security risks, we first present an example sample-wise authentication system.

Investigation

Pixel-wise Image Authentication

The pixel-wise image authentication system presented here was first described by Yeung and Mintzer in [302] and is probably one of the most widely studied systems for localized authentication. This means that many of the attacks we will be describing have been applied to it.

System 19: E_PXL/D_PXL

The extraction process employs a pseudo-random mapping from pixel intensities into binary values. For example, intensities 0 through 3 might map to a

Fig. 10.15 A tiled, binary pattern that can be used as a watermark in the E_PXL/D_PXL authentication system.

bit value of 1, intensities 4 and 5 to a bit value of 0, intensities 6 through 9 to a bit value of 1, and so on. This mapping is determined by a table constructed by a pseudo-random number (PN) generator. The seed to the PN generator serves as a secret key. Each pixel in the image thus holds one bit of watermark information. The bit patterns used in [302] are tiled, binary images, usually in the form of a logo, as illustrated in Figure 10.15.

Note that an LSB watermark is a special case of this system, in which the mapping from intensities to bit values simply alternates between 1 and 0; that is, even-valued intensities map to 0 and odd-valued intensities map to 1. The use of a pseudo-random mapping, however, makes copy attacks more difficult.

The E_PXL embedder compares the extracted mark to the reference mark pixel by pixel. At pixel locations that do not match, the image values are replaced with the closest match from the mapping table. Thus, assuming the previously described intensity mapping, if the original pixel intensity is 3 and the corresponding watermark value is 0 at this location, then the embedder would alter the pixel value to 4.

Of course, when the watermark embedder alters pixel intensities, visible artifacts can be introduced. To reduce the risk of artifacts, we employ a common halftoning technique known as *error diffusion* [134]: as each pixel is modified, a fraction of the error introduced in its value is added to each of the neighboring pixels that have not yet been modified. Because the embedder proceeds from top to bottom, left to right, this means we distribute the errors down and to the right. Figure 10.16 shows the weights used for this distribution.

Fig. 10.16 Weights used for error diffusion in the E_PXL/D_PXL authentication system (from [134]).

The D_PXL detector simply extracts the mark using the pseudo-random mapping table, thereby generating a binary pattern. If the image has not been modified, this extracted pattern exactly matches the reference pattern. However, if a region has been modified, these alterations will likely show up as noise in the binary pattern.

Experiments

To illustrate the performance of this algorithm, we performed an experiment similar to that in Figure 10.14. The watermark pattern of Figure 10.15 was embedded into the image in Figure 10.4a, using the E_PXL embedder. Pixels from Figure 10.5 were then pasted into the watermarked image to remove the woman from the scene. Figure 10.17 shows the pattern extracted by the D_PXL

Fig. 10.17 Pattern extracted from a tampered image by the E_PXL/D_PXL authentication system.

detector. Most of this pattern matches the original watermark pattern, but the area containing the woman is corrupted.

10.3.3 Security Risks with Localization

There are a number of security risks associated with localized authentication systems. Although the risks discussed here can be countered with simple modifications, or proper use of the systems, it is important to be aware of them.

We are concerned with forgery attacks in which an adversary wishes to embed a valid watermark into either a modified or counterfeit Work. Two basic categories of attack, each of which requires different resources, will be examined. In *search* attacks, the adversary is assumed to have a black-box detector that can determine whether a Work is authentic or not. In *collage* attacks, the adversary is assumed to have two or more Works embedded with the same watermark key.

Search Attacks

Let's consider the situation in which everyone, including potential adversaries, has access to a watermark detector. This situation might arise, for example, if Works are being distributed to the general public over the Internet, and we want to use an authentication system to guarantee that each Work is delivered without corruption.

Under these circumstances, the adversary can, in theory, use the detector to thwart any authentication system (regardless of whether it is localized). To do so requires a brute-force search. To embed a forged watermark into a Work, an adversary can enter slightly modified versions of the Work into the detector until one is found that the detector reports as authentic.

In practice, of course, this search would usually be prohibitive. However, with a block-wise or sample-wise authentication system, the search space can be considerably smaller. The adversary can perform a separate, independent search on each block. If the block size is small enough—especially if it is a single sample—the search becomes feasible.

Such attacks can be countered by choosing a larger block size. The E_PXL/D_PXL system is clearly susceptible, in that the search would require *at most* 256 iterations per pixel (one for each possible intensity). The E_DCTQ/D_DCTQ system, with its 64-pixel blocks, is much safer.

Collage Attacks

The second category of attacks relies on having access to one or more authentic watermarked Works. By examining these Works, an adversary can come up with sets of blocks that are all authentic and construct a counterfeit Work from them like a "collage."

Holliman and Memon [118] described an attack applicable to block-wise watermarks. They considered the case in which a cryptographic signature is embedded in each block (see Section 10.1.2), and the signature depends only on the content of the block itself. This is referred to as *block-wise independence.* Consider what happens in such a system when two blocks of a watermarked Work are interchanged, thereby changing the Work as a whole. Because each block contains a self-authenticating watermark, and because each block remains unaltered, the work is deemed authentic. Thus, even if all blocks are scrambled into a random order, the system will regard the entire Work as authentic.

By exploiting this weakness of block-wise independent systems, it is possible to create a completely new Work that is assembled from the set of independent, authentic blocks. Suppose an adversary has a number of Works available, all watermarked using the same key. This can be viewed as a large database of authentic blocks from which a new image can be built. To forge a watermark in an unwatermarked Work, the adversary divides the Work into blocks and replaces each block with the most similar block from the database. With a large enough database of watermarked Works, the results may be quite good. Figure 10.18 shows an image constructed out of 8×8 blocks from 500 images. The fidelity of the forgery is surprisingly high, although some block artifacts are present. However, the number of such artifacts will diminish as the size of the database increases.

This attack only applies to block-wise independent systems in which the mark embedded in a block is independent of the block's location. However, systems such as E_DCTQ/D_DCTQ and E_PXL/D_PXL, which embed different information

Fig. 10.18 Image constructed by assembling 8 × 8 blocks from 500 different images.

into different locations, can also be attacked in a similar fashion. An example of this attack on a sample-wise authentication system, presented in [87], is described in the following.

The idea is very simple. For each sample of an unwatermarked image, look through the set of watermarked Works to find the one with the closest sample value in the same location. Then replace the sample in the unwatermarked Work with the one that was found, and use error diffusion to compensate for any fidelity impact.

The pixel-wise forgery attack of [87] is implemented using a database of 100 images authenticated with the E_PXL embedder. The goal is to use these images to forge a new image that will be considered authentic by the D_PXL detector.

Figure 10.19 shows the result of this attack. In this case, the forgery is nearly perfect and yet only 100 images were needed, significantly less than for the block-based method illustrated in Figure 10.18. The D_PXL detector reports this image as authentic. However, this attack would not fool the D_DCTQ detector because neither the relationships between the pixels nor the relationships between the DCT coefficients within a block are maintained.

If the adversary obtains two or more Works known to contain the same water-mark, it is sometimes possible to learn enough about that watermark to embed it in another Work. To illustrate this threat, consider the situation in which blocks at the same locations in different Works contain the same watermark information. Using this fact, the adversary can identify sets of blocks that can

Fig. 10.19 Image constructed by assembling pixels from 100 different watermarked images.

legitimately appear in each location. Armed with this knowledge, the adversary can forge a watermark in a new Work by replacing each of its blocks with the most similar block in the corresponding set.

A more sophisticated form of attack on sample-wise authentication systems was described in [87]. Consider two images, both of which have had the same binary watermark embedded using the E_PXL embedder. If the upper-left pixel in one image is 0, and the corresponding pixel in the other image is 2, then we know that both 0 and 2 map into the same bit value of the watermark. If at another location the first image has a 2 and the second image has a 25, we know that 0, 2, and 25 all map to the same bit value. Using this knowledge, we can build up a nearly complete picture of the pseudo-random mapping function at the heart of the E_PXL/D_PXL system.

With two images, the algorithm proceeds as follows:

1. Initialize a collection of sets of intensity values, S, to contain 256 sets, each containing one intensity value. That is,

$$S \leftarrow \{\{0\}, \{1\}, \{2\}, \ldots, \{255\}\}. \tag{10.11}$$

2. For each pixel location, identify the two sets in S that contain that location's intensities in the two images. Then combine those two sets. For example, if the first pixel in one image is intensity 0, and in the other image is intensity 2, the two sets, {0} and {2}, would be combined thus:

$$S \leftarrow \{\{0, 2\}, \{1\}, \{3\}, \ldots, \{255\}\}. \tag{10.12}$$

If the next location contained 2 in one image and 25 in the other, {0, 2} and {25} would then be combined. And so on. After visiting every pixel location, S will contain only a few sets (perhaps just two), and we know that all of the pixel values in each set map into the same bit value in the watermark pattern.

3. Having found S, we can now embed a forged watermark in an unwatermarked Work. At each pixel location, identify the set in S that contains the value in one of the *watermarked* Works. Then replace the pixel in the *unwatermarked* Work with the closest value in that set. Use error diffusion to compensate for the damage to fidelity.

In our example, one of the Works has a 0 in the first pixel location. Let us say the set in S that contains 0 is {0, 2, 27, 34, 89, 126, 134, 158, 230}. We know that all of these intensities map into the same watermark bit value. We also know that whatever it is, that value is the correct value for the first pixel location. Suppose the first pixel in the unwatermarked Work has a value of 136. We would change this to the closest value in the set, 134, and distribute the error to neighboring pixels.

In principle, this same attack could be applied to larger block sizes, but it quickly becomes impractical as the number of possible blocks increases. Even with the 8×8 blocks of the E_DCTQ/D_DCTQ system, the size of S is prohibitive.

The surest way to counter these types of attacks is to use a different key for watermarking every Work. However, such an approach is not always feasible, in that a given Work can only be authenticated if the correct key is available. The keys would need to be either known to the users or stored as associated data (e.g., in a header field of each Work). The application might prohibit both of these solutions.

A more practical approach, suggested in [118], is to make the signature in each block depend on some of the surrounding data, as well as the data within the block itself. This introduces some ambiguity to the localization, because a change in one block can change the signature that should be embedded in its neighbors. However, it dramatically complicates the adversary's attempt to build a Work out of watermarked blocks, as each block must match up properly with the neighboring blocks.

10.4 Restoration

We have seen that it is possible to determine if a Work has been altered, where a Work has been altered, and even how a Work has been altered. This naturally leads to an examination of whether an altered Work can be restored.

There are two basic restoration strategies: *exact restoration* and *approximate restoration*. As the names suggest, exact restoration seeks to restore the Work to its original state (i.e., the goal is a perfect copy with not a single bit in error). This is a very well-studied problem in communications and is discussed in Section 10.4.1.

Approximate restoration is a more recent concept that seeks to restore a Work while accepting that there will be differences between the restored and original Works. However, the restored Work is still valuable if these differences are not significant. Sections 10.4.2 and 10.4.3 describe two approaches to approximate restoration. In the first, additional information is embedded in the Work to assist in the restoration. In the latter, the watermark is first analyzed to determine how the Work has been distorted, and this information is then used to invert the distortion. Clearly, the latter process is only applicable if the distortion is invertible.

10.4.1 Embedded Redundancy

It is well known that error detection and correction codes allow changes in data to be detected and, in many cases, corrected [97]. Error correction codes (ECC) are widely used in communication and data storage to maintain the integrity of digital data. ECC codes are similar to digital signatures in that the code bits are typically appended to the data. However, there are also important differences between ECC codes and signatures.

The purpose of a digital signature is, of course, to verify that the data has not changed. The use of a one-way hash function makes the probability of an

undetected change exceedingly small. In contrast, ECC codes usually assume a maximum number of bit changes. If this number is exceeded, it is possible for errors to go undetected. However, with careful design, the likelihood of missed errors can be low. It is possible to use a digital signature in conjuction with an error correction code.

The size of an ECC code is usually very much larger than a digital signature. In fact, an ECC code can represent a significant fraction of transmitted bits. The size of the ECC code determines both the maximum number of bit changes that can be detected and the maximum number of bits that can be corrected. These two numbers are sometimes different, some ECC codes being able to detect many more changes than they can correct.

A Work can be considered simply as a collection of bits, and a variety of different error correction codes can be applied (e.g., Hamming codes, turbo codes, trellis codes, etc.). Once more, this metadata can be represented using a watermark. For example, a Reed Solomon ECC code can be used to generate parity bytes for each row and column of an image [156, 157]. These parity bytes can be embedded as a watermark in the two least significant bit planes of the image.[5] It is reported in [156, 157] that for a 229×229 image up to 13 bytes in a single row or column can be corrected. Even if the errors cannot be corrected, they can be localized, because parity bytes are calculated for each row and column.

A variant to this method exploits the assumption that errors often come as bursts [156, 157]. This is especially true if a localized region of an image has been modified or cropped. To increase the resistance to burst errors, the locations of the pixels in the image are randomized prior to calculation of the ECC codes. This randomization is a function of a watermark key.

Clearly, if we want to restore a Work to its original state, a very significant cost must be incurred to store the ECC codes. If this cost is too high, or the resources are simply unavailable, then approximate restoration techniques may be a good compromise. Two such approaches are discussed next.

10.4.2 Self-embedding

Several authors [85, 159] have proposed "self-embedding," in which a highly compressed version of the Work is embedded in the Work itself. Thus, if portions of the watermarked Work are removed or destroyed, these modified regions can be replaced with their corresponding low-resolution versions.

To illustrate self-embedding, we briefly describe the fundamental ideas behind an algorithm proposed by Fridrich and Goljan [85]. Their method takes an original image Work and extracts a JPEG compressed version at about a 50%

5. Thus, if eight bits are used to represent each pixel intensity value, the ECC code consumes 25% (2/8) of the available data—very much more than a digital signature.

quality factor. This low-resolution image requires only one bit per pixel and can thus be inserted in the LSB plane of the Work. However, rather than insert each compressed DCT block in the LSB of its corresponding spatial block, the binary sequence is first encrypted and then inserted in the LSB plane of a block that is at least a minimum distance away and in a randomly chosen direction. The authors suggest a minimum distance of 3/10 the image size. The random mapping is generated using a key that must be known to both the embedder and detector. Storing the low-resolution version of a block some distance away from the corresponding block allows this block to be restored even if it has been completely deleted. Of course, a higher-quality reconstruction is always possible if more bits are allocated to the storage of the low-resolution Work. The method is severely affected by any modifications to the encoding plane. However, more robust embedding methods can be used, as described in [85].

Although this example uses a comparable number of bits to the ECC method of [156], its "correction" capability is very much greater. It can essentially correct the entire image, albeit at a lower resolution.

10.4.3 Blind Restoration

An alternative model for the approximate correction of errors is based on *blind restoration*. Blind restoration [144] attempts to first determine what distortions a Work has undergone, and then to invert these distortions to restore the Work to its original state. Such a process is only appropriate if the distortion is invertible. Thus, blind restoration is not useful against, for example, clipping.

In Section 10.2.4 we described how tell-tale watermarks can be used to determine *how* a Work has been distorted. We also described one such method, proposed in [146]. This work on tell-tale watermarks has been extended to support image restoration [145] under the assumption that the image degradation can be modeled by localized linear blurring. This information is then used to approximately invert the blur distortion.

The fact that the watermark undergoes the same distortions as the cover Work suggests that a carefully designed watermark might be very useful in estimating the form of distortion a Work has undergone. Once this distortion is known, it is relatively straightforward to invert the process, assuming, of course, that the distortion is invertible. A combination of blind restoration and self-embedding may also be appropriate. In principle, blind restoration might allow a lower-resolution Work to be embedded. This is because at least some of the distortion may be invertible. In addition, where clipping or other non-invertible distortions have been applied, the self-embedded information allows for a low-resolution restoration. The complementary nature of the two methods is an interesting research topic.

10.5 Summary

This chapter covered several issues related to the use of watermarks for authenticating content. The following main points were made:

- Several questions may be asked about the authenticity of a Work, including
 - Has the Work been altered in any way whatsoever?
 - Has the Work been *significantly* altered?
 - What parts of the Work have been altered?
 - Can an altered Work be restored?
- Although other techniques for answering these questions exist, watermarks may be useful because they do not require auxiliary data and they undergo the same transformations as their cover Works. However, whether these advantages outweigh their disadvantages remains to be seen.
- An *exact authentication* system seeks to verify that a Work has not been changed *at all*. We discussed two basic methods for doing this:
 - *Fragile watermarks* are designed to become undetectable with the slightest change in their cover Works.
 - *Embedded signatures* are simply cryptographic signatures (as discussed in Chapter 9) embedded as watermarks.
- It is sometimes possible to create an *erasable watermark,* which, after being detected, can be removed to obtain an exact copy of the original. However, this type of watermark must be designed with careful consideration of the application to avoid unacceptable embedding effectiveness or false positive probability.
- A *selective authentication* system seeks to verify that a Work has not been modified by any of a predefined set of *illegitimate distortions*, while allowing modification by *legitimate distortions*. We discussed three basic approaches for doing this:
 - *Semi-fragile watermarks* are designed to survive legitimate distortions but be destroyed by illegitimate distortions.
 - *Semi-fragile signatures* are signatures computed from properties of the content that are unchanged by legitimate distortions. These can be embedded in content using robust or semi-fragile watermarks.
 - *Tell-tale watermarks* are designed to be examined in detail after a Work is modified. By determining how the watermark has changed, we can infer how the Work has been distorted and make a subsequent determination as to whether or not the distortion was legitimate.
- *Localization* refers to the ability of an authentication system to identify which portions of a Work are authentic and which are corrupted. This is usually done by dividing the Work into parts and authenticating each part separately. However, there are some security concerns with the most straightforward approaches.

■ *Restoration* refers to the ability of a system to restore portions of a Work that have been corrupted. We discussed three basic approaches:

⊞ *Embedded redundancy* embeds error correction bits in a Work as a watermark.

⊞ *Self-embedding* embeds a low-quality copy of a Work in a robust watermark.

⊞ *Blind restoration* uses a tell-tale watermark to identify distortions that have been applied to a Work, and then attempts to invert those distortions.

APPENDIX

A

Background Concepts

A.1 Information Theory

In our discussion of message coding with side information, we use several concepts from information theory. For those readers unfamiliar with information theory, we now present a brief description of each of these concepts. Our intention in this appendix is to develop some intuition for these concepts, rather than provide a rigorous analysis. Those interested in more detailed discussions of these ideas are referred to one of the many books on information theory, such as [54, 97].

A.1.1 Entropy

The *entropy* of a random variable, x, is a value that gives some idea of *how* random that variable is. It is defined, mathematically, as

$$H(x) = -\sum_{x} P_x(x) \log_2 P_x(x), \tag{A.1}$$

where $P_x(x)$ is the probability that x will be equal to x. To compute entropy when $P_x(x) = 0$ for some value of x, we specify that $0 \log_2 0 = 0$. If x is a continuous variable (i.e., real-valued), the summation in Equation A.1 can be replaced with integration, and the probability distribution with a probability density function.

Intuitively, the entropy of x is the average number of bits of information required to identify its value. An example illustrates this idea. Imagine that two people, Alice and Bob, play a simple game with a deck of four cards. The backs of the cards are all identical to one another (as in a normal deck). The face of

359

each card is labeled with a number from 1 to 4. Bob draws a card from this deck and examines it. Alice then asks him yes/no questions about the card, obtaining one bit of information from Bob with each question, until she knows for certain what the card's value is. She tries to do this with as few questions as possible, averaged over many iterations of this game.

Clearly, Alice's best strategy is to ask, first, whether the card's value is greater than 2. If the answer is yes, she then asks whether it is greater than 3; otherwise, she asks whether it is greater than 1. In this way, she can always identify the correct value in two questions, and therefore the entropy of the card values is 2. This is the same entropy we obtain if we let $P_x(x) = .25$ for $x = 1, 2, 3, 4$ and plug this distribution into Equation A.1.

Now consider what happens if we modify the game slightly. Instead of labelling the cards labeled 1 through 4, we now label two cards with a 3, and one card each with 1 and 2. Thus $P_x(1) = .25$, $P_x(2) = .25$, and $P_x(3) = .5$.

Alice's best first question in this case is still to ask whether the card is greater than 2. However, if the answer is yes, she knows the card must be a 3, and she need not ask any further questions. Thus, whenever Bob draws a 3, Alice will ask only one question. Whenever he draws a 1 or a 2, Alice must still ask two questions. Because Bob will draw a 3, on average, half the time, the average number of questions that Alice must ask is 1.5.

By thinking about games like this, the reason for Equation A.1 becomes clear. The probability of Bob drawing card x is $P_x(x)$, and the number of questions Alice must ask to identify that card is $\log_2 P_x(x)$. Thus, Equation A.1 just gives the expected number of questions Alice must ask.

A.1.2 Mutual Information

The *mutual information* between two random variables, x and y, is a measure of how closely related their values are. It is defined, mathematically, as

$$I(x; y) = H(x) - H(x|y), \tag{A.2}$$

where $H(x|y)$ is the expected entropy of x after a value for y is chosen. This is given by

$$H(x|y) = \sum_y P_y(y) H(x|y = y)$$

$$= -\sum_y P_y(y) \left(\sum_x P_{x|y=y}(x) \log P_{x|y=y}(x) \right), \tag{A.3}$$

where $P_{x|y=y}(x)$ is the probability that $x = x$, given that $y = y$.

Table A.1 Values of $P_{x|y=y}(x)$ for different values of x (columns) and y (rows) in a simple game played with a deck of four cards.

	1	2	3
red	0.0	0.0	1.0
blue	0.5	0.5	0.0

Intuitively, the mutual information between x and y is the number of bits of information we learn about x by examining a value of y. To illustrate this idea, imagine that we further modify Alice and Bob's game so that the backs of the cards are not all identical. The cards with 1 and 2 on their faces have blue backs, and the two cards with 3 on their faces have red backs. If Bob draws a 3, Alice sees that the back of the card is red, and need not ask any questions to determine its value. If Bob draws a 1 or a 2, Alice must ask one question to identify it. Thus, half the time Alice must ask one question, and the average number of questions she will ask is 0.5. Because without seeing the backs of the cards Alice must ask an average of 1.5 questions, the mutual information between the face values and the back colors is 1 bit.

To obtain the mutual information between card faces and backs using Equation A.2, we must compute the expected entropy of the face values given the color backs. Let x represent face values, and y represent color backs. The six possible values of $P_{x|y=y}(x)$ are shown in Table A.1. Applying Equation A.3 to this table yields $H(x|y) = 0.5$. We know from the preceding section that $H(x) = 1.5$. Therefore, Equation A.2 gives us $I(x;y) = 1$.

It is interesting, and a little surprising, to note that the mutual information between any two random variables is symmetrical. That is,

$$I(x;y) = I(y;x). \tag{A.4}$$

This can easily be verified algebraically. In the game between Alice and Bob, it means that the mutual information between card faces and backs is the same if the cards are turned around, so that Alice sees the face and must guess the back color. Of course, she knows the back color immediately if she sees the face value, and therefore never needs to ask a question at all, and $H(y|x) = 0$. If she did not get to see the face, she would have to ask one question to identify the color, and thus $H(y) = 1$. The mutual information is the difference between these two; that is, 1 bit.

A.1.3 Communication Rates

We make use of two closely related ideas: *code rate* and *achievable rate*.

Code Rate

A *code rate* is a property of a code (i.e., a mapping between messages and sequences of symbols as discussed in Chapter 4). It is defined, mathematically, as

$$R = \frac{\log_2 |\mathcal{M}|}{L}, \tag{A.5}$$

where $|\mathcal{M}|$ is the number of distinct messages that can be encoded with sequences of length L. The relation expressed in this definition is often written with $|\mathcal{M}|$ as a function of R and L; that is,

$$|\mathcal{M}| = 2^{LR}. \tag{A.6}$$

Intuitively, the rate of a code is the number of bits of information encoded in each symbol. For example, consider the trellis code described in Chapter 4. This code converts a source sequence of bits (a message) into a sequence of bits four times longer. Thus, if we have $|\mathcal{M}| = 256$ different 8-bit messages, the code produces sequences of $L = 32$ 1-bit symbols. This gives a rate of $R = \frac{1}{4}$, or a quarter bit of information for each symbol in the sequence.

Achievable Rate

Whereas code rate is a property of a code, *achievable rate* is a property of a communication channel. Intuitively, saying that a given code rate, R, is *achievable* for a given channel means that it is possible to design rate R codes that perform well over that channel. However, the precise definition of achievable rate is subtle and requires some explanation.

Suppose we are interested in determining whether a rate of $R = \frac{1}{4}$ is achievable in some channel. Begin by considering a code for just one bit of information, where $|\mathcal{M}| = 2$. This would require sequences of four symbols. Depending on the noise in the channel, even the best such code will have some probability of errors (i.e., some probability that the message decoded by the receiver is not the message that was transmitted). Let e_1 denote the probability of error using the best-possible code for transmitting 1-bit messages. Similarly, let e_2 denote the probability of error when using the best-possible code for transmitting 2-bit messages in sequences of eight symbols. Note that these two codes need not be related.

We say that the rate of $R = \frac{1}{4}$ is achievable if, as b tends to infinity, e_b tends asymptotically to 0. Thus, saying that a rate is achievable means that we can obtain arbitrarily low probability of errors by using codes with arbitrarily long symbol sequences, L, and correspondingly large sets of messages, $|\mathcal{M}| = 2^{LR}$.

In most communications applications it is feasible to use long enough symbol sequences to obtain negligible error probabilities, with codes of any achievable

rate. However, it is sometimes important to keep in mind that very short codes may still produce unacceptable error probabilities, even if their code rates are "achievable." That is, $R = \frac{1}{4}$ might be considered technically achievable, even if e_1 or e_2 is unacceptably large.

A.1.4 Channel Capacity

The *capacity* of a channel is defined as the maximum achievable rate for that channel, or, more precisely, the supremum of all achievable rates. That is, any rate less than the channel capacity is achievable, but the channel capacity itself cannot necessarily be achieved. In our discussions of coding with side information in Appendix B, we refer to two expressions for capacity: one that gives the capacity of an arbitrary channel, and one that gives the capacity of an additive, white Gaussian-noise (AWGN) channel.

Capacity of Arbitrary Channels

In principle, any channel can be characterized by a conditional distribution, $P_{y|x=x}(y)$, which gives the probability of receiving y when x is transmitted. Using this conditional distribution and a probability distribution, $P_x(x)$, for the transmitted symbols, x, we can compute the mutual information between transmitted and received symbols, $I(x; y)$. It has been shown that the capacity of a channel is

$$C = \max_{P_x} I(x; y), \tag{A.7}$$

where x is a transmitted symbol, y is a received symbol, and the maximum is taken over all possible distributions of x.

To gain some intuition about Equation A.7, first note that in a given communications system (that is, a given channel plus a given code) the distribution of transmitted signals, $P_x(x)$, is determined by the distribution of messages and the method of encoding. If we assume the messages are uniformly distributed, then the probability of symbol x being transmitted is just the frequency with which that symbol appears in code words. With this in mind, we can view Equation A.7 as resulting from two distinct points:

- For a given distribution, P_x, it is possible to design a code with rate $I(x; y)$ that has negligible probability of error (or, more strictly, diminishing probability of error as the code length increases). Conversely, it is not possible to design a reliable code with a higher rate. Given that the mutual information between x and y is defined as the number of bits of information that y provides about x, it is not surprising that this should be the number of bits that may be reliably transmitted with each symbol.
- Codes can be designed that lead to *any* distribution, P_x. This is trivially true for the case of uniformly distributed messages and arbitrarily long codes.

Although a formal proof is rather involved, these two points make intuitive sense and lead naturally to Equation A.7. (For the formal proof, see [54].)

Capacity of AWGN channels

Although Equation A.7 is completely general, it is difficult to apply directly to real channels. Rather, it is normally used as the foundation for deriving expressions for the capacity of more specific classes of channel. In our discussions, we refer to AWGN channels, and now turn our attention to the formula for their capacity.

In an AWGN channel, each transmitted symbol, x, is an arbitrary, real value. The transmitter is limited by a power constraint, which says that for any transmitted code word, \mathbf{x}, of length L,

$$\frac{1}{L}\sum \mathbf{x}[i]^2 \le p, \tag{A.8}$$

where p is a constant. At the other end of the channel, the symbol received when x is transmitted is $y = x + n$, where n is drawn from a Gaussian distribution with variance σ_n^2. Successive values of n are drawn independently from one another. It has been shown that the capacity of such a channel is

$$C = \frac{1}{2}\log_2\left(1 + \frac{p}{\sigma_n^2}\right). \tag{A.9}$$

To construct an intuitive argument for Equation A.9, view each code word of length L as a point in an L-dimensional space. The power constraint (Equation A.8) restricts all code words to lie within a radius \sqrt{Lp} sphere, centered at zero.

After a code word, \mathbf{x}, is transmitted and noise, \mathbf{n}, is added, the received vector, $\mathbf{y} = \mathbf{x} + \mathbf{n}$, is drawn from a Gaussian distribution centered at \mathbf{x}. As the dimensionality of the space, L, increases, it becomes increasingly likely that \mathbf{y} lies in a radius $\sqrt{L\sigma^2}$ sphere around \mathbf{x}.

If we can ensure that the "noise spheres" around the various code words do not overlap, the probability of error will vanish as L approaches infinity. Thus, the maximum number of messages we can reliably encode is roughly the number of radius $\sqrt{L\sigma_n^2}$ spheres we can pack into a radius $\sqrt{L(p + \sigma_n^2)}$ sphere, as illustrated in Figure A.1.

The formula for the volume of a sphere in L dimensions is of the form

$$v = K_L r^L, \tag{A.10}$$

where r is the radius of the sphere and K_L is a constant that depends on the dimensionality of the space (see Section B.3 in Appendix B for the actual formula). Thus, the number of radius $\sqrt{L\sigma_n^2}$ spheres that can be packed into a sphere of

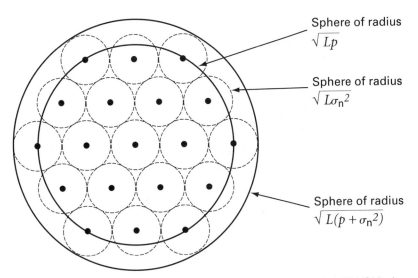

Fig. A.1 Channel capacity of an additive, white Gaussian noise (AWGN) channel viewed as a sphere-packing problem.

radius $\sqrt{L(p + \sigma_n^2)}$, and hence the maximum number of possible messages, is limited by

$$|\mathcal{M}| \leq \frac{K_L \left(\sqrt{L(p + \sigma_n^2)} \right)^L}{K_L \left(\sqrt{L\sigma_n^2} \right)^L}$$

$$= \left(1 + \frac{p}{\sigma_n^2} \right)^{\frac{L}{2}}. \tag{A.11}$$

It turns out that as L increases we can encode a number of messages arbitrarily close to this bound. This leads directly to Equation A.9.

A.2 Cryptography

Cryptography is broadly defined as "the art and science of keeping messages secure" [240]. The reader is directed to the source of this definition for a comprehensive and excellent description of this field, and to [130] for a comprehensive account of its history. The main types of problems cryptography addresses include

- ■ *Confidentiality:* Only the sender and receiver should be able to read a message.
- ■ *Authentication:* The receiver should be able to verify the originator of a message.

■ *Integrity:* The receiver should be able to verify that the message has not been altered while in transit.

■ *Nonrepudiation:* The sender should not be able to deny that the message originated from him or her.

Several of these problems are similar to security problems that watermarking must address. We might therefore expect cryptographic technologies to be useful in building secure watermarks. In the following we briefly describe four such technologies: symmetric-key cryptography, asymmetric-key cryptography, one-way hash functions, and cryptographic signatures.

A.2.1 Symmetric-Key Cryptography

In *symmetric-key cryptography,* also known as *secret-key cryptography,* two or more correspondents share a single cipher key, which they use to secure the communication between them. The key, K, is employed in a *cryptographic code,* or *cipher,* consisting of an encryption function, $E_K(\cdot)$, and a decryption function, $D_K(\cdot)$. A message, m, usually referred to as *plaintext* or *cleartext,* is converted to encrypted *ciphertext,* m_c, by

$$m_c = E_K(m). \tag{A.12}$$

Similarly, the ciphertext, m_c, is decrypted back to the cleartext message m by

$$m = D_K(m_c). \tag{A.13}$$

The use of a symmetric-key algorithm is straightforward. If Alice and Bob wish to engage in confidential communication, they can share a secret key, K. Alice can use this key to encrypt a message, and Bob can use the same key to decrypt it, and vice versa. Not only is the communication confidential, but because only Alice and Bob know the secret key they can also be certain that messages are authentic (i.e., that they originated from Alice or Bob).

The key must remain known only to Alice and Bob. Clearly, if a third party discovers the key, the messages are no longer secure. The problem of managing and communicating keys securely is nontrivial and is particularly difficult at the beginning of a communication session. Before sending encrypted messages, Alice and Bob must somehow agree on the secret key they will use. Because they have not yet agreed on one, their preliminary discussion must take place in the open. If a third party, Eve, listens in on this discussion, she can learn the key they plan to use, and the subsequent secret messages are compromised from the start.

Another difficulty with symmetric-key cryptography arises when more than two people need to communicate. Consider the situation in which Alice, Bob, and Carol want to communiate confidentially to one another. Again, all three can share the key, K. However, now Bob cannot be certain that a message that

claims to be from Alice was not sent by Carol, because both Alice and Carol use the same key.

A.2.2 Asymmetric-Key Cryptography

Asymmetric-key cryptography solves several problems that cannot be solved by symmetric-key cryptography. The basic idea here is to use a different key for encryption than is used for decryption. That is, to communicate a message, we use a pair of keys,[1] K_E and K_D. The message is encrypted using K_E, in

$$m_c = E_{K_E}(m), \tag{A.14}$$

and is decrypted using K_D, in

$$m = D_{K_D}(m_c). \tag{A.15}$$

For each possible encryption key there is exactly one decryption key that will correctly decrypt the message.

Ideally, we might like an asymmetric-key system to be designed so that knowledge of either key does not allow an adversary to find out the other key. However, in practical asymmetric-key cryptography algorithms, such as the popular RSA [230], this constraint is only satisfied in one direction (i.e., one of the keys can be discovered from the other, but not vice versa [240]). The key that can be discovered is often called the *public key*, and the one that cannot is called the *private key*. The public key can be widely distributed without risk of giving away the private key. Depending on the application, either the encryption key or the decryption key can be public.

In the abstract, we can think of an asymmetric-key system as comprising two different descriptions of a single mapping between cleartext and ciphertext. One description, based on the public key, allows feasible computation of the mapping in only one direction. The other description, based on the private key, allows feasible computation of the mapping in the other direction. This view is illustrated in Figure A.2.

Asymmetric-key cryptography can be used in a variety of ways. To alleviate the key-management problem, Alice and Bob can each have a pair of keys. They exchange their public keys, in the clear, with Eve listening in. When Alice wants to send a message that only Bob can read, she encrypts it using Bob's public key. Even though Eve probably knows Bob's public key, she cannot read Alice's message because it can only be decrypted with Bob's private key. In fact, even Alice herself cannot decrypt the message. Thus, when public keys are used for

1. In the cryptographic literature it is common to use K to represent both keys, because it is generally easy to tell which key is being used from the context. However, as we will not be making heavy use of these variables, we have chosen to distinguish them with subscripts for added clarity.

Clear text Cypher text

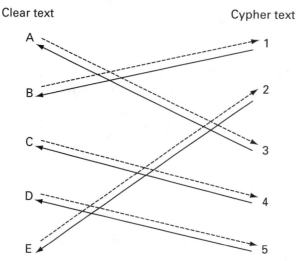

Fig. A.2 Asymmetric-key watermarking as two descriptions of the same mapping between cleartext and ciphertext. In this figure, the public key describes the mapping in a way that allows only encryption (dashed arrows). The private key describes the mapping in a way that allows either encryption or decryption (solid arrows).

encryption, the content of messages can be kept secret, even when the adversary knows the public key.

The problem of authentication can be solved by using an asymmetric key the other way around (i.e., using the private key for encryption and the public key for decryption). For example, let's return to the situation in which Alice, Bob, and Carol wish to communicate with one another. Each person could have his or her own pair of keys. Everyone would know everyone else's public keys, but they would keep their private keys secret from each other. When Alice wants to send a message to Bob, she encrypts the message using her private key. Both Bob and Carol can read the encrypted message, because they know Alice's public key. However, neither Bob nor Carol is able to forge a message from Alice because neither party knows Alice's private key. Thus, Bob can be certain that the message came from Alice, and not Carol. This system is illustrated in Figure A.3.

Unfortunately, asymmetric-key algorithms require much more computation than symmetric-key algorithms, and it is usually impractical to encrypt and decrypt large messages. For this reason, it is common to use a symmetric-key algorithm for large amounts of data, and to transmit its key using an asymmetric-key algorithm.

There are also times when we are not concerned with keeping the message itself secure, but only with authenticating the sender. Bob might not care whether Carol and Eve read his messages to Alice, as long as they cannot send her their

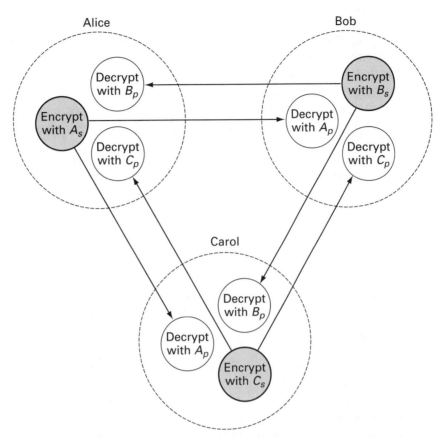

Fig. A.3 Alice, Bob, and Carol using asymmetric-key cryptography to authenticate the senders of their messages. Each of them has his or her own set of keys: A_s and A_p are Alice's private (secret) and public keys, respectively. B_s and B_p are Bob's keys. C_s and C_p are Carol's keys. Each keeps his or her private key secret, but allows the others to know the corresponding public key. Messages are encrypted with private keys and decrypted with public keys.

own messages and claim they came from him. In these cases, it is not necessary to encrypt the messages in their entirety. Rather, Bob can make use of cryptographic signatures, which are constructed using asymmetric-key cryptography and one-way hash functions. One-way hash functions and cryptographic signatures are described in the following.

A.2.3 One-Way Hash Functions

A *hash function* maps a variable-length string into a fixed-length hash value. A simple example of a hash function might return the bitwise XOR of all the bytes

in a character string. No matter how long the character string is, the output is still only one byte. Clearly, hash functions are many-to-one mappings.

A *one-way hash function* is a hash function that is reasonably cheap to calculate, but is prohibitively expensive to invert. That is, given an input string, it is easy to find the corresponding output. However, given a desired output, it is virtually impossible to find a corresponding input string. Common one-way hash functions are MD5 [229] and the U.S. government's Secure Hash Algorithm (SHA) [196].

One use of one-way hash functions is for guaranteeing the integrity of a message (i.e., that the message has not been altered between the time it was sent and the time it was received). To provide a simple test for this, the sender (Bob) can compute a hash, H, of the message, m, with a secret key, K, as

$$H = h(m + K), \tag{A.16}$$

where $m + K$ indicates the string concatenation of m and K and $h(\cdot)$ is a one-way hash function. The hash value is often referred to as a *message authentication code* (MAC), or *data authentication code* (DAC). Bob transmits the message with the MAC appended (i.e., he sends $m + H$).

The secret key is shared with the recipient of the message (Alice), as is the hash function. Upon receipt, she can compute the one-way hash of $m + K$ and compare it with the appended MAC, H. If the two are the same, the message has not been altered. Even if an adversary such as Eve alters the message, she is unable to compute the associated MAC because despite the fact that the hash function is public the shared key that forms part of the hash is private to Alice and Bob.

Of course, this system requires that only Alice and Bob know the secret key, as anyone who knows the key can compute valid MACs for altered or forged messages. Once again, this involves all of the problems of key management inherent in cryptography. Furthermore, if more than two people are involved in the communication, they all need to know the key, and the recipient can never be sure who originated any given message.

A.2.4 Cryptographic Signatures

A *cryptographic signature* serves the same purpose as a MAC, but employs asymmetric-key cryptography to alleviate problems of key management and authentication. The procedures for constructing and verifying cryptographic signatures are illustrated in Figure A.4.

To produce a cryptographic signature, S, Bob computes a one-way hash of the message and encrypts it using a private key, thus:

$$S = E_{K_E}(h(m)). \tag{A.17}$$

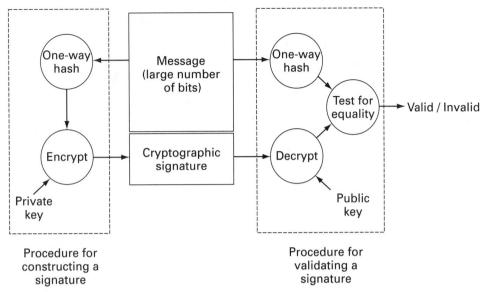

Fig. A.4 Procedures for constructing and verifying cryptographic signatures.

The resulting signature is then appended to the message before transmission. To verify the sender of the message, Alice decrypts the signature using Bob's public key, K_D, and compares the result against the hash of the message. If $D_{K_D}(S)$ is equal to $h(m)$, she knows the message came from Bob.

Selected Theoretical Results

B.1 Capacity of Channels with Side Information at the Transmitter (Gel'fand and Pinsker)

We now develop an intuitive understanding of Gel'fand and Pinsker's formula for the capacity of channels with side information [94], on which Costa's work is based.

B.1.1 General Form of Channels with Side Information

The class of channels studied by Gel'fand and Pinsker is illustrated in Figure B.1. For each use of the channel, t, a random value, $s[t]$, is drawn from a set of possible values, \mathcal{S}. Before the transmitter chooses a code word to transmit, it is told what *all* values of $s[t]$ will be during the entire transmission (i.e., it is told that $s[t] = s[t]$, for $t = 1 \dots L$, where L is the length of the transmission). The transmitter then chooses a sequence of L values, \mathbf{x}, from a set of possible values, \mathcal{X}, and transmits them. Each of the sequence of values then received by the receiver, $y[t]$, is a random value dependent on both $\mathbf{x}[t]$ and $s[t]$. This dependency is described by a conditional probability distribution, $P_{y|x=\mathbf{x}[t], s=s[t]}(y)$.

This class of channels includes the dirty-paper channel. Here, \mathbf{s} and \mathbf{x} are vectors of real numbers, and \mathbf{y} is the sum of \mathbf{x}, \mathbf{s}, and an additional random vector, \mathbf{n}. However, the class also includes an infinite variety of other possible channels, such as channels that apply multiplicative noise, random filtering, quantization, or any other type of nonadditive distortion.

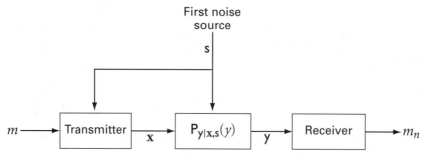

Fig. B.1 General class of channels studied by Gel'fand and Pinsker. Costa's dirty-paper channel (Figure 5.12) is a special case of this class.

B.1.2 Capacity of Channels with Side Information

Gel'fand and Pinsker showed that the capacity of channels in this class is given by

$$C = \max_{P_{sux}}(I(u;y) - I(u;s)), \tag{B.1}$$

where the maximum is taken over a range of probability distributions, described in the following. Note that this formula bears some similarity to the formula for the capacity of arbitrary channels without side information (Equation A.7).

To understand Equation B.1, it is first necessary to understand the probability distributions, P_{sux}, and how they relate to codes like those described in Chapter 5. The three random variables here are

- s = the value of the side information known to the transmitter. In the dirty-paper channel, s is the value of the first noise source. This is independent of the method of coding.
- u = an *auxiliary variable,* which in the case of the codes described previously can be thought of as an element of a code word, u, chosen from a set \mathcal{U}. This depends on the distribution of messages (which we will assume to be uniform) and the effect of s on the coding method. For example, in the coding methods of Figures 5.14, 5.15, and 5.16, the message specifies a subset of \mathcal{U}, which we denote \mathcal{U}_m. The code word, u, is then the member of \mathcal{U}_m that is closest to s. Because the message is random, u might take on a number of different values for a given value of s.
- x = an element of the transmitted signal. This is generally a function of s and u. In the case of the codes shown in Figures 5.14 and 5.15, $x = u - s$. In the code of Figure 5.16, $x = \alpha(u - s)$. We can generalize this to an arbitrary function, $x = f(u, s)$. In all codes discussed in Chapter 5, $f()$ is deterministic. However, in principle, $f()$ could be a random function, so that for any given value of u and s, x could take on a number of different values.

P_{sux} is the joint probability distribution of these three variables. That is, $P_{sux}(s, u, x)$ is the probability that $s = s$ and $u = u$ and $x = x$. Note that this joint probability distribution is determined entirely by the distribution of s, the distribution of messages, and the method of coding. However, the distribution of s is given as part of the channel description, and we can assume the distribution of messages is uniform. Thus, in Equation B.1, taking the maximum over possible probability distributions P_{sux} is equivalent to taking the maximum over possible coding systems.

The value inside the maximum in Equation B.1 involves an additional random variable, y. This is the value received by the receiver. It is determined by the values of x and s, and the conditional probability distribution that describes the channel, $P_{y|x=x,s=s}$. Thus, P_{sux} can be expanded into a larger joint probability distribution, P_{suxy}, where

$$P_{suxy}(s, u, x, y) = P_{sux}(s, u, x) P_{y|x=x,s=s}(y). \qquad . \tag{B.2}$$

From this four-dimensional joint probability distribution it is then possible to calculate P_u, $P_{u|y=y}$, and $P_{u|s=s}$, which are sufficient to compute $I(u;y) - I(u;s)$.

But what does $I(u;y) - I(u;s)$ mean? $I(u;y)$ is the amount of information we obtain about u when we receive y. $I(u;s)$ is the amount of information about u determined by s. If we learn more about y than is determined by s, then, by designing an appropriate code, we can use this extra information to identify a message.

For a different interpretation, begin by considering coding systems such as those of Chapter 4, which simply assign a specific value of u to each possible message. In these systems, $I(u;s) = 0$, and the capacity is given by

$$
\begin{aligned}
C &= \max_{P_{sux}}(I(u;y) - I(u;s)) \\
&= \max_{P_u} I(u;y),
\end{aligned}
\tag{B.3}
$$

which is equivalent to Equation A.7. Thus, we can think of the first part of the expression, $I(u;y)$, as describing the code rate obtainable if we ignore s. In other words, if we are transmitting length L code words, the number of code words we may reliably use is bounded by

$$|\mathcal{U}| < 2^{L I(u;y)}. \tag{B.4}$$

The second part of the expression, $I(u;s)$, describes the amount of capacity lost if we base our selection of u on s. If we think in terms of a dirty-paper code as described in Chapter 5, where \mathcal{U} is divided into subsets of equal size,

$\mathcal{U}_A, \mathcal{U}_B, \ldots$, to represent different messages, we find that

$$|\mathcal{M}| < 2^{L(I(u;y)-I(u;s))}$$
$$= \frac{2^{LI(u;y)}}{2^{LI(u;s)}}$$
$$= \frac{|\mathcal{U}|}{|\mathcal{U}_m|}. \tag{B.5}$$

Thus, we can think of $I(u; s)$ as \log_2 of the number of code words devoted to each subset, \mathcal{U}_m.

B.2 Capacity of the AWGN Dirty-Paper Channel (Costa)

We now briefly describe the method Costa used to find the capacity of his dirty-paper channel, described in Chapter 5. Costa finds the capacity of dirty-paper channels by defining a class of random codes and showing that the maximum value of $I(u; y) - I(u; s)$ obtained by any code in this class is equal to the capacity of the channel without the first noise source. Clearly the capacity cannot be higher than this, and therefore this is the capacity of the channel.

Costa's codes are generated using the specifications of the channel (the power constraint, p, the variance of the first noise source, σ_s^2, and the variance of the second noise source, σ_n^2) along with a parameter, α. This parameter is used in the function for choosing \mathbf{x} once a value has been chosen for \mathbf{u}:

$$\mathbf{x} = f(\mathbf{u}, \mathbf{s}) = \mathbf{u} - \alpha \mathbf{s}. \tag{B.6}$$

Note that this equation is equivalent to that used for the code in Figure 5.16, namely, $\alpha(\mathbf{u} - \mathbf{s})$, if we scale all \mathbf{u}'s by α^{-1}.

In Costa's code, the set of code words, \mathcal{U}, is drawn randomly from an i.i.d. Gaussian distribution with variance σ_u^2. Because the variance of \mathbf{x} is limited to p/L, and σ_s is given by the channel, σ_u^2 must be at most

$$\sigma_u^2 = p + \alpha^2 \sigma_s^2. \tag{B.7}$$

The code words are then divided randomly into $|\mathcal{M}|$ disjoint subsets, \mathcal{U}_A, \mathcal{U}_B, \ldots, each representing one message. The size of the set of code words, $|\mathcal{U}|$, is $L I(u; y)$, where u is any element of \mathbf{u} (i.e. $u = u[t]$) and y is the corresponding element of the received signal, \mathbf{y} (i.e. $y = y[t]$). The size of each subset $|\mathcal{U}_m|$, is $L I(u; s)$ where s is any element of \mathbf{s} (i.e. $s = s[t]$).

To compute the sizes of $|\mathcal{U}|$ and $|\mathcal{U}_m|$, we need to find the joint probability distribution for P_{sux}, and this entails specifying how the transmitter chooses u based on s. In the dirty-paper codes of Chapter 5, the transmitter searches through all the code words in one of the subsets, \mathcal{U}_m, and chooses the one closest

to s as u. Unfortunately, the statistical behavior of this method is difficult to analyze. Instead, Costa defines his system to search for a code word that is *jointly typical* with s. The notion of joint typicality is a standard tool in analysis of this type. However, the details of this idea are outside the scope of this book. For our purposes, it is sufficient to note that as the length of the code words, L, tends toward infinity, the behavior of a search for jointly typical code words tends to be the same as that of a search for closest code words.

Applying known theorems for mutual information between Gaussian variables, and for the behavior of joint typicality, Costa shows that

$$I(u;y) = \frac{1}{2}\log_2\left(\frac{(p+\sigma_s^2+\sigma_n^2)(p+\alpha^2\sigma_s^2)}{p\sigma_n^2+\sigma_n^2\sigma_s^2\alpha^2+p\sigma_s(1-\alpha^2)}\right) \tag{B.8}$$

and

$$I(u;s) = \frac{1}{2}\log_2\left(\frac{p+\sigma_s^2\alpha^2}{p}\right). \tag{B.9}$$

These equations yield the number of code words and size of each subset, thereby completing the specification of the code. They also, of course, allow us to calculate the best possible code rate for a given value of α as

$$\begin{aligned}R(\alpha) &= I(u;y) - I(u;s)\\ &= \frac{1}{2}\log_2\left(\frac{p(p+\sigma_n^2+\sigma_s^2)}{p\sigma_n^2+\sigma_n^2\sigma_s^2\alpha^2+p\sigma_s(1-\alpha^2)}\right).\end{aligned} \tag{B.10}$$

The maximum value of $R(\alpha)$ is obtained when

$$\alpha = \frac{p}{p+\sigma_n^2}. \tag{B.11}$$

Substituting this value of α into Equation B.10 and simplifying, we find that

$$R(\alpha) = \frac{1}{2}\log_2\left(1+\frac{p}{\sigma_n^2}\right), \tag{B.12}$$

which is exactly the capacity of an AWGN channel with noise of variance σ_n^2. Thus, the first noise source—the dirty paper—has no effect on the capacity of the channel.

B.3 Information-Theoretic Analysis of Secure Watermarking (Moulin and O'Sullivan)

In [201], O'Sullivan et al. suggest that watermarking can be viewed as a game played between an information hider and an adversary. The information hider embeds watermarks in content, and the adversary attempts to remove them. The

resulting system can be studied using a combination of information theory and game theory.

The study of watermarking as a game was extended by Moulin and O'Sullivan in [190, 191]. In this section of the appendix, we briefly summarize two main results of their analysis and provide some insight as to what these results mean. Those interested in the actual proofs are referred to [190].

B.3.1 Watermarking as a Game

The formal description of the watermarking game studied by Moulin and O'Sullivan is based on formal definitions of a *distortion function*, a *watermarking code*, and an *attack channel*. These are defined as follows:

- A *distortion function* is a real-valued function, $D(c_1, c_2)$, where c_1 is a Work and c_2 is a distorted version of c_1. This function is meant to be monotonic with the perceptual difference between the two Works. For their most general results, Moulin and O'Sullivan assume only that $D(c_1, c_2)$ is a classical extension of a distortion function applied to the individual elements of c_1 and c_2; that is,

$$D(c_1, c_2) = \frac{1}{N} \sum_i^N d(c_1[i], c_2[i]). \tag{B.13}$$

For example, if $d(a, b) = (a-b)^2$, then $D(c_1, c_2)$ is the mean squared error between c_1 and c_2.

Of course, realistic perceptual distance models, as discussed in Chapter 7, seldom fit into the pattern of Equation B.13. In particular, masking effects mean that the perceptual difference between one pair of terms can be affected by the values of other terms, and therefore the distance function might not be separable into successive applications of a one-dimensional function, $d()$. However, many models can be implemented by first applying some nonlinear transform to the two Works, and then computing an L_p norm between them (see, for example, [13, 287]). Masking effects are embodied in the nonlinear transform, and thus the perceptual distance can be computed simply as

$$L_p(C_1, C_2) = \left(\sum_i^N |C_2[i] - C_1[i]|^p \right)^{1/p}, \tag{B.14}$$

where C_1 and C_2 are the transformed versions of c_1 and c_2, and p is a constant. If we let $d(a, b) = |b - a|^p$, then $D(C_1, C_2) = (1/N) \sum |C_2[i] - C_1[i]|^p$ is monotonic with $L_p(C_1, C_2)$. Thus, assuming that true perceptual distance can be captured by an L_p norm applied to a nonlinear transform of two Works, we can assume a meaningful distortion function exists in the form of Equation B.13.

■ A *length-N information-hiding code subject to distortion* D_1 comprises three parts:

— A set of messages, \mathcal{M}

— A watermark embedding function, $\mathcal{E}_K(\mathbf{c_o}, m)$, where $\mathbf{c_o}$ is an unwatermarked Work of dimensionality N, $m \in \mathcal{M}$ is a message, and K is a watermarking key

— A watermark detection function, $\mathcal{D}_K(\mathbf{c})$, where \mathbf{c} is a (possibly watermarked) Work and K is a key

The watermark embedding function is constrained to yield an expected distortion less than or equal to D_1. That is,

$$\sum_{\mathbf{c_o}, K, m} \frac{1}{|\mathcal{M}|} P_{\mathbf{c_o}, K}(\mathbf{c_o}, K) D(\mathbf{c_o}, \mathcal{E}_K(\mathbf{c_o}, m)) \leq D_1, \tag{B.15}$$

where the summation is performed over all possible combinations of cover Work $\mathbf{c_o}$, key K, and message m. The expression $P_{\mathbf{c_o}, K}(\mathbf{c_o}, K)$ is the probability of $\mathbf{c_o}$ being drawn from the distribution of unwatermarked content and K being used as a key for that Work. This is expressed as a joint probability distribution to handle the case where the key is dependent on the cover Work.

■ An *attack channel subject to distortion* D_2 is a conditional probability function, $Q_2(\mathbf{c_n}|\mathbf{c}) = P_{\mathbf{c_n}|\mathbf{c}}(\mathbf{c_n})$, which gives the probability of obtaining the Work $\mathbf{c_n}$ after applying a specific attack to \mathbf{c}. The probability function is constrained to yield an expected distortion less than or equal to D_2, when applied to watermarked content. That is,

$$\sum_{\mathbf{c_n}, \mathbf{c_w}} P_{\mathbf{c_w}}(\mathbf{c_w}) Q_2(\mathbf{c_n}|\mathbf{c_w}) D(\mathbf{c_w}, \mathbf{c_n}) \leq D_2. \tag{B.16}$$

Here, $P_{\mathbf{c_w}}(\mathbf{c_w})$ is the probability of obtaining $\mathbf{c_w}$ by embedding a random message in a randomly selected cover Work; that is, the *embedding distribution* (see Chapter 3).

If the distortion function is symmetric, so that $D(\mathbf{c_1}, \mathbf{c_2}) = D(\mathbf{c_2}, \mathbf{c_1})$, then we should assume that $D_2 \geq D_1$, because the adversary should always be satisfied with the original unwatermarked Work as the result of an attack (so D_2 must be at least equal to D_1). In general, D_2 will be greater than D_1 because the adversary will be satisfied with low fidelity.

In an *information-hiding game subject to distortions* (D_1, D_2), the information hider designs an information-hiding code subject to distortion D_1, and the adversary designs an attack channel subject to distortion D_2. The information hider is trying to maximize the information communicated across the attack channel, and the adversary is trying to minimize it. A given rate, R, is achievable for distortions (D_1, D_2) if it is possible to design information-hiding codes with

rates of at least R, such that the probability of error after the worst-case attack diminishes to 0 as N increases toward infinity (see Section A.1.3 of Appendix A). The data-hiding capacity, $C(D_1, D_2)$, is the supremum of all rates achievable for distortions (D_1, D_2).

B.3.2 General Capacity of Watermarking

Moulin and O'Sullivan's main result is a general expression for data-hiding capacity, $C(D_1, D_2)$. As in Gel'fand and Pinsker's expression for the capacity of communications with side information (see Section B.1), this expression involves the use of an auxiliary variable, u.

The watermark-embedding algorithm can be divided into two steps. First, a value of u is selected based on the desired message, m; the cover Work, c_o; and a key, K. Assuming messages are uniformly distributed, this gives rise to a conditional distribution of u based on the distribution of unwatermarked content and keys, $P_{u|c_o, K}(\mathbf{u})$. Second, the value of u = \mathbf{u} is combined with the unwatermarked Work, c_o, with reference to the key, K, to obtain the watermarked Work, c_w. This gives rise to a distribution of watermarked Works from a given cover Work and key:

$$Q_1(c_w, \mathbf{u}|c_o, K) = P_{c_w|c_o, \mathbf{u}, K}(c_w) P_{u|c_o, K}(\mathbf{u}). \tag{B.17}$$

In general, it is possible to design an embedding algorithm that leads to any desired distribution for $Q_1()$, provided that distribution satisfies the embedding distortion constraint

$$\sum_{c_w, c_o, \mathbf{u}, K} D(c_w, c_o) Q_1(c_w, \mathbf{u}|c_o, K) P_{c_o, K}(c_o, K) \leq D_1. \tag{B.18}$$

The capacity of a data-hiding game subject to distortions (D_1, D_2) is given by

$$C(D_1, D_2) = \max_{Q_1} \min_{Q_2} I(u; c_n|K) - I(u; c_w|K), \tag{B.19}$$

where u, c_n, and c_w are corresponding elements of \mathbf{u}, $\mathbf{c_n}$, and $\mathbf{c_w}$. The maximum is taken over all embedding distributions that satisfy the D_1 distortion constraint, and the minimum is taken over all attack channels that satisfy the D_2 distortion constraint. $I(u; c|K)$ is the mutual information between u and c, computed with their probability distributions conditioned on K.

Equation B.19 can be understood intuitively by recognizing that the value inside the max-min, $I(u; c_n|K) - I(u; c_w|K)$, is essentially the same as the value maximized in Gel'fand and Pinsker's expression (Equation B.1). Thus, if we were to limit the possible attack distributions, Q_2, to one, specific distribution, we would obtain the capacity of communications with side information at the transmitter.

Of course, the adversary is not limited to only one attack and will choose the one that minimizes the amount of information that gets through. Therefore, the

amount of information that can be transmitted with a given Q_1 distribution is the minimum over all possible attacks. The best Q_1 (from the point of view of the data hider) is the one that maximizes this minimum. Thus, the data-hiding capacity is maximized over possible Q_1s, and minimized over possible Q_2s.

The value of Equation B.19 depends on D_1, D_2, and the distortion function, $D()$. It may or may not also depend on the distribution of unwatermarked content. One can argue that for a given type of content there is a single distortion function that best reflects human perception, and a single distribution of unwatermarked Works. Thus, in principle, the data-hiding capacity is determined by D_1, D_2, and the type of cover content. However, for images, video, and audio, the best distortion function and true distribution are as yet unknown, and therefore Equation B.19 can only be used to obtain estimates of capacity under some simplifying assumptions.

B.3.3 Capacity with MSE Fidelity Constraint

Moulin and O'Sullivan explore the hiding capacity that results under two assumptions,

- $D()$ is mean squared error (MSE), that is,

$$D(\mathbf{c}_1, \mathbf{c}_2) = \frac{1}{N} \sum_{i}^{N} (\mathbf{c}_2[i] - \mathbf{c}_1[i])^2, \tag{B.20}$$

and
- the cover Work, \mathbf{c}_o, is drawn from an i.i.d. Gaussian distribution with variance $\sigma_{\mathbf{c}_o}^2$.

Of course, these assumptions are known to be unrealistic for the types of media with which we have been concerned. MSE correlates poorly with perceptual distance (see Chapter 7), and the distribution of unwatermarked content is correlated and non-Gaussian (see Chapter 3). However, the results obtained under these assumptions may indicate some qualitative behaviors of capacity under a more realistic distortion function. These qualitative behaviors are as follows:

- The value of $\sigma_{\mathbf{c}_o}^2$ affects capacity only by affecting the severity of the attacks the adversary may perform.
- If $D_1, D_2 \ll \sigma_{\mathbf{c}_o}^2$, the value of $\sigma_{\mathbf{c}_o}^2$ has little effect on capacity and can be ignored.
- Furthermore, if $D_1, D_2 \ll \sigma_{\mathbf{c}_o}^2$, the assumption of Gaussian-distributed content can be relaxed. That is, non-Gaussian distributions should behave in essentially the same way.

Under the assumptions previously listed, Moulin and O'Sullivan show that

$$C(D_1, D_2) = \begin{cases} 0 & \text{if } D_2 \geq \sigma_{c_o}^2 + D_1 \\ \frac{1}{2} \log\left(1 + \frac{D_1}{\beta D_2}\right) & \text{otherwise} \end{cases},$$

(B.21)

where

$$\beta = \left(1 - \frac{D_2}{\sigma_{c_o}^2 + D_1}\right)^{-1}.$$

(B.22)

Intuitively, Equation B.21 results from three assertions.

First, if we look at the vector added by an optimal embedding algorithm, $\mathbf{w_a} = \mathbf{c_w} - \mathbf{c_o}$ (where $\mathbf{c_w}$ is the watermarked Work and $\mathbf{c_o}$ is the original), we will find that it has expected magnitude $|\mathbf{w_a}| \approx \sqrt{ND_1}$, and expected correlation with the original $\mathbf{c_o} \cdot \mathbf{w_a} \approx 0$. That it should have expected magnitude $\sqrt{ND_1}$ is ensured because the expected mean squared error between $\mathbf{c_o}$ and $\mathbf{c_w}$ is constrained to D_1. That it should be orthogonal to $\mathbf{c_o}$ is intuitive, because, in high dimension, most vectors are orthogonal to a given vector. A coding system that led to non-orthogonal added vectors would severely limit its use of the space, and thereby limit its capacity. Because the expected magnitude of the original Work is $|\mathbf{c_o}| \approx \sqrt{N}\sigma_{c_o}$, we can conclude that the expected magnitude of the watermarked Work will be $|\mathbf{c_w}| \approx \sqrt{N(\sigma_{c_o}^2 + D_1)}$.

Second, if $D_2 \geq \sigma_{c_o}^2 + D_1$, the adversary can simply zero out the watermarked Work to remove the watermark. That is, the attacked Work, $\mathbf{c_n}$, is just $\mathbf{c_n}[i] = 0$ for all i, regardless of the watermarked Work. The mean squared error will be

$$D(\mathbf{c_w}, \mathbf{c_n}) = \frac{1}{N}|\mathbf{c_w}|^2 = \sigma_{c_o}^2 + D_1 \leq D_2.$$

(B.23)

Obviously, after such an attack, no information is retained, and the capacity is 0.

Finally, if $D_2 < \sigma_{c_o}^2 + D_1$, the optimal attack will be the *Gaussian test channel*. A geometric interpretation of this attack is shown in Figure B.2. The first step of the attack is to add Gaussian white noise with power βD_2. The noise vector added is likely to be orthogonal to the watermarked Work, as shown in the figure. The second step is to scale the resulting vector by β^{-1}. With the β given in Equation B.22, and assuming that $|\mathbf{c_w}| = \sqrt{N(\sigma_{c_o}^2 + D_1)}$, this yields a point on the edge of the region of acceptable fidelity defined by D_2 (shown as a circle in the figure). The resulting channel is equivalent to an AWGN dirty-paper channel with the first noise source having power $\sigma_{c_o}^2$ and the second noise source having power βD_2. Thus, regardless of whether the detector is blind or informed, the capacity is $\frac{1}{2}\log(1 + D_1/\beta D_2)$.

Note that unlike the case of Costa's capacity for dirty-paper channels the distribution of unwatermarked content affects capacity in a data-hiding game,

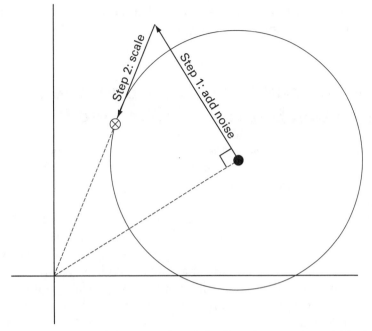

Fig. B.2 Geometric interpretation of the Gaussian test channel. The black dot represents a watermarked Work. The two steps of the attack are shown with solid arrows. The ⊗ represents the result of the attack. Note that the resulting Work lies on the edge of the region of acceptable fidelity, shown with a circle. Note also that this attack maximizes the angle between the attacked Work and the original Work, thereby minimizing the signal-to-noise ratio.

in that β depends on $\sigma_{c_o}^2$. This leads to the first qualitative point with which we began this discussion of capacity under an MSE distortion function.

The reason that $\sigma_{c_o}^2$ affects capacity is that it affects the severity of attack the adversary may perform. In the case of an MSE distortion function, a smaller value of $\sigma_{c_o}^2$ allows the adversary to perform a more severe attack, adding more noise in the first step and scaling down by a larger amount in the second step to stay within the region of acceptable fidelity. In the case of more realistic distortion functions that account for masking effects, it may be that *larger* values of $\sigma_{c_o}^2$ allow for more severe attacks, because they imply more noise in each Work and thus greater ability to hide distortions. In either case, the qualitative point that $\sigma_{c_o}^2$ affects capacity still holds.

The second qualitative point, that $\sigma_{c_o}^2$ has little effect on capacity if D_1, $D_2 \ll \sigma_{c_o}^2$, follows from Equation B.22. As $D_2/\sigma_{c_o}^2$ tends toward 0, β tends toward 1, and the capacity tends toward $\frac{1}{2}\log(1 + D_1/D_2)$. Because both watermarks and attacks are meant to be imperceptible, it is generally safe to assume that D_1 and D_2 are small relative to $\sigma_{c_o}^2$, so that $\sigma_{c_o}^2$ can be ignored. Moulin and O'Sullivan

go on to prove the third qualitative point: that the shape of the distribution of unwatermarked content can also be ignored when D_1, $D_2 \ll \sigma_{c_o}^2$.

B.4 Error Probabilities Using Normalized Correlation Detectors (Miller and Bloom)

We here describe a precise method of estimating the false positive probability when using a normalized correlation detector. We also extend this to estimate the effectiveness of blind embedding when using normalized correlation at the detector.

We refer to this method, described in [183], as the *spherical method*. It gives an exact value for the false positive probability, under the assumption that the random vectors are drawn from a radially symmetric distribution. We derive the spherical method for the case of a random watermark, \mathbf{w}_r, and a constant Work, \mathbf{c}. We assume that the distribution of \mathbf{w}_r is radically symmetric. That is, we assume that the probability of obtaining a given random vector, \mathbf{w}_r, depends only on the length of \mathbf{w}_r, and that it is independent of the direction of \mathbf{w}_r. A white Gaussian distribution satisfies this assumption.

The derivation of the spherical method begins by observing that if we normalize each randomly drawn vector to unit length before computing normalized correlation we will not change the probability of detection. Thus, we have

$$\mathbf{w}_r' = \frac{\mathbf{w}_r}{|\mathbf{w}_r|} \tag{B.24}$$

$$z_{nc}(\mathbf{c}, \mathbf{w}_r') = \frac{\mathbf{c} \cdot \mathbf{w}_r'}{|\mathbf{c}||\mathbf{w}_r'|} = \frac{\mathbf{c} \cdot \mathbf{w}_r}{|\mathbf{c}||\mathbf{w}_r|} = z_{nc}(\mathbf{c}, \mathbf{w}_r), \tag{B.25}$$

where \mathbf{c} is the constant vector against which the random vectors are being compared.

The distribution of \mathbf{w}_r' is limited to the surface of the unit N-sphere. That is, we never obtain a vector \mathbf{w}_r' that is not on this surface. The probability of obtaining a given \mathbf{w}_r' is clearly independent of its direction, because the distribution of \mathbf{w}_r is assumed to be radially symmetric. This means that \mathbf{w}_r' is drawn from a distribution uniformly distributed over the surface of the unit N-sphere.

The probability that a randomly chosen \mathbf{w}_r' will lie in the detection region for \mathbf{c} can be found by simply finding the fraction of the surface of the unit N-sphere that lies within the detection region. Because the detection region is an N-dimensional cone, we need to determine the fraction of the surface of the sphere that is intersected by the cone. The intersection of an N-cone and an N-sphere is an N-spherical cap, and we need to find the ratio between the

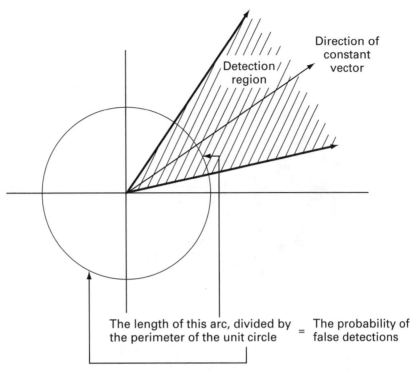

Fig. B.3 Computing the false positive probability when using normalized correlation in a two-dimensional marking space.

$(N-1)$-content[1] of a given N-spherical cap and the $(N-1)$-surface content of the N-sphere. This point is illustrated for $N = 2$ in Figure B.3 and for $N = 3$ in Figure B.4.

Let $\text{cap}(N, \theta)$ be the $(N-1)$-content of the N-spherical cap obtained by intersecting the unit N-sphere with an N-cone that subtends angle θ (in radians). We then have

$$P_{\text{fp}} = \frac{\text{cap}(N, \tau_\theta)}{2\text{cap}(N, \pi/2)}. \tag{B.26}$$

Note that $2\text{cap}(N, \pi/2)$ is the complete $(N-1)$-surface content of the unit N-sphere. The cap() function, found in [249], is

$$\text{cap}(N, \theta) = S_{N-1} I_{N-2}(\theta), \tag{B.27}$$

1. *Content* is a generalization of the terms *length, area,* and *volume.* The 1-content of a one-dimensional region (i.e., a line) is the length of that region. The 2-content of a two-dimensional region is the area of that region. The 3-content of a three-dimensional region is the volume of that region. In higher dimensions, content has the analogous meanings.

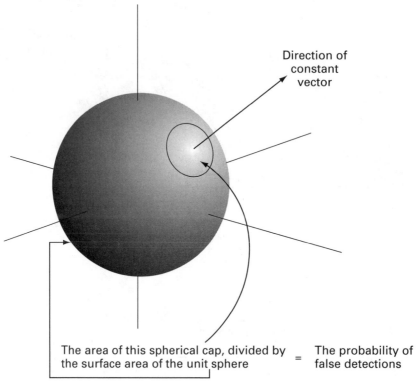

Direction of constant vector

The area of this spherical cap, divided by the surface area of the unit sphere = The probability of false detections

Fig. B.4 Computing the false positive probability when using normalized correlation in a three-dimensional marking space.

where θ is half the angle subtended by the N-cone, and where, for any d,

$$S_d = \frac{d\pi^{\lfloor d/2 \rfloor}}{\lfloor d/2 \rfloor!} \tag{B.28}$$

and

$$I_d(\theta) = \int_0^\theta \sin^d(u)\,du. \tag{B.29}$$

Thus, if a random N-dimensional vector is drawn from a radially symmetric distribution, the probability that its normalized correlation with some constant vector will be over a given threshold, τ_{nc}, is given exactly by

$$P_{fp} = \frac{I_{N-2}(\cos^{-1}(\tau_{nc}))}{2\,I_{N-2}(\pi/2)} = \frac{\int_0^{\cos^{-1}(\tau_{nc})} \sin^{N-2}(u)\,du}{2 \int_0^{\pi/2} \sin^{N-2}(u)\,du}. \tag{B.30}$$

Evaluating Equation B.30 requires calculation of the integral $I_d(\theta)$, with $d = N - 2$. This integral has a closed-form solution for all integer values of d.

Table B.1 Closed-form solutions for $I_d(\theta)$.

d	$I_d(\theta)$
0	θ
1	$1 - \cos(\theta)$
2	$\dfrac{\theta - \sin(\theta)\cos(\theta)}{2}$
3	$\dfrac{\cos^3(\theta) - 3\cos(\theta) + 2}{3}$
4	$\dfrac{3\theta - (3\sin(\theta) + 2\sin^3(\theta))\cos(\theta)}{8}$
5	$\dfrac{4\cos^3(\theta) - (3\sin^4(\theta) + 12)\cos(\theta) + 8}{15}$
>5	$\dfrac{d-1}{d} I_{d-2}(\theta) - \dfrac{\cos(\theta)\sin^{d-1}(\theta)}{d}$

Table B.1 provides the solutions for $d = 1$ through 5. When $d > 5$, the solution can be found by the recursive formula shown on the last row of the table.

The spherical method can also be used to estimate the effectiveness of a blind embedding system for which detection is performed using normalized correlation. To illustrate this, we consider the case of a fixed Work and random watermarks.

Figure B.5 illustrates the process geometrically. We are given a fixed vector, $\mathbf{v_o}$, which is extracted from an unwatermarked Work. To test for effectiveness, we generate a series of random watermark vectors from a radially symmetric distribution, one of which is depicted in Figure B.5, aligned with the horizontal axis. The angle, ϕ, between these two vectors is therefore a random value.

Given the Work vector, $\mathbf{v_o}$, and a random watermark vector, $\mathbf{w_r}$, the blind embedder adds $\alpha \mathbf{w_r}$ to the Work vector to produce a watermarked vector, $\mathbf{v_w}$. The Work is said to be watermarked if this vector falls inside the detection region defined by θ. Clearly, when $\mathbf{v_w}$ lies on the surface,

$$\phi = \tau_\phi = \theta + \phi_o = \theta + \sin^{-1}\left(\frac{\alpha}{|v_o|}\sin\theta\right), \tag{B.31}$$

where τ_ϕ is the critical angle. Thus, provided the angle subtended by a Work vector and a random watermark vector (i.e., ϕ) is less than or equal to τ_ϕ, watermark embedding will be successful. If the watermarks are drawn from a radially symmetric distribution, as we have assumed, then the probability that $\phi \leq \tau_\phi$ (i.e., the probability of successful embedding, or probability of a *true* positive) can be calculated in the same manner as the false positive probability using the spherical method. The effectiveness (i.e., true positive probability), P_{tp}, is the fraction of the

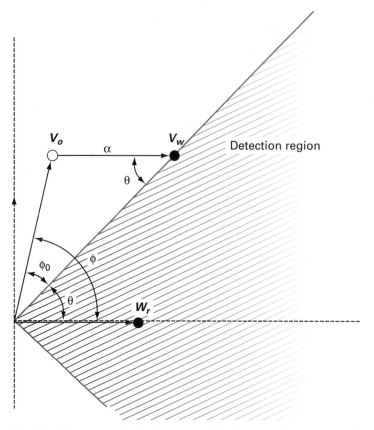

Fig. B.5 Calculation of effectiveness of blind embedding for normalized correlation detection.

surface of an N-sphere that lies within the detection region. That is, it is the fraction of the surface of the N-sphere that lies within the detection region, given by

$$P_{tp} = \frac{\int_0^{\tau_\phi} \sin^{N-2}(u)\, du}{2 \int_0^{\pi/2} \sin^{N-2}(u)\, du}.$$

(B.32)

If the probability of a false negative, P_{fn}, is required rather than the effectiveness, it is simply $P_{fn} = 1 - P_{tp}$.

B.5 Effect of Quantization Noise on Watermarks (Eggers and Girod)

Quantization noise is often considered to be independent of the signal. When the quantization step size is small, this approximation is valid. However, as the

quantization step size increases, this assumption breaks down. In the following analysis, we model a blind watermark detector as equivalent to non-subtractive dither quantization. This analysis results in a model for the correlation between the quantization noise and the watermark.

Assume the embedder simply adds a reference mark, so $\mathbf{c_w} = \mathbf{c_o} + \mathbf{w_r}$, and let $\mathbf{c_{wq}}$ denote the output from the watermarking and quantization process. The quantization error, \mathbf{n}, is defined as

$$\mathbf{n} = \mathbf{c_{wq}} - \mathbf{c_w} = \mathbf{c_{wq}} - \mathbf{c_o} - \mathbf{w_r}. \tag{B.33}$$

The output from the correlator, $z_{lc}(\mathbf{c_{wq}}, \mathbf{w_r})$, is given by

$$\begin{aligned} z_{lc}(\mathbf{c_{wq}}, \mathbf{w_r}) &= \mathbf{c_{wq}} \cdot \mathbf{w_r} \\ &= (\mathbf{c_o} + \mathbf{w_a} + \mathbf{n}) \cdot \mathbf{w_r} \\ &= \mathbf{c_o} \cdot \mathbf{w_r} + \mathbf{w_a} \cdot \mathbf{w_r} + \mathbf{n} \cdot \mathbf{w_r}. \end{aligned} \tag{B.34}$$

Assuming that $\mathbf{c_o} \cdot \mathbf{w_r} = 0$, this gives us

$$z_{lc}(\mathbf{c_{wq}}, \mathbf{w_r}) = w_a w_r + \mathbf{n} \cdot \mathbf{w_r}, \tag{B.35}$$

where N is the dimensionality of marking space and σ_{w_r} is the standard deviation of $\mathbf{w_r}$. Ideally, the quantization error, \mathbf{n}, would be independent of the watermark, and Equation B.35 would simply equal $N\sigma_{w_r}^2$. However, if the quantization error is negatively correlated with the watermark, the correlator output will be reduced.

The independence assumption is often reasonable for small quantization factors. However, for large quantization factors, the quantization error does indeed become negatively correlated with the watermark. In fact, when the quantization factor is large enough, the quantization output will always be zero, and the error, given by Equation B.33, will be $\mathbf{n} = -\mathbf{c_o} - \mathbf{w_r}$. Thus, $\mathbf{n} \cdot \mathbf{w_r}$ will equal $-N\sigma_{w_r}^2$, and the correlator output will be zero.

Our objective, then, is to find the expected correlation between the quantization noise and the reference mark. We consider both the Work and the watermark as being chosen at random. The quantization factor for each term, on the other hand, is prespecified. The correlation between the error vector, \mathbf{n}, and the reference mark, $\mathbf{w_r}$, is the sum of random values, $\mathbf{n}[1]\mathbf{w_r}[1] + \mathbf{n}[2]\mathbf{w_r}[2] + \cdots + \mathbf{n}[N]\mathbf{w_r}[N]$. The expected value of these random values' sum is just the sum of their respective expected values; that is,

$$E(\mathbf{n} \cdot \mathbf{w_r}) = \sum_i E(\mathbf{n}[i]\mathbf{w_r}[i]). \tag{B.36}$$

Thus, we can meet our objective by finding the expected value of the product of two random scalar values, $E(nw)$, where w is drawn from some distribution with a density function of $P_w(w)$ and n is computed as

$$n = c_{wq} - c - w \tag{B.37}$$

where c, a scalar value for the term of the cover Work that corresponds with w, is drawn from a distribution with density function $P_c(c)$, and where c_{wq} is the corresponding term of the watermarked and quantized Work, given by

$$c_{wq} = q \lfloor (w + c)/q \rfloor, \tag{B.38}$$

where q is given.

B.5.1 Background

Before we continue, we briefly review some facts about statistics [204]. Given a random variable, x, the *characteristic function, $C_x(u)$*, of its probability density function, $P_x(x)$, is defined as

$$C_x(u) = \int_{-\infty}^{\infty} P_x(x) e^{Jux} \, dx. \tag{B.39}$$

Thus, $C_x(-2\pi u)$ is the Fourier transform of the probability density function, $P_x(x)$. The *moment-generating function, $M_x(s)$*, of $P_x(x)$ is defined as

$$M_x(s) = \int_{-\infty}^{\infty} P_x(x) e^{sx} \, dx. \tag{B.40}$$

Thus,

$$M_x(Ju) = C_x(u). \tag{B.41}$$

The importance of the moment-generating function derives from the property that the moments of a random variable can be determined from the derivatives of its moment-generating function

$$E(x^k) = J^{-k} \frac{d^k}{du^k} M_x(Ju) \bigg|_{u=0}. \tag{B.42}$$

B.5.2 Basic Approach

The expected value of nw can be found by determining the moment-generating function for n, given $P_w(w)$, $P_c(c)$, and q. We begin by finding the probability density function for n while assuming a constant value for w; that is, $P_{n|w=w}(n)$, where w is some constant. From this, we find the moment-generating function $M_{n|w=w}(s)$, which gives us the expected value of n for $w = w$. The derivation of $M_{n|w=w}(s)$ is due to Schuchman [241]. Finally, $E(nw)$ is found by integrating $P_w(w) w E(n|w = w)$ over all possible values of w.

B.5.3 Finding the Probability Density Function

To find $P_{n|w=w}(n)$, start by assuming that the watermarked and quantized value, c_{wq}, is equal to some given integer, b, times q. Because $c_{wq} = q \lfloor (w + c)/q \rfloor$, the assumption that $c_{wq} = bq$ holds whenever

$$-q/2 \le w + c - bq < q/2. \tag{B.43}$$

The quantization error, n, is

$$n = bq - w - c. \tag{B.44}$$

From Inequality B.43, and Equation B.44, it is clear that n must lie between $-q/2$ and $q/2$, regardless of the value of b. Because $w = w$ is a constant, c is the only random value in Equation B.44, and the probability that a given value of n arises is just the probability that $c = bq - w - n$. Thus,

$$P_{n|cwq=bq,w=w}(n) = P_c(bq - w - n), \quad -q/2 < n \leq q/2. \tag{B.45}$$

The total probability of a given error value, n, is then the sum of the probabilities of n occurring for each possible value of b; that is,

$$P_{n|w=w}(n) = \sum_{b=-\infty}^{\infty} P_{n|cwq=bq,w=w}(n)$$

$$= \sum_{b=-\infty}^{\infty} P_c(bq - w - n). \tag{B.46}$$

B.5.4 Finding the Moment-Generating Function

We will now derive the moment-generating function, $M_{n|w=w}(ju)$. The moment-generating function is defined as

$$M_{n|w=w}(ju) = \int_{-\infty}^{\infty} P_{n|w=w}(n)e^{jun} \, dn. \tag{B.47}$$

Substituting Equation B.46 into Equation B.47, and noting that $P_{n|w=w}(n) = 0$ when $|n| > q/2$, we obtain

$$M_{n|w=w}(ju) = \int_{-q/2}^{q/2} \sum_{b=-\infty}^{\infty} P_c(bq - w - n)e^{jun} \, dn. \tag{B.48}$$

Now we convert this into an expression equivalent to a Fourier transform, so that we can take advantage of the Fourier convolution theorem. To perform the conversion, we substitute $-2\pi u'$ for u, and multiply by the rect() function, which allows the integral to go from $-\infty$ to ∞. This results in

$$M_{n|w=w}(-j2\pi u') = \int_{-\infty}^{\infty} \text{rect}\left(\frac{n}{q}\right) \sum_{b=-\infty}^{\infty} P_c(bq - w - n)e^{-j2\pi u'n} \, dn$$

$$= \mathcal{F}_n\left\{ \text{rect}\left(\frac{n}{q}\right) \sum_{b=-\infty}^{\infty} P_c(bq - w - n) \right\}, \tag{B.49}$$

where

$$\text{rect}\left(\frac{n}{q}\right) = \begin{cases} 1 & \text{if } |n| < \frac{q}{2} \\ 0 & \text{otherwise} \end{cases} \tag{B.50}$$

and $\mathcal{F}_x\{f(x)\}$ denotes the Fourier transform of $f(x)$. Now, applying the Fourier convolution theorem [26], and noting that $\mathcal{F}_n\{\text{rect}(n/q)\} = q\,\text{sinc}(qu')$, we have

$$M_{n|w=w}(-j2\pi u') = q\,\text{sinc}(qu') * \mathcal{F}_n\left\{\sum_{b=-\infty}^{\infty} P_c(bq - w - n)\right\}$$

$$= q\,\text{sinc}(qu') * \sum_{b=-\infty}^{\infty} \mathcal{F}_n\{P_c(bq - w - n)\}. \tag{B.51}$$

Let's now look at the Fourier transform of $P_c(bq - w - n)$:

$$\mathcal{F}_n\{P_c(bq - w - n)\} = \int_{-\infty}^{\infty} P_c(bq - w - n)e^{-j2\pi u'n}\,dn. \tag{B.52}$$

This can be converted into a function of the moment-generating function for c (which we have if we are given the probability density function for c). We introduce the substitution, $v = bq - w - n$, so that $n = bq - w - v$ and $dn = -dv$. Equation B.52 becomes

$$\mathcal{F}_n\{P_c(bq - w - n)\} = -\int_{\infty}^{-\infty} P_c(v)e^{-j2\pi u'(bq-w-v)}\,dv$$

$$= e^{-j2\pi u'(bq-w)}\int_{-\infty}^{\infty} P_c(v)e^{j2\pi u'v}\,dv. \tag{B.53}$$

The remaining integral in Equation B.53 is the moment-generating function, $M_c(j2\pi u')$ of c.

Referring to Equation B.51, we now examine the summation of the Fourier transform. This can be rewritten as

$$\sum_{b=-\infty}^{\infty} \mathcal{F}_n\{P_c(bq - w - n)\} = \sum_{b=-\infty}^{\infty} e^{-j2\pi u'(bq-w)} M_c(j2\pi u')$$

$$= e^{j2\pi u'w} M_c(j2\pi u') \sum_{b=-\infty}^{\infty} e^{-j2\pi u'bq}. \tag{B.54}$$

Using the substitution

$$\sum_{b=-\infty}^{\infty} e^{-j2\pi u'bq} = \frac{1}{q}\sum_{b=-\infty}^{\infty} \delta\left(u - \frac{b}{q}\right), \tag{B.55}$$

Equation B.54 becomes

$$\sum_{b=-\infty}^{\infty} \mathcal{F}_n\{P_c(bq - w - n)\} = e^{j2\pi u'w} M_c(j2\pi u')\frac{1}{q}\sum_{b=-\infty}^{\infty} \delta\left(u - \frac{b}{q}\right). \tag{B.56}$$

Finally, we substitute Equation B.56 into B.51, replacing u' with $-u/2\pi$, and simplifying, we obtain

$$M_{n|w=w}(Ju) = \sum_{b=-\infty}^{\infty} M_c\left(J2\pi\frac{b}{q}\right)e^{-2\pi\left(\frac{b}{q}\right)w}\operatorname{sinc}\left(\frac{q}{2\pi}\left(u+2\pi\frac{b}{q}\right)\right). \qquad (B.57)$$

B.5.5 Determining the Expected Correlation for a Gaussian Watermark and Laplacian Content

Having derived a model for the moment-generating function of $P_{n|w=w}(n)$, we are now in a position to analyze the quantization error in more detail. Ideally, the error n should be independent of the watermark, w. Equation B.57 shows that in general this will not be true. For dithered quantization, a careful choice of the dither signal can be made. However, for watermarking we do not have control over the content and must therefore assume that the quantization noise is not independent of the watermark signal.

At this point, we can now outline the derivation of Eggers and Girod. Application of Equation B.42 to B.57 yields

$$E(n|w=w) = -J\sum_{\substack{b=-\infty \\ b\neq 0}}^{\infty} \frac{(-1)^b}{2\pi b/q}M_c\left(\frac{J2\pi b}{q}\right)e^{J\frac{2\pi b}{q}w}. \qquad (B.58)$$

We would like to determine $E(nw)$. By definition, we have

$$E(nw) = \int_{-\infty}^{\infty} P_w(w)\,w\,E(n|w=w)\,dw. \qquad (B.59)$$

Substituting Equation B.58 in B.59, we have

$$E(nw) = -J\sum_{\substack{b=-\infty \\ b\neq 0}}^{\infty} \frac{(-1)^b}{2\pi b/q}M_c\left(\frac{J2\pi b}{q}\right)\int_{-\infty}^{\infty} w\,P_w(w)e^{J\frac{2\pi b}{q}w}\,dw, \qquad (B.60)$$

which can be rewritten as

$$E(nw) = \sigma_w^2\sum_{b=1}^{\infty} \frac{(-1)^b}{\pi b\sigma_w/q}M_c(J2\pi b/q)\operatorname{Im}\left\{\frac{1}{\sigma_w}M_w^{(1)}(J2\pi b/q)\right\}, \qquad (B.61)$$

where $M_x^{(k)}(Ju)$ is defined as

$$M_x^{(k)}(Ju) = \int_{-\infty}^{\infty} x^k P_x(x)e^{Jux}\,dx \qquad (B.62)$$

and σ_w is the standard deviation of the watermark.

To apply Equation B.61, we need to know the probability density functions for the watermark and the content. The probability distribution for the watermark is

up to the designer of the watermarking system. For convenience, we will assume it is Gaussian.

As discussed in Chapter 3, the probability distribution for the content is difficult to model accurately. In Chapter 6, when deriving the whitening filter of System 11, we assumed an elliptical Gaussian distribution as a model of image pixel values. In that case, the Gaussian assumption led to a reasonable result. However, Eggers and Girod investigated the use of an elliptical Gaussian model for the distribution of coefficients in an image's block DCT and found that the resulting predictions of $E(nw)$ did not match experimental results. Instead, they suggested using a Laplacian distribution, as recommended in [19, 225], or a generalized Gaussian, as recommended in [19, 192]. The generalized Gaussian yielded better results, but it was not possible to compute $E(nw)$ analytically. We therefore conclude this section by providing the equation for $E(nw)$ when c is drawn from a Laplacian distribution.

We are assuming that the content has a Laplacian distribution with zero mean and standard deviation σ_c,

$$P_c(c) = \frac{1}{\sqrt{2}\sigma_c} e^{-\frac{\sqrt{2}}{\sigma_c}|c|}, \tag{B.63}$$

and that the watermark has a Gaussian distribution with zero mean and standard deviation σ_w, rendering

$$P_w(w) = \frac{1}{\sigma_w\sqrt{2\pi}} e^{-\frac{w^2}{2\sigma_w^2}}. \tag{B.64}$$

Under these assumptions, the expected value, $E(nw)$, is given by

$$E(nw) = \sigma_w^2 \sum_{b=-\infty}^{\infty} (-1)^b \frac{1}{1+2(\pi b\sigma_c/q)^2} e^{-2(\pi b\sigma_w/q)^2}. \tag{B.65}$$

Source Code

In this appendix, we provide most of our source code for the example watermarking systems tested in the book. This code is intended to help clarify the descriptions of those algorithms, and to show every detail of our implementations that might affect the test results. Toward this end, we have attempted to make it match the descriptions of the algorithms as closely as possible, often at the expense of efficiency. We have also attempted to avoid some of the more cryptic constructs in the C language, such as the "+=" operator and pointer arithmetic.

The source code for each watermarking system is presented in its own section. The source for any routine called by more than one system is given only in the section for the first system that uses it. In subsequent systems, we indicate where the routine can be found.

In a few cases, we do not present source for routines that implement standard algorithms, such as computation of 8×8 DCTs. Instead, we provide a comment block describing the routine's calling conventions, followed by a note indicating the algorithm used.

Throughout the following source code, images are represented with arrays of 8-bit integers (`unsigned char` in C), with 0 representing black and 255 representing white.

C.1 E_BLIND/D_LC

```
/* ---------------------------------------------------------- *
 |                                                            |
 |   E_BLIND -- embed a watermark by simply adding a message pattern |
 |                                                            |
 |   Arguments:                                               |
 |     c -- image to be watermarked (changed in place)        |
 |     width -- width of image                                |
 |     height -- height of image                              |
 |     m -- one-bit message to embed                          |
 |     alpha -- embedding strength                            |
 |     wr -- reference pattern (width × height array of doubles) |
 |                                                            |
 |   Return value:                                            |
 |     none                                                   |
 *  ---------------------------------------------------------- */
void E_BLIND( unsigned char *c, int width, int height,
              int m, double alpha, double *wr )
{
    static double wm[ MAX_IMG_SIZE ];     /* pattern that encodes m */

    /* Encode the message in a pattern */
    ModulateOneBit( m, wr, wm, width, height );

    /* Scale and add pattern to image (with clipping and rounding) */
    AddScaledPattern( c, width, height, alpha, wm );
}

/* ---------------------------------------------------------- *
 |                                                            |
 |   D_LC -- detect watermarks using linear correlation       |
 |                                                            |
 |   Arguments:                                               |
 |     c -- image                                             |
 |     width -- width of img                                  |
 |     height -- height of img                                |
 |     tlc -- detection threshold                             |
 |     wr -- reference pattern (width by height array of doubles) |
 |                                                            |
 |   Return value:                                            |
 |     decoded message (0 or 1), or NO_WMK if no watermark is found |
 *  ---------------------------------------------------------- */
int D_LC( unsigned char *c, int width, int height,
          double tlc, double *wr )
{
    double lc;                            /* linear correlation */
    int m;                                /* decoded message (or NO_WMK) */

    /* Find the linear correlation between the image and the reference pattern */
    lc = ImgPatInnerProduct( c, wr, width, height ) / (width * height);
```

```
/* Decode the message */
if( lc > tlc )
  m = 1;
else if( lc < -tlc )
  m = 0;
else
  m = NO_WMK;

return m;
}
```

```
/* ---------------------------------------------- *
 |                                                |
 |  ModulateOneBit -- encode a 1-bit message by either copying or negating  |
 |              a given reference pattern          |
 |                                                |
 |  Arguments:                                    |
 |    m -- message to be encoded                  |
 |    wr -- reference pattern                     |
 |    wm -- where to store resulting message pattern  |
 |    width -- width of wm                        |
 |    height -- height of wm                      |
 |                                                |
 |  Return value:                                 |
 |    none                                        |
 *  ---------------------------------------------- */
void ModulateOneBit( int m, double *wr, double *wm,
                     int width, int height )
{
  int i;                              /* index into patterns */

  if( m == 0 )
    for( i = 0; i < width * height; i = i + 1 )
      wm[ i ] = -wr[ i ];
  else
    for( i = 0; i < width * height; i = i + 1 )
      wm[ i ] = wr[ i ];
}
```

```
/* -------------------------------------------------------------- *
 |                                                                |
 |  AddScaledPattern -- scale and add a pattern to an image with clipping
 |                      and rounding                              |
 |                                                                |
 |  This multiplies w by alpha to obtain the added pattern, and adds it to the
 |  image, clipping and rounding each pixel to an 8-bit integer.  |
 |                                                                |
 |  Arguments:                                                    |
 |    c -- image to which to add pattern (changed in place)       |
 |    width -- width of image                                     |
 |    height -- height of image                                   |
 |    alpha -- scaling factor                                     |
 |    w -- pattern to scale and add (width times height array of doubles)
 |                                                                |
 |  Return value:                                                 |
 |    none                                                        |
 |                                                                |
 * -------------------------------------------------------------- */
void AddScaledPattern( unsigned char *c, int width, int height,
                       double alpha, double *w )
{
  int i;                                  /* pixel index */

  for( i = 0; i < width * height; i = i + 1 )
    c[ i ] = ClipRound( (double)c[ i ] + alpha * w[ i ] );
}

/* -------------------------------------------------------------- *
 |                                                                |
 |  ImgPatInnerProduct -- get the inner product of an image and a pattern
 |                                                                |
 |  Arguments:                                                    |
 |    c -- image                                                  |
 |    w -- pattern                                                |
 |    width -- width of the image and the pattern                 |
 |    height -- height of the image and the pattern               |
 |                                                                |
 |  Return value:                                                 |
 |    inner product of c and w                                    |
 |                                                                |
 * -------------------------------------------------------------- */
double ImgPatInnerProduct( unsigned char *c, double *w,
                           int width, int height )
{
  double product;                   /* inner product of c and w */
  int i;                            /* index into patterns */

  product = 0;
  for( i = 0; i < width * height; i = i + 1 )
    product = product + c[ i ] * w[ i ];

  return product;
}
```

```
/* ---------------------------------------------------- *
  |                                                      |
  |  ClipRound -- clip and round a real value to an 8-bit integer |
  |                                                      |
  |  Arguments:                                          |
  |    v -- real value                                   |
  |                                                      |
  |  Return value:                                       |
  |    clipped and rounded value                         |
  |                                                      |
  * ---------------------------------------------------- */

int ClipRound( double v )
{
  int iv;                               /* clipped and rounded value */

  if( v < 0 )
    iv = 0;
  else if( v > 255 )
    iv = 255;
  else
    iv = (int)floor( v + .5 );

  return iv;
}
```

C.2 E_FIXED_LC/D_LC

```
/* ------------------------------------------------- *
 |                                                     |
 |   E_FIXED_LC -- embed a watermark by adding a reference pattern after
 |                 scaling to obtain a specific linear correlation
 |                                                     |
 |   Arguments:                                        |
 |     c -- image to be watermarked (changed in place) |
 |     width -- width of image                         |
 |     height -- height of image                       |
 |     m -- 1-bit message to embed                     |
 |     tlc -- threshold that will be used during detection |
 |     beta -- embedding strength (target correlation will be tlc + beta) |
 |     wr -- reference pattern (width × height array of doubles) |
 |                                                     |
 |   Return value:                                     |
 |     none                                            |
 |                                                     |
 * ------------------------------------------------- */
void E_FIXED_LC( unsigned char *c, int width, int height,
                 int m, double tlc, double beta, double *wr )
{
  static double wm[ MAX_IMG_SIZE ];      /* pattern that encodes m */
  double cDotWm;                          /* inner product of c and wm */
  double wmDotWm;                         /* inner product of wm with itself */
  double alpha;                           /* scaling factor that will lead to
                                             desired linear correlation */

  /* Encode the message in a pattern */
  ModulateOneBit( m, wr, wm, width, height );

  /* Determine scaling factor */
  cDotWm = ImgPatInnerProduct( c, wm, width, height );
  wmDotWm = PatPatInnerProduct( wm, wm, width, height );
  alpha = (width * height * (tlc + beta) - cDotWm) / wmDotWm;

  /* Add pattern to image (with clipping and rounding) */
  AddScaledPattern( c, width, height, alpha, wm );
}
```

```
/* ------------------------------------------------ *
 |                                                  |
 |   PatPatInnerProduct -- get the inner product of two patterns |
 |                                                  |
 |   Arguments:                                     |
 |     w1 -- one of the patterns                    |
 |     w2 -- the other pattern                      |
 |     width -- width of both patterns              |
 |     height -- height of both patterns            |
 |                                                  |
 |   Return value:                                  |
 |     inner product of w1 and w2                   |
 |                                                  |
 * ------------------------------------------------ */

double PatPatInnerProduct( double *w1, double *w2,
                           int width, int height )
{
  double product;                    /* inner product of w1 and w2 */
  int i;                             /* index into patterns */

  product = 0;
  for( i = 0; i < width * height; i = i + 1 )
    product = product + w1[ i ] * w2[ i ];

  return product;
}
```

Routines from earlier systems:

- ModulateOneBit—Section C.1
- ImgPatInnerProduct—Section C.1
- AddScaledPattern—Section C.1
- D_LC—Section C.1

C.3 E_BLK_BLIND/D_BLK_CC

```
/* ---------------------------------------------------- *
|                                                        |
|  E_BLK_BLIND -- embed a block-based watermark by simply adding a
|                 reference mark                         |
|                                                        |
|  This routine performs the following three basic steps:|
|                                                        |
|  1. Extract a mark from the unwatermarked image.       |
|  2. Choose a new mark that is close to the extracted mark and (hopefully)
|     within the detection region for the given reference mark.
|  3. Modify the image so that when a mark is extracted from it the
|     result will be (approximately) the new mark chosen above.
|                                                        |
|  Step 2 is performed by blindly adding a fraction of the reference mark
|  to the extracted mark: newMark = origMark + alpha * refMark.
|                                                        |
|  It should be pointed out that this routine could be greatly simplified,
|  in that step 3 involves adding a fraction of newMark – origMark to each
|  pixel of the image, and newMark – origMark = alpha * refMark. This
|  means that steps 1 and 2 could be skipped, with step 3 using
|  alpha * refMark directly.                             |
|                                                        |
|  However, in later block-based embedding algorithms, step 2 will be
|  performed in more sophisticated ways, which do not allow such
|  simplification. The present routine is coded with steps 1 and 2 in place
|  so that its relationship to these later routines is apparent.
|                                                        |
|  Arguments:                                            |
|    c -- image to be watermarked (changed in place)     |
|    width -- width of image                             |
|    height -- height of image                           |
|    m -- 1-bit message to embed                         |
|    alpha -- embedding strength                         |
|    wr -- reference mark (length 64 vector of doubles)  |
|                                                        |
|  Return value:                                         |
|    none                                                |
|                                                        |
* ---------------------------------------------------- */
void E_BLK_BLIND( unsigned char *c, int width, int height,
                  int m, double alpha, double *wr )
{
  double wm[ 64 ];                    /* message mark */
  double vo[ 64 ];                    /* mark extracted from image before
                                         modification */
  double vw[ 64 ];                    /* new mark that is (hopefully) inside
                                         the detection region around wm */

  /* Encode message in a pattern */
  ModulateOneBit( m, wr, wm, 64, 1 );
```

```
/* Embed */
ExtractMark( c, width, height, vo );
MixBlind( vo, alpha, wm, vw );
InvExtractMark( c, width, height, vw );
}
```

```
/* ------------------------------------------------- *
 |                                                   |
 |  D_BLK_CC -- detect block-based watermarks using normalized correlation |
 |                                                   |
 | Arguments:                                        |
 |    c -- image                                     |
 |    width -- width of image                        |
 |    height -- height of image                      |
 |    tcc -- detection threshold                     |
 |    wr -- reference mark (8 x 8 array of doubles)  |
 |                                                   |
 | Return value:                                     |
 |    decoded message (0 or 1), or NO_WMK if no watermark is found |
 |                                                   |
 * ------------------------------------------------- */
int D_BLK_CC( unsigned char *c, int width, int height,
              double tcc, double *wr )
{
  double v[ 64 ];                 /* mark extracted from image */
  double cc;                      /* correlation coefficient between
                                     wr and v */
  int m;                          /* decoded message (or NO_WMK) */

  /* Compute the correlation coefficient between wr and a mark extracted
     from the image */
  ExtractMark( c, width, height, v );
  cc = CorrCoef( v, wr );

  /* Decode the message */
  if( cc > tcc )
    m = 1;
  else if( cc < -tcc )
    m = 0;
  else
    m = NO_WMK;

  return m;
}
```

```
/* ---------------------------------------- *
 |  ExtractMark -- extract a mark vector from an image by dividing the image   |
 |              into 8 × 8 blocks and taking their average.                    |
 |                                                                             |
 |  Arguments:                                                                 |
 |    c -- image from which to extract mark                                    |
 |    width -- width of image                                                  |
 |    height -- height of image                                                |
 |    v -- where to store resulting 64-element vector                          |
 |                                                                             |
 |  Return value:                                                              |
 |    none                                                                     |
 * ---------------------------------------- */
void ExtractMark( unsigned char *c, int width, int height, double *v )
{
  int imgX, imgY;                    /* coordinates in image */
  int imgI;                          /* index into c */
  int markX, markY;                  /* coordinates in averaged block */
  int markI;                         /* index into averaged block */
  int n[ 64 ];                       /* number of pixels accumulated into
                                        each of the 64 elements of v */

  /* Initialize v and n to 0. */
  for( markI = 0; markI < 64; markI = markI + 1 )
  {
    v[ markI ] = 0;
    n[ markI ] = 0;
  }

  /* Accumulate pixels. */
  for( imgY = 0; imgY < height; imgY = imgY + 1 )
    for( imgX = 0; imgX < width; imgX = imgX + 1 )
    {
      /* Find index for this pixel in image. */
      imgI = imgY * width + imgX;

      /* Find index for this pixel in accumulated block */
      markX = imgX % 8;
      markY = imgY % 8;
      markI = markY * 8 + markX;

      /* Accumulate. */
      v[ markI ] = v[ markI ] + c[ imgI ];
      n[ markI ] = n[ markI ] + 1;
    }

  /* Divide by n to obtain average of 8 × 8 blocks. */
  for( markI = 0; markI < 64; markI = markI + 1 )
    v[ markI ] = v[ markI ] / n[ markI ];
}
```

```
/* ------------------------------------------------------- *
   |                                                          |
   |   MixBlind -- use blind embedding to choose a new vector in mark space  |
   |               that is close to a given extracted mark and (hopefully) inside  |
   |               the detection region                       |
   |                                                          |
   |   Arguments:                                             |
   |      vo -- mark extracted from original image            |
   |      alpha -- embedding strength                         |
   |      wm -- message mark                                  |
   |      vw -- where to store resulting vector               |
   |                                                          |
   |   Return value:                                          |
   |      none                                                |
   |                                                          |
   * ------------------------------------------------------- */

void MixBlind( double *vo, double alpha, double *wm, double *vw )
{
  int i;
  for( i = 0; i < 64; i = i + 1 )
    vw[ i ] = vo[ i ] + alpha * wm[ i ];
}
```

```
/* ------------------------------------------------------- *
   |                                                          |
   |   InvExtractMark -- modify an image so that when entered into ExtractMark  |
   |                  it will produce (approximately) a given mark  |
   |                                                          |
   |   In principle, for each pixel in the image, c, this function could simply let  |
   |                                                          |
   |      c[ imgI ] = c[ imgI ] + vw[ markI ] - vo[ markI ],  |
   |                                                          |
   |   where imgI is the index of a pixel, markI is the corresponding index in  |
   |   the extracted vector, vw is the desired new vector, and vo is the vector  |
   |   obtained by applying ExtractMark to the original, unmodified image.  |
   |   (Recall that each element of an extracted mark is the average of a set  |
   |   of pixels.) Unfortunately, due to clipping and round-off errors, this  |
   |   does not achieve the level of precision required for our experiments.  |
   |   In other words, if we implement this with clipping and rounding, and  |
   |   then enter the resulting image into ExtractMark, the vector we obtain is  |
   |   not always close enough to vw.                         |
   |                                                          |
   |   To fix this problem, we use the following algorithm:   |
   |                                                          |
   |   1. Initialize n[ markI ] to the number of pixels averaged together to obtain  |
   |      the markI'th element of an extracted vector.        |
   |   2. Initialize delta[ markI ] = n[ markI ] (vw[ markI ] - vo[ markI ]) to the total  |
   |      amount we want to add to the pixels that go into the markI'th element  |
   |      of an extracted vector.                             |
   |   3. Loop through the pixels in the image. At the imgI'th pixel, perform  |
   |      the following steps:                                |
   |      a. Let oldPixel = the original value of the pixel, c[ imgI ].  |
```

> b. Compute newPixel = c[imgI] + delta[markI] / n[markI], where markI is the index of the extracted vector element that corresponds to imgI.
> c. Set c[imgI] to the value of newPixel with clipping and rounding. Thus, c[imgI] will not be exactly equal to newPixel.
> d. Decrement n[markI]. This is now the number of pixels remaining in the set that are averaged for element markI.
> e. Let delta[markI] = delta[markI] – (c[imgI] – oldPixel). This is now the total amount to be added to the remaining n[markI] pixels.
>
> If no errors were introduced by clipping and rounding, this algorithm would yield exactly the same results as the simpler method. However, when an error is introduced, it will usually be corrected over subsequent pixels. Thus, this represents a simple form of error diffusion.
>
> Arguments:
> c -- image to modify (changed in place)
> width -- width of image
> height -- height of image
> vw -- new mark
>
> Return value:
> none

```
void InvExtractMark( unsigned char *c, int width,
                     int height, double *vw )
{
    int nvo[ 64 ];                  /* sums of pixels that would be
                                       averaged to obtain extracted mark
                                       (nvo[ i ] = n[ i ] * vo[ i ] in
                                       the comment block above this
                                       routine) */

    double delta[ 64 ];             /* total values to be added to pixels
                                       that have not yet been modified */
    int n[ 64 ];                    /* numbers of pixels that have not yet
                                       been modified */
    int oldPixel;                   /* value of a pixel before being
                                       modified */
    double newPixel;                /* desired value of a pixel after
                                       being modified, but before clipping
                                       and rounding */
    int imgX, imgY;                 /* coordinates in image */
    int imgI;                       /* index into c */
    int markX, markY;               /* coordinates in averaged block */
    int markI;                      /* index into averaged block */

    /* Initialize nvo and n to 0. */
    for( markI = 0; markI < 64; markI = markI + 1 )
    {
        nvo[ markI ] = 0;
        n[ markI ] = 0;
    }
```

```
/* Accumulate pixels. */
for( imgY = 0; imgY < height; imgY = imgY + 1 )
  for( imgX = 0; imgX < width; imgX = imgX + 1 )
  {
     /* Find index for this pixel in image. */
     imgI = imgY * width + imgX;

     /* Find index for this pixel in accumulated block */
     markX = imgX % 8;
     markY = imgY % 8;
     markI = markY * 8 + markX;

     /* Accumulate. */
     nvo[ markI ] = nvo[ markI ] + c[ imgI ];
     n[ markI ] = n[ markI ] + 1;
  }

/* Initialize delta. */
for( markI = 0; markI < 64; markI = markI + 1 )
  delta[ markI ] = n[ markI ] * vw[ markI ] - nvo[ markI ];

/* Modify image. */
for( imgY = 0; imgY < height; imgY = imgY + 1 )
  for( imgX = 0; imgX < width; imgX = imgX + 1 )
  {
     /* Find index for this pixel in image. */
     imgI = imgY * width + imgX;

     /* Find index for this pixel in accumulated block */
     markX = imgX % 8;
     markY = imgY % 8;
     markI = markY * 8 + markX;

     /* Find desired value of this pixel */
     oldPixel = c[ imgI ];
     newPixel = (double)c[ imgI ] + delta[ markI ] / n[ markI ];

     /* Set pixel to new value, with clipping and rounding */
     c[ imgI ] = ClipRound( newPixel );

     /* Update n and delta. */
     n[ markI ] = n[ markI ] - 1;
     delta[ markI ] = delta[ markI ] - (c[ imgI ] - oldPixel);
  }
}
```

```
/* -------------------------------------------------- *
   |                                                    |
   |  CorrCoef -- compute the correlation coefficient between two vectors in
   |              mark space                             |
   |                                                    |
   |  Arguments:                                        |
   |     v1 -- one vector                               |
   |     v2 -- the other vector                         |
   |                                                    |
   |  Return value:                                     |
   |     correlation coefficient between v1 and v2      |
   |                                                    |
   * -------------------------------------------------- */
double CorrCoef( double *v1, double *v2 )
{
    double cc;                          /* correlation coefficient */
    double v1n[ 64 ];                   /* v1 – mean of v1 */
    double v2n[ 64];                    /* v2 – mean of v2 */
    double v1v2;                        /* dot product of v1n and v2n */
    double v1v1;                        /* dot product of v1n and v1n */
    double v2v2;                        /* dot product of v2n and v2n */
    double mean;                        /* mean of v1 or v2 */
    int i;                              /* index into vectors */

    /* Subtract out the mean of v1. */
    mean = MarkMean( v1 );
    for( i = 0; i < 64; i = i + 1 )
      v1n[ i ] = v1[ i ] - mean;

    /* Subtract out the mean of v2. */
    mean = MarkMean ( v2 );
    for( i = 0; i < 64; i = i + 1 )
      v2n[ i ] = v2[ i ] - mean;

    /* Compute various dot products. */
    v1v2 = MarkMarkInnerProduct( v1n, v2n );
    v1v1 = MarkMarkInnerProduct( v1n, v1n );
    v2v2 = MarkMarkInnerProduct( v2n, v2n );

    /* Test for the pathological case in which the two vectors have essentially
       zero magnitude (ESSENTIALLY_ZERO is a very small number--testing for
       exactly zero does not work because of round-off problems). If we have
       that case, let the correlation coefficient = 0. Otherwise, compute the
       correlation coefficient properly. */
    if( fabs(v1v1 * v2v2) < ESSENTIALLY_ZERO )
      cc = 0;
    else
      cc = v1v2 / sqrt( v1v1 * v2v2 );

    return cc;
}
```

```
/* ------------------------------------------------- *
  |                                                   |
  |   MarkMean -- get the mean of the elements of a vector in mark space
  |                                                   |
  |   Arguments:                                      |
  |     v -- vector to find mean of                   |
  |                                                   |
  |   Return value:                                   |
  |     mean of v                                     |
  * ------------------------------------------------- */

double MarkMean( double *v)
{
  double mean;                        /* mean of v */
  int i;                              /* index into v */

  mean = 0;
  for( i = 0; i < 64; i = i + 1 )
    mean = mean + v[ i ];
  mean = mean / 64;

  return mean;
}
```

```
/* ------------------------------------------------- *
  |                                                   |
  |   MarkMarkInnerProduct -- get the inner product of two vectors in mark
  |                           space (64 dimensions)   |
  |                                                   |
  |   Arguments:                                      |
  |     v1 -- one of the vectors                      |
  |     v2 -- the other vector                        |
  |                                                   |
  |   Return value:                                   |
  |     inner product of v1 and v2                    |
  * ------------------------------------------------- */

double MarkMarkInnerProduct( double *v1, double *v2 )
{
  double product;                     /* inner product */
  int i;                              /* index into vectors */

  product = 0;
  for( i = 0; i < 64; i = i + 1 )
    product = product + v1[ i ] * v2[ i ];

  return product;
}
```

Routine from earlier systems:

- ModulateOneBit—Section C.1

C.4 E_SIMPLE_8/D_SIMPLE_8

```
/* ------------------------------------------------------------ *
 |                                                              |
 |  E_SIMPLE_8 -- embed an 8-bit watermark by adding or         |
 |               subtracting a reference pattern for each bit   |
 |                                                              |
 |  Arguments:                                                  |
 |     c -- image to be watermarked (changed in place)          |
 |     width -- width of image                                  |
 |     height -- height of image                                |
 |     m -- 8-bit message to embed                              |
 |     alpha -- embedding strength                              |
 |     seed -- seed for generating patterns                     |
 |                                                              |
 |  Return value:                                               |
 |     none                                                     |
 |                                                              |
 * ------------------------------------------------------------ */
void E_SIMPLE_8( unsigned char *c, int width, int height,
                 int m, double alpha, int seed )
{
   static double wm[ MAX_IMG_SIZE ];    /* pattern that encodes m */

   /* Encode message in a pattern */
   SimpleModulate( m, seed, wm, width, height );

   /* Normalize the encoded pattern to have zero mean and unit variance
      (this is done only to ensure that a given value of alpha leads
      to the same fidelity impact in E_SIMPLE_8 as in E_BLIND, so that
      the parameters in our experiments are comparable) */
   NormalizePattern( wm, width, height );

   /* Scale and add pattern to image (with clipping and rounding) */
   AddScaledPattern( c, width, height, alpha, wm );
}

/* ------------------------------------------------------------ *
 |                                                              |
 |  D_SIMPLE_8 -- detect and decode 8-bit watermarks embedded   |
 |               with E_SIMPLE_8                                |
 |                                                              |
 |  Arguments:                                                  |
 |     c -- image                                               |
 |     width -- width of image                                  |
 |     height -- height of image                                |
 |     seed -- seed for generating reference patterns           |
 |                                                              |
 |  Return value:                                               |
 |     decoded message (does not determine whether watermark is present) |
 * ------------------------------------------------------------ */
```

```
int D_SIMPLE_8( unsigned char *c, int width, int height, int seed )
{
  static double v[ MAX_IMG_SIZE ];        /* image converted to real values for
                                             call to SimpleDemodulate */
  int i;                                  /* pixel index */

  /* Convert image to data type compatible with SimpleDemodulate (this is
     just done for symmetry, because SimpleModulate makes an array of
     real values) */
  for( i = 0; i < width * height; i = i + 1 )
    v[ i ] = c[ i ];

  return SimpleDemodulate( v, width, height, seed );
}
```

```
/* ------------------------------------------------- *
 |                                                   |
 |  SimpleModulate -- encode a message in a pattern by adding or subtracting |
 |                a reference pattern for each bit   |
 |                                                   |
 |  Arguments:                                       |
 |    m -- message to be encoded                     |
 |    seed -- each seed leads to a unique encoding of m |
 |    wm -- where to store resulting message pattern |
 |    width -- width of wm                           |
 |    height -- height of wm                         |
 |                                                   |
 |  Return value:                                    |
 |    none                                           |
 * ------------------------------------------------- */
void SimpleModulate( int m, int seed, double *wm,
                     int width, int height )
{
  int bitNum;                             /* bit number */
  static double wr[ MAX_PATTERN_SIZE ];   /* reference pattern for bit bitNum */
  int bitVal;                             /* value of bit bitNum */
  int i;

  /* Initialize the message pattern to 0 */
  for( i = 0; i < width * height; i = i + 1 )
    wm[ i ] = 0;

  /* Loop through the eight bits of the message */
  for( bitNum = 0; bitNum < 8; bitNum = bitNum + 1 )
  {
    /* Get the reference pattern for this bit
       (NOTE: by calling MakeRandomPattern with a seed of seed + bitNum,
       we get a distinct pattern for each bit) */
    MakeRandomPattern( seed + bitNum, wr, width, height );
```

```
      /* Find the value of this bit */
      if( m & (1 << bitNum) )
        bitVal = 1;
      else
        bitVal = 0;

      /* Either add or subtract the reference pattern */
      if( bitVal == 1 )
        for( i = 0; i < width * height; i = i + 1 )
          wm[ i ] = wm[ i ] + wr[ i ];
      else
        for( i = 0; i < width * height; i = i + 1 )
          wm[ i ] = wm[ i ] - wr[ i ];
    }
}

/* ------------------------------------------------------ *
 |                                                        |
 |   NormalizePattern -- normalize a pattern to have zero mean and unit
 |                      standard deviation                |
 |                                                        |
 |   Arguments:                                           |
 |     w -- pattern to be normalized (changed in place)   |
 |     width -- width of w                                |
 |     height -- height of w                              |
 |                                                        |
 |   Return value:                                        |
 |     none                                               |
 |                                                        |
 * ------------------------------------------------------ */
void NormalizePattern( double *w, int width, int height )
{
    double mean;                      /* mean of pattern */
    double std;                       /* standard deviation of pattern */
    int i;

    /* subtract out mean */
    mean = 0;
    for( i = 0; i < width * height; i = i + 1 )
      mean = mean + w[ i ];
    mean = mean / (width * height);
    for( i = 0; i < width * height; i = i + 1 )
      w[ i ] = w[ i ] - mean;

    /* normalize standard deviation */
    std = 0;
    for( i = 0; i < width * height; i = i + 1 )
      std = std + w[ i ] * w[ i ];
    std = sqrt( std / (width * height) );
    if( std > ESSENTIALLY_ZERO )
      for( i = 0; i < width * height; i = i + 1 )
        w[ i ] = w[ i ] / std;
}
```

```
/* ------------------------------------------------------------------ *
   |                                                                  |
   |   SimpleDemodulate -- decode a message by correlating an image against |
   |                       a reference pattern for each bit           |
   |                                                                  |
   |   Arguments:                                                     |
   |      c -- image                                                  |
   |      width -- width of image                                     |
   |      height -- height of image                                   |
   |      seed -- seed for generating reference patterns              |
   |                                                                  |
   |   Return value:                                                  |
   |      decoded message                                             |
   |                                                                  |
   * ------------------------------------------------------------------ */

int SimpleDemodulate( double *v, int width, int height, int seed )
{
   static double wr[ MAX_IMG_SIZE ];   /* reference pattern for one bit */
   int bitNum;                         /* bit number */
   int m;                              /* decoded message */

   /* Initialize all the bits to 0. */
   m = 0;

   /* Set each bit to 1 if the correlation between its reference pattern and the
      given image is positive */
   for( bitNum = 0; bitNum < 8; bitNum = bitNum + 1 )
   {
      MakeRandomPattern( seed + bitNum, wr, width, height );
      if( PatPatInnerProduct( v, wr, width, height ) > 0 )
         m = m | (1 << bitNum);
   }

   return m;
}

/* ------------------------------------------------------------------ *
   |                                                                  |
   |   MakeRandomPattern -- make a random pattern by drawing pixel values |
   |                        independently from a Normal distribution and then |
   |                        normalizing to have zero mean and unit variance |
   |                                                                  |
   |   Arguments:                                                     |
   |      seed -- each seed leads to a unique pattern                 |
   |      w -- where to store generated pattern                       |
   |      width -- width of w                                         |
   |      height -- height of w                                       |
   |                                                                  |
   |   Return value:                                                  |
   |      none                                                        |
   |                                                                  |
   * ------------------------------------------------------------------ */
```

```
void MakeRandomPattern( int seed, double *w, int width, int height )
{
  int i;

  SeedRand( seed );
  for( i = 0; i < width * height; i = i + 1 )
    w[ i ] = RandNormal();
  NormalizePattern( w, width, height );
}
```

```
/* ----------------------------------------------- *
 |                                                 |
 |  SeedRand -- seed the RandNormal() random-number generator  |
 |                                                 |
 |  Arguments:                                     |
 |    seed -- seed for the random-number generator |
 |                                                 |
 |  Return value:                                  |
 |    none                                         |
 * ----------------------------------------------- */
```

See note for `RandNormal`.

```
/* ----------------------------------------------- *
 |                                                 |
 |  RandNormal -- generate Normally distributed random numbers  |
 |                                                 |
 |  The sequence of values returned by this routine depends on the last call  |
 |  to SeedRand.                                   |
 |                                                 |
 |  Arguments:                                     |
 |    none                                         |
 |                                                 |
 |  Return value:                                  |
 |    pseudo-random number                         |
 * ----------------------------------------------- */
```

`SeedRand` *and* `RandNormal` *implement the random-number generator described in [3].*

Routines from earlier systems:

- `AddScaledPattern`—Section C.1
- `PatPatInnerProduct`—Section C.2

C.5 E_TRELLIS_8/D_TRELLIS_8

```
/* ------------------------------------------------- *
|                                                     |
|   E_TRELLIS_8 -- embed an 8-bit watermark by adding a trellis-coded pattern |
|                                                     |
|   Arguments:                                        |
|      c -- image to be watermarked (changed in place) |
|      width -- width of image                        |
|      height -- height of image                      |
|      m -- 8-bit message to embed                    |
|      alpha -- embedding strength                    |
|      seed -- seed for generating patterns           |
|                                                     |
|   Return value:                                     |
|      none                                           |
 * ------------------------------------------------- */

void E_TRELLIS_8( unsigned char *c, int width, int height,
                  int m, double alpha, int seed )
{
   static double wm[ MAX_IMG_SIZE ];     /* pattern that encodes msg */

   /* Encode message in a pattern */
   TrellisModulate( m, seed, wm, width, height );

   /* Normalize the encoded pattern to have zero mean and unit variance
      (this is done only to ensure that a given value of alpha leads
       to the same fidelity impact in E_SIMPLE_8 as in E_BLIND, so that
       the parameters in our experiments are comparable) */
   NormalizePattern( wm, width, height );

   /* Add pattern to image (with clipping and rounding) */
   AddScaledPattern( c, width, height, alpha, wm );
}

/* ------------------------------------------------- *
|                                                     |
|   D_TRELLIS_8 -- detect and decode 8-bit watermarks coded with a simple |
|                  trellis code                       |
|                                                     |
|   Arguments:                                        |
|      c -- image                                     |
|      width -- width of image                        |
|      height -- height of image                      |
|      seed -- seed for generating reference patterns |
|                                                     |
|   Return value:                                     |
|      decoded message (does not determine whether or not mark is present) |
 * ------------------------------------------------- */
```

```
int D_TRELLIS_8( unsigned char *c, int width, int height, int seed )
{
    static double v[ MAX_IMG_SIZE ];       /* image converted to real values
                                              for call to TrellisDemodulate */
    int i;                                 /* pixel index */

    /* Convert image to data type compatible with SimpleDemodulate (this is
       just done for symmetry, because TrellisModulate makes an array of
       real values) */
    for( i = 0; i < width * height; i = i + 1 )
        v[ i ] = c[ i ];

    return TrellisDemodulate( seed, v, width, height );
}
```

```
/* ------------------------------------------------------------ *
   |                                                            |
   |    TrellisModulate -- encode a message in a pattern using a simple form of |
   |                       trellis-coded modulation             |
   |                                                            |
   |    Arguments:                                              |
   |       m -- message to be encoded                           |
   |       seed -- each seed leads to a unique encoding of m    |
   |       wm -- where to store resulting message pattern       |
   |       width -- width of wm                                 |
   |       height -- height of wm                               |
   |                                                            |
   |    Return value:                                           |
   |       none                                                 |
   |                                                            |
   * ------------------------------------------------------------ */

/* nextState -- description of the graph that defines the code.
   For each state, nextState contains two entries.
   nextState[ s ][ 0 ] gives the state reached by crossing the 0 arc from
   state s. nextState[ s ][ 1 ] gives the state reached by crossing
   the 1 arc.
   nextState is global so that it can be used in other routines based on
   this trellis (TrellisDemodulate, TrellisEncode, and TrellisDecode) */
static int nextState[ NUM_STATES ][ 2 ] =
{
    0, 1,
    2, 3,
    4, 5,
    6, 7,
    0, 1,
    2, 3,
    4, 5,
    6, 7,
};
```

```
void TrellisModulate( int m, int seed, double *wm,
                      int width, int height )
{
  int state;                              /* current state */
  int bitNum;                             /* bit number */
  static double wr[ MAX_PATTERN_SIZE ]; /* reference pattern for bitNum */
  int bitVal;                             /* value of bit bitNum */
  int i;

  /* Initialize the message pattern to 0 */
  for( i = 0; i < width * height; i = i + 1 )
    wm[ i ] = 0;

  /* Start at state 0 */
  state = 0;

  for( bitNum = 0; bitNum < NUM_BITS; bitNum = bitNum + 1 )
  {
    /* Get the reference pattern for this bit
       (NOTE: by calling MakeRandomPattern with a seed of
       seed + state * NUM_BITS + bitNum, we get a distinct pattern
       for each transition in the trellis) */
    MakeRandomPattern( seed + state * NUM_BITS + bitNum,
                       wr, width, height );

    /* Find the value of this bit */
    if( m & (1 << bitNum) )
      bitVal = 1;
    else
      bitVal = 0;

    /* Either add or subtract the reference pattern */
    if( bitVal == 1 )
      for( i = 0; i < width * height; i = i + 1 )
        wm[ i ] = wm[ i ] + wr[ i ];
    else
      for( i = 0; i < width * height; i = i + 1 )
        wm[ i ] = wm[ i ] - wr[ i ];

    /* Go on to the next state */
    state = nextState[ state ][ bitVal ];
  }
}
```

```
/* ----------------------------------------------- *
   |                                                 |
   |   TrellisDemodulate -- use Viterbi's algorithm to decode a message from a |
   |                    trellis-modulated pattern    |
   |                                                 |
   |   Arguments:                                    |
   |     seed -- seed used during modulation of message |
   |     v -- pattern to decode                      |
   |     width -- width of v                         |
   |     height -- height of v                       |
   |                                                 |
   |   Return value:                                 |
   |     decoded message                             |
   |                                                 |
   * ----------------------------------------------- */
int TrellisDemodulate( int seed, double *v, int width, int height )
{
  /* Uses global nextState (see TrellisModulate) */
  static double wr[ MAX_IMG_SIZE ];     /* reference pattern for one arc */
  double lc0[ 8 ];                      /* correlation obtained from best
                                           path (so far) to each state */
  int m0[ 8 ];                          /* message obtained from best path
                                           (so far) to each state */
  double lc1[ 8 ];                      /* values of lc0 in next iteration */
  int m1[ 8 ];                          /* values of m0 in next iteration */
  int bitNum;                           /* bit number */
  int state;                            /* state index */
  int next;                             /* index of state at the other end
                                           of an arc */
  double lc;                            /* correlation between v and wr */
  int bestState;                        /* state with the highest correlation
                                           at the end of the algorithm */

  /* All paths must start from state 0, so we initialize that state to
     0 correlation and null message, and label the remaining states as
     unreached. */
  lc0[ 0 ] = 0;
  m0[ 0 ] = 0;
  for( state = 1; state < 8; state = state + 1 )
    lc0[ state ] = STATE_NOT_REACHED;

  /* Apply the Viterbi algorithm to decode 10 bits. */
  for( bitNum = 0; bitNum < 10; bitNum = bitNum + 1 )
  {
    /* Indicate that the states in the next iteration are not yet reached. */
    for( state = 0; state < 8; state = state + 1 )
      lc1 [ state ] = STATE_NOT_REACHED;
```

```
      /* Loop through all the states in the current iteration, updating the values
         for states in the next iteration. */
      for( state = 0; state < 8; state = state + 1 )
        if ( lc0 [ state ] != STATE_NOT_REACHED )
        {
          /* Find the correlation between v and the reference mark for the
             two arcs leading out of this state (the arc for 1 is labeled with
             a positive version of this reference mark, the arc for 0 is labeled
             with a negative version) */
          MakeRandomPattern( seed + state * 10 + bitNum, wr, width, height );
          lc = PatPatInnerProduct( v, wr, width, height ) / (width * height);

          /* Update values for the state connected to this state by a 0 arc */
          next = nextState[ state ][ 0 ];
          if( lc1[ next ] == STATE_NOT_REACHED ||
              lc1[ next ] < lc0[ state ] - lc )
          {
            lc1[ next ] = lc0[ state ] - lc;
            m1[ next ] = m0[ state ];
          }

          /* We know that the last two bits of the message must be 0 (because
             they are padding added by TrellisModulate), and therefore only
             update using the 1 arc if this bit is not one of them. */
          if( bitNum < 8 )
          {
            next = nextState[ state ][ 1 ];
            if( lc1[ next ] == STATE_NOT_REACHED ||
                lc1[ next ] < lc0[ state ] + lc )
            {
              lc1[ next ] = lc0[ state ] + lc;
              m1[ next ] = m0[ state ] | (1 << bitNum);
            }
          }
        }

    /* Go on to the next iteration. */
    for( state = 0; state < 8; state = state + 1 )
    {
      lc0[ state ] = lc1[ state ];
      m0[ state ] = m1[ state ];
    }
  }

  /* Find the state with the highest correlation. */
  bestState = 0;
  for( state = 1; state < 8; state = state + 1 )
    if( lc0[ state ] > lc0[ bestState ] )
      bestState = state;

  /* Return the message for the best state. */
  return m0[ bestState ];
}
```

Routines from earlier systems:

- `NormalizePattern`—Section C.4
- `AddScaledPattern`—Section C.1
- `MakeRandomPattern`—Section C.4
- `PatPatInnerProduct`—Section C.2

C.6 E_BLK_8/D_BLK_8

```
/* ----------------------------------------------- *
 |                                                   |
 |    E_BLK_8 -- embed a trellis-coded 8-bit watermark in a block-based   |
 |               watermark                           |
 |                                                   |
 |    Arguments:                                     |
 |       c -- image to be watermarked (changed in place)   |
 |       width -- width of image                     |
 |       height -- height of image                   |
 |       m -- 8-bit message to embed                 |
 |       alpha -- embedding strength                 |
 |       seed -- seed for generating patterns        |
 |                                                   |
 |    Return value:                                  |
 |       none                                        |
 |                                                   |
 * ----------------------------------------------- */
void E_BLK_8( unsigned char *c, int width, int height,
              int m, double alpha, int seed )
{
  double wm[ 64 ];              /* message mark */
  double vo[ 64 ];              /* mark extracted from image before
                                   modification */
  double vw[ 64 ];              /* new mark that is (hopefully) inside
                                   the detection region around wm */

  /* Encode message in a pattern */
  TrellisModulate( m, seed, wm, 8, 8 );

  /* Normalize the encoded pattern to have zero mean and unit variance */
  NormalizePattern( wm, 8, 8 );

  /* Embed */
  ExtractMark( c, width, height, vo );
  MixBlind( vo, alpha, wm, vw );
  InvExtractMark( c, width, height, vw );
}
```

```
/* ------------------------------------------------- *
 |                                                   |
 |   D_BLK_TRELLIS_8 -- detect block-based, trellis-coded, 8-bit watermarks
 |                      using correlation coefficient |
 |                                                   |
 |   Arguments:                                      |
 |     c -- image                                    |
 |     width -- width of image                       |
 |     height -- height of image                     |
 |     tcc -- detection threshold                    |
 |     seed -- seed for generating reference marks   |
 |                                                   |
 |   Return value:                                   |
 |     decoded message (8 bits), or NO_WMK if no watermark is found |
 |                                                   |
 * ------------------------------------------------- */
int D_BLK_TRELLIS_8( unsigned char *c, int width, int height,
                     double tcc, int seed )
{
  double v[ 64 ];                    /* mark extracted from image */
  int m;                             /* message decoded from v */
  double wm[ 64 ];                   /* message mark obtained by
                                        re-encoding m */
  double cc;                         /* correlation coefficient between
                                        v and wm */

  /* Decode the watermark. */
  ExtractMark( c, width, height, v );
  m = TrellisDemodulate ( seed, v, 8, 8 );

  /* Determine whether the message m was embedded. */
  TrellisModulate( m, seed, wm, 8, 8 );
  cc = CorrCoef( v, wm );
  if( cc < tcc )
    m = NO_WMK;

  return m;
}
```

Routines from earlier systems:

- TrellisModulate—Section C.5
- NormalizePattern—Section C.4
- ExtractMark—Section C.3
- MixBlind—Section C.3
- InvExtractMark—Section C.3
- TrellisDemodulate—Section C.5
- CorrCoef—Section C.3

C.7 E_BLK_FIXED_CC/D_BLK_CC

```
/* ------------------------------------------- *
 |  E_BLK_FIXED_CC -- embed a block-based watermark with fixed-correlation  |
 |                     coefficient embedding                                |
 |                                                                          |
 |  This routine performs the following three basic steps:                  |
 |                                                                          |
 |  1. Extract a mark from the unwatermarked image.                         |
 |  2. Choose a new mark that is close to the extracted mark and has a fixed |
 |     correlation coefficient with the given reference mark.               |
 |  3. Modify the image so that when a mark is extracted from it the result  |
 |     will be (approximately) the new mark chosen above.                    |
 |                                                                          |
 |  Arguments:                                                              |
 |     c -- image to be watermarked (changed in place)                      |
 |     width -- width of image                                              |
 |     height -- height of image                                            |
 |     m -- 1-bit message to embed                                          |
 |     tcc -- detection threshold that will be used by detector            |
 |     beta -- embedding strength                                           |
 |     wr -- reference mark (length 64 vector of doubles)                  |
 |                                                                          |
 |  Return value:                                                          |
 |     none                                                                |
 * ------------------------------------------- */

void E_BLK_FIXED_CC( unsigned char *c, int width, int height,
                     int m, double tcc, double beta, double *wr )
{
  double wm[ 64 ];                  /* message mark */
  double vo[ 64 ];                  /* mark extracted from image before
                                       modification */
  double vm[ 64 ];                  /* new mark that is inside the
                                       detection region around wm */

  /* Encode message in a pattern */
  ModulateOneBit( m, wr, wm, 64, 1 );

  /* Embed */
  ExtractMark( c, width, height, vo );
  MixFixedCC( vo, tcc, beta, wm, vw );
  InvExtractMark( c, width, height, vw );
}
```

```
/* ----------------------------------------------------------- *
 |                                                             |
 |   MixFixedCC -- compute a vector that is close to a given   |
 |                 extracted vector, and has a fixed           |
 |                 correlation coefficient with a              |
 |                 given message mark                          |
 |                                                             |
 |   The correlation between the new vector and the reference  |
 |   vector is specified as the sum of a detection threshold   |
 |   and a "strength" parameter. The new vector is as close as |
 |   possible to the given extracted vector, measured by       |
 |   Euclidian distance.                                       |
 |                                                             |
 |   Arguments:                                                |
 |      vo -- mark extracted from original image               |
 |      tcc -- detection threshold                             |
 |      beta -- strength parameter                             |
 |      wm -- message mark                                     |
 |      vw -- where to store resulting vector                  |
 |                                                             |
 |   Return value:                                             |
 |      none                                                   |
 |                                                             |
 * ----------------------------------------------------------- */

void MixFixedCC( double *vo, double tcc, double beta,
                 double *wm, double *vw )
{
  double wmMean;                  /* mean of wm */
  double voMean;                  /* mean of vo */
  double X[ 64 ];                 /* unit vector aligned with
                                     wm - wmMean */
  double Y[ 64 ];                 /* unit vector orthogonal to X, such
                                     that X and Y describe the plane
                                     containing wm - wmMean,
                                     vo - voMean, and the origin */
  double xvo, yvo;                /* coordinates of vo in the XY plane */
  double xt, yt;                  /* unit vector in the XY plane that
                                     has the desired correlation with
                                     the watermark */
  double xvw, yvw;                /* coordinates of new vector in the
                                     XY plane */
  int i;                          /* index into vectors */

  /* Subtract out the mean of wm to obtain an initial version of X. */
  wmMean = MarkMean( wm );
  for( i = 0; i < 64; i = i + 1 )
    X[ i ] = wm[ i ] - wmMean;

  /* Subtract out the mean of vo to obtain an initial version of Y. */
  voMean = MarkMean( vo );
  for( i = 0; i < 64; i = i + 1 )
    Y[ i ] = vo[ i ] - voMean;
```

```
/* Apply Gram-Schmidt orthonormalization to obtain two orthogonal
   unit vectors. */
Orthonormalize( X, Y );

/* Find projection of vo into the XY plane. */
xvo = MarkMarkInnerProduct( vo, X );
yvo = MarkMarkInnerProduct( vo, Y );

/* Find unit vector in the XY plane that has a normalized correlation with the
   watermark of tcc + beta */
xt = tcc + beta;
yt = sqrt( 1 - xt * xt );

/* Find the point on the line described by xa,ya that is closest to xvo,yvo */
xvw = xt * (xt * xvo + yt * yvo);
yvw = yt * (xt * xvo + yt * yvo);

/* Project xvw,yvw back into mark space */
for( i = 0; i < 64; i = i + 1 )
  vw[ i ] = xvw * X[ i ] + yvw * Y[ i ] + voMean;
}

/* ------------------------------------------------- *
   |                                                 |
   |  Orthonormalize -- convert two vectors into two unit-length orthogonal |
   |                  vectors that lie in the same plane                     |
   |                                                 |
   | Arguments:                                      |
   |   X -- vector whose direction will not be changed (changed in place)    |
   |   Y -- vector whose direction will be changed (changed in place)        |
   |                                                 |
   | Return value:                                   |
   |   none                                          |
   * ------------------------------------------------- */

void Orthonormalize( double *X, double *Y )
{
  double XDotY;                /* inner product of original Y and
                                  unit-length X */
  double len;                  /* Euclidian length (magnitude) of a
                                  vector */
  int i;                       /* index into marks */

  /* Normalize X to unit length. */
  len = 0;
  for( i = 0; i < 64; i = i + 1 )
    len = len + X[ i ] * X[ i ];
  len = sqrt( len );
  for( i = 0; i < 64; i = i + 1 )
    X[ i ] = X[ i ] / len;
```

```
/* Subtract X * (X dot Y) from Y to ensure that X and Y are orthogonal. */
XDotY = MarkMarkInnerProduct ( X, Y );
for( i = 0; i < 64; i = i + 1 )
  Y[ i ] = Y[ i ] - XDotY * X[ i ];

/* Normalize Y to unit length. */
len = 0;
for( i = 0; i < 64; i = i + 1 )
  len = len + Y[ i ] * Y[ i ];
len = sqrt( len );
for( i = 0; i < 64; i = i + 1 )
  Y[ i ] = Y[ i ] / len;
}
```

Routines from earlier systems:

- D_BLK_CC—Section C.3
- ModulateOneBit—Section C.1
- ExtractMark—Section C.3
- InvExtractMark—Section C.3
- MarkMean—Section C.3
- MarkMarkInnerProduct—Section C.3

C.8 E_BLK_FIXED_R/D_BLK_CC

```
/* ---------------------------------------------- *
 |                                                                |
 |  E_BLK_FIXED_R -- embed a block-based watermark with fixed-robustness
 |                    embedding                                   |
 |                                                                |
 |  This routine performs the following three basic steps:        |
 |                                                                |
 |  1. Extract a mark from the unwatermarked image.               |
 |  2. Choose a new mark that is close to the extracted mark and has a fixed
 |     estimated robustness with respect to a given reference mark and
 |     detection threshold.                                       |
 |  3. Modify the image so that when a mark is extracted from it the result
 |     will be (approximately) the new mark chosen above.          |
 |                                                                |
 |  Arguments:                                                    |
 |    c -- image to be watermarked (changed in place)            |
 |    width -- width of image                                     |
 |    height -- height of image                                   |
 |    m -- 1-bit message to embed                                 |
 |    tcc -- detection threshold that will be used by detector     |
 |    r -- embedding strength                                     |
 |    wr -- reference mark (length 64 vector of doubles)          |
 |                                                                |
 |  Return value:                                                 |
 |    none                                                        |
 * ---------------------------------------------- */

void E_BLK_FIXED_R( unsigned char *c, int width, int height,
                    int m, double tcc, double r, double *wr )
{
  double wm[ 64 ];                  /* message mark */
  double vo[ 64 ];                  /* mark extracted from image before
                                       modification */
  double vw[ 64 ];                  /* new mark that is inside the
                                       detection region around wm */

  /* Encode message in a pattern */
  ModulateOneBit( m, wr, wm, 64, 1 );

  /* Embed */
  ExtractMark( c, width, height, vo );
  MixFixedR( vo, tcc, r, wm, vw );
  InvExtractMark( c, width, height, vw );
}
```

```
/* – – – – – – – – – – – – – – – – – – – – – – – – – – – – – – – – – – – *
 |                                                                     |
 |  MixFixedR -- compute a vector that is close to a given extracted vector, |
 |            and has a fixed estimated robustness value with respect to |
 |            a given reference mark and detection threshold            |
 |                                                                     |
 |  The robustness value is specified with a "strength" parameter.      |
 |  The new vector is as close as possible to the given extracted vector, |
 |  measured by Euclidian distance.                                     |
 |                                                                     |
 |  Arguments:                                                          |
 |     vo -- mark extracted from original image                         |
 |     tcc -- detection threshold                                       |
 |     r -- strength parameter                                          |
 |     wm -- message mark                                               |
 |     vw -- where to store resulting vector                            |
 |                                                                     |
 |  Return value:                                                       |
 |     none                                                             |
 |                                                                     |
 * – – – – – – – – – – – – – – – – – – – – – – – – – – – – – – – – – – – */

void MixFixedR( double *vo, double tcc, double r, double *wm,
               double *vw )
{
  double wmMean;                 /* mean of wm */
  double voMean;                 /* mean of vo */
  double X[ 64 ];                /* unit vector aligned with
                                    wm - wmMean */

  double Y[ 64 ];                /* unit vector orthogonal to X, such
                                    that X and Y describe the plane
                                    containing wm - wmMean,
                                    vo - voMean, and the origin */

  double xvo, yvo;               /* coordinates of vo in the XY plane */
  double xvw, yvw;               /* possible coordinates for new vector
                                    in the XY plane (this point yields
                                    the desired robustness value, but
                                    might not be the closest one) */

  double dx;                     /* = xvw - xvo */
  double dy;                     /* = yvw - yvo */
  double d;                      /* Euclidian distance between xvo,yvo
                                    and  xvw,yvw */

  double bestXvw, bestYvw;       /* closest point in XY plane that
                                    yields the desired robustness */

  double bestD;                  /* Euclidian distance between xvo,yvo
                                    and bestXvw,bestYvw */

  int i;                         /* index into vectors, and counter
                                    during search for bestXvw,
                                    bestYvw */

  /* Subtract out the mean of wm to obtain an initial version of X. */
  wmMean = MarkMean( wm );
  for( i = 0; i < 64; i = i + 1 )
    X[ i ] = wm[ i ] - wmMean;
```

```
/* Subtract out the mean of vo to obtain an initial version of Y. */
voMean = MarkMean( vo );
for( i = 0; i < 64; i = i + 1 )
  Y[ i ] = vo[ i ] - voMean;

/* Apply Gram-Schmidt orthonormalization to obtain two orthogonal
   unit vectors. */
Orthonormalize( X, Y );

/* Find projection of vo into the XY plane. */
xvo = MarkMarkInnerProduct( vo, X );
yvo = MarkMarkInnerProduct( vo, Y );

/* Perform brute-force search for the point on the XY plane that yields
   the desired robustness and is closest to xvo,yvo. */
for( i = 0; i < 10000; i = i + 1 )
{
  /* Find coordinates of this point (the formula for xvw ensures that the point
     will yield the desired robustness) */
  yvw = yvo * i / 10000;
  xvw = sqrt( tcc * tcc * (r + yvw * yvw) / (1 - tcc * tcc) );

  /* Compute the distance from this point to xvo,yvo. */
  dx = xvw - xvo;
  dy = yvw - yvo;
  d = dx * dx + dy * dy;

  /* Keep track of the closest point found so far. */
  if( i == 0 || d < bestD )
  {
    bestXvw = xvw;
    bestYvw = yvw;
    bestD = d;
  }
}
/* Project bestXvw,bestYvw back into mark space */
for( i = 0; i < 64; i = i + 1 )
  vw[ i ] = bestXvw * X[ i ] + bestYvw * Y[ i ] + voMean;
}
```

Routines from earlier systems:

- ■ D_BLK_CC—Section C.3
- ■ ModulateOneBit—Section C.1
- ■ ExtractMark—Section C.3
- ■ InvExtractMark—Section C.3
- ■ MarkMean—Section C.3
- ■ Orthonormalize—Section C.7
- ■ MarkMarkInnerProduct—Section C.3

C.9 E_DIRTY_PAPER/D_DIRTY_PAPER

```
/* -------------------------------------------------------- *
 |                                                          |
 |   E_DIRTY_PAPER -- embed a block-based watermark with fixed-robustness
 |                    embedding and a dirty-paper code      |
 |                                                          |
 |   This routine performs the following four basic steps:  |
 |                                                          |
 |  1. Extract a mark from the unwatermarked image.         |
 |  2. Search through a set of random message marks to find the one that
 |     has the highest correlation with the extracted mark. This becomes
 |     the message mark that will be embedded.              |
 |  3. Choose a new mark that is close to the extracted mark and has a fixed
 |     estimated robustness with respect to the message mark and the given
 |     detection threshold.                                 |
 |  4. Modify the image so that when a mark is extracted from it the result
 |     will be (approximately) the new mark chosen above.   |
 |                                                          |
 |   Arguments:                                             |
 |     c -- image to be watermarked (changed in place)      |
 |     width -- width of image                              |
 |     height -- height of image                            |
 |     m -- 1-bit message to embed                          |
 |     tcc -- detection threshold that will be used by detector
 |     r -- embedding strength                              |
 |     seed -- seed for random number generator (this specifies the set of
 |             random reference marks)                      |
 |     N -- number of reference marks for each message      |
 |                                                          |
 |   Return value:                                          |
 |     none                                                 |
 |                                                          |
 * -------------------------------------------------------- */
void E_DIRTY_PAPER( unsigned char *c, int width, int height,
                    int m, double tcc, double r, int seed, int N )
{
  double vo[ 64 ];              /* mark extracted from
                                   unwatermarked image */

  double w[ 64 ];              /* one reference mark from the set of
                                   random marks that represent the
                                   message */

  double wm[ 64 ];              /* best reference mark for
                                   representing the message */

  double vw[ 64 ];              /* mark that is reasonably close to
                                   vo, but is inside the detection
                                   region for wm */

  int markNum;                 /* counter for searching through
                                   reference marks */

  double cor;                  /* correlation between vo and w */
  double bestCor;              /* correlation between vo and wm */
  int i;                       /* index into mark vectors */

  /* Extract a mark from the unwatermarked image. */
  ExtractMark( c, width, height, vo );
```

```
/* Find the best message mark. */
  StartMarks( seed, m );
  for( markNum = 0; markNum < N; markNum = markNum + 1 )
  {
     /* Find the correlation between vo and this mark. */
     GetNextMark( w );
     cor = MarkMarkInnerProduct ( w, vo );

     /* Keep track of the mark with the highest correlation. */
     if( markNum == 0 || cor > bestCor )
     {
       for( i = 0; i < 64; i = i + 1 )
         wm[ i ] = w[ i ];
       bestCor = cor;
     }
  }

  /* Embed */
  MixFixedR( vo, tcc, r, wm, vw );
  InvExtractMark( c, width, height, vw );
}

/* ----------------------------------------------- *
 |                                                 |
 |   D_DIRTY_PAPER -- detect dirty-paper coded watermarks
 |                                                 |
 |   Arguments:                                    |
 |     c -- image                                  |
 |     width -- width of image                     |
 |     height --height of image                    |
 |     tcc -- detection threshold                  |
 |     seed -- seed for generating reference marks |
 |     N -- number of marks for each message       |
 |                                                 |
 |   Return value:                                 |
 |     decoded message (0 or 1), or NO_WMK if no watermark is found |
 |                                                 |
 * ----------------------------------------------- */

int D_DIRTY_PAPER( unsigned char *c, int width, int height,
                   double tcc, int seed, int N )
{
  double v[ 64 ];                /* mark extracted from image */
  double wr[ 64 ];               /* a reference mark */
  int m;                         /* message */
  double cc;                     /* correlation coefficient between v
                                    and reference mark for message m */
  int bestM;                     /* message represented by the
                                    reference mark that has the highest
                                    correlation with v */
  double bestCC;                 /* highest correlation coefficient
                                    with v */
  int markNum;                   /* counter for looping through the
                                    reference marks for each message */
```

```
/* Extract a mark from the image. */
ExtractMark( c, width, height, v );

/* Loop through all the possible messages (0 and 1), and find the
   message mark that has the highest correlation coefficient with
   the extracted mark */
for( m = 0; m < 2; m = m + 1 )
{
    StartMarks( seed, m );
    for( markNum = 0; markNum < N; markNum = markNum + 1 )
    {
        /* Find the correlation coefficient between v and this mark. */
        GetNextMark( wr );
        cc = CorrCoef( wr, v );

        /* Keep track of the message with the highest correlation. */
        if( (m == 0 && markNum == 0) || cc > bestCC )
        {
            bestM = m;
            bestCC = cc;
        }
    }
}

/* Determine whether the watermark is present. */
if( bestCC < tcc )
    m = NO_WMK;
else
    m = bestM;

return m;
}

/* -------------------------------------------------------------- *
 |                                                                |
 |   StartMarks -- set up to make a sequence of marks specified by a seed and
 |                   a message value                              |
 |                                                                |
 |   Arguments:                                                   |
 |     seed -- for a given message, each seed leads to a different sequence
 |              of marks                                          |
 |     m -- message                                               |
 |                                                                |
 |   Return value:                                                |
 |     none                                                       |
 * -------------------------------------------------------------- */

void StartMarks( int seed, int m )
{
    SeedRand( seed + m );
}
```

```
/* ------------------------------------------------ *
 |                                                  |
 |   GetNextMark -- get the next mark in the sequence initiated by a call
 |                 to StartMarks                    |
 |                                                  |
 |   Arguments:                                     |
 |     w -- where to store mark                     |
 |                                                  |
 |   Return value:                                  |
 |     none                                         |
 |                                                  |
 * ------------------------------------------------ */
void GetNextMark( double *w )
{
  int i;                                   /* index into mark */

  for( i = 0; i < 64; i = i + 1 )
    w[ i ] = RandNormal();
  NormalizePattern( w, 8, 8 );
}
```

Routines from earlier systems:

- ExtractMark—Section C.3
- MarkMarkInnerProduct—Section C.3
- MixFixedR—Section C.8
- InvExtractMark—Section C.3
- CorrCoef—Section C.3
- SeeRand—Section C.4
- RandNormal—Section C.4
- NormalizePattern—Section C.4

C.10 E_LATTICE/D_LATTICE

```
/* ------------------------------------------------- *
 |  E_LATTICE -- embed a message using lattice-coded watermarking  |
 |                                                   |
 |  Arguments:                                       |
 |    c -- image in which to embed (changed in place)  |
 |    width -- width of image                        |
 |    height -- height of image                      |
 |    m -- message to embed (array of integer bit values)  |
 |    mLen -- length of message (number of bits)     |
 |    alpha -- embedding strength                    |
 |    beta0 -- lattice spacing (as a multiple of the length of wr0)  |
 |    wr0 -- basic reference mark (8 x 8 pattern)    |
 |                                                   |
 |  Return value:                                    |
 |    none                                           |
 * ------------------------------------------------- */
void E_LATTICE( unsigned char *c, int width, int height, int *m,
                int mLen, double alpha, double beta0, double *wr0 )
{
  double beta;                      /* value of beta0 after normalizing */
  double wr[ 64 ];                  /* value of wr0 after normalizing */
  int mc[ MAX_CODED_BITS ];         /* message after coding */
  int numRows;                      /* number of block rows in image */
  int numCols;                      /* number of block columns in
                                        image */

  int row, col;                     /* location of a block */
  int i0;                           /* index of first pixel in block */
  double cor;                       /* correlation between block and wr */
  int bitNum;                       /* number of bit embedded in block */
  int zm;                           /* index in sublattice for message */
  double wa;                        /* one element of added pattern */
  int x, y;                         /* position within block */

  /* Normalize the description of the lattice. */
  beta = NormalizeLatticeDesc( beta0, wr0, wr );

  /* Find number of blocks in image. */
  numRows = height / 8;
  numCols = width / 8;

  /* Encode message. */
  PadAndCodeMsg( m, mLen, mc, numRows * numCols );
```

```
/* Embed coded bits. */
bitNum = 0;
for( row = 0; row < numRows; row = row + 1 )
  for( col = 0; col < numCols; col = col + 1 )
  {
      /* Find the first pixel of this block. */
      i0 = row * 8 * width + col * 8;

      /* Correlate this block with the reference pattern. */
      cor = 0;
      for( y = 0; y < 8; y = y + 1 )
        for( x = 0; x < 8; x = x + 1 )
          cor = cor + c[ i0 + y * width + x ] * wr[ y * 8 + x ];

      /* Find the index of the closest point in the sublattice for this
         message. */
      zm = (int)floor( (cor - mc[ bitNum ] * beta) / (2 * beta) + .5 ) * 2
           + mc[ bitNum ];

      /* Modify the block so that its correlation with the reference pattern,
         scaled by beta, will be close to zm. */
      for( y = 0; y < 8; y = y + 1 )
        for( x = 0; x < 8; x = x + 1 )
        {
            /* Find one element of the added pattern. */
            wa = alpha * (beta * zm - cor) * wr[ y * 8 + x ];

            /* Add wa to the image with clipping and rounding. */
            c[ i0 + y * width + x ] = ClipRound( c[ i0 + y * width + x ] + wa );
        }

      /* Go on to the next bit. */
      bitNum = bitNum + 1;
  }
}

/* ----------------------------------------------------------- *
 |                                                             |
 |  D_LATTICE -- detect a message embedded with lattice-coded watermarking |
 |                                                             |
 | Arguments:                                                  |
 |    c -- image                                               |
 |    width -- width of image                                  |
 |    height -- height of image                                |
 |    alpha0 -- lattice spacing (as a multiple of the length of wr0) |
 |    wr0 -- basic reference mark (8 x 8 pattern)              |
 |    m -- where to store detected message                     |
 |                                                             |
 | Return value:                                               |
 |    length of detected message (number of bits)              |
 |                                                             |
 * ----------------------------------------------------------- */
```

```
int D_LATTICE( unsigned char *c, int width, int height,
               double beta0, double *wr0, int *m )
{
  double beta;                  /* value of beta0 after normalizing */
  double wr[ 64 ];              /* value of wr0 after normalizing */
  int mc[ MAX_CODED_BITS ];     /* coded message */
  int mcLen;                    /* length of coded message */
  int mLen;                     /* length of decoded message */
  int numRows;                  /* number of block rows in image */
  int numCols;                  /* number of block columns in
                                   image */
  int row, col;                 /* location of a block */
  int i0;                       /* index of first pixel in block */
  double cor;                   /* correlation between block and wr */
  int bitNum;                   /* number of bit embedded in block */
  int z;                        /* index in lattice */
  int x, y;                     /* position within block */

  /* Normalize the description of the lattice. */
  beta = NormalizeLatticeDesc( beta, wr0, wr );

  /* Find number of blocks in image. */
  numRows = height / 8;
  numCols = width / 8;

  /* Detect coded bits. */
  bitNum = 0;
  for( row = 0; row < numRows; row = row + 1 )
    for( col = 0; col < numCols; col = col + 1 )
    {
      /* Find the first pixel of this block. */
      i0 = row * 8 * width + col * 8;

      /* Correlate this block with the reference pattern. */
      cor = 0;
      for( y = 0; y < 8; y = y + 1 )
        for( x = 0; x < 8; x = x + 1 )
          cor = cor + c[ i0 + y * width + x ] * wr[ y * 8 + x ];

      /* Find the index of the closest point in the lattice */
      z = (int)floor( cor / beta + .5 );

      /* The least significant bit of z is the watermark bit in this block */
      mc[ bitNum ] = z & 1;

      /* Go on to the next bit. */
      bitNum = bitNum + 1;
    }
  mcLen = bitNum;
```

```
/* Decode the detected bit sequence. */
mLen = TrellisDecode( mc, mcLen, m );

return mLen;
}
```

```
/* --------------------------------------------------- *
 |                                                     |
 |   NormalizeLatticeDesc -- normalize the description of a lattice  |
 |                                                     |
 |   This takes a lattice described by a reference mark and a multiplier. It  |
 |   scales the multiplier by the length of the reference mark and normalizes  |
 |   the mark to unit length. This results in the same lattice as the one  |
 |   described originally, but simplifies its use.     |
 |                                                     |
 |   Arguments:                                        |
 |     wr0 -- original reference mark                  |
 |     beta0 -- original multiplier                   |
 |     wr1 -- where to store new reference mark        |
 |                                                     |
 |   Return value:                                     |
 |     new multiplier                                  |
 * --------------------------------------------------- */
double NormalizeLatticeDesc( double beta0, double *wr0, double *wr1 )
{
  double beta1;                        /* new multiplier */
  double wr0Len;                       /* Euclidian length of wr0 */
  int i;                               /* index into wr0 and wr1 */

  /* Find the length of wr0. */
  wr0Len = 0;
  for( i = 0; i < 64; i = i + 1 )
    wr0Len = wr0Len + wr0[ i ] * wr0[ i ];
  wr0Len = sqrt( wr0Len );

  /* Scale the multiplier. */
  beta1 = wr0Len * beta0;

  /* Normalize the reference mark. */
  for( i = 0; i < 64; i = i + 1 )
    wr1[ i ] = wr0[ i ] / wr0Len;

  return beta1;
}
```

```
/* ----------------------------------------------- *
   |                                                 |
   |   PadAndCodeMsg -- prepare a message for embedding with E_LATTICE  |
   |                                                 |
   | Arguments:                                      |
   |    m -- message to prepare (expressed as an array of bits)  |
   |    mLen -- length of message                    |
   |    mc -- where to store resulting coded bit sequence  |
   |    mcLen -- desired length of mc                |
   |                                                 |
   | Return value:                                   |
   |    none                                         |
   |                                                 |
   * ----------------------------------------------- */

void PadAndCodeMsg( int *m, int mLen, int *mc, int mcLen )
{
  int paddedBits[ MAX_MSG_BITS ];        /* message padded with enough
                                            zeros to make its length as close as
                                            possible to (mcLen / 4), without
                                            going over */
  int paddedLen;                         /* length of padded sequence */
  int i;                                 /* index into bit sequences */

  /* Pad the message to obtain the maximum number of message bits that can
     be represented with codedLen code bits. */
  paddedLen = (int) floor( mcLen / 4 );
  for( i = 0; i < mLen; i = i + 1 )
    paddedBits[ i ] = m[ i ];
  for( i = mLen; i < paddedLen; i = i + 1 )
    paddedBits[ i ] = 0;

  /* Encode the padded message. */
  TrellisEncode( paddedBits, paddedLen, mc );

  /* Pad the encoded bits to exactly codedLen bits (this is necessary if codedLen
     is not an integral multiple of 4) */
  for( i = 4 * paddedLen; i < mcLen; i = i + 1 )
    mc[ i ] = 0;
}

/* ----------------------------------------------- *
   |                                                 |
   |   TrellisEncode -- encode a message with a sequence of bits, using a trellis  |
   |                    code                         |
   |                                                 |
   | Arguments:                                      |
   |    m -- message to be encoded (expressed as an array of bits)  |
   |    mLen -- length of message                    |
   |    mc -- where to store resulting coded bit sequence  |
   |                                                 |
   | Return value:                                   |
   |    none                                         |
   |                                                 |
   * ----------------------------------------------- */
```

```
/* trellisBits -- Labels on arcs in graph. For each state, there are two 4-bit codes:
       one for the arc traversed by a 0 in the message, and one for the arc traversed
       by a 1. This table is global so that it can be used in TrellisDecode. */
static int trellisBits[ 8 ][ 2 ][ 4 ] =
{
    0, 0, 0, 0,
    0, 0, 0, 1,
    0, 0, 1, 0,
    0, 0, 1, 1,
    0, 1, 0, 0,
    0, 1, 0, 1,
    0, 1, 1, 0,
    0, 1, 1, 1,
    1, 0, 0, 0,
    1, 0, 0, 1,
    1, 0, 1, 0,
    1, 0, 1, 1,
    1, 1, 0, 0,
    1, 1, 0, 1,
    1, 1, 1, 0,
    1, 1, 1, 1,
};

void TrellisEncode( int *m, int mLen, int *mc )
{
    /* Uses global nextState (see TrellisModulate in E_TRELLIS_8/D_TRELLIS_8) */

    int state;                          /* current state */
    int bitNum;                         /* message bit number */
    int bitVal;                         /* = m[ bitNum ] */
    int i;                              /* index into arc label */

    /* Start at state 0 */
    state = 0;

    for( bitNum = 0; bitNum < mLen; bitNum = bitNum + 1 )
    {
        /* Get the value of this message bit */
        bitVal = m[ bitNum ];

        /* Copy label of appropriate arc into mc */
        for( i = 0; i < 4; i = i + 1 )
            mc[ bitNum * 4 + i] = trellisBits[ state ][ bitVal ][ i ];

        /* Go on to the next state */
        state = nextState[ state ][ bitVal ];
    }
}
```

```
/* ------------------------------------------------ *
|                                                   |
|   TrellisDecode -- use Viterbi's algorithm to decode a trellis-coded |
|                    bit sequence                   |
|                                                   |
|   Arguments:                                      |
|     mc -- coded bits                              |
|     mcLen -- length of mc                         |
|     m -- where to store decoded bits              |
|                                                   |
|   Return value:                                   |
|     length of decoded message                     |
|                                                   |
* ------------------------------------------------ */

int TrellisDecode( int *mc, int mcLen, int *m )
{
   /* Uses global nextState(see TrellisModulate in E_TRELLIS_8/D_TRELLIS_8) */
   /* Uses global trellisBits (see TrellisEncode) */

   int h0[ 8 ];                      /* Hamming distance obtained from
                                        best path (so far) to each state */
   static int m0[ 8 ][ MAX_MSG_BITS ];  /* message obtained from best path
                                        (so far) to each state */
   int h1[ 8 ];                      /* values of h0 in next iteration */
   static int m1[ 8 ][ MAX_MSG_BITS ];  /* values of m0 in next iteration */
   int mLen;                         /* length of message */
   int bitNum;                       /* bit number */
   int state;                        /* state index */
   int next;                         /* index of state at the other end
                                        of an arc */
   int h;                            /* Hamming distance between portion
                                        of mc and label for an arc */
   int bestState;                    /* state with the lowest Hamming
                                        distance at the end of the
                                        algorithm */
   int i;                            /* index into messages */

   /* Find length of message */
   mLen = mcLen / 4;

   /* All paths must start from state 0, so we initialize that state to 0 hamming
      distance, and label the remaining states as unreached. */
   h0[ 0 ] = 0;
   for( state = 1; state < 8; state = state + 1 )
      h0[ state ] = STATE_NOT_REACHED;

   /* Apply the Viterbi algorithm to decode. */
   for( bitNum = 0; bitNum < mLen; bitNum = bitNum + 1 )
   {
      /* Indicate that the states in the next iteration are not yet reached. */
      for( state = 0; state < 8; state = state + 1 )
         h1[ state ] = STATE_NOT_REACHED;
```

```
/* Loop through all the states in the current iteration, updating the values
   for states in the next iteration. */
for( state = 0;  state < 8;  state = state + 1 )
  if( h0[ state ] != STATE_NOT_REACHED )
  {
    /* Update values for the state connected to this state by a 0 arc.
       (Note: mc + 4 * bitNum is pointer arithmetic. The four bits used to
       encode bit bitNum of m are (mc + 4 * bitNum)[ 0 ... 3 ]. */
    next = nextState[ state ][ 0 ];
    h = HammingDist( mc + 4 * bitNum, trellisBits[ state ][ 0 ], 4 );
    if( h1[ next ] == STATE_NOT_REACHED ||
        h1[ next ] > h0[ state ] + h )
    {
      h1[ next ] = h0[ state ] + h;
      for( i = 0;  i < bitNum;  i = i + 1 )
        m1[ next ][ i ] = m0[ state ][ i ];
      m1[ next ][ bitNum ] = 0;
    }

    /* Update values for the state connected to this state by a 1 arc. */
    next = nextState[ state ][ 1 ];
    h = HammingDist( mc + 4 * bitNum, trellisBits[ state ][ 1 ], 4 );
    if( h1[ next ] == STATE_NOT_REACHED ||
        h1[ next ] > h0[ state ] + h )
    {
      h1[ next ] = h0[ state ] + h;
      for( i = 0;  i < bitNum;  i = i + 1 )
        m1[ next ][ i ] = m0[ state ][ i ];
      m1[ next ][ bitNum ] = 1;
    }
  }

  /* Go on to the next iteration. */
  for( state = 0;  state < 8;  state = state + 1 )
  {
    h0[ state ] = h1[ state ];
    for( i = 0;  i < mLen;  i = i + 1 )
      m0[ state ][ i ] = m1[ state ][ i ];
  }
}

/* Find the state with the minimum Hamming distance. */
bestState = 0;
for( state = 1;  state < 8;  state = state + 1 )
  if( h0[ state ] < h0[ bestState ] )
    bestState = state;

/* Return the message for the best state. */
for( i = 0;  i < mLen;  i = i + 1 )
  m[ i ] = m0[ bestState ][ i ];

return mLen;
}
```

```
/* ---------------------------------------------- *
 |                                                |
 |   HammingDist -- compute the Hamming distance between two bit sequences
 |                                                |
 |   Arguments:                                   |
 |      b1 -- one bit sequence                    |
 |      b2 -- other bit sequence                  |
 |      len -- length of sequences                |
 |                                                |
 |   Return value:                                |
 |      Hamming distance                          |
 * ---------------------------------------------- */

int HammingDist( int *b1, int *b2, int len )
{
  int h;
  int i;

  h = 0;
  for( i = 0; i < len; i = i + 1 )
    if( b1[ i ] != b2[ i ] )
      h = h + 1;

  return h;
}
```

Routines and global variables from earlier systems:

- ■ nextState—Section C.5 (in routine TrellisModulate)
- ■ ClipRound—Section C.1

C.11 E_BLIND/D_WHITE

```
/* ----------------------------------------------- *
|                                                   |
|  D_WHITE -- detect watermarks using whitening and linear correlation |
|                                                   |
|  Arguments:                                       |
|    c -- image                                     |
|    width -- width of image                        |
|    height -- height of image                      |
|    twh -- detection threshold                     |
|    wr -- reference pattern (width × height array of doubles) |
|                                                   |
|  Return value:                                    |
|    decoded message (0 or 1), or NO_WMK if no watermark is found |
|                                                   |
* ----------------------------------------------- */

int D_WHITE( unsigned char *c, int width, int height,
             double twh, double *wr )
{
  static double c1[ MAX_IMG_SIZE ];    /* whitened image */
  static double wr1[ MAX_IMG_SIZE ];   /* whitened reference pattern */
  double lc;                           /* correlation between c1 and wr1 */
  int m;                               /* decoded message (or NO_WMK) */
  int i;                               /* index into patterns */

  /* Whiten the image. */
  for( i = 0; i < width * height; i = i + 1 )
    c1[ i ] = c[ i ];
  Whiten( c1, width, height, 0 );

  /* Whiten the watermark reference pattern. */
  for( i = 0; i < width * height; i = i + 1 )
    wr1[ i ] = wr[ i ];
  Whiten( wr1, width, height, 0 );

  /* Compute the correlation between the whitened image and whitened
     reference pattern. */
  lc = PatPatInnerProduct( c1, wr1, width, height) / (width * height);

  /* Decode the message */
  if( lc > twh )
    m = 1;
  else if( lc < -twh )
    m = 0;
  else
    m = NO_WMK;

  return m;
}
```

```
/* ------------------------------------------------- *
 |                                                   |
 |  Whiten -- apply a whitening filter to a pattern  |
 |                                                   |
 |  This routine is used in two detection algorithms: D_WHITE and  |
 |  D_WHITE_BLK_CC. In D_WHITE_BLK_CC, the filter must wrap around at  |
 |  the edges of the given array. In D_WHITE it must not. Therefore, Whiten  |
 |  takes a flag as one argument, indicating whether or not to wrap around.  |
 |                                                   |
 |  Arguments:                                       |
 |    v -- pattern to whiten (changed in place)      |
 |    width -- width of pattern                      |
 |    height -- height of pattern                    |
 |    mustWrapAround -- 1 if filter must wrap around at edges of pattern  |
 |                    (as in D_WHITE_BLK_CC). 0 if it must not (as in  |
 |                    D_WHITE).                       |
 |                                                   |
 |  Return value:                                    |
 |    none                                           |
 |                                                   |
 * ------------------------------------------------- */

void Whiten( double *v, int width, int height, int mustWrapAround )
{
    /* Whitening filter. */
    static double fwh[ 11 ][ 11] =
    {
        0.0,  0.0,  0.0,  0.0,  0.1, -0.2,  0.1,  0.0,  0.0,  0.0,  0.0,
        0.0,  0.0,  0.0,  0.0,  0.1, -0.3,  0.1,  0.0,  0.0,  0.0,  0.0,
        0.0,  0.0,  0.0,  0.0,  0.2, -0.5,  0.2,  0.0,  0.0,  0.0,  0.0,
        0.0,  0.0,  0.0,  0.1,  0.4, -1.1,  0.4,  0.1,  0.0,  0.0,  0.0,
        0.1,  0.1,  0.2,  0.4,  1.8, -5.3,  1.8,  0.4,  0.2,  0.1,  0.1,
       -0.2, -0.3, -0.5, -1.1, -5.3, 15.8, -5.3, -1.1, -0.5, -0.3, -0.2,
        0.1,  0.1,  0.2,  0.4,  1.8, -5.3,  1.8,  0.4,  0.2,  0.1,  0.1,
        0.0,  0.0,  0.0,  0.1,  0.4, -1.1,  0.4,  0.1,  0.0,  0.0,  0.0,
        0.0,  0.0,  0.0,  0.0,  0.2, -0.5,  0.2,  0.0,  0.0,  0.0,  0.0,
        0.0,  0.0,  0.0,  0.0,  0.1, -0.3,  0.1,  0.0,  0.0,  0.0,  0.0,
        0.0,  0.0,  0.0,  0.0,  0.1, -0.2,  0.1,  0.0,  0.0,  0.0,  0.0
    };

    static double v1[ MAX_IMG_SIZE ];    /* whitened version of v */
    double t;                            /* accumulator for computing each
                                            element of v1 */
    int x, y;                            /* location in v and v1 */
    int xOff, yOff;                      /* offsets from x,y */
    int x1, y1;                          /* location x,y plus offsets, possibly
                                            wrapped around */
    int i;                               /* index into v and v1 */
```

```
/* Loop through each element of v1. */
for( y = 0; y < height; y = y + 1 )
  for( x = 0; x < width; x = x + 1 )
  {
      /* Compute value of v1[x,y] by applying filter to v, centered at x,y.
         This loops through the 11 x 11 neighborhood around x,y, multiplying
         each element in the neighborhood by the corresponding element of
         fwh, and accumulating the results in t. */
      t = 0;
      for( yOff = -5; yOff <= 5; yOff = yOff + 1 )
      {
          /* Find the row of elements corresponding to offset yOff.
             If mustWrapAround is set, this will wrap around instead
             of going off the edge. (Note: the '+ height' in the expression
             for wrapping around is necessary to deal with negative values
             of y1. This will not work if height < 5.) */
          y1 = y + yOff;
          if( mustWrapAround )
              y1 = (y1 + height) % height;

          /* If row y1 is not off the edge ... */
          if( 0 <= y1 && y1 < height )
            for( xOff = -5; xOff <= 5; xOff = xOff + 1 )
            {
                /* Find the column corresponding to offset xOff, with wraparound
                   if mustWrapAround is set. */
                x1 = x + xOff;
                if( mustWrapAround )
                    x1 = (x1 + width) % width;

                /* If column x1 is not off the edge, accumulate. */
                if( 0 <= x1 && x1 < width )
                    t = t + fwh[ yOff + 5 ][ xOff + 5 ] * v[ y1 * width + x1 ];
            }
      }

      /* Store the accumulated value. */
      v1[ y * width + x] = t;
  }

/* Copy v1 into v. */
for( i = 0; i < width * height; i = i + 1 )
  v[ i ] = v1[ i ];
}
```

Routines from earlier systems:

- E_BLIND—Section C.1
- PatPatInnerProduct—Section C.2

C.12 E_BLK_BLIND/D_WHITE_BLK_CC

```
/* -------------------------------------------------- *
|                                                     |
|    D_WHITE_BLK_CC -- detect block-based watermarks using whitening and
|                      correlation coefficient        |
|                                                     |
|    Arguments:                                       |
|      c -- image                                     |
|      width -- width of image                        |
|      height -- height of image                      |
|      tcc -- detection threshold                     |
|      wr -- reference mark (8 × 8 array of doubles)   |
|                                                     |
|    Return value:                                    |
|      decoded message (0 or 1), or NO_WMK if no watermark is found
|                                                     |
* -------------------------------------------------- */

int D_WHITE_BLK_CC( unsigned char *c, int width, int height,
                    double tcc, double *wr )
{
  double wr1[ 64 ];                     /* whitened reference mark */
  double v[ 64 ];                       /* mark extracted from image and
                                           whitened */
  double cc;                            /* correlation coefficient between
                                           v and wr1 */
  int m;                                /* message */
  int i;                                /* index into marks */

  /* Whiten the reference mark. */
  for( i = 0; i < 64; i = i + 1 )
    wr1[ i ] = wr[ i ];
  Whiten( wr1, 8, 8, 1 );

  /* Extract a mark from the image and whiten it. Note: the last argument
     in the call to Whiten indicates that whitening is performed with
     wrap-around. */
  ExtractMark( c, width, height, v );
  Whiten( v, 8, 8, 1 );

  /* Find the correlation coefficient between the whitened reference mark
     and the whitened extracted mark. */
  cc = CorrCoef( v, wr1 );

  /* Decode the message */
  if( cc > tcc )
    m = 1;
  else if( cc < -tcc )
    m = 0;
  else
    m = NO_WMK;

  return m;
}
```

Routines from earlier systems:

- E_BLK_BLIND—Section C.3
- Whiten—Section C.11
- ExtractMark—Section C.3
- CorrCoef—Section C.3

C.13 E_PERC_GSCALE/D_LC

```
/* ------------------------------------------------------------- *
  |                                                               |
  |    E_PERC_GSCALE -- embed a watermark by adding a reference pattern |
  |                     after scaling to obtain a fixed fidelity  |
  |                                                               |
  |  Arguments:                                                   |
  |     c -- image to be watermarked (changed in place)           |
  |     width -- width of image                                   |
  |     height -- height of image                                 |
  |     m -- 1-bit message to embed                               |
  |     jnds -- embedding strength (target according to Watson's model) |
  |     wr -- reference pattern (width by height array of doubles) |
  |                                                               |
  |  Return value:                                                |
  |     none                                                      |
  * ------------------------------------------------------------- */
void E_PERC_GSCALE( unsigned char *c, int width, int height,
                    int m, double jnds, double *wr )
{
  static double wm[ MAX_IMG_SIZE ];     /* pattern that encodes m */

  /* Encode the message in a pattern */
  ModulateOneBit( m, wr, wm, width, height );

  /* Scale the message pattern by an amount that yields close to the desired
     fidelity, and add it to image (with clipping and rounding) */
  AddPercScaledPattern( c, width, height, jnds, wm );
}
```

```
/* ------------------------------------------------------------- *
  |                                                               |
  |  AddPercScaledPattern -- scale a pattern by an amount that leads to a |
  |                          desired number of JNDs (according to Watson's |
  |                          model), and add it to an image       |
  |                                                               |
  |  Arguments:                                                   |
  |     c -- image to which to add pattern (changed in place)     |
  |     width -- width of image                                   |
  |     height -- height of image                                 |
  |     targetJNDs -- desired number of JNDs                      |
  |     w -- pattern to scale and add (width times height array of doubles) |
  |                                                               |
  |  Return value:                                                |
  |     none                                                      |
  * ------------------------------------------------------------- */
```

```
void AddPercScaledPattern( unsigned char *c, int width, int height,
                           double targetJNDs, double *w )
{
  static double C[ MAX_IMG_SIZE ];        /* image in block DCT domain */
  static double s[ MAX_IMG_SIZE ];        /* slacks for block DCT coefficients
                                             computed using Watson's model */
  double jnds;                            /* perceptual distance */
  double alphaInTheory;                   /* theoretically best alpha */
  double bestAlpha;                       /* best value of alpha found in
                                             practice */
  double bestJNDs;                        /* perceptual impact of using
                                             bestAlpha */
  double alpha, alpha0, alpha1;           /* used during search for best value
                                             of alpha in practice */
  static unsigned char c1[ MAX_IMG_SIZE ]; /* temporary copy of c used
                                             during search for best value of
                                             alpha */
  static double w1[ MAX_IMG_SIZE ];       /* pattern added using a given value
                                             of alpha (different from
                                             alpha*w because of clipping and
                                             rounding) */
  static double W[ MAX_IMG_SIZE ];        /* added pattern in the block DCT
                                             domain */
  int i;                                  /* index into block DCT arrays */
  int n;                                  /* counter for brute-force search */

  /* Get the slacks for the block DCT coefficients */
  Img2BlockDCT( c, C, width, height );
  GetWatsonSlks( C, s, width, height );

  /* Determine perceptual impact of adding w to image */
  Pat2BlockDCT( w, W, width, height );
  jnds = 0;
  for( i = 0; i < width * height; i = i + 1 )
    jnds = jnds + pow( W[ i ] / s[ i ], 4. );
  jnds = pow( jnds, 0.25 );

  /* In theory, if there were no clipping and rounding, the value of alpha
     we should use is targetJNDs/jnds */
  alphaInTheory = targetJNDs / jnds;

  /* In practice, with clipping and rounding, alphaInTheory might not result
     in the desired number of JNDs. This probably would not be a serious
     problem in an actual application. However, the size of this problem is
     different in different embedding algorithms, which could invalidate
     our comparative tests. Therefore, to ensure that all our algorithms result
     in JNDs tightly distributed around the target value, we now perform
     a simple brute-force search around alphaInTheory to find a better value
     of alpha. */
  alpha0 = alphaInTheory * 0.2;
  alpha1 = alphaInTheory * 1.1;
  for( n = 0; n <= 40; n = n + 1 )
  {
    /* Find the value of alpha to try in this iteration */
    alpha = alpha0 + n * (alpha1 - alpha0) / 40;
```

```
    /* Make a temporary watermarked version of c using this value of alpha */
    for( i = 0; i < width * height; i = i + 1 )
      c1[ i ] = c[ i ];
    AddScaledPattern( c1, width, height, alpha, w );

    /* Find out the actual pattern that was added (this might be different from
       alpha*w because of clipping and rounding) */
    for( i = 0; i < width * height; i = i + 1 )
      w1[ i ] = c1[ i ] - c[ i ];

    /* Determine the perceptual impact of adding this pattern */
    Pat2BlockDCT( w1, W, width, height );
    jnds = 0;
    for( i = 0; i < width * height; i = i + 1 )
      jnds = jnds + pow( W[ i ] / s[ i ], 4. );
    jnds = pow( jnds, 0.25 );

    /* Keep track of the value of alpha that results in a number of JNDs
       closest to targetJNDs */
    if( n == 0 || fabs( jnds - targetJNDs ) <
                            fabs( bestJNDs - targetJNDs ) )
    {
      bestAlpha = alpha;
      bestJNDs = jnds;
    }
  }

  /* Add the pattern using the best value of alpha found */
  AddScaledPattern( c, width, height, bestAlpha, w );
}

/* ------------------------------------------------------- *
 |                                                         |
 |   Img2BlockDCT -- convert an image into the block DCT domain
 |                                                         |
 |   Arguments:                                            |
 |      c -- image to be converted                         |
 |      C -- result of conversion (filled in by this routine)
 |      width -- width of image                            |
 |      height -- height of image                          |
 |                                                         |
 |   Return value:                                         |
 |      none                                               |
 |                                                         |
 * ------------------------------------------------------- */

void Img2BlockDCT( unsigned char *c, double *C, int width, int height )
{
  double block[ 8 ][ 8 ];        /* 8 x 8 block in DCT domain */
  int row, col;                  /* location in array of 8 x 8 blocks */
  int x, y;                      /* location within an 8 x 8 block */
  int i0;                        /* index of upper-left corner of
                                    current block */
```

```
/* Loop through the 8 × 8 blocks in the image */
for( row = 0; row < height / 8; row = row + 1 )
  for( col = 0; col < width / 8; col = col + 1 )
    {
      /* Find the upper-left corner of this block */
      i0 = row * 8 * width + col * 8;

      /* Copy the image block into an 8 × 8 array of doubles */
      for( y = 0; y < 8; y = y + 1 )
        for( x = 0; x < 8; x = x + 1 )
          block[ y ][ x ] = c[ i0 + y * width + x ];

      /* Convert block to DCT domain */
      Data2DCT88( block );

      /* Copy the 8 × 8 array of doubles into the block DCT array */
      for( y = 0; y < 8; y = y + 1 )
        for( x = 0; x < 8; x = x + 1 )
          C[ i0 + y * width + x ] = block[ y ][ x ];
    }
}
```

```
/* ------------------------------------------------------ *
 |                                                        |
 |  Data2DCT88 -- convert an 8 × 8 block from the spatial domain to the
 |                DCT domain                               |
 |                                                        |
 |  Arguments:                                            |
 |      block -- block to convert (changed in place)      |
 |                                                        |
 |  Return value:                                         |
 |      none                                              |
 |                                                        |
 * ------------------------------------------------------ */
```

Data2DCT88 *is calibrated to yield the standard,* JPEG DCT, *as described in* [206].

```
/* ------------------------------------------------------ *
 |                                                        |
 |  GetWatsonSlks -- using Watson's model, compute the slacks for all the
 |                   terms in the block DCT representation of an image
 |                                                        |
 |  Arguments:                                            |
 |      C -- image in the block DCT domain                |
 |      s -- where to store resulting 8 × 8 array of slacks |
 |      width -- width of C                               |
 |      height -- height of C                             |
 |                                                        |
 |  Return value:                                         |
 |      none                                              |
 |                                                        |
 * ------------------------------------------------------ */
```

```
void GetWatsonSlks( double *C, double *s, int width, int height )
{
    int numBlkRows;                          /* number of rows of 8 × 8 blocks
                                                in C */
    int numBlkCols;                          /* number of columns of blocks in C */
    int blkRow, blkCol;                      /* location in array of blocks */
    int x, y;                                /* location within a block */
    double CBlk[ 64 ];                       /* one block in C */
    double sBlk[ 64 ];                       /* one block in s */
    double C00;                              /* average DC term of blocks in C */
    int i;

    /* Find the number of block rows and columns in this image */
    numBlkRows = (int)(height / 8);
    numBlkCols = (int)(width / 8);

    /* Find the average DC term of blocks in C */
    C00 = 0;
    for( blkRow = 0; blkRow < numBlkRows; blkRow = blkRow + 1 )
      for( blkCol = 0; blkCol < numBlkCols; blkCol = blkCol + 1 )
        C00 = C00 + C[ (blkRow * 8 + 0) * width + (blkCol * 8 + 0) ];
    C00 = C00 / (numBlkRows * numBlkCols);

    /* Prevent divide-by-zeros in the pathological case of a completely
       black image */
    if( C00 == 0 )
      C00 = 1;

    /* Initialize all the slacks to 1 (this is necessary if the image width or height is
       not an even multiple of 8, because, in that case, some rows or columns
       of s will not be filled in, and subsequent use of the array could lead
       to problems) */
    for( i = 0; i < width * height; i = i + 1 )
      s[ i ] = 1;

    /* Loop through the blocks of the image, computing the slacks for each one */
    for( blkRow = 0; blkRow < numBlkRows; blkRow = blkRow + 1 )
      for( blkCol = 0; blkCol < numBlkCols; blkCol = blkCol + 1 )
      {
        /* Copy the block into a temporary, 8 × 8 array */
        for( y = 0; y < 8; y = y + 1 )
          for( x = 0; x < 8; x = x + 1 )
            CBlk[ y * 8 + x ] =
              C[ (blkRow * 8 + y) * width + (blkCol * 8 + x) ];

        /* Compute the slacks for this block */
        GetWatsonSlksForOneBlock( CBlk, C00, sBlk );

        /* Copy the slacks for this block into the full array of slacks */
        for( y = 0; y < 8; y = y + 1 )
          for( x = 0; x < 8; x = x + 1 )
            s[ (blkRow * 8 + y) * width + (blkCol * 8 + x) ] =
              sBlk[ y * 8 + x ];
      }
}
```

```
/* ------------------------------------------------ *
 |  GetWatsonSlksForOneBlock -- compute the slacks for one 8 x 8 DCT block  |
 |                                                                          |
 |  Arguments:                                                              |
 |     C -- block for which to compute slacks                               |
 |     C00 -- mean DC value of all blocks in image                          |
 |     s -- where to store resulting 8 x 8 array of slacks                  |
 |                                                                          |
 |  Return value:                                                           |
 |     none                                                                 |
 * ------------------------------------------------ */
void GetWatsonSlksForOneBlock( double *C, double C00, double *s )
{
  /* table of sensitivity values */
  static double t[ 8 * 8 ] =
  {
     1.404, 1.011, 1.169, 1.664,  2.408,  3.433,  4.796,  6.563,
     1.011, 1.452, 1.323, 1.529,  2.006,  2.716,  3.679,  4.939,
     1.169, 1.323, 2.241, 2.594,  2.988,  3.649,  4.604,  5.883,
     1.664, 1.529, 2.594, 3.773,  4.559,  5.305,  6.281,  7.600,
     2.408, 2.006, 2.988, 4.559,  6.152,  7.463,  8.713, 10.175,
     3.433, 2.716, 3.649, 5.305,  7.463,  9.625, 11.588, 13.519,
     4.796, 3.679, 4.604, 6.281,  8.713, 11.588, 14.500, 17.294,
     6.563, 4.939, 5.883, 7.600, 10.175, 13.519, 17.294, 21.156
  };

  double tL;                       /* luminance masking threshold */
  double m;                        /* contrast masking threshold */
  int i;                           /* index into block */

  /* Loop through the block */
  for( i = 0; i < 64; i = i + 1 )
  {
    /* Compute luminance masking (which incorporates sensitivity) */
    tL = t[ i ] * pow( C[ 0 ] / C00, .649 );

    /* Compute contrast masking (which incorporates luminance masking)
       NOTE: for the DC term, there is no contrast masking */
    if( i == 0 )
      m = tL;
    else
      m = max( tL, pow( fabs( C[ i ] ), .7 ) * pow( tL, .3 ) );

    /* Store resulting slack */
    s[ i ] = m;
  }
}
```

```
/* — — — — — — — — — — — — — — — — — — — — — — — — — — — — — — — — — — *
 |                                                                     |
 |   Pat2BlockDCT -- convert an array of doubles into the block DCT domain  |
 |                                                                     |
 |   Arguments:                                                        |
 |     w -- array to be converted                                      |
 |     W -- result of conversion (filled in by this routine)           |
 |     width -- width of image                                         |
 |     height -- height of image                                       |
 |                                                                     |
 |   Return value:                                                     |
 |     none                                                            |
 |                                                                     |
 * — — — — — — — — — — — — — — — — — — — — — — — — — — — — — — — — — — */

void Pat2BlockDCT( double *w, double *W, int width, int height )
{
  double block[ 8 ][ 8 ];          /* 8 × 8 block in DCT domain */
  int row, col;                    /* location in array of 8 × 8 blocks */
  int x, y;                        /* location within an 8 × 8 block */
  int i0;                          /* index of upper-left corner of
                                      current block */

  /* Loop through the 8 × 8 blocks in the pattern */
  for( row = 0; row < height / 8; row = row + 1 )
    for( col = 0; col < width / 8; col = col + 1 )
    {
      /* Find the upper-left corner of this block */
      i0 = row * 8 * width + col * 8;

      /* Copy the pattern block into an 8 × 8 array of doubles */
      for( y = 0; y < 8; y = y + 1 )
        for( x = 0; x < 8; x = x + 1 )
          block[ y ][ x ] = w[ i0 + y * width + x ];

      /* Convert block to DCT domain */
      Data2DCT88( block );

      /* Copy the 8 × 8 array of doubles into the block DCT array */
      for( y = 0; y < 8; y = y + 1 )
        for( x = 0; x < 8; x = x + 1 )
          W[ i0 + y * width + x ] = block[ y ][ x ];
    }
}
```

Routines from earlier systems:

- ModulateOneBit—Section C.1
- AddScaledPattern—Section C.1
- D_LC—Section C.1

C.14 E_PERC_SHAPE/D_LC

```
/* -------------------------------------------------- *
|                                                      |
|    E_PERC_SHAPE -- embed a watermark by adding a reference pattern after |
|                      simple perceptual shaping       |
|                                                      |
|    Arguments:                                        |
|      c -- image to be watermarked (changed in place) |
|      width -- width of image                         |
|      height -- height of image                       |
|      m -- 1-bit message to embed                     |
|      jnds -- embedding strength (target according to Watson's model) |
|      wr -- reference pattern (width by height array of doubles) |
|                                                      |
|    Return value:                                     |
|      none                                            |
|                                                      |
 * -------------------------------------------------- */
void E_PERC_SHAPE( unsigned char *c, int width, int height,
                   int m, double jnds, double *wr )
{
  static double wm[ MAX_IMG_SIZE ];    /* pattern that encodes m */
  static double C[ MAX_IMG_SIZE ];     /* image in block DCT domain */
  static double s[ MAX_IMG_SIZE ];     /* perceptual slacks */
  static double W[ MAX_IMG_SIZE ];     /* pattern in block DCT domain */
  static double ws[ MAX_IMG_SIZE ];    /* shaped version of wm */
  int i;                               /* index into block DCT */

  /* Encode the message in a pattern */
  ModulateOneBit( m, wr, wm, width, height );

  /* Get the perceptual slacks for this image */
  Img2BlockDCT( c, C, width, height );
  GetWatsonSlks( C, s, width, height );

  /* Convert the message pattern into the block DCT domain, shape it using the
     slacks computed from the image, and convert it back into the spatial domain
     to obtain the shaped pattern, ws */
  Pat2BlockDCT( wm, W, width, height );
  for( i = 0; i < width * height; i = i + 1 )
    W[ i ] = W[ i ] * s[ i ];
  BlockDCT2Pat( W, ws, width, height );

  /* Scale the shaped pattern by an amount that yields close to the desired
     fidelity, and add it to image (with clipping and rounding) */
  AddPercScaledPattern( c, width, height, jnds, ws );
}
```

```
/* ------------------------------------------------------------------ *
 |                                                                    |
 |  BlockDCT2Pat -- convert an array of doubles from the block DCT domain |
 |                  into the spatial domain                           |
 |                                                                    |
 |  Arguments:                                                        |
 |    W -- pattern in the block DCT domain                            |
 |    w -- result of conversion (filled in by this routine)           |
 |    width -- width of image                                         |
 |    height -- height of image                                       |
 |                                                                    |
 |  Return value:                                                     |
 |    none                                                            |
 |                                                                    |
 * ------------------------------------------------------------------ */
void BlockDCT2Pat( double *W, double *w, int width, int height )
{
    double block[ 8 ][ 8 ];          /* 8 × 8 block in DCT domain */
    int row, col;                    /* location in array of 8 × 8 blocks */
    int x, y;                        /* location within an 8 × 8 block */
    int i0;                          /* index of upper-left corner of
                                        current block */

    /* Loop through the 8 × 8 blocks in the block DCT array */
    for( row = 0; row < height / 8; row = row + 1 )
      for( col = 0; col < width / 8; col = col + 1 )
        {
          /* Find the upper-left corner of this block */
          i0 = row * 8 * width + col * 8;

          /* Copy the DCT block into an 8 × 8 array of doubles */
          for( y = 0; y < 8; y = y + 1 )
            for( x = 0; x < 8; x = x + 1 )
              block[ y ][ x ] = W[ i0 + y * width + x ];

          /* Convert block to spatial domain */
          DCT2Data88( block );

          /* Copy the 8 × 8 array into the pattern */
          for( y = 0; y < 8; y = y + 1 )
            for( x = 0; x < 8; x = x + 1 )
              w[ i0 + y * width + x ] = block[ y ][ x ];
        }
}
```

```
/* ----------------------------------------------- *
 |                                                 |
 |  DCT2Data88 -- convert 8 × 8 block from the DCT domain into the spatial
 |                domain                           |
 |                                                 |
 |  Arguments:                                     |
 |     block -- block to convert (changed in place) |
 |                                                 |
 |  Return value:                                  |
 |     none                                        |
 |                                                 |
 * ----------------------------------------------- */
```

DCT2Data88 *is calibrated to yield the standard,* JPEG DCT, *as described in [208].*

Routines from earlier systems:

- ■ ModulateOneBit—Section C.1
- ■ Img2BlockDCT—Section C.13
- ■ GetWatsonSlks—Section C.13
- ■ Pat2BlockDCT—Section C.13
- ■ AddPercScaledPattern—Section C.13
- ■ D_LC—Section C.1

C.15 E_PERC_OPT/D_LC

```
/* ------------------------------------------------- *
 |  E_PERC_OPT -- embed a watermark by adding a reference pattern after   |
 |               "optimal" perceptual shaping                             |
 |                                                                        |
 |  Arguments:                                                            |
 |    c -- image to be watermarked (changed in place)                     |
 |    width -- width of image                                             |
 |    height -- height of image                                           |
 |    m -- 1-bit message to embed                                         |
 |    jnds -- embedding strength (target according to Watson's model)     |
 |    wr -- reference pattern (width by height array of doubles)          |
 |                                                                        |
 |  Return value:                                                         |
 |    none                                                                |
 *  ------------------------------------------------- */

void E_PERC_OPT( unsigned char *c, int width, int height,
                 int m, double jnds, double *wr )
{
  static double wm[ MAX_IMG_SIZE ];      /* pattern that encodes m */
  static double C[ MAX_IMG_SIZE ];       /* image in block DCT domain */
  static double s[ MAX_IMG_SIZE ];       /* perceptual slacks */
  static double W[ MAX_IMG_SIZE ];       /* pattern in block DCT domain */
  static double ws[ MAX_IMG_SIZE ];      /* shaped version of wm */
  int i;                                 /* index into block DCT */

  /* Encode the message in a pattern *
  ModulateOneBit( m, wr, wm, width, height );

  /* Get the perceptual slacks for this image */
  Img2BlockDCT( c, C, width, height );
  GetWatsonSlks( C, s, width, height );

  /* Convert the message pattern into the block DCT domain, shape it using the
     slacks computed from the image, and convert it back into the spatial domain
     to obtain the shaped pattern, ws
     (NOTE: the C library routine pow() cannot take cube roots of negative
     numbers) */
  Pat2BlockDCT( wm, W, width, height );
  for( i = 0; i < width * height; i = i + 1 )
    if( W[ i ] < 0 )
      W[ i ] = -pow( -W[ i ] * pow( s[ i ], 4. ), 1. / 3. );
    else
      W[ i ] = pow( W[ i ] * pow( s[ i ], 4. ), 1. / 3. );
  BlockDCT2Pat( W, ws, width, height );

  /* Scale the shaped pattern by an amount that yields close to the desired
     fidelity, and add it to image (with clipping and rounding) */
  AddPercScaledPattern( c, width, height, jnds, ws );
}
```

Routines from earlier systems:

- ■ ModulateOneBit—Section C.1
- ■ Img2BlockDCT—Section C.13
- ■ GetWatsonSlks—Section C.13
- ■ Pat2BlockDCT—Section C.13
- ■ BlockDCT2Pat—Section C.14
- ■ AddPercScaledPattern—Section C.13
- ■ D_LC—Section C.1

C.16 E_MOD/D_LC

```
/* ------------------------------------------------ *
 |                                                   |
 |  E_MOD -- embed a watermark using modulo 256 addition |
 |                                                   |
 |  Arguments:                                       |
 |    c -- image to be watermarked (changed in place) |
 |    width -- width of image                        |
 |    height -- height of image                      |
 |    m -- 1-bit message to embed                    |
 |    alpha -- embedding strength                    |
 |    wr -- reference pattern (width × height array of doubles) |
 |                                                   |
 |  Return value:                                    |
 |    none                                           |
 |                                                   |
 * ------------------------------------------------ */

void E_MOD( unsigned char *c, int width, int height,
            int m, double alpha, double *wr )
{
  static double wm[ MAX_IMG_SIZE ];     /* pattern that encodes m */
  int i;                                /* pixel index */

  /* Encode the message in a pattern */
  ModulateOneBit( m, wr, wm, width, height );

  /* Scale the message pattern by alpha and add it to the image, modulo 256
     (NOTE: the scaled reference pattern is rounded to an integer before
     adding) */
  for( i = 0; i < width * height; i = i + 1 )
    c[ i ] = (int)(c[ i ] + floor( alpha * wm[ i ] + .5)) % 256;
}
```

Routines from earlier systems:
- ModulateOneBit—Section C.1
- D_LC—Section C.1

C.17 E_DCTQ/D_DCTQ

```
/* ------------------------------------------------ *
 |                                                    |
 |   E_DCTQ -- embed an authentication mark by quantizing coefficients in the |
 |             block DCT of an image                  |
 |                                                    |
 |   Arguments:                                       |
 |      c -- image in which to embed mark (changed in place) |
 |      width -- width of image                       |
 |      height -- height of image                     |
 |      seed -- a different mark is embedded for each value of seed |
 |      alpha -- maximum JPEG quantization factor that the mark should survive |
 |                                                    |
 |   Return value:                                    |
 |      none                                          |
 * ------------------------------------------------ */

void E_DCTQ( unsigned char *c, int width, int height,
             int seed, double alpha )
{
    static int sigBits[ 4 * (MAX_IMG_SIZE / 64) ];  /* bit pattern to embed */
    int numBits;                                    /* number of bits embedded in
                                                       image */

    /* Make the pseudo-random bit pattern. */
    numBits = (height / 8) * (width / 8) * 4;
    GetRandomSignature( seed, sigBits, numBits );

    /* Embed bits into the image. */
    EmbedDCTQWmkInImage( c, width, height, seed, alpha, sigBits );
}

/* ------------------------------------------------ *
 |                                                    |
 |   D_DCTQ -- determine whether or not an image is authentic using a |
 |             semi-fragile watermark based on DCT quantization |
 |                                                    |
 |   Arguments                                        |
 |      c -- image                                    |
 |      width -- width of image                       |
 |      height -- height of image                     |
 |      tmatch -- fraction of bits that must match embedded pattern for |
 |                image to be considered authentic    |
 |      seed -- seed for random-number generator (must be same as the seed |
 |              used during embedding)                |
 |      alpha -- multiplier for quantization matrix   |
 |                                                    |
 |   Return value:                                    |
 |      1 if the image appears authentic, 0 otherwise |
 * ------------------------------------------------ */
```

```
int D_DCTQ( unsigned char *c, int width, int height,
            double tmatch, int seed, double alpha )
{
    static int sigBits[ 4 * (MAX_IMG_SIZE / 64) ];  /* random signature that
                                                       was embedded if this image was
                                                       authenticated using this seed */
    static int wmkBits[ 4 * (MAX_IMG_SIZE / 64) ];  /* bit pattern actually
                                                       found in image */
    int numBits;                                    /* number of bits embedded in
                                                       image */
    int numMatches;                                 /* number of extracted bits that
                                                       match sigBits */
    double matchFract;                              /* fraction of extracted bits that
                                                       match sigBits */
    int i;                                          /* index into bit arrays */

    /* Make the pseudo-random signature. */
    numBits = (height / 8) * (width / 8) * 4;
    GetRandomSignature ( seed, sigBits, numBits );

    /* Extract bits from the image. */
    ExtractDCTQWmkFromImage( c, width, height, seed, alpha, wmkBits );

    /* Find the fraction of watermark bits that match the signature. */
    numMatches = 0;
    for( i = 0; i < numBits; i = i + 1 )
        if( wmkBits[ i ] == sigBits[ i ] )
            numMatches = numMatches + 1;
    matchFract = (double)numMatches / numBits;

    /* Decide whether watermark is authentic. */
    if( matchFract > tmatch )
        return 1;
    else
        return 0;
}

/* ------------------------------------------------- *
 |                                                   |
 |   GetRandomSignature -- get a sequence of bits specified by a given seed
 |                                                   |
 |  Arguments:                                       |
 |     seed -- determines bit sequence               |
 |     sigBits -- where to store resulting bit pattern |
 |     numBits -- number of bits                     |
 |                                                   |
 |  Return value:                                    |
 |     none                                          |
 |                                                   |
 * ------------------------------------------------- */
```

```
void GetRandomSignature( int seed, int *sigBits, int numBits )
{
  int i;                                    /* index into bit pattern */

  srand( seed );
  for( i = 0; i < numBits; i = i + 1 )
    if( rand() > RAND_MAX / 2 )
      sigBits[ i ] = 1;
    else
      sigBits[ i ] = 0;
}
```

```
/* ----------------------------------------------------- *
 |                                                       |
 |   EmbedDCTQWmkInImage -- embed a given sequence of bits in an image  |
 |                                                       |
 |  Arguments:                                           |
 |     c -- image (changed in place)                     |
 |     width -- width of image                           |
 |     height -- height of image                         |
 |     seed -- seed for random-number generator (must be same as the seed  |
 |             used during embedding)                    |
 |     alpha -- multiplier for quantization matrix       |
 |     wmkBits -- bits to embed                          |
 |                                                       |
 |  Return value:                                        |
 |     none                                              |
 * ----------------------------------------------------- */
```

```
void EmbedDCTQWmkInImage( unsigned char *c, int width, int height,
                          int seed, double alpha, int *wmkBits )
{
  double aQ[ 64 ];                /* quantization matrix */
  int coefs[ 28 ];               /* assignment of coefficients to bits
                                    in a block (coefs[ 0 ... 6 ] give
                                    the indices of the 7 coefficients
                                    used for the first bit,
                                    coefs[ 7 ... 13 ] are the
                                    coefficients used for the second
                                    bit, etc.) */

  double block[ 64 ];            /* one 8 × 8 block in the image */
  int numBlockRows;              /* number of block rows in image */
  int numBlockCols;              /* number of block columns in
                                    image */

  int blockNum;                  /* block number */
  int row, col;                  /* location in array of 8 × 8 blocks */
  int i0;                        /* index of first pixel in current
                                    block */

  int x, y;                      /* location within an 8 × 8 block */
```

```
      /* Get the quantization matrix, scaled by alpha. */
      GetDCTQMatrix( alpha, aQ );

      /* Compute the number of 8 × 8 blocks in this image. */
      numBlockRows = height / 8;
      numBlockCols = width / 8;

      /* Embed 4 bits in each block. */
      for( row = 0; row < numBlockRows; row++ )
        for( col = 0; col < numBlockCols; col++ )
          {
            /* Get the assignment of coefficients to bits in this block. */
            blockNum = row * numBlockCols + col;
            GetDCTQBitAssignments( seed, blockNum, coefs );

            /* Get the pixel values of the block. */
            i0 = row * 8 * width + col * 8;
            for( y = 0; y < 8; y++ )
              for( x = 0; x < 8; x++ )
                block[ y * 8 + x ] = c[ i0 + y * width + x ];

            /* Embed four bits into this block. Note: wmkBits + blockNum * 4 is
               pointer arithmetic. The 4 bits embedded in this block are given by
               (wmkBits + blockNum * 4) [ 0 ... 3 ]. */
            EmbedDCTQWmkInOneBlock( block, coefs, aQ, wmkBits + blockNum * 4 );

          /* Copy the modified block into the image. */
          for( y = 0; y < 8; y++ )
            for( x = 0; x < 8; x++ )
              c[ i0 + y * width + x] = (int)block[ y * 8 + x ];
      }
  }

/* ------------------------------------------------------------- *
   |                                                             |
   |   EmbedDCTQWmkInOneBlock -- embed four bits in a block      |
   |                                                             |
   |   Arguments:                                                |
   |     c -- block in which to embed (in spatial domain)        |
   |     coefs -- lists of coefficients to use for the four bits |
   |     aQ -- quantization matrix                               |
   |     wmkBits -- array of four bits to embed                  |
   |                                                             |
   |   Return value:                                             |
   |     none                                                    |
   |                                                             |
 * ------------------------------------------------------------- */
```

```
void EmbedDCTQWmkInOneBlock( double *c, int *coefs,
                            double *aQ, int *wmkBits )
{
    double Co[ 64 ];                 /* DCT of block before embedding */
    int numIterationsLeft;          /* counter for limiting number of
                                        iterations to 10 */

    int notDone;                     /* flag set to 0 when bits have
                                        been successfully embedded */

    int bitWasFlipped;               /* flag set to 1 when
                                        EmbedOneDCTQWmkBit had to flip a
                                        bit found in the block */

    int i;                           /* index into block or bit sequence */

    /* Record the DCT of the original, unmodified block. This is used for
       comparisons inside DCTQSetBit. */
    for( i = 0; i < 64; i = i + 1 )
      Co[ i ] = c[ i ];
    Data2DCT88( Co );

    /* Embed four bits into this block, then quantize and clip to 8-bit values.
       Repeat up to 10 times or until all the bits are correctly embedded. */
    numIterationsLeft = 10;
    do
    {
        notDone = 0;

        /* Convert the block into the DCT domain, embed four bits into it, and
           convert it back to the spatial domain. */
        Data2DCT88( c );
        for( i = 0; i < 4; i = i + 1 )
        {
            /* Note: coefs + i * 7 is pointer arithmetic. The 7 coefficients
               that are used for bit i are given by (coefs + i * 7)[ 0 ... 6 ]. */
            bitWasFlipped = EmbedOneDCTQWmkBit( c, Co, coefs + i * 7, aQ,
                                                wmkBits[ i ] );

            if( bitWasFlipped )
              notDone = 1;
        }
        DCT2Data88( c );

        /* Clip and round to 8-bit values. */
        for( i = 0; i < 64; i = i + 1 )
          c[ i ] = ClipRound( c[ i ] );

        /* Keep track of the number of iterations remaining. */
        numIterationsLeft = numIterationsLeft - 1;
    }
    while( notDone && numIterationsLeft > 0 );
}
```

```
/* ------------------------------------------------ *
 |                                                  |
 |  EmbedOneDCTQWmkBit -- embed one bit in a block  |
 |                                                  |
 |  Arguments:                                      |
 |     C -- DCT of block in which to embed bit (changed in place)      |
 |     Co -- DCT of original version of block, before any bits were embedded |
 |     coefs -- list of seven coefficients to use for this bit         |
 |     aQ -- quantization matrix                    |
 |     b -- desired value of bit                    |
 |                                                  |
 |  Return value:                                   |
 |     0 if the block already decodes to the given bit value, 1 otherwise |
 |                                                  |
 * ------------------------------------------------ */

int EmbedOneDCTQWmkBit( double *C, double *Co, int *coefs,
                        double *aQ, int b )
{
    int Ci[ 64 ];                   /* multipliers for aQ that yield new
                                       coefficient values (note: in any
                                       given call to this routine, only 7
                                       elements of this array are used) */
    int be;                         /* value of bit represented by the
                                       coefficients listed in coefs, before
                                       embedding */
    int flippedCi;                  /* value of a member of Ci after
                                       flipping its least significant
                                       bit by either incrementing or
                                       decrementing */
    double flipError;               /* error that results from using
                                       flippedCi */
    int bestJ;                      /* index of coefficient that leads
                                       to the smallest flipError */
    int bestFlippedCi;              /* value of flippedCi for coefficient
                                       bestJ */
    double bestFlipError;           /* smallest value of flipError */
    int i;                          /* index into coefs */
    int j;                          /* coefficient index (= coefs[i]) */

    /* When this routine is used in E_SFSIG, the bit value (b) might be 2,
       meaning that we should not embed anything here. Thus, if b==2, just
       return without making any changes. */
    if( b == 2 )
        return 0;

    /* Find the quantization factor multiples, Ci, that get closest to the current
       coefficient values. (That is, Ci[j]*aQ[j] is as close as possible to C[j],
       with integer Ci[j].) */
    for( i = 0; i < 7; i = i + 1 )
    {
        j = coefs[ i ];
        Ci[ j ] = (int)floor( C[ j ] / aQ[ j ] + .5 );
    }
```

```
/* Find the current bit value. */
be = 0;
for( i = 0; i < 7; i = i + 1 )
{
  j = coefs[ i ];
  be = be ^ (Ci[ j ] & 1);
}
```

```
/* If this is not the desired bit value, flip the least significant bit (lsb) of
   one of the Ci values. */
if( be != b )
{
```
```
  /* Find the Ci value that results in the smallest error when its lsb is
     flipped. */
  for( i = 0; i < 7; i = i + 1 )
  {
```
```
    /* Get the index of the i'th coefficient. */
    j = coefs[ i ];
```

```
    /* Find what the new value of Ci[j] would be if we flip the lsb.
       We will flip the lsb by either adding or subtracting 1, depending on
       whether the unquantized value is greater than or less than the current
       quantized value, respectively. This yields the value of aQ[j]*flippedCi
       that is closest to Co[j]. */
    if( Co[ j ] < aQ[ j ] * Ci[ j ] )
        flippedCi = Ci[ j ] - 1;
    else
        flippedCi = Ci[ j ] + 1;
```

```
    /* Find the magnitude of the error that would result from replacing
       Ci[j] with flippedCi */
    flipError = fabs( aQ[ j ] * flippedCi - Co[ j ] );
```

```
    /* Keep track of the coefficient that results in the smallest error */
    if( i == 0 || flipError < bestFlipError )
    {
        bestJ = j;
        bestFlippedCi = flippedCi;
        bestFlipError = flipError;
    }
  }
```

```
  /* Flip the lsb of the selected Ci. */
  Ci[ bestJ ] = bestFlippedCi;
}
```

```
   /* Change the coefficient values to the selected multiples of their respective
      quantization step sizes. */
   for( i = 0; i < 7; i = i + 1 )
   {
     j = coefs[ i ];
     C[ j ] = aQ[ j ] * Ci[ j ];
   }

   /* If we had to flip a bit, return 1. Otherwise, return 0. */
   return be != b;
}
```

```
/* ----------------------------------------------------------------- *
   |                                                                 |
   |   ExtractDCTQWmkFromImage -- extract a watermark from the       |
   |                              high-frequency DCT coefficients of an |
   |                              image's block DCT                  |
   |                                                                 |
   |  Arguments:                                                     |
   |     c -- image                                                  |
   |     width -- width of image                                     |
   |     height -- height of image                                   |
   |     seed -- seed for random-number generator (must be same as the seed |
   |          used during embedding)                                 |
   |     alpha -- multiplier for quantization matrix                 |
   |     wmkBits -- where to store watermark bits                    |
   |                                                                 |
   |  Return value:                                                  |
   |     none                                                        |
   |                                                                 |
   * ----------------------------------------------------------------- */
void ExtractDCTQWmkFromImage( unsigned char *c, int width, int height,
                              int seed, double alpha, int *wmkBits )
{
   double aQ[ 64 ];                    /* quantization matrix */
   int coefs[ 28 ];                    /* assignment of coefficients to bits
                                          in a block (coefs[ 0 ... 6 ] give
                                          the indices of the 7 coefficients
                                          used for the first bit,
                                          coefs[ 7 ... 13 ] are the
                                          coefficients used for the second
                                          bit, etc.) */
   double block [ 64 ];                /* one 8 × 8 block in the image */
   int numBlockRows;                   /* number of block rows in image */
   int numBlockCols;                   /* number of block columns in
                                          image */
   int blockNum;                       /* block number */
   int row, col;                       /* location in array of 8 × 8 blocks */
   int i0;                             /* index of first pixel in current
                                          block */
   int x, y;                           /* location within an 8 × 8 block */

   /* Get the quantization matrix, scaled by alpha. */
   GetDCTQMatrix( alpha, aQ );
```

```
/* Compute the number of 8 × 8 blocks in this image. */
numBlockRows = height / 8;
numBlockCols = width / 8;

/* Extract 4 bits from each block. */
for( row = 0; row < numBlockRows; row++ )
  for( col = 0; col < numBlockCols; col++ )
  {
    /* Get the assignment of coefficients to bits in this block. */
    blockNum = row * numBlockCols + col;
    GetDCTQBitAssignments( seed, blockNum, coefs );

    /* Get the pixel values of the block. */
    i0 = row * 8 * width + col * 8;
    for( y = 0; y < 8; y++ )
      for( x = 0; x < 8; x++ )
        block[ y * 8 + x ] = c[ i0 + y * width + x ];

    /* Extract four bits from this block. Note: wmkBits + blockNum * 4
       is pointer arithmetic. The 4 bits extracted from this block are
       (wmkBits + blockNum * 4)[ 0 ... 3 ]. */
    ExtractDCTQWmkFromOneBlock( block, coefs, aQ, wmkBits +
                               blockNum * 4 );
  }
}
```

```
/* ------------------------------------------------------------ *
 |                                                              |
 |   ExtractDCTQWmkFromOneBlock -- extract four watermark bits from the
 |                                 high-frequency DCT coefficients of
 |                                 an 8 × 8 block                |
 |                                                              |
 | Arguments:                                                   |
 |   c -- block from which to extract bits (in spatial domain)  |
 |   coefs -- lists of coefficients to use for each bit         |
 |   aQ -- quantization matrix                                  |
 |   wmkBits -- where to store bits                             |
 |                                                              |
 | Return value:                                                |
 |   none                                                       |
 |                                                              |
 * ------------------------------------------------------------ */

void ExtractDCTQWmkFromOneBlock( double *c, int *coefs, double *aQ,
                                 int *wmkBits )
{
  int i;                                   /* index into bit sequence */

  /* Convert the block into the DCT domain and extract four bits */
  Data2DCT88( c );
  for( i = 0; i < 4; i = i + 1 )
  {
    /* Note: coefs + i * 7 is pointer arithmetic. The 7 coefficients that are
       used for bit i are given by (coefs + i * 7)[ 0 ... 6 ]. */
    wmkBits[ i ] = ExtractOneDCTQWmkBit( c, coefs + i * 7, aQ );
  }
}
```

```
/* ----------------------------------------------- *
 |                                                 |
 |  ExtractOneDCTQWmkBit -- extract one watermark bit from the
 |                          high-frequency DCT coefficients of an 8 × 8 block|
 |                                                 |
 |  Arguments:                                     |
 |    C -- DCT of block                            |
 |    coefs -- list of seven coefficients to use for this bit  |
 |    aQ -- quantization matrix                    |
 |                                                 |
 |  Return value:                                  |
 |    value of bit                                 |
 |                                                 |
 * ----------------------------------------------- */

int ExtractOneDCTQWmkBit( double *C, int *coefs, double *aQ )
{
    int Ci[ 64 ];                   /* multipliers for aQ that yield new
                                       coefficient values (note: in any
                                       given call to this routine, only
                                       seven elements of this array are
                                       used) */
    int b;                          /* value of bit represented by the
                                       coefficients listed in coefs */
    int i;                          /* index into coefs */
    int j;                          /* coefficient index (= coefs[i]) */

    /* Find the quantization factor multiples, Ci, that get closest to the current
       coefficient values. (That is, Ci[j]*aQ[j] is as close as possible to C[j],
       with integer Ci[j].) */
    for( i = 0; i < 7; i = i + 1 )
    {
        j = coefs[ i ];
        Ci[ j ] = (int)floor( C[ j ] / aQ[ j ] + .5 );
    }

    /* Find the bit value. */
    b = 0;
    for( i = 0; i < 7; i = i + 1 )
    {
        j = coefs[ i ];
        b = b ^ (Ci[ j ] & 1);
    }

    return b;
}
```

```
/* ------------------------------------------------------------- *
 |                                                               |
 |   GetDCTQMatrix -- get the JPEG quantization matrix, multiplied by a given |
 |                    scaling factor                             |
 |                                                               |
 |   Arguments:                                                  |
 |     alpha -- scaling factor                                   |
 |     aQ -- where to store scaled quantization matrix           |
 |                                                               |
 |   Return value:                                               |
 |     none                                                      |
 |                                                               |
 * ------------------------------------------------------------- */

void GetDCTQMatrix( double alpha, double *aQ )
{
   /* Quantization table (from W. B. Pennebaker and J. L. Mitchell, "JPEG: Still
      Image Data Compression Standard," Van Nostrand Reinhold, 1993,
      page 37, Table 4-1) */
   static int Q[ 64 ] =
   {
      16, 11, 10, 16,  24,  40,  51,  61,
      12, 12, 14, 19,  26,  58,  60,  55,
      14, 13, 16, 24,  40,  57,  69,  56,
      14, 17, 22, 29,  51,  87,  80,  62,
      18, 22, 37, 56,  68, 109, 103,  77,
      24, 35, 55, 64,  81, 104, 113,  92,
      49, 64, 78, 87, 103, 121, 120, 101,
      72, 92, 95, 98, 112, 100, 103,  99
   };

   int i;                                    /* index into Q and aQ */

   for( i = 0; i < 64; i = i + 1 )
      aQ[ i ] = alpha * Q[ i ];
}

/* ------------------------------------------------------------- *
 |                                                               |
 |   GetDCTQBitAssignments -- get the lists of coefficients to be used for each |
 |                            of the four bits in a given block  |
 |                                                               |
 |   Arguments:                                                  |
 |     seed -- seed given as a key to the embedder or detector   |
 |     blockNum -- number of block                               |
 |     coefs -- where to store lists of coefficients (coefs[0...6] will be |
 |              the indices of coefficients used for the first bit, coefs[7...13] |
 |              will be the coefficients for the second bit, etc.) |
 |                                                               |
 |   Return value:                                               |
 |     none                                                      |
 |                                                               |
 * ------------------------------------------------------------- */
```

```
void GetDCTQBitAssignments( int seed, int blockNum, int *coefs )
{
  /* Set of coefficients used for embedding */
  static int embeddingCoefs[ 28 ] =
  {

                                    15,
                               22, 23,
                          29, 30, 31,
                     36, 37, 38, 39,
                43, 44, 45, 46, 47,
           50, 51, 52, 53, 54, 55,
      57, 58, 59, 60, 61, 62, 63
  }

  int i;                               /* index into list of coefficients */

  for( i = 0; i < 28; i = i + 1 )
    coefs[ i ] = embeddingCoefs[ i ];
  Shuffle( coefs, 28, seed + blockNum + 1 );
}
```

```
/* ---------------------------------------------------------------- *
 |                                                                  |
 |  Shuffle -- reorder a given list of integers according to a given seed  |
 |                                                                  |
 |  Arguments:                                                      |
 |    list -- list to be shuffled                                   |
 |    len -- length of list                                         |
 |    seed -- seed for random-number generator                     |
 |                                                                  |
 |  Return value:                                                   |
 |    none                                                          |
 *  ---------------------------------------------------------------- */
```

```
void Shuffle( int *list, int len, int seed )
{
  int i, j;                       /* indices into list */
  int tmp;                        /* temporary variable used for
                                     swapping values in place */

  /* Seed the random-number generator */
  srand( seed );
```

```
/* Shuffle list by swapping each element with another element, chosen at
   random */
for( i = 0; i < len; i++ )
{
    /* Note: rand() is a C library routine that returns a random value uniformly
       distributed between 0 and RAND_MAX, inclusive */
    j = rand() * len / (RAND_MAX + 1);
    tmp = list[ i ];
    list[ i ] = list[ j ];
    list[ j ] = tmp;
}
}
```

Routines from earlier systems:

- Data2DCT88—Section C.13
- DCT2Data88—Section C.17
- ClipRound—Section C.1

C.18 E_SFSIG/D_SFSIG

```
/* --------------------------------------------- *
 |  E_SFSIG -- embed an authentication mark using a semi-fragile signature  |
 |             and quantized-DCT embedding                                   |
 |                                                                           |
 |  Arguments:                                                               |
 |    c -- image in which to embed mark (changed in place)                   |
 |    width -- width of image                                                |
 |    height -- height of image                                              |
 |    seed -- a different mark is embedded for each value of seed            |
 |    alpha -- maximum JPEG quantization factor that the mark should survive  |
 |                                                                           |
 |  Return value:                                                            |
 |    none                                                                   |
 * --------------------------------------------- */

void E_SFSIG( unsigned char *c, int width, int height,
              int seed, double alpha )
{
  static int sigBits[ 4 * (MAX_IMG_SIZE / 64) ];  /* bit pattern to embed */
  static int wmkBits[ 4 * (MAX_IMG_SIZE / 64) ];  /* pattern that was
                                                     actually embedded */
  int numBits;                              /* number of bits in signature */
  int notDone;                              /* flag set to 0 when the extracted
                                               bits match the signature */
  int numIterationsLeft;                    /* counter for limiting number of
                                               iterations to 10 */
  int i;                                    /* index into bit sequences */

  /* Find the number of bits in a signature. */
  numBits = (height / 8) * (width / 8) * 4;

  /* Extract a signature and embed it up to 10 times, or until all the bits
     extracted from the image match the signature. */
  ExtractSignature( c, width, height, seed, sigBits );
  numIterationsLeft = 10;
  do
  {
    /* Embed signature into the image. */
    EmbedDCTQWmkInImage( c, width, height, seed, alpha, sigBits );
```

```
        /* Check whether the embedded bits match the signature. Note: clipping
           and roundoff errors during the embedding process might have changed
           the signature, and therefore we need to extract it again. */
        ExtractSignature( c, width, height, seed, sigBits );
        ExtractDCTQWmkFromImage( c, width, height, seed, alpha, wmkBits );
        notDone = 0;
        for( i = 0; i < numBits; i = i + 1 )
          if( sigBits[ i ] != 2 && wmkBits[ i ] != sigBits[ i ] )
          {
            notDone = 1;
            break;
          }

        /* Keep track of the number of iterations remaining */
        numIterationsLeft = numIterationsLeft - 1;
    }
    while( notDone && numIterationsLeft > 0 );
}

/* -------------------------------------------------- *
   |                                                    |
   |   D_SFSIG -- determine whether or not an image is authentic using a
   |              semi-fragile signature embedded with DCT quantization
   |                                                    |
   |   Arguments                                        |
   |     c -- image                                     |
   |     width -- width of image                        |
   |     height -- height of image                      |
   |     tmatch -- fraction of bits that must match embedded pattern for image
   |               to be considered authentic           |
   |     seed -- seed for random-number generator (must be same as the seed
   |             used during embedding)                 |
   |     alpha -- multiplier for quantization matrix    |
   |                                                    |
   |   Return value:                                    |
   |     1 if the image appears authentic, 0 otherwise  |
   |                                                    |
   * -------------------------------------------------- */

int D_SFSIG( unsigned char *c, int width, int height,
             double tmatch, int seed, double alpha )
{
    static int sigBits[ 4 * (MAX_IMG_SIZE / 64) ]; /* signature extracted
                                                       from image */
    static int wmkBits[ 4 * (MAX_IMG_SIZE / 64) ]; /* bit pattern actually
                                                       found in image */
    int numBits;                        /* number of bits embedded in
                                           image */
    int numMatches;                     /* number of extracted bits that
                                           match sigBits */
    int numPossibleMatches;             /* number of bits where the signature
                                           has a defined value (i.e., where
                                           sigBits has not been set to 2) */
    double matchFract;                  /* = numMatches divided by
                                           numPossibleMatches */
    int i;                              /* index into bit arrays */
```

```
/* Find the number of bits in a signature. */
numBits = (height / 8) * (width / 8) * 4;

/* Extract the signature. */
ExtractSignature( c, width, height, seed, sigBits );

/* Extract bits from the image. */
ExtractDCTQWmkFromImage( c, width, height, seed, alpha, wmkBits );

/* Find the fraction of bits that match the embedded pattern. */
numPossibleMatches = 0;
numMatches = 0;
for( i = 0; i < numBits; i = i + 1 )
  if( sigBits[ i ] != 2 )
  {
    numPossibleMatches = numPossibleMatches + 1;
    if( wmkBits[ i ] == sigBits[ i ] )
      numMatches = numMatches + 1;
  }
  matchFract = (double)numMatches / numPossibleMatches;

/* Decide whether watermark is authentic */
if( matchFract > tmatch )
  return 1;
else
  return 0;
}

/* ----------------------------------- *
 |                                     |
 |  ExtractSignature -- extract a semi-fragile signature from the
 |                      low-frequency coefficients of an image's block DCT
 |                                     |
 |  Arguments:                         |
 |    c -- image from which to extract signature
 |    width -- width of image          |
 |    height -- height of image        |
 |    seed -- a different signature is extracted for each value of seed
 |    sigBits -- where to store resulting signature
 |                                     |
 |  Return value:                      |
 |    none                             |
 |                                     |
 * ----------------------------------- */

void ExtractSignature( unsigned char *c, int width, int height,
                       int seed, int *sigBits )
{
  /* Set of coefficients used for signatures */
  static int sigCoefs[ 8 ] =
  {
     0,  1,  2,
     8,  9, 10,
    16, 17
  };
```

```
static int blockI[ MAX_IMG_SIZE / 64 ];  /* randomized list of blocks
                                             (each element of this array is the
                                             pixel index of the first pixel in a
                                             block) */
static double block0[ 64 ];              /* first block in a pair */
static double block1[ 64 ];              /* second block in a pair */
int numBlocks;                           /* number of blocks in image */
int bitNum;                              /* counter for extracting eight bits
                                             from each block pair */
int blockNum;                            /* counter for making list of blocks */
int pairNum;                             /* counter for looping through pairs
                                             of blocks */
int row, col;                            /* indices of a block */
int i0;                                  /* index of first pixel in a block */
int x, y;                                /* coordinates in a block */
int i;                                   /* index into DCT of a block */

/* Make the randomized list of blocks. */
blockNum = 0;
for( row = 0; row < height / 8; row = row + 1 )
  for( col = 0; col < width / 8; col = col + 1 )
  {
    blockI[ blockNum ] = row * 8 * width + col * 8;
    blockNum = blockNum + 1;
  }
numBlocks = blockNum;
Shuffle( blockI, numBlocks, seed );

/* Loop through pairs of blocks, extracting eight signature bits from
   each pair. */
for( pairNum = 0; pairNum < numBlocks / 2; pairNum = pairNum + 1 )
{
  /* Get the first block and convert it to the DCT domain. */
  i0 = blockI[ pairNum * 2 + 0 ];
  for( y = 0; y < 8; y = y + 1 )
    for( x = 0; x < 8; x = x + 1 )
      block0[ y * 8 + x ] = c[ i0 + y * width + x ];
  Data2DCT88( block0 );

  /* Get the second block and convert it to the DCT domain. */
  i0 = blockI[ pairNum * 2 + 1 ];
  for( y = 0; y < 8; y = y + 1 )
    for( x = 0; x < 8; x = x + 1 )
      block1[ y * 8 + x] = c[ i0 + y * width + x ];
  Data2DCT88( block1 );
```

```
/* Extract eight bits. */
for( bitNum = 0; bitNum < 8; bitNum = bitNum + 1 )
{
    /* Note: if the two blocks are equal at this coefficient, the bit value is
       undetermined, which is indicated by setting sigBits to 2. */
    i = sigCoefs[ bitNum ];
    if( block0[ i ] < block1[ i ] )
        sigBits[ pairNum * 8 + bitNum ] = 0;
    else if( block0[ i ] > block1[ i ] )
        sigBits[ pairNum * 8 + bitNum ] = 1;
    else
        sigBits[ pairNum * 8 + bitNum ] = 2;
}
  }
}
```

Routines from earlier systems:

- `EmbedDCTQWmkInImage`—Section C.17
- `ExtractDCTQWmkFromImage`—Section C.17
- `Shuffle`—Section C.17
- `Data2DCT88`—Section C.13

C.19 E_PXL/D_PXL

```
/* ------------------------------------------------- *
 |                                                   |
 |  E_PXL -- embed an authentication mark using the Yeung & Mintzer method  |
 |                                                   |
 |  Arguments:                                       |
 |    c -- image to be watermarked (changed in place) |
 |    width -- width of image                        |
 |    height -- height of image                      |
 |    seed -- seed for random mapping from pixel values to bit values  |
 |    bitPat -- bit pattern to embed                 |
 |                                                   |
 |  Return value:                                    |
 |    none                                           |
 *  ------------------------------------------------- */
void E_PXL( unsigned char *c, int width, int height,
            int seed, unsigned char *bitPat )
{
  int pixel2BitTable[ 256 ];          /* table for mapping pixel values to
                                         bit values (generated according to
                                         seed) */
  int newPixelVal0[ 256 ];            /* table of new values for pixels that
                                         should have 0s embedded (that is,
                                         if pixel i, with intensity c[i],
                                         should have a 0 embedded, its
                                         new value should be
                                         newPixelVal0[ c[i] ]) */
  int newPixelVal1[ 256 ];            /* table of new values for pixels that
                                         should have 1s embedded */
  int oldPixelVal;                    /* value of a pixel before
                                         embedding */
  double err;                         /* error introduced by embedding */
  int x, y;                           /* location in image */
  int bestJ;                          /* used to find best value for each
                                         entry in newPixelVal0 and
                                         newPixelVal1 tables */
  int i, j;                           /* general-purpose counters */

  /* Get the table mapping pixel values into bit values. */
  GetPixel2BitTable( seed, pixel2BitTable );

  /* Find the pixel-value substitutions required for embedding 0s and 1s. */
  for( i = 0; i < 256; i = i + 1 )
  {
    /* Find the pixel value closest to i that maps into 0. */
    bestJ = -1;
    for( j = 0; j < 256; j = j + 1 )
      if( pixel2BitTable[ j ] == 0 )
        if( bestJ == -1 || abs( j - i ) < abs( bestJ - i ) )
          bestJ = j;
    newPixelVal0[ i ] = bestJ;
```

```
  /* Find the pixel value closest to i that maps into 1. */
  bestJ = -1;
  for( j = 0; j < 256; j = j + 1 )
    if( pixel2BitTable[ j ] == 1 )
      if( bestJ == -1 || abs( j - i ) < abs( bestJ - i ) )
        bestJ = j;
  newPixelVal1[ i ] = bestJ;
}

/*Embed watermark. */
for( y = 0; y < height; y = y + 1 )
  for( x = 0; x < width; x = x + 1 )
  {
    /* Find the index of this pixel. */
    i = y * width + x;

    /* Change the pixel's value to encode the corresponding bit of
       the watermark pattern, and find the error that was introduced. */
    oldPixelVal = c[ i ];
    if( bitPat[ i ] )
      c[ i ] = newPixelVal1[ oldPixelVal ];
    else
      c[ i ] = newPixelVal0[ oldPixelVal ];
    err = oldPixelVal - c[ i ];

    /* Distribute error to neighboring pixels that have not yet been
       processed. */
    if( x + 1 < width )
    {
      j = y * width + (x + 1);
      c[ j ] = ClipRound( c[ j ] + err * 7 / 16 );
    }
    if( x - 1 > 0 && y + 1 < height )
    {
      j = (y + 1) * width + (x - 1);
      c[ j ] = ClipRound( c[ j ] + err * 3 / 16 );
    }
    if( y + 1 < height )
    {
      j = (y + 1) * width + x;
      c[ j ] = ClipRound( c[ j ] + err * 5 / 16 );
    }
    if( x + 1 < width && y + 1 < height )
    {
      j = (y + 1) * width + (x + 1);
      c[ j ] = ClipRound( c[ j ] + err * 1 / 16 );
    }
  }
}
```

```
/* ------------------------------------------------ *
 |                                                  |
 |   D_PXL -- detect a pixel-based authentication mark |
 |                                                  |
 |   Arguments:                                     |
 |     c -- image to authenticate (changed in place to the detected pattern) |
 |     width -- width of image                      |
 |     height -- height of image                    |
 |     seed -- seed for random mapping from pixel values to bit values |
 |                                                  |
 |   Return value:                                  |
 |     none                                         |
 |                                                  |
 * ------------------------------------------------ */
void D_PXL( unsigned char *c, int width, int height, int seed )
{
  int pixel2BitTable[ 256 ];         /* table for mapping pixel values to
                                        bit values (generated according to
                                        seed) */

  int i;                             /* index into image */

  GetPixel2BitTable( seed, pixel2BitTable );
  for( i = 0; i < width * height; i++ )
    c[ i ] = pixel2BitTable[ c[ i ] ] * 255;
}
```

```
/* ------------------------------------------------ *
 |                                                  |
 |   GetPixel2BitTable -- get a table mapping pixels into bit values |
 |                                                  |
 |   Arguments:                                     |
 |     seed -- each seed generates a unique table   |
 |     pixel2BitTable -- where to store table       |
 |                                                  |
 |   Return value:                                  |
 |     none                                         |
 |                                                  |
 * ------------------------------------------------ */
void GetPixel2BitTable( int seed, int *pixel2BitTable )
{
  int i;                             /* pixel value */

  srand( seed );
  for( i = 0; i < 256; i = i + 1 )
    if( rand() < RAND_MAX / 2 )
      pixel2BitTable[ i ] = 0;
    else
      pixel2BitTable[ i ] = 1;
}
```

Routine from earlier systems:

■ ClipRound—Section C.1

Notation and Common Variables

D.1 Variable Naming Conventions

In this book, we employ the following variable notation:

- scalar values, n, in italic, serifed font
- random scalar values, n, in italic, sans serif font
- vectors and higher dimensional arrays, \mathbf{c}, in bold face, serifed font
- random vectors, \mathbf{c}, in bold, sans serif font
- transform domain vectors and arrays, \mathbf{C}, in uppercase, bold, serifed font
- sets, \mathcal{A}, in uppercase, caligraphic font

Scalar variables are also used for objects of unspecified datatype, such as messages, m.

Subscripts are used to denote different versions of a variable. For example, \mathbf{c} denotes a Work, $\mathbf{c_o}$ denotes the original version of a Work, $\mathbf{c_w}$ denotes a watermarked Work, etc. Subscripts usually have the same type style as the variables to which they are attached. However, when it refers to another variable, a subscript has the type style of that variable instead. For example, \mathbf{w}_m is a watermark pattern or vector that represents message m.

For vectors and higher dimensional arrays, indices are specified in square brackets. For example the pixel of image \mathbf{c} located at row i, and column j is specified by $\mathbf{c}[i, j]$. When discussing Works of unspecified type, we regard them as one-dimensional (e.g. $\mathbf{c}[i]$).

We are not always strict about distinguishing between random and non-random variables. In general, we use a random variable, such as n, only when we intend to discuss its statistical properties.

The probability distribution or density function for random variable n is denoted $P_n(n)$. Thus, $P_n(n)$ is either the probability that $n = n$ (if it is a probability distribution) or the derivative of the probability that $n < n$ (if it is a density function).

D.2 Operators

We use the asterisk symbol to indicate convolution. The convolution of vector \mathbf{v} and filter \mathbf{f} is $\mathbf{v} * \mathbf{f}$.

We use a dot, \cdot, to denote the inner product of two vectors. Thus, $\mathbf{c} \cdot \mathbf{w} = \sum_i \mathbf{c}[i]\mathbf{w}[i]$. If \mathbf{c} and \mathbf{w} are two-dimensional arrays, then $\mathbf{c} \cdot \mathbf{w} = \sum_{i,j} \mathbf{c}[i,j]\mathbf{w}[i,j]$.

The floor function is denoted $\lfloor \ldots \rfloor$. This function rounds its real-valued argument down to the next integer.

Absolute-value bars, $|\ldots|$, have various meanings depending on the type of value between them:

- $|n|$ is the absolute value of scalar n
- $|\mathbf{c}|$ is the Euclidian length, or magnitude, of vector \mathbf{c}, computed as $\sqrt{\mathbf{c} \cdot \mathbf{c}}$
- $|\mathcal{A}|$ is the number of elements in set \mathcal{A}

We use $\mathcal{F}_x\{expression\}$ to indicate the Fourier transform of an expression. The subscript indicates which variable in the expression should be considered "time". Thus

$$\mathcal{F}_x\{expression\ involving\ x\ and\ y\} = \int_{-\infty}^{\infty} expression\ dx,\ with\ y\ held\ constant$$

and

$$\mathcal{F}_y\{expression\ involving\ x\ and\ y\} = \int_{-\infty}^{\infty} expression\ dy,\ with\ x\ held\ constant.$$

D.3 Common Variable Names

Table D.1 Common variables.

Variable	Description		
μ_r	Statistical mean of random variable r		
σ_r	Statistical standard deviation of random variable r		
σ_r^2	Statistical variance of random variable r		
\bar{r}	Sample mean of vector r		
s_r	Sample standard deviation of vector r		
s_r^2	Sample variance of vector r		
\mathbf{c}	A Work		
$\mathbf{c_o}$	Cover Work (original)		
$\mathbf{c_w}$	Watermarked Work		
\mathbf{w}	Watermark vector or pattern		
$\mathbf{w_r}$	Reference vector or pattern		
$\mathbf{w_a}$	Added vector or pattern		
$\mathbf{w_s}$	Shaped vector or pattern		
\mathbf{w}_m	Message mark for message m		
$\mathbf{w_{ri}}$	Reference mark for symbol location i		
s	An array of perceptual slacks		
m	Message		
a	Symbol		
K	Key		
K_c	Cipher key		
K_w	Watermark key		
\mathbf{v}	Extracted mark		
$\mathbf{v_o}$	Mark extracted from a cover Work		
$\mathbf{v_w}$	Mark extracted from a watermarked Work		
τ_{lc}	Linear correlation detection threshold		
τ_{nc}	Normalized correlation detection threshold		
τ_{cc}	Correlation coefficient detection threshold		
τ_{white}	Whitened linear correlation detection threshold		
\mathcal{A}	Alphabet (set of symbols)		
\mathcal{M}	Set of messages		
\mathcal{R}	Set of real numbers		
L	Length of a sequence of symbols		
\mathcal{W}_{AL}	A set of $L \times	\mathcal{A}	$ reference marks
P_{fp}	False positive probability		
α	Blind embedding strength/weighting factor for informed embedding		
β	Embedding strength in some informed embedders		

D.4 Common Functions

Table D.2 Common functions.

Variable	Description
$z_{lc}(\mathbf{v}, \mathbf{w})$	Linear correlation detection statistic
$z_{nc}(\mathbf{v}, \mathbf{w})$	Normalized correlation detection statistic
$z_{cc}(\mathbf{v}, \mathbf{w})$	Correlation coefficient detection statistic
$z_{white}(\mathbf{v}, \mathbf{w})$	Whitened linear correlation detection statistic
$D(\mathbf{a}, \mathbf{b})$	Perceptual distance measure between \mathbf{a} and \mathbf{b}
$D_{wat}(\mathbf{a}, \mathbf{b})$	Perceptual distance measure between \mathbf{a} and \mathbf{b} as measured by the Watson perceptual model
$D_{mse}(\mathbf{a}, \mathbf{b})$	Perceptual distance measure between \mathbf{a} and \mathbf{b} as measured by mean square error
$D_{snr}(\mathbf{a}, \mathbf{b})$	Perceptual distance measure between \mathbf{a} and \mathbf{b} based on the reciprocal of signal-to-noise ratio
$\mathbf{v} = \mathcal{X}(\mathbf{c})$	Extraction function
$\mathbf{c_w} = \mathcal{E}_K(m, \mathbf{c_o})$	Embedding function
$m = \mathcal{D}_K(\mathbf{c_w})$	Blind detection function

Glossary

2AFC See *Two Alternative, Forced Choice.*

Absolute threshold (of hearing) The minimum audible intensity of a pure tone in a noiseless environment.

Active attack Any attempt to thwart the purpose of a watermarking system by modifying content. This includes *unauthorized removal* (or *removal attacks*) and *unauthorized embedding* (or *forgery attacks*).

Added pattern The sample-by-sample difference between an original and a watermarked version of a Work (i.e., the pattern added to a Work to embed a watermark).

Added vector/mark The difference between a marking-space vector extracted from a watermarked version of a Work and one extracted from the original version of that Work. This is analogous to an *added pattern*, which is the corresponding vector in media space.

Additive noise A random signal, independent of a Work, that is added to the Work.

Additive noise channel A communications channel in which the transmitted signal is corrupted by additive noise before reaching the receiver.

Adversary Anyone who attempts to thwart the purpose of a watermarking system. Depending on the application, adversaries might attempt a variety of attacks, including *unauthorized removal, unauthorized detection,* and *unauthorized embedding.* Other terms from the literature that have been used for an adversary include *pirate, hacker, attacker,* and *traitor.*

Alphabet A set of symbols, sequences of which can be used to represent messages.

Aspect ratio The ratio of width to height of an image or video frame. This ratio is sometimes presented as a fraction (e.g., 4/3), but more commonly as the width and height separated by a colon (e.g., 4:3).

Asymmetric fingerprinting A phrase sometimes used to refer to a special type of watermarking system designed for transaction tracking. In such a system, the owner of a Work transmits the Work to a buyer in such a way that the buyer receives a watermarked copy, but neither the owner nor the buyer knows what the watermark is. (This type of system is not discussed in this book.)

Asymmetric key cryptography Any method of cryptography in which encryption and decryption require the use of different cipher keys.

Asymmetric key watermarking Any method of watermarking in which embedding and detection require the use of different watermarking keys. The aim of such systems, as yet unattained, is to allow individuals to detect and decode a watermark without allowing them to embed or remove one.

Asymmetric watermarking See *Asymmetric key watermarking*.

Attack Any attempt to thwart the purpose of a watermarking system.

Attacker See *Adversary*.

Authentication The process of verifying the integrity of a watermark or its cover Work. See also *Exact authentication* and *Selective authentication*.

Authentication mark A watermark designed to verify the integrity of the cover Work in which it is embedded.

AWGN Additive white Gaussian noise. This is an additive noise source in which each element of the random noise vector is drawn independently from a Gaussian distribution.

Base bits In an error correction code word, the bits from which the parity bits are computed. Generally, these bits are identical to the bit sequence the code word represents and are thus more commonly referred to as *message bits*. However, in a syndrome code, the message is encoded in the parity bits, and the base bits can take any value.

BCH Bose-Chandhuri-Hocquenghem. A form of error correction code.

BER See *Bit error rate*.

Bit error rate (BER) The frequency of bit errors when detecting a multibit watermark message.

Blind coding Any method of mapping messages into message marks that is independent of the cover Work in which the mark will be embedded. This is in contrast to *informed coding*.

Blind detection Detection of watermarks without any knowledge of the original, unwatermarked content. This is in contrast to *informed detection*. Some authors restrict *blind detection* to refer to detection without any key, as well as no knowledge of the original.

Blind embedding A simple approach to watermark embedding in which the *added pattern* is independent of the cover Work. This is in contrast to *informed embedding* and *informed coding*.

Blind watermarking Watermarking systems that use *blind detection*. We avoid this term, preferring instead to specify whether we mean blind embedding or blind detection.

Block DCT A linear transform, commonly used in image processing. An image is first divided into blocks, and then the discrete cosine transform is applied to each block.

Brightness sensitivity The ability of the human eye to discriminate between different brightnesses of light. This generally changes as a function of mean brightness. Perceptual models account for this variable sensitivity when determining the visibility of a particular intensity change.

Broadcast monitoring An application of watermarking in which a detector monitors radio or television broadcasts, searching for watermarks. This can be used to ensure that advertisements are properly broadcast, and that royalties are properly paid.

Channel capacity The maximum achievable code rate for a channel, or, more precisely, the supremum of all achievable rates. That is, any rate less than the channel capacity is achievable, but the channel capacity itself cannot necessarily be achieved.

Channel decoder A process that inverts the channel encoding process and attempts to identify and correct any transmission errors. This is performed at the receiver.

Channel encoder A function that maps messages into signals that can be reliably transmitted over a channel.

Chip In spread spectrum communications, a pseudo-random spreading sequence used to modulate a signal. In watermarking, chips may be considered analogous to reference patterns.

Cipher Any method of encrypting and decrypting messages.

Cipher key A secret key or pair of keys used for encryption and decryption of a message, as opposed to a *watermark key*, used for embedding and detecting messages in watermarks.

Ciphertext A message in encrypted form.

Cleartext A message that is not encrypted and can be understood by anyone.

Code book A set of *code words* or *code vectors*.

Code division multiplexing The transmission of multiple messages or symbols over a single channel by representing them with orthogonal signals that might overlap in time, space, and/or frequency.

Code vector A vector that represents a message.

Code word A vector, sequence of symbols, or sequence of bits that represents a message.

Collusion attack A method of *unauthorized removal* in which an adversary obtains several versions of a Work, each with a different watermark. The Works are then combined to create a Work in which the watermarks are essentially undetectable. This term is sometimes also used to refer to attacks in which the adversary obtains many different Works that contain the same watermark, and uses them to identify the pattern associated with that mark.

Collusion-secure code A code that is secure against certain types of collusion attack. Specifically, it is secure against attacks that employ several copies of the same Work containing different watermark messages.

Compliant device A device that complies with a given standard for copy control technology. In the context of watermarking, a compliant device is a media recorder or player that detects watermarks and responds to them in appropriate ways.

Content The set of all possible Works of a particular type.

Contrast sensitivity The sensitivity of the human visual system to changes in luminance as a function of spatial frequency.

Convolution code A class of error correction codes. Equivalent to *trellis codes*.

Copy attack An attack in which an adversary copies a legitimate watermark from one Work to another. This constitutes a form of unauthorized embedding.

Copy control The prevention of copyright violations. This includes any system for preventing the recording of copyrighted content or playback of pirated content.

Copyright protection The legal protection afforded a Work by national and international law. Also used to refer to *copy control* technologies.

Correlation See *Linear correlation, Normalized correlation,* and *Correlation coefficient.*

Correlation coefficient A form of normalized correlation in which the each vector is first modified to have zero mean prior to the magnitude normalization.

Coset A subset that results from partitioning a larger set.

Cover-<*data type*> A cover Work. The *datatype* indicates the type of the Work. For example, "cover-text" or "cover-audio".

Cover Work A Work in which a watermark is embedded (or is about to be embedded). The term is derived from the idea is that the Work "covers" the watermark.

Covert communications Secret communication between two or more parties. Adversaries should not know that the communication is taking place.

CPTWG Copy Protection Technical Working Group—an open committee founded in 1995 to propose a copy control system for DVD video.

Critical bandwidth A psychophysical property of hearing. Consider a narrow-band noise source we perceive with a certain loudness. If the bandwidth of the noise source is increased, the perceived loudness will remain constant until the bandwidth exceeds the critical bandwidth. The critical bandwidth varies with frequency.

Cryptography The study and practice of keeping messages secure.

CSS Content scrambling system—a method of scrambling video used in the copy control system of DVD video.

Data hiding See *Information hiding.*

Data payload The number of bits a watermark encodes within a unit of time or within a Work.

DCT See *Discrete cosine transform.*

Decipher See *Decryption.*

Decoder See *Watermark decoder.*

Decryption The translation of ciphertext to plaintext.

DeCSS An illegal computer program that descrambles video protected with CSS.

Detection measure See *Detection statistic.*

Detection region A region of media space or marking space representing the entire collection of Works that yield positive watermark detections. Each watermark message has a distinct detection region.

Detection statistic Any measure of the likelihood that a signal is present. Common detection statistics include linear correlation, normalized correlation, and the correlation coefficient.

Detector See *Watermark detector.*

Device control The use of watermarks to control devices. This term encompasses more than just copy control applications. For example, watermarks have been used to synchronize a toy's actions with video.

DHSG Data Hiding Sub-Group—a subgroup of the *CPTWG* devoted to studying video watermarking technologies.

Digital rights management (DRM) Technical, legal, and business issues pertaining to copyright management and control when a Work is in a digital form.

Digital signature The digital equivalent of a traditional signature. They are used to verify the identity of the sender. A digital signature can be constructed by encrypting a one-way hash of a message with the sender's private key.

DIM See *Dithered index modulation.*

Direct message coding A method of coding watermark messages in which a separate reference mark is predefined for each message. The reference marks are usually generated pseudorandomly. This is in contrast to *multi-symbol message coding.*

Dirty-paper codes A class of codes in which each message is represented by a number of dissimilar code vectors. Named in reference to Costa's article "Writing on Dirty Paper" [53]. These codes are instrumental in informed coding.

Discrete cosine transform A transform commonly used in image and video compression. The basic functions in this transform are real-valued cosine waves.

Distribution of unwatermarked Works Indicates the likelihood of each Work entering a watermark embedder or detector. Note that this distribution is application dependent.

Dithered index modulation A method of implementing a lattice code in which a Work is first correlated with a predefined set of patterns, and each correlation value is quantized to an integral multiple of some quantization step size.

Dithered quantization A process in which a *dither signal* is added to an original signal prior to quantization. The dither signal is usually pseudo-random. If a well-chosen dither signal is added to the input signal prior to quantization, the quantization error will be independent of the input signal.

Document See *Work*.

DRM See *Digital rights management*.

ECC See *Error correction code*.

Effectiveness The probability that a watermark embedder will successfully embed a watermark in a Work.

Elimination attack The removal of a watermark (by an adversary) so that no amount of subsequent postprocessing will retrieve it. This is in contrast to a *masking attack*.

Embedded-<*data type*> A watermark. The *datatype* indicates what the watermark represents. For example, "embedded-text" or "embedded-image."

Embedder An algorithm or mechanism for inserting a watermark in a Work. Embedders take at least two inputs: the message to be embedded as a watermark and the cover Work in which we want to embed the mark. The output is a watermarked Work. Embedders may also employ a watermark key.

Embedding region A region of media or marking space that represents the collection of all possible output Works from a watermark embedder.

Encipher See *Encryption*.

Encoder Abstractly: a mapping of messages into signals or code vectors. Concretely: an algorithm or mechanism that takes messages as input (usually represented with binary sequences) and outputs symbolic sequences or real-valued vectors. Encoders are typically implemented in multiple stages. For example, the first stage—*error correction coding*—generates symbolic sequences that contain redundancy so that the messages can be identified even after errors are introduced. The second stage—*modulation*—maps symbolic sequences into real-valued vectors that can be physically transmitted (embedded in a watermark).

Encryption The translation of a plaintext message into ciphertext.

Erasable watermark A watermark that can be exactly removed from a Work, thereby obtaining a bit-for-bit copy of the original unwatermarked Work. Such watermarks are more commonly referred to as *invertible*, but this conflicts with another meaning of *invertible* in the context of proof of ownership (see *Invertible watermark*).

Error correction code (ECC) A mapping of messages into sequences of symbols such that not every possible sequence represents a message. In decoding such a code, sequences that do not correspond to messages are interpreted as corrupted code words. By defining the mapping between messages and code words in an appropriate way, it is possible to build decoders that can identify the code word closest to a given, corrupted sequence (i.e., decoders that correct errors).

Error correction encoder An encoder that implements an error correction code.

Exact authentication Verification that every bit of a given Work has remained unchanged. This is in contrast to *selective authentication*.

Extracted mark A vector obtained by applying an extraction function to a Work.

Extraction function A function that maps media-space vectors (content) into marking-space vectors.

Fading channel A type of communications channel in which the signal strength varies over time.

False negative A type of error in which a detector fails to detect a watermark in a watermarked Work.

False negative probability The probability that a *false negative* will occur during normal usage of a detector. Note that this is application dependent, in that "normal usage" is application dependent.

False positive A type of error in which a detector incorrectly determines that a watermark is present in a Work that was never watermarked.

False positive probability The probability that a *false positive* error will occur during normal usage of a detector. Note that depending on the application this might have subtly different meanings (see *Random-watermark false positive probability* and *Random-Work false positive probability*).

False positive rate The frequency with which *false positives* occur during normal usage of a detector.

Fidelity The perceptual similarity between an original Work and a Work that has undergone some processing, such as watermark embedding. This is in contrast to *quality*.

Fingerprinting In the context of watermarking, usually synonymous with transaction tracking. However "fingerprinting" sometimes refers to the practice of extracting inherent feature vectors that uniquely identify the content. We avoid using this term to prevent confusion.

Forgery See *Unauthorized embedding*.

Fragile watermark A watermark that becomes undetectable after even minor modifications of the Work in which it is embedded. These are unsatisfactory for most applications, but can be useful for authentication.

Frequency division multiplexing The transmission of multiple messages or symbols over a single channel by representing them with patterns that are disjoint in the frequency domain.

Frequency domain watermarking A watermarking system that modifies specific frequency coefficients of a Work. Note that the implementation of such a system does not necessarily require that the operations be performed in the frequency domain. Equivalent operations can be performed in the temporal or spatial domain.

Frequency hopping A method of spread spectrum communication in which the transmitter broadcasts a message by first transmitting a fraction of the message on one frequency, the next portion on another frequency, and so on.

Frequency sensitivity The response of a human perceptual system to differences in the frequencies of stimuli. In audition, the frequency of interest is the frequency of sounds. In vision, there are three distinct types of frequency sensitivity: sensitivity to spatial frequency, temporal frequency, and color.

Generational copy control The allowance of some copying while preventing subsequent copies from being made. This is of particular interest in the copy protection of content broadcast over the public airwaves, because under U.S. law consumers have the right to make a single copy of such content, but may not make a copy of the copy.

Gold sequences A specific set of binary sequences that have low cross correlation with one another. See [237].

Golden ears People who possess extremely acute hearing.

Golden eyes People who possess extremely acute vision.

Hamming code An error correction code.

HAS Human auditory system.

Hash See *Hash function*.

Hash function A mapping of a variable-length string into a fixed-length string called a *hash*. Typically, the hash of a string is shorter than the original.

HVS Human visual system.

Illegitimate distortion A distortion that makes a Work invalid for some application. For example, in medical imaging, a distortion that might lead a doctor to an incorrect diagnosis. This is in contrast to *legitimate distortion*.

Imperceptible Undetectable by a human perceptual system. This is often defined statistically. See *Just noticeable difference*.

Implicit synchronization A class of methods for making watermarks robust against geometric transformations. In such methods, existing features of a Work are used for synchronization.

Information hiding The art and science of hiding information. The fields of steganography and watermarking are examples of information hiding, but the term covers many other subjects, such as anonymous communications and preventing unauthorized database inference.

Informed coding Any method of mapping messages into message marks that examines the cover Work during the coding process and determines the best code to use. In informed coding a given message can be mapped into different message marks for different cover Works. This is in contrast to *blind coding*.

Informed detection Detection of a watermark with some knowledge of the original unwatermarked Work. This knowledge can take the form of the original Work itself or some function of the original Work. Informed detection is in contrast to *blind detection*.

Informed embedding A form of embedding in which the modification of a message mark into an added mark is based on an examination of the cover Work. This includes perceptual shaping of a mark before embedding, as well as optimization of the added mark based on an estimate of robustness. It is in contrast to *blind embedding*.

Inseparability The property of watermarks in which they are not separated from their cover Works by conversion between formats or other forms of processing that preserve perceptual quality.

Invertible watermark A watermark that is susceptible to the ambiguity attack. This occurs if it is possible to generate a fake original from a distributed Work such that the distributed Work appears to be obtained by embedding a given watermark into the fake (i.e., it is possible to "invert" the embedding process). The term has also been used to describe what we refer to as an *erasable watermark*.

ITU International Telecommunications Union—a standards organization that, among other things, establishes guidelines for measuring television picture quality.

Jamming A term used in military communications to describe an adversary's effort to prevent a communications signal from being received.

JND See *Just noticeable difference*.

JPEG Joint Picture Experts Group—JPEG is a standard image compression technique based on block DCT quantization. JPEG 2000 is a multi-scale wavelet-based image compression standard.

Just noticeable difference (JND) In psychophysics studies: a level of distortion that can be perceived in 50% of experimental trials. Multiple JNDs are defined a variety of ways.

Key See *Watermark key* and *Cipher key*.

Key management Procedures for ensuring the integrity of keys used in cryptographic systems. This can include key generation, key distribution, and key verification.

Keyspace The space from which keys are chosen. A large keyspace implies many keys and increased security because a larger space must be searched by an adversary.

Lattice code A form of dirty-paper code in which all code vectors lie on a lattice. *Dithered index modulation* and *least-significant-bit watermarking* employ lattice codes.

Least-significant-bit watermarking The practice of embedding watermarks by placing information in the least significant bits of their cover Works.

Legitimate distortion A distortion that does not change a Work's value for a given application. For example, in most applications lossless compression does not introduce perceptible artifacts. This is in contrast to *illegitimate distortion*.

Letterbox A format for displaying wide-screen movies on standard television sets. In *letterbox* format, the image is reduced in size so that it fits onto the 4:3 television screen in its entirety, with some black lines added above and below.

Linear correlation A standard detection statistic. The linear correlation of two N-dimensional vectors, \mathbf{u} and \mathbf{v}, is defined as

$$z_{lc}(\mathbf{u}, \mathbf{v}) = \frac{1}{N}\mathbf{u} \cdot \mathbf{v}.$$

Loudness sensitivity The ability of the human auditory system to distinguish between different loudnesses. This generally changes as a function of average loudness. Perceptual models account for this variable sensitivity when determining the audibility of a particular sound pressure change.

L_p-norm (Also called a *Minkowski summation*.) A class of measures of vector lengths. The L_p-norm of a vector, \mathbf{x}, is defined as

$$L_p(\mathbf{x}) = \sqrt[p]{\sum_i (\mathbf{x}[i])^p}.$$

The L_2-norm is a Euclidian length.

m-sequence A specific set of binary sequences that have low cross correlation with one another. See [237].

MAC See *Message authentication code*.

Marking space Any space in which watermark embedding and detection takes place. This may be a subspace or distortion of media space.

Masking A measure of an observer's response to one stimulus when a second stimulus is present.

Masking attack A form of watermark removal attack that makes watermarks undetectable using existing detectors, but does not prevent detection using more sophisticated detectors. In this sense, it does not truly remove the watermark. An example of a masking attack would be to imperceptibly rotate an image if existing detectors cannot correct for rotations. This is in contrast to *elimination attacks*.

Media The means of representing, transmitting, and recording content. For example, an audio CD-ROM, a JPEG image file, or a VHS tape.

Media space A high-dimensional space in which each point corresponds to one Work.

Message Information to be transmitted over a channel or embedded in a watermark.

Message authentication code A one-way hash of a message that is then appended to the message. This is used to verify that the message is not altered between the time the hash is appended and the time it is tested.

Message bits See *Base bits.*

Message mark A vector in marking space that encodes a particular message.

Message pattern A watermark pattern that encodes a particular message. This is a vector in media space (i.e., a digital object of the same type and dimension as the cover Work).

Messaging layer A layer of a networking system concerned with composing and interpreting messages. This is in contrast to a *transport layer.*

Metric A function of two vectors, $d(\mathbf{x}, \mathbf{y})$, that satisfies the following conditions for all \mathbf{x}, \mathbf{y}, and \mathbf{z}:

- $d(\mathbf{x}, \mathbf{y}) \geq 0$
- $d(\mathbf{x}, \mathbf{y}) = 0$ if and only if $\mathbf{x} = \mathbf{y}$
- $d(\mathbf{x}, \mathbf{y}) = d(\mathbf{y}, \mathbf{x})$
- $d(\mathbf{x}, \mathbf{y}) \leq d(\mathbf{x}, \mathbf{z}) + d(\mathbf{z}, \mathbf{y})$

Minkowski summation See L_p*-norm.*

Modulator An algorithm or device that converts a sequence of symbols into a physical signal that can travel over a channel. For example, it might use its input to modulate the amplitude, frequency, or phase of a physical carrier signal for radio transmission. See also *Encoder.*

MPEG Motion Picture Experts Group—MPEG, MPEG-2, and MPEG-4 are standard video compression algorithms.

MP3 MPEG Layer 3 Audio—A standard audio compression algorithm.

Multimedia object See *Work.*

Multi-symbol message coding A method of representing messages as sequences of symbols, which are then modulated. This is in contrast to *direct message coding.*

N-ball A spherical volume in N-dimensional space. That is, where as N-sphere includes only the points on the surface, an N-ball includes the internal points as well.

N-cone A conical region in N-dimensional space.

N-sphere A spherical surface in N-dimensional space.

Non-subtractive dither A method of reconstructing signals after *dithered quantization,* in which the dither signal is not subtracted before reconstruction. This is in contrast to *subtractive dither.*

Normalized correlation A standard detection statistic. The normalized correlation of two vectors, \mathbf{u} and \mathbf{v}, is defined as

$$z_{\text{nc}}(\mathbf{u}, \mathbf{v}) = \frac{\mathbf{u} \cdot \mathbf{v}}{|\mathbf{u}||\mathbf{v}|}.$$

NTSC National Television Systems Committee—A television standard used in North America and Japan.

Oblivious In the context of watermarking, oblivious means blind. It is usually used to refer to blind detection.

One-way hash A hash function reasonably inexpensive to calculate, but prohibitively expensive to invert. That is, given an input string, it is easy to find the corresponding output. However, given a desired output, it is virtually impossible to find a corresponding input string.

Panscan A format for displaying wide-screen movies on standard television sets. In *panscan* format, the image fills the 4:3 television screen, but is cropped at the left and right.

Parity bits The bits of a code word that are added to the base bits during encoding.

Passive attack See *Unauthorized detection*.

Patchwork A watermarking algorithm described in [15].

Payload See *Data payload*.

Perceptual shaping The practice of modifying a message mark according to the masking capabilities of a cover Work. This usually takes the form of attenuating the mark in areas where the cover Work cannot hide much noise, and amplifying it in areas where noise can easily be hidden.

Perceptual slack In a perceptual model: a measure of the relative amount by which a given component of a Work may be changed without serious perceptual impact.

Perceptually adaptive watermarking Watermarking systems that attempt to shape the added pattern according to some perceptual model.

Perceptually significant components Those components (features, frequencies, and so on) in which all but the most subtle changes will result in a loss of fidelity. Although at first it seems as though these are the components to avoid when watermarking, these are also the most generally robust components.

Pirate In general, an *adversary*. In the literature on transaction tracking, *pirate* is used more specifically to refer to a person who receives an unauthorized copy of a Work from a *traitor*.

Playback control Preventing playback of illegally recorded, copyrighted Works. A component of *copy control*.

Pooling In a model of perceptual distance: combining the perceptibilities of separate distortions to give a single estimate for the overall change in the Work.

Power-spectrum condition A constraint on the spectrum of a watermark that has been derived in [257, 258] to provide robustness to Wiener filtering. The constraint states that the power spectrum of the added mark should closely match that of the cover Work.

Private watermarking The use of watermarking for any application in which a group called the *public* is not authorized to perform any watermarking operations, including watermark detection. There has been confusion in the literature between private watermarking and private-key cryptography, and between private watermarking and informed detection. For this reason, we avoid the use of this term.

Projected mark See *Extracted mark*.

Proof of ownership An application of watermarking in which a watermark is used to determine the owner of a cover Work.

Public watermarking This use of watermarking for any application in which a group called the *public* is authorized to detect the watermark, but is not authorized to perform any other watermarking operations. There has been confusion in the literature between public watermarking and public-key cryptography, and between public watermarking and blind detection. For this reason, we avoid the use of this term.

Public-key cryptography See *Asymmetric key cryptography*.

QIM See *Quantization index modulation*.

Quality An absolute measure of the goodness of a Work. This is in contrast to *fidelity*.

Quantization index modulation A method of watermarking in which each message is associated with a distinct vector quantizer. The embedder quantizes the cover Work (or a vector extracted from the cover Work) according to the quantizer associated with the desired

message. The detector quantizes the Work using the union of all quantizers, and identifies the message. This is a method of implementing dirty-paper codes, described in [45]. It can be implemented with dithered index modulation.

Quantization watermarking Embedding watermarks by quantizing content in some domain. See, for example, *Dithered index modulation* and *Quantization index modulation*.

Random-watermark false positive probability The probability that a randomly selected watermark is detected in a given Work.

Random-Work false positive probability The probability that a given watermark is detected in a randomly selected Work.

Record control Preventing the recording of copyrighted content. A component of *copy control*.

Reference mark A vector in marking space used for comparison during watermark detection.

Reference pattern A pattern in media space used for comparison during watermark detection.

Reference vector See *Reference mark*.

Region of acceptable distortion See *Region of acceptable fidelity*.

Region of acceptable fidelity A set of points in media or marking space that represents all Works that appear essentially identical to a given cover Work. Each cover Work has a distinct region of acceptable fidelity.

Registration See *Synchronization*.

Removal attacks See *Unauthorized removal*.

Robustness The ability of watermarks to survive signal processing operations. We draw a distinction between *robustness*, which refers to common operations, and *security*, which refers to hostile operations. Many authors do not draw this distinction and use robustness to refer to both types of operations.

SDMI Secure Digital Music Initiative—an organization specifying a copy-control system for digital music. The copy-control system itself is also referred to as SDMI.

Second-generation watermarking Strictly: watermarking systems that employ some form of feature detection [149]. However, this term has been more loosely applied to any system that either does not embed watermarks by simply adding patterns or does not detect watermarks by simple linear or normalized correlation.

Secure transmission Transmission of messages in such a way that they are virtually guaranteed to arrive intact, even if an adversary is attempting to prevent it.

Security In watermarking, the ability of a watermark to resist intentional tampering. More generally, the ability of an entire system (which may incorporate watermarking) to resist intentional tampering.

Selective authentication Verification that a Work has not been subjected to a certain selected set of distortions. A selective authentication process detects application of *illegitimate distortions*, while ignoring application of *legitimate distortions*. This is in contrast to *exact authentication*.

Semi-fragile watermark A watermark that is fragile against certain distortions but robust against others. This is useful for *selective authentication*.

Sensitivity In perception: the human perceptual system's response to direct stimuli.

Sensitivity analysis attack An unauthorized removal attack possible when the adversary has a watermark detector but does not know the detection key. The watermark reference pattern is estimated by adding random patterns to a corrupted version of the Work and testing for detection. Once the reference pattern is estimated, it is subtracted from the Work to remove the watermark.

Side information Any information provided to either the transmitter or receiver in a communications system, other than the message to be transmitted or the received signal to be decoded. In watermarking, the cover Work is available to the embedder as side information.

Signal-to-noise ratio The power or amplitude of a given signal, divided by the power or amplitude of the noise that has been added to it. Usually expressed in decibels. In watermarking, either the watermark pattern or the cover Work can be considered the signal, the other being considered noise. This results in two different signal-to-noise ratios that might be reported: the *signal-to-watermark ratio* and the *watermark-to-noise ratio*.

Signal-to-watermark ratio The power or amplitude of a given cover Work divided by the power or amplitude of a watermark pattern added to it.

Signature See *Digital signature*.

Shaped pattern A message pattern that has been modified by perceptual shaping.

Slack See *Perceptual slack*.

SNR See *Signal-to-noise ratio*.

Sound pressure level The intensity of sound, in decibels (dB), relative to a reference intensity of $20\,\mu$ Pascals.

Space division multiplexing The transmission of multiple messages or symbols over a single channel by representing them with patterns that are disjoint in the spatial domain.

SPL See *Sound pressure level*.

Spread spectrum The spreading of a narrow-band signal over a much larger bandwidth.

Spread spectrum communications Communications in which narrow-band signals are spread over much larger bandwidths. This was originally developed by the military to provide resistance to jamming and interference. The exact form of the spreading is a secret known only by the transmitter and receivers. Without knowledge of the spreading function, it is almost impossible for an adversary to detect or interfere with a transmission.

Steganalysis The art of detecting and decoding messages that have been hidden steganographically.

Steganographic message A message the existence of which is kept secret by being hidden within a seemingly innocuous object.

Steganography The art of concealed communication by hiding messages in seemingly innocuous objects. The very existence of a steganographic message is secret. This term is derived from the Greek words *steganos*, which means "covered," and *graphia*, which means "writing."

Stegoanalysis See *Steganalysis*.

Stego-<*datatype*> A Work containing a steganographic message. The datatype indicates the type of the Work. For example, "stego-text" or "stego-image".

Stego-key A key required to detect a steganographic message.

StirMark A specific computer program that applies a variety of distortions to a watermarked Work to evaluate the robustness and security of the mark [211].

Structured codes Codes that can be efficiently represented and that allow efficient search for the closest code word.

Subtractive dither A method of reconstructing signals after *dithered quantization* in which the dither signal is subtracted before reconstruction. This is opposed to *non-subtractive dither*.

Symbols Unique elements that can be sequenced to represent messages.

Symmetric key cryptography Method of encryption in which encryption and decryption require the use of the same secret cipher key.

Synchronization The process of aligning two signals in time or space.

Syndrome The pattern of differences between the parity bits in a received word and parity bits recomputed from the received base bits. This gives some indication of the errors in the received word. It is also used to encode messages in a *syndrome code.*

Syndrome code A class of structured code in which messages are represented in the syndromes of modified code words.

System attack An attack that exploits weaknesses in how watermarks are used, rather than weaknesses in the watermarks themselves.

Tamper resistance The ability of a watermark to resist tampering or attack. See *Security.*

Telecine process The process of converting movies on film into electronic video.

Tell-tale watermarking The use of watermarks to try to identify processes that have been applied to a cover Work.

Time division multiplexing The transmission of multiple messages or symbols over a single channel by representing them with patterns that are disjoint in the time domain.

Traitor In the literature on transaction tracking: a person who obtains a Work legally and subsequently misuses it. In this book, we do not differentiate between traitors and other types of adversaries.

Transaction tracking A watermarking application in which watermarks indicate transactions that have occurred in the history of a Work. In a typical transaction tracking application, the watermark identifies the first legal recipient of the Work. If it is subsequently discovered that the Work has been illegally redistributed, the watermark can help identify the person responsible.

Transparent watermark An imperceptible watermark. This is opposed to *visible watermark.* We do not use these terms in this book because we do not discuss visible watermarks.

Transport layer A layer in a network model concerned with the transmission of messages, but not with their composition or interpretation. This is in contrast to a *messaging layer.*

Trellis code A class of error correction code in which messages specify paths through a graph known as a *trellis.* Each arc in the trellis is labeled with a sequence of symbols, and the sequences for arcs in a given path are concatenated to encode the message corresponding to that path.

Trellis-coded modulation A class of modulation techniques in which sequences of symbols specify paths through a trellis (see *Trellis code*). Each arc in the trellis is labeled with a vector, and the vectors for arcs in a given path are added to modulate the sequence corresponding to that path.

Trustworthy camera A camera that computes an authentication signature and appends it to the image.

Turbo code A class of error correction code.

Two Alternative, Forced Choice (2AFC) A classical experimental paradigm for measuring perceptual phenomena. For each trial stimulus, the observers are forced to choose one of two alternative responses.

Unauthorized deletion See *Unauthorized removal.*

Unauthorized detection A form of attack in which an adversary, who should not be permitted to detect and/or decode watermarks, nevertheless succeeds in detecting or decoding one.

Unauthorized embedding A form of attack in which an adversary, who should not be permitted to embed valid watermarks, nevertheless succeeds in embedding one.

Unauthorized reading See *Unauthorized detection.*

Unauthorized removal A form of attack in which an adversary, who should not be permitted to remove watermarks, nevertheless succeeds in removing one. This can take the form of either a *masking attack* or an *elimination attack.*

Unauthorized writing See *Unauthorized embedding.*

Unobtrusive See *Imperceptible.*

Valumetric distortion A distortion that changes the values of individual samples in a Work.

VBI See *Vertical blanking interval.*

Vertical blanking interval That portion of a video signal that does not contain any picture content.

Visible watermark A visible mark placed over the content of an image or video. Usually, the mark has the properties that it is difficult to remove and is partially transparent. We do not discuss visible watermarks in this book.

Viterbi decoder A method of decoding trellis-coded or trellis-modulated messages.

Watermark A general term that can refer to either an embedded message, a reference pattern, a message pattern, or an added pattern. We use this term only informally.

Watermark decoder The portion of a watermark detector that maps extracted marks into messages. In most cases, this is the entire operation of the watermark detector. Therefore, in this book we generally make no distinction between a watermark detector and watermark decoder.

Watermark detector A hardware device or software application that detects and decodes a watermark.

Watermark key A secret key or key pair used for watermark embedding and detection. This key is analogous to the secret PN-sequences (chips) used in spread spectrum communications. A watermark key can be used in conjunction with a cipher key.

Watermark pattern In general: either a reference pattern, a message pattern, or an added pattern, determined by context.

Watermark-to-noise ratio The power or amplitude of a watermark pattern, divided by the power or amplitude of the cover Work to which it has been added. The denominator of this ratio may also include noise introduced by subsequent processing.

Watermark vector In general: either a reference vector, a message mark, or an added vector, determined by context.

Watermarking The practice of imperceptibly altering a Work to embed a message about that Work. However, note that some authors define this term in other ways. First, imperceptibility is not always considered a defining characteristic of watermarking. Second, the term "watermarking" is sometimes considered to cover only applications in which the same message is embedded in every copy of a Work (i.e. watermarking is not considered to include *transaction tracking*). In this case, the term "marking" is used to encompass both watermarking and transaction tracking.

Work A song, video, picture, or any other object that can have watermarks embedded in it. This definition of the term *Work* is consistent with the language used in United States copyright law [273]. Other terms used to describe a Work in the literature include *document* and *(multimedia) object.*

References

1. J. Abbate. "Inventing the Web," *Proceedings of the IEEE,* 87(11):1999–2002, 1999.

2. J. H. Ahrens and U. Dieter. "Extensions of Forsythe's Method for Random Sampling from the Normal Distribution," *Mathematics of Computation,* 27(124):927–937, 1973.

3. A. J. Ahumada and H. A. Peterson. "Luminance-model-based DCT Quantization for Color Image Compression," *Proceedings of the SPIE,* 1666:365–374, 1992.

4. M. Alghoniemy and A. H. Tewfik. "Geometric Distortion Correction Through Image Normalization," *Proceedings of the International Conference on Multimedia and Expo,* volume 3, pp. 1291–1294, 2000.

5. R. Anderson, editor. *Information Hiding,* volume 1174 of *Lecture Notes in Computer Science.* Berlin; New York: Springer-Verlag, 1996.

6. R. J. Anderson. "Stretching the Limits of Steganography," in Ross Anderson, editor, *Information Hiding: First International Workshop,* volume 1174 of *Lecture Notes in Computer Science,* pp. 39–48. Berlin; New York: Springer-Verlag, 1996.

7. D. Augot, J.-M. Boucqueau, J.-F. Delaigle, C. Fontaine, and E. Goray. "Secure Delivery of Images over Open Networks," *Proceedings of the IEEE,* 87(7):1251–1266, 1999.

8. Z. Bahrav and D. Shaked. "Watermarking of Dithered Halftoned Images," in *Proceedings of the SPIE Conference on Security and Watermarking of Multimedia Data,* volume 3657, pp. 307–316, 1999.

9. M. Barni, F. Bartolini, V. Cappellini, and A. Piva. "A DCT-domain System for Robust Image Watermarking," *Signal Processing,* 66(3):357–372, 1998.

10. J. M. Barton. "Method and Apparatus for Embedding Authentication Information Within Digital Data," *United States Patent* 5,646,997, 1997.

11. P. Bas, J.-M. Chassery, and F. Davoine. "A Geometrical and Frequential Watermarking Scheme Using Similarities," in *Proceedings of the SPIE Conference on Security and Watermarking of Multimedia Contents,* volume 3657, pp. 264–272, 1999.

12. P. Bas, J.-M. Chassery, and B. Macq. "Robust Watermarking Based on the Warping of Pre-defined Triangular Patterns," *Security and Watermarking of Multimedia Contents II,* SPIE-3971:99–109, 2000.

13. J. G. Beerends. "Audion Quality Determination Based on Perceptual Measurement Techniques," in M. Kahrs and K. Brandenburg, editors, *Applications of Digital Signal Processing to Audio and Acoustics,* pp. 1–38. Boston: Kluwer Academic Press, 1998.

14. A. E. Bell. "The Dynamic Digital Disk," *IEEE Spectrum,* 36(10):28–35, 1999.

15. W. Bender, D. Gruhl, N. Morimoto, and A. Lu. "Techniques for Data Hiding," *IBM Systems Journal,* 35(3/4):313–336, 1996.

16. O. Benedens. "Geometry-based Watermarking of 3D Models," *IEEE Computer Graphics and Applications,* 19:46–55, 1999.

17. C. Berrou and A. Glavieux. "Near Optimum Error Correcting and Decoding: Turbo-codes," *IEEE Transactions on Communications,* 44(10):1261–1271, 1996.

18. S. Bhattacharjee and M. Kutter. "Compression-tolerant Image Authentication," in *IEEE International Conference on Image Processing,* volume 1, pp. 435–439, 1998.

19. K. A. Birney and T. R. Fischer. "On Modeling of DCT and Subband Image Data for Compression," *IEEE Transactions on Image Processing,* 4(2):186–193, 1995.

20. J. A. Bloom, I. J. Cox, T. Kalker, J-P. Linnartz, M. L. Miller, and B. Traw. "Copy Protection for DVD Video," *Proceedings of the IEEE,* 87(7):1267–1276, 1999.

21. J. Boeuf and J. P. Stern. An Analysis of One of the SDMI Candidates," in *Proceedings of Info Hiding '01,* 2001.

22. B. P. Bogert, M.J.R. Healy, and J. W. Tukey. "The Quefrency Alanysis of Time Series for Echos: Cepstrum, Pseudo-autocovariance, Cross-cepstrum, and Saphe Cracking," in *Proceedings of the Symposium Time Series Analysis,* pp. 209–243, 1963.

23. D. Boneh and J. Shaw. "Collusion-secure Fingerprinting for Digital Data," in *Proceedings of Advances in Cryptology: CRYPTO'95, Lecture Notes in Computer Science* 963, pp. 452–465, Berlin; New York: Springer-Verlag, 1995.

24. L. Boney, A. H. Tewfik, and K. N. Hamdy. "Digital Watermarks for Audio Signals," in *Proceedings of the Third IEEE International Conference on Multimedia Computing and Systems,* pp. 473–480, 1996.

25. A. Borodin, R. Ostrovsky, and Y. Rabani. "Lower Bounds for High-Dimensional Nearest Neighbor Search and Related Problems," in *Proceedings of the 31st ACM STOC,* pp. 312–321, 1999.

26. R. N. Bracewell. *The Fourier Transform and Its Applications.* New York: McGraw-Hill, 1986.

27. J. Brassil, S. Low, N. Maxemchuk, and L. O'Gorman. "Electronic Marking and Identification Techniques to Discourage Document Copying," in *Proceedings of IEEE Inforcom'94,* volume 3, pp. 1278–1287, 1994.

28. J. Brassil, S. Low, N. Maxemchuk, and L. O'Gorman. "Electronic Marking and Identification Techniques to Discourage Document Copying," *IEEE Journal of Selected Areas in Communication,* 13:1495–1504, 1995.

29. G. W. Braudaway, K. A. Magerlein, and F. Mintzer. "Protecting Publicly Available Images with a Visible Image Watermark," in *SPIE Conference on Optical Security and Counterfeit Deterrence Techniques,* volume 2659, pp. 126–133, 1996.

30. H.-J. Braun. "Advanced Weaponry of the Stars," *American Heritage of Invention & Technology,* 12(4):10–16, 1997.

31. R. S. Broughton and W. C. Laumeister. "Interactive Video Method and Apparatus," *United States Patent* 4,807,031, 1989.

32. J. Brown. "Playmate Meets Geeks Who Made Her a Net Star," Wired News Web Site, May 1997, *http://www.wired.com/news/culture/0,1284,4000,00.html.*

33. L. G. Brown. "A Survey of Image Registration Techniques," *ACM Computing Surveys,* 24(4):325–376, 1992.

34. R. A. Burke. "The Most Beautiful Book of the Fifteenth Century: Hypnerotomachia Poliphili," *Bulletin of the New York Public Library,* 58(9):419–428, 1954.

35. P. Buser and M. Imbert. Translated by R. H. Kay. *Audition.* Cambridge, MA: MIT Press, 1992.

36. F. W. Campbell and J. J. Kulikowski. "Orientation Selectivity of the Human Visual System," *Journal of Physiology,* 187:437–445, 1966.

37. F. W. Campbell, J. J. Kulikowski, and J. Levinson. "The Effect of Orientation on the Visual Resolution of Gratings," *Journal of Physiology,* 187:427–436, 1966.

38. C. Carr and P. E. O'Neill. "Adding INSPEC to Your Chemical Search Strategy: Let's Get Physical," *Database,* 18(2):99–102, 1995.

39. D. Casasent and D. Psaltis. "Position, Rotation, and Scale-invariant Optical Correlation," *Applied Optics,* 15(7):1795–1799, 1976.

40. D. Casasent and D. Psaltis. "New Optical Transforms for Pattern Recognition," *Proceedings of the IEEE,* 65(1):77–84, 1977.

41. A. Chakrabarti, B. Chazelle, B. Gum, and A. Lvov. "A Lower Bound on the Complexity of Approximate Nearest Neighbor Searching on the Hamming Cube," in *Proceedings of the 31st ACM STOC,* pp. 305–311, 1999.

42. E.-C. Chang and M. Orchard. "Geometric Properties of Watermarking Schemes," *IEEE International Conference on Image Processing,* 3:714–717, 2000.

43. B. Chen and C.-E. Sundberg. "Digital Audio Broadcasting in the FM Band by Means of Contiguous-band Insertion and Pre-canceling Techniques," *IEEE Transactions on Communications,* 48(10):1634–1637, 2000.

44. B. Chen and G. W. Wornell. "Digital Watermarking and Information Embedding Using Dither Modulation," in *IEEE Second Workshop on Multimedia Signal Processing,* pp. 273–278, 1998.

45. B. Chen and G. W. Wornell. "An Information-theoretic Approach to the Design of Robust Digital Watermarking Systems," *IEEE Conference on Acoustics, Speech, and Signal Processing,* volume 4, pp. 2061–2064, 1999.

46. B. Chen and G. W. Wornell. "Pre-processed and Post-processed Quantization Index Modulation Methods for Digital Watermarking," in *Security and Watermarking of Multimedia Contents II,* SPIE-3971, pp. 48–59, 2000.

47. Q. Cheng and T. S. Huang. "Blind Digital Watermarking for Images and Videos and Performance Analysis," in *IEEE International Conference on Multimedia and Expo,* volume 1, pp. 389–392, 2000.

48. J. Chou, S. S. Pradhan, and K. Ramchandran. "On the Duality Between Distributed Source Coding and Data Hiding," *Thirty-third Asilomar Conference on Signals, Systems, and Computers,* 2:1503–1507, 1999.

49. J. H. Conway and N. J. A. Sloane. *Sphere Packings, Lattices, and Groups.* New York: Springer-Verlag, 1988.

50. D. Coppersmith, F. Mintzer, C. Tresser, C. W. Wu, and M. M. Yeung. "Fragile Imperceptible Digital Watermark with Privacy Control," in *Security and Watermarking of Multimedia Contents,* SPIE-3657, pp. 79–84, 1999.

51. Corel Stock Photo Library 3, Corel Corporation, Ontario, Canada.

52. T. N. Cornsweet. *Visual Perception.* New York: Academic Press, 1970.

53. M. Costa. "Writing on Dirty Paper," *IEEE Transactions on Information Theory,* 29:439–441, 1983.

54. T. M. Cover and J. A. Thomas. *Elements of Information Theory.* New York: John Wiley & Sons, 1991.

55. I. J. Cox. "Spread Spectrum Watermark for Embedded Signaling," *United States Patent* 5,848,155, 1998.

56. I. J. Cox. "Watermarking of Image Data Using MPEG/JPEG Coefficients," *United States Patent* 6,069,914, 2000.

57. I. J. Cox and J.-P. M. G. Linnartz. "Public Watermarks and Resistance to Tampering," *IEEE International Conference on Image Processing,* volume 3, pp. 0-3–0-6, 1997.

58. I. J. Cox and M. L. Miller. "Counteracting Geometric Distortions for DCT-based Watermarking," *United States Patent* 6,108,434, 2000.

59. I. J. Cox, M. L. Miller, and A. McKellips. "Watermarking as Communications with Side Information," *Proceedings of the IEEE,* 87(7):1127–1141, 1999.

60. I. J. Cox, J. Kilian, F. T. Leighton, and T. Shamoon. "Secure Spread Spectrum Watermarking for Multimedia," *IEEE Transactions on Image Processing,* 6(12):1673–1687, 1997.

61. I. J. Cox and M. L. Miller. "A Review of Watermarking and the Importance of Perceptual Modeling," in *Proceedings of SPIE, Human Vision & Electronic Imaging II,* volume 3016, pp. 92–99, 1997.

62. S. Craver. "On Public-key Steganography in the Presence of an Active Warden," in D. Aucsmith, editor, *Workshop on Information Hiding, Portland, OR,* volume 1525 of *Lecture Notes in Computer Science,* pp. 355–368. Berlin; New York: Springer-Verlag, 1998.

63. S. Craver, N. Memon, B.-L. Yeo, and M. M. Yeung. "Can Invisible Watermarks Solve Rightful Ownerships?" IBM Technical Report RC 20509, IBM Research, July 1996. IBM CyberJournal: *http://www.research.ibm.*

64. S. Craver, N. Memon, B.-L. Yeo, and M. M. Yeung. "Resolving Rightful Ownerships with Invisible Watermarking Techniques: Limitations, Attacks, and Implications," *IEEE Journal of Selected Areas in Communication,* 16(4):573–586, 1998.

65. G. Csurka, F. Deguillaume, J. J. K. O'Ruanaidh, and T. Pun. "A Bayesian Approach to Affine Transformation-resistant Image and Video Watermarking," in *Proceedings of the Third International Information Hiding Workshop,* pp. 315–330, 1999.

66. S. Daly. "The Visible Difference Predictor: An Algorithm for the Assessment of Image Fidelity," in A. B. Watson, editor, *Digital Images and Human Vision,* Chapter 14, pp. 179–206. Cambridge, MA: MIT Press, 1993.

67. S. Decker. "Engineering Considerations in Commercial Watermarking," *IEEE Communications Magazine,* To be published, 2001.

68. J. F. Delaigle, C. De Vleeschouwer, and B. Macq. "Watermarking Algorithm Based on a Human Visual Model," *Signal Processing,* 66(3):319–335, 1998.

69. D. Delannay and B. Macq. "Generalized 2-D Cyclic Patterns for Secret Watermark Generation," in *IEEE International Conference on Image Processing,* volume 2, pp. 77–79, 2000.

70. G. Depovere, T. Kalker, J. Haitsma, M. Maes, L. de Strycker, P. Termont, J. Vandewege, A. Langell, C. Alm, P. Norman, B. O'Reilly, G. Howes, H. Vaanholt, R. Hintzen, P. Donnelly, and A. Hudson. "The VIVA Project: Digital Watermarking for Broadcast Monitoring," *IEEE International Conference on Image Processing,* 2:202–205, 1999.

71. G. Depovere, T. Kalker, and J.-P. Linnartz. "Improved Watermark Detection Using Filtering Before Correlation," in *IEEE International Conference on Image Processing,* volume 1, pp. 430–434, 1998.

72. J. Dittmann, T. Fiebig, and R. Steinmetz. "A New Approach for Transformation-invariant Image and Video Watermarking in the Spatial Domain: SSP Self-spanning Patterns," *Security and Watermarking of Multimedia Contents II,* SPIE-3971:176–185, 2000.

73. R. Dolby. "Apparatus and Method for the Identification of Specially Encoded FM Stereophonic Broadcasts," *United States Patent* 4,281,217, 1981.

74. M. Dolson. "The Phase Vocoder: A Tutorial," *Computer Music Journal,* 10:14–27, 1986.

75. J.-L. Dugelay and F. A. P. Petitcolas. "Possible Counter-attacks Against Random Geometric Distortions," in *Proceedings of the SPIE Conference on Security and Watermarking of Multimedia Content II,* volume 3971, pp. 338–345, 2000.

76. J. J. Eggers, J. K. Su, and B. Girod. "A Blind Watermarking Scheme Based on Structured Codebooks," in *IEE Seminar on Secure Images and Image Authentication,* pp. 4/1–4/21, 2000.

77. J. J. Eggers, J. K. Su, and B. Girod. "Robustness of a Blind Image Watermarking Scheme," in *IEEE International Conference on Image Processing,* volume 3, pp. 17–20, 2000.

78. J. J. Eggers and B. Girod. "Watermark Detection After Quantization Attacks," in A. Pfitzmann, editor, *Third International Workshop on Information Hiding,* volume 1768 of *Lecture Notes in Computer Science,* pp. 172–186, 1999.

79. J. J. Eggers and B. Girod. "Quantization Effects on Digital Watermarks," *Signal Processing,* 81(2):239–263, 2001.

80. J. J. Eggers, J. K. Su, and B. Girod. "Public Key Watermarking by Eigenvectors of Linear Transforms," in *EUSIPCO,* Tampere, Finland, September 2000.

81. "Epson Introduces Revolutionary Image Authentication System for Epson Digital Cameras," *Business Wire,* April 5, 1999.

82. F. Ergun, J. Kilian, and R. Kumar. "A Note on the Limits of Collusion-resistant Watermarks," in *Advances in Cryptology: EUROCRYPT '99,* pp. 140–149. Berlin; New York: Springer-Verlag, 1999.

83. A. J. S. Ferreira. "An Odd-DFT-based Approach to Time-scale Expansion of Audio Signals," *IEEE Transactions on Speech and Audio Processing,* 7(4):441–453, 1999.

84. D. J. Field. "Relations Between the Statistics of Natural Images and the Response Properties of Cortical Cells," *Journal of the Optical Society of America A,* 4(12):2379–2394, 1987.

85. J. Fridrich and M. Goljan. "Images with Self-correcting Capabilities," in *Proceedings of the IEEE International Conference on Image Processing,* volume 3, pp. 792–796, 1999.

86. J. Fridrich, M. Goljan, and M. Du. "Invertible Authentication," in *Proceedings of SPIE, Security and Watermarking of Multimedia Contents,* 2001.

87. J. Fridrich, R. Du, and M. Long. "Steganalysis of LSB Encoding in Color Images," *IEEE International Conference on Multimedia and Expo,* volume 3, pp. 1279–1283, 2000.

88. G. L. Friedman. "The Trustworthy Camera: Restoring Credibility to the Photographic Image," *IEEE Transactions on Consumer Electronics,* 39(4):905–910, 1993.

89. G. L. Friedman. "Digital Camera with Apparatus for Authentication of Images Produced from an Image File," *United States Patent* 5,499,294, 1996.

90. M. S. Fu and O. C. Au. "Data Hiding for Halftone Images," in *Proceedings of the SPIE Conference on Security and Watermarking of Multimedia Data,* volume 3971, pp. 228–236, 2000.

91. T. Furon and P. Duhamel. "An Asymmetric Public Detection Watermarking Technique," in *Proceedings of the Third International Information Hiding Workshop*, pp. 88–100, 1999.

92. T. Furon and P. Duhamel. "Robustness of an Asymmetric Watermarking Technique," *IEEE International Conference on Image Processing*, 3:21–24, 2000.

93. R. A. Garcia. "Digital Watermarking of Audio Signals Using a Psychoacoustic Auditory Model and Spread Spectrum Theory." To be published.

94. S. I. Gel'fand and M. S. Pinsker. "Coding for Channel with Random Parameters," *Problems of Control and Information Theory*, 9(1):19–31, 1980.

95. *Gentlemen's Magazine*, XLIX, 1779.

96. B. Girod. "What's Wrong with Mean-squared Error?" in A. B. Watson, editor, *Digital Images and Human Vision*, Chapter 15, pp. 207–220. Cambridge, MA: MIT Press, 1993.

97. R. D. Gitlin, J. F. Hayes, and S. B. Weinstein. *Data Communications Principles*. New York: Plenum Press, 1992.

98. H. M. Gladney, F. C. Mintzer, and F. Schiattarella. "Safeguarding Digital Library Contents and Users: Digital Images of Treasured Antiquities," *D-Lib Magazine*, July/August 1997.

99. M. Goljan, J. Fridrich, and R. Du. "Distortion-free Data Embedding for Images," in *Fourth International Information Hiding Workshop*, 2001.

100. R. C. Gonzalez and R. E. Woods. *Digital Image Processing*. Reading, MA: Addison-Wesley, 1992.

101. D. M. Green and J. A. Swets. *Signal Detection Theory and Psychophysics*. Huntington, New York: Robert E. Krieger Publishing Co., 1974.

102. C. F. Hall and E. L. Hall. "A Nonlinear Model for the Spatial Characteristics of the Human Visual System," *IEEE Transactions on Systems Man and Cybernetics*, 7(3):161–170, 1977.

103. K. N. Hamdy, A. H. Tewfik, T. Chen, and S. Takagi. "Time-scale Modification of Audio Signals with Combined Harmonic and Wavelet Representations," *IEEE International Conference on Acoustics, Speech, and Signal Processing*, 1:439–442, 1997.

104. A. Hanjalic, G. C. Langelaar, P. M. B. van Roosmalen, J. Biemond, and R. L. Lagendijk. *Image and Video Databases: Restoration, Watermarking and Retrieval*. New York: Elsevier, 2000.

105. F. J. Harris. "On the Use of Windows for Harmonic Analysis with the Discrete Fourier Transform," *Proceedings of the IEEE*, 66(1):51–83, 1978.

106. F. Hartung, P. Eisert, and B. Girod. "Digital Watermarking of MPEG-4 Facial Animation Parameters," *Computers and Graphics*, 22(4):425–435, 1998.

107. F. Hartung and B. Girod. "Watermarking of Uncompressed and Compressed Video," *Signal Processing*, 66(3):283–301, 1998.

108. F. Hartung, J. K. Su, and B. Girod. "Spread Spectrum Watermarking: Malicious Attacks and Counterattacks," in *SPIE Conference on Security and Watermarking of Multimedia Content,* volume 3657, pp. 147–158, 1999.

109. F. Hartung and M. Kutter. "Multimedia Watermarking Techniques," *Proceedings of the IEEE,* 87(7):1079–1107, 1999.

110. C. Heegard and A. El Gamal. "On the Capacity of Computer Memory with Defects," *IEEE Transactions on Information Theory,* 29:731–739, 1983.

111. C. W. Helstrom. *Statistical Theory of Signal Detection.* New York: Pergamon Press, 1960.

112. E. F. Hembrooke. "Identification of Sound and Like Signals," *United States Patent* 3,004,104, 1961.

113. J. J. Hernandez, F. Perez-Gonzalez, J. M. Rodriguez, and G. Nieto. "Performance Analysis of a 2-D Multipulse Amplitude Modulation Scheme for Data Hiding and Watermarking Still Images," *IEEE Journal of Selected Areas in Communication,* 16(4):510–524, 1998.

114. J. R. Hernandez, M. Amado, and F. Perez-Gonzalez. "DCT-domain Watermarking Techniques for Still Images: Detector Performance Analysis and a New Structure," *IEEE Transactions on Image Processing,* 9(1):55–68, 2000.

115. J. R. Hernandez, J.-F. Delaigle, and B. Macq. "Improving Data Hiding by Using Convolutional Codes and Soft-decision Decoding," in *Proceedings of the SPIE Conference on Security and Watermarking of Multimedia Content II,* volume 3971, pp. 24–47, 2000.

116. J. R. Hernandez and F. Perez-Gonzalez. "Statistical Analysis of Watermarking Schemes for Copyright Protection of Images," *Proceedings of the IEEE,* 87(7):1142–1166, 1999.

117. Herodotus. *The Histories.* Translated by Aubrey de Sélincourt. London: Penguin Books, 1996.

118. M. Holliman and N. Memon. "Counterfeiting Attacks on Oblivious Block-wise Independent Invisible Watermarking Schemes," *IEEE Transactions on Image Processing,* 9(3):432–441, 2000.

119. L. Holt, B. G. Maufe, and A. Wiener. "Encoded Marking of a Recording Signal," *U.K. Patent* GB 2196167A, 1988.

120. C. Honsinger. "Data Embedding Using Phase Dispersion," *IEEE Seminar on Secure Images and Image Authentication,* 3(9):51–57, 2000.

121. C. W. Honsinger and S. J. Daly. "Method for Detecting Rotation and Magnification in Images," *United States Patent* 5,835,639, 1998.

122. C. W. Honsinger, P. Jones, M. Rabbani, and J. C. Stoffel. "Lossless Recovery of an Original Image Containing Embedded Data," *U.S. Patent Application, Docket No. 77102/E-D,* 1999.

123. C.-T. Hsu and J.-L. Wu. "Hidden Digital Watermarks in Images," *IEEE Transactions on Image Processing,* 8(1):58–68, 1999.

124. Y. N. Hsu, H. H. Arsenault, and G. April. "Rotation-invariant Digital Pattern Recognition Using Circular Harmonic Expansion," *Applied Optics,* 21:4012–4015, 1982.

125. D. Hunter. *Handmade Paper and Its Watermarks: A Bibliography.* New York: B. Franklin, 1967.

126. D. W. Jacobs. "Grouping for Recognition," AI Memo 1177, MIT, Cambridge, MA, 1989.

127. N. Jayant, J. Johnston, and R. Safranek. "Signal Compression Based on Models of Human Perception," *Proceedings of the IEEE,* 81(10), pp. 1385–1422, 1993.

128. N. Johnson, Z. Duric, and S. Jajodia. *Information Hiding: Steganography and Watermarking: Attacks and Countermeasures.* Boston, MA: Kluwer Academic Publishers, 2000.

129. JTC1/SC29/WG11 MPEG. "Information Technology: Coding of Moving Pictures and Associated Audio for Digital Storage Media at up to About 1.5 Mbits/s," Part 3: Audio. Technical Report IS11172-3, ISO/IEC, 1992.

130. D. Kahn. *The Codebreakers: The Story of Secret Writing.* New York: Scribner, 1967.

131. A. B. Kahng, S. Mantik, I. L. Markov, M. Potkonjak, P. Tucker, H. Wang, and G. Wolfe. "Robust IP Watermarking Methodologies for Physical Design," *Proceedings of the 35th Design and Automation Conference,* pp. 782–787, 1998.

132. T. Kalker and A. J. E. M. Janssen. "Analysis of Watermark Detection Using SPOMF," in *Proceedings of the International Conference on Image Processing,* volume 1, pp. 316–319, 1999.

133. T. Kalker, J.-P. Linnartz, and M. van Dijk. "Watermark Estimation Through Detector Analysis," in *Proceedings of the International Conference on Image Processing,* volume 1, pp. 425–429, 1998.

134. H. R. Kang. *Digital Color Halftoning.* Bellingham, WA; New York: SPIE Optical Engineering Press; IEEE Press, 1999.

135. S. Katzenbeisser and F. Petitcolas, editors. *Information Hiding Techniques for Steganography and Digital Watermarking.* Boston: Artech House, 2000.

136. D. H. Kelly. "Visual Responses to Time-dependent Stimuli: Amplitude Sensitivity Measurements," *Journal of the Optical Society of America A,* 51:422–429, 1961.

137. Aguste Kerckhoff. "La Cryptographie Militaire," *Journal des Sciences Militaires,* IX(Jan., Feb.):5–38, 161–191, 1883.

138. D. Kesdogan, J. Egner, and R. Büschks. "Stop-and-Go MIXes Providing Probabilistic Anonymity in an Open System," in *Proceedings of the Second International Information Hiding Workshop,* pp. 83–98, 1998.

139. D. Kilburn. "Dirty Linen, Dark Secrets," *Adweek,* volume 38, no. 40, pp. 35–40, October 6, 1997.

140. J. Kilian, F. T. Leighton, L. R. Matheson, T. Shamoon, and R. E. Tarjan. *Resistance of Watermarked Documents to Collusional Attacks.* Technical Report TR 97-167, Princeton, NJ: NEC Research Institute, 1997.

141. E. Koch and J. Zhao. "Towards Robust and Hidden Image Copyright Labeling," in *IEEE Workshop on Nonlinear Signal and Image Processing,* 1995.

142. N. Komatsu and H. Tominaga. "Authentication System Using Concealed Images in Telematics," *Memoirs of the School of Science and Engineering, Waseda University,* 52:45–60, 1988.

143. N. Komatsu and H. Tominaga. "A Proposal on Digital Watermark in Document Image Communication and Its Application to Realizing a Signature," *Electronics and Communications in Japan,* 73(5):208–218, 1990.

144. D. Kundur and D. Hatzinakos. "Blind Image Deconvolution," *IEEE Signal Processing Magazine,* 13(3):43–64, 1996.

145. D. Kundur and D. Hatzinakos. "Semi-blind Image Restoration Based on Tell-tale Watermarking," in *Conference Record of the Thirty-second Asilomar Conference on Signals, Systems, and Computers,* volume 2, pp. 933–937, 1998.

146. D. Kundur and D. Hatzinakos. "Digital Watermarking for Tell-tale Tamper Proofing and Authentication," *Proceedings of the IEEE,* 87(7), pp. 1167–1180, 1999.

147. M. Kutter. "Watermarking Resisting to Translation, Rotation, and Scaling," in *Multimedia Systems and Applications,* SPIE-3528:423–431, 1998.

148. M. Kutter. "Performance Improvement of Spread-spectrum-based Image Watermarking Schemes Through M-ary Modulation," in A. Pfitzmann, editor, *Third International Workshop on Information Hiding,* volume 1768 of *Lecture Notes in Computer Science,* pp. 237–252, 1999.

149. M. Kutter, S. K. Bhattacharjee, and T. Ebrahimi. "Towards Second-generation Watermarking Systems," in *IEEE International Conference on Image Processing,* volume 1, pp. 320–323, 1999.

150. M. Kutter and F. Hartung. "Introduction to Watermarking Techniques," in S. Katzenbeisser and F. A. P. Petitcolas, editors, *Information Hiding: Techniques for Steganography and Digital Watermarking,* Chapter 5, pp. 97–120. Boston: Artech House, 2000.

151. M. Kutter and F. A. P. Petitcolas. "A Fair Benchmark for Image Watermarking Systems," *Security and Watermarking of Multimedia Contents,* SPIE-3657:226–239, 1999.

152. M. Kutter, S. Voloshynovskiy, and A. Herrigel. "The Watermark Copy Attack," in *Security and Watermarking of Multimedia Contents II,* SPIE-3971:371–380, 2000.

153. J. Lach, W. Mangione-Smith, and M. Potknojak. "Fingerprinting Digital Circuits on Programmable Hardware," in *Proceedings of the Second International Information Hiding Workshop,* pp. 16–31, 1998.

154. J. Laroche and M. Dolson. "Improved Phase Vocoder Time-scale Modification of Audio," *IEEE Transactions on Speech and Audio Processing,* 7(3):323–332, 1999.

155. J. Le Moigne. "Towards a Parallel Registration of Multiple Resolution Remote Sensing Data," in *Proceedings of the 1995 International Geoscience and Remote Sensing Symposium,* pp. 1011–1013, July 1995.

156. J. Lee and C. S. Won. "Authentication and Correction of Digital Watermarking Images," *Electronic Letters,* 35(11), pp. 886–887, 1999.

157. J. Lee and C. S. Won. "Image Integrity and Correction Using Parities of Error Control Coding," in *IEEE International Conference on Multimedia and Expo,* volume 3, pp. 1297–1300, 2000.

158. T. Liang and J. J. Rodríguez. "Robust Watermarking Using Robust Coefficients," *Security and Watermarking of Multimedia Contents II,* SPIE-3971:326–335, 2000.

159. C.-Y. Lin and S.-F. Chang. "Semi-fragile Watermarking for Authenticating JPEG Visual Content," in *Security and Watermarking in Multimedia Contents II,* SPIE-3971:140–151, 2000.

160. C.-Y. Lin and S.-F. Chang. "A Robust Image Authentication Algorithm Surviving JPEG Lossy Compression," *Storage and Retrieval of Image/Video Databases,* SPIE-3312:296–307, 1998.

161. C.-Y. Lin and S.-F. Chang. "Issues and Solutions for Authenticating MPEG Video," *Security and Watermarking of Multimedia Contents,* SPIE-3657:54–65, 1999.

162. C.-Y. Lin, M. Wu, J. A. Bloom, I. J. Cox, M. L. Miller, and Y. M. Lui. "Rotation, Scale, and Translation-resilient Public Watermarking for Images," *Security and Watermarking of Multimedia Contents,* SPIE-3971:90–98, 2000.

163. C.-Y. Lin and S.-F. Chang. "Distortion Modeling and Invariant Extraction for Digital Image Print-and-scan Process," *International Symposium on Multimedia Information Processing,* 1999.

164. E. T. Lin, C. I. Podilchuk, and E. J. Delp. "Detection of Image Alterations Using Semi-fragile Watermarks," SPIE-3971:152–163, 2000.

165. F. Lin and R. D. Brandt. "Towards Absolute Invariants of Images Under Translation, Rotation, and Dilation," *Pattern Recognition Letters,* 14(5):369–379, 1993.

166. T. Lindkvist. *Fingerprinting Digital Documents.* PhD. thesis, Linköping University, Linköping, Sweden, 1999.

167. J. P. M. G. Linnartz and J. C. Talstra. "MPEG PTY Marks: Cheap Detection of Embedded Copyright Data in DVD Video," in *Proceedings of ESORICS98 5th European Symposium on Research in Computer Security,* pp. 221–240, 1998.

168. J. P. M. G. Linnartz, A. C. C. Kalker, and G. F. Depovere. "Modeling the False-alarm and Missed Detection Rate for Electronic Watermarks," in D. Aucsmith, editor, *Workshop on Information Hiding, Portland, OR,* volume 1525 of *Lecture Notes in Computer Science,* pp. 329–343. New York: Springer-Verlag, 1998.

169. J. P. M. G. Linnartz and M. van Dijk. "Analysis of the Sensitivity Attack Against Electronic Watermarks in Images," in *Workshop on Information Hiding, Portland, OR,* 15–17 April, pp. 258–272, 1998.

170. J. Löfvenberg. "Random Codes for Digital Fingerprinting." PhD. thesis, Linköping University, Linköping, Sweden, 1999.

171. S. Low and N. Maxemchuk. "Performance Comparison of Two Text Marking Methods," *IEEE Journal of Selected Areas in Communication,* 16:561–572, 1998.

172. C.-S. Lu, H.-Y. M. Liao, S.-K. Huang, and C.-J. Sze. "Cocktail Watermarking on Images," in A. Pfitzmann, editor, *Third International Workshop on Information Hiding,* volume 1768 of *Lecture Notes in Computer Science,* pp. 333–347, 1999.

173. J. Lubin. "The Use of Psychophysical Data and Models in the Analysis of Display System Performance," in A. B. Watson, editor, *Digital Images and Human Vision,* pp. 163–178. Cambridge, MA: MIT Press, 1993.

174. B. D. Lucas and T. Kanade. "An Iterative Image Registration Technique with an Application to Stereo Vision," *Proceedings of the International Joint Conference on Artificial Intelligence,* pp. 674–679, 1981.

175. B. M. Macq and J-J. Quisquater. "Cryptology for Digital TV Broadcasting," *Proceedings of the IEEE,* 83(6):944–957, 1995.

176. F. J. MacWilliams and N.J.A. Sloane. "Pseudo-random Sequences and Arrays," *Proceedings of the IEEE,* 64(12):1715–1729, 1976.

177. M. J. J. J. B. Maes and C. W. A. M. van Overveld. "Digital Watermarking by Geometric Warping," in *IEEE International Conference on Image Processing,* volume 2, pp. 424–426, 1998.

178. J. L. Mannos and J. J. Sakrison. "The Effects of a Visual Fidelity Criterion on the Encoding of Images," *IEEE Transactions on Information Theory,* IT-4:525–536, 1974.

179. H. K. Markey and G. Antheil. *Secret Communication System.* Technical Report 2,292,387, United States Patent, 1942.

180. J. Meng and S.-F. Chang. "Embedding Visible Video Watermarks in the Compressed Domain," in *IEEE International Conference on Image Processing,* volume 1, pp. 474–477, 1998.

181. *Methodology for the Subjective Assessment of the Quality of Television Pictures: Recommendation ITU-R BT.500-10.* ITU Radiocommunication Assembly, 2000.

182. M. L. Miller. "Watermarking with Dirty-paper Codes." To appear in International Conference on Image Processing May 15–18, Thessaloniki, Greece, 2001.

183. M. L. Miller and J. A. Bloom. "Computing the Probability of False Watermark Detection," in *Proceedings of the Third International Workshop on Information Hiding,* pp. 146–158, 1999.

184. M. L. Miller, I. J. Cox, and J. A. Bloom. "Informed Embedding: Exploiting Image and Detector Information During Watermark Insertion," in *IEEE International Conference on Image Processing,* volume 3, pp. 1–4, September 2000.

185. F. Mintzer, J. Lotspiech, and N. Morimoto. "Safeguarding Digital Library Contents and Users: Digital Watermarking," *D-Lib Magazine, http://www.dlib.org/dlib/december97/ibm/12lotspiech.html#FM2,* 1997.

186. S. P. Mohanty, K. R. Ramakrishnan, and M. S. Kankanhalli. "A DCT Domain Visible Watermarking Technique for Images," in *IEEE International Conference on Multimedia and Expo,* volume 2, pp. 1029–1032, 2000.

187. W. D. Moon, R. J. Weiner, R. A. Hansen, and R. N. Linde. "Broadcast Signal Identification System," *United States Patent* 3,919,479, 1975.

188. T. Moriya, Y. Takashima, T. Nakamura, and N. Iwakami. "Digital Watermarking Schemes Based on Vector Quantization," in *Proceedings of the IEEE Workshop on Speech Coding for Telecommunications*, pp. 95–96, 1997.

189. I. S. Moskowitz and L. W. Chang. "An Entropy-based Framework for Database Inference," in *Proceedings of the Third International Information Hiding Workshop*, pp. 405–418, 1999.

190. P. Moulin and J. A. O'Sullivan. "Information-theoretic Analysis of Information Hiding." Preprint available from *http://www.ifp.uiuc.edu/moulin/Papers*, 1999.

191. P. Moulin and J. A. O'Sullivan. "Information-theoretic Analysis of Watermarking," in *Proceedings of the International Conference on Acoustics, Speech, and Signal Processing*, vol. 6, pp. 3630–3633, 2000.

192. F. Müller. "Distribution Shape of Two-dimensional DCT Coefficients of Natural Images," *Electronics Letters*, 29(22):1935–1936, 1993.

193. H. Murase and S. Nayar. "Visual Learning and Recognition of 3D Objects from Appearance," *International Journal of Computer Vision*, 14(1):5–25, 1995.

194. H. Muratani. "A Collusion-secure Fingerprinting Code Reduced by Chinese Remaindering and Its Random-error Resilience," in *Proceedings of Info Hiding '01*, 2001.

195. J. D. Murray and W. van Ryper. *Encyclopedia of Graphics File Formats, Second Edition*. Sebastopol, CA: O'Reilly & Associates, 1996.

196. National Institute of Standards and Technology. *Digital Signature Standard*. Technical Report NIST FIPS PUB 185, U.S. Department of Commerce, May 1994.

197. R. Ohbochi, H. Masuda, and M. Aono. "Watermarking Three-dimensional Polygonal Models Through Geometric and Topological Modifications," *IEEE Journal of Selected Areas in Communication*, 16(4):551–560, 1998.

198. A. V. Oppenheim and R. W. Schafer. *Digital Signal Processing*. Englewood Cliffs, NJ: Prentice-Hall, 1975.

199. J. J. K. Ó Ruanaidh, E. M. Boland, and W. J. Dowling. "Phase Watermarking of Digital Images," *Proceedings of the IEEE International Conference on Image Processing*, 3:239–242, 1996.

200. J. J. K. Ó Ruanaidh and T. Pun. "Rotation, Scale, and Translation-invariant Spread Spectrum Digital Image Watermarking," *Signal Processing*, 66(3):303–317, 1998.

201. J. A. O'Sullivan, P. Moulin, and J. M. Ettinger. "Information-theoretic Analysis of Stenography," *Proceedings of the IEEE International Symposium on Information Theory*, 297, 1998.

202. T. Painter and A. Spanias. "Perceptual Coding of Digital Audio," *Proceedings of the IEEE*, 88(4):451–513, 2000.

203. H. C. Papadopoulos and C.-E. W. Sundberg. "Simultaneous Broadcasting of Analog FM and Digital Audio Signals by Means of Precanceling Techniques," in *IEEE International Conference on Communications, ICC 98*, volume 2, pp. 728–732, 1998.

204. A. Papoulis. *Probability, Random Variables, and Stochastic Processes. Third Edition.* New York: McGraw-Hill, 1991.

205. A. Patrizio. "Why the DVD Hack Was a Cinch," *Wired*, November 1999.

206. W. B. Pennebaker and J. L. Mitchell. *JPEG Still Image Data Compression Standard.* New York: Van Nostrand Reinhold, 1993.

207. S. Pereira, J. J. K. Ó Ruanaidh, and T. Pun. "Secure Robust Digital Watermarking Using the Lapped Orthogonal Transform," in *SPIE Conference on Security and Watermarking of Multimedia Content*, SPIE-3657:21–30, 1999.

208. S. Pereira and T. Pun. "Robust Template Matching for Affine-resistant Image Watermarks," *IEEE Transactions on Image Processing*, 9(6):1123–1129, 2000.

209. S. Pereira, J. J. K. Ó Ruanaidh, F. Deguillaume, G. Csurka, and T. Pun. "Template-based Recovery of Fourier-based Watermarks Using Log-polar and Log-log Maps," in *IEEE International Conference on Multimedia Computing and Systems*, volume 1, pp. 870–874, 1999.

210. S. Pereira, S. Voloshynovskiy, and T. Pun. "Effective Channel Coding for DCT Watermarks," in *IEEE International Conference on Image Processing*, volume 3, pp. 671–673, 2000.

211. F. A. P. Petitcolas, R. J. Anderson, and M. G. Kuhn. "Attacks on Copyright Marking Systems," in *Workshop on Information Hiding, Portland, OR*, pp. 218–238, 15–17 April, 1998.

212. F. A. P. Petitcolas, R. Anderson, and M. G. Kuhn. "Information Hiding: A Survey," *Proceedings of the IEEE*, 87(7):1062–1077, 1999.

213. R. Petrovic, J. M. Winograd, K. Jemili, and E. Metois. "Data Hiding Within Audio Signals," in *Fourth International Conference on Telecommunications in Modern Satellite, Cable, and Broadcasting Services*, volume 1, pp. 89–95, 1999.

214. R. L. Pickholtz, D. L. Schilling, and L. B. Milstein. "Theory of Spread-spectrum Communications: A Tutorial. *IEEE Transactions on Communications*, 30(5):855–884, 1982.

215. *Playboy Magazine.* Playboy Enterprises International, Inc., November 1972.

216. C. I. Podilchuk and W. Zeng. "Image-adaptive Watermarking Using Visual Models," *IEEE Journal of Selected Areas in Communication*, 16(4):525–539, 1998.

217. S. S. Pradhan and K. Ramchandran. "Distributed Source Coding: Symmetric Rates and Applications to Sensor Networks," in *Proceedings of the IEEE Data Compression Conference*, pp. 363–372, 2000.

218. S. S. Pradhan and K. Ramchandran. "Distributed Source Coding Using Syndromes: Design and Construction," in *Proceedings of the Data Compression Conference (DCC)*, pp. 158–167, March 1999.

219. W. H. Press, S. A. Teukolsky, W. T. Vetterling, and B. P. Flannery. *Numerical Recipies in C: The Art of Scientific Computing.* New York: Cambridge University Press, 1992.

220. R. D. Preuss, S. E. Roukos, A. W. F. Huggins, H. Gish, M. A. Bergamo, P. M. Peterson, and A. G. Derr. "Embedded Signaling," *United States Patent* 5,319,735, 1994.

221. L. Qiao and K. Nahrstedt. "Non-invertible Watermarking Methods for MPEG-encoded Audio," in *Proceedings of the SPIE Conference on Security and Watermarking of Multimedia Data,* volume 3657, pp. 194–203, 1999.

222. H. A. Rahmel. "System for Determining the Listening Habits of Wave Signal Receiver Users," *United States Patent* 2,513,360, 1950.

223. M. Ramkumar. "Data Hiding in Multimedia: Theory and Applications," PhD. thesis, New Jersey Institute of Technology, Newark, 1999.

224. C. Reidy. "Knocking Off the Knockoff," *The Boston Globe,* p. D1, November 17, 2000.

225. R. C. Reininger and J. D. Gibson. "Distribution of the Two-dimensional DCT Coefficients for Images," *IEEE Transactions on Communication,* 31(6):835–839, 1983.

226. C. Rey and J.-L. Dugelay. "Blind Detection of Malicious Alterations on Still Images Using Robust Watermarks," *IEE Seminar: Secure Images and Image Authentication,* pp. 7/1–7/6, 2000.

227. G. B. Rhoads. "Image Steganography System Featuring Perceptually Adaptive and Globally Scalable Signal Embedding," *United States Patent* 5,748,763, 1998.

228. G. B. Rhoads. "Steganography System," *United States Patent* 5,850,481, 1998.

229. R. L. Rivest. "RFC 1321: The MD5 Message-Digest Algorithm," *Internet Activities Board,* 1992.

230. R. L. Rivest, A. Shamir, and L. M. Adleman. "A Method for Obtaining Digital Signatures and Public-key Cryptsystems, *Communications of the ACM,* 21(2):120–126, 1978.

231. P. M. J. Rongen, M. J. J. J. B. Maes, and C. W. A. M. van Overveld. "Digital Image Watermarking by Salient Point Modification Practical Results," in *SPIE Conference on Security and Watermarking of Multimedia Content,* volume 3657, pp. 273–282, 1999.

232. C. B. Rorabaugh. *Error Coding Cookbook: Practical C/C++ Routines and Recipes for Error Detection and Correction.* New York: McGraw-Hill, 1996.

233. H. L. Royden. *Real Analysis.* New York: MacMillan Publishing Co., 1968.

234. D. L. Ruderman and W. Bialek. "Statistics of Natural Images: Scaling in the Woods," *Physics Review Letters,* 73:814–817, 1994.

235. J. Ryan. "Method and Apparatus for Preventing the Copying of a Video Program," *United States Patent* 4,907,093, 1990.

236. *http://www.sag.org/pressreleases/prla990826_spotchecks.html,* 1999.

237. D. V. Sarwate and M.-B. Pursley. "Cross-correlation Properties of Pseudo-random and Related Sequences," *Proceedings of the IEEE,* 688(5):593–619, 1980.

238. E. Sayrol, J. Vidal, S. Cabanillas, and S. Santamaria. "Optimum Watermark Detection for Color Images," in *IEEE International Conference on Image Processing*, volume 2, pp. 231–235, 1999.

239. M. Schneider and S.-F. Chang. "A Robust Content-based Digital Signature for Image Authentication," in *IEEE International Conference on Image Processing*, volume 3, pp. 227–230, 1996.

240. B. Schneier. *Applied Cryptography*. New York: John Wiley & Sons, 1996.

241. L. Schuchman. "Dither Signals and Their Effect on Quantization Noise," *IEEE Transactions on Communications Technology*, 12:162–165, 1964.

242. "SDMI Portable Device Specification," Part 1, Version 1.0, Document number pdwg99070802, July 1999.

243. C. E. Shannon. "Channels with Side Information at the Transmitter," *IBM Journal of Research and Development*, pp. 289–293, 1958.

244. Y. Sheng and H. H. Arsenault. "Experiments on Pattern Recognition Using Invariant Fourier-Mellin Descriptors," *Journal of Optical Society of America A*, 3:771–776, 1986.

245. Y. Sheng and J. Duvernoy. "Circular-Fourier–Radial-Mellin Transform Descriptors for Pattern Recognition," *Journal of the Optical Society of America A*, 3:885–888, 1986.

246. G. J. Simmons. "The History of Subliminal Channels," in R. Anderson, editor, *Information Hiding: First International Workshop*, volume 1174 of *Lecture Notes in Computer Science*, pp. 237–256. Berlin; New York: Springer-Verlag, 1996.

247. E. P. Simoncelli. "Statistical Models for Images: Compression, Restoration, and Synthesis," *Thirty-First Asilomar Conference on Signals, Systems, and Computers*, pp. 673–678, 1997.

248. J. Simpson and E. Weiner, editors. *Oxford English Dictionary*. New York: Oxford University Press, 2000.

249. W. D. Smith. "Studies in Computational Geometry Motivated by Mesh Generation," PhD. thesis, Princeton University, Princeton, NJ, 1988.

250. V. Solachidis, N. Nikolaidis, and I. Pitas. "Watermarking Polygonal Lines Using Fourier Descriptors," *IEEE International Conference on Image Processing*, 4:1955–1958, 2000.

251. J. P. Stern, G. Hachez, F. Koeune, and J.-J. Quisquater. "Robust Object Watermarking: Application to Code," in *Proceedings of Info Hiding '99*, volume 1768 of Lecture Notes in Computer Science, pp. 368–378, 1999.

252. D. R. Stinson. *Cryptography: Theory and Practice*. Boca Raton, FL: CRC Press, 1995.

253. T. G. Stockham. "Image Processing in the Context of a Visual Model," *Proceedings of the IEEE*, 60(7):828–841, 1972.

254. H. S. Stone. *Analysis of Attacks on Image Watermarks with Randomized Coefficients*. Technical Report TR 96-045, NEC Research Institute, 1996.

255. H. S. Stone. "Progressive Wavelet Correlation Using Fourier Methods," *IEEE Transactions on Signal Processing,* 47(1):97–107, Jan. 1999.

256. D. Storck. "A New Approach to Integrity of Digital Images," in *IFIP Conference on Mobile Communication,* pp. 309–316, 1996.

257. J. K. Su and B. Girod. "On the Imperceptibility and Robustness of Digital Fingerprints," *Proceedings of the IEEE International Conference on Multimedia Computing and Systems,* 2:530–535, 1999.

258. J. K. Su and B. Girod. "Power-spectrum Condition for Energy-efficient Watermarking," in *IEEE International Conference on Image Processing,* volume 1, pp. 301–305, 1999.

259. M. D. Swanson, B. Zhu, and A. H. Tewfik. "Transparent Robust Image Watermarking," in *Proceedings of the IEEE International Conference on Image Processing,* volume 3, pp. 211–214, 1996.

260. M. D. Swanson, B. Zhu, and A. H. Tewfik. "Data Hiding for Video-in-Video," in *Proceedings of the IEEE International Conference on Image Processing,* volume 2, pp. 676–679, 1997.

261. M. D. Swanson, B. Zhu, A. H. Tewfik, and L. Boney. "Robust Audio Watermarking Using Perceptual Masking," *Signal Processing,* 66(3):337–355, 1998.

262. W. Szepanski. "A Signal Theoretic Method for Creating Forgery-proof Documents for Automatic Verification," in J. S. Jackson, editor, *1979 Carnahan Conference on Crime Countermeasures,* pp. 101–109, 1979.

263. K. Tanaka, Y. Nakamura, and K. Matsui. in *Military Communications Conference, 1990. MILCOM '90, Conference Record, A New Era. 1990 IEEE,* volume 1, pp. 216–220, 1990.

264. J. Taylor. *DVD Demystified.* New York: McGraw-Hill, 1998.

265. M. M. Taylor. "Visual Discrimination and Orientation," *Journal of the Optical Society of America A,* 53:763–765, 1963.

266. A. Tefas and I. Pitas. "Multi-bit Image Watermarking Robust to Geometric Distortions," in *IEEE International Conference on Image Processing,* volume 3, pp. 710–713, 2000.

267. Telecommunications Act of 1996, Section 305.

268. Telecommunications Act of 1996, United States Public Law 104-104.

269. E. Terhardt. "Calculating Virtual Pitch," *Hearing Research,* 1:155–182, 1979.

270. A. Z. Tirkel, C. F. Osbourne, and T. E. Hall. "Image and Watermark Registration," *Signal Processing,* 66(3):373–383, 1998.

271. W. M. Tomberlin, L. G. MacKenzie, and P. K. Bennett. "System for Transmitting and Receiving Coded Entertainment Programs," *United States Patent* 2,630,525, 1953.

272. S. Ullman and R. Basri. "Recognition by Linear Combinations of Models," *IEEE Transactions on Pattern Analysis and Machine Intelligence,* 13(10):992–1006, 1991.

273. United States Code, Title 17.

274. C. J. van den Branden Lambrecht and J. E. Farrell. "Perceptual Quality Metric for Digitally Coded Color Images," *Proceedings of EUSIPCO,* pp. 1175–1178, 1996.

275. R. G. van Schyndel, A. Z. Tirkel, and C. F. Osborne. "A Digital Watermark," in *International Conference on Image Processing,* volume 2, pp. 86–90. IEEE, 1994.

276. R. G. van Schyndel, A. Z. Tirkel, and I. D. Svalbe. "Key-independent Watermark Detection," in *Proceedings of the IEEE International Conference on Multimedia Computing and Systems,* pp. 580–585, Florence, Italy, 1999.

277. R. G. van Schyndel, A. Z. Tirkel, I. D. Svalbe, T. E. Hall, and C. F. Osborne. "Algebraic Construction of a New Class of Quasi-orthogonal Arrays in Steganography," in *Proceedings of SPIE on Security and Watermarking of Multimedia Contents,* volume 3657, pp. 354–364, 1999.

278. B. Vasudev and V. Ratnakar. "Fragile Watermarks for Detecting Tampering in Images," US Patent 6,064,764; 2000.

279. P. Viola and W. M. Wells III. "Alignment by Maximization of Mutual Information," *International Journal of Computer Vision,* 24(2):137–154, 1997.

280. A. J. Viterbi. *CDMA: Principles of Spread Spectrum Communications.* Reading, MA: Addison-Wesley Longman, 1995.

281. S. Voloshynovskiy, A. Herrigel, N. Baumgaetner, and T. Pun. "A Stochastic Approach to Content-adaptive Digital Image Watermarking," in *Third International Workshop on Information Hiding,* 1999.

282. M. J. Wainwright and E. P. Simoncelli. "Scale Mixtures of Gaussians and the Statistics of Natural Images," in S. A. Solla, T. K. Leen, and K. R. Müller, editors, *Advances in Neural Information Processing Systems 12,* pp. 855–861. Cambridge, MA: MIT Press, 2000.

283. C. Walker. "Personal Communication," Muzak Corporation, June, 2001.

284. S.-G. Wang and K. T. Knox. "Embedding Digital Watermarks in Halftone Screens," in *Proceedings of the SPIE Conference on Security and Watermarking of Multimedia Data,* volume 3971, pp. 218–227, 2000.

285. A. B. Watson, G. Y. Yang, J. A. Solomon, and J. Villasenor. "Visual Thresholds for Wavelet Quantization Error," *Human Vision and Electronic Imaging,* SPIE-2657:381–392, 1996.

286. A. B. Watson. "DCT Quantization Matrices Optimized for Individual Images," *Human Vision, Visual Processing, and Digital Display IV,* SPIE-1913:202–216, 1993.

287. A. B. Watson, editor. *Digital Images and Human Vision.* Cambridge, MA: MIT Press, 1993.

288. A. Westfeld and A. Pfitzmann. "Attacks on Steganographic Systems," in *Proceedings of the Third International Information Hiding Workshop,* pp. 61–76, 1999.

289. B. Widrow. "Statistical Analysis of Amplitude-quantized Sample-data Systems," *Transactions of the AIEE (Applications and Industry),* 79:555–568, 1960 (Jan. '61 section).

290. R. B. Wolfgang and E. J. Delp. "A Watermark for Digital Images," in *Proceedings of the 1996 International Conference on Image Processing*, volume 3, pp. 219–222, 1996.

291. R. B. Wolfgang, C. I. Podilchuk, and E. J. Delp. "Perceptual Watermarks for Digital Images and Video," *Proceedings of the IEEE*, 87(7):1108–1126, 1999.

292. P. W. Wong. "A Public Key Watermark for Image Verification and Authentication," in *IEEE International Conference on Image Processing*, volume 1, pp. 455–459, 1998.

293. P. W. Wong and E. J. Delp, editors. *Security and Watermarking of Multimedia Contents, Proceedings of the Society of Photo-optical Instrumentation Engineers*, volume 3657, 1999.

294. P. W. Wong and E. J. Delp, editors. *Security and Watermarking of Multimedia Contents II, Proceedings of the Society of Photo-optical Instrumentation Engineers*, volume 3971, 2000.

295. C.-P. Wu, P.-C. Su, and C.-C. J. Kuo. "Robust and Efficient Digital Audio Watermarking Using Audio Content Analysis," *Security and Watermarking of Multimedia Contents*, SPIE-3971:382–392, 2000.

296. M. Wu, E. Tang, and B. Liu. "Data Hiding in Digital Binary Images," *IEEE International Conference on Multimedia and Expo (ICME)*, volume 1, pp. 393–396, 2000.

297. M. Wu and B. Liu. "Watermarking for Image Authentication," in *IEEE International Conference on Image Processing*, volume 2, pp. 437–441, 1998.

298. R. Wu and H. Stark. "Rotation-invariant Pattern Recognition Using Optimum Feature Extraction," *Applied Optics*, 24:179–184, 1985.

299. A. D. Wyner and J. Ziff. "The Rate Distortion Function for Source Coding with Side Information at the Decoder," *IEEE Transactions on Information Theory*, 22:1–10, 1976.

300. C. Xu, J. Wu, and Q. Sun. "Audio Registration and Its Application to Digital Watermarking," *Security and Watermarking of Multimedia Contents*, SPIE-3971:393–401, 2000.

301. N. Yasumasa, I. Shintaro, and M. Kazuto. "Digital Camera and Image Authentication System Using the Same," *Japanese Patent* JP 11215452, 1999.

302. M. Yeung and F. Mintzer. "An Invisible Watermarking Technique for Image Verification," in *Proceedings of the International Conference on Image Processing*, volume 1, pp. 680–683, 1997.

303. G.-J. Yu, C.-S. Lu, H.-Y. M. Liao, and J.-P. Sheu. "Mean Quantization Blind Watermarking for Image Authentication," in *IEEE International Conference on Image Processing*, volume 3, pp. 706–709, 2000.

304. B. Zhu and A. H. Tewfik. "Media Compression via Data Hiding," *Thirty-First Asilomar Conference on Signals, Systems, and Computers*, pp. 647–651, 1997.

Index

About the Authors

Ingemar J. Cox received his B.Sc. from University College London and Ph.D. from Oxford University. He was a member of the Technical Staff at AT&T Bell Labs at Murray Hill from 1984 until 1989 where his research interests were focused on mobile robots. In 1989, he joined NEC Research Institute in Princeton, NJ as a senior research scientist in the computer science division. At NEC, his research interests shifted to computer vision and he was responsible for creating the computer vision group at NECI. He has worked on problems to do with stereo and motion correspondence and multimedia issues of image database retrieval, as well as watermarking. In 1999, he was awarded the IEEE Signal Processing Society Best Paper Award (Image and Multidimensional Signal Processing Area) for a paper he co-authored on watermarking. From 1997–1999, he served as Chief Technical Officer of Signafy, Inc., a subsidiary of NEC responsible for the commercialization of watermarking. Between 1996 and 1999, he led the design of NEC's watermarking proposal for DVD video disks and later collaborated with IBM in developing the technology behind the joint "Galaxy" proposal supported by Hitachi, IBM, NEC, Pioneer, and Sony. In 1999, he returned to NEC Research Institute as a research Fellow.

He is a senior member of the IEEE and on the editorial board of both the *Int. Journal of Autonomous Robots* and the *Pattern Analysis and Applications Journal.* He has co-edited two books, *Autonomous Robots Vehicles,* and *Partitioning Data Sets: with Applications to Psychology, Computer Vision and Target Tracking.*

Matthew Miller began working in graphics and image processing at AT&T Bell Labs in 1979, and obtained a B.A. in cognitive science from the University of Rochester in 1986. Since then he has written several commercial software applications and delivered lecture courses at a number of universities in Europe. From 1993 to 1997, he divided his time between running Baltic Images, a company he founded in Lithuania, and consulting for NEC Research Institute. Between 1997 and 1999, he was employed by Signafy Inc. where he was jointly responsible for the design, implementation, and testing of state-of-the-art video watermarking technologies. He was also a key participant of NEC's and later Galaxy's DVD watermarking proposals. He is currently a scientist at NEC Research Institute.

Jeffrey A. Bloom has been working in the field of digital watermarking research since 1998 at Signafy, Inc. and later at NEC Research Institute. He was jointly responsible for advanced image and video watermarking technologies at Signafy and participated in the development of the NEC and Galaxy DVD video watermarking proposals. He has given numerous invited talks on digital watermarking to industry, academic, and government groups. He joined the Sarnoff Corporation in 2000 where he leads Sarnoff's watermarking R&D efforts.

Dr. Bloom holds B.S. and M.S. degrees in electrical engineering from Worcester Polytechnic Institute, and a Ph.D. from the University of California, Davis. He has expertise in the areas of signal and image processing, image and video compression, and human visual models. His current research interests include digital watermarking, digital rights management, machine learning, and data mining. He is a member of IEEE and Sigma Xi.